Praise for *Krazy*

A *New York Times* Notable Book

Eisner Award Winner for Best Comics-Related Book

A Louisiana Endowment for the Humanities Book of the Year

A *Kirkus Reviews* Best Book

A National Book Critics Circle Finalist and PEN America Finalist

"Who was the man behind *Krazy Kat*? This fascinating biography and guide to the work of the cartoonist, who passed for white, tells the full story."
—*New York Times*

"A wonderful biography of one of our greatest American comic-strip artists. . . . The surreal, Kafkaesque adventures of besotted Krazy Kat and the indifferent Ignatz are examined in this massively researched book as commentary on the artist's racial identity and the uneasy place of African-Americans in US society in the early twentieth century." —Joyce Carol Oates

"Michael Tisserand's lovingly-baked brick of a biography is essential for every comics and art lover's library. . . . Tisserand conscientiously explores the enigmatic traces of a great artist's life hidden in plain sight. He follows the diffident and elusive Herriman's journey through thickly crosshatched surrealist mesas right into the heart of America's darkness—the color line that shaped and looped through all of *Krazy Kat*'s other lines to intersect with so much of America's culture. Zip! Pow!"
—Art Spiegelman, author and cartoonist of Pulitzer Prize winner *MAUS*

"For decades I've been hoping for a new, experimental African-American voice to emerge in the language of comics, but Michael Tisserand's *Krazy* draws back the curtain on the one who's been with us all along. A true archeological dig through the details of George Herriman's Creole origins and the racial bigotry his family faced in Louisiana before reinventing themselves in California as white, *Krazy* reconnects the leads of the greatest comic strip ever to its tragic source, illuminating not only its poetic complexities, but also allowing it to burn as brightly as all of the great art of the twentieth century. Tisserand's irresistible, rollicking re-creation of the insane world of early newspapering, the unsettled West, and especially our unsettling country proves George Herriman's individual lyrical voice—an equal, I think, of Baldwin's, Ellison's, and Angelou's—was really asking the saddest single question of all: Why do they hate us so much?" —Chris Ware, author of *Building Stories*

"*Krazy* skillfully returns context to *Krazy Kat*, revealing that it could have come from no other time or place than during the accelerated rise of the American media empire. . . . Tisserand's work is impressive. His seating of Herriman's achieve-

ments among other battling art forms of the time is essential for understanding comics history." —*Washington Post*

"One of the many virtues of Michael Tisserand's richly illustrated biography of George Herriman, the creator of Krazy Kat, is its evocation of the early twentieth-century newspaper world from which it sprang."
—Cullen Murphy, *Wall Street Journal*

"[In] an authoritative new biography of Herriman . . . Tisserand is one of the first scholars to show us how Herriman's closeted life, especially his conflicting desire for acceptance and fear of exposure, affected his work."
—*Los Angeles Review of Books*

"By charting Herriman's early, bicoastal newspaper career, Tisserand, a diligent detective, gives us a glimpse into something rare: the world of early twentieth-century newspapermen. . . . Even for those of us who hate real cats, Tisserand's *Krazy* is the Kat's pajamas." —*L.A. Weekly*

"Tisserand . . . has written the rarest kind of book: scholarship that is accessible and captivating, genuinely fun to read. His prose sparkles, smooth and flowing, rich with metaphor and invention." —*Chicago Tribune*

"One of [2016's] best biographies." —*Boston Globe*

"Tisserand builds a strong case for Herriman's reach and influence as a cartoonist and illustrator . . . also bring[ing] to light the role race played in Herriman's work." —*Seattle Times*

"*Krazy*, so rich in anecdote and so warm in affection, succeeds in adding a good deal to the wonder of George Herriman's legacy—mainly by putting the artist in the last place on Earth he liked to be: in the spotlight, center stage."
—*Christian Science Monitor*

"It's one of the best true stories told in 2016." —*Philadelphia Enquirer*

"As an American history *Krazy* is an engaging dissection of a very different time not far distant from our own. As a biography, it is a fascinating look at the life of a genius cartoonist, one who helped invent the rules of comics even as he himself was breaking them." —*Pittsburgh Post-Gazette*

"Engaging, revealing. . . . Herriman's adventures in newspapering in the early years of the twentieth century are alone worth the price of the book. . . . Whether you're a longtime *Krazy Kat* fan, as I am, or a new acquaintance, this biography will enrich your knowledge of the Kat and its creator." —*Tampa Bay Times*

"Herriman's delight in anarchic transformation and gentle subversion had personal roots, as Michael Tisserand reveals in this scrupulously researched, luminously written and eye-opening biography." —*Times Literary Supplement* (London)

"Tisserand tells a big story and a compelling one. Equally spellbinding is the deeply personal portrait of a man with a secret—and a man who had many friends, loved his family, endured his share of tragedy but kept, as Tisserand puts it, 'his sense of wonder and delight.' " —*New Orleans Advocate*

"An absorbing study of a genius with a secret." —*New Orleans Times-Picayune*

"Tisserand deserves props for giving Herriman's body of work the thought-provoking examination it deserves." —*Atlanta Journal-Constitution*

"Lucky for us, Michael Tisserand's formidable new biography, *Krazy*, is here. Not only do we get a sense of Herriman's enormous influence but we also learn about this private man's life and his startling family secret. This here is an ideal holiday gift for the comic lover in your life." —*Esquire*

"Perhaps no one in his field is as deserving of a top-notch, in-depth biography as Herriman. And with Michael Tisserand's *Krazy* we now have a most valuable, studiously researched, and, indeed, definitive profile of the man that does him full justice." —*Print* magazine

"Tisserand is a thoroughgoing researcher and a great storyteller. He delivers Herriman's tale with a detective's precision, rarely intruding on the narrative as he leaves the reader to ask the obvious questions and hang on the razor's edge of suspense." —*OffBeat* magazine

"Rich in original research, New Orleans writer Tisserand's encyclopedia biography of *Krazy Kat* artist George Herriman is also an enlightening history of modern comic strips." —*Shelf Awareness*

"Tisserand's writing is beautifully free of steering; its modifiers rarely push the reader towards a set interpretation. . . . Once one has seen Herriman's mutating landscapes and the characters that whirl through it like tumbleweed, 'art' is the word that seems right; Tisserand's account helps us see how right it is." —*Rain Taxi*

"Tisserand decenters whiteness and the pseudosciences used to prop it up without pretending that they aren't key characters in Herriman's life, thus humanizing Herriman as a prolific though sometimes indecisive artist with deep-seated insecurities, without condemning him as a tragic mulatto." —*Know Louisiana*

"Herriman has been more thoroughly reproduced than just about any other of the old masters of comics. . . . [But] Tisserand's book of Herriman's life is the perfect shelf companion to all of that. It is the context, as life is the context of the best cartooning." —*The Comics Journal*

"Under Tisserand's eye, Herriman gradually becomes something more than a mere cartoonist, though Tisserand keeps from turning in a piece that's hagiographic. This is 100 percent a journalistic endeavor and all the more respectable for it. It's a huge, sprawling, and appealing overview of one of the medium's greats." —*Multiversity Comics*

"Michael Tisserand shares his decade-long dive into Herrima's personal papers, surrealistic sketches, and very private life. . . . With subtle references to race and power, *Krazy Kat* traces Herriman's reality. Tisserand's book shades in the details."
—*Garden & Gun*

"A visionary strip. Who drew it, and wherefrom? Tisserand's robust research illuminates, without diminishing, the mystery."
—Roy Blount Jr.

"An athletic feat of scholarship and an effort of love—like one of Ignatz's bricks to the head. Tisserand's immaculately researched and super-readable biography captures the madcap modernist Herriman and the weird America of surreal racial realities and publishing superpowers that shaped his revolutionary art."
—Hillary Chute, author of *Why Comics?*

"*Krazy* is crazy good—a powerful and endlessly entertaining treatment of one of our most original artists. Michael Tisserand has given us a book as bold, brilliant, and beautiful as Herriman's own body of work. This will surely stand as the definitive biography, one that will be read for generations to come."
—Jonathan Eig, author of *New York Times* bestseller *Ali: A Life*

"George Herriman was a poet in a new visual language. As a man, he was an enigma to match his greatest creation, the sublime *Krazy Kat*. Michael Tisserand has done a masterful job of illuminating this life lived in the shadowy borderlands of racial identity; along the way he also gives a brilliant overview of the golden years of American cartooning. *Krazy* is a monumental work of biography about a true American genius."
—Tom Piazza, author of *Why New Orleans Matters* and *A Free State*

"A remarkable work documenting how one of the most singular achievements in twentieth-century popular culture came to be. Michael Tisserand has dug deep in the archives and examined George Herriman's work with ingenuity and insight, emerging with a riveting narrative that wears its impressive scholarship with lightness and grace."
—Ben Yagoda, author of *About Town: The New Yorker and the World It Made*

"Essential reading for comics fans and history buffs, *Krazy* is a roaring success, providing an indispensable new perspective on turn-of-the-century America."
—*Kirkus Reviews* (starred review)

"This is a gripping read at the intersection of pop culture and American history."
—*Publisher's Weekly*

"Tisserand presents a well-researched, engaging biography of George Herriman. . . . At every step, this work brilliantly re-creates the milieu of its subject's life by shading in the historical context. A significant book for comics scholars and those interested in tracing Herriman's development from novice to master of the medium."
—*Library Journal*

ALSO BY
MICHAEL TISSERAND

SUGARCANE ACADEMY

THE KINGDOM OF
ZYDECO

KRAZY

GEORGE HERRIMAN, a LIFE
in BLACK and WHITE

MICHAEL TISSERAND

HARPER ● PERENNIAL

An Imprint of HarperCollinsPublishers

Image credits: pp. ii, iii, vi, 9, 17, 24, 28, 31, 36, 39, 43, 46, 49, 53, 63, 65, 69, 87, 122, 211, 243, 246, 248, 249, 256, 263, 270, 271, 276, 282, 298, 325, 328, 331, 341, 343, 347, 353, 355, 368, 375, 383, 394, 416, 418, 432 (2), 434, 440, courtesy Fantagraphics Books; pp. 38, 50, 51, 75, 254, 259, 279, 285, 287, 288, 316, 319, 336, 344, 359, 364, 370, 388, 395, 401, 407, 413, 429, 438, courtesy Heritage Auctions; pp. 158, 164, 181, 196 courtesy Allan Holtz/Stripper's Guide; pp.105, 110, 114, 146, 155, 186, 217, 219, 225, 245, 266, 274, 291, 305, 306, 310 courtesy San Francisco Academy of Comic Art Collection, The Ohio State University Billy Ireland Cartoon Library and Museum; pp. 92, 126 courtesy Peter Maresca/Sunday Press Books; p. 104 courtesy Christopher Stoner; p. 240 courtesy Hirshhorn Museum and Sculpture Garden, Smithsonian Institution, Washington, D.C., Gift of the Joseph H. Hirshhorn Foundation, 1966; p. 360 courtesy Tim Samuelson.

HarperCollins books may be purchased for educational, business, or sales promotional use. For information, please email the Special Markets Department at SPsales@harpercollins.com.

P.S.™ is a trademark of HarperCollins Publishers.

FIRST HARPER PERENNIAL EDITION PUBLISHED IN 2018.

Designed by William Ruoto

Library of Congress Cataloging-in-Publication Data has been applied for.

ISBN 978-0-06-173300-0 (pbk.)

18 19 20 21 22 LSC 10 9 8 7 6 5 4 3 2 1

FOR TAMI

l'il ainjil

CONTENTS

PART I: WATTA WOIL

PART II: THE GREEK

PART III: COCONINO

PART IV: MARAVILLA

The language of *Krazy Kat* presents special challenges for transcribing from comics to the pages of a biography. Capitalization and quotation marks often appear for emphasis, as well as for their expected jobs. In many cases, I was unable to determine if odd punctuations, unusual grammar, or nonstandard spellings were by design, or if they were just errors. For this reason, I have preserved Herriman's original language, grammar, and punctuation choices whenever possible. I have also preserved the line breaks in Herriman's letters.

The dimensions of this book do not allow for a full presentation of Herriman's grand comics, but I have included panels from his works to illustrate certain ideas, and to give at least a hint of their splendors. Individual cartoons and comics cited in these pages have been posted on michaeltisserand.com. I also strongly urge readers to peruse any of the collections listed in the bibliography, including those from Fantagraphics Books, Sunday Press Books, the Library of American Comics, Abrams Books, or any other publisher that is keeping *Krazy Kat* and other Herriman comics in print.

Finally, to the frustration of newspaper readers everywhere, Herriman made clear that Krazy Kat should be neither male nor female. To accomplish this, Herriman made personal pronouns interchangeable. For this book, when referring to Krazy Kat, they are avoided altogether.

PART I

WATTA WOIL

ANCESTORS

IGNATZ: It's great to be a revered and honored ancestor—
KRAZY: It is, heh?
IGNATZ: Sure is—
KRAZY: How do you know it is?
IGNATZ: Because everybody says it's great to be a revered, and honored ancestor—everybody
KRAZY: Everbody? But the "ancestor"—
　　—*Krazy Kat*, June 28, 1926

The *San Francisco Sunday Examiner and Chronicle* landed on doorsteps on August 22, 1971, on what would have been George Herriman's ninety-first birthday. Inside the paper was a story by San Francisco State University professor Arthur Asa Berger, detailing his attempt to write an entry on Herriman for the *Dictionary of American Biography*. In his research, Berger had obtained information from the New Orleans Health Department about a child of that name born in 1880. But, Berger decided, the child had to be a different George Herriman. The reason? The birth certificate was marked "colored." The cartoonist George Herriman, Berger believed, was white.

Berger finished his work for the *Dictionary* and sent it to his edi-

tor, Edward T. James. A year later he learned that his entry had been rejected. James also had sent away to New Orleans and obtained the 1880 birth certificate. Unlike Berger, James decided that it was for the same person. "Personally speaking, I have been taught a most profound lesson—for I let my 'illusions' prevent me from seeing a truth that was staring me in the face," Berger wrote candidly under the headline, "Was Krazy's Creator a Black Cat?"

Such news might have ruined Herriman, had it appeared during the cartoonist's lifetime. Herriman himself had known this. In 1907, when he was a twenty-seven-year-old staff artist at William Randolph Hearst's *Los Angeles Examiner*, the *Examiner* published front-page news stories about the racial sleights of hand performed by prominent citizens. Under one headline, "Talented Co-Ed in Chicago Proves to be Negress," the newspaper reported that a popular University of Chicago student named Cecilia Johnson had been passing for white so that she could join an exclusive sorority. She was, as it turned out, related to the notorious black gambling tycoon John "Mushmouth" Johnson. "We all liked her very much until we found out the facts," a sorority member said.

A few months later, the *Examiner* ran "Lived as Spanish, Woman a Negress," concerning a chiropodist named Dr. Madeline Francisco, whose secret was reportedly revealed when an undertaker "accidentally tore off her wig with a comb and disclosed a mass of kinky Ethiopian hair."

At the time of these stories, Herriman held a position in Hearst's legendary stable of cartoonists and sportswriters. These were some of the best gag men in the business, able to pop up a good joke faster than a fly ball at a Los Angeles Angels game at Chutes Park, where they spent many long afternoons. A favorite target in the art room was Herriman's murky ancestry. If you want inspiration, they would say, just rub Herriman's knotty locks. And good luck trying to dope out Herriman's lineage: sometimes French, sometimes German or Greek.

"If Herriman keeps insisting that he's Irish, [cartoonist Walter] Hoban and I will both turn Swedish," *New York Journal* office boy-turned-sportswriter Walter "Gunboat" Hudson would later write.

Yet their comments about Herriman's race never rose above one-liners, at least in public. There is no evidence that anyone seriously questioned just what the popular and amiable Herriman was doing working in a white newsroom, living in a white neighborhood, married to a white wife. His secret stayed safe until that Sunday in 1971, more than twenty-seven years after his ashes found their final home in Monument Valley, part of the desert land in northern Arizona and southern Utah where Herriman set his masterpiece *Krazy Kat*.

By that point, Herriman's fifty-year run in comics had long ended. Few knew his name, and fewer still knew that he had been acclaimed by his peers as the greatest cartoonist of them all. Yet, armed with a handful of *Krazy Kat* reprint volumes, fans had remained devoted. Word about the birth certificate started to spread, sparking debates about both the accuracy and importance of the document. Some embraced Herriman anew as a pioneering African-American artist. Others doubted the birth certificate was real.

First came writer Ishmael Reed, who dedicated his 1972 satirical novel *Mumbo Jumbo* to "George Herriman, Afro-American, who created Krazy Kat." Around this time, writer Stanley Crouch had a conversation with writer and critic Ralph Ellison, the author of *Invisible Man*. "He expressed amazement at the fact that Herriman was, as he said, 'a Negro,'" Crouch later wrote. "Since Ellison was a first-class cultural detective and possessed of the most penetrating mind of any American intellectual, we can assume that this was not general knowledge and had not even appeared in the mumbled underground of claims and half truths that all ethnic minorities seem to have in common."

Some friends and former colleagues of Herriman's were perplexed, even indignant. "I never saw any indication in pigmentation, facial

structure or speech inflection that indicated anything Negroid about George Herriman," recalled cartoonist Karl Hubenthal, who first met Herriman in the 1930s. Bob Naylor, who had worked with Herriman on a series of cartoons titled *Embarrassing Moments*, said he started hearing from scholars and fans, all asking the same question: "Was George Herriman a Negro?" Remembered Naylor: "I vaguely recall the subject passing through my young mind, in 1928, that he probably was Jewish."

Still, the facts seemed to be in. George Joseph Herriman was a black man born in New Orleans and raised in Los Angeles. For their own reasons, the Herrimans had obscured their identity and "passed" for white. This made it possible for George Herriman to socialize easily with whites, to attend the family's chosen school, to work on the staff of Joseph Pulitzer's and William Randolph Hearst's newspapers, to marry his white wife, and to purchase property in the Hollywood Hills bound by a racial covenant that prohibited ownership to blacks.

The birth certificate tells little of the story beyond that handwritten designation "colored." It does not reveal how Herriman imagined himself or if he feared an eventual telling of his secret. In fact, it's most likely that Herriman himself never saw the document. Comics scholar Bill Blackbeard, whose tireless work of amassing and cataloging old newspapers made much of modern comics research possible, was one of many experts who initially believed that Herriman was the son of a Greek baker. For him, the riddles of George Herriman were not answered by the new discovery—they multiplied. "What we don't know is when the day of revelation came with Herriman," Blackbeard said. "Was he told when he was twelve? Was he told when he was fourteen, when he was sixteen?"

Most important: Did this revelation, whatever it was, find its way into his wondrous comics? Is it a source of the wonder?

The answers, like Herriman himself, begin in New Orleans.

At one time, three George Herrimans resided in nineteenth-century New Orleans: George Herriman Sr.; his son, George Herriman Jr.; and George Jr.'s son, George Joseph Herriman. Only one would be buried there.

The Herrimans' adventures in Louisiana started in the winter of 1816, when Philip Spencer, a former county clerk from Poughkeepsie, New York, announced plans to purchase seventy black convicts and ship them to the Red River Valley in central Louisiana to work on a sugar plantation on the palmetto-and-cypress laden Bayou Boeuf. Northern newspapers denounced Spencer's "new speculation," especially the racial composition of the party. The Hudson, New York newspaper *Northern Whig* described Spencer's group as "black spirits and white spirits, who mingle, mingle, mingle." But Spencer paid no heed, pressing forward into Louisiana, accompanied by his wife, Susan, and their daughter, Janett.

At some point in their journey, the Spencers met up with a boat captain in his midtwenties, also seeking his fortune in Louisiana. The captain was Stephen Herriman, a fifth-generation American from Jamaica, Long Island, with ancestral roots in England. Stephen Herriman, who was white, was George Joseph Herriman's great-grandfather.

Philip Spencer died in late 1817, shortly after his arrival in Louisiana. In 1820, an auction was held on the public square in the town of Alexandria, and a parcel of the land on Bayou Boeuf was sold for taxes. Susan Spencer was forced to sell off some of her jewelry. The next year, on May 7, Janett was married to Stephen Herriman.

Most of the known facts of Captain Stephen Herriman's time in Louisiana are found in the records of his financial transactions, collected in massive blue-bound conveyance books and in smaller notary public logs, all shelved in the New Orleans City Hall. The documents first place Herriman in New Orleans in April 1819, when he signed

papers for an eighty-four-dollar debt owed him. His first registered ship was the steamboat *Hercules*, which he captained in 1828. Later that same year, the *Hercules* collided with another boat and went down in the Mississippi River. Casualties included a passenger and the ship's cook, identified as a free mulatto man. Herriman survived the accident and, over the next two decades, built an impressive career on the state's waterways. His boats would depart every Saturday morning from the foot of St. Louis Street in the French Quarter, carrying passengers and cargo downriver to La Balize, Louisiana, near the mouth of the Mississippi.

Stephen and Janett had two sons and two daughters, with one daughter dying young. In 1843, Stephen moved his family from their home near the New Orleans railroad depot to a more impressive residence at the edge of the French Quarter, on Esplanade Avenue between Bourbon and Royal Streets. He added onto that property, and the following year also purchased land on the Black River in Concordia Parish, in cotton country on the western edge of the state.

In this manner, Herriman took his place among the successful, white, English-speaking Americans who flocked to New Orleans after the Louisiana Purchase. He became a Mason and served as grand treasurer for the Grand Lodge of the State of Louisiana, organized balls at the Odd Fellows Hall, and coordinated national fund-raising efforts to aid the city during the 1853 yellow fever epidemic.

He also learned to navigate the city's complex racial landscape. When, in the 1840s, the city started requiring the registration of free blacks who were born outside of New Orleans or who were born enslaved and then freed, Herriman vouched for William Henry Jacobs, a thirty-four-year-old man described as a mulatto. Jacobs, Herriman explained, had arrived in 1816 to work for Philip Spencer. Herriman also testified that a woman named Mary Gilbert was free, and that she had been born in New York.

Yet, at the same time that Herriman was vouching for Jacobs and

Gilbert, his growing wealth allowed him to acquire more enslaved workers. The records of slave transactions are also bound in heavy volumes in the New Orleans City Hall, nearly indistinguishable from the records of property sales. In chillingly efficient language, the books describe how, in 1841, Herriman purchased a "mulatress" named Ellen and her three-year-old son James. The price was $1,000. An 1846 document itemizes Herriman's purchase of a twenty-five-year-old man named Richard, who was "somewhat of a French cook." In 1850, Herriman purchased a twenty-year-old woman

From *Krazy Kat*, March 22, 1917

named Elizabeth and her infant. The next year he bought a fami
four for $1,200.

By the early 1850s, the Herriman family had ten slaves workir
their house. At least one woman, thirty-one-year-old Sarah Ba
tried to escape. In 1853, Herriman took out an advertisement ir
Daily Picayune offering ten dollars reward for return of a "mu
boy" named John, owned by a Massachusetts native named
Payson. Herriman might have been doing a favor for a friend,
might have been working as a bounty hunter.

Stephen Herriman died suddenly on Friday, June 9, 1854, a
home on Esplanade Avenue. The listed cause of death was "
plexy," which usually meant a heart attack or stroke. His wealth
estimated at just over $43,000. Janett Herriman and her children
the Esplanade house and moved to their land on the Black R
There, a son soon died of typhoid fever, and the rest of Stephen
Janett's descendants eventually scattered across the country.

This would seem to end the tale of Stephen Herriman and
family in New Orleans. There are no heirs listed in Herriman's
beyond his wife, Janett Spencer, and their children. No conveya
book or notary public record has surfaced to indicate any finar
contact with children from a different marriage or relationship.
when Stephen moved his family to Esplanade Avenue in the e
1840s, he was also moving just blocks away from the home of a
sourceful and well-established "free woman of color" named Jus
Olivier and her two sons: Frederic and George Herriman.

U nderstanding the relationship of Stephen Herriman with Jus
Olivier and her sons requires a closer look at nineteenth-cent
New Orleans—a cultural landscape as strange and restless as
Coconino County that Stephen's great-grandson would one
bring to extraordinary life.

Gilbert, his growing wealth allowed him to acquire more enslaved workers. The records of slave transactions are also bound in heavy volumes in the New Orleans City Hall, nearly indistinguishable from the records of property sales. In chillingly efficient language, the books describe how, in 1841, Herriman purchased a "mulatress" named Ellen and her three-year-old son James. The price was $1,000. An 1846 document itemizes Herriman's purchase of a twenty-five-year-old man named Richard, who was "somewhat of a French cook." In 1850, Herriman purchased a twenty-year-old woman

From *Krazy Kat*, March 22, 1917

named Elizabeth and her infant. The next year he bought a family of four for $1,200.

By the early 1850s, the Herriman family had ten slaves working in their house. At least one woman, thirty-one-year-old Sarah Banks, tried to escape. In 1853, Herriman took out an advertisement in the *Daily Picayune* offering ten dollars reward for return of a "mulatto boy" named John, owned by a Massachusetts native named Asa Payson. Herriman might have been doing a favor for a friend, or he might have been working as a bounty hunter.

Stephen Herriman died suddenly on Friday, June 9, 1854, at his home on Esplanade Avenue. The listed cause of death was "apoplexy," which usually meant a heart attack or stroke. His wealth was estimated at just over $43,000. Janett Herriman and her children sold the Esplanade house and moved to their land on the Black River. There, a son soon died of typhoid fever, and the rest of Stephen and Janett's descendants eventually scattered across the country.

This would seem to end the tale of Stephen Herriman and his family in New Orleans. There are no heirs listed in Herriman's will beyond his wife, Janett Spencer, and their children. No conveyance book or notary public record has surfaced to indicate any financial contact with children from a different marriage or relationship. Yet, when Stephen moved his family to Esplanade Avenue in the early 1840s, he was also moving just blocks away from the home of a resourceful and well-established "free woman of color" named Justine Olivier and her two sons: Frederic and George Herriman.

Understanding the relationship of Stephen Herriman with Justine Olivier and her sons requires a closer look at nineteenth-century New Orleans—a cultural landscape as strange and restless as the Coconino County that Stephen's great-grandson would one day bring to extraordinary life.

When Stephen Herriman first glimpsed New Orleans as part of the Philip Spencer expedition, he would have looked upon a Mississippi River cluttered with flatboats, sailing ships, and the recently arrived steamboat. As he walked along the levee, he would have encountered even greater oddities than he'd seen and heard in New York. Perhaps a bagpiper lifting his feet and dancing while he played. A macaw that, its vendor promised, could speak in Chinese. It all made for "a sound more strange than any that is heard anywhere else in the world," said architect Benjamin Latrobe. "It is a more incessant, loud, rapid, and various gabble of tongues of all tones than was ever heard at Babel."

This was New Orleans, not long after Major General Andrew Jackson defeated the British at the Battle of New Orleans. The Louisiana Purchase was secure, but self-rule was still a novelty. New Orleanians had survived wars, yellow fever, hurricanes, and two fires that roared through the French Quarter. Now the city had to survive a growing population. This included thousands of new arrivals following the Haitian Revolution: whites and both free and enslaved people of color. This sudden influx meant that Stephen Herriman was seeing a city that was more black than white.

It likely was his first encounter with a group of people known as "Creoles," an elastic term that once distinguished American-born slaves from African-born slaves, and would come to mean locally born people of partial African descent, both slave and free. Over the years the word "Creole" would lurch from meaning to meaning, with some claiming it exclusively for native-born whites of European ancestors. Confusion over these meanings continues today. The broadest definition now includes anyone born in the New World from Old World ancestors, whether that Old World is in Europe, Africa, or elsewhere. As historian Gwendolyn Midlo Hall has explained, in Louisiana a Creole is best understood as someone whose cultural roots are deeply embedded in African, French, and Spanish influences.

Justine Olivier was a Creole of unclear origins. She was born some-

time around 1799 and had family in Pointe Coupee Parish, which sits along the Mississippi River northwest of present-day Baton Rouge. Pointe Coupee was the site of an attempted slave rebellion just a few years before Olivier was born. Authorities put the accused organizers on trial and executed twenty-three of them, posting their severed heads along the river to New Orleans.

Olivier was, perhaps, born among these slaves. She might have been freed in a plantation owner's will, or purchased her freedom with money she was allowed to earn on the side. Or she might have been raised in freedom, part of a class of free people of color who balanced precariously between black and white, enslavement and liberty. Free people of color might be well educated and prosperous, and some owned slaves themselves.

Among Justine Olivier's relatives was a free woman of color named Melania Olivier; they served as godmothers to each other's children, but their exact relationship is not clear. Melania Olivier's mother was Rosa Gaillard; she might have been Justine's mother as well. Another likely relative was David Olivier, a wealthy landowner with whom Justine had business dealings. Justine Olivier also had an aunt, Marie Louise Colin, who in her will left Justine both money and an enslaved woman named Charlotte.

In 1818, Olivier celebrated the wedding of Melania Olivier to Paul Cheval, a grocer and member of a prominent free-people-of-color family in New Orleans's Tremé neighborhood. By this time Justine Olivier had already encountered Stephen Herriman not long after his arrival in Louisiana.

As a free woman of color, Justine Olivier was forbidden by law to marry either a white man or an enslaved black man. She seems to have met Herriman on one of his visits to New Orleans from the Red River Valley, joining him in a *"plaçage"* relationship, in which white men set up long-term arrangements with free women of color, often establishing their mistresses and children in a separate house. Wrote

one traveler to the city: "Every young man early selects one and establishes her in one of those pretty and peculiar houses, whole rows of which may be seen in the Ramparts."

For a woman, *plaçage* might offer a means to economic improvement, if she is allowed to keep the house and furniture when the relationship ends. It's not known what long-term arrangements were made between Olivier and Herriman, but by the time of Stephen Herriman's marriage to Janett Spencer, he and Justine had two sons together. Their first, Frederic Herriman, was born around 1818, and their second child, George Herriman, was born two years later.

No civil documents cover the birth and early childhood of either Frederic or George Herriman. Stephen Herriman's paternity does not emerge until his sons reach adulthood, when both men named their father in the Catholic church records of their marriages. Stephen Herriman is not, however, listed among the witnesses to the ceremonies.

Within a few years of the birth of her two sons, Justine Olivier began a lifelong relationship with another white man, Joseph Alexandre Chessé, who went by his middle name, Alexandre. The son of a French tinsmith, Chessé worked as a cabinetmaker and also managed a ballroom. Chessé and Olivier never married: the law still forbade it. But together they raised a large family that, in addition to the two Herriman boys, included eleven Chessé children.

The earliest record for George Herriman, grandfather to the cartoonist George Joseph Herriman, is in church archives. In March 1836, Father Antoine Blanc, the first archbishop of New Orleans, confirmed a "George Herimand" in the St. Louis Cathedral. Herriman's half sister, Louise Chessé, also is listed in the confirmation records that year. At the time, St. Louis was an integrated congregation; its bell tower and spires towered over the city while in the church "white children and black, with every shade between, knelt side by side," as described by one visitor. Justine Olivier raised her children Catholic, a faith that would remain in the family through

several generations. She also ensured that her children would be well educated.

There were opportunities for economic advancement for a resourceful, ambitious woman of color in the 1830s and 1840s, and Justine Olivier seized them. Neighborhoods formed near the French Quarter from the dismantling of plantations owned by two notorious men: the politician and gambler Bernard de Marigny, credited with introducing the game of craps to this country; and a French hatter and convicted murderer named Claude Tremé. Free people of color purchased lots in both sections, living side by side with recently arrived white immigrants. Olivier bought and sold both property and slaves with some regularity, with each move rising to greater social prominence.

Among Olivier's Faubourg Marigny acquisitions were two adjoining parcels of land on History Street between Craps and Love (the location is now Kerlerec Street between Burgundy and North Rampart). She paid $2,500 cash for the properties. These two lots became the first known addresses for Frederic and George Herriman, who lived there in the mid-1840s.

Frederic worked as a carpenter, but his life would prove to be short and marked by frequent tragedies. He and his wife, Adelaide Andrieux, had three children, two of whom died as infants. In 1855 a yellow fever epidemic raged through New Orleans, and Frederic died at the age of thirty-seven. He left behind a widow and an eleven-year-old son, also named Frederic, who would grow up to be a shoemaker.

George fared much better. Throughout the 1840s and 1850s, he took steps to establish himself as a prominent free man of color in New Orleans. He courted Louisa Eckel, a twenty-year-old mixed-race native of Havana, Cuba, the daughter of a merchant who traveled between Cuba and New Orleans. On September 4, 1846, George Herriman and Louisa Eckel were married at St. Mary's Italian Church on Chartres Street. George's brother, Frederic, signed as a witness, along with members of the extended Chessé family.

By this time, George Herriman had developed a particularly close family bond with his half brother, Alexander Laurent (A. L.) Chessé. In 1847 Chessé served as godfather to Herriman's first child, Louise Carmelite Herriman. The following year they both purchased new homes on Girod Street in the Faubourg Marigny. By 1850 A. L. Chessé and George Herriman were working together as tailors, in a shop on St. Ann Street.

George and Louisa Herriman soon had a houseful of children on Girod Street. Louise Carmelite was followed the next year by another daughter, Josephine. The couple's only son, George Herriman Jr. (the cartoonist's father), was born in 1850. Three years later Marie Adelaide (Alice) Herriman was born. Also in 1853, their oldest daughter, Louise Carmelite, died during the three-year spike in yellow fever deaths that also claimed Frederic Herriman.

The following year the elder George Herriman, then thirty-four, would have learned of the death of his father, Stephen Herriman. At this time he and A. L. Chessé opened a new tailor shop on busy Royal Street near the Bank of Louisiana, in the heart of the French Quarter. Herriman & Chessé occupied the ground floor of a three-story brick building, below an upscale apartment. Customers would enter the store and walk up to one of two counters; Herriman would fit them for fine suits from imported French fabric, sewn on the latest Chicago-built machines. The tailor shop became the economic engine for several families, and it would carry George Herriman and his only son, George Herriman Jr., through a social upheaval that neither of them could have anticipated.

From the start, Tremé was a mixed neighborhood, the first lots purchased by free people of color as well as the sons and daughters of settlers from France and Spain. Residents nestled together in brick homes fronted by stoops where neighbors congregated on warm, muggy nights. Nearby, recent immigrants from Germany and Ireland

operated a series of boardinghouses in an area that would evolve into the infamous red-light district known as Storyville.

Crisscrossed by canals, brick and dirt roads, and streetcar tracks, Tremé became home to a bustling market, a parish prison, and the towering St. Augustine Church, which was built in 1841 and partially financed by free people of color. Tremé also was the site of a long-gone military fort on land that now was named Circus Place. Local law required that enslaved blacks be given Sundays off; another city ordinance stated that slaves could congregate for "dancing or other merriment" at certain locations. One of these sites was Circus Place, also known as Congo Square, which became an exotic destination for nineteenth-century tourists and is credited as a seedbed for jazz.

This was the Herrimans' home. Two family lots stood on Villere Street between Laharpe (now Kerlerec) and Columbus. This property and other Tremé lots passed in and out of Herriman and Chessé hands until, in 1867, George Herriman purchased lot number thirty-seven facing Villere Street for $800. Eight years later, he spent another $900 for the adjoining lot. Siblings and cousins were building houses on surrounding lots. George and Louisa Herriman planned for their children to be raised here, and quite likely their children's children.

Their dreams would prove elusive. By the 1850s and 1860s, as war drew nearer and white fears of slave rebellions grew, the city's free people of color were regarded with greater suspicion, their unique mixture of freedom and blackness feared as a contagion. The Herrimans faced new threats to their jobs, their children's educational opportunities, and even their ability to move freely about their city, from home to church to tailor shop.

On January 26, 1861, Louisiana became the sixth state to join the Confederate States of America. The first major battle of the Civil War took place less than three months later, when Confederate soldiers forced the Union to abandon its post at Fort Sumter, South Carolina. Yet, in strategic importance, Fort Sumter offered no comparison to

New Orleans, a major slave center and the South's most important port city. New Orleanians prepared for an invasion.

So too, it seems, did the Herrimans. The aims of the Confederacy were no secret. "Our new government is founded upon . . . the great truth that the Negro is not equal to the white man; that slavery, subordination to the superior race is his natural and normal condition," stated Confederate vice president Alexander Stephens in his Cornerstone Speech. Yet George Herriman initially responded to the impending invasion by signing up for the Confederate States Army. Not long after Fort Sumter, an article appeared in the *Daily Picayune* titled "Meeting of the Free Colored Population." Nearly two thou-

From *Krazy Kat*, January 7, 1916

sand people, the newspaper reported, met to pledge their services to the city "in case of an invasion by the enemy." Fifteen hundred men in this throng pledged to fight, representing "the flower of the free colored population of New Orleans." Among the enlistees was Herriman, who served as a private in the Louisiana Native Guards.

Herriman's reasons to join might have been similar to those of white volunteers: to protect wealth and property. He had, after all, a shop in the French Quarter and had grown up in a family that owned slaves. Yet, as a free man of color, he also faced threats that could only be answered by a very public display of allegiance to the Confederacy. All eyes were on the Herrimans and their friends to see how they would act. An 1862 newspaper article raised concerns about the loyalty of "free colored men, exceedingly saucy towards white folks," but took pains to note it was not referring to the "class of colored folks among who were raised . . . those fine companies of natives."

History does not record George Herriman Sr.'s specific reasons for his actions, but his close friends later offered more details about their support of the Confederacy. Among these was Arnold Bertonneau, a successful coffee shop owner and wine merchant, and a leader in the Native Guards movement. He later testified that free people of color were under siege from all fronts. "Without arms and ammunition, or any means of self-defence, the condition and position of our people was extremely perilous," he recalled.

Yet, it didn't take long to realize that even volunteering for the army didn't ensure respect. Free people of color were treated poorly in the Confederate States Army, with many receiving neither uniforms nor weapons. One Native Guards member recalled that they were "hooted at in the streets of New Orleans as a rabble of armed plebeians and cowards." On May 1, 1862, after skirmishes outside city limits, Union general Benjamin Butler occupied the city. His forces were quickly strengthened by free blacks. But their hopes were

dashed there as well. Blacks in the Union's "Corps d'Afrique" did not fare much better than they had in the Confederate army.

Civilian life also proved difficult. In the chaos of war, many slaves fled to New Orleans. The city teemed with the new arrivals, many desperate for work and food. Now, when George Herriman walked from his home on Villere Street to the Herriman & Chessé tailor shop, he had to show a work pass. If caught without one, he risked being taken for an escaped slave and sent to a plantation on the outskirts of town. The "free" designation in "free people of color" was quickly losing all meaning.

George Herriman Sr. decided to fight. In the mid-1860s, he helped lead what would become the largest black-led protest for rights in the nineteenth century, helping to develop models that would be used a hundred years later in the civil rights movement. Much of the effort centered around the French-language *L'Union* newspaper, which later became the bilingual *New Orleans Tribune*, the nation's first black-owned daily newspaper. Its pages were both practical and romantic, championing the cause of equality in both editorials and poetry. Its offices were on Conti Street, one block from the Herriman & Chessé tailor shop.

The newspaper's founder was Dr. Louis Charles Roudanez, a Dartmouth- and University of Paris–trained physician and a leader in the free-people-of-color community. On January 5, 1864, Roudanez helped to assemble an ambitious meeting to gather one thousand signatures on a petition for the right to vote, which *Tribune* publisher Jean Baptiste Roudanez and Arnold Bertonneau would personally deliver to President Abraham Lincoln. Signers were established men of property. George Herriman signed on, as did members of the Chessé family. Also signing was Herriman's son (and George Joseph Herriman's father), George Herriman Jr., then just fourteen years old.

On March 12, Roudanez and Bertonneau were received at the White House by President Lincoln, who advised the two visitors that a few edits might make the petition more effective. The delegation from Louisiana shocked the president by offering to immediately write in the changes. "Are you, then, the author of this eloquent production?" Lincoln reportedly asked the men in disbelief. The next day Lincoln wrote a letter to the new governor of Louisiana urging that the state give the vote to blacks—at least to those who were educated and war veterans.

On April 11, 1865—two days after the surrender of Confederate general Robert E. Lee—Lincoln gave a rousing speech at the White House, during which he spoke specifically of the progress in Louisiana. "The colored man, too, in seeing all united for him, is inspired with vigilance, and energy, and daring to the same end," he offered to the crowd, his meeting with Roudanez and Bertonneau clearly in his mind. Among his listeners that day was his future assassin, John Wilkes Booth.

Three days later, when Booth shot Lincoln at Ford's Theatre, he also snuffed out whatever support Herriman and his community had in the White House. Still, the Herriman & Chessé tailor shop soldiered on. In addition to offering fine silks and velvets, it now provided tickets to political events such as a public concert and lecture at the Orleans Theater that featured Louise De Mortie, one of the nation's most prominent black speakers. De Mortie had come to New Orleans to raise money for an orphanage and school for the children of black Union soldiers; Herriman donated to the cause. Later that year, at a raucous Republican meeting at the Orleans Theatre, Herriman was named a state party vice president.

Despite these efforts, conditions for blacks in New Orleans only worsened. President Andrew Johnson, a former slave owner, didn't consider blacks fit to vote. Declaring that the aims of the Civil War had been achieved, he granted amnesty to nearly all former Confed-

erates, who quickly returned to political power in cities throughout the South, including New Orleans.

In 1866, Herriman and other black Republican leaders hatched a plan to reconvene a constitutional convention to write into the state constitution an amendment that would give blacks the vote. For the former Confederates, here was a crisis to rival the revolution in Haiti, and they reacted swiftly. As notices in the *Daily Picayune* stoked white fears, the police force, largely former Confederate soldiers, prepared for battle.

The meeting was called for July 30 at the Mechanics' Institute, an imposing brick building in downtown New Orleans. The Herrimans' specific location this day is not known; they might have been in the throng outside the Mechanics' Institute, or they might have joined a procession of former black soldiers that made its way through the city in support of the convention. According to congressional testimony, trouble began when a white boy, about twelve or thirteen years old, started to taunt the soldiers. Going to a pile of bricks on Canal Street, the boy grabbed a brick in each hand and threatened the men. A police officer reached for him. Black men in the crowd picked up more bricks from the pile. Shots were fired. The first of the day's many black bodies lay on the street.

Firefighters and police charged to the scene from their posts at Jackson Square and the Tremé market. Officers raced through the crowd, brandishing pistols and waving axes. The day was a volley of gunfire, fists, and bricks. Mobs took over the city, some uniformed, some not. Bodies lay strewn on dirt roads and brick walks. "Carts were constantly passing, laden with the bodies of murdered negroes," recalled an eyewitness. An estimated forty-eight people were killed and hundreds more wounded. Recalled *New Orleans Tribune* editor Jean-Charles Houzeau: "It was not a battle, but a frightful massacre."

The following month, *Harper's Weekly* devoted a cover story to the tragedy. Congress held hearings, and the New Orleans riot became a factor in the impeachment of Andrew Johnson. The events inspired one of political cartoonist Thomas Nast's masterpieces, a double-page illustration titled *AMPHITHEATRUM JOHNSONIANUM— MASSACRE OF THE INNOCENTS AT NEW ORLEANS, July 30, 1866.* Nast depicted Johnson as Nero, attired in robes and garlands, surveying from a gallery the carnage in New Orleans.

For the Herrimans, the tragedies of 1866 were not over. Four years earlier, George Herriman Sr.'s stepfather, sixty-two-year-old Alexandre Chessé, had killed himself, reportedly after discovering that two women in his employment had robbed him of $10,000 in gold. Then in December 1866, four years after the Herrimans and Chessés laid their patriarch's body to rest, Justine Olivier also met a tragic end. She was traveling home from Pointe Coupee, where she had witnessed the christening of a grandchild. Her steamship, the *Fashion*, was also transporting thousands of bales of cotton. Sparks from a chimney landed on the bales. In the ensuing fire, reported the *New York Times*, the deck passengers, most of whom were black, leaped into the churning Mississippi River to avoid the flames. A fellow passenger reported that he had seen Olivier on the steamboat as it went up in flames and that she had jumped into the water, emerged two times, then finally disappeared. Her body was never recovered.

Justine Olivier and Alexandre Chessé had raised a generation of Herriman and Chessé children to prominence in a city that had grown hostile to them. Now their children were on their own.

By war's end, George Herriman Sr.'s father (whom he possibly never knew) had died, the man who raised him had killed himself, and his mother had jumped to her death from a blazing steamship. He had survived a yellow fever epidemic and a race riot. Now, with

Reconstruction taking hold, he had reason to hope that he and his family might thrive.

Initially, Louisiana promised to lead the way in postwar gains for former free blacks and slaves. The state's civil code even allowed interracial marriages. In 1872 P. B. S. Pinchback would become governor of Louisiana, which at the time was the highest office in the United States to be held by a black man. "[We are] proud of our manhood and perfectly content to stand where God has placed us in the human scale," Pinchback declared, "and would not lighten or darken the tinge of our skins, nor change the color or current of our blood."

Former Confederates fought back, pushing through laws to hamper black voting, and forming militia groups. More riots erupted; more bodies collected in the streets. Herriman and other former free people of color tried to anchor themselves in a changing society by turning to a centuries-old international fraternal organization: the Masons.

Stephen Herriman had been a prominent Mason, but on July 9, 1867, his son George joined a very different faction: the racially integrated Fraternité Lodge No. 20. With this new lodge, the *New Orleans Tribune* cheered, "the Scotch Rite Masons have taken the initiative in unfurling the banner of fraternity and equality, under whose glorious folds so much good may be accomplished."

George Herriman Sr. joined Fraternité No. 20 just three weeks after its founding and quickly rose to become an officer. The lodge met on the corner of Exchange Alley and St. Louis Street, near the Herriman & Chessé tailor shop in the French Quarter. *Tribune* editor Paul Trévigne was a founding member. So was Henry Rey, a hardware store clerk, a neighbor of Herriman's, and, like Herriman, a parishioner of St. Augustine Church.

Although Rey was a devout Catholic, he also had become famous in the Creole community for séances he conducted in Tremé homes. In these meetings, attended by both George Herriman Sr.

From *Krazy Kat*, July 27, 1921

and George Herriman Jr., figures such as Jesus Christ and Benjamin Franklin spoke through "automatic writing," encouraging those gathered to keep up their struggles for a better world. Forty years before séances and spiritualism would become themes in George Joseph Herriman's cartoons, his father and grandfather received messages from beyond, with the heroes of the past instructing them on how their souls could free themselves of their chains to wander the eternal regions in search of truths.

At Fraternité No. 20, George Herriman Sr. worked with Rey on more earthly matters. He served on the rules committee; welcomed new members from New Orleans, France, and Cuba; and assisted members with funerals. Then, on January 15, 1873, George Herriman presented his only son, George Herriman Jr., for membership.

His father looked on as twenty-two-year-old Herriman entered the temple to be praised for his courage, prudence, and modesty. Since signing the petition to Lincoln eight years earlier, young Herriman had been closely following his father's lead. They lived in the same house on Villere Street, attended the same church and the same séances, and now were members of the same lodge. The New Orleans city directory's first listing for George Herriman Jr. is in its 1872 edition; he is already a tailor, an occupation he would keep for the next half century.

The better world promised by the spirits proved elusive, however. Among the lodge members was George Herriman Sr.'s brother-in-law, Charles Sauvinet, a Civil War hero who became the first man of color to serve as civil sheriff in Orleans Parish. Neither Sauvinet's heroics nor his social standing guaranteed him fair treatment in schools and saloons, however. In 1868 his daughter had been among the twenty-eight children at the Bayou Road School suspected of being of "African descent" in a local scandal reported by the *Daily Picayune*. The school board transferred all the students, including Sauvinet's daughter, to all-black schools.

In 1871 Sauvinet sued a Royal Street tavern that had denied him a drink. He won his case, as did more than a dozen other blacks who filed similar lawsuits against saloons, theaters, and even the French Opera House. The case went to the Louisiana state supreme court, which upheld the decision. But Sauvinet had little time to celebrate his victory. The next year he was put out of his office by a new Louisiana governor, who installed his own civil sheriff. In 1873 Sauvinet was named in a suit concerning property that had allegedly disappeared under his watch as sheriff. His brothers-in-law, George Herriman Sr. and Alexander Laurent Chessé, backed him financially, putting up their tailor shop as collateral. Sauvinet was found responsible for the damages. The financial arrangement isn't clear, but during this time Herriman and Chessé sold their shop to George Herriman Jr., the judgment from the

Sauvinet case appended to the sale documents. The price of the property and shop was $10,600. (Within a few years, George Herriman Jr. would sell the shop back to his father and his uncle.)

Herriman and Chessé had risked their shop to assist their brother-in-law, but they were unable to help him a few years later. In 1878, in grief over the failing health of his son, Sauvinet put his gun to his right temple and pulled the trigger. He was at his house on Kerlerec Street when he died. The report of his gun would have been audible at the Herriman house, just around the corner.

As the turbulent 1870s ended, George and Louisa Herriman's household still had a few reasons to celebrate. On November 8, 1879, the couple attended St. Joseph's Catholic Church to witness the wedding of George Herriman Jr. to Claire Marie "Clara" Morel, a twenty-year-old mixed-race native of Iberville Parish, Louisiana. (Morel's father had died when she was two; when she was six, her mother had remarried a French confectioner named Christian Ebel. Little else is known about her family.) Just one month later the Herrimans gathered again to celebrate Alice Herriman's wedding to twenty-eight-year-old Ralph Hecaud, a musician and piano tuner.

Yet, such celebrations were short lived. Creoles of color continued to challenge segregation but now were losing more of their cases. For the Herriman family, with two children recently married and planning families of their own, no ruling would have been more discouraging than *Bertonneau v. Board of Directors of City Schools*. Arnold Bertonneau, the Herrimans' longtime friend and lodge brother, lived just three blocks from the Herriman home. He once had sat in the White House across from President Lincoln; now his children were being denied entrance to the nearest public school because of their race. In 1878 a federal judge decided this act did not violate the Constitution. The next year the courts turned back a similar case filed by Paul Trévigne.

It was into this world that George Joseph Herriman was born.

LOSING BOUNDARIES

George Joseph Herriman was born on August 22, 1880, in his parents' home at 348 Villere Street in the Tremé neighborhood. It was a hot and steamy Sunday. There are no further details of his birth, but Ralph Chessé, a cousin who grew up five blocks from the Herriman home, recalled that the family midwife was a commanding woman named Mrs. Broomhof, who "took charge like a Prussian general," enlisting grandmothers as assistants and sending fathers to other rooms, ordering pans of hot water from the woodstove and more coal on the roaring fires.

The good news didn't have far to travel. The Herrimans shared their house with young George's aunt Alice and her husband, Ralph Hecaud. His aunt Josephine lived next door with his grandparents, George and Louisa Herriman. Other cousins were scattered on surrounding blocks.

The new child would be the family's third and final George Herriman. His middle name, Joseph, honored Joseph Alexandre Chessé, the man with whom Justine Olivier had raised two Herriman boys to adulthood in the Chessé family, the paterfamilias who had died by his own hand in 1863.

On Sunday, October 17, George and Clara Herriman brought their baby boy to Father Antoine Borias at Our Lady of the Sacred Heart, a new church with a mostly black congregation, located four blocks

From *Krazy Kat*, June 19, 1933

away on North Claiborne Avenue. At the church, George Herriman Sr. stepped forward to the baptismal font to serve as *parrain*, or godfather. Eliza Ebel—Clara's mother—served as *marraine*, or godmother. Eliza had recently moved in with the family on Villere Street after her husband, Christian Ebel, died of malaria. Eliza Ebel also would die suddenly in 1883 of unknown causes, just three years after the birth of her godson.

If young George Herriman's home was like his cousin Ralph's, it was close quarters. There would have been no nursery, and for his first years George likely shared his bed with his *mère*, lying beneath a mosquito bar to ward off swarms of the whining, deadly insects. A bottle of freshly blessed holy water tied to the foot of the bed would protect against spiritual threats.

On the first day of January 1881, Alice and Ralph Hecaud added to the household commotion when their son, Hector Henry Hecaud, was born. The next year, on July 13, 1882, Clara Herriman gave birth to her second son, Henry Walter Herriman. Three young boys now shared one roof. Yet only George would be baptized at Our Lady of the Sacred Heart, for the Herrimans and Hecauds no longer were welcome in their parish church.

It had been just two generations since George Herriman Sr. was

confirmed at St. Louis Cathedral, and visitors to New Orleans had marveled at how freely white and black parishioners knelt side by side. Now, complained one missionary, "the whites who call themselves Catholics do not want the colored in church and resort to every sort of meanness to keep them out." In 1881, just one year after George Joseph Herriman's baptism, Our Lady of the Sacred Heart disbanded all church organizations that had been started by black parishioners. George and Clara Herriman returned to St. Augustine, where long-time parish priest Father Joseph Subileau, a native of France, baptized Hector Henry Hecaud on March 13, 1881, and Henry Herriman on October 8, 1882.

George Herriman never revealed specific details about his boy-hood events in New Orleans, at least not in any surviving writings or comics. In fact, he usually said he was from California. But it's likely that he grew up with a degree of comfort and stability, even as the adults around him were becoming less sure of their social and economic footing. "It was a strange, mysterious, unpredictable world, full of strange people and unexplainable happenings," recalled Ralph Chessé. "There were so many old people all around—people telling me what to do and what not to do; what to say and what not to say; where to go and where not to go. '*Ne touche pas*' was the oft-repeated command."

Among these elders was George's aunt, Rosa Esnard, the wife of Alexander Laurent Chessé. Esnard was a tall woman who favored long, black taffeta dresses and white lace. She was known to scoop family children in her lap and frighten them with gruesome tales about the *loup garou* (werewolf). Other popular tales for young chil-dren included the "Lapin" stories, similar to Brer Rabbit folktales. Such Creole stories and proverbs often turned to animal characters to make a point about human life. "Cutting a mule's ears doesn't make him a horse," Rosa Esnard might have murmured to the children, always in French.

Growing up with his cousin and brother under the same roof, George's boundaries would have included his grandparents' home next door and nearby Chessé homes. On shopping trips with his mother, George could run in the wide expanse of the median, or "neutral ground," on Orleans Street near the Tremé market. The cries of fruit vendors wafted in the air, melodic songs for fresh blackberries and eggplants. To a child, bales of cotton on flatbed carts must have floated by like clouds.

A heavy, constant rain fell the winter after George Herriman was born, leaving deep valleys in the city's shell and cobblestone roads. For drinking, rainwater was brought into the house "after the wiggling mosquito larvae had been carefully screened out," recalled Ralph Chessé. Cattle grazed nearby, and goats rustled throughout the neighborhood. Smells could be overpowering. The odor from one Tremé market seafood stand was so strong that the newspaper published editorials about it.

Walking through the iron-laced French Quarter, young George would have come across a new and bustling Café Du Monde serving steaming cups of café au lait and café noir. The chatter of cooped chickens and young boys crying out prices for bananas and turnips mingled with shouts in German, Italian, and Choctaw. "Every language spoken on the globe is slanged, docked, or insulted by uncivilized innovations on its original purity," wrote Will H. Coleman in a city guide for visitors to the 1884 World's Industrial and Cotton Centennial Exposition. Equally insulted, Coleman wrote, is any chance for racial purity. He might well have been regarding the Herriman family when he described local shoppers: "The strangest and most complicated mixture of negro and Caucasian blood, with negroes washed white, and white men that mulattoes would scorn to claim as of their own particular hybrid."

From the French Market, it was a short walk past St. Louis Cathedral, where Justine Olivier once had taken George's grandfather to be

confirmed, past the *New Orleans Tribune* offices, where family friends had gathered fearfully during the 1866 massacre, past his father and grandfather's Masonic lodge building, to the family tailor shop on Royal Street. A trip to Royal Street would also mean stopping in to see family friends who owned a nearby dry goods store. The three Cauvertie brothers were, like the Herrimans, listed as "mulattoes" in the 1880 census, and like the Herrimans, were successful business-men. "I have still filed away in my memory the odor of cottons and calicos combined with the damp, musty smell of old calsomine on the plastered brick walls," Chessé wrote about his childhood visits to the shop.

Herriman's childhood was also a musical one. Choirs and strings were heard at feast day celebrations at St. Augustine. Brass bands per-formed schottisches and quadrilles at dances and picnics, as well as marches in street parades and dirges in funeral processions.

In Herriman's own home was his uncle Ralph Hecaud, a musi-cian and piano tuner. Hecaud was related to Eulalie Hecaud, whose name is known in music history as the influential godmother of Ferdinand Lamothe, the son of a French-speaking bricklayer who achieved fame as jazz musician Jelly Roll Morton. Morton was born too late to know young Herriman in New Orleans, but he later

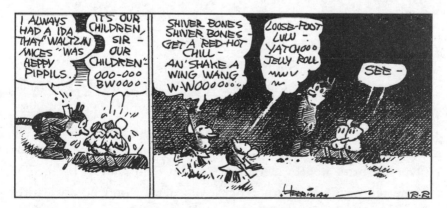

From *Krazy Kat*, December 2, 1938

would recall the Sunday parades that regularly circled the Herriman neighborhood. These were thundering processions of bands and horses and giant streamers, he said, and long days of trumpets and sandwiches and gin.

Mardi Gras brought larger parades sponsored by organizations with classical names such as Comus, Momus, and Rex. In Herriman's neighborhood, there also were street gangs of masked "Indians," Creole men who painted and dressed in Indian-inspired costumes and chanted call-and-response cries that harkened to African-Caribbean musical traditions. One inspiration appears to have been Buffalo Bill's Wild West Show, which came to town during the 1884 Cotton Expo. Dozens of Indians from Buffalo Bill's show joined the Mardi Gras processions in 1885, when Herriman was an impressionable four years old.

Remembered Jelly Roll Morton: "Even when the parades that cost millions of dollars would be coming along, if a band of Indians was coming . . . the parade wouldn't have anybody there. Everybody would flock to see the Indians." For a young child in the neighborhood, Morton recalled, the "big chiefs" seemed to magically appear in a flash of sound and color. Then they would fade away as the Mardi Gras Indians themselves returned to their work as masons, tinners, and tailors.

Just as his firstborn son was nearing the age to start school, George Herriman Jr. received another stark reminder of the threat of racial violence in his city.

In 1884 Herriman was chosen to serve on a jury to decide the fate of a blacksmith and accused murderer named Patrick Egan. Over the next months Herriman and his fellow jurors listened as witnesses described the night of the murder. Egan, who was white, and another horseshoer named Colbert Bailey, who was black, had

walked into Baltz's saloon on Royal Street. They ordered their usual: a pony of beer with ginger for Egan, whiskey for Bailey. After a short time, Egan stepped outside for a light. There he saw Baltz, the saloonkeeper, talking with Bailey and George Blake, a white mechanic from Maryland. Blake was holding Bailey's arm. Blake, full of liquor, made a grab for Egan, who pulled out a pistol and fired twice.

The case occupied Herriman and other jurors for the rest of the year. Discussion centered around whether or not to allow testimony about the feelings of Blake toward white men who associated with people of color. The jury ultimately sentenced Egan to be hanged; he appealed and received a life sentence of hard labor.

The shooting took place less than a block from Herriman & Chessé. Sudden violence over an errant racial comment wasn't unusual; the newspapers were filled with similar occurrences. Then there were lynchings: Louisiana's total of 313 blacks lynched between 1889 and 1918 was only surpassed by those of Georgia, Mississippi, and Texas.

Herriman also knew that he was losing the chance to properly educate his sons. His friends Paul Trévigne and Arnold Bertonneau had tried and failed to integrate public schools. Of the sixty Catholic schools in New Orleans in 1885 only five now accepted black students. From 1879 to 1917, there were no city-run public high schools available for blacks. Robert Mills Lusher, the state superintendent of education, infamously declared that the purpose of education was for white students to be "properly prepared to maintain the supremacy of the white race."

The mid-1880s brought numerous changes for the Herriman family. On May 25, 1885, the Herrimans' first daughter, Mary Louisa (who later would be known as "Ruby"), was born. In August 1886, George Herriman Sr. wrote to his brother, Alexander Laurent Chessé, from Paris, where he and George Herriman Jr. were purchasing fabrics for the tailor shop. After his return, in the summer of 1887, George

Herriman Sr. sold his share of the tailor shop to Chessé for $5,000, dissolving the decades-long Herriman and Chessé partnership. In August 1887 George Herriman Jr. purchased his first house away from his parents, across Canal Street on Jackson. Still, he remained close to his father, borrowing $1,300 in cash for the new home. A new Herriman & Son tailor shop opened on bustling Customhouse Street, just one block from Canal.

On March 9, 1888, the family added another daughter when Louise Herriman was born. The next month she was baptized under the name "Camillia," and she would later go by "Pearl." Louise was not baptized at St. Augustine, and neither of George Jr.'s parents served as godparents. Instead, Louise, or Camillia, received the sacrament at St. Anthony's Chapel, a church that served Italian immigrants, located on Esplanade near the Mississippi River. This is the first indication that George Herriman Jr. might have been exploring the option of having his young family pass for white.

The Herriman and Chessé families remained close. On February 26, 1889, Josephine Herriman, the last unmarried child of George and Louisa Herriman, married Theophile Esnard, a local businessman and son of a Cuban immigrant. Theophile's sister was Rosa Esnard, the family storyteller and the wife of Alexander Laurent Chessé. The Esnards and Herrimans celebrated the wedding at St. Augustine, and George Herriman Sr. and George Herriman Jr. both served as witnesses.

The Esnard-Herriman wedding proved to be one of the last times the extended family would come together in celebration, however. On August 18, 1890, George Herriman Jr. sold his house on Jackson Street. He had owned the property for only three years. The transaction seems to have been conducted in a hurry; the sale was for $1,100, which was $200 less than the purchase price. Soon after, George Herriman Jr., his wife Clara, and their children would leave New Orleans, never to return.

I n 1892, in a heroic effort to integrate local train cars, St. Augustine parishioner Homer Plessy stepped on board the East Louisiana Railroad express and moved to the whites-only car. The conductor regarded Plessy. "Are you a colored man?" he asked. Plessy replied that he was. Then, in a strategy that would be successfully employed sixty-three years later by Rosa Parks in Montgomery, Alabama, Plessy stated that he would rather be arrested than give up his seat. *Plessy v. Ferguson* went all the way to the United States Supreme Court, which ultimately decided against Plessy and ruled that "separate but equal" accommodations were constitutional.

George Herriman Jr. would have known Plessy from church and other social functions, and the Herriman family's efforts helped lay the political groundwork for Plessy's challenge. Yet, by the time Plessy stepped onto the train car, George Herriman Jr. had reestablished his family in Los Angeles, having opted for another method to shield his children from racial oppression and violence: *passé blanc*, or passing for white.

Racial passing was—and remains—a controversial practice. Only a select number of blacks had the opportunity to pass. Although there are no existing photographs of George and Clara Herriman, photos of George Joseph Herriman reveal a shade of skin and general physical characteristics that might, to some eyes, render him racially ambiguous. Members of the Herriman family, it appears, were what some Creoles called "nations," able to present themselves in many different lights.

Passing was, by definition, a divisive strategy. Some could; others couldn't. In popular novels such as Nella Larsen's *Passing* (1929) and Fannie Hurst's *Imitation of Life* (1933), the story generally plays out the same way: first the decision to pass, then the inevitable discovery and ruined lives. William Faulkner and Ralph Ellison both created characters who passed for white and suffered tragic consequences. "The

From *Krazy Kat*, February 21, 1931

character who jumps the color line is a fascinating American rogue," wrote the critic Touré in 2010. Such racial shape-shifters, he added, have "Huck Finn's independence, an identity in turmoil, a secret that could destroy their world, a refusal to be defined by others and a vantage on race that very few ever get to have."

Edward Larocque Tinker based his 1928 novel *Toucoutou* on the court case of a mid-nineteenth-century New Orleans woman named Anastasie Desarzant, who had filed and lost a slander suit against neighbors for referring to her as a person of color. She became a target for ridicule when a local barber—and Herriman family friend—named Joseph Beaumont composed a satirical song titled "Toucoutou." Soon Beaumont's sharp lyrics could be heard across New Orleans: "Who does not know you? / No soap will make you white." Louisiana-born jazz trombonist Edward "Kid" Ory recorded a full-band version of the "Toucoutou" tune titled "Blanche Touquatoux."

Creoles in New Orleans have two distinct phrases to describe passing: *passé blanc* and *blanc fo'cé*. One is passive, the other active. "While the first term seems to depend mainly on the perception of others, *blanc fo'cé* gives the impression of actively forcing or falsifying a perception of whiteness," writes Shirley Elizabeth Thompson in *Exiles*

at Home. Passing also has been referred to as "losing boundaries," but for many Louisiana Creoles, the decision wasn't really like a border crossing, past a single racial checkpoint from one territory to another. Passing might better be seen as a lifelong journey that involved frequent crossings.

Adding to the confusion, legal definitions of race shifted constantly during the Herrimans' years in New Orleans. In 1850 the federal government added the designation "mulatto" (the word is related to "mule") to describe Americans with mixed ancestry. It was used, along with "colored" and "negro," as an official description of the Herrimans. Yet, when questioned as part of court proceedings if he was colored, George Herriman Sr.'s brother-in-law, Charles Sauvinet, replied, "When I go among strangers I am received as a gentleman." He added: "I never inquired whether I was received as a white or colored man." Another family member, J. B. Esnard, when asked about his race during a congressional inquiry about the 1866 Mechanics' Institute riot, offered an assessment of his ambiguous identity that Krazy Kat would appreciate: "I cannot answer that: I do not know exactly whether I am or not."

Some Creoles maintained separate racial identities for work and home. Still others passed for church. One man recalled that his father didn't want him to go to Sacred Heart Church—the church where George Joseph Herriman had been baptized—because "he said there was too much discrimination there." So, he said, "I had an aunt living in St. Louis Cathedral's parish and I went there white."

This type of selective passing seemed to take place within the Herriman family, as well. The 1880 census listed the Herrimans as mulattoes, but Ralph and Alice Hecaud—who were living in the same house as George and Clara Herriman—were recorded as whites. The next year their child, Hector Henry Hecaud, was baptized at St. Augustine. The church maintained two registers of sacraments—one for black, the other for white. Hecaud's name was inscribed in the *Registre*

From *Krazy Kat*, May 4, 1941

des Baptêmes pour les personnes blanches, or "the white book." Hecaud appears to have passed as white for the rest of his life.

Choosing to pass might lead to a lifetime of editing out anything or anybody that did not fit into the new story. Born in New Orleans in 1920, the writer Anatole Broyard grew up two generations after George Herriman in a family that had, like the Herrimans, played a central role in the nineteenth-century struggle for civil rights. Broyard later moved to New York, where he gained stature as a writer and as the literary critic for the *New York Times*. He lived his life as a white man, falling out of touch with members of his family who didn't pass. His daughter, Bliss Broyard, in her memoir *One Drop: My Father's Hidden Life—A Story of Race and Family Secrets,* remembered picking up an old issue of *Commentary* magazine and noticing a neat incision on the left-hand corner of the first page, where her father had taken a razor to an editor's note that made reference to his intimate knowledge of black life. "Once again here was my father picking and choosing about how he would be presented to the world," Bliss Broyard wrote. "Here he was hiding in plain sight."

"The darker the skin, the more explanation is needed, or the more silence," said scholar Wendy Gaudin, a Creole who grew up in Cal-

ifornia. At the 1909 National Negro Conference in New York City, activist and educator William L. Bulkley addressed the issue head-on: "There is scarcely a colored man who could not tell of some friend or relative who has crossed the line North or South, now prominent in business, professors in institutions of learning, married into good society, and rearing families that have no dreams of the depths that their parent has escaped. We could tell the story, if we would, but who would be the knave to disturb their peace?"

For some, the peace could only be disturbed in art. Bliss Broyard recalled that her father had told her that if she wanted to know him better, she simply should read more of his writing. "Throughout my father's writing ran the theme that a person's identity was an act of will and style," she discovered.

Ralph Chessé—whose grandfather was Alexander Laurent Chessé, George Herriman Sr.'s partner in the tailor shop—went on to become a renowned Works Progress Administration (WPA) painter and puppeteer. He also moved from New Orleans and passed for white. Chessé's paintings frequently depicted black life, even lynchings. As a regional director of puppetry for the Federal Theatre Project during the Great Depression, he staged a marionette version of Eu-

From *Krazy Kat*, March 13, 1931

gene O'Neill's *The Emperor Jones*, a tale of an escaped black murderer who establishes himself as a white ruler of a Caribbean island. Chessé returned to the *Emperor Jones* story repeatedly, staging it several times throughout his career.

It would fall to George Joseph Herriman to find his way to tell his family's story. In a *Krazy Kat* comic published on February 11, 1917, Joe Stork reveals that he delivered the infant Krazy to a lowly wash-boiler in the cellar of a haunted house. Following the news, Krazy walks around sporting the wash-boiler, shunned by the other animals of Coconino County. The story of Krazy's birth is, Herriman writes, "a tale which must never be told, and yet which everyone knows."

P assage from New Orleans to California was found aboard the Texas and Pacific Railway, which departed New Orleans each morning at eight. Sometime around George Herriman's tenth birthday, in late August of 1890, his father went down to the corner of St. Charles Avenue and Terpsichore Street and bought tickets for a family of six: George and Clara Herriman and their four children: George, Henry, Ruby, and Pearl. They were in Los Angeles by September.

The rest of the extended family remained in New Orleans, where they stayed close. In 1891, George Herriman's uncle and aunt, Theophile and Josephine Herriman, had a daughter, Marie; his other aunt, Alice Hecaud, served as the child's godmother at St. Augustine. Alice and her son Hector lived with the Esnards, in the house where George Joseph Herriman had grown up. Next door, George Herriman Sr. still worked as a tailor, yet he also became a banker of sorts, purchasing property and then reselling it to the previous owners for promissory notes plus interest.

On Sunday afternoon, March 2, 1902, George Herriman's grand-mother, Louisa Eckel Herriman, died at home after a bout with pneu-monia. She was seventy-six years old and listed in the death certificate as being white. Five years later, in the same house on Villere Street, her

husband, George Herriman Sr., at eighty-seven, also passed away. The family gathered on Villere Street and then later on Esplanade Avenue, where his body was interred at St. Louis Cemetery No. 3.

George Herriman Sr. had been careful with his money, placing $8,000 in three banks, with gold and nearly $5,000 in cash and bonds stored in a lock box. George Herriman Jr. did not make the trip to New Orleans for his father's funeral. The previous year he had visited a notary public in Los Angeles and signed a power of attorney to his brother-in-law, Theophile Esnard. In 1908 he sold his portion of the Villere Street property to his sisters for $600.

In fact, there is no evidence that George or Clara Herriman, or any of their children, ever returned to their native city. As George Joseph Herriman's fame as a cartoonist started to spread, however, his aunts in New Orleans would have had the opportunity to follow his career. Before her death on April 8, 1928, Josephine Herriman Esnard might have read her nephew's comics in the *New Orleans Item*, and for a dime she could visit the Empire movie theater to see *Krazy Kat* films, which were billed in the *Item* as "Herriman's Animated Cartoons." Yet, nowhere in the newspaper did it mention that the cartoonist was from New Orleans.

In 1940, at the age of seventy-seven, Alice Herriman Hecaud died at her home on Villere Street. She was the last living child of George Herriman and Louisa Eckel. It had been sixty years since she and her brother, George Herriman Jr., watched their young sons grow up together under the same roof. It had been a half century since her brother moved his family to Los Angeles. Although she appears to never have seen her brother's family again, she did have a chance to witness a homecoming of a different sort. On Thursday, November 29, 1934, the streets of downtown New Orleans filled with spectators for a parade to herald the Christmas season. Children marched with pet dogs, roosters, turtles, and squirrels. A hundred painted clowns pranced alongside papier-mâché storybook characters. High above soared a procession of massive rubber figures, among them a giant Krazy Kat.

AS THE OFFICE BOY SAW IT

I n 1883 a golden spike near the Pecos River in West Texas marked the completion of the final section of track linking New Orleans and Los Angeles on the nation's second transcontinental rail line. The southern route passed through Louisiana and into Texas, New Mexico, and Arizona before reaching California. Some passengers enjoyed a cushioned journey in a Pullman sleeper, where porters offered pillows at night and chefs prepared multicourse meals. Most likely, the Herrimans were not among them.

Money was tight. Three years earlier, George Herriman Jr. had borrowed from his father for a new house and then sold that property for a loss. The distinguished name of Herriman & Chessé—the tailor shop whose proprietor had toured Europe for new fabrics—would have no currency in Los Angeles. Most likely, the family of six bedded down in an "emigrant car," with slat benches and adjustable seat backs, wooden planks to lie on at night, and a stove at one end where families took turns cooking.

The writer Robert Louis Stevenson, who also rode an emigrant car across the country to California, recalled newsboys who walked up the aisles, selling cigars, coffee pitchers, and tins of hash and beans. "A man played many airs upon the cornet," he said, "and none of them were much attended to, until he came to 'Home, Sweet Home.' It was

From *Krazy Kat*, May 19, 1921

truly strange to note how the talk ceased at that, and the faces began to lengthen."

A less romantic view was offered by an Arizona woman on the leg from Tucson to Yuma, who found herself on an emigrant car when there were no first-class accommodations available. "The emigrant car was filthy in the extreme," she wrote to the *Los Angeles Times*. "All classes were mixed together. Chinamen, emigrants, Mexicans, laborers and people smoking tobacco."

George Joseph Herriman could turn away from the commotion and look out the window with the eyes of a boy seeing the world for the first time. Dense bayous changed to open prairies, then to pink and orange deserts. There was the passing of dusty western towns like San Antonio and El Paso, Tucson and Yuma. When the train pulled into Los Angeles, he had arrived in his new hometown. Here, the Herriman family, like so many other westward travelers, was starting over.

T he gateway to the Herrimans' new lives was Southern Pacific's Arcade Depot, a newly built wood-and-awning palace with a ninety-foot arch that opened to the palm trees of Alameda Street. Nearby, hotels and boardinghouses offered lodging for those just off the train. Saloons promised free lunches for the price of a drink. Four blocks north on Banning Street, nestled amid feed yards, corrals, and warehouses, waited the Herrimans' first home in California. Laying their heads beneath a rented roof, the family could hear machinery turn just a few doors away at the Los Angeles Soap Company, which churned out borax and whale oil soaps throughout the night.

For the Herrimans, Los Angeles must have seemed a small and graceless town. New Orleans in 1890 was the twelfth-largest city in the country, with a population of nearly a quarter million souls. Los Angeles had only fifty thousand, many of them new arrivals. It had been just forty years since California became a state.

Yet Los Angeles was a city in quick change, "like a vaudeville actor putting on a new costume for every act," in the words of Harry C. Carr, the future *Los Angeles Times* editor who would become a close friend of George Herriman's. Carr had arrived just a few years before the Herrimans on his own emigrant car from Iowa, and he wasn't alone. California had been busy selling itself to the nation. The state sent oranges to the 1884 World's Industrial and Cotton Centennial Exposition in New Orleans, and in 1888, *Times* owner Harrison Gray Otis and other business leaders embarked on what was the most massive promotional campaign that had been undertaken for an American city, printing more than two million flyers and dispatching "California on Wheels" train cars across the country. The state's population doubled in the ten years from 1880 to 1890.

Why did the Herrimans choose Los Angeles? Possibly, George Herriman Jr. had tasted one of those oranges or read one of those flyers. Perhaps he figured that this new paradise would need tailors.

But he never established himself in his own business, as his father had done in New Orleans. Soon after his arrival, he found employment with the tailor M. D. Godfrey, in a shop on First Street in the heart of the business district. He remained with Godfrey for about three years, then, for unknown reasons, moved on to another employer. He became an active member in the local Tailors' Union No. 81, but for the rest of his life he would move from job to job through a series of shops and small factories, never staying at the same place for more than a few years.

More likely, the family moved for their children's future. As school doors closed in New Orleans to students of color, priests were arriving with news of St. Vincent's College in Los Angeles, a growing school that offered a rigorous education, commercial degrees, and careful instruction in the Catholic faith. There were no black students allowed at St. Vincent's, but the Herrimans had a way around that restriction. Just a few weeks after George Herriman's tenth birthday on August 22, 1890, St. Vincent's started a new school year. Its rolls included George and Henry Herriman.

St. Vincent's College was a modern school for a modern age. The new campus had opened at the corner of Washington Street and Grand Avenue just three years earlier, in 1887. The main building was three stories tall, with lofty ceilings and spacious halls. Laboratories for chemistry and physics classes occupied the first floor, along with dining and recreation halls. The main floor was one level up and was entered under a "fine Gothic porch," reported the *Los Angeles Times*. This opened to classrooms, recitation rooms, and a study hall that seated two hundred students. A cloister attached the school to St. Vincent's Church, which offered Masses in both English and Spanish.

Father Aloysius Meyer, a German immigrant educated in France

and raised in Illinois, ran the school. In 1890, 126 enrolled students—including George and Henry Herriman—received instruction from a small army of robed priests, who also coached the school's championship football and baseball teams. Students came from California, Arizona, and Texas, with a few from as far away as Wisconsin and New York. Boarders paid $140 for each five-month school session. Los Angeles residents such as the Herrimans paid the day-pupil rate of $25 per session. There were extra charges for piano instruction, for academic degrees, and to learn typewriting. George Herriman Jr. was expected to make payment for his two sons before the first day of classes.

From *Krazy Kat*, October 15, 1934

George and Henry both enrolled in St. Vincent's collegiate course, studying grammar, elocution, ancient and modern history, natural philosophy, mathematics (including trigonometry and calculus), astronomy, metaphysics, Latin, and Greek. Catholics such as the Herrimans were required to attend confession each month, and each would receive Communion "as often as permitted by his confessor," according to a school catalogue. Expellable offenses included "refusal to submit to punishment, and open contempt of religion."

Doors opened at eight each morning and closed at three thirty. As day pupils, George and Henry Herriman likely rode the streetcar to and from school, but the family could all come to St. Vincent's for special events, such as school fairs, when the grounds were illuminated by locomotive headlights and Chinese lanterns, and church women dressed as Indians and served lemonade. Other days brought lectures on missionary work in China, and even a controversial speaker named Dr. Allen Griffiths, who preached the gospel of theosophy, detailing human evolution while, according to the *Times*, making contemptuous gestures toward heaven.

Humor among the boys of St. Vincent's included constant punning and, according to the student newspaper, the "excessive use of French phrases." Colorful figures at St. Vincent's included the school's cook, a cartoonish character with whiskers worn in the "latest pumphandle style," who said his prayers in French when he wasn't swearing in Spanish or scooping potatoes off the floor in Dutch.

By the time the Herriman boys entered their second year, their father was able to move the family away from Alameda's boardinghouses, taverns, and factories. George Herriman Jr. purchased a small home at 2144 Glowner Street at the southern reaches of the city, in a neighborhood that had more hog corrals and chicken coops than houses. Again, the family appears to have primarily moved for the children: St. Vincent's was just seven blocks away.

For George Joseph Herriman, the move would prove significant

for another reason. Five blocks from the Herrimans' new home, at 831 East Twentieth Street, a plasterer and brickmason named Marcus Bridge and his wife, Amy, were raising two daughters. The youngest girl, Mabel, was one year younger than George. She had dark hair and plump cheeks, and in the decade following the Herrimans' move to the neighborhood, George Herriman and Mabel Bridge would marry. It's not clear when they began to date, but a friend would later describe them as childhood sweethearts.

Also by their second year at St. Vincent's, both Herriman boys were bringing home high marks from their teachers. Henry Herriman received honors in penmanship, arithmetic, Christian doctrine, and dictation. George received honors only in penmanship and geography, but in his third year received a "Special Premium" for courses ranging from grammar to geography, and would earn praise for his work in Christian doctrine, Latin, and English composition. The multilingualism of *Krazy Kat* would owe a debt to St. Vincent's: adding to French (his first language) and English, George Herriman now learned Latin and German. Over the years he would pick up conversational Spanish and Navajo as well.

Drawing and painting lessons at St. Vincent's cost an extra two dollars for each session. There are no school records indicating that George Herriman took any of these classes. Among Herriman's friends and fellow students was Leo Carrillo, who later drew comics for the *San Francisco Examiner* before turning to acting and eventually being cast as the sidekick Pancho on television's *Cisco Kid*. Carrillo recalled that cartooning at St. Vincent's was a punishable offense and that he had been "reprimanded for drawing cartoons and caricatures of my fellow pupils."

Yet, if the priests prohibited cartooning, they fostered in George Herriman a voracious reading habit, introducing him to classic works that would surface in his comics again and again. In Greek class, Herriman read Aesop's fables, animal tales he reimagined in some of

From *Krazy Kat*, September 5, 1934

his first newspaper comics, as well as in *Krazy Kat*. Herriman read Shakespeare in school and had the opportunity to attend special Shakespeare evenings and public lectures, including a performance by Frederick Warde, who in 1912 would portray Richard III in what is considered the earliest surviving American feature film. Herriman would later build gags from Shakespearean quotations and incorporate Elizabethan English into Krazy Kat's language. Also at St. Vincent's, Herriman encountered his other major literary influence: Miguel de Cervantes's *Don Quixote*. Herriman would return to Cervantes's story of a mad knight to mine names and characters, as well as borrow Cervantes's grand themes of holy illusions and obsessive devotion.

In 1895, Clara Herriman gave birth to her third daughter, Daisy. By now George Herriman Jr. had left M. D. Godfrey to work for H. F. Gabel, whose Spring Street shop, Gabel the Tailor, was hiring coat makers at eighteen dollars a week. He moved to a new job the next year as part of a fifty-tailor hire by Jacoby Bros., one of

From *Krazy Kat*, April 1, 1917

the city's largest clothing retailers. Jacoby's colorful picture window on Spring Street was a popular downtown destination, with crowds gathering to see its Catalina Island display featuring a live alligator and a 2,700-gallon fish tank. But Herriman soon left this employer too, going to work for Buffalo Woolen Co., which had posted a notice that it was hiring five new coat makers.

It was a time of change for young George Herriman as well. On the morning of May 13, 1896, he and his classmates piled into a decorated six-horse stagecoach for an hour-and-a-half-long ride to a stock farm in Compton for the school's annual field day outing. The *Times* reported: "As the long line of jolly boys and their friends swept along it was greeted with cheers from all who passed by, to which the expedition gave answer with the college yell: 'Rah rah rah! Hoop vah zee! Yell boys! Yell boys! S.V.C.!'" At Compton the students poured out of the stagecoach for a day of three-legged races and egg-and-

spoon races, baseball, and broad jumps. Before climbing back into the stagecoach, the boys gathered for a class picture. It is the first known photograph of George Herriman. In it, he stands in the center of the group. Other students fool around behind him, making faces and tipping their hats; but he poses respectfully, tilting his head a bit to the right, looking straight ahead with a slight smile. His hair is parted in the center beneath a wide-brimmed hat, and he is dressed in a suit and high collar. The photograph was taken just a few months before his sixteenth birthday.

In his final year in school, George Herriman joined the St. Vincent's Lyceum, which gave advanced students "an opportunity of perfecting themselves in English Literature and the Art of Oratory," according to the school catalogue. On Tuesday, May 26, 1896, the Lyceum sponsored a public debate, with its twenty-three members taking on the question of Cuban independence. The next month the

From *Krazy Kat*, May 19, 1918

annual Literary Exercises were staged at the grand Los Angeles Theater. Once again George Herriman received the highest honor for English Composition. Two days later, students returned to the Los Angeles Theater for commencement exercises, and Herriman's school days were over.

A small yet unusual advertisement appeared in the center of the twelfth page of the *Los Angeles Times* on Sunday, April 28, 1895. It is a drawing of an animal in a suit and top hat, holding a cane. The ad is for Gabel the Tailor, and it ran during the brief period that George Herriman Jr. worked for H. F. Gabel.

The ad looked like no other clothing ads in the paper. Most displayed only blank-faced gentlemen and typeset letters. By contrast, the animal in the Gabel the Tailor suit crudely approximates the creatures that T. S. Sullivant was drawing for *Life* magazine. The lettering is by hand, with spontaneous capitalization and punctuation: "Bear in Mind we can Fit—Any Shape HELLO! SUITS TO ORDER $15.00 High Kicking Trousers TO ORDER 3.50 Gabel the Tailor." The final *S* in "SUITS" extends into a long underline, and the top of the *G* in "Gabel" unfurls a little banner over the name.

The lettering is markedly similar to that seen in George Joseph Herriman's first newspaper cartoons. The advertisement is unsigned, so there is no way to confirm the artist's identity. But the similarities to Herriman's early work suggest that George Herriman Jr. might have informed his new employer that his son had a knack for drawing, which would make this ad Herriman's first known published drawing.

It is otherwise unclear just how Herriman first found his way to newspaper work. Herriman's own recollections don't help. Later in his career he composed a series of short letters to magazines about his youthful misadventures before he became a cartoonist. Most of his

From *Krazy Kat*, May 12, 1915

letters fly in the face of all documented facts of his family's life during this time.

Writing to the *Dead-Line* magazine in 1917, Herriman acknowledged a humble childhood as well as some later health problems. He wrote: "We were born in Los Angeles, Cal., and raised on plain skimmed milk taken out of a gourd bottle—glass ones being too expensible and high-toned them days—and whether it was the milk, or that we inhaled a few gourd seeds, it seems like we did not get a fair start—being a trifle anaemic and stubby, and also addicted to rheumatism."

HOTEL PETROLIA, SANTA PAULA

From "Beautiful and Prosperous Ventura County," *Los Angeles Herald*, August 15, 1897

In a letter to *Ziff's* magazine in 1926, Herriman said that he was the son of a baker and that his father planned for him to continue the family line. "Once, when a youth, I aspired to become a baker, a kneader of dough, to mould bread and fashion a doughnut or stencil a cookie. Full of the spirit of adolescence I buried a dead mouse in a loaf of bread once—it found its way into a tough family and not only did I get a sweet trimming but I got the air also. . . . Then I became a cartoonist—as a sort of revenge on the world."

In another letter Herriman added a moral: "Our father tried to tell us in his learned way not to forsake the bakery for art. Bread, said he, the world must have and will forever cry for, but art, while a few cry for it, still it allays neither hunger nor thirst.

"There are a thousand bakeshops and bun emporiums to the art

shop and nobody ever sees any art wagons on the highways, but look at all the bread busses and the bun cabs we see dashing about at all hours answering the wild calls of a starving populace."

There was, however, no family bakery. The stories suggest that George Herriman Jr. might have attempted to bring his son into the family tailor trade—or perhaps young Herriman did have one brief fling with baking. Among his father's employers was Bernard Gordon, a tailor who, in 1894, converted part of his Spring Street operations into a bakery, restaurant, and saloon named the Royal Bakery. It served everything from fresh crullers to fried brains, and briefly made the newspapers when an employee with a circus past as a glass eater tried to end his life by chewing up two whiskey glasses. It is possible that Herriman helped his fifteen-year-old son find a job at the Royal Bakery in the summer of 1896, when the boy was out of St. Vincent's and searching for a job.

The picture becomes clearer on Sunday, August 15, 1897, exactly one week before Herriman's seventeenth birthday. Angelenos who plunked down a nickel for their *Los Angeles Herald* could turn to page twenty-four of the twenty-eight-page newspaper to read a long article extolling Ventura County as "the Land of Barley and Beans, Luscious Fruits and Fragrant Flowers." Few readers would have noticed that three of the five illustrations on the page—realistic depictions of the Hotel Petrolia, the Hotel Anacapa, and the wells of the Union Oil Company—are each signed with a tiny *GH* in the lower right corner.

George Joseph Herriman dismissed any warnings about forsaking either the bakery or the tailor shop. When he signed those three drawings, Herriman declared that he had chosen art, no matter how few were crying for it.

T he *Los Angeles Herald*, the "Leading Democratic and Free Silver paper in Southern California," was first published in 1873. It trumpeted its coverage of news, sports, politics, theater, courts,

and mining, and noted that its articles were "illustrated by some of the finest newspaper artists in the land."

The newspaper's offices stood at the corner of Broadway and Second Street. Herriman likely visited the newspaper sometime in the summer of 1897, squeezing past downtown shoppers who crowded at the newspaper's picture window to watch the printing press in action and to try to guess the number of particles in a vial of Klondike gold.

The front doors opened to a handsome interior of oak, pink marble, and gleaming brass. Across a heavy rug was a roll-top desk, where sat editor William A. Spalding, a larger-than-life figure who became a local legend when, in 1879, as a reporter for the *Los Angeles Express*, he had a lunch date with the then-editor of the *Herald* and pulled out his pistol and shot at him. The shot missed, grazing a bystander on the leg instead. Somehow, Spalding both escaped jail time and took over the *Herald* editorship.

A glass-paneled door led to the art department, which was divided into a drawing room, a photographing and etching room, and a dark room. The head of the *Herald* art department was Andy Barber. Ten years older than Herriman, Barber was a versatile if limited artist as well as an amateur Shakespearean actor.

The *Herald*, like other newspapers of the time, used two primary methods for getting illustrations onto the page. In photoengraving, a photograph is taken of an illustration. An etching is then made through a process that involves a zinc plate, light-sensitive gelatin, and acid. The other method was the chalk plate. The process started with hard chalk being layered on flat steel plates. The chalk plate artist first traced the drawing—which might be his own work or another artist's—and then plowed his way through the chalk with a sharp steel pencil, blowing the dust away as he worked. Molten lead was poured over the plate, producing a cut for printing. As the *Herald* art department's office boy, Herriman would have traced the work of established artists such as Robert Edgren and Homer Davenport for use in

the *Herald*, helping him develop his own caricaturing skills. He would also have copied the drawings of Jimmy Swinnerton, the *San Francisco Examiner*'s rising cartoonist and Herriman's future friend and mentor.

No signed Herriman work appeared in the *Herald* for two months following the Ventura County illustrations. Then, on Tuesday morning, October 19, Herriman published his first sports cartoons when he caricatured railbirds at the horse track. Herriman had attended the Monday races at Agricultural Park and sketched three of his fellow spectators. The lines are scratchy and the poses are frantic. A bulbous-nosed figure dances with a fist of dollars in *Uncle Silas Wins a Wad*; a man grins at a ticket in *Bet on the Right Horse*; and in *Pat's Unlucky Day*, a gambler is shocked by his own bad fortune, a cigarette popping out of his mouth. A careful "GH" appears by each figure's oversized feet. The illustrations are rough, but Herriman's loose, energetic style is already setting his work apart from other comics in the paper.

No more signed Herriman comics appeared for the rest of the year. Then, on Thursday, January 27, 1898, after a local blacksmith shot and killed a former mistress, Herriman turned in a workmanlike rendering of the scene. He signed this work "HERR," which would remain his usual signature while at the *Herald*.

In the spring of 1898, after the USS *Maine* sank in the Havana harbor, the *Herald* mustered artists and cartoonists to cover the Spanish-American War. It picked up Homer Davenport cartoons from the *New York Journal*, assigned a soldier to send back drawings from the Philippines, and offered lithographs of warships by Andy Barber as a subscription bonus. The *Herald* published Herriman's first contribution to the war effort, a scene of a Spanish torpedo flotilla, on March 27, following it with numerous other wartime drawings over the next month, none of them particularly distinguished.

Herriman quickly found a better showcase for his talents. As the war raged on, Barber gave his young assistant a humble job, just the sort of thing an art editor might fob off on the office boy so he could

get back to producing color lithographs. In the summer of 1898, Herriman took on the task of illustrating the newspaper's want ads.

No artist has ever done more with such a meager assignment. From June to October, Herriman contributed nearly fifty signed, single-panel cartoons. He experimented with lettering, let loose with some bizarre concepts, and created his first continuing character. There was another debut as well. Herriman's first want-ad cartoon, published on June 12, depicts a line of men marching into a sunset that is labeled "Herald Want Ads"; the second showed a "Herald Want Ads" horseshoe. The third cartoon, which ran on Friday morning, June 17, depicts a gentleman reading the *Herald* want ads. At his side quietly sits a black cat—Herriman's first.

A month into his new assignment, Herriman added to the cartoons an Irishman named Timothy O'Toole, who arrives in Los Angeles

From the *Los Angeles Herald*, June 17, 1898

and finds a copy of the *Herald* in the street. O'Toole answers an ad and soon is dancing with his hat off in front of a window that reads "O'Toole & Co. Brokers."

Barber was impressed. The *Herald* sent Herriman to a Republican Party convention at Hazard's Pavilion, and on September 14 splashed his cartoon, *The Convention as the Office Boy Saw It*, across the bottom of its page of political coverage. In the cartoon, Herriman eschews partisanship in favor of visual gags such as *A Study in Whiskers* and *A Blissful Dream*, which shows a portly delegate dreaming of a nickel mug of beer. The following week, Herriman turned in *The Office Boy's Impressions of the Democratic Convention*, again focusing on the delegates' thirst for beer as well as on one poor soul who apparently sat in a dish of frijoles. At eighteen Herriman already discovered that he'd rather draw a funny picture than score political points.

Following the convention, Barber assigned Herriman to report on the stranger goings-on in Los Angeles's courtrooms. Herriman's beat was the drunks, bunco artists, fleecers, and brawlers who came through the court system. His cartoons might gleefully veer far off topic, and he began to employ a delightfully ornate language all his own. When a constable fell asleep, Herriman depicted him as he who "disturbs the court by snoring vociferously," adding little musical notes shooting from the constable's open mouth.

By the final months of 1898, Herriman often drew two or three cartoons daily. He toyed with classical themes in a courtroom cartoon about a boy who stole a sweater, transforming the boy, Milton Alexander, into "Miltonius Alexandrieus." He drew his first of many boxing cartoons. He started depicting animals as sentient characters. The more humdrum the assignment, the more fun he had. This is best seen in a series of cartoons covering Los Angeles's various planning commissions, councils, and license boards. While Barber's portraits of the meetings are as dull as the proceedings themselves, Herriman seized the opportunity to play with caricature and language. "'No sir

From "Still Are Kicking," *Los Angeles Herald*, December 16

don't abandon it, we must have it, yes sir! We must, said Petchner he with face unshorn," read one cartoon, depicting a stubbled speaker. Read another: "And gentlemen the best thing to do now is to abandon it said Judge Landt waxing quite wroth." In Herriman's last months at the *Herald*, his language grew ever more fanciful, already blending Shakespeare and street slang, Latin phrases and quotes from Dickens. In one courtroom cartoon, an Italian man is drinking red wine—or, as Herriman puts it, "Carosa imbibith of ye shining bottle & getting jaggy thereof."

For the first time, there is evidence that Herriman, who now carried his white identity into the workplace, came into close contact with black life in Los Angeles. When assigned to portray blacks in the city's courtrooms, he turned in works that included overt racial stereotyping, at times mirroring the grotesque minstrel characters seen in a *Herald* Sunday comic, *The Kalsomine Kennel Klub*. In early Herriman cartoons, such as *Colored Republicans Hold a Jubilee*, nothing suggests that, just ten years earlier, the cartoonist had been growing up in a politically active black Republican family in New Orleans. Herriman was learning the cartooning conventions for depicting race. He was not yet transcending them.

Still, Herriman's overall work continued to grow more sophisticated and more humorous, and he was well on his way to developing a distinct style. It all came to a crashing end on the morning of Friday, May 19, 1899. That day, readers opened the *Herald* to see nothing but a dismal wash of grey, with line after line of uninterrupted type. There were no editorial cartoons, no amusing little drawings alongside the banner, no comical week in review. Instead, the paper announced in heavy letters that it was dropping its daily price to two cents a copy. "In all the larger cities of the United States the most successful newspapers are those which follow the motto of 'Low price and large circulation,'" wrote editor Spalding. For the first but not the last time in Herriman's experience, a publisher had decided to do away with comics altogether. Any words spoken by George Herriman Jr. about bakeries or tailor shops must have been ringing in his son's ears.

The century did not end smoothly for the Herrimans. In August 1898, the family reported to the police that Henry had gone to the beach to help a fisherman but never returned. His parents had heard tales of a local character known as the "crazy fisherman" and were worried. After being gone for more then two days, Henry

finally came home; it is not clear why he vanished or how he made it back. Later that year, a local boy named Henry Herman was arrested for breaking into a grocery store. When fingers started pointing at their youngest son, the Herrimans were obliged to take an ad out in the *Times* to clear his name.

George still lived at home when he celebrated his nineteenth birthday, just months after being dismissed from the newspaper. The next month, on Wednesday, September 20, George and Henry attended a surprise party with old friends from St. Vincent's. Apparently working odd jobs—some accounts suggest he painted signs—George Herriman was considering his options. Then, at some point in the next six months, he appears to have received a job offer, however tenuous. On March 17, 1900, the *Herald* reported that Herriman had been summoned to New York by *Judge* magazine with the promise of a staff position. Herriman, the *Herald* reported, "is but a boy but one who possesses the gift of humor that he can put into pictures. If he works hard he will be favorably heard from in a short time."

There is no indication that Herriman ever actually took a position at *Judge*; he did not report the magazine as his employer in the summer census. However, in the first months of 1900, he did travel to New York. Just how he got there would be a running gag among his colleagues, with Herriman playing along.

"And beat it he did—he beat it in box cars, coal cars, gondolas, flats, blind baggage and every other way except on the cushions," wrote Herriman's friend and collaborator Roy McCardell, in a profile published two decades after the fact. Added sports cartoonist Thomas "Tad" Dorgan: "He came here on a side door Pullman. . . . He hangs around with a lot of painters, poets and authors these days, but when I first saw him he still had grease from box cars on his pants." Herriman himself said that he had hopped a freight train, saying he "blew the old pueblo, cheated Mr. Santa Fe and Mr. Erie out of carfare, and landed in N.Y."

From *Krazy Kat*, March 25, 1921

The stories don't hold up. Dorgan arrived in New York several years after Herriman, long after any grease would have dried. After steady newspaper work, Herriman likely just purchased a ticket on one of several passenger trains that advertised their frequent departures in the *Herald*, such as the *California Limited*, which billed itself as the "Fastest Train Across the Continent" for its four-day journey. He carried with him little more than ambition, talent, and, perhaps, a job offer. It was his second cross-country trip in ten years. This time he traveled alone.

ORIGIN OF A NEW SPECIES

Accounts of George Herriman's arrival in New York City are livened with the blend of fact and storytelling that is the hallmark of early newspaper humor writing. Some stories are Herriman's own creations. Others are from friends. Some tales are plausible, others ludicrous. Herriman acknowledged this years later when an interviewer came to his house to ask about the early days. "I think it would be a good thing if you had two or three men all together," he said. "Maybe they would be telling the truth."

This much is known: in late 1899 or early 1900, at the age of nineteen, George Herriman arrived in New York City. Needing a place to live, he promptly made his way to Coney Island.

It's not hard to see why Herriman would choose Coney Island. In fact, it is difficult to imagine him wanting to be anywhere else. During the past century Coney Island had transformed from a beach resort to "the oddest place about New York," as described in a *Los Angeles Herald* article that appeared when Herriman still worked at the newspaper. Amid the rumble of rides and the smells of seawater and circus animals, doorways led to "what no one can ever know who has not investigated," promised the *Herald*. For new neighbors, Herriman could choose among the Island's "peddlers, fakirs, shell game men, disorderly women, intoxicated persons, and petty gamblers."

Little is known of any early relationships in New York, but several years later Charles Emmett Van Loan, a friend and newspaper colleague, reported that Herriman had made the acquaintance of a woman who performed in Coney Island's *Sultan's Harem* show: "He used to know a girl down at Coney Island—'Zuleika, the Sultan's Favorite,' on the bills but Mary Callahan to her friends—and that was where he got his taste for Oriental music." Callahan might have been one of the women who dressed in billowy harem clothes, smoking Turkish cigarettes while barkers gave mock-scholarly lectures about the Orient. Possibly she is the woman seen in a three-dimensional "anaglyph" from the era titled "The Sultan's Favorite," which features a dark-haired woman reclining on plush pillows, her robe indelicately opened to expose a long, bare leg. Nothing more is known about Mary Callahan, however.

Herriman lived in a boardinghouse on Jones Walk, a block-long stretch of games and concessions. His landlord, Jacob Jones, a forty-three-year-old son of German immigrants, owned the Jones Shooting Gallery, which sat close enough to the boardinghouse for the reports of its rifles to be heard in Herriman's room. On Friday, June 1, 1900, a census taker visited the house on Jones Walk and enumerated thirteen men, along with Jones and his wife. Most boarders were, like Herriman, in New York to help build the nation's culture capital. These included a German sign painter, a Russian photographer, an Italian cigar vendor, and two New York–born brothers who managed a local theater. Herriman appears in the census as a white, Louisiana-born son of French immigrants.

Herriman had good reason to obscure his origins. Jones's boarders might have hailed from varied ports, but anyone admitting to African blood would not have been welcome. Herriman, speaking fluent French, would have had no trouble convincing the census taker that his parents hailed from France. The census doesn't reveal when Herriman landed at Jones's boardinghouse or how long he planned to stay

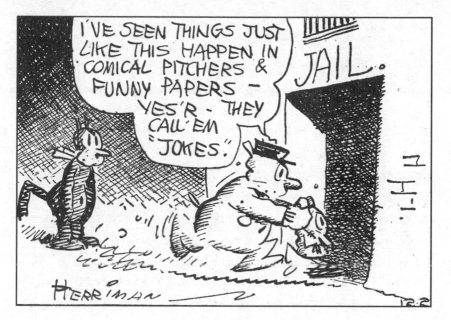

From *Krazy Kat*, December 25, 1933

there. But it leaves no doubt as to his reasons for coming east. When asked to name his trade, Herriman gave a ready answer: "newspaper artist."

It was the dawn of the American comic strip. There was a new industry to build and a new art form to create.

A comic strip is, most broadly defined, a series of pictures that tell a story, usually combined with words and most often published in a newspaper or magazine or, more recently, online. Over the years, comics developed their own visual language: word balloons, radiating worry lines, droplets of nervous sweat, hats popping off heads, and "grawlixes," the term coined by cartoonist Mort Walker for typographical symbols indicating profanity. At its best and with rare exceptions (such as the wordless *Henry*), the comic strip's unique in-

tegration of those three elements—words, pictures, and symbols—allows it to tell a story, whether humorous or serious, that can't as effectively be told any other way.

The comic strip is largely an invention of the nineteenth and early twentieth centuries, but antecedents date back to the very beginnings of "sequential art." Maya codices, the Chauvet Cave drawings in France, pictographs carved on Egyptian tombs, the gilded "illuminated manuscripts" of the Middle Ages and Renaissance, and medieval stained glass windows all had their visual stories to tell. In a twelfth-century Japanese scroll drawing, rabbits and frogs wrestle and shoot arrows like humans, precursors to the works of anthropomorphists like Herriman and Walt Disney.

In Britain in the early eighteenth century, the painter and engraver William Hogarth wrote and drew stories that satirized such cartoonist go-to subjects as gambling, drinking, and the excesses of the very rich. Nineteenth-century Swiss artist Rodolphe Töpffer, celebrated as the father of the modern comic strip, called his cartoon panels "little follies," and the 1842 English translation of his *The Adventures of Mr. Obadiah Oldbuck* is widely considered the first American comic book. In 1865 in Germany, Wilhelm Busch introduced two misbehaving boys named Max and Moritz, who would later inspire the Katzenjammer Kids and, through them, every other rotten child in American cartoons.

The earliest American comics reflected the serious business of building a nation. "Join, or Die," commanded Ben Franklin in an editorial in his *Pennsylvania Gazette* in 1754, illustrated by a woodcut of a severed snake representing eight colonies (the four New England colonies were merged together). The cartoon is unsigned but is believed to be by Franklin himself. A hundred years later the celebrated Thomas Nast brandished his wit in the pages of *Harper's Weekly* and other publications, creating or popularizing symbols such as the Republican elephant, the Democratic donkey, and even the modern

Santa Claus. Nast's version of the "Tammany Tiger" helped bring down William H. "Boss" Tweed's corrupt political machine, with Tweed trying in vain to both bully and bribe Nast into retreat.

The age of American humor magazines began in 1871, when the first issue of *Puck* rolled off the presses. It was soon joined by competing magazines such as *Judge* and *Life*. In addition to Nast-style political caricatures, cartoons in these magazines covered a range of topics, from news topics such as immigration and public transportation to gags about romance and marriage. Similar illustrations began to adorn newspapers, especially the *New York Daily Graphic*, which began publishing in 1873.

It should be no surprise that American newspaper comics and American vaudeville started out at the same time. Both offered humor and grotesqueries as popular entertainment, appealing to a growing urban audience willing to spend money for a laugh. In 1883 a circus barker named Benjamin Franklin Keith opened a museum in Boston soon dedicated to variety acts; two years later he opened the Bijou Theatre in New York, which presented continuous vaudeville shows that were sanitized just enough for women and children to join the audience. Also in 1883 a Hungarian-born newspaperman named Joseph Pulitzer ushered in the great era of the newspaper comic when he purchased the *New York World* and promised to make it a "thorough American newspaper."

For Pulitzer, comics were the key. "There is always an extra demand for the World when it is illuminated, so to speak," Pulitzer wrote in 1884. Among his early hires was a twenty-six-year-old sign painter, vaudeville performer, and cartoonist named Walt McDougall, who was paid fifty dollars a week to fill his paper with illustrations and cartoons, often on the front page.

In 1890, Pulitzer moved operations to a palatial skyscraper capped by a golden dome, which elevated his newspaper above both the Trinity Church's spire and the Statue of Liberty's torch. Pulitzer also in-

stalled a new, state-of-the-art printing press. Writer Roy McCardell recalled that there was an office battle over whether to dedicate the new color printer to fashion or comics, with editor Morrill Goddard emerging victorious. "He went in for the weird and wonderful in every-day life, and if things were not weird and wonderful enough for him, he made them so," McCardell said of Goddard. "It was his professional opinion that American humor, not fashion, ought to have a colored pictorial outlet."

In 1894, Pulitzer signed on Richard Felton Outcault, whose previous work included designing Thomas Edison's traveling light displays. Among Outcault's first contributions was a six-panel comic similar to Rudyard Kipling's *Just So Stories*. The story opens with a clown and a dog going to a picnic. A snake slithers down a tree, ingests the dog, and becomes a crocodile. The comic bore a prescient title, *The Origin of a New Species*.

The next year Outcault brought to the *World* his comic *Hogan's Alley*, vivid scenes of tenement life featuring a bald, jug-eared kid named Mickey Dugan who dressed in an oversized nightshirt. Soon the nightshirt was printed in yellow ink, and the Yellow Kid was born.

In comics featuring the Yellow Kid, glee and brutality share the same page. *Hogan's Alley* is spectacularly overrun with stray dogs, crying babies and old ladies in tattered clothes. The Yellow Kid put a child's face on immigrant America; in the midst of squalor, he was guileless but wise, and he never gave up. "The Yellow Kid was not an individual but a type," Outcault said in 1902. "When I used to go about the slums on newspaper assignments I would encounter him often, wandering out of doorways or sitting down on dirty doorsteps."

The Yellow Kid became the first American cartoon superstar, appearing in advertisements for everything from ginger wafers to cigarettes. In 1897 at the *Los Angeles Herald*, he had even appeared in a local tailor shop ad wearing an oversized nightshirt that read,

"Hully Gee, I be de Yellow Kid rite from New York wid new goods." It's quite likely the ad was drawn by Herriman, then the *Herald*'s office boy, carefully outlining the Kid's nightshirt and paying close attention to the opportunities that were opening up a continent away.

I n California, the Yellow Kid also caught the attention of another ambitious young man, this one with considerable resources: publisher William Randolph Hearst. Best known for his promulgation of sensationalistic "yellow journalism," as well as for inspiring Orson Welles's cinematic portrait of power-mad publisher Charles Foster Kane, Hearst also deserves credit as American newspapers' greatest champion of comics and cartoonists.

In 1887, Hearst's wealthy father, George Hearst, gave him control over the *San Francisco Examiner*, a newspaper the elder Hearst had acquired as payment on a gambling debt. William Hearst, then twenty-three years old, built his first art department out of teenagers and roustabouts, most notably Jimmy Swinnerton, who at that point was a former horse track exercise boy, minstrel show performer, and art school dropout. At the *Examiner*, Swinnerton turned the California state symbol, the grizzly bear, into a series of cartoons titled *The Little Bears,* making him one of the first cartoonists in American newspapers to draw a comic strip with recurring characters.

For Hearst, the *San Francisco Examiner* was just the beginning. In 1895 he moved east, purchasing the *New York Morning Journal* and soon adding an evening edition. Backed by a family fortune, Hearst set about raiding Pulitzer of his top men, from editor Morrill Goddard to Richard F. Outcault. On Saturday, October 17, 1896, *Journal* readers opened the newspaper to a promotion that a Coney Island barker would envy:

THE YELLOW KID–TOMORROW! TOMORROW!

An expectant public is waiting for the 'American Humorist,' the New York Journal's Comic Weekly, 8 full pages of color that make the kaleidoscope pale with envy. Bunco-steerers may tempt your fancy with a color supplement that's but a black and tan—4 pages of weak, wishy-washy color and four pages a desolate waste of black. But the Journal's Colored Comic Weekly, ah there's the difference. Eight pages of iridescent polychromous effulgence that makes the rainbow look like a lead pipe. That's the sort of a Colored Comic Weekly people want—and—THEY SHALL HAVE IT!

Hearst continued to raid Pulitzer's staff, bringing in business manager Solomon S. Carvalho and managing editor Arthur Brisbane. He never lost sight of the comics. "Mr. Hearst came along with money to spend," Swinnerton recalled. "The reaction brought on the best newspaper artists, cartoonists and writers. Cartoonist Clarence Rigby purchased himself a high hat when this occurred. As far as other human coverings that are supposed to go with the high hat he paid little or no attention."

When Swinnerton arrived in New York, he turned his bears into tiger cubs, a spoof of the ferocious tiger seen in Thomas Nast's Tammany Hall cartoons. Swinnerton, who became personally close to Hearst, remembered visiting "the Chief" in his antique-laden office at the *Journal* and watching in amusement as Hearst would spread the comics on the floor and do a little dance between the pages, swooping down to scrawl notes in the page margins. "He never cared to have people around him who didn't understand humor," Swinnerton said.

In 1897 Hearst hired Pulitzer's features editor, Rudolph Block, to edit his comic supplements. Also that year, the *Journal* adapted the German series *Max und Moritz* into *The Katzenjammer Kids*. (The name translates to "howling cats" and is slang for a hangover; adver-

tisements for katzenjammer cures regularly appeared in newspapers during this time.) The artist, Rudolph Dirks, was born in Germany in 1877 and raised in Chicago; like Herriman, he moved to New York and took up residence in Coney Island. In Dirks's hands, Hans and Fritz Katzenjammer danced across the line from mischief to anarchy, constantly foiling their Mama and, later, a pair of bulb-nosed authority figures named only "der Captain" and "der Inspector."

In 1900 the *Journal* debuted Frederick Opper's first newspaper comic strip, *Happy Hooligan*, about a hobo with a tin-can hat who blunders into situations with the best of intentions, only to wreak havoc and receive a pummeling. "People falling down stairs, slipping on banana skins, being thrown out of buildings and chased by dogs were staple subjects," Opper said of the early comics.

In short time Opper, Swinnerton, and Dirks became Hearst's leading lights in cartooning, as seen in a May 5, 1901, "jam comic" that

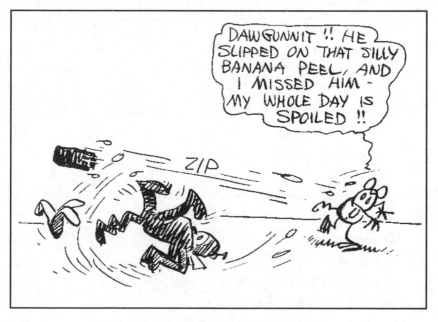

From *Krazy Kat*, May 2, 1920

featured the Katzenjammers, Happy Hooligan, and a Swinnerton bulldog in a riotous episode that ends with Mama whipping Hans and Fritz, and Happy Hooligan being dragged off by a policeman. Commenting on the action from a nearby tree branch are a pair of bugs drawn by Rudolph Dirks's brother, Gus.

At the top of that Sunday color page, arranged like portraits on a mantel, were the faces of Swinnerton, Opper, and Rudolph and Gus Dirks. These Hearst men formed a select fraternity, and to any hopeful young cartoonist with limited experience, the sight of those visages lined across the page must have been daunting.

During his first year in New York, George Herriman does not appear to have published a single signed cartoon. What he did for money is unclear. As writer and future collaborator Roy McCardell described it, the young cartoonist knocked on the doors of the great metropolitan dailies, but they found his work too bizarre to publish. Then, wrote McCardell, the cartoonist was discovered by Harry Tudor, who ran an attraction at Coney Island's Dreamland called "Bosco, the Snake Eater":

> It was while so employed that George Herriman first conceived and declaimed that verse libre epic that all outdoor orators for snake eaters now raucously quote at every pit show, dime museum or carnival throughout the country:
> Bosco, the Wonderful!
> Bosco, the Silurian Senegambian Snake Eater!
> He eats them alive!
> He bites their heads off!
> He grovels in a den of loathsome reptiles!
> An exhibition for the educated!
> And a show for the sensitive and refined!

At the close of snake-eating season, McCardell wrote, Herriman again made the rounds with his portfolio. This time the editors ushered Herriman inside.

The story, however, is apocryphal. Dreamland didn't open in Coney Island until 1904, after Herriman had established himself as a cartoonist in New York. As it turns out, McCardell pilfered his account from his own previous work. He first wrote about Bosco in a serialized piece of fiction titled "The Shirtwaist Girl," which ran in *Puck* in 1901. In fact, Bosco gags were a favorite of writers and cartoonists, later appearing in articles and comics by both Swinnerton and Herriman.

McCardell seems to have been closer to the truth when he wrote that Herriman, while living in Coney Island, painted targets for his landlord's shooting gallery. Later, Herriman would make a nod to his old landlord in a 1907 cartoon, which included a boy writing this note: "kin i have the ole job on the shootin gallery this summer." In 1910 Herriman would even draw the Jones Shooting Gallery into an early *Krazy Kat* comic.

As Herriman continued to trudge across the city to knock on editors' doors, he knew he was not alone. "One of the familiar sights of the district was that of a meek-faced youth walking into a newspaper office with his precious sketches and walking out again with precious little ceremony," cartoonist Rube Goldberg recalled. Then, at some point in late 1900 or early 1901, Herriman made his way to the corner of Park Row and Spruce Street to the Tribune Building, an imposing skyscraper with Victorian embellishments, to bring his sketches to William Randolph Hearst.

Herriman and Hearst had an inauspicious start together. "The first time—there wasn't any signing to be done," Herriman later recalled. "I went to work for Mr. Block. I got ten dollars a week. Just a single column drawing, and it wasn't good. Just a beginning."

Herriman's work for Hearst appears to have started on January 15, 1901, when the *Evening Journal* published two cartoons that, although unsigned, are strikingly similar in style to Herriman's earliest signed works. The first, *A Mean Advantage*, shows a man hanging from a tree branch; beneath him, a bulldog (similar to those drawn by Swinnerton) holds a patch of clothing in his teeth. A farmer leans on a rake, asking, "I hate to bother you while you're so busy, neighbor Jones, but would you mind paying me that ten dollars you owe me?" The second is a more ambitious two-panel comic titled *A Modern Artist*. In the first panel, a bearded artist floats in a hot-air balloon, painting the billowy clouds. In the second, he sits on a stool in a submerged diving bell, painting fish.

Although fairly crude, these early cartoons suggest Herriman's emerging themes and visual style. Faces are maps of laugh wrinkles and worry lines. *A Mean Advantage* introduces the landscape that Herriman would favor throughout the next decade: a hilly, rural expanse dotted by a house with a pointed roof. *A Modern Artist* displays more shading and crosshatching than seen in most *Evening Journal* cartoons, and the gag shows Herriman exploring the nature of art as a topic.

The next days brought more unsigned gags. Topics ranged from Shakespeare to tramps, from Dante to drunks. Herriman's favorite target, however, was social pretension in its many forms. In one panel a couple is dining at a restaurant. The woman asks the man if he is fond of Ibsen; he replies that he is, and suggests that she order some. Another panel introduces a Prof. Bugbugs, who stands over a hole in the earth and, holding a bone in his right hand, pronounces that it might be the remains of a *Glyptodon* or a *Megatherium*. His daughter looks down at the hole. "Why, papa," she says, "that is where we buried poor Rover." This last cartoon also introduced an early visual signature: a wavy cloud with a single hole in the center, looking like a squashed doughnut. Similar clouds would drift over Herriman's landscapes throughout the next decade.

Herriman's cartoons appeared on the *Evening Journal*'s editorial page, next to works by the Dirks brothers, Swinnerton, and Opper. Block must have seen something he liked, for he raised Herriman's pay from ten to fifteen dollars a week and, on March 22, the *Evening Journal* published its first signed Herriman cartoon. Titled *Between the Devil and the Deep Sea*, it is built on a familiar premise: a man hangs from a tree branch, with an eager bulldog eyeing him from below. Herriman lavishly illustrated his first signed work, adding a landscape of rooftops and leafy trees, a lightly shaded sky, and a long tree branch that arcs gracefully across the top of the two-column panel.

Throughout the spring of 1901, Herriman would sign his name to nearly two dozen cartoons in the *Evening Journal*. A gag about a penniless European count hints at Herriman's future comic strip *Baron Bean*. A cartoon about two tramps, *Hard to Resist*, was one of Herriman's wryest panels to date. In it, the tramps are offered a piece of pie if they would wash themselves. One tramp turns to the other. "Ah Willie," he says, "dat's a great temptation, but pray dat you may cast it aside an' stick true to de noble precepts of de perfesh."

From the start, Herriman's cartoons jumbled high and low culture, citing Greek historian Xenophon, the Latin book *Viri Romae*, and the Macedonian general Parmenion, as well as trafficking in stock ethnic caricatures such as Chinese launderers and coin-pinching Jews. An unsigned Herriman cartoon published on Tuesday, March 19, provides an intriguing read on his use of such stereotypes. A well-dressed actress stands meekly before a theater manager. Gems sparkle from his suit; his cigar emits a small, doughnut-shaped puff of smoke. He holds up a single, porky finger. "Well, as long as you can interpret a coon song satisfactorily, Shakespeare is a second consideration," he tells her.

Most remarkably, Herriman also produced his first weekday comic strip series. The four-panel *Maybe You Don't Believe It—*, published five times in April, recasts the fables of Aesop with happy endings. It

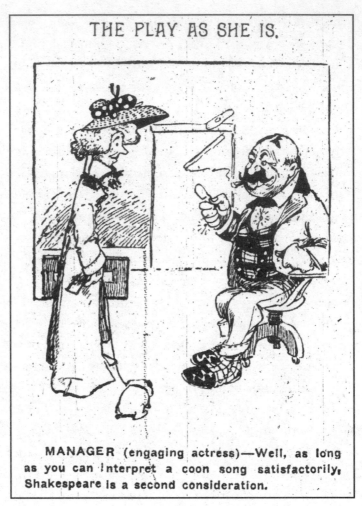

THE PLAY AS SHE IS.

MANAGER (engaging actress)—Well, as long as you can interpret a coon song satisfactorily, Shakespeare is a second consideration.

From the *New York Evening Journal*, March 19, 1901

features Herriman's first consistent use of dialogue balloons as well as his first sustained use of talking animals. Some episodes of *Maybe You Don't Believe It*— hint at the later wonders of Coconino County, as when Herriman's clouds hook around a mountain peak like a slow-motion game of ring toss, or a milkmaid tumbles over a tree root while a distant windmill spins feverishly.

From *Maybe You Don't Believe It—*, *New York Evening Journal*, April 13, 1901

Nonetheless, after just four months, Herriman's position at the newspaper grew shaky. Sometime around April 1901, Herriman was summoned by Block. The conversation didn't go well. Block, for unknown reasons, had a change of mind about Herriman. "He gave me two weeks' salary and told me to quit, not to try it, because I didn't have a spark, and would never succeed," Herriman later recalled. With that, the door to William Hearst's magical cartoon kingdom suddenly slammed shut.

IMPUSSANATIONS

R udolph Block failed to see a spark in George Herriman, but others soon would. Despite his dismissal from Hearst's *Evening Journal*, Herriman was set to enter the first major creative period of his career, a ten-year run that would include employment as a staff artist at six newspapers in two cities. Under his pen, humans and animals of all shapes and sizes, sporting comical names and speaking in a polyphony of dialects, would multiply across the country. "George Herriman arguably created more titles and characters than any other major cartoonist in American strip history," comics scholar Rick Marschall has noted. It began with a vengeance a mere two months after being fired from Hearst's flagship.

Herriman, perhaps not for the first time, visited the offices of *Judge* magazine, located in an eight-story building on the corner of Fifth Avenue and Sixteenth Street. Later he would consider his cartoons there to be his first significant work in New York. "I worked on *Judge* for my first pictures," he recalled. "Grant Hamilton bought them. They were pretty nice to me."

Launched in 1881 by disaffected *Puck* artists, *Judge* featured star political cartoonist Hamilton, whose works about the 1896 William McKinley–William Jennings Bryan presidential contest helped land McKinley in the White House. Nonetheless, when Hamilton was

named *Judge*'s art editor, he lobbied the owners to move away from politics and toward general humor. With fellow cartoonist Eugene "Zim" Zimmerman, he procured one of New York's first "instantaneous cameras," and the two would roam the city, "slumming for character studies," as Zimmerman later remembered.

Puck's editors were known to be hostile to new talent, but Hamilton encouraged young artists. "*Judge* . . . kept open house for visiting talent, got the pick of their work, and started some of America's foremost cartoonists on the road to fame," Zimmerman recalled.

Herriman's first cartoon for the magazine appeared in its June 15, 1901, issue. *In Old Ben Franklin's Day* is the smallest of four cartoons on the page, dwarfed by a tramp-and-bulldog gag by star cartoonist T. S. Sullivant. Yet Herriman clearly labored over his *Judge* debut. In a detailed village scene, rain slashes across the skies as boys fly kites in a storm. A man stands at the door of his home, rifling through his pockets while water drips from his hat. "Confound that Franklin boy and his lightning and key electrical discovery!" he says. "There can be no storm come up without having every key in the neighborhood missing!"

From mid-June through mid-October, eleven signed Herriman drawings appeared in *Judge*. In every way, Herriman's work for *Judge* is more elaborate than his *Evening Journal* and *Herald* cartoons. Faces have grown more grotesque, with thick, deliberate lines around eyes and mouths that suggest an influence by *Puck* cartoonist Frank M. Howarth. Beneath these masklike faces, skinny bodies flail about like marionettes. Stories range across literature, history, sports, current events, the Bible, and vaudeville. In one cartoon, Herriman turned to the book of Genesis: Eve scratches her rib and sends Adam into a fit of laughter. Another retells Henry Wadsworth Longfellow's *Courtship of Miles Standish*, while a baseball cartoon shows a lady wondering why the catcher is signaling for a high ball instead of just getting his own drink.

A TICKLISH QUESTION.

LITTLE ABEL—"Every time ma scratches herself pa gets a laughing fit and seems to be tickled to death over something."

CAIN—"Gee! wouldn't it tickle you, too, if your rib was being scratched?"

From *Judge*, July 20, 1901

Herriman never became a star *Judge* contributor along the lines of Gus Dirks, whose *Bugville* cartoons were bound as a book and advertised in the magazine's back pages. At some point Herriman must have realized that Hamilton did not plan to bring him on as a staff artist, and he continued searching for new markets. His next break came thanks to a new media phenomenon: the newspaper comics syndicate.

A former Baraboo, Wisconsin, publisher named Ansel Nash Kellogg is credited with launching the first newspaper syndicate in 1865 when he began sending preprinted stories to small newspapers across the country. In 1884 an Irish immigrant named Samuel

S. McClure started the first profitable literary syndicate, which he named Associated Literary Press. McClure was a driven man, called a "dog on the hunt" by muckraking journalist Ida Tarbell and a "holy terror" by novelist Joseph Conrad. McClure introduced those writers and more to readers across the country, eventually handing over operations to his brother, T. C. McClure, who added a printing plant capable of turning out color comic supplements. In 1900 the operation was renamed the McClure Newspaper Syndicate.

In 1901, McClure client newspapers published florid announcements promising "four pages of harmonious color blended for the purpose of producing smiles, wide smiles of delight and such laughter as is induced only by clean American humor." Among the providers of that humor was Herriman, who now was being introduced to a national readership thanks to McClure papers such as the *Minneapolis Tribune*, the *New York Press*, and the *Boston Post*.

The promise of clean humor didn't satisfy preachers across the country, who took to pulpits to condemn the full color pleasures that threatened to keep worshippers home on Sunday mornings. In Philadelphia, city leader John Wanamaker, a religious man, discovered to his horror that his own son, Thomas B. Wanamaker, planned to launch a Sunday edition of the *Philadelphia North American*. The elder Wanamaker did everything in his power to stop his son, even attempting to buy the newspaper out from under him. His efforts failed spectacularly. On Saturday, September 28, 1901, the *North American*'s front page featured a letter from Thomas B. Wanamaker denouncing his father's actions.

As promised, the next day brought the new *Sunday North American*, which included special praise for the cartoonist as "a rare student of human nature and of animal nature. . . . His figures must show action, weird and wonderful." A newspaper promotion noted that the *North American*'s comics were drawn "by the men who made *Life*, *Puck* and *Judge* famous."

Now creating full-color strips for a Sunday newspaper, Herriman again shifted his style. A comic titled *The Mystery of the Chicken Robbery Made Clear* displays a thinner, wilder line. There is a greater sense of improvisation, with the clouds and even the chicken thief's face changing shape from panel to panel. Painstakingly detailed figures and backgrounds are forsaken for quick pen strokes and slapstick action. The new style is deeply influenced by Frederick Opper, the Dirks brothers, and Jimmy Swinnerton; it also appears to have resulted from time limitations. Herriman was becoming an in-demand cartoonist, juggling multiple assignments from various newspapers and syndicates.

Herriman's next big break came on Sunday, September 29, 1901. On that day, readers could open up Joseph Pulitzer's comic supplement, *Funny Side of The World*, for a four-panel tale of romantic revenge titled *The Wicked Rival and the Tell-Tale Photograph*, signed by Herriman. Being hired by the *World* must have been particularly satisfying for a cartoonist who just months earlier had been dismissed by Pulitzer's chief rival.

For the rest of the year, Herriman produced several comics each week for numerous newspapers and syndicates, including half- and full-page strips for the *World*. Yet the real ticket to success was a continuing character. Each week Herriman auditioned a new cast, searching for his own Katzenjammer or Hooligan. One week Colonel Gimp would take the stage. Then Pinky Doolittle. Then a tramp named Punky Pheetes and another named Pedesy Fuzzyplace. There were Little Pretonius and Percival Pinkus (names pulled from Herriman's classical studies), and Mr. Lige de Poke and Miss Lillybell Cohnfed (which came straight from vaudeville). Herriman tried out a cowboy in *Broncho Pete, of Bitter Creek, Revolts and Makes a Solemn Vow*, and attempted a German strip with *Herr Kronsestiner Sees a Spook*. Neither lasted for more than a week.

On December 29, 1901, the *Philadelphia North American* published

Herriman's most bizarre comic to date. In *The Curious Theosophic Tale of a Lobster's Tender Romance*, Herriman introduced ideas that he would explore more deeply in *Krazy Kat*—ideas that he appears to have obtained from a curious religious movement called theosophy.

Founded in New York in 1875 by Madame Helena Blavatsky, theosophy blended Christian doctrine, Eastern mysticism, ancient Greek philosophy, and Atlantean myths. Herriman might have encountered the belief when Dr. Allen Griffiths delivered a lecture in St. Vincent's College in 1892, when Herriman was a student. The *Los Angeles Times* recounted Griffith's message: "We are pilgrims of eternity evoluting from the mineral to the vegetable, from the vegetable to the animal kingdoms." ("A pilgrim on the road to nowhere," Herriman would later call his Coconino character Bum Bill Bee.)

Reincarnation propels *The Curious Theosophic Tale of a Lobster's Tender Romance*. In the first panel, two lobsters cuddle in the deep. The love scene shifts to two monkeys on a branch. Then a man chisels hieroglyphs of "sweet tender stuff." Next comes a young man balanced on a Venetian mooring pole, in full serenade. In the final panel, a woman brandishes a rolling pin. Her husband sits in a chair, puffing

From *Krazy Kat*, April 20, 1919

a cigar, ignoring the baby on the floor. She grimaces: "You're a nice lobster, you are." He wonders: "Where have I heard that word before?"

Years later, Herriman would pen another story that traced the origins of love to ancient times. Egyptians once chiseled love letters in stone, he wrote, which explains Ignatz's compulsion to throw a brick at Krazy Kat, and the Kat's interpretation of that brick as proof of Ignatz's love.

The Curious Theosophic Tale was a distinct Herriman creation, unlike anything done by Swinnerton or Opper at the time. However, it also did not last beyond a week. Herriman's first continuing comic strip character would not derive from theosophy but from another peculiarly American invention: the minstrel show.

N ew York was far from New Orleans, where the Herriman family history was known by many, and from Los Angeles, where it was known to only a few. Here, George Herriman was fully on his own, free to rewrite his past as he planned his future. However, when he created his first recurring comic strip character, it would be Musical Mose, a black musician who tries and fails to pass for white and is regularly punished for his masquerades.

Musical Mose stands as Herriman's first sustained riff on the American minstrel show. From its beginnings in mid-nineteenth-century New York, minstrelsy served to grossly caricature blacks at the very time that former slaves were struggling to find a foothold in society. It had also grown to become the most popular entertainment in the country. Performed primarily by white men darkened by burnt cork, minstrelsy was the "black-faced figure of white fun" that is found "at the deep dark bottom of the melting pot, where the private is public and the public private, where black is white and white black," wrote Ralph Ellison in his 1958 landmark essay "Change the Joke and Slip

From *Judge*, September 21, 1901

the Yoke." Minstrelsy's stock characters—the northern dandy Zip Coon, the dull-witted southern black named Jim Crow—lingered well into the twentieth century, providing stock characters for movies, radio, and television. They are still seen on the painted faces of circus clowns as well as the black-faced, white-gloved Mickey Mouse.

In early newspaper comics, pen-and-ink minstrelsy adopted many of the same characters and stories as staged shows. George Herriman had published his first caricatures of blacks when he drew courtroom scenes for the *Los Angeles Herald*. His first full-fledged minstrel cartoon, *The Starter of Ragtime*, appeared in 1901 in *Judge* magazine. In it, Noah lectures his son, Ham: "See here, Ham; you've got to go to Africa and populate it—see? . . . How do you think this world is going to get along without ragtime in a few generations from now?" While he speaks, Noah's other two sons taunt Ham with shouts of "Look at de coon!"

The readers of *Judge* would have understood Ham to be the son of Noah sent to populate Africa. They also would have known the minstrel show *Sons of Ham*, onstage when Herriman's cartoon was published. *Sons of Ham* featured the popular minstrel team of Bert Williams and George Walker. It was the first of many nods from Herriman to Williams, a black immigrant from the West Indies, called by W. C. Fields "the funniest man I ever knew, and the saddest man I ever knew." Williams offered Herriman an example of how to work within a minstrel tradition and create unique, even subversive work. In Williams's dialect song "Evah Dahkey Is a King," lyrics credited to E. P. Moran and the poet Paul Laurence Dunbar have fun with the social order: "Evah dahkey has a lineage dat de white fo'ks can't compete with, / An' a title, such as duke or earl, / Why we wouldn't wipe our feet wid." Williams also poked fun at pretension in "White Folks Call It Chantecler but It's Just Plain Chicken to Me":

> *They may call coffee "demitasse,"*
> *And "croquette" is another name for hash;*
> *You may call a barn fowl Chantecler*
> *But it's just plain chicken to me.*

The lyrics would be echoed in numerous *Krazy Kat* gags about pretension that also turn on French words and phrases, such as a daily strip in which Krazy Kat informs Mr. Kiskidee, "I was not leffing at your 'shappoo' . . . but it was at that silly-looking hat y'got on."

If Bert Williams had drawn a comic, it might have looked like *Musical Mose*. Herriman's minstrel series got its start with a comic published on October 20, 1901, in the *New York Press* and other McClure papers, which featured a Jim Crow character named Sam. In the first panel, Col. Gimp, an elderly white man, hands Sam an envelope and instructs him to go to "the 4th house from the corner, No. 11, on . . . 44th Street and—" Sam suddenly dashes off to a building

marked "Policy Shop." The gag played off the numbers "4-11-44," a bet known as the "washerwoman's gig" that was said to be favored by poor black men in an illegal lottery game called "policy" (later called "the numbers"). The game appeared in numerous minstrel shows and, later, in several jazz and blues songs. Readers of Herriman's comic also would have recalled the Williams and Walker minstrel show *The Policy Players*, originally titled *4-11-44*, which played in New York in the fall of 1899.

Sam next appeared in the pages of the *World* on January 19, 1902. In *The Musician's Impossible Task*, Gimp has been replaced by a rotund black-faced character in a shiny top hat—a Zip Coon to Sam's Jim Crow. Sam, now a musician, plays his piccolo outside a window while his employer dines on turkey, pork chops, lamb, chicken, and possum.

Little in the gross caricatures of the first two *Musical Mose* comics distinguish them from other minstrel comics of the time. The name "Mose" already had a long history in both minstrel shows and comics. Onstage, the first Mose was the mid-nineteenth-century Mose the Bowery Boy, an Irish firefighter. In short time he transformed to a blackface Mose, a Broadway dandy. Numerous Mose characters appeared in the comics, most notably R. F. Outcault's Pore Lil Mose, a black child from Cottonville, Georgia.

Herriman took his character of Mose into new territory. On February 16, 1902, the *World* published "Musical Mose 'Impussanates' a Scotchman, with Sad Results." The action starts in Mose's house, where Mose stands before his wife, Sal. He is clad in a Scotsman's garb and carrying a bagpipe.

"Isn't yo rather dark complected fo a Scotchman?" Sal asks Mose.

"Not so *very* much Sal," he says.

In the next panel he is playing the bagpipe at a gate, to the delight of two ladies. "T'is a Scotch laddie and his bagpipe," says one. Then they peer out the doorway and see Mose. "Hivins its a nagur!!!" they shout. "Git de ax."

The next panel is the most brutal scene ever drawn by Herriman. Mose is on the ground, overpowered by the women. One woman sprays a hose into Mose's face. "How d'yez like thot, Scotty!" says the other, stomping on his stomach with heavy shoes. Mose's white-gloved hands wave in the air. Beneath him, his broken bagpipe wheezes, "I wish mah color would fade." The line came from a popular song with the chorus: "Coon, coon, coon, I wish my color would fade / Coon, coon, coon, I'd like a different shade."

From "Musical Mose Tries Another 'Impussanation,'" *St. Louis Post-Dispatch*, February 23, 1902

In his book *The Souls of Black Folk*, W. E. B. Du Bois coined the phrase "double consciousness" to describe being both black and American, a state of having "two souls, two thoughts, two unreconciled strivings; two warring ideals in one dark body, whose dogged strength alone keeps it from being torn asunder." Herriman might not have publicly identified himself as a black man, but reading *Musical Mose* more than a century after its first appearance, it is hard not to interpret the comic as a sign that Herriman could not fully, in Du Bois's words, "bleach his Negro blood in a flood of white Americanism."

The following week, Mose returned for the final time to the pages of the *World* in "Musical Mose Tries Another 'Impussanation,'" when Mose fails to convince the crowd that he is an Irish fiddler. Mose reappeared for an encore two weeks later, in the March 9, 1902, *Philadelphia North American*, in a comic titled "No Use, These Days, to Try to Break into Those Exclusive Professions." Mose now wears large hoop earrings and has acquired an organ-grinder box. He positions himself on a city sidewalk. A man appears before him, shaking his fist.

"Why you playa da org?" he asks. "You no Ginny."

Mose's hat flies off his head. Rows of kinky hair are exposed, and Mose protests that he's just a "l'il bit tanned."

The final panel finds Mose in a hospital bed. His wife, Sal, asks a doctor if he'll recover. "Oh yes," the doctor says, brandishing a saw and hatchet. "After I remove part of his brain."

At the foot of the hospital bed, Herriman has added the numbers "4-11-44," a reminder of how Williams and Walker inspired Herriman's unique minstrel show. *Musical Mose* would serve as Herriman's only sustained commentary on race until seven years later, when he would return to ideas from minstrelsy for a series of sports cartoons about the black boxing champion Jack Johnson, leading to the creation of *Krazy Kat*.

For the remainder of 1902, Herriman found limited success with the irreverent churchman Deacon Skeezicks, who enjoyed a brief career in scattered McClure newspapers, and two memorable if short-lived characters that appeared in the *World*, each inspired by a popular craze of the day.

Prof. Otto and His Auto first appeared in the *World* on March 30, 1902, and returned frequently through the end of the year. Craving "scorching," or driving at high speeds, Otto gleefully chases down dogs and sends them flying, until one day he mistakes a large bronze statue for a dog and crashes into it. In one episode, Herriman satirizes William K. Vanderbilt, infamous for speeding through Long Island, by adding a wealthy scorcher named Mr. Reggie Funnybilt. A thrilling, full-page *Prof. Otto and His Auto* served as the lead comic in the April 20, 1902, edition of the *Funny Side of The World*. In it, Otto's wild ride is seen from multiple perspectives: the car plows through a park, through a fence, over a cliff, across a barn roof, down the center of an apple orchard, through a farmer's hay bale, and into a laundry line.

Also appearing in the *World* was *Acrobatic Archie*, Herriman's response to a craze for physical fitness ignited by the new president, Theodore Roosevelt. Archie swings on curtain rods and leaps on beds, torturing everyone around him with his constant flips and somersaults.

In both *Acrobatic Archie* and *Prof. Otto and His Auto*, Herriman experimented with action and pacing in comics of varying lengths. He also added animals to both strips. On April 13, readers of the *World* could enjoy, in *Acrobatic Archie*, a little sideshow that featured a black cat and a white bulldog. For the first time, the cat speaks: "T'was a mighty chase."

Animals briefly claimed a starring role for Herriman's most impressive one-shot *World* cartoon, a grand single-panel fantasy titled

Ho! For the Great Animals' Own Circus, a Swinnerton-influenced affair in which the animals take over the tent, forcing the humans to pose on chairs and stilts. An overthrown circus worker wails the Herrimanesque cry, "Oh me of gentle birth to fall as low as this," as the reviewing stands fill with cheering giraffes and rhinos.

Pulitzer quickly moved Herriman from contributor to staff artist, and by July 1902 it could be reported that Herriman "occupies an excellent position on the staff of the *New York World*." That news came out of a return trip that Herriman made that summer to California, his first visit home since making his way to New York nearly three years earlier.

It was just before his twenty-second birthday, and Herriman already was the most successful member of his family. His father had moved on to yet another position with another Spring Street tailor. Both Ruby and Henry lived at home with their parents, along with their little sisters, Pearl and Daisy. Ruby had just graduated from Commercial High School and would take a stenographer job with a local attorney. Henry worked as a lithographer and was active in sports; in July he competed in an eighteen-mile bicycle race from Los Angeles to Santa Monica, for a top prize of a gold watch and a twenty-five-dollar suit.

Herriman might have arrived in Los Angeles in time to attend his sister's graduation and his brother's race. But he had another reason for returning. For whether or not he had enjoyed a dalliance with a Coney Island performer billed as "the Sultan's Favorite," his three years away from Los Angeles had not severed his ties with his former neighbor and childhood sweetheart Mabel Bridge. On Monday, July 7, 1902, Herriman and Bridge, now a twenty-one-year-old dressmaker, were married in a quiet ceremony at the Bridge home on Essex Street. Family friends William Briggs, a druggist, and Frances Sidener, a clerk, were in attendance. Mabel, described as wearing a "conventional white dress," was given away by her father.

It was a mixed marriage in both religion and race. There is no way to know if Mabel Herriman was aware of her new husband's racial background, or how much that news would have mattered to her. The religious differences, however, took some negotiating. Two ministers from different faiths—Father William Gorrell of St. Vincent's Church and Reverend William Irvine of East Side Baptist Church—presided over the ceremony. Herriman's granddaughter, Dee Cox, recalled hearing that George's parents would assent to his marrying outside the faith only if he promised that any children would be raised Catholic.

After the wedding, George and Mabel Herriman boarded a train for New York, where they set up their first home together on Ninety-Fifth Street, in an Upper West Side neighborhood of railroad tracks, ash heaps, and a budding Riverside Park. The last time Herriman had made a journey to New York, he had traveled alone and landed in a boardinghouse in Coney Island. Now he was back in New York with a new bride and, for now, with a place in the *World*.

BUBBLESPIKER

I n 1902 a poet named Ernest La Touche Hancock visited the leading lights of cartooning to ask each of them, "What inspires your work?" He published the replies in a two-part series in the *Bookman* literary magazine titled "American Caricature and Comic Art."

Answers varied from complaints ("I work systematically from ten to four in a dingy little room where no earthly imagination could possibly come," Homer Davenport said) to common sense (Carl Schultze said he invented his Foxy Grandpa character because he needed the money and "kept him alive because the desire for the same commodity has never since left me"). Jimmy Swinnerton, Frederick Opper, Walt McDougall, and Thomas "T. E." Powers all had their say, along with Gene Carr, who alluded to *Uncle Tom's Cabin* by answering that his character Lady Bountiful "kind of grew on me, like Topsy."

By this time George Herriman had been bounced from the *Evening Journal,* drawn for *Judge* and the McClure syndicate, and found work on the *World.* Commercially, Prof. Otto and Acrobatic Archie weren't in the same league as Lady Bountiful or Foxy Grandpa. Yet Hancock singled him out for high praise. "Art combined with poetry is the characteristic of George Herriman," Hancock said. "Were his drawings not so well known one would think he had mistaken his vocation."

When Hancock posed his question to Herriman, he received a response that he might have expected more from a cynical old-timer than a young cartoonist with relatively few credits. "Inspiration!" Herriman scoffed. "Who ever heard of a comic artist being inspired? Take him out into a field where the green grasses, swept by caressing zephyrs, bend and nod in rapt delight, dodging the nibble of the frisky, hungry lamb as it gambols hither and thither, and see if he (the artist, not the lamb), can see in this any blissful clutch, grasping heart, mind and soul in a grip of steely delight. No! He'll draw a lamb all right—a lamb so distorted that the green nodding field will rise in disgust to smite him."

Concluded a jaded Herriman, all of twenty-two years old: "His mind and soul have lost that delicate sense of the poetic and the artistic, which one would naturally think were indigenous, and he will turn away with a sigh, sit down at his desk and continue to worry out idioticies for the edification of an inartistic majority!"

By the time Herriman began working there, the New York World Building had become a tourist attraction. Hundreds of visitors arrived each day to take the elevator down into its cavernous basement and witness the massive Hoe printing press in action. "Few thrills compared with hearing the sound of the bell announcing the first turns of a press and the ensuing locomotive-like thumping cadence building to a deafening roar as the procession of cut, folded and gathered pages poured forth with increasing speed," wrote Pulitzer biographer James McGrath Morris.

To get to his new job, Herriman first had to pass through a massive three-story vault constructed from Scottish stone. Above him stood four bronze statues of female torchbearers representing art, literature, science, and invention. Herriman ascended past ten floors bustling with lawyers and businessmen. When the doors opened to the twelfth

floor, he was greeted by four more statues, these made from black copper and representing "the four races": Caucasian, Indian, Mongolian, Negro. Here was Joseph Pulitzer's office, connected to the office of Sunday editor Nelson Hersh, where sat the desk of Herriman.

Herriman later remembered Hersh for being a look-alike of the boxer and former world heavyweight champion Bob Fitzsimmons, whose freckles, spindly legs, and bald head made him a favorite target for caricaturing. "They were ringers—they used to go out to lunch," Herriman recalled. "And whenever Bob came in he used to wear the funny old hat and the Prince Albert coats they used to have, and they used to change hats and coats when they went down the street, and you couldn't tell which was which."

Former *World* reporter Albert Terhune recalled Hersh's wicked sense of humor. One day Hersh assigned Terhune to box three rounds with a different boxer each day, including Fitzsimmons and Jim Jeffries (who had taken the championship from Fitzsimmons in 1899), and then write about the experience. Terhune imagined friendly bouts— then he got in the ring. "The gladiators went at me, apparently, with all they had in them," he recalled. Terhune, with a face cut to ribbons, later learned that Hersh had set the whole thing up as a joke.

Herriman's other supervisors were comic art department head Paul West, also a songwriter and playwright; city editor John Tennant; and Tom McVeigh, who oversaw the paper's metropolitan section. Herriman later described the day in November 1902, when tragedy struck the office. "Mr. Hersh was killed by a little horse that Mr. Brisbane had given him, a horse called Titmouse," Herriman remembered. "[H]e and Tom both lived out in Staten Island. One Saturday afternoon they had left the *World* for home. . . . And instead of driving home immediately, they went to some little inn, and he and Tom were there a little bit longer than he should have been, and when he came out he wasn't in just the right shape." The drunken Hersh took a corner too quickly; the two men were thrown from the carriage and

Hersh fractured his skull. Herriman and the rest of the newspaper's staff met for the funeral at Hersh's home on Staten Island.

New Year's 1903 dawned in the pages of the *World* with futuristic news of a motorized "skycycle" and an interview with Guglielmo Marconi about his recent feat of sending two thousand words via telegraph across the Atlantic. The *World* also started the year with Herriman's most successful comic strip to date. On Friday, January 9, Herriman published a news illustration that accompanied a strange report about a black crow that had joined the Marine Corps, where it was surviving on a diet of tobacco and grog. Two days later Herriman continued the sailor jokes on the front page of the *World*'s comics supplement, *Funny Side of The World,* in a comic titled *A Strange Craft,* about a nautical pair named Bill and Pete who eventually become *The Two Jolly Jackies.*

"Jackies" was the street name for sailors on leave in New York. Despite the recent praise in the *Bookman* for Herriman's poetic language, *Jolly Jackies* is among the least writerly of his early comics. Some strips were pure pantomime; in others, sparse dialogue served only to advance breakneck action that often careens toward chaos. Throughout the nearly yearlong run, *Jackies* stories read as if Hans and Fritz Katzenjammer were sailors with endless shore leaves. In *The Two Jolly Jackies Put Out a Fire and Are Themselves Put Out,* the Jackies start to extinguish a fire but instead start blasting the water cannons at other volunteers. In *The Two Jolly Jackies Impose on a Charitable Public,* they sit on wooden boxes and tell passersby that they lost their legs in Manila Bay. In *The Middy Saves the Shipwrecked Jolly Jackies,* they actually threaten to eat a child.

At its best, *The Two Jolly Jackies* is pure visual extravagance, as in the spectacular *Twenty Minutes in a Submarine Boat,* a full-page episode costarring "our old friend Lib," a living Statue of Liberty. In *The Jolly Jackies and the "Lost" Dog,* a dog increases in size with each panel, presaging the later dream-influenced work of Winsor McCay. And in

The Jolly Jackies Both Invest in Mascots, detailed landscapes shift through open windows of a rolling train car, offering a hint of the peripatetic scenery of Coconino County still more than a decade away.

O n Sunday, May 10, in the Herrimans' home on Ninety-Fifth Street, Mabel Herriman gave birth to the Herrimans' first child, a daughter. They gave the baby Mabel's name, although it would rarely be used; to family and friends alike the oldest Herriman child was "Toodles" or simply "Toots."

George Herriman now had both a growing family and increasing duties at Pulitzer's *World*. The next month, on Sunday, June 28, the newspaper introduced a feature titled the "Metropolitan Section's Geographical Survey," to be helmed by Herriman and Roy McCardell, then the *World*'s most popular humor writer.

The partnership sparked a lasting friendship. "I found Herriman as modest and as lovable a fellow as I have ever met," McCardell later wrote, "and my association with him is among the pleasantest recollections of my newspaper experiences."

The idea for the "Geographical Survey" might have come from editor Tom McVeigh, but more likely it was hatched by McCardell and Herriman in one of the many newsmens' taverns that circled Park Row. They tailored the premise to give them ultimate artistic license: they would explore the city with notepads in hand, on the prowl for whatever amused them.

Early adventures included taking the "big iron steamer" for a breezy ride to visit Glen Island, on the Long Island Sound. They chugged past workhouses and asylums, with breweries "tantalizingly out of reach," McCardell wrote. Reaching the island, McCardell and Herriman met twenty-three circus performers who had been brought from India by a balloonist and stage manager named James W. Price. Herriman and McCardell received a private rickshaw tour from Price,

then watched a juggling act and a magician who, McCardell wrote, sat down next to Herriman and started convulsing, producing handfuls of pebbles from his mouth.

McCardell's writing adopts many racist clichés typical to jungle adventure tales of the era, and some of Herriman's drawings resort to boilerplate cartoon stereotypes. One small drawing in the corner of the page is a notable exception: well-dressed white children stare across a fence at a darker-skinned Indian child, who stares back at them. They all appear equally puzzled.

Urban exotica fueled the team's next adventure, a visit to "Japan by Night" at Madison Square Garden, where a rooftop garden had been decorated in dragons and golden fish, palms and pines. Herriman and McCardell tried Japanese food and sake, watched an opera, and looked on as Japanese immigrants got their fortunes told. Herriman and McCardell then went to Coney Island to meet up with Henry Clay Weeks, a local professor famous for his crusade against mosquitoes. McCardell makes several inside jokes about "snake-bite cure," an obvious reference to alcohol. He also started to turn Herriman into a semifictionalized comic character:

"A council of war was held, and it was resolved to advance upon the herd and rush it after nightfall, killing all we could, dying ourselves if need be. But Herriman pointed out to us that we were not prepared for a night attack, none of us having had the forethought to bring evening attire with us. . . .

"Herriman rightly observed that the mosquito was at least worthy of our respect, and that it showed bad form, to say the least, to move upon them after 6 P.M. in negligee."

The team made an inspired expedition to the corner of Twenty-Third Street and Fifth Avenue, where the city of New York had erected an elevated walkway, called an Isle of Safety, for pedestrians. Herriman contributed a panoramic cartoon with fantastic winged carts flying in the air, and mermaids and sharks swimming in the

"DEATH TO PEDESTRIANS!" SHOUTED "MIKE, THE MANGLER," OUR CHAUFFEUR. "WHAT RIGHT HAVE THEY ON THE STREET, ANY WAY?"

From *"Fogarty of the Survey" Dashes Through New York in a "Red Devil,"* New York World, November 29, 1903

streets. The team returned to Coney Island to track wild beasts in an animal show, armed only with rifles and dry martinis, and then visited the "Vaudeville Farmers" in Centerport, Long Island, a community of stage performers who had taken residence in summer cottages and farms. A favorite prank, McCardell wrote, was to dress visitors in blackface for a costume dinner. When the visitor shows up at the table, nobody else is in costume. McCardell did not report if he and Herriman fell victim.

In August 1903 Herriman began contributing to the *Evening World*'s "Home Magazine" page, starting with a spread of cartoons on two news stories: an odd debate over sailors wearing pajamas, and a counterfeit coin scandal at Coney Island. For the Coney Island cartoon, Herriman affixed the name "Jones" over a tintype shop, a private greeting to his former landlord.

From *Mrs. Waitaminnit—The Woman Who Is Always Late*, *New York Evening World*,
September 21, 1903

Pulitzer next tapped Herriman to draw daily strips for the page. On Tuesday, September 15, Herriman debuted his first daily strip with recurring characters, a domestic comedy titled *Mrs. Waitaminnit—The Woman Who Is Always Late*, about a husband named James who fails to hurry along his dawdling wife, Hortense. *Mrs. Waitaminnit*, which ran nearly every day for one month, mirrored other strips named for characters' rude habits, especially Charles (C. W.) Kahles's *Mr. Butt-In*, which was popular enough to be adapted into a short film in 1906. In one *Mrs. Waitaminnit*, James's acrobatic attempts to contain a leaky pipe give Herriman the opportunity to play with vertical and horizontal space, tracking the story from left to right while steam pipes direct the eye from top to bottom.

A baby showed up in the Waitaminnit household in October, about the same age as Herriman's then-five-month-old daughter Toots; for

the final weeks of the strip, the baby engages in a humorous little sideshow of tail-pulling with the family cat. Herriman attempted another daily strip, *Little Tommy Tattles*, but it quickly ended. Herriman's contributions to the page were through by mid–October, when his work was replaced by an unappealing minstrel comic that went under several titles, including *Little Dixie* and *The New Little Coon*.

Herriman stayed busy, drawing *Lariat Pete*, a short-lived cowboy series, for both the McClure syndicate and *Judge*, as well as numerous one-shot comics for Pulitzer's *Funny Side of The World*, with some appearing in newspapers as far off as the *San Francisco Call*. Meanwhile, the Geographical Survey excursions were growing ever more weird. Writer Roy McCardell again cast Herriman as a comic character, this time in a story about seeing theatrical depictions of hell in *Ulysses* at

From *Lariat Pete*, September 6, 1903

the Garden and Dante's *Inferno* at the Broadway. Wrote McCardell: "From what we saw and heard, the classical or Greek hell is in the nature of what is called at Coney Island, an 'Old Mill.' You get in a boat and float around through dark and gruesome caverns and see things on the side in illuminated grottos.

"Charon was our boatman. Prof. Herriman irreverently began to whistle, 'Strike Up the Band, Here Comes a Sailor,' and we could see Charon's whiskers crinkle with rage."

The *World* published the Survey's final outing on November 29, 1903. This time the gang visited a garage on Thirty-Eighth Street. "We were to ride through the streets of Greater New York in the car of a juggernaut they call an automobile," wrote McCardell. "Our chauffeur was a thickset young man, with a firm, determined chin, with previous convictions of manslaughter to his credit even before he ever turned the lever of a Winton, Cadillac or Panhard.

"His name was Michael Meagher, he informed us, but at the garage among his fellow Parisian chauffeurs, he was generally called 'Mike the Mangler.' He did not know why he was so named. He could not even guess."

Herriman drew a detailed map that traced their route up Broadway, through Forty-Second Street, up Fifth Avenue to Fifty-Ninth Street, through Fifty-Ninth Street to Third Avenue, down Third Avenue and the Bowery to Park Row, and back to the garage. "Crosses show where bodies were found," joked McCardell.

The gang was luckier than they might have imagined. Three years later, the *New York Times* reported, a woman was killed after being thrown from her husband's automobile and landing directly in the path of a streetcar driven by none other than Mike the Mangler.

Herriman and McCardell survived their last ride together, but the partnership had reached its end. Herriman closed out the year with the impressive Christmas strip *Santa Claus Finds Changes in the Children*, in which Santa tries in vain to deliver a jumping jack to various

spoiled children and young toughs. That Christmas, the popularity of Herriman's cartoons was underscored by a display of cartoon characters at Macy's department store on Herald Square. Reported the *World*: "'And there's the Jolly Jackies, too, mamma,' cried out an enthusiastic youngster."

By then, however, Herriman had already departed the *World* for a new opportunity. On December 27, the *New York Daily News* (no relation to the later *Daily News*) informed its mostly Irish-Catholic readership that it was making sweeping changes, including changing the publication day of its five-cent Sunday paper to Saturdays. "We have just installed a mammoth Hoe color press, capable of printing nine colors at a time," the newspaper trumpeted. "We have had to get together a corps of artists and engravers and Sunday paper editors and writers. They have been selected from widely separated newspaper and magazine offices. Few, if any, of them have ever before worked together."

Although Herriman's salary is not known, it's likely that he was offered a substantial paycheck to leave the prestigious *World*. The *New York Daily News* also gave Herriman an opportunity that he couldn't get with either Pulitzer or Hearst: the chance to be a newspaper's star cartoonist.

The *New York Daily News* was founded in 1855 by Benjamin Wood, brother to New York mayor Fernando Wood. During the Civil War, the Woods were "copperheads," New York Democrats sympathetic to the Confederacy, and their *News* was fiercely pro-secession. Following the Civil War, the newspaper primarily served New York's Irish community, with newsboys hawking papers to parishioners leaving Sunday Mass. After Benjamin Wood's death, the newspaper started to falter; in 1901 his widow, Ida Wood, sold the former $2 million company for $340,000. The eccentric Wood de-

manded the sum in $1,000 bills delivered in person to her Fifth Avenue hotel room.

The purchaser, Frank Andrew Munsey, is best remembered as the originator of pulp magazines the *Argosy* and *Munsey's Magazine*. The *Daily News* was part of a scheme to purchase five hundred newspapers and go head-to-head with Pulitzer and Hearst. However, Munsey detested the roughhouse environment of newsrooms. Wrote Allen Churchill in his portrait of Park Row: "As soon as Munsey purchased a newspaper, he ordered all fat men on the staff fired, for he considered them lazy as a breed." Munsey even demanded that "No Smoking" signs be put up, as he considered smoking a waste of time. "God hates a waster," Munsey told his unhappy reporters.

With Munsey stalking the office, the holidays couldn't have been an easy time for Herriman. An editorial in the *Daily News'* inaugural issue admitted to troubles. The "delays and difficulties that are inevitable in starting up any mammoth mechanical creature" nearly did in the new staff. "So great has been our rush that they have had no time in which to adjust themselves to one another or to take on anything of the atmosphere of the office. It has been a case of tremendous hustle to reach this first Saturday in 1904." The paper finally hit the newsstands, laden with plaudits from local ministers congratulating Munsey for publishing on Saturday and returning the "sacred character" to Sunday.

From the beginning, Herriman turned out an incredible sum of cartoons and comics for the *Daily News*. These were both signed and unsigned, and appeared in all sections of the newspaper, from news to editorial to sports. His position as top illustrator was secured, if only he and the *Daily News* could survive Munsey.

The star character of the *Daily News'* first four-page comic supplement was Herriman's Major Ozone, a willowy old man with an obsessive craving for fresh air. *Major Ozone's Fresh Air Crusade* quickly became Herriman's most successful early comic: it received top bill-

ing in *Daily News* comics promotions, frequently occupying the full front page of the supplement, and even found a national readership after Frank Munsey struck a business arrangement with the St. Louis–based syndicate World Color Printing.

Herriman possibly dreamed up Major Ozone the previous year when on assignment for the *World* to caricature the thousands of zealots who were flocking to Madison Square Garden to see the Scottish faith healer John Alexander Dowie, also known as "Elijah the Restorer." Reported Herriman for the *World*: "From Brooklyn, too, come the Spiritualists and the Adamites. With these are uncooked-food cranks, cold-air cranks, free-love cranks, personal-magnetism cranks—in short, a crank revival is upon us."

In Ozone's first appearance, on Saturday, January 2, 1904, he is seen riding a train car, insisting on opening the window. "He'll be sorry," predicts a nearby child. A gang of kids push an avalanche of snow through the open window, burying the major. "I knew he'd get it," the child says.

Undaunted, each week Major Ozone opens more windows and wreaks more havoc. He boards a ship and proclaims, "Open wide the port-hole!!!" and fish pour in. He joyfully sits before a broken window as the cold wind howls. Ozone is beaten up and says it is good for his rheumatism, and is pummeled by snowballs and even bricks. Major Ozone is Herriman's most quixotic creation, barely capable of registering ill intentions.

Unlike Musical Mose, Ozone never pledges to change his behavior. In one of the strip's loveliest episodes, Ozone climbs a tall chimney in his quest for fresh air. As he takes in the view, he doesn't realize that, below him, two workers have removed the ladder and are dismantling the scaffolding. Soon, Ozone is stranded, alone but for a moon shining in the crosshatched darkness. "Oh well, I dare say it will do me good," he says, a knight-errant who would rather perch on a windmill than slay one.

From *Major Ozone's Fresh Air Crusade,* February 11, 1906

I n addition to *Major Ozone's Fresh Air Crusade*, the first Saturday edition of the *Daily News* included another Herriman milestone: the first of his full-fledged sports cartoons.

Over the past decade, sports cartoons had become a necessary topper for any self-respecting sports page. Usually drawn by an expert who might also write a bylined story, a typical cartoon featured a large illustration of an athlete surrounded by little drawings either of that same athlete in funny poses or of scenes of the competition.

For Herriman's inaugural sports-page cartoon, *Just a Peep at the Physical Culture Show at Madison Square Garden*, he offered various scenes from the show: a man on a fast dreaming of steak and pie; a skinny, bookish man striking a muscular pose; and the prizewinning bodybuilders Al Treloar and Miss Marshall. Herriman also seized the chance to draw a caricature of illustrator Harrison Fisher, who was in the Garden to be "Judge of the Venuses." Herriman's Fisher is a portly

man in a plaid suit and spats, a ring on his left hand sparkling as he carefully marks his ballot. It was the first of many times that Herriman would lampoon his elder illustrators and cartoonists.

Over the next months Herriman covered everything from bowling to billiards to ice yachting. He returned to Madison Square Garden for the Poultry, Pigeon and Pet Stock Association, caricaturing the "heavy framed and strong in chickendom." But it was an upcoming prizefight between Tom Sharkey and Jack Munroe, set for Philadelphia in February 1904, that became the talk of New York sports fans and the first major sporting event covered by Herriman.

Boxing in New York had become illicit. A *Daily News* sportswriter described illegal bouts in secret barns, with kerosene lamps flickering while "two disgraceful 'dubs' maul each other until one falls down and refuses to be kicked up again." Herriman parodied the authorities' hapless attempts to stop illegal fights with a cartoon of a giant "Burlap Homes" (Sherlock Holmes) scanning the landscape for a match while, at his feet, swarms of tiny boxers pound away.

Big fights were permitted in Philadelphia, though, and the Sharkey-Munroe match was the season's main event. Tom Sharkey, the "Sailor," was a squat, broad-shouldered Irish brawler and the favorite over the Canadian Jack Munroe, the "Cape Breton Miner." The victor would earn the opportunity to climb into the ring with the champion Jim Jeffries. Jeffries himself would be among the ringside fans in Philadelphia.

The Sharkey-Munroe fight would inspire Herriman's first grand sports cartoon, in which he clad Sharkey in breastplate and plumed helmet and posed him over a wailing Munroe. The citizens hang over the walls, giving thumbs-down signs to signal Sharkey to kill his foe. Corbett and other boxers are strewn across the ground; Jeffries is scaling the wall, trying to escape. On a closer look, it's revealed that the entire scene is a dream. Sharkey lies at the very bottom of the drawing, cozily wrapped in a blanket embroidered with flowers and the words "Our Tom."

Other sports cartoonists of the time, including Tad Dorgan and Robert Edgren, also drew irreverent and playful cartoons, occasionally riffing on classical themes. But for these artists the illustrations served to explicate the sport: a boxing cartoon might reveal the stance or punch that decided the match. Herriman's sports cartoons offered remarkably little sports analysis. He preferred to caricature the larger-than-life characters who inhabited the sporting world, and the mock-mythic dimensions of their contests. Neither Edgren nor Dorgan tended toward sweeping panoramas or language like "Perchance, ah perchance he brings a bid!!"—the dialogue in a Herriman cartoon about Sharkey and Munroe waiting to hear from a fight promoter.

Herriman sat ringside for Sharkey and Munroe's six-round bout, which was set for ten o'clock Saturday evening, February 27, at the Second Regiment Armory in Philadelphia. In *Some Things Cartoonist Herriman Saw at the Sharkey-Munroe Fight*, he gently ribbed Edgren, who appears to have been nursing a hurt foot. Herriman depicted him with a notepad in one hand and a cane in the other.

The fight started and, as predicted, Munroe was knocked to the canvas almost immediately. He stayed down for nearly the full count but then stood up and shocked fans by pounding Sharkey into the ropes, tearing open gashes around his opponent's eyes. At the end of the bout, Herriman and the rest of the Second Regiment Armory regarded the fallen fighter whom Herriman had depicted just one month earlier in a sweet sleep, dreaming about Rome. "Bruised, cut, bleeding, gasping, rocking—a far more sorrowful picture for the great throng to gaze upon than were he prone upon the floor, senseless but unmarred," reported the *Daily News*.

One month into his tenure at the *Daily News*, Herriman received his first assignment to illustrate a newspaper crusade: assail the unpopular "Near-side Car Ordinance," which required surface

car passengers to exit on the near, or sidewalk, side and not into the middle of the street. Passions ran high. Proponents said that the ordinance was necessary for public safety. Opponents were outraged at having to step from the car into a mound of snow or mud. The Women's Health Protective Association declared that any decrease in accidents was offset by a fifty percent increase in people catching cold from walking through slush.

Herriman launched his first salvo in a front-page cartoon showing men sinking headfirst in snowbanks, women being forced to hike up their skirts, horses stamping about, and children being whisked from the danger. As with his sports cartoons, Herriman seemed more interested in finding humor in the battle than in championing either side.

Each successive issue of the *Daily News* revealed Herriman's news cartoons and comics growing more absurd. There is a man named Noah Thingortwo and an Owl Eye family. A leering train car with Maurice Sendak–style clawed feet perches on the stomach of a startled sleeper. In *If Parsifal Came to New York*, Herriman placed the Arthurian hero in various cityscapes, from Central Park to the Bowery. Here, Herriman anticipated future praise by P. G. Wodehouse, who would write, "In Krazy, Mr. Herriman has got what Wagner was groping for in Parsifal."

As when he had caricatured Harrison Fisher at the physical culture show and Robert Edgren at the boxing match, Herriman seized another opportunity to needle an elder statesman of his craft. The *Evening Journal*'s Homer Davenport was launching a series of lectures titled "The Power of the Cartoon," and Herriman attended a special invitation-only appearance at the Manhattan Theatre. "Like a ray of crystalline sweetness in the season's abyss of prurient drama Cartoonist Homer Davenport hurled himself upon the stage of the Manhattan Theatre yesterday afternoon," Herriman wrote, listing audience notables including his old *Evening World* colleague T. E. Powers. At one point, Herriman recounted, Davenport opined that no good cartoon-

ist can avoid making enemies. "Then Mr. Davenport looked straight at Mr. Powers and observed that there wasn't even a good—much less a first-class—comic cartoonist in the United States. Mr. Powers shifted uneasily."

Herriman launched a second *Daily News* Saturday comic, *Bud Smith, the Boy Who Does Stunts*, a calmer version of *Acrobatic Archie*. He also added a new daily strip, titled *Home, Sweet Home*. Published just four times over the course of two weeks, the modest domestic comedy of marital strife is notable mostly for a black cat who appears in the final installment to utter the last words of the series: "It's human nature."

There were already indications that the *Daily News* experiment was going awry. In February, just two months after announcing its special Saturday editions, the newspaper announced that it was returning to

From *Bud Smith, the Boy Who Does Stunts*, New York *Daily News*, February 27, 1904

Sundays. Still, Herriman forged ahead with new ideas. On Sunday, March 6, the *Daily News* went head-to-head with the Metropolitan Section Geographical Survey, which Roy McCardell was still writing for the *World*. For the *Daily News*, Herriman and Walter S. Murphy, a British-born reporter thirteen years Herriman's senior, launched a new feature named "Bubblespikers":

> Whenever you see a bubble, spike it!
>
> That is the short and simple slogan of the metropolitan section's doughty team of truth hunters—Walter Murphy and Herriman, the cartoonist. Truth crushed to earth sometimes takes its own time in rising again. Now with the aid of their nimble pens, the popular bubblespikers will make it get up with greater agility. . . . If you hear it from the Bubblespikers, believe it.

As he did with McCardell, Herriman toured New York with Murphy, searching for stories. The team first visited the palatial Hoffman House, on Broadway between Twenty-Fourth and Twenty-Fifth Streets, to track down a rumor that it was hosting "the most famous turf plungers, owners, breeders and trainers in the country." The report features two large cartoons by Herriman, showing himself and Murphy in long coats and bowlers. The head clerk, a whiskered gentleman named Colonel Peacock, informed them that the rumor was unfounded. The bubble spiked, Herriman and Murphy "went out into the cold drab mist again, doubly chilled by the realization of a shattered dream," and presumably returned to the *Daily News* to try to make a full-page feature out of an eventless hour in a hotel lobby.

Murphy's writing is not as fanciful as McCardell's, and the Bubblespikers' journeys are more reportorial than the *World*'s Metropolitan Section Geographical Survey. For "The National Popular Song of 1904," the Bubblespikers visited Music Row publishing offices on lower Broadway, also known as Tin Pan Alley. Herriman and Murphy

met up with songwriter Andrew B. Sterling, who had penned hits for minstrel performer Bert Williams and who was about to debut "Meet Me in St. Louis, Louis" for the upcoming St. Louis Exposition. They met Indiana songwriter Paul Dresser, the brother of novelist Theodore Dreiser, and finished their visit with the legendary black musician and composer Will Marion Cook. It is tantalizing to speculate about Herriman's historic meeting with Cook, a violinist, composer, and teacher whose students would include Duke Ellington and who served as musical director for Bert Williams and George Walker's *The Sons of Ham*, the minstrel show that had inspired one of Herriman's first *Judge* cartoons. Murphy offers frustratingly few details about their visit. Herriman's caricature shows Cook in profile, holding his coat and hat on his arm, a gem sparkling in his necktie. There is not a hint of minstrelsy in the drawing.

The Bubblespikers' most rollicking adventure was a tour of the city to learn about chop suey. At a chop suey bazaar by Greeley Square, Murphy wrote, they encountered a pair of beautiful women, with Herriman admiringly whispering, "That one—the blonde— looks like a Newport debutante." The women passed them, Murphy reported, murmuring something about cheapskates. Herriman contributed a wistful silhouette of the two men, walking side by side into the Chinatown night. It would be one of the Bubblespikers' final outings.

A s summer 1904 approached, ominous promotions began appearing in the *Daily News* for a "Sane, Satisfying Newspaper." On Saturday, June 4, a banner headline announced the purchase of the newspaper by Munsey's managing editor, Thomas C. Quinn. The next day Quinn published a letter to the readers titled "A Return to First Principles." It became quickly apparent that those first principles did not include cartoons.

Munsey's *Daily News* had proven a financial failure. *Editor & Publisher* estimated the losses at $750,000, and two years later the *Daily News* finally quit publication altogether. Nonetheless, the experiment made a few significant contributions to cartooning. The *Daily News'* partnership with the World Color Printing syndicate introduced *Major Ozone* and *Bud Smith* to a national readership. Most important, George Herriman had made the most of his brief time there to announce himself as one of the city's top sports and editorial cartoonists.

His efforts did not go unnoticed. Herriman's last *Daily News* illustrations appeared on Sunday, April 10. Eleven days later, on Thursday, April 21, the New York Giants baseball team hosted the Philadelphia Phillies at the Polo Grounds, in Coogan's Hollow on 155th Street. Sitting in the bleachers was George Herriman. His cartoon about the game would appear in the next day's *New York American*. It had taken him three years and two newspapers to accomplish it, but Herriman had returned to the employ of William Randolph Hearst.

The *New York American*'s offices occupied the same Tribune Building in which, just three years earlier, Rudolph Block had fired Herriman from the *Evening Journal*. The *American*—formerly the *Morning Journal*—and the *Evening Journal* shared close quarters. Former Hearst photographer Harry J. Coleman described a large, smoke-thick room with a single table stretching down the middle of the two operations. "The none-too-sober copyreaders sniped wisecracks at each other across a no-man's-land of paste pots, typewriters, telephones and gooseneck lamps," Coleman said.

A pair of headstrong managing editors lorded over them: Foster Coates at the *Evening Journal* and, at the *American*, the future socialist leader and cofounder of the National Association for the Advancement of Colored People (NAACP) Charles Edward Russell.

A photograph dated January 1904 shows members of Hearst's impressive art staff for both papers, just prior to Herriman's arrival. It was taken on a subzero winter's day, and the artists trekked outside in long coats and bowlers. T. S. Sullivant is nearly out of the picture, smiling and tipping his hat. Jimmy Swinnerton puffs on a pipe and mocks the camera. Marjorie Organ, the only woman in the group, tilts her head back and grins. Other leading lights in New York cartooning are shown, including H. A. MacGill, T. S. Allen, Paul Bransom, and

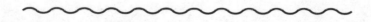

Gus Mager. To the right of the photograph is Willie Carey, an office boy who later would play a pivotal role in the creation of *Krazy Kat*.

"You know in the old days when I first went to New York comic men were like a lot of school boys," recalled cartoonist George Mc-Manus, creator of *Bringing Up Father*. "They were all in a room and they had to have somebody watch them because they were being paid a salary and they weren't interested in doing too much work." One day, Harry Coleman remembered, Hearst's editor Arthur Brisbane sought out cartoonist Robert Carter but found only an empty whiskey flask. Brisbane conducted an "all-out foray to the coolers and groggeries in the vicinity." An inebriated Carter was finally located in a room in the Astor House. A *Journal* artist applied paint to a black eye, and the gang went out to celebrate.

Despite stories like these, Herriman clearly put in long hours for the *American*. Mostly drawing sports cartoons, he worked under sports editor Harry Beecher, a former Yale football star and grandson of anti-slavery advocate Reverend Henry Ward Beecher (and grand-nephew of Harriet Beecher Stowe, the author of *Uncle Tom's Cabin*). New York offered an abundance of material. It was the second year for the New York Highlanders (whom the *American* and other news-papers had started nicknaming the "Yankees"), and the team hosted games in its new stadium in Washington Heights' Hilltop Park. Just a few blocks away at the Polo Grounds, the Giants were on their way to a pennant season. The one-mile Jamaica Race Course recently opened in Queens (in the same town that Stephen Herriman once left to seek his fortune in Louisiana). Boxing was temporarily quiet, with Jim Jeffries in his training camp preparing to fight Jack Munroe, but that would change soon.

The *American* published its first Herriman sports cartoon, *Artist Herriman's Impressions of the Giants' Ignominious Defeat on Their Home Grounds*, on Friday, April 22, 1904. It was a modest first outing, with the Philadelphia team represented by capital *P*'s dancing around. Yet, sports-

themed masterpieces were soon to appear, spurred by a new collaboration with a writer named Charles Somerville, who was later to make his name by discovering a cache of letters written by murderer Charles Gillette when covering the case that inspired Theodore Dreiser's *American Tragedy*. A fanciful prose stylist and future novelist, Somerville had his own elusive family story. Apparently a couple of years older than Herriman, he claimed New Orleans as his birthplace, although no official birth records have emerged. He left his family at fourteen to be an actor and, like Herriman, started newspaper work when he was sixteen. A passport application noted his dark complexion, and when he died in 1931, the *New York Times* reported that he was Creole.

The evidence suggests that two sons of New Orleans, both passing for white, had coincidentally been teamed up by Hearst's *American*. It is tempting to speculate that, during some long afternoon at a Highlanders game, Herriman and Somerville compared notes about their childhoods. What is certain is that the two men shared journalistic sensibilities. Somerville's ornate prose matched (and at times exceeded) the irreverence of Herriman's drawings. It was Herriman's good fortune to find a sportswriter who led stories with lines like "Pride and the banana peel have long had association in song, story and sure enough bumps."

On Thursday, April 28, in between trips to the Polo Grounds and the Jamaica Race Course, Herriman published another auspicious cartoon. It was a caricature of Jimmy Britt, the current featherweight boxing champion. Britt recently had broken his hand on an opponent's head, and he stopped by the Tribune Building to re-create the punch for a photographer. Herriman added a few odd cartoons of Britt in a toga and garlands, strumming a lyre. He also drew a small scene of Britt standing in the rain on a New York street corner, holding an umbrella to keep his bandaged hand dry. Next to Britt stands a tall man smoking a cigar. Britt's friend, the caption reads, is the "artistic phenom from Frisco."

With this cartoon, Herriman welcomed Thomas Aloysius "Tad" Dorgan to New York.

A s surely as F. Scott Fitzgerald embodied the Lost Generation, and Neal Cassady was, in the words of poet Allen Ginsberg, the "secret hero" of the Beats, so did Tad Dorgan define what might be called the "Sports": an informal group of writers and artists, mostly based in newspapers in New York, Los Angeles, and San Francisco in the early decades of the twentieth century. Largely self-educated and self-made men, the Sports celebrated a hard-brawling immigrant America. Their influence in art included the "Ashcan" school of urban realism, and their sensibilities entered literature and theater via writers Ring Lardner and Damon Runyon. Runyon's street-savvy, slang-speaking hustlers took to the stage in the musical *Guys and Dolls*, and the term "Runyonesque" would later define the Sports aesthetic. But the Sports themselves agreed that their finest was Thomas Aloysius "Tad" Dorgan, a physically frail man with shiny blue eyes, half a right hand, and a quick-jab wit.

"Tad was for years the life of the Roaring Forties," wrote O. O. McIntyre, referring to New York's theater district. "It was the playground for this shy, funereal humorist who liked to pry into the mechanism of a hectic night life to see what made it tick."

The Sports' motto might be found on a sign that Dorgan said should hang over every man's desk: "Don't Kid Yourself." Dorgan has been credited with coining much of the glossary of the age. H. L. Mencken wrote that Dorgan either invented or popularized "skiddoo," "drugstore cowboy," "cat's pajamas," and "Yes, we have no bananas." Upon Tad's death in 1929, the newspapers brimmed with accolades, and at Madison Square Garden ten thousand fight fans stood in reverence while a bugler played taps. "Oh, yes, there was the greatest fellow that ever lived," Herriman once said. "He had a million friends, all kinds."

From *Krazy Kat,* June 9, 1917

Born in San Francisco's "South of the Slot" tenements in 1877, Dorgan was the oldest of eleven children. His father ran a small shop near the boarding and livery stable owned by the father of fighter Jim Corbett. Young Dorgan was a scrappy boy who only wanted to box and play sandlot baseball. When he was five, his dreams of turning pro were crushed by a house-moving accident that tore off his right four fingers. Dorgan then found a new idol: Jimmy Swinnerton.

Dorgan later remembered how he "used to follow Jimmy Swinnerton along Market Street . . . when Jimmy wore a flat derby and a canary-colored overcoat with pearl buttons. I longed to be an artist but there I was with that nub of a mitt." He taught himself to write and draw left-handed, and he posted his cartoons in his father's shop windows. Then Dorgan got his first newspaper job, at the *San Francisco Bulletin*.

Dorgan summed up his acerbic point of view in a large *Bulletin* cartoon titled *This Is a Fighting World: Wherever You Go You Will Always See the Beginning or the End of a Scrap*. No activity embodied this ethos more than boxing. For Dorgan and the other Sports, boxing wasn't brutal. Life was brutal, and boxing elevated brutality to art.

In 1903 Dorgan started contributing to the Pulitzer newspapers; his boxing cartoons were datelined "San Francisco" and "drawn especially for the *Evening World*." On Thursday, March 31, 1904, he put his family on an east-bound train and planned to take a job at the *World*, but Hearst's editor Arthur Brisbane intercepted the play. "He sent him a wire and said, 'Come and see me first—whatever the *World* says, we'll meet that price.' Tad had a little affection, not for Hearst, but for San Francisco, and that is probably how he strayed in to the *Journal*," said Herriman.

Over time, a unique boss-employee relationship developed between Brisbane and Dorgan, with the editor feeding the cartoonist a steady diet of books to read, and Dorgan praising the editor as a rare literary man who also could think in pictures. Recalled Herriman, "Brisbane used to say, 'Tad, I'm interested in you; I like you because you're half guttersnipe and you're half genius,' and he said, 'I like the genius side of you.'"

Soon Herriman was turning in near-daily sports cartoons that eclipsed even his best *Daily News* work. Under his increasingly confident hand, boxing bouts, horse races, and baseball games

transformed into mini-pageants of human endeavor and conflict. His tales harkened to classic myths while speaking the language of the street. They were among the most extravagant sports cartoons ever published.

Harry Beecher's enthusiasm for Herriman is most evident in sports pages that wrap text around massive cartoons, as in a Herriman cartoon about the many delays leading up to the Jim Jeffries–Jack Munroe bout. The news from San Francisco was that Munroe couldn't be located, so Herriman suggested how the boxer might be hiding: "parading Fifth Avenue disguised as an heiress," "fondly dreaming in the soft green grass of some bosky dell," "doing the ostrich act," or "retired to some deep, deep mine to wait till things blow over." His cartoon of the boxer hiding in the mine drops deep into the page, through a substrata of amateur baseball scores, with Munroe curled up at the bottom.

Such creative use of vertical space was only one of many ideas Herriman developed and refined while at the *American*. Over the summer, he added signature flourishes such as comical motion lines and the "dingbat" symbol of an *X* inside a circle; sympathetic, anthropomorphized animal characters; frequent depictions and mentions of both himself and other cartoonists; literary and classical allusions; imagined dreamlike states; panoramic landscapes; supernatural appearances; and minstrelsy as metaphor. All of these would carry forward into *Krazy Kat*. There seemed to be no end to what Herriman could do on a sports page when working with a sympathetic editor and a witty New Orleans–born sportswriter, egged on by the likes of Tad Dorgan.

Herriman's home life is less documented, but his relentless schedule of ball games, horse races, and boxing matches suggests that he spent many days and nights away from Mabel and Toots, including frequent out-of-town trips. On Saturday, May 14, Herriman's cartoon anticipated a six-round bout between Kid McCoy and Philadelphia Jack

O'Brien, scheduled for the next day in the Second Regiment Armory in Philadelphia. Herriman and Somerville (along with Dorgan, who covered the fight for the *Evening Journal*) joined the Sports traveling to Philadelphia. The McCoy-O'Brien battle was unimpressive, with fans shouting their disapproval by the fourth round. Somerville and Herriman proved once again to be a perfect team, however. Somerville reported that the punches "bore a neat resemblance to the sort of arm projectiles that are put forth by fighters by request of the entertainment committee at ladies' day boxing tournaments," and Herriman offered irreverent scenes, such as a caricature of a well-known baseball player taking in the fight, with the iambic caption, "Rube Waddell at times did well enthuse."

That summer, Somerville and Herriman took in numerous ball games together. Herriman noted the players' reaction to the new invention of the pitching machine ("On the level I can't express my contempt for that object") and came up with sounds for speeding baseballs that would later be echoed by speeding bricks ("when the ball zizzed through the curious rabble"). Cartoonists making cameo appearances in Herriman's *American* sports cartoons included Charles Dana Gibson, the creator of the Gibson Girl, and Frederick Opper.

Tad Dorgan, however, claimed the starring role. In one cartoon, Herriman portrays the ghosts of bare-knuckle boxing legends John Heenan and Tom Sayers as they "ask leave of abscence [*sic*] from over the Styx that they may look over the field of scrapping heroes, who hold sway in this, our happy day." The old-time boxers weep when they see Dorgan. "How could their battered phizes be embellished in ever-lasting print when in their day the illustrious 'Tad' did not exist," Herriman asks.

Herriman's baseball cartoons grew ever more strange: a pitcher is a human windmill; a base runner has an airship attached to his head. Herriman and Somerville both tended toward Shakespearean prose: "Us to the expression of more hoorays, dear friend," Somer-

From *Giants and Yankees Shut Out Opponents, New York American,* May 3, 1904

ville wrote, while Herriman noted "a trio of Cleveland rooters who rooted not wisely, but too well." At times Somerville cast his report in verse: "We're happy, oh, we're happy and we root in much defiance / for any other bloomin' team to come and beat the Giants." If there was a rainout, Herriman brought in the god "Jupe Pluvious," complete with a crown and duck feet.

Meanwhile, for the delayed Jeffries-Munroe fight, Herriman relied on visual metaphors: Jeffries tries to blow out a Munroe flame; Jeffries is a prospector; Jeffries is a giant gopher. Another cartoon riffed on minstrelsy: Jeffries plays the Jim Crow role, with Miss Championship on his arm, and Munroe is Zip Coon, leering at her from behind a picket fence.

In the July 27 edition of the *New York American*, Herriman gave sports prose a rare try in anticipation of a bantamweight bout between champion Frankie Neil and challenger Hugh McGovern. In *Herriman Says Knockout is Likely: Cartoonist Compares the Two Little Fellows to Torpedo Boats, but Is in a Quandary as to Which Is the Better*, Herriman scripted a conversation between an old man and a young boy on a train to Philadelphia, packing the dialogue with barely comprehensible lines such as "Each and every biff and bang means the long seance of moon talk about monkey jibbers, and there you are." The only thing missing was any insight about the fight itself. Few Herriman sports articles would follow.

I n 1904, the first English translation of Sigmund Freud's *The Interpretation of Dreams* was still nine years away. Cartoonist Winsor McCay would soon stake his own claim in the dreamworld with *Little Nemo in Slumberland*, which the *New York Herald* first published in 1905. In his sports cartoons for the *American* of May 25, 1904, Herriman introduced his own dreamscapes, as in *My! What a Rude Awakening There'll Be for Some in This Dream Herriman Depicts When the Brooklyn Handicap Is Over*. A group of horsemen, asleep in a boat that is being piloted by Morpheus, the Greek god of dreams, is collectively dreaming of a dachsund-like horse whose name combines the names of all the horses in the Brooklyn Handicap: "Irishladhermisafricandermcchesneypickethurstbourneetc—" Wrote Herriman: "On the sea of dreams—in the bark of sleep—their slumbers doth merge their thoughts in ONE!!!"

Other track cartoons show Herriman throwing his sympathies in with the horses, as in a June 12 cartoon that addressed the illegal but common practice of injecting horses with drugs such as cocaine or morphine. In *Recent Uprisings in Equine Circles, from Happy Beginnings to Sad Sequel, Pictured by Artist Herriman*, the horse Nixcomarouse

leads a strike for "less dope and more humanity." Their owners relent. In the final panel, however, it is revealed as an equine fantasy. "Alas, poor nag, it wound up thusly," sadly reports Herriman, as the horse is kicked to her feet and commanded to take her dope.

As the much-delayed Jeffries-Munroe bout finally approached, Hearst syndicated Herriman's fight cartoons to readers around the country. This included Herriman's *Jeffries as the Modern Jason*, which included a short comic essay that riffed on the legend of the Argonauts' leader sowing dragon's teeth that would grow into a field of soldiers. Writes Herriman: "He didn't sow a lot of decayed dragon teeth, but real live challenges, and he didn't sow them over a dinky ten-acre ranch either, but like a great grim reaper, he sowed broadcast, over the entire face of the earth, in every dell, in every sylvan wild, in every mountain canyon, in every nook and cranny, aye, to the very tops of snowy peaks did he sow the seed!" The only challenger that pops out of the ground is Munroe, in full battle armor.

The fight was scheduled for Friday night, August 26, at San Francisco's Mechanics' Pavilion. Herriman likely joined the New York crowds gathered to follow fight bulletins on three giant boards in front of the Tribune Building. It was over quickly when Jeffries landed solid body punches on Munroe and the fight was stopped in the second round. The short match left much empty room in the next day's sports page, which Herriman filled with a series of historic tales recast as boxing bouts: *Extra! Hercules Knocks Out Antaeus!*; *Achilles's Backer Denies He Faked*; and *Goliath Loses Bout to Unknown*. He finished with a gag about the advancing age of boxer Robert Fitzsimmons: *Fitz Challenges a Winner in 1498, B.C.*

The lanky, freckled, and bald Fitzsimmons had become Herriman and Dorgan's favorite target, and played a starring role in one of the cartoonists' off-duty misadventures. In August 1904 Fitzsimmons took to the stage at the Metropolis Theatre in the Bronx to star in *A Fight for Love* as "Robert Fitzsimons, a country gentleman." Harry

J. Coleman later recounted how he'd received an assignment to photograph Fitzsimmons onstage and that, along with Herriman and Dorgan, he'd decided to make a night of it.

The trio arrived at the ornate, 1,600-seat Metropolis, located at the corner of Third Avenue and 142nd Street, and were ushered into box seats overlooking the stage. The curtain opened to reveal a set of a blacksmith shop. (Fitzsimmons, a former blacksmith in New Zealand, was nicknamed "the Fighting Blacksmith.") When Fitzsimmons entered, Coleman, Herriman, and Dorgan were close enough to see the greasepaint smeared over the boxer's trademark freckles. They were even more amused "that his bald pate was hidden beneath a sheepdog coiffure of resplendent artificial red hair," Coleman wrote.

After a few melodramatic blacksmith scenes and quick boxing exhibitions, it was time for intermission. Coleman, Dorgan, and Herriman headed backstage so Coleman could snap some pictures. "Temptingly near the door," said Coleman, "perched on a stand, was 'Ruby Robert's' flaming red wig."

Coleman, Herriman, and Dorgan returned to their seats for the second act. The script called for Fitzsimmons to stride into a parlor and sweep the heroine off her feet. That night, however, Fitzsimmons missed his cue. Wrote Coleman: "Suddenly the papier-mâché begonias and hollyhocks parted and the missing swain flounced on stage, all dolled up in his immaculate calling clothes—Prince Albert and patent leather dogs with yellow spats. He wore a highly polished stovepipe skimmer, slid well down over his red, horizontal ear tips. A hat rack stood waiting, as he entered, but Bob arched an eyebrow in our direction and made no use of it."

Still wearing his hat, Fitzsimmons bumbled through his scene as the audience started heckling him. "Tad winked at Herriman and me and pointed to his side pocket," Coleman said. "We were shocked to see a bright portion of the wig protruding from it."

For the next several months, Herriman found opportunities to slide

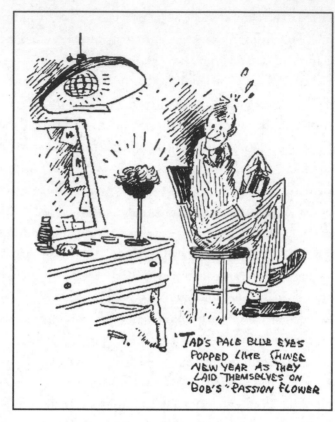

From Harry J. Coleman's *Give Us a Little Smile, Baby*

private jokes about Fitzsimmons into his cartoons, with one showing a tag marked "wig" stuck to the boxer's head. Herriman also contributed two original illustrations for Coleman's memoir, which was published in 1943. One recalls how "Tad's pale blue eyes popped like Chinese New Year as they laid themselves on 'Bob's' passion flower." The other shows Fitzsimmons onstage shaking a fist at Dorgan.

Coleman recounted another memorable prank, this one involving Dorgan, Herriman, and their old friend Leo Carrillo, who was performing at Proctor's Theatre. Carrillo specialized in animal mimicry; his masterpiece, Coleman said, was the mating call of a wild stal-

lion that drew a response from "every sway-backed hansom cab mare within ten blocks."

After Carrillo's show, the four friends began touring some of their favorite watering holes, including Jim Corbett's at Herald Square and "Silver Dollar" Smith's on Essex Street. At night's end, they found themselves in a group of New Yorkers at the rim of a large cavern that had been excavated for the city's first subway line. Inspiration struck: Dorgan would lean over the rail and start pointing excitedly while Carrillo would send out his stallion mating call.

"Crowds of night rovers, with their meaty floozies, and early milkmen gathered at the scene," Carrillo wrote. Word spread that a horse was loose in the subway tunnel. The police arrived, then the fire department. Dorgan, Carrillo, Herriman, and Coleman hurried down the block to another subway hole and Carrillo repeated his call. Someone in the crowd insisted he'd actually seen the horse. "As dawn broke, the scene was an inextricable mass of fire department equipment, police squads, milkmen, and drunks, getting in each other's way and inciting all parties to riot," Coleman wrote, with perhaps some embellishment. "It was probably the largest horse hunt in history and the most frustrated."

On the last weekend of August 1904, Herriman joined a group of cartoonists and illustrators on the "First Annual Outing of the Fish Exterminators." On a sunny, cool day, they posed for a photograph at Shelter Island, on the eastern end of Long Island. In addition to Herriman, the "Exterminators" included cartoonists and illustrators C. W. Kahles, who had worked with Herriman at the *World*; Worden Wood; Dan Smith; Harry Dart; and Louis Biedermann, who later headed King Features' art department. Herriman, dressed in white and sporting a straw skimmer, stands next to Jimmy Swinnerton, likely his introduction into the social group. Other photographs from

this time show Herriman on Fifth Avenue for the Easter Parade, and near Riverside Drive and Eighty-Sixth Street, seated in a boat that belonged to Dan Smith.

Nothing in the photographs indicates that Herriman's good times in New York were about to come crashing to a sudden end. Yet, shortly after his outing with the "Fish Exterminators," his work for the *American* began to suffer. His cartoons could still be magnificent, but these grew fewer with each passing month. The newspaper seemed to have less use for him.

One reason might be the advent of photography. The *American* began publishing photo-cartoon hybrids—sometimes inventive but usually horrendous—with a central photograph and "a few pictorial comments by Herriman." In short time, Herriman's little doodles started to appear alongside the photographs with humble notes such as "A Few Side Lights on the Race by a Comic Artist."

Herriman's final cartoons for the *American* took a darker turn, suggesting that he might have been aware of upcoming changes in his life. In a baseball cartoon, a robed figure named "Fate" juggles the Boston and New York teams. And in one of Herriman's most striking sports cartoons, *Cartoonist Herriman's Idea of the Sad Fate That Will Befall the Tailenders of the Big Baseball Leagues*, grizzled caricatures, exaggerated choreography, and detailed crosshatching sharply anticipate the work of underground comix legend Robert Crumb. Herriman devoted the cartoon to the pennant losers. A personification of "Hoodoo" drags by rope two players from Washington and Philadelphia. Signs announce their shame: "I'm lost, strayed and buncoed."

The last athletic event that Herriman would extensively cover for the *American* was also the most prescient one: a controversial color-line battle between black boxer Joe Gans, then the lightweight champion, and white challenger Jimmy Britt. Gans, a student of Fitzsimmons and a teacher of future heavyweight champion Jack Johnson, was the better boxer—but Britt nearly overpowered him in the vicious fight,

which finally was awarded to Gans after Britt began punching out the referee. In *Who Will Come Out of the Small End of the Pugilistic Horn?* a procession of boxers enters a large funnel. Herriman, well aware of the racial implications of the bout, shows the "Sporting Public" nervously eyeing the narrow end to see who emerges.

B oth Herriman and New York endured an arduous winter. In January 1905, the *American* reported that New York's worst blizzard in decades was halting trains and forcing downtown workers to find rooms in boardinghouses. For Herriman, it was enough to make him pine for any other home. In the ironically titled *Charms of Training at Gravesend Track These Days*, horse trainers in a snowstorm are seen dreaming fondly of being anywhere else. "I wonder how the weather is in Los Angeles," says one. "Oh, for New Orleans," says the other.

With fewer sports cartoons bearing his name, Herriman began contributing to other sections of the newspaper. In 1904, William Randolph Hearst had made an unsuccessful bid for the Democratic nomination for president, then started building up steam for a third-party run for mayor of New York by championing antitrust laws. Essential to Hearst's political plans were his cartoonists. Along with mainstays Frederick Opper and Robert Carter, Herriman and Dorgan were put to work drawing cartoons championing Hearst's causes.

Herriman's heart was rarely in his political work. Beginning in December, he started to regularly file antitrust cartoons that were competent but often clunky, perhaps illustrating metaphors that had been dictated to him by Hearst or Arthur Brisbane, such as an "Injunction" hand holding a torch to a "City Treasury" tree in which a "Gas Trust" fat cat is hiding out. In February, Herriman was paired with muckraking journalist Ida Tarbell for a series of articles on the Standard Oil trust. Perhaps inspired by the elegant prose of Tarbell, Herriman turned in several finely drawn editorial cartoons, including

a striking caricature of John D. Rockefeller as a carnival performer, lying on his back juggling a barrel of oil, a train, and a bag of money.

In March, Jimmy Swinnerton, Frederick Opper, and T. S. Sullivant traveled to Washington, D.C., to report on Theodore Roosevelt's inauguration, while Herriman received the decidedly less glamorous job of going to Albany to cover a gas contract lawsuit brought by Hearst against New York City mayor George B. McClellan Jr. That spring, Herriman contributed a few political cartoons that approached the artistry of his sports work, especially a scene of Tammany boss Charles Murphy sitting astride a giant "Contract Trust" toadstool, which is growing out of Manhattan itself. A Herriman cartoon on the Battle of Mukden in the Russo-Japanese War was reprinted in the prestigious journal *Current Literature*.

Yet, for Herriman, such successes were becoming rare. When a new racetrack opened at Belmont, Sullivant and Swinnerton—but not Herriman—were dispatched to draw cartoons. On Saturday, May 20, the *American* published the sort of front-page announcement that Herriman, after his experiences at the *Los Angeles Herald* and the *New York Daily News*, had learned to dread: "Important Announcement to Sportsmen and Athletes! The Morning American Makes a New Departure That Will Give Its Readers the Most Complete and Up-to-Date Sporting Department in the World."

The newspaper had named a new sports editor: Julian Hawthorne, a Harvard graduate and the son of author Nathaniel Hawthorne. The newspaper noted his college athletic accomplishments and even listed his chest and arm measurements. The *American* also announced its team of sports experts, including W. W. Naughton, sporting editor for the San Francisco *Examiner*, and writer Charles Van Loan, reporting from the California racetracks. There was no mention of Herriman.

Hawthorne and Herriman appear to have had little use for each other. Writer Bob Callahan has called Hawthorne "easily the most boring sports editor ever to serve in the offices of a major American daily,"

THE MASTER JUGGLER.

From the *New York American*, February 24, 1905

noting that he even tried to suspend printing the daily ball scores. Herriman's former collaborator Charles Somerville was long gone by the time Hawthorne started filing his stilted prose from the racetrack: "But it was a beautiful scene, and upon its manifold and ever-moving surface lay broad and golden the afternoon sunshine." Hawthorne also added stuffy self-improvement columns that bore titles such as "Overcome Your Objections to Indulging in Exercise."

Yet Herriman appears to have been already on the way out when Hawthorne arrived. Shortly after Herriman returned from Albany, even his occasional editorial cartoons stopped appearing. It is difficult to believe that Herriman would have quit the *American* or that this rising star was summarily fired. An explanation wouldn't appear until decades later, in an interview of artist and illustrator Clyde "Vic" Forsythe by writer Ed Ainsworth. Forsythe, Ainsworth wrote, was working on the *Los Angeles Examiner* when he received "a call to New York to take the place on the *New York American* of George Harriman [*sic*], the cartoonist whose health had broken."

A modest baseball cartoon published on Friday, June 2, appears to be Herriman's last drawing as an *American* staff artist. By that time an ailing Herriman might already have moved his family back to Los Angeles. There is no signature on the cartoon. It is punctuated only by a tiny sign in the corner that reads, "Finis."

HOBO CORNER

I n the summer of 1905, George Herriman moved his family across the country to a new home at 1166 East Fortieth Street, in a neighborhood of modest new construction on the southern reaches of Los Angeles. County railway lines connected the neighborhood to downtown; twenty blocks to the south stood Ascot Park, home to horse and automobile races and frequent boxing matches.

For both George and Mabel Herriman, returning to Los Angeles meant being closer to their families. A single cartoon from this time suggests that George was keeping informed of family news from New Orleans as well. Herriman's grandmother, Louisa Eckel, had died in 1902, and in 1906 her heirs prepared to sell off some of her real estate. As the only heir not living in New Orleans, George Herriman Jr. notarized documents appointing his brother-in-law, Theophile Esnard, to represent him in the matter. A political cartoon drawn by Herriman during this time used the unique name "Theophile" for an incidental character.

In Los Angeles, nobody in the family appeared to be doing particularly well financially. George Herriman Jr. remained employed as a tailor but rarely stayed in the same shop for long. Now his oldest son, after enjoying early success in New York, no longer was in the employ of either Joseph Pulitzer or William Randolph Hearst, or

even Frank Munsey. George Joseph Herriman faced his twenty-fifth birthday without a job and, apparently, in poor health.

Thanks to his New York contacts, he still had work. In late summer, World Color Printing sent a letter to client newspapers announcing that Herriman had signed a contract with the syndicate. Herriman created a short-lived children's strip titled *Rosy Posy—Mamma's Girl*. He also revived both *Major Ozone* and *Bud Smith*, yet his heart no longer seemed to be with his two lead players. Black characters entered the stories more often, but there were none of the sly reversals of *Musical Mose*. These were stock servants, drawn in minstrel style. Various animals—including an occasional black cat—lurked around the stories' edges, but they too seemed less sure of their roles.

A *Major Ozone* from October, featuring a man called "the Colonel" who suffers from rheumatism, suggests more details about Herriman's health. It was the second mention of rheumatism in a *Major Ozone* strip, and gags about the ailment would reappear in Herriman's comics for the next several years, until they stated flatly that Herriman himself was a sufferer. No longer a term used in medicine, "rheumatism" served to describe various arthritic pains in the back, neck, and joints. This early appearance of rheumatism in *Major Ozone* suggests that even in his midtwenties Herriman might have been feeling its pains—possibly explaining why artist Vic Forsythe had described his health as broken.

Herriman also contended with a rapidly changing Los Angeles that no longer was the frontier town of his youth. In the decade from 1900 to 1910, the city's population would triple to nearly 320,000. The newly laid Sunset Boulevard pointed to bungalows and mansions that sprouted from the fertile soil of the Cahuenga Valley, in a new development called Hollywood. The popularity of recent short films such as *The Great Train Robbery* heralded future "dream factories," as moviemakers flocked to balmy, sunwashed Southern California to set up lots. Among these was an Irishman named Hal

Roach, whose studio would, in later years, become a second home to Herriman.

In late 1905, however, Herriman searched for a foothold in the growing city. He would soon find it—but not until he thoroughly ensnared himself in both a newspaper war and a political scandal, barely keeping himself out of jail.

A lthough his grandfather and father had both been politically active in New Orleans, George Herriman—perhaps after learning how it had turned out for his family—steered clear of politics. As an editorial cartoonist, he might be sent to the front lines of a newspaper crusade, yet his work lacked the sustained outrage of Thomas Nast's crusade against Tammany Hall or Frederick Opper's skewers of trusts. In his personal life as well, Herriman appeared to shy away from politics; there are few comments on such topics in any surviving letters, and unlike other members of his family his name does not appear on voter registration lists.

Shortly after Herriman's return to Los Angeles, however, political scandal found him. Not surprising for a story about young Los Angeles, it starts with a controversy over water.

In 1903 former Los Angeles mayor Fred Eaton schemed to build a massive viaduct to divert river water from nearby Owens Valley to Los Angeles—a proposal that included duping Owens Valley farmers into selling off their water rights for cheap. Leading the effort was *Los Angeles Times* president Harrison Gray Otis, along with his son-in-law and general manager, Harry Chandler. Under Otis and Chandler's direction the *Times* stirred hysteria of a water shortage until, in the morning edition on Saturday, July 29, 1905, a front-page headline promised, "Titanic Project to Give City a River."

Otis and Chandler had a prominent detractor in William Randolph Hearst, himself a recent arrival to Los Angeles's newspaper market. In

December 1903, just a few blocks away from the *Times'* headquarters on the 500 block of Broadway, Hearst had opened his *Los Angeles Examiner* with a display of fireworks and parades and a pledge of support from unions, who were foes of the archconservative *Times*. Shortly after the *Times* announced the Owens Valley plan, *Examiner* reporters discovered that Otis and Chandler had financial stakes in the deal. Hearst, campaigning for the United States presidency, ended up supporting the aqueduct anyway, but the *Times* never forgave him. "Hearst himself has no more moral sense than a monkey, no more convictions than a wooden Indian, but he has cunning and money enough to hire men having convictions and enthusiasms to thunder for him," the *Times* railed, while editorial cartoonist A. J. Taylor mercilessly caricatured Hearst as a multilimbed monster laying his feet on San Francisco, New York, Chicago, Boston, and Los Angeles—all cities where Hearst now had newspapers.

On January 8, 1906, another Hearst-related illustration appeared in the *Times*. This one wasn't by A. J. Taylor. The subject was New York politician Bourke Cockran, who recently had arrived in Pasadena for a visit. In an interview, Cockran opined about Hearst's papers, calling them "cheap sensation," and the *Times* made the most of it. The cartoon, titled *Bourke Cockran Chasing Butterflies and Discussing Politics in Pasadena*, featured the caption, "Hearst for President? Not if he's like his papers." At the bottom of the cartoon appeared the dateline "Pasadena" and the artist byline: "George Herriman." The *Times* had hired Herriman and immediately assigned him to take a swipe at his most recent employer.

Herriman remained at the *Times* for the next eight months, working under art editor A. B. "Boss" Dodge, a former *San Francisco Call* illustrator. Dodge's San Francisco friends included Tad Dorgan, which possibly explains how Herriman found a job at the *Times*.

The *Times* sent Herriman out to find odd stories with local color: a city government meeting where supervisors debated prostitution and gambling; a San Diego "automobile jamboree." The single-panel jamboree cartoon, published on January 28, is a richly detailed portrait of a begoggled driver, and it's the loveliest work by Herriman in months. Herriman's *Times* contributions never achieved the scale and extravagance of his work for the *World, Daily News,* and *American.* The more conservative Chandler rarely allowed illustrators to take over a page. Yet, constrained to a smaller frame, Herriman sharpened his focus, narrowing on character details instead of widening his lens for grand allegorical epics.

Herriman's health appears to have improved, for in the next few months he visited a carnival at Venice, anticipated a boxing match between Terry McGovern and Oscar Nielsen (aka "Battling Nelson"), and caricatured German pianist Alfred Reisenauer nursing a hangover. He attended a performance by actor Joseph Galbraith and bylined it "front row," even adding what seems to be rare caricature of Mabel and himself sitting in rapt attention. Herriman occasionally drew multiple-panel scenes, such as in a slapstick about a bathhouse patron who drops cigar ashes and sets his shirt aflame; accompanying text describes the man as a "huge bulk of dripping white flesh shooting and slushing like a cake of fat ice out across the marble floor."

On February 22, Herriman attended a chamber of commerce banquet, where in a cloud of cigar smoke he listened to a rousing chorus of "I've been drunk for the past six months / I do want to go home" (the "staid men failed to realize they were singing a 'coon song,'" reported the *Times*) along with speeches about the Owens Valley project. In early March, Herriman took the new Sierra Madre trolley line to Mount Wilson, where he joined Angelenos making a two-day hike up the peak, lampooning the "gentleman mountaineers" who cried in agony over wood ticks.

From *Back From San Diego!*, *Los Angeles Times*, January 28, 1906

Most notable about the Mount Wilson cartoon is Herriman's part-
ner on the journey: young staff writer Harry C. Carr. Herriman and
Carr had much in common. Carr's family had moved to Los Angeles
from Iowa at about the same time that the Herrimans arrived from
Louisiana. A dogged cub reporter with a nervous temperament, Carr

was Herriman's match both in intellectual curiosity and tender heart: it would pain Carr to crush a fly, a friend once recalled. Also like Herriman, Carr was ambitious, and his career eventually would include writing a column and serving as an editor at the *Times*, as well as international reporting, books, and film work. The month after climbing Mount Wilson with Herriman, Carr boarded the first train to San Francisco following that city's massive earthquake, ultimately penning a masterpiece in disaster reporting, "The Epic of the Dynamited Metropolis."

While Carr reported from the wreckage in the north, Herriman was assigned the social goings-on in Southern California. He covered horse shows in Pasadena and the opening of trout season, reported on a Greek bootblack who had assaulted a Prussian count, and chronicled the adventures of a visiting sheriff named Jerome J. "Sandy" Donahue. Although Herriman doesn't mention it—and might not have been aware of it—the sheriff was formerly of Coconino County, Arizona, the future setting of *Krazy Kat*.

Herriman contributed the first of many caricatures of Joe Margolis, the "Yiddish butcher of Turner Street." Described by admirers as a man of high ideals in greasy trousers, Margolis was friendly with Los Angeles reporters, cartoonists, and other Sports. Herriman also chronicled the battle over a proposed new union for vegetable vendors; the accompanying article took yet another swipe at Hearst and his "Los Angeles yellow newspapers who live on sop thrown out by the unions."

The *Times*, like the *Herald* before it, also sent Herriman to cover Los Angeles's African-American culture. After visiting an all-black roller-skating rink, Herriman drew a cartoon that, like a Bert Williams minstrel act, satirized social pretension. In *Darktown Aristocracy Caught in the Swirl*, published on May 27, two men in rags watch a proud gent go by on skates. They speak to each other in dialect: "If it wasn't fo his complexion I'd say dat man was rockfeller."

That summer Herriman returned to boxing to draw a sympathetic portrait of Chinese-American fighter Ah Wing, and several caricatures of featherweight champion Abe "the Little Hebrew" Attell, in Los Angeles to defend his title in what proved to be a brutal, twenty-round fight at Naud Junction pavilion against San Francisco fighter Frankie Neil. Reported the *Times* from Naud Junction: "Blood flowed from [Neil's] mouth and nose, and whenever Attell's glove would reach those points, already deadened and impervious to pain, the claret bespattered those sitting near the ring." As a member of the press, Herriman would have been among those ringside spectators.

Herriman likely was joined ringside by Harry Carr. The pair took several adventures together that summer, going on deck on the warship *Milwaukee* and driving to San Diego to cover a yacht race. Then they crossed the border to Tijuana for what would become their most striking collaboration as well as the angriest work Herriman would ever draw.

The subject was Félix Robert, a celebrated French matador. Advertisements in Los Angeles newspapers announced exhibitions in Tijuana, where Robert would "fight to the death Four Wild Bulls." Train fare, including grandstand admission, was six dollars. On Sunday, July 22, 1906, Herriman and Carr crossed the border to join the attendees at the fight. One week later the *Times* published their scathing review under the title "He-cow Fighting Tame as Ping Pong." Herriman and Carr both make it clear just who they considered to be the real beast. "Many an old sport wondered why he felt queer when that little brown bull mooed for sympathy under the grandstand," Herriman captioned one drawing, showing a gentleman, oblivious to the blood-spattered bull just over the fence from him, discussing biscuits and tea.

Herriman's centerpiece drawing is a portrait of the massive bull, head lowered, tears pouring, blood gushing from its knifed back. Before it lies Félix Robert in dandy repose, lifting his hat in the air.

Taunts Herriman in the caption: "Ooh! Will the bad bull hurt Mister Feelicks? No the bad bull will not hurt him. Mister Feelicks has just stuck the bad bull for the honors of the day."

Harry Carr further detailed Herriman's reactions: "Mr. Herriman, the artist, insists that the first 'wild raging' bull killed at Tia Juana last Sunday was an associate and playmate of his youth. He says he can distinctly remember when that kind-faced old bovine used to come round to the kitchen door and eat potato peelings from his baby hand."

Carr described in grisly detail how each bull, drenched in its own blood, fell heavily to the ground. A group of French sailors cheered when the matador released a dove, but a "sarcastic American voice" was heard to shout out, "Why don't you kill the dove?" Then a voice shouted out, "You can't milk the cow unless you get a pail."

Carr didn't identify those sarcastic shouts until years later. Nor did he note that the heckler was shouting at Robert in the matador's native tongue. In 1931, writing in his column "The Lancer," Carr recalled his trip to Tijuana with Herriman, adding one new detail: "When the French matador swore—in the usual melodrama—to give his life or the life of the bull, George yelled back in French: 'Wait a minute; are you not going to milk that poor old cow before killing it?'"

By early August 1906, another political season was heating up, and the *Times* assigned Herriman to cover various local campaigns. His editors most appreciated an antiunion cartoon titled *The Trust*, which depicted "Labor Unionism" as a thug about to strike the "Independent Workman." Here, Herriman's cartoon was taking the opposite position of his former work for Hearst. It doesn't seem to represent a change of heart for the cartoonist; just a change of newspapers. The *Times* republished this cartoon on multiple dates.

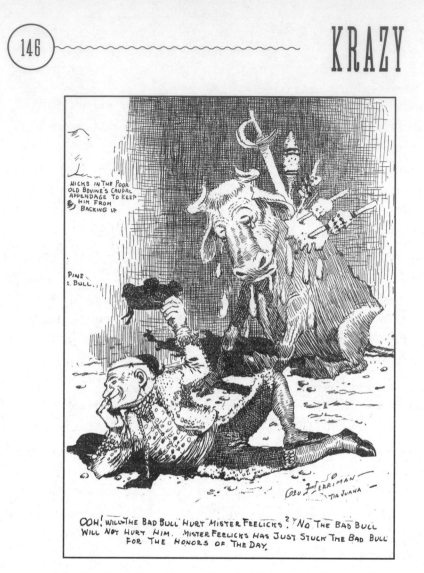

From "He-Cow 'Fighting' Tame as Ping Pong," *Los Angeles Times*, July 29, 1906

One campaign was growing particularly contentious: the Republican nomination for county sheriff, called by the *Times* "the hottest contest of a tabasco campaign." Herriman drew numerous caricatures of the candidates, including the incumbent, Sheriff William White. Then on Tuesday, August 14, Herriman became personally involved in the sheriff's campaign in a way he neither predicted nor desired. That day he and Carr visited, for unknown reasons, a section of North

Main Street known as the "Hobo Corner." A man stopped in front of them. He was, as Carr remembered, a "big, good-natured fellow with a fast horse." He identified himself as Deputy H. C. Vignes, a shady character who had previously been in charge of an insane asylum and now worked as a night guard in a juvenile detention home. Vignes told the two men that he was rounding up votes for Sheriff William White. "We are out to win, and we don't care how," he bragged, seemingly unaware that he was speaking with newspapermen. Then he reportedly offered Carr and Herriman two dollars each if they would use false names to vote in that day's primary for delegates to the upcoming Republican county convention.

Carr took the bait, later writing that he decided to carry out the bluff "to the very edge of the law." Herriman appears to have participated in the scam as well. The two men were ushered into a waiting buggy and driven to a voting tent on the corner of Eighth and Figueroa Streets. On the way, their escort bragged that he'd already paid out fifty dollars for votes that morning and expected to buy another twenty votes before the day was through. He gave Carr and Herriman slips of papers with lists of candidates' names. Carr asked if he could get in trouble. "Why, Lord, no," the man reportedly said. "I am an officer; I ought to know."

Carr took the slip of paper and went into the tent but didn't vote. Herriman appears to have followed Carr's lead. Carr filed a complaint, and Vignes was arrested. Vignes denied the charges, saying that Carr and Herriman must have been mistaken. "There are half a dozen men in Los Angeles who resemble me," he told the *Times*.

Over the next weeks, the *Times* devoted much ink to exposing White, repeatedly printing a cartoon by A. J. Taylor titled *Crush Him or He Will Crush Us*, showing a grizzled, cigar-chomping goon hoisting bundles of bogus registrations and a bag of cash. The newspaper dredged up charges that Vignes, as a juvenile detention guard, took a twenty-dollar bribe from a "half-witted boy prisoner." In an editorial

titled "Vignes, Ballot-Debaucher," the newspaper stated flatly: "The evidence against Deputy Sheriff H. C. Vignes dooms him." Hearst's *Examiner*, not surprisingly, took the other side, running a story that was sympathetic to both Vignes and White. White denied to an *Examiner* reporter ever paying Vignes to do political work, and Vignes suggested that the whole story was trumped up by White's political enemies. "I promise you there will be some surprises when the time comes," Vignes added with some mystery.

Indeed, there quickly came an unexpected turn in both the Vignes case and in Herriman's career. On Tuesday, August 21, just six days after Herriman's fateful trip to Hobo Corner, a caricature of Southern Pacific Railroad employee and political boss Walter F. Parker, titled *The Man Who Deals the Cards*, appeared on the front page of the *Los Angeles Examiner*. There are six candidates on the cards, including White. The cartoon was drawn by Herriman. It was his first appearance in a Hearst newspaper since leaving the *New York American*.

Did Herriman's role in the sheriff's race precipitate his departing the *Times* and joining the *Examiner*? Certainly, Herriman's work for the *Times* had distinguished itself on its own merits. He was included in a 1906 Press Artists' Association exhibition at the Hotel Alexandria, as well as in a book that the Los Angeles Press Club distributed to a boys' detention home. Herriman's friends, especially Tad Dorgan and Jimmy Swinnerton, likely encouraged Hearst to bring Herriman back on board. There can be no doubt, after all, that Herriman belonged at a Hearst paper, given "the Chief's" great enthusiasm for comics. After he was hired, Herriman would remain a Hearst employee for the rest of his career, long after White and Vignes became footnotes in Los Angeles political history.

Yet the events that transpired in the Los Angeles courts over the next several months suggest that political mischief also played a part in Herriman's pathway back to his old employer. Two days after his first cartoon for the *Examiner*, Herriman was sent to Venice to cover the Republican

county convention. His front-page cartoon *Scenes and Incidents of the Closing Day of the Venice Convention*, published on August 23 and datelined Venice, included gags about the sheriff's race. On September 2 Republicans began gathering for their state convention in Santa Cruz. That same week, a grand jury convened to investigate Vignes and summoned Herriman to testify. The *Examiner* ignored the summons and sent Herriman to Santa Cruz. When the grand jury in the Vignes case learned that Herriman had left town, it cited him in contempt of court. A bench warrant was issued for his arrest. The *Times* reported the warrant, making it clear that Herriman was now an employee of the *Examiner.*

Herriman was given a choice of a fifty-dollar fine or jail time. "Herriman ignored the subpoena and went to Santa Cruz to the Republican state convention to cartoon the delegates," reported the *Los Angeles Herald.* "He was rudely brought back yesterday by Sheriff White, and gladly gave up $50 for the contempt rather than go to the county jail and eat Sheriff White's meals."

In late September, Vignes was arraigned. He was freed, apparently due to a technicality, and two days later was rearrested and charged under a different statute. This time, the *Times* reported, a second bill specifically charged Vignes with bribing Herriman to vote.

Meanwhile, in the pages of the *Examiner*, Herriman confirmed that any Hearst-bashing was now behind him. His cartoons mocked both Republicans and Democrats as puppets of the Southern Pacific Railroad, and championed Hearst's Independence League candidate for governor, William Henry Langdon. These were ornate works that combined Herriman's detailed work for the *Times* with the grand scope of his cartoons for the *American.* A stunning cartoon published on November 3, 1906, *They Can't Hide the Bunch Behind Them*, depicted the Democratic and Republican gubernatorial candidates onstage, with Southern Pacific's kingmakers barely visible behind a translucent scrim. It is a showcase of sharp caricatures, clever dialogue, and breathtakingly fine inkwork.

Herriman based another anti–Southern Pacific cartoon on a book illustration by socialist artist William Balfour Ker. Herriman makes his debt to Ker and writer John Ames Mitchell explicit with an "apologies to" note by his signature. Mitchell's book *The Silent War* had been published that year; it was a radical piece of fiction that celebrated socialism and anarchism, and condemned captains of industry who bore names like "Railroad King" and "Owner of Coal Mines." There could be no doubt that Herriman had left the conservative *Times*.

Despite Hearst's best efforts, when Election Day came, the Independence League gubernatorial candidate received only fifteen percent of the vote. Sheriff William White was voted out of office, but his deputy still awaited his day in court. On the morning of Wednesday, December 19, a jury was called for the Vignes trial. This time both Carr and Herriman were in the courtroom, the sole witnesses for the prosecution.

Carr took the stand first. His *Times* article about the vote buying was read in court. His description of Vignes in the article was a "trifle uncertain," according to the *Los Angeles Herald*, which supported White. But the case against Vignes truly fell apart in the afternoon, when the court called Herriman to the stand. Reported the *Herald*: "He looked at Vignes and Vignes looked at him, and then Herriman shook his head. 'I do not think that is the man who offered me the bribe,' he said. 'It may be but I cannot recognize him. The man who offered me the bribe, I think, was a bigger man.'"

The defense then called a Main Street saloonkeeper named Bark Gibbons who had been said to have introduced Vignes to Carr and Herriman. When he took the stand, the *Herald* reported, he muttered that he "never introduced nobody to nobody." Then Herriman's illustration for Carr's original *Los Angeles Times* report was passed around. The defense charged that it resembled any number of men in the courtroom as much as it resembled Vignes. It took the jury less than nine

minutes to acquit Vignes. Reported the *Herald*, "Herriman's positive statement that he did not think Vignes was the man with whom he had talked went far toward the accused man's acquittal."

The timing of Herriman's return to Hearst's papers, plus the cartoonist's sudden out-of-town assignments during the Vignes trial, make it fairly clear that the vote-buying scheme played at least some part in Herriman's rehiring. Herriman and Carr would remain lifelong friends even though they now worked for rival newspapers. Meanwhile, over the next four years, the inventiveness, beauty, and sheer volume of Herriman's work for the *Examiner* would be more than enough to make anyone forget any political shenanigans that had helped land him there.

KID HERRIMAN

A t five stories, the *Los Angeles Examiner* headquarters stood taller than any other building on its block of Broadway. An electric masthead blazed across its roof, announcing triumphantly William Randolph Hearst's entrance into Los Angeles.

Outside, the street filled with the noise of horses, motorcars, and electric trolleys competing for the future of urban transportation. Pandemonium might erupt during prizefights: on September 3, 1906, shortly after Herriman joined the newspaper, five thousand people crowded around the building's ground-floor windows to read ringside bulletins sent from the Joe Gans–Battling Nelson bout in Goldfield, Nevada. After each round, a squad of police struggled to hold back the mob.

Up in the *Examiner*'s fifth-floor newsroom, Herriman enjoyed the company of a remarkable staff of writers. His editor on the sporting pages, thirty-year-old Charles Van Loan, was a stout, slope-shouldered California native whose childhood was spent beating the drum for a Salvation Army band. After his time at the *Examiner*, Van Loan would pen sports-themed fiction and serve as a *Saturday Evening Post* editor; he later described his years at the *Examiner* as "looking at life through a kaleidoscope." Also on the sports pages was Harley M. "Beanie" Walker, a twenty-eight-year-old transplanted midwesterner with a

boyish face and a gruff personality, later to write Hal Roach's film comedies. Walker would become Herriman's closest friend.

At the *Examiner*, Herriman worked closely with Van Loan and Walker, drawing cartoons—sometimes several each day—to accompany their columns and stories. The trio worked and caroused together, attending show matinees and political conventions, ball games and fights, and taking automobile excursions to out-of-town events. They traded stories about their adventures in print, at times turning the *Examiner* into their private journal of the Los Angeles sporting life. They reported from Tom McCarey's and Jim Jeffries's blood-stained fight clubs and joined the "plungers" who sought fortunes at the track. As *Examiner* men, they had reserved seats for both minstrel plays and opera; a true Sport never missed a good show, "whether operatic, dramatic or pugilistic," as Herriman described it. For meals, they jostled with journeyman fighters—the "pork-and-beaners"—for stools at tamale stands and countertop steakhouses.

It was during this time that Herriman acquired a new nickname: "George the Greek," or simply, "the Greek." The name first surfaced in print on November 12, 1906, in an *Examiner* article by Van Loan about a visit to the opera: "So I thought I would take George the Greek and go over and see about it. George the Greek is the cartoonist and he has seen grand opera in New York." The monicker—a riff on popular boxer nicknames of the day, such as "Abdo the Turk"—had nothing to do with Greek ancestry, although it later would be misunderstood as such. Years later the name would be revealed as one of many newspaper jokes about Herriman's mysterious family background. "None of us knew what he was, so we called him the Greek," Tad Dorgan would write.

As Dorgan all but made explicit, "the Greek" nicely sealed an agreement among Herriman's friends to not inquire about the cartoonist's bloodline. However, it didn't stop the jokes. Kinky hair had become a minor obsession in both the *Examiner* pages and in the

newsroom. Herriman illustrated an article about a university lecturer who discussed how the "qualities and characteristics of the future man" can be seen in the "straight hair on one head and kinky wool on the other." In other *Examiner* stories of the era, "kinky-headed patrons" frequented the Twinkling Star lunch wagon, and the "Congo Coon," a Memphis boxer, was praised as a "kinky-roofed scrapper." "Kinky" was also the name given the newspaper's black elevator operator.

Artists constantly joked to Herriman about his hair, recalled cartoonist Ed Wheelan, who later worked in the *New York Evening Journal* newsroom with Herriman. At the *Examiner*, one of these gags found its way into print, in a single line about how Van Loan, in search of inspiration, was "rubbing all the 'witch threads' out of George the Greek's kinky locks." The reference was to the common superstition that good luck comes from rubbing a black man's hair.

It was around this time that Herriman first became known for always keeping his hat on, both indoors and out.

T he November 1906 trip to the opera became Herriman's first major collaboration with Van Loan. It was sparked by *Examiner* theater critic Otheman Stevens, who strolled into the newsroom one day sporting a "spike-tailed coat and accordion lid," talking up a current production of *Aida*. Herriman and Van Loan each claimed a ticket and went off to a matinee. In the next day's newspaper, Van Loan reviewed the opera as if it were a boxing match, adding, "They stung George the Greek for a dope sheet, but when he found out that the boy who sold it to him would not stick around and explain the first chapter George grew peevish and wanted his two-bits back." Herriman illustrated Van Loan's article with a splash of comic scenes, adding irreverent captions such as the "Kink of Egypt . . . kept his panties on under his regal robe."

That same week Walker, Van Loan, and Herriman took in a fight at Naud Junction, a massive barn that boxing promoter Uncle Tom McCarey had recently put up on a dirt-road intersection near Alameda Street. Fight fans crowded into the dollar seats, but the *Examiner* men sat ringside. It would be a familiar haunt for the next several years, with Van Loan or Walker providing the blow-by-blow results, and Herriman sketching fight scenes or—when the boxing didn't inspire him—caricaturing his fellow fans.

Animals began appearing in Herriman's drawings with greater frequency. A scene of a dog show included a cameo by Herriman's own dog, a terrier named Mike. There was more than a hint of minstrelsy in a news comic about a lost black cat, which featured a boy covering a grey cat with black mud to try to claim the reward. And just a few months after starting at the *Examiner*, Herriman introduced a short-lived but monumental weekday series: a comic about a cat named Zoo Zoo.

A charming comedy based around Christmas and Christmas shopping, the *Zoo Zoo* stories lasted for just six installments in December. They introduced Emmett Pozner Jimson; his wife, Evangeline; their (unnamed) child; and their fluffy white cat, Zoo Zoo. There are jokes

From *Zoo Zoo, Los Angeles Examiner*, December 15, 1906

about Shriners and chili con carne, and about the daily skirmishes between husbands and wives. In one episode, Evangeline is caught in the rain and her dress shrinks scandalously above her ankle. In another, Emmett embarrassedly carts Zoo Zoo in a basket while his wife shops. The standout *Zoo Zoo* story appeared in the middle of the series' run, on Saturday, December 15. In it, Emmett and Evangeline leave Zoo Zoo alone in the house. Street cats appear at the window and descend upon Zoo Zoo's opulent spread of cream and mountain trout. "Sweet showers of aqua zemzem wot is it?" exclaims Zoo Zoo, but then quickly joins the party. In the final scene, the shocked Jimsons return home to find the cats passed out on the bed, the fluffy white Zoo Zoo curled up with a black street cat. "I guess we didn't Andy Comstock that pose hey?" says the black cat, referencing the anti-obscenity Comstock Act, a favorite target for cartoonists.

Although much different in appearance, Zoo Zoo and Krazy Kat had more in common than their alliterative names. In this short-lived comic, Herriman experimented further with the idea of using animals for gags about race. He also quietly switched Zoo Zoo's gender during the run of the strip, not seeming to mind too much if his lead character was male or female.

L os Angeles celebrated the first days of 1907 at the Automobile Show of Southern California, held at Morley's Grand Avenue Skating Rink. Suffering from what Herriman termed "automobilitis," five thousand Angelenos showed up in the first three hours of the show alone. Inside, overhead lights cast a green-and-white pattern over new roadsters and runabouts. Henry Ford was there to showcase his latest models, but when Herriman attended, his attention went to racer Barney Oldfield, who had brought his famous "Green Dragon," capable of a fifty-three-second mile. "This auto show is but the beginning," Van Loan predicted. "Ten years from now the car of today

will be just as much of a curiosity as the hoopskirt and the chimney-pot hat."

Herriman contributed numerous automobile-themed comics and cartoons over the next few months. He offered customized models, such as a cannon that fired rubber balls to inform animals of impending danger, and a perfume spray that emitted a patchouli exhaust. These works were among his most visually adventurous to date; comics historian Allan Holtz has pointed out how one suggests a storyboard for a Warner Bros. cartoon.

Herriman seemed to suffer his own case of automobilitis, for accompanying one illustration was this editorial note: "Even the man who is guilty for the pictures which accompany this article took the automobile editor into a dark corner and anxiously inquired if there were any chance to trade a lot in Antelope Valley for a runabout."

The line about trading a lot in the mining-rich Antelope Valley was a gag. Yet Herriman might indeed have acquired such a lot, for during this time, he started a lifelong practice of investing in real estate. Among his first purchases were new homes. In late 1906 or early 1907, he moved Mabel and Toots to a newly constructed two-bedroom bungalow at 835 East Thirty-Third Street, in his and Mabel's old neighborhood near St. Vincent's College. At the same time, his parents moved to a new house in the same neighborhood, with Herriman likely providing some financial help for the move. Mabel Herriman's parents also lived nearby, which must have been helpful to Mabel. As in New York, her husband's workload kept him away from home for long hours, as he went on assignments for everything from sumo wrestling matches to city council meetings.

George Herriman also joined a local fishing club, with the *Los Angeles Times* listing him among the "piscatorial elite" at a Southern California Rod and Reel Club outing off Point Vicente in July 1907. Herriman and other club members piled into boats to catch barracuda, mackerel, and bass, which were cooked up for an evening's feast

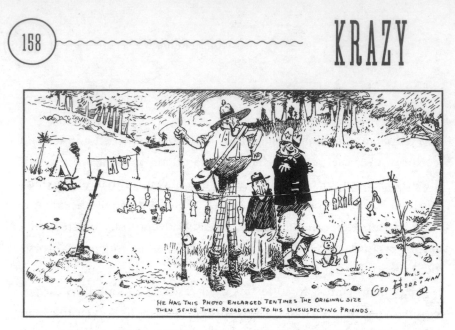

He has this photo enlarged ten times the original size then sends them broadcast to his unsuspecting friends.

From *Have You Met This Nature Faker?*, *Los Angeles Examiner*, July 29, 1907

that included an orchestra, a fencing exhibition, and a "coon song" by club member and vaudeville performer Ellsworth Salyer. Another Rod and Reel Club outing, this one at Redondo Beach, launched at three in the morning. Herriman and fifty other men went out in a dozen boats, "clad in khaki and ready for sun or rain," the *Examiner* reported. By noon they had caught only three fish, so they spent the remainder of the day at Redondo eating beef barbecue, drinking beer, and enjoying another Salyer performance.

One adventure took place right in the *Examiner* office. As Van Loan chronicled it, a mysterious young man walked into the art department, set down a pasteboard box wrapped in twine, and quickly disappeared. Van Loan and Herriman guessed at the contents. Wrote Van Loan: "'Maybe it's good to eat,' hazarded George the Greek, whose god is his stomach and his altar a tamale joint on North Broadway." Someone finally opened the box to reveal a live, six-foot-long gopher snake. "George the Greek climbed out on the fire escape," Van Loan reported, "and the Honorable Beanie, who had taken no part in the investigation, swarmed up the partition and

roosted among the dusty flies." The snake seems to have remained an office pet, reappearing in various newsroom stories over the next couple of years.

In spring 1907, Herriman was enlisted to cover an upcoming national Shriners' convention. The *Examiner* was determined to out-Shriner every other newspaper in Los Angeles, and Herriman dutifully filled the pages with oversized caricatures of fez-capped revelers. The cartoonist apparently joined the thousands who cheered the "evening electrical Moorish and Turkish parades" that marched in front of the *Examiner* building, which was now lit up in Shriner symbols. Herriman also illustrated a special Shriners' menu for the Mission Indian Grill, located in the nearby Hotel Alexandria. Beside listings for twenty-cent draft beer, sweetbreads, and Welsh rarebit, Herriman's portly Shriners strut to cheers of "Zem zem" and "Let er loose."

When the summer brought a lull in boxing, Herriman more frequently attended the Belasco and other theaters with *Examiner* writer Otheman Stevens, teaming up for reviews and cartoons that freely mixed sports, theater, literature, and politics. He also branched out to novelty sports. Wrote Van Loan:

The other night a very affable gentleman dropped in to explain the game of cricket to the sporting department. . . . So George the Greek, who makes the funny pictures, went out yesterday afternoon with me.

We found fifteen or twenty men in white flannels, solemnly moving about in the infield; and as many more tidy looking gentlemen loafing about the timer's stand, evidently waiting for something to happen.

"When is this thing going to begin?" asked George the Greek, who likes action . . . and would rather see a rattling fist fight than his pay envelope any day.

"Going to begin?" repeated a well tubbed individual in flan-

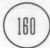

nels. "Going to begin old chap? I beg your pardon, but the fact is, the match began one hour ago."

Herriman stayed busy all summer with a constant string of cartoons in the *Examiner*. The season began with newspaper staff taking to the diamond for its own baseball game against local theater folk, beating them 13 to 2. The Sports also were abuzz about a big minstrel show revival planned for the Mason Opera House, complete with blackface actors seated in the traditional semicircle; Stevens wrote the preview for the *Examiner*, with Herriman contributing cartoons. Herriman visited Spring Street for boxer Jim Jeffries's opening of a new saloon, and attended a training school for boxers at Naud Junction.

Then, in late August 1907, there came a rare stretch of days without any Herriman contributions in the *Examiner*. During this time, by all appearances, George Herriman first found his way to Arizona.

Most accounts give credit to Herriman's friend and fellow cartoonist Jimmy Swinnerton for introducing George Herriman to the future home of Krazy Kat. A few years earlier Swinnerton had discovered the desert when, battling illness, he was put on a train for Colton, California. The oft-told story goes that Hearst knew he had to get his employee and friend away from New York, where Swinnerton was barely surviving on a diet of alcohol and black coffee. Three doctors had given Swinnerton no more than thirty days. After moving to the desert, Swinnerton recovered and outlived them all. He also became a proselytizer for the region. "Why don't you come out to the far Southwest, to the Great American Desert and the mountains surrounding it, and by so doing forget for a few minutes the slops and false perfume of the big town?" Swinnerton wrote.

In future years, Herriman and Swinnerton would take many adventures together in and around northern Arizona. The best evidence suggests, however, that Herriman first visited the region in the company of cartoonist Charles "C. M." Payne. In 1907, Payne moved his wife and children from the East Coast to Hollywood. He had enjoyed some success with early comics such as *Coon Hollow Folks* and *Honeybunch's Hubby*; his biggest hit, *S'Matter Pop?*, was still years away. Payne was an astronomy buff, and he started taking his family on regular trips to Arizona, returning to California to show his photographs at meetings of the Southern California Camera Club. One time, according to Payne's friend Richard Sprang, Payne invited Herriman along. "It was the first time Herriman saw the buttes," Sprang said.

The visit appears to have taken place in August, when Herriman's *Examiner* work markedly dropped off. Additionally, Herriman and Payne's friendship during this time is demonstrated by the gift of an original cartoon that Payne signed and dated on September 3, 1907. Numerous references to the region started showing up in Herriman's *Examiner* work around this time as well. Herriman went to Naples, California, for a meeting of five hundred Arizonans, who had gathered to debate statehood. Herriman also illustrated an article about the swastika (then a mere design fad) that linked it to Navajo art. In April 1908, he added Navajo designs to an otherwise boilerplate caricature of American Indian ballplayer Ed Pinnance.

Herriman's first published reference to Coconino County—a real county in Arizona, whose name Herriman took for Krazy Kat's home—appeared in October 1909, in a cartoon about an actors' ball game. The splash of scenes includes a caricature of actor Robert Z. Leonard that is captioned, "Bob Leonard doing his Coconino Goose Strut." Nothing else is known about Leonard's ties to Coconino—nor, in those early years, about Herriman's.

I n September 1907 George Herriman returned to his alma mater, St. Vincent's College, to report on the football team's 10–0 routing of the University of Denver. He took his place on "the rah-rah line" making notes on other alumni for his cartoon.

It had been ten years since he left St. Vincent's, and recently he had been reminded of how far he'd come. A visiting club of newspaper humorists arrived in Los Angeles; Herriman and Van Loan joined what Van Loan called the "sad-eyed savants" for their travels. On a hike up Mount Lowe, Herriman followed closely behind pacesetter William J. Lampton, a cousin to Mark Twain. Herriman also rode along on trips to Venice and Riverside, where the humorists took automobile tours through orange groves and met for an elegant dinner at the Riverside Inn. There were songs and speeches, and on the train ride back to Los Angeles the membership voted both Herriman and Van Loan into the group.

Herriman and Van Loan returned to the opera in October 1907 for a matinee performance of *Tosca*. In his report, Van Loan offered a few rare gags concerning Herriman and the opposite sex:

> The Greek's seats were down in front where we could get a line on the orchestra. The violinists were locating the A, the clarinets were cantering over the course and the man with the bull fiddle was reaching around for a little ragtime. Suddenly the bassoon began to warm up and George the Greek beat his breast like the old man in the poem. . . .
>
> The orchestra began some of the sort of music they play at the Burbank when the leading man discovers that the check has been forged, the door opened and The Peach came in. George said he never saw one like her—not even at Coney Island. She was pretty enough to make every married man in the house ask his wife for the opera glasses and she had a voice like a young angel. Black

hair, black eyes, a complexion like strawberries in the snow and a profile to set an artist crazy. That was The Peach.

She chased Little Casino around the stage for about seven minutes, finally treed him in a corner and held both his hands while she sang to him.

"What's the matter with that fellow? " asked the Greek, squirming in his seat. "I bet she wouldn't come to chase Me."

At the *Examiner*, Herriman could freely experiment. He varied the shape and size of panels, which he began enumerating in everything from Roman numerals to numbers written out in German. Dickens, Cervantes, Shakespeare, astronomy, Greek and Roman mythology, *Uncle Tom's Cabin*, and popular songs such as "Cottage by the Sea" and "La Paloma" all made appearances. So did frequent mentions of his peers, especially Tad Dorgan and Jimmy Swinnerton, whom he kidded as "that humic Raphael." His editors played along, running names such as "Kid Herriman" and "Husky Herriman" above his work, with the "Kid Herriman" note also stating that Herriman weighed in at a mere 133 pounds.

Not all assignments were to his liking, as when he was sent to cover the local appearance of a portly New York actor. Wrote Van Loan: "Herriman said he would rather go to the circus and see the real elephants perform, but orders are orders, be they ever so painful." Herriman had more fun at a luncheon of circus clowns that included Spader Johnson, Ringling Brothers' famed "King of Clowns." In Herriman's caricature, Johnson is without his "clown skins," debating Darwinian theory.

Yet, despite his friendships at the *Examiner* and an outpouring of creative work, Herriman still felt insecure in his position. He had been dismissed by at least one Hearst paper, and had seen nearly all the cartoons and comics eliminated from two other newspapers where he

worked. Unlike friends such as Jimmy Swinnerton, who had recent-
ly come to town to oversee a stage production of his popular comic
strip *Little Jimmy*, Herriman still had no successful character to call his
own. And even though Herriman was publishing impressive work
on the sports pages, Tad Dorgan's long shadow stretched across the
continent from New York to California.

In May 1908, Herriman listed his fears in a lengthy letter to his
friend and former colleague Ralph "Pinky" Springer, who had moved
to Colorado to accept a job with the *Denver Post*. Herriman decorated
the envelope with lighthearted cartoons, but his humor couldn't mask
persistent doubts.

Herriman started with what seems to be a few unusual jokes about
syphilis or a similar disease: "Glad to hear of your recovery . . . but
they do say, and I must confess, I can but say the same, that people
never have pneumonia in the Dink, but of course you know what you
had, so we'll pass that topic by."

He followed with some scatological humor about an old colleague
who makes claims of being the only man "that could made you Hur-

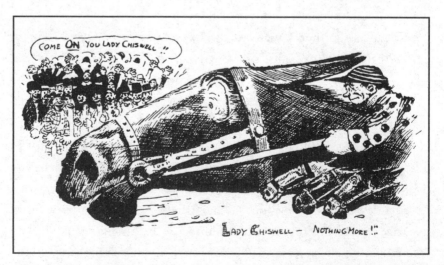

From *Lady Chiswell, 50 to 1, Puts a Dent in Books, Los Angeles Examiner*, December 20, 1906

dle the art room fence and tear for the more secluded regions of the can . . . there were others if you remember right who not only made you beat it to the crapatoire, but mess in your pantaloons long ere the goal was reached." Such jokes were commonly heard from Herriman and Springer, remembered Pinky's son, Wilson Springer. "George seemed to suffer from constipation a great deal," Wilson Springer said. "I recall hearing my Dad and George talking and discussing his constipation problem; I think they were going to drive down to Arizona and my Dad said something about taking along some toilet tissue because they were going into very rural Indian country. George remarked that he wouldn't need toilet tissue . . . all he would need would be a whisk broom for that problem, and I remember my Dad laughing hard."

The heart of Herriman's letter, however, was a recounting of Herriman's troubles at work. Editor Foster Coates, famous for being a difficult boss, had arrived from New York. Known as "Curser Coates," he would choose "strange ways to spur us on to high endeavor," journalist Albert Terhune later recalled. Coates was, Terhune added, the most "fluently talented blasphemer I have ever met." Rather than shout out his curses, Terhune said, Coates would emit them through a half smile.

After he arrived in Los Angeles, Coates turned that half smile toward the *Examiner*'s cartoonist. In his letter to Springer, Herriman parodied Uriah Heep in Charles Dickens' *David Copperfield* to describe the unhappy scene:

> Foster Coates is here for a while and is busy revising things, to begin with he slams me a few, like this, and mind you to me face, 'You know Herriman—Tad's the big man, we pay him big money, and we've got to use him, I say, that's right Mr. Coates, 'humble like,' then says he, Herriman, you are only a rank imitation of Tad, now and you know it, I say, I know it, Mr. Coates,

'very umble,' Then why, by the immaculate tit of Josephine, do we want to use the spurious article, when we can git the genuine goods? Why? and my 'umble' echo echoes, 'why?'— goodnight says he, goodnight says I, and as I leave him, I can hear him shout to Beanie, thusly—Mr. Walker, see if you have a Tad cartoon and use it for tomorrow, Herriman's a punk German carpenter—Beanie says something about 'shit' and I beat it to the art room and pour forth woe upon woe, and wail me life's young blood away to water, but then N.Y.'s the place, from which all great editorial wit floweth and the tide has come this way, but my humble soul is resigned it's nothing new to me, to sit in daily communion with myself while great editors flourish overhead—amen—

After penning the single word "gloom" on a separate line, Herriman tried to laugh off the encounter: "It was like a breath of new air when that Elephantine Mass of bull dung blew into town, my ribs are still a bit awry, and my kidneys are gradually returning to their proper places, and outside of that, what's left of me is joyful that he came."

Herriman concluded his letter with some lighthearted jokes about the actress Billie Burke (three decades before Burke would play Glinda the Good Witch in *The Wizard of Oz*) and the Shakespearean actor John Drew Jr., in a closing note that reveals Springer was a family friend as well as a colleague:

Mrs. Herriman was all swelled up over that line of Bull you handed her about Billie Burke, Punkus, if I'm still within the deadline of your affection please don't spring anything like that on me, Lord, she did everything but express a desire to go on to the stage, I asked her if I wasn't as good as John Drew, but she shriveled me with a look of scorn, she said the best she could

do was to try to imagine that she was trying to imagine that I was John Drew and it was the hardest kind of imagination work she'd ever done, I humor her by saying she's the leading lady of the Herriman show, at least.

After some mock-concern that his daughter Toots and dog Mike will be the next ones to get stage fever, Herriman shared some family news: Toots is about to celebrate her fifth birthday, and Mike has gotten over a scratch. He informed Springer that Tad Dorgan is now married to a Greek woman, adding, "nothing's too good for them Irish, not even the Greeks." His news and complaints finished, Herriman closed with a few last lines of affection and a joke that only the son of a tailor might tell:

Well Punkus old boy, here's to you, I will try to come through oftener with a letter but whether I write or not you know that I'm there with a heart full for you—

Our paths may lead apart for a while but someday the "old guard" will all meet at some crossing, then the jubilations

Regards from all the boys here and pass the good word along to the boys around there—in the meanwhile keep your nuts in the middle of your pants, and behave yourself—

Thine—

Greek

PROONES, MOOCH, AND GOOSEBERRY SPRIG

Nobody gives me nothing; nothing but nothing is free. Ah
wot a world, wot a world, and there ain't no how ever.
—*Baron Mooch*, October 10, 1909

On December 6, 1907, George Herriman's grandfather, George
Herriman Sr., nearing ninety years of age, died in his home in
New Orleans. At the time, travel to New Orleans was increas-
ing: an article in the Los Angeles *Examiner* had touted New
Orleans as a "rejuvenated city" after the Civil War, noting
that thousands voyaged there each year by steamer and train.
Yet none of the Herrimans in California made a return trip for the
funeral, including the deceased's sole surviving son and namesake,
George Herriman Jr.

In Los Angeles, the Herriman family gathered for more festive af-
fairs, including a 1908 production of *Remembrances of Colonial Times*,
a patriotic play given by the Young Ladies' Sodality in the St. Joseph
Catholic Church auditorium, located on the corner of Twelfth and
Los Angeles Streets. The production boasted music, a special-effects
snowstorm, and a cast that included George Herriman's sisters Ruby
and Pearl (Pearl played Abigail Adams).

Also that year, the family returned to St. Vincent's Church to cel-

ebrate the First Communion of Daisy Herriman, George's youngest sister. Daisy appears to have emulated her older brother, for she submitted a drawing for a contest sponsored by the *Los Angeles Herald*. George Herriman's history at the *Herald* proved to be no help, however, for his sister was not among the winners. "Daisy Herriman drew a picture that had many good points, but her lines were not all heavy or firm enough," the judges noted.

The Herriman family soon would have another reason to celebrate. At seven in the morning on Friday, May 15, 1908, Mabel Herriman gave birth to her second daughter, Barbara May Herriman. George was not home for the delivery, having gone to Sacramento to cover a political convention for the *Examiner*. But he would become singularly devoted to his new daughter, who would be the couple's last child. His devotion would only grow when Barbara, whom George and Mabel nicknamed "Bobbie," proved to be in fragile health, and from a young age began to experience frequent seizures.

Providing for a family of four gave George Herriman even greater reason to be concerned about his job. True to Foster Coates's word, the newspaper started running more cartoons by Tad Dorgan, and even picked up sports cartoons from Chicago cartoonist Sidney Smith, later to achieve success with his strip *The Gumps*. Herriman knew all too well that sports cartoons, theater illustrations, and editorial crusades over graft would never be his ticket to national prominence. His best shot was dreaming up a popular strip with characters that readers would embrace as their own—but harnessing his wild imagination to a long-lasting strip was proving difficult.

For a model of success, Herriman had to look no further than San Francisco *Chronicle* cartoonist Harry Conway "Bud" Fisher, who in November 1907 introduced *A. Mutt*, a comic starring a railbird named Augustus Mutt. Fisher's hook: Each day, Mutt would place a bet on an actual horse racing at a local track. The next day the strip would disclose if Mutt won or lost his bet. Gamblers turned to *A. Mutt*, eager

to see how Mutt's wagers fared. Rumors spread that Fisher had inside information. Once brought to the strip, readers stayed on. Fisher's drawing was scratchy and his backgrounds sparse, but his gags were sharp and timely, and his racetrack vernacular finely tuned.

A. Mutt wasn't wholly original. Four years earlier, in December 1903, the *Chicago Evening American* had run an occasional racetrack comic by Clare Briggs with a similar title: *A. Piker Clerk*. Mutt even looked like Clerk: a rail-thin gambler with a bushy mustache beneath a peg nose. The following spring, on April 27, 1904, Herriman had tried out Briggs's idea for the *New York American*, adding the name of an actual horse running at a local track. Beneath the title *Artist Herriman Depicts the Fate of an Eavesdropper and Sketches Some Familiar Turf Figures He Saw at Jamaica Yesterday*, the strip recounted the hard luck of a spaghetti-limbed eavesdropper who overhears a tip from "Peeree Lorillard," whom Herriman based on tobacco magnate and horseman Pierre Lorillard V. Herriman's eavesdropper made no more appearances, however, and Briggs's *A. Piker Clerk* didn't last past the summer. Fisher might not have composed the original tune, but he alone had the hit.

William Randolph Hearst noticed Fisher's success, and the *San Francisco Examiner* quickly lured *A. Mutt* to its pages. On Tuesday, December 10, 1907, Fisher drew his final strip for the *Chronicle*. Surely not coincidentally, on that very same day in the *Los Angeles Examiner*, Herriman debuted a racetrack character of his own: Mr. Proones the Plunger.

To "plunge" is to go all in with a wager; newspapers teemed with stories of reckless plungers who lost their fortunes at the betting window. Proones first appeared just three days after the opening of Santa Anita Park in Arcadia, which held its first races under low-hanging clouds. Herriman had joined the opening-day crowd of seven thousand, most of whom traveled from downtown Los Angeles in red train cars that moved so slowly that passengers could step off to pick

oranges. Despite slow trains and a first-day muddy track, Santa Anita, the *Examiner* reported, promised to be the Saratoga of the West.

The *Examiner* blanketed its pages with coverage. Herriman cartoons appeared everywhere from the front page to the sports section. Then on Tuesday, alongside the previous day's track results, a comic titled *Cartoonist Herriman Sees Queer Sights at Races* introduced a short, portly man with the upper-class trimmings of a cigar, cane and ear-to-ear "burnside" whiskers. He tells a passerby that he is waiting for his "shofer" to buzz along, promising that he has a "warm one in the pan" and will place "not bashful money" on a hundred-to-one long shot. He is, however, a pretender. He reaches Santa Anita by stowing atop a train car, and tries to sneak into the park through a drainage pipe.

Two days later the plunger, now named Cicero Q. Proones, finally makes it into Santa Anita to bet it all on the horse All Alone, which he had dreamed would take the purse. (Herriman once again used the names of actual horses.) This time Proones has the horse but not the money. Proones thinks he has snuck out of the house with a sock filled with his wife's scrip, but discovers to his shock that the sock holds only cold cream and clothespins.

One day Proones overhears what he thinks are millionaires discussing a horse, only to learn the men are escapees from an insane asylum. Another day he wins a sack of money—but the windfall proves to be a dream. In a Friday, December 13, installment of the strip—now titled *Mr. Proones, the Plunger*—Proones appears in blackface. "Just watch your ole pal Cicero Q. Proones work a few pikers for some of that superstitious money," he says, corking his face and holding a sign that reads: "'Rococo' the Coon with the Lucky Conk." Proones receives coins from passersby who rub his head for good fortune—the same joke that had been told on Herriman by his newsroom friends.

Herriman allowed Proones to cash in just once, on Christmas Day. Proones finds a bundle of money and turns it in, and the grateful re-

cipient places a winning bet for Proones. Yet good fortune would not linger, for the next day's strip would be the last, with Proones's hired automobile crashing into a farmer's horse and buggy. It's not clear if Herriman or his editor first tired of Proones. Perhaps the strip had served its limited purpose by welcoming Santa Anita to town, and besides, Hearst had Fisher now. Whatever the cause of death, Cicero Q. Proones quietly departed after a mere ten installments, a loser to the end.

A long with *Examiner* sportswriters Beanie Walker and Charles Van Loan, and theater critic Otheman Stevens, Herriman's circle now included New Zealander Charles Eyton, a fight referee who hosted all-night poker games; and Dick Ferris, a wealthy promoter who took the gang on adventurous road trips in his large automobile. Ferris was the most celebrated among them, a "venturesome, golden-haired boy," Walker wrote, a Sport among Sports who started out penniless and now boasted mansions in several cities.

Out-of-town excursions included a memorable night when Ferris led a caravan of cars to a fight in San Bernadino. Walker and Herriman rode in Ferris's car. "The parties who enjoyed this personally conducted excursion will never forget the last sixteen miles of the journey," said Walker. "Striking the long stretch of smooth desert road, Dickie boy gave the machine free rein and yanked his party over the sand at a speed that kept their heads bumping against the top of the car."

Ferris took the wheel for another late-night adventure when he piled Walker, Herriman, and others into his car to go searching for a lost hot-air balloon. When the journey was over, Ferris brought the gang to his palatial home on West Adams Street. "It was a rough-looking lot of 'soldiers' that tramped over Dick's Persian rugs, toured the wine cellar, and assembled themselves in the music room," Walker

wrote, adding that a security guard followed the gang around to ensure nothing went missing.

For lunch, Herriman could predictably be found at a popular diner owned by T-Bone Riley, who was beloved by boxers for extending credit during dry spells. Customers stood three-deep at the walls, waiting for a place to sit down, and they knew not to complain about the food. Riley was known to pick up a steak and slam it against an unhappy customer's head.

Herriman, befitting his Louisiana childhood, was notorious for his appetite for spicy food. "George the Greek is the star boarder at Tony's chili foundry," Walker wrote in his column. "He holds all records for consuming the flaming food at the peppery table." Herriman even penned his own unique homage to the proprietor, Tony Ramirez, who seemed to have equal passions for food, art, and music:

A few weeks ago Tony Ramirez fell for "Art." One Michael Angelo Gonzalez blew along two days shy of a meal and traded his "Art" for a bowl of beans, and thus was life sustained and "art" prolonged.

The frijoles continued to come regular, and now the Mexican Rembrandt has festooned Tony's Appajara emporium with artistic gems depicting the life Mexicana in all its colorful reality.

But the soul of Tony lusted for other muses to conquer, and he wasn't slow in the act, either, for last evening the word was given out that Tony had burst into the rapturous depths of melody and now the strains of La Paloma mixed in with a decided odor of chili con carne waffling its way down upper Broadway in such a gay and festive manner as to thoroughly mesmerize your olfactory sense and get a half nelson on your appetite and lead you in delirious joy to mingle with Tony's Bohemian clientele. . . .

What may be expected next from maestro Tony Ysmile Ramirez is not difficult to conceive, but let us hope he will not

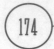

lose his "art" of dishing out an appajara or a Yaqui sandwich in the pursuit of his muses.

Walker appended Herriman's article with a note that the cartoonist's "high dive into journalism" might be caused by a desire to score a month of free lunches. The *Examiner* continued to indulge Herriman's unique journalistic voice, publishing theater reviews that Herriman delivered in the persona of an artichoke merchant named Joe Beamish:

> When I laid my eyes first off on the program and spotted all those lords, markees, barons, maitres and generals, I says, well here's quality; then the bo brunos, tic tacs, tiger claws and grizzly beards, I murmurs, soft like, here's the action—it sounds so much like one of T. Jefferson McCarey's scrapful menues, it argufies much speed and voluminous velocity wedged in the high.

Nominally, that review was for a play titled *Under Two Flags*. In other Herriman-penned reviews, it could be difficult to discern even the production's title.

Herriman followed *Mr. Proones the Plunger* with a volley of new titles. Some he based on current news and observations made around the city, including *Today in Sports*, *The News of the Day in Black and White*, *People One Meets in Los Angeles*, and *Guess Who?*, which challenged readers to identify local celebrities. None lasted. So at the start of 1909, Herriman, as he had done nearly ten years earlier, traveled to New York in the hopes of getting a break.

Herriman's trip lasted about three months, from February through May 1909. In his *Examiner* column for April 12, Beanie Walker noted that Herriman was in New York with Charles Van Loan, who had

signed on with the *New York American* to file boxing reports. On May 4, Walker announced Herriman's return to California, noting that "George, the Greek, will drive in from Kokomo, Indiana, to-morrow night." (Walker doesn't explain what Herriman was doing in Kokomo or give any more details about the driving trip.) Herriman's time in New York bore results. On February 19 the *New York Evening Journal* launched a new Herriman daily comic strip titled *Mary's Home from College* and offered it to Hearst papers across the country.

The premiere opens at a train station, where Mary's family eagerly awaits the return of their "collegely educated daughter." Mary's mother is eager to show her daughter her new shawl. Her father aims to impress with his new whiskers. There is a brother, Prunious, and Joe Beamish is now the name of Mary's hometown boyfriend. Not insignificantly, a white dog and black cat engage in various sotto voce conversations at the bottom of the panels.

Amid this hubbub, Mary arrives. She is dressed in the latest fash-ions, and breezes past her "pa–pah," declining to kiss him because "mustachios are so conducive to microbes." Mary's mother sadly ob-serves that her daughter never even noticed her new shawl.

Mary's Home from College appeared irregularly in the *Evening Journal*, then after ten episodes moved over to the *New York American*, where it ran through May. Gags centered around Mary's oddball college chums (including a professor who converses about "psycho-thero-pootisms") and Mary's haplessness with household chores (she feeds baked beans to the pet canary). Herriman pulled jokes from headlines about the changing roles of women, then sprinkled in some minstrel gags. At an evening gathering, when Mary's guests insist she perform a "coon song," she chooses Barney Fagan's "My Gal is a High–Born Lady," a tune with sharp gags about race and status that must have appealed to Herriman: "My gal is a high born lady / She's black but not too shady / Feathered like a peacock, just as gay, / She is not col-ored, she was born that way." (The song also appealed to Bugs Bunny,

who in a 1948 cartoon reprised the song as "My Gal is a High–Born Stepper.")

During his brief stay in New York, Herriman also contributed several sports cartoons to the *New York American*, and drew illustrations for "Under the Old Straw Hat," a new column by Van Loan. But before long, the stories in *Mary's Home from College* start to become labored, with Herriman having more fun with the growing menagerie of talking animals that are collecting at Mary's feet. Then, in the *Mary* comic published on March 8, 1909, came a small but momentous transformation. The story concerned Mary's urge to show off her new artistic talent by painting the family's dishes. Just as the black cat is about to drink from a bowl of water, the dog leaps up. "Touch it not Kat, touch it not, somebody's doped it with fresh paint," he warns.

For the first time a Herriman cat has become Kat.

The spelling might have been inspired by the Kit Kat Club, a New York organization for which Walt Kuhn had begun organizing annual masked balls; members included Herriman's friends Rudolph Dirks and Tad Dorgan. A month prior to Herriman's first mention of "Kat," police had raided that year's ball, after having been tipped off about a risqué "Salome dance." They were turned back with the explanation that the show had an all-male cast. Herriman likely attended the ball, but even if he didn't, the controversy made the newspapers and, surely, led to much joking in the *Evening Journal* offices.

The Kat remained with Mary throughout the duration of the strip. In *Mary's Home from College* published on April 6, 1909, she (this Kat is a female) was joined by a duck in a top hat. It is the same duck who had appeared as Lord Carbondale de Duck in a 1907 *Examiner* sports cartoon, and then waddled through various sports scenes throughout the past year, chomping on a cigar and offering pithy observations, sometimes in mock-Elizabethan diction. In a series of cartoons about a fishing trip chartered by boxer Battling Nelson, Herriman had

Mary's Home from College, March 8, 1909

turned the duck into a detective named Gooseberry Sprig. Herriman had named his first two future residents of Coconino County.

As *Mary's Home from College* neared the end of its run, an odd love triangle developed with Gooseberry, Kat, and the dog (now named Mr. Butsie), presaging the future Ignatz–Krazy Kat–Officer Pupp triangle of *Krazy Kat.* Here, Gooseberry Sprig courts Kat, and Mr. Butsie tries to thwart his intentions. The triangle finally ends when Mr. Butsie, anticipating Gooseberry's future title "the Duck Duke," delivers an ultimatum: "Chose, Kat, me or the Duke." Kat goes with Gooseberry, and in Mr. Butsie's final scene, he prepares to shoot himself.

The *New York American* quietly ended *Mary's Home from College* on May 19. By then Herriman had returned to Los Angeles. At the end of the year, Herriman brought back the strip for a few *Los Angeles Examiner* installments and, a full ten years later, tried out a revival in

the *New York American*. Yet Herriman would leave it to other artists to more fully realize his idea of basing a strip around the actions of a young, modern woman. In 1912 Herriman's friend and colleague Cliff Sterrett would debut the sensational *Positive Polly*, later renamed *Polly and Her Pals*. A decade later Chicago-born cartoonist Chic Young developed a series of female-led strips, including *The Affairs of Jane*, *Beautiful Bab*, *Dumb Dora*, and, in 1930, a comic about a memorable flapper-turned-housewife named Blondie.

B ack in Los Angeles, Herriman kept up a busy social and professional calendar. In July 1909 he gathered with Walker and a dozen other sportswriters at the local Delmonico's restaurant, where they toasted Mike Donlin, a former Giants baseball player in town on a vaudeville tour. Later that month, the *Examiner* welcomed a massive Elks convention to Los Angeles by mounting a giant elk head on its facade ("Colored lights have been placed in the eyes and nostrils of the head, and add to the beauty of the piece," the newspaper reported), and Herriman joined with Dick Ferris and friends in an organization called the Cactus Club in hosting a dinner for journalists with the Elks. At the dinner, held at the Casa Verdugo restaurant in present-day Glendale, visitors received special editions of the club newspaper, *The Spineless Cactus*, which featured cartoons by Herriman.

One newspaper assignment must have been galling, however. On January 8, 1909, with Herriman still struggling to create an enduring comic character, the *Examiner* added Bud Fisher to its pages with the headline, "The Mutt Family Breaks into Los Angeles." Having conquered San Francisco, Fisher's strip was now taking Southern California by storm, with the Oakland Angels adopting as a new mascot a goat named A. Mutt and the *Examiner* running a story about a Cambridge English professor who predicted that Fisher's *Mutt and Jeff* might some day be regarded as classic literature. Years later Herriman

would be credited as an influence on Fisher, with *New Yorker* cartoonist Robert Day stating that Herriman "was really the founder of the Bud Fisher style of comic art and in the early Fisher drawings you could see that he was copying George's style." (In truth, both Herriman and Fisher drew much inspiration from Tad Dorgan.) There have long been rumors that Herriman "ghosted" strips for Fisher. These have never been substantiated. However, in October 1909, the *Examiner* published a special series of *Mutt and Jeff* comics to advertise a local brewery, unsigned but tagged "with apologies to Bud Fisher." By all appearances Herriman received the inglorious job of copying Fisher's characters.

Perhaps this helps explain why, around this time, new color comic strips bearing Herriman's signature started to appear in non-Hearst papers. A few Herriman comics had been running in the syndicates the past couple of years, including some final episodes of *Bud Smith* and a charming but modest weekday series titled *The Amours of Marie Ann Magee*, recounting the story of Marie Ann, her suitors, and her mischievous little brother Tobias. When in New York, Herriman seems to have reconnected with World Color Printing, because by year's end a pair of new Herriman features appeared in Sunday comics supplements across the country, in cities from Nashville to Mobile to Kansas City.

In these large-scale, usually color comics, Herriman brought his animals out of the margins and onto center stage. A half-page *Daniel and Pansy* introduced a Dan Coyote and a pig named Cincho Pansy, both early models of future Coconino County denizens. The names offered yet another homage to Miguel de Cervantes, but the visually crude strip (by Herriman standards, at least) survived for just three installments. A slyer and more successful comic, *Alexander*, lasted under Herriman's direction for ten episodes, appearing in World Color Printing newspapers from November 1909 to January 1910. *Alexander* brought back several characters and themes of Herriman's *Zoo Zoo*

stories: the title character was, again, a spoiled, all-white Angora cat living in a comfortable home, doted on by the woman of the house and barely tolerated by her husband. This time around, Herriman bestowed upon the man of the house a cantaloupe torso and pencil-thin legs, as well as a new name: Charlie Van Bones. The joke was on Herriman's friend Charles Van Loan, who possessed a similarly bulbous physique.

Van Bones is a successful businessman who would like nothing better than to unwind at home in vest and shirtsleeves, smoking his pipe. He and his wife, Leila, have no children, and share their house only with Alexander, a fluff of uncertainty in Van Bones's otherwise well-managed life. Each week Alexander dashes out of the house, leading Van Bones on madcap rescue missions. In one clever scene Herriman nods to his Ashcan artist friends when Van Bones sighs, "Oh well, I guess, being a full blood royal fuzzy Angora he's entitled to more eccentricities than the ash can variety of feline would be." Other Herriman flourishes include Navajo designs on the Van Bones's throw pillows, and a neighbor bearing the unusual name "Mr. Mushwa." The name refers to a Haitian scarf, sometimes used in religious ceremonies, commonly worn by Creoles in New Orleans. Herriman had begun using it without explanation in his comics, including a boxer named Kid Mooshwah and a newspaper photographer named Doosenberry Mooshwah.

The most intriguing *Alexander*—titled "First White—Then, Black—Then, White Again!"—appeared in newspapers in late November. The gags begin when Van Bones drops a stovepipe on Alexander, blackening him in soot. Alexander dashes upstairs, where Leila, not recognizing her pet, shoos him off. Alexander then leaps into a tub of water being carried by a black servant, who warbles a minstrel song about possums and banjos. The servant brings the cat, now returned to sparkling white, to her grateful employer, while Van Bones slips his servant a dollar to keep quiet. The racial themes of *Musical Mose*

From *Alexander*, November 28, 1909

were overt; with *Alexander*, Herriman has introduced multiple color reversals into a world of animals.

*A*lexander would be the last series that Herriman would create for an employer other than Hearst. When Herriman suspended it—perhaps on Hearst's orders—World Color Printing assigned the characters to new cartoonists, including the capable C. S. Rigby, who previously had taken over *Major Ozone*.

Herriman's public flirtation with another employer might have alerted Hearst to his talented staff artist, for the *Los Angeles Examiner* quickly found space for two new remarkable Herriman weekday strips. The first, *Baron Mooch*, appeared in the *Examiner* from September through December 1909 and later in the *New York American* and in

various newspapers across the country, including the *Boston American* and the *Idaho Statesman*. *Baron Mooch* is Herriman's most outlandish all-human strip, the first sustained visit to the outer reaches of his imagination.

Mooch was inspired by a swarm of "ticket moochers" who pestered sports promoters and journalists. The previous year Herriman had dedicated a sports cartoon to Los Angeles boxing promoter Baron Long (likely Mooch's namesake), who was being targeted by a Dudley Pest, "the prince of ticket moochers." By March 1909, Beanie Walker was railing against the "impudent individual who butts his way into press stands and ringside chairs." The "ticket mooching evil," Walker thundered, "has reached tremendous proportions."

On September 27, 1909, Herriman gave a face to that evil when he debuted *Baron Mooch*. Bearing the same cantaloupe torso and spindly legs as Charlie Van Bones from *Alexander* and speaking in artichoke merchant Joe Beamish's mock high diction, Mooch first tries to talk his way into a baseball game. Ensuing plots turn on Mooch's attempts to beat the turnstile with elaborate disguises, turning *Baron Mooch* into a screwball comedy of false identities. Costumes and settings are lavish; Bud Fisher's *A. Mutt* occasionally appeared on the page opposite *Baron Mooch*, and Fisher's bare-bones artistry proved a stark contrast to Herriman's visual flourishes. Yet Fisher's minimalism might have been a secret to his success, for as both Mooch's appearance and schemes grew more extravagant, the strip must have seemed increasingly puzzling to its readers. Not content with gaining free tickets to boxing matches, Mooch begins trying for free haircuts and tooth extractions, "stereoptican views of our fertile lands" from a land developer, and even a hot-air balloon ride from Herriman's friend Dick Ferris. As he would later do in *Krazy Kat*, Herriman attached a family lineage to Baron Mooch, highlighting his noble origins in a strip that christened him "Freequentius DeLunch Mooch." Mooch poses for a portrait, stating, "They say I look like Wilkins Micawber," referencing Charles Dickens's *David Copperfield*.

From *Baron Mooch*, October 27, 1909

Yet again, Herriman built in a minstrel theme, this one in a sequence that lands in an enormous splash of self-referential gags. The strip for Saturday, October 16, opens with Mooch blackening his face with ink and stowing away on the *Owl*, the Southern Pacific's night train, for black heavyweight boxer Jack Johnson's training camp. Mooch meets Johnson himself and convinces him that they are relations, offering to hold his water bucket for an upcoming fight. To the delight of Beanie Walker, who is sit-

ting ringside, Johnson spies Mooch's white arms and sends him packing.

The next week Mooch shows up right at the *Examiner* newspaper office; Walker tosses him out. A few days later Mooch is thrown into jail in a case of mistaken identity: he had mooched a convict's clothes because the stripes made him feel like a butterfly. In "Hooray! Baron Mooch Is Free Again," published on October 27, none other than Herriman and Walker rush off to free him in time to make his daily appearance in the *Examiner*.

In a November 16 *Baron Mooch* episode titled "He Strikes the Suburbs," Herriman explicates a symbol he frequently had been using in place of a signature for his smaller *Examiner* illustrations: an *X* placed inside a circle. Says a hobo to Mooch: "That, sir, is the hobo sign for 'kind lady' it means that you may here find grub given free." It is neither the first nor last time that Herriman will identify himself as one of society's wandering outsiders.

In a remarkable, race-themed episode, the Los Angeles Angels' upcoming game with the all-black team the Occidentals inspires Baron Mooch to cork up—blacken his face with burnt cork, in the manner of minstrel shows—in order to gain entrance as "Jack Johnson's own l'il brudder." The Occidentals bring him onto the field for an introduction, but Mooch is beaned by a stray ball and knocked out cold. A bucket of water both revives him and washes away his blackface. And so Mooch, like the cat Alexander, starts out as white, then turns black, then turns white again. In fact, this Mooch episode was published on November 19, 1909, one day before the *Alexander* strip "First White—Then, Black—Then, White Again!" appeared in World Color Printing newspapers.

The stories grew stranger, with Mooch hopping a train to a Death Valley borax mine, a gag Herriman likely aimed at his friend C. M. Payne, who took a prospecting trip to Death Valley. Mooch escapes the mine work thanks to a fairy godmother who appears and in-

structs him to say "mushwa," which renders Mooch invisible. Various mushwa invisibility gags followed in subsequent strips, then Herriman abruptly switched course and launched a story about Mooch's employment at a boardinghouse operated by a Mrs. Lillydale and her dog, Mike (the name of a Herriman family dog during this time). Mooch again corks up, this time to con some food from the black cook, Euphemia, who scandalously promises a tryst behind the henhouse. Then she sees him washing away the cork and knocks him out. "Woman—woman bleached or unbleached, when scorned . . ." Mooch mutters, dazed.

Herriman suddenly concluded the series on Saturday, December 18, with an episode titled "His Boss Goes to Sleep on the Job." In this final strip, Mooch dives through a rip in the newspaper as Beanie Walker rouses Herriman from what turns out to be a dream. "But my dear sporting editor I—I—was just trying to think of an idea—" Herriman protests. It is too late, for Herriman's most recent hope for a hit lead character has disappeared along with all his disguises, to mooch no more.

Perhaps Herriman welcomed—even requested—Mooch's demise. With no warning, *Baron Mooch* was immediately followed by the even more remarkable *Gooseberry Sprig*, a nearly full-dress rehearsal for *Krazy Kat*, minus its leading players.

Gooseberry Sprig most recently had shown up in the margins of *Baron Mooch*, where he might announce that "Gooseberry Sprig the duck gymnast will now do flip-flaps," or break the fourth wall by peering below the strip and noting, "That's some sport page down there." Mostly, Gooseberry was a font of classical quotations and misquotations. One day he quotes: "The warrior bowed his crested head," from *Bernardo del Carpio*, a poem by Felicia Hemans, whose *Casabianca* (aka *The Boy Stood on the Burning Deck*) would later be referenced in *Krazy Kat*. On other days, Gooseberry offers multiple quotations and

misquotations from Mary Russell Mitford's nineteenth-century trag-
edy *Rienzi*. Yet he preferred Shakespeare over all others, as when he
misquoted Wolsey from *Henry VIII*: "Farewell, a long farewell to all
me greatness—"

On December 11, 1909, in an episode about Baron Mooch steal-
ing dinner from a parrot, Gooseberry was reunited with Kat, his old
partner from *Mary's Home from College*. Says Gooseberry, "Ah Kat,
were you not such a lowbrow, I would a tale unfold to you—" The
reference is to *Hamlet*, when the Ghost tells Hamlet, "I could a tale
unfold whose lightest word / Would harrow up thy soul." The word
"lowbrow" harkens to the racist pseudoscience of phrenology. It was
becoming a favorite word for Herriman, who would later make ex-
plicit a connection between phrenology and Krazy Kat.

One week following Mooch's final vanishing act, on Thursday,
December 23, 1909, Gooseberry Sprig moved from the margins to
his own breathtaking strip. For the next month Herriman brought
an expanding cast of birds and beasts into pen-and-ink vaudevilles
that stretched to as many as fourteen panels. Something new came
over Herriman when he worked with an all-animal cast. Unlike
Mary's Home from College, which grew tired, and *Baron Mooch*, which

From *Gooseberry Sprig*, December 30, 1909

imploded in its own absurdities, *Gooseberry Sprig* remained fresh and funny throughout its run. In each episode, Gooseberry, a royal "duck duke," entangles himself in some complication, such as defending the honor of a lady duck, thwarting a thieving dicky bird, or apprehending an egg-napping coyote. He is joined by his prime minister, Joe Stork, another future Coconino character now making his entrance onto Herriman's comic stage. The language further bent Shakespearean diction and added lines of street slang such as "Youse can't run no rannygazoo on me, you rhums." (The writer P. G. Wodehouse has been credited with first publishing the modern spelling of "rannygazoo," meaning a scam, in 1924; Herriman beat him by fourteen years.) Most Gooseberry denouements involve the hero receiving a pummeling, in the manner of Frederick Opper's *Happy Hooligan*. In *Gooseberry Sprig* the punisher caps off the beating with the line "fresh duck."

At the dawn of 1910, California literally soared into a new age with the Los Angeles International Aviation Meet, produced by Dick Ferris and cosponsored by the *Examiner.* The city was getting "airship habit," the *Examiner* announced, with Angelenos flocking to Aviation Field (in modern-day Carson) to watch the sky fill with spindly monoplanes and biplanes. It was the first extensive air show in the United States, with most onlookers observing humans in flight for the first time. "This conquest of the air could not be accomplished in a more fitting place," the *Examiner* proclaimed. "Los Angeles and the great Southwest have battled with nature, and have won."

The *Examiner* estimated that a quarter million onlookers flocked to Aviation Field, passing through a carnival sideshow that included conjoined twins newly christened "the Human Biplane." Over their heads, famed aviators such as American Glenn Curtiss and Frenchman Louis Paulhan set new world records in takeoff speed and air height. Before week's end, William Randolph Hearst himself would take to the skies.

Herriman joined the throng at Aviation Field, filling the *Examiner* with cartoons of the event. He saved his best ideas, however, for

Gooseberry Sprig. While the *Examiner* trumpeted the new era of flight, its star cartoonist lampooned the proceedings with comics showing birds crashing to the ground and a heavy ballast dropping onto the Duck Duke. Herriman even poked fun at his friend Ferris, showing a turtle named Dick selling subscriptions to the tournament. Ducks and storks scattered about to welcome the famed aviator Escopett, a French-speaking dog based on Paulhan's pet poodle, Escapade.

Gooseberry Sprig had made liftoff to become a grand show of ducks and animals, a "sheer effulgence of verve and joy" as well described by comics scholar Bill Blackbeard. Drawn with what *Mutts* cartoonist Patrick McDonnell has called a "unique combination of cute and gritty," *Gooseberry Sprig* could never be mistaken for anything by Bud Fisher. Every strip dawned new until, on Monday, January 24, 1910, the *Examiner* suddenly published what would prove to be its final *Gooseberry Sprig*. In it, Herriman returned to themes of spiritualism, with Gooseberry, revered as a "gratitudinous eminence," setting up a table beneath a tree and calling forth spirits. A woodpecker's taps are mistaken for communication from beyond; Joe Stork is fooled until he spies the woodpecker. He turns over the table and stalks off, scorning Gooseberry with a final "fresh duck."

Then that was it. It's possible that the *Examiner*'s sports readers tired of Herriman's little animal stories. More likely, Gooseberry's sudden demise can be attributed to Hearst's recent appearance at the air show. The publisher had been well aware of Herriman; he kept a close watch on all the comics in his papers. While visiting Los Angeles, Hearst had a unique opportunity to witness Herriman at work. The Chief seemed to be hatching new plans for his cartoonist.

Before that, however, Herriman had another type of engagement to honor. He had, from the very start, been turning to minstrel show humor for many of his gags. At times his drawings did not rise above

the ugly stereotypes of the day; in other works he often twisted the racial parodies to his own purposes, adding complicated reversals that reflected his own experiences with racial masking. In the spring of 1910, Herriman incredibly took this all one step further. He corked up and took his own place on the minstrel stage.

"A mist of minstrelsy is hovering over the town," Herriman wrote in the *Examiner* on Thursday, March 17. A grand minstrel revival was scheduled for April at the Belasco Theatre, with the proceeds furnishing a "Players' Country Club" for actors and newspapermen. Los Angeles's best actors, Herriman wrote, were covering their "immaculately groomed mushes in a mess of burnt cork." Joining them under that cork were amateurs such as Dick Ferris, Beanie Walker, Jimmy Swinnerton, and Herriman himself.

Two matinee performances took place on Tuesday and Wednesday, April 12 and 13. The show followed the classic three-act minstrel format: following a parade to the theater, the curtain opens with a series of burlesque songs. Next comes the "olio" portion, which includes blackface performers in a semicircle; after the command "Gentlemen, be seated," a straight-man "interlocutor" poses questions to wise-cracking "end men," who respond in dialect, puns, and malapropisms. The classic minstrel show concludes with a one-act comedy; in the case of the Belasco performance, the play, titled "Bargain Day," concerned the foibles of a shoplifter.

Herriman had a part in each act. For the parade, he took to the streets of downtown Los Angeles in blackface sporting a high silk hat, long frock coat, and massive boutonniere. He and his fellow performers strutted "in regular Primrose and West style," the *Examiner* reported, citing a popular nineteenth-century minstrel troupe. The group concluded on Main Street, at the doors of the Belasco. Once inside, Herriman took his seat on stage in the olio's semicircle. Then he and Swinnerton stepped forward to perform a "lightning cartoon" act, in which Herriman began a drawing and Swinnerton quickly

finished it. Herriman and Swinnerton's routine, the newspapers reported, was "exceptionally pleasing," "genuine comedy," and proved to be "the biggest laugh-maker of the entire minstrels." Herriman took part in the final act as well, which featured the men in female roles, dressing in petticoats and shrieking in falsettos.

The show was a hit, netting the club $2,000. There are no further accounts of Herriman again performing in blackface, although he attended numerous other minstrel shows, and friends such as Swinnerton would again apply the burnt cork. Yet, even as Herriman corked up to participate in his own bizarre version of "black, then white, then black again," he was soon to unleash a pen-and-ink minstrelsy that, like the works of the blackface performer Bert Williams, would subvert the tradition to his own ends.

This began in early 1910, when a single sporting event, a heavyweight boxing match between black champion Jack Johnson and white challenger Jim Jeffries, became the focal point of racial hatred in the country. Herriman would become one of Hearst's primary chroniclers of the bout, and he would rely on his close knowledge of minstrelsy to savagely lampoon a national hysteria that surrounded the fight from its press-hyped buildup to its bitter, bloody finish—a finish that would lead directly to the creation of *Krazy Kat*.

TRANSFORMATION GLASSES

I n 1892, bare-knuckle champion John L. Sullivan drew boxing's color line when he declared, "I will not fight a Negro. I never have, I never shall." For the next two decades, most top white boxers followed Sullivan's lead. Yet, by 1906, with the emergence of superior black fighters in every class—Baltimore lightweight Joe Gans, Canadian middleweight Sam Langford, and Texas heavyweight Jack Johnson—boxing fans turned on the "lily-white club." In his *Examiner* column, Beanie Walker offered up the "true dope straight from the shoulder" on the color line: "Every time you hear a top-notch white fighter whining about the 'color line' you can bet 100 to 1 that there is a dangerous black man fighting in that class."

Herriman worked at the *Times* when he first turned his attention to the color line. In July 1906, in advance of what would be a forty-two-round match in Goldfield, Nevada, between Joe Gans and the Danish fighter Battling Nelson, he submitted a striking piece of fiction titled "Prehistoric Ringside Dope." It was, ostensibly, a humor article, a fantasy about cavemen. Yet it scarcely masked a personal commentary on race.

"There was to be a battle of men in the glen," the article opens in the mock-solemn tones of a ring announcer. Fighters are announced: an Italian, a Mexican, a Jew. The piece seems to be a quick vaudeville-style sketch—until another boxer enters.

Half-uttered words died on the lips, the silence was thick, the gaze of all was fixed on the nearing figure of a tall, thin man, with a sad brown complexion, armed with a short javelin and a small shield of rawhide.

He belonged to the tribe of black skins. Not only had he battled as man and man and man and beast, but he had suffered the ignominy of those of lighter skins. There was a churlish hatred in his heart, for the men of white clashing with the hungry desire to be one of them and forsake his black hide forever. He loved neither white nor black; he hated because he was the one and could not be the other.

The piece finishes in a volley of gags. There will be no more mention of churlish hatred clashing with envy. Never again would Herriman write about the battle of white and black hides so bleakly. Yet his commentaries on boxing's color line were just beginning.

Friday, August 2, 1907, dawned cloudy and mild in Los Angeles. A noisy throng of socially prominent local blacks—"Darktown's swelldom," as Charles Van Loan saw it—gathered at the Arcade Depot to greet the arrival of the Southern Pacific's *Owl* and its famous passenger, boxer Joe Gans. Nobody seemed prepared for the welcome, especially Gans himself. "Strangers in town may have wondered at the dark wave which overflowed the Arcade depot," Van Loan wrote.

Herriman and Van Loan looked on as a brass band played. Officials honored Gans with a key to the city. Gans—a lithe and precise fighter whom Tad Dorgan respectfully named the "Old Master"—had achieved heroic status for "establishing the supremacy of the sunburnt athlete as compared with his lily-white brother," Van Loan wrote. "Every way he turned he was met by outstretched hands of all shades, from delicate saddle-colored tan right up the line to the fast black of the true Senegambian representative."

Gans was in town to prepare for a bout against San Francisco boxer Jimmy Britt. Two days after meeting Gans's train, Herriman visited his training camp at the Oakwood Hotel in Arcadia. He joined a thousand paying fans who cheered as Gans entered the sparring ring and shed his signature grey robe to reveal a black gymnasium suit and an American-flag belt. Herriman would caricature Gans frequently in the pages of the *Examiner*, bringing his race into nearly each cartoon. In one he portrayed him as a "Pugilistic Othello." In another he mocked a Gans opponent, portraying him as a washwoman holding a pair of dark pants labeled "lightweight championship," declaring, "I'll bleach these out to a lilly-whiteness today or know the reason why."

Gans easily defeated Britt in five rounds, jabbing with his left hand "as a man might use an oyster knife to open an oyster," Van Loan wrote. In Los Angeles, where a mob of both white and black fight fans met outside the *Examiner* office to follow ringside bulletins, a lusty cheer erupted at the announcement of Gans's victory. But the next day a curious front-page *Examiner* headline, "Champion Not a Negro, but an Arab or Egyptian," revealed white America's discomfort about the result. The writer, a minor poet and frequent Hearst contributor named Joaquin Miller, insisted: "In the first place, Gans is not a Negro. With all respect to the mass of colored people who came to see him, and to sympathize with him, I should say the man is something of an Arab, Ishmaelite or an Egyptian. He has the negro's hair and the negro's feet, but his face is the face of an Arab. His nose is almost a pyramidal nose."

The gang in the sports section had their own fun with Miller's assessment, and at Herriman's expense. A subsequent Herriman cartoon about duck hunting included an editorial note likely written by Walker: "A study of the picture will show what a thorough knowledge the Egyptian cartoonist has of this sport."

Herriman celebrated the Gans win with a triumphant panel titled *Bah, Bah, White Sheep!!!* showing Gans trimming a flock of sorry-

looking sheep, each one named for a different white boxer. But Herriman added a small yet ominous scene in the upper corner of his cartoon. In it, he showed angry white fans chasing down and threatening black fight fans. Two small dogs, one black and one white, also skirmish. "I 'spose cos Im black—" says the first. "Yaas, cos yer black," growls the other.

During Herriman's four years at the *Examiner*, race anxiety bled through every section of the newspaper. On November 3, 1907, the *Examiner* published a Sunday feature covering a medical fad of the day. Under the title "Can the Negro's Skin Be Made White?" the story began, "Ever since the negro was emancipated from slavery it has been the dream of the race to change their color." To this end, it reported, scientists had been submitting blacks to a barrage of X-rays. Other *Examiner* articles exposed citizens who, like the Herrimans, attempted other means to become white. The discovery that a person was racially passing was treated as a front-page scandal.

It was during this nervous time that Jack Johnson strode into full public view. If the victory of the lightweight Gans kept the color-line controversy simmering, the heavyweight Johnson—a massive, cultured, audacious, and gifted fighter then regarded as "the most hated man in white America"—blew off the lid.

John Arthur Johnson was born in Galveston, Texas, in 1878; his parents were former slaves. Tad Dorgan first took notice of Johnson in 1901 and remained a lifelong supporter. "It was his easy-going manner in the ring that fooled many," Dorgan wrote admiringly in his introduction to Johnson's memoirs. "He smiled and kidded in the clinches and many thought he was careless, but all the time he held his opponent safe, knew every move the other made and was at all times the boss of the job."

It's likely that Herriman met Johnson during one of the fighter's

many visits to the *Examiner* offices. Had they compared their early careers, the two men would have noticed several similarities. They were born two years and four hundred miles apart from each other. Both men spent an early childhood in a thriving southern coastal town, and both followed a singular talent to reach New York by the turn of the century. Both achieved professional success and both married white women. Johnson, however, was as ostentatious as Herriman was modest, as self-promoting as Herriman was self-effacing. While Herriman and his family quietly labored to build their lives in white America, Johnson swung his fists across the color line, ultimately at great personal cost.

Johnson began to regularly appear in Herriman's cartoons in summer 1907. The Hearst writers all agreed that Johnson was, as Van Loan wrote, "unquestionably the greatest heavyweight left in the game." Yet Tommy Burns, then the white champion, was clinging to the color line to avoid a fight. In early 1908 Herriman and Van Loan teamed up to cast the story in a metaphor of a ship called *Fistiana*. Van Loan wrote that the ship passengers were ignoring the cries of "several smoked gentlemen of the Ethiopian race." In Herriman's cartoon, the white fighters sail on past Johnson, Gans, and others, who have all crashed on rocks marked "color line." A song rises from the passing ship: "Oh, the lily-white champs are we."

In August, Johnson was traveling Europe to attend Burns's fights and mock him from ringside. "The patient lump of chocolate-covered disturbance has all but given up hope of cornering Tommy Burns," Beanie Walker reported.

Herriman and Walker mercilessly taunted Burns throughout the fall. Then, on December 26, 1908, Johnson and Burns finally entered the ring in Sydney, Australia. They lasted fourteen rounds. Johnson leered and laughed in the heavyweight champion's face, the *Examiner* reported, and at one point suggested he "get a hammer." Finally, he rained a series of punishing blows

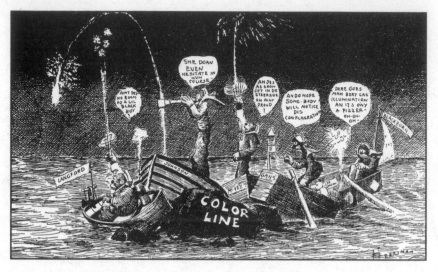

From *Distress Indeed in the Dusky Fleet!!!*, *Los Angeles Examiner*, January 26, 1908

on Burns until the police finally stepped in to halt the fight. The unthinkable had occurred: a black man had become the new heavyweight champion of the world.

In Los Angeles, the *Examiner* staff had gathered at the office to follow the match via telegraph. They were joined at the newspaper by former heavyweight champion Jim Jeffries, who bitterly disparaged Burns for crossing the color line. "Burns has sold his pride, the pride of the Caucasian race," Jeffries wrote in the *Examiner*.

Not everyone agreed. "Thousands Cheer Black Victor; Negro Borne Triumphantly on the Shoulders of Seconds While Man He Defeated Sobs in Ring," the *Examiner* reported. Herriman's cartoon capped the day's sports page, borrowing ideas from minstrel shows to strike a note of victory. Johnson is seen as a triumphant Zip Coon, smoking a twenty-five-cent cigar and painting the crown black. In the cartoon, Johnson calls himself "Chawles Dana Gibjohnson," referring to the dandy cartoonist whose Gibson Girl, like Johnson himself, had become a national icon.

The cries for a black-white "Battle of the Century" grew louder, with novelist Jack London leading the charge for Jim Jeffries to come out of retirement. "Jeffries must emerge from his alfalfa farm and remove that smile from Johnson's face. Jeff, it's up to you," wrote London in the *New York Herald*.

In the eyes of many whites, Johnson had become a minstrel monstrosity. During fights, Johnson slyly mimicked minstrel shows to stoke white fears, speaking in dialect and even cakewalking, then outrageously referring to himself as the "master" of inferior fighters. He went even further in his private life, courting both white fear and white women. Among those who applauded Johnson's success was black minstrel performer Bert Williams, who raised $100,000 to back Johnson against Jeffries or any other white boxer.

Hearst's sportswriters and cartoonists played leading roles in the developing national minstrel show. Some of Herriman's cartoons during this time don't rise above boilerplate gags, such as a panel that showed Johnson in a watermelon patch. Yet, the more that white cries for Jeffries to revenge the race grew louder, the more Herriman started to lace his cartoons with the types of bitter ironies once seen in his comic *Musical Mose*. Among these was a caricature that ran in the *Examiner* on January 5, 1909, appearing later in other Hearst papers. Titled *A Barnyard Study in Black and White* (a title later to be echoed in a memorable *Krazy Kat* strip), the cartoon shows Johnson as a plantation overlord, puffing on a cigar as he strolls past the "pugilistic barnyard." Gooseberry Sprig stands nearby, commenting, "I draw the color line myself." The cartoon included a sardonic essay written by Herriman:

> En masse, they have emerged from their coops and let out a loud, patriotic howl about rescuing the "title of titles" from the possession of a black man. . . .
>
> All the while the surface of the sea of swat lay bland, placid

and unrippled. Now the Galvestonian comes back with the prime prize, and the tombs resound with challenges from every pugilistic mummy since the deluge.

The country reverberates with the brave cry of "the title must come back to the Caucasian." . . . They clang their tin armor and puff their age worn breasts and acclaim themselves Davids ready to crack the dome of somber hued heavyweight Goliath to bring back our fair title to its home.

On April 21, 1909, the *Examiner* finally could announce on its front page that "Jeff Says He Will Fight Negro for the Title." Reporting from New York, Charles Van Loan derided the Johnson-Burns "hugging match," saying that films from that fight show that Johnson's championship was built on a "miserably weak foundation." The next day in Los Angeles, Beanie Walker saw it differently. Johnson controlled the fight from the start, he said. "In his mauling of Burns the negro reminds me of a big, fat, sleek cat toying with a wounded rat that is crazed just enough by its injuries to try to fight back," Walker wrote.

Herriman also began turning to cat metaphors, as in an August 29 cartoon titled *The Heavyweight Situation* that showed Johnson as a striped cat stuck on the top of the "Tree de Champion." In his cartoons about boxing's color line, Herriman exhibited the sustained outrage that was lacking in his political works. Later that year, on Tuesday, December 21, 1909, he published a comic strip that pointedly mocked the hypocrisy of those who harbored great white hopes. Titled *Three Can Put Up an Argument Better Than Two*, the story opens with a pair of Sports puffing on cigars and discussing the Jeffries-Johnson fight, soberly assessing Jeffries's slim chances. Then they are joined by a one-man minstrel show: a black man with a bowler, plaid suit, spats, and a face that, notably, resembles the visage that Herriman will soon start to use for black cats. When the interloper chimes

in about Jeffries and Johnson, the Sports pummel him with cries of "unbleached" and "pigeon faced." As the man receives his beating, he looks to the reader as if to share a private understanding of the absurdity of it all.

Again and again Herriman explicitly portrayed the boxing controversy as a minstrel show. In late January 1910—just as Herriman was preparing for his own minstrel performance in the Los Angeles benefit—he drew *Speaking of the "Color Line,"* which taunted cow-

From *The Cat Came Back, Los Angeles Examiner,* March 19, 1910

ardly white boxers who refused to face black opponents. In one panel he portrayed black Canadian boxer Sam Langford in the minstrel garb of plaid pants, top hat, and a cane. Behind him was the white boxer Fireman Jim Flynn heating cork to blacken up for his turn in the show.

Before the controversial Johnson-Jeffries match, Langford and Flynn were scheduled to face each other in a less-publicized series of bouts on the color line. These fights took place in Los Angeles in February and March 1910, and Herriman followed them closely, even visiting Langford's training camp. In his Langford comics, Herriman more fully developed his idea of caricaturing black boxers as cats. When Flynn surprised fans by winning a decision over Langford at Naud Pavilion, Herriman drew a comic of Flynn tracking and capturing a scrawny black cat. Next up was a bout at Pacific Athletic Club. Herriman anticipated the fight in a strip titled *Look Out! He's Not Tamed Yet*, in which the cat, much larger in size, bursts through the cage. The cat's face has now become oval shaped, with a white face; it is a template for the earliest version of Krazy Kat.

Herriman's prediction came true: at Pacific Athletic Club, Langford leveled Flynn in the eighth round. Langford battled with a "savage delight that is animal-like in its fury. Mercy and pity have no place in his glistening black chest," wrote Beanie Walker. Herriman's comic, titled *The Cat Came Back*, begins with Flynn banishing the cat from a club marked "The Lily White Inn." The cat then returns, demanding his rightful reentrance.

Herriman, like the rest of the *Examiner* staff, knew Jim Jeffries well. Jeffries frequently visited the newspaper, and Herriman visited Jeffries at his various businesses, including a 1908 trip to Jeffries's office, in which Herriman had asked him about the chance he'd ever fight again. The question, Herriman wrote, made Jeffries as "pettish

as a bull pup just after the usual amputation of his caudal appendix." Herriman then quoted Jeffries's heated response to him:

> Every time a sporting editor gets a flash of intelligence he marathons it over here, smokes half a dozen of my best fuses, engulfs a few gin rickeys, fills up on free lunch, all the time telling me that something great is about to break.
>
> Finally, when he gets all primed and his great gleam gets too bright for him to hold, he comes at me with: "On the level, Jeff, ARE you going to fight again?" Sa-ay, heaven forbid that I ever hit a journalist.

Even if the Hearst men weren't fooled by the pro-Jeffries hysteria coming from Jack London and others, they still did their part to stoke interest in the fight. Beanie Walker joined Jim Jeffries when the challenger arrived in Los Angeles in late February 1910, and they drove off together to Oakland to discuss proposed referees. (Arthur Conan Doyle and Booker T. Washington had declined.) In March, Herriman joined a crowd on the streets to watch a parade starring Jeffries. By this time he had begun frequently caricaturing the white boxer as a female. In an April cartoon set at Jeffries's wilderness training camp at Hotel Rowardennan, Jeffries's trainers and sparring partners are recast as ladies of the lake. Jeffries is Narcissus in drag, dressed in a polka-dotted gown and staring into a pool of water.

Also in April, Herriman was on hand to witness the excitement surrounding a visit by Jack Johnson to Los Angeles. He caricatured the porters, janitors, elevator men, and bootblacks who closed down their posts to line the train tracks to greet the champion. Johnson made the rounds in Los Angeles, even posing on an ostrich and calling him "a friend from Africa." When he staged a short exhibition bout at the Pacific Athletic Club, he faced a jeering crowd of whites. Walker wrote with admiration of Johnson's response: "In the begin-

From *Isn't It the Truth?*, *Los Angeles Examiner*, May 13, 1910

ning the low-brow element in the galleries attempted to hoot and howl the big black down, but he quieted them with a slow, dignified roast as follows: 'I have found that a hobo is a hobo, and a ruffian is a ruffian, no matter where you put him.' Jack had the hall to himself after this thrust."

Herriman followed with a cartoon that showed a black mother promising her child that someday he'll be a "great man like 'Jack Johnson' am today."

In the month of May alone, Herriman contributed a full fifteen cartoons covering the upcoming fight, many picked up by Hearst newspapers across the country. Along with cats, he debuted what would become another favorite metaphor for race:

coffee. The cartoon *Bring on the Large Black* depicts a morning at "Cafe Fistiana," with Jeffries leaning back in his chair, ordering a "large black." "Large black, coming up—" promises a chef labeled "TIME."

In June, with the proposed fight just a month away, California governor James Gillett banned the event from his state. The ring death of San Francisco boxer Tommy McCarthy had reignited public opposition to boxing, and Gillett worried that the state would lose its bid for an upcoming World's Fair. Plus, the governor said, he was certain that Johnson was getting paid to take a dive.

Promoters hurried the event to Reno, Nevada, chosen for being on a rail line as well as for its notorious absence of civic morals. (The Nevada governor was said to be "prayerproof.") Hearst also sprang into action, sending his writers and cartoonists to the boxers' training camps. Van Loan joined Jeffries at Rowardennan, and Tad Dorgan reported from Johnson's camp in Ocean Beach. Dorgan's deep respect for Johnson is evident in a cartoon that cast Johnson as the rightful heir of boxing greats: "Johnson tears off 12 miles a day . . . along the same roads that Tom Sharkey and Terry McGovern trod when they were boxing here in their palmy days."

Meanwhile, Herriman's Jeffries-Johnson cartoons grew even more elaborate. One day a black hen considers a plunge into "Ye Lily-White Sea." On another a circus performer named "La Senorita de Jeff," attired in a wide, polka-dotted skirt and low-cut blouse, is set to ride a prancing black stallion straight from the "wilds of Galveston." For the Sunday, June 12, edition of the *Examiner*, Herriman contributed a pantomime showing a pair of Sports—one white, one black—silently watching as a blind man tosses a coin in the air. The personification of fate would prove to be appropriate, as the cartoon, titled *Black or White—Which?*, would be Herriman's final work as an *Examiner* staff artist.

With the Battle of the Century drawing near, Hearst's men scrambled across the country to take their positions. Tad Dorgan, already in California at Jack Johnson's camp, now boarded Jim Jeffries's train car from San Francisco to Reno, joining a rolling pinochle party that also included boxing legend Gentleman Jim Corbett and famed minstrel performer Eddie Leonard. Dorgan arrived in Reno just in time to see Johnson hop off the afternoon *Overland Limited* on Friday, June 24. "It was a great crowd that looked Mr. Johnson over," he reported. "They were on top of the railroad station, all the way up to the top on the telegraph poles, and as thick as sardines on the fire escapes of the hotels."

Also in Reno to cover the fight was Jimmy Swinnerton: "The thousands who have laughed at Mr. Swinnerton's 'Jimmie' cartoons will want to see his impression of the funny side of the fight," Hearst newspapers promised. Bud Fisher was there too. In fact, nearly every colleague and friend of Herriman would be at the fight, including Charles Van Loan and Beanie Walker.

George Herriman, however, received other orders. The *New York Evening Journal* needed someone to cover the home front, and Hearst called him east. The details of Herriman's first cross-country train trip to New York—which he'd taken ten years earlier—might be elusive, but Herriman had come a long way since then. This journey was announced in a large cartoon and article in the *Evening Journal*'s June 14 issue, titled *As George Herriman Came East—What He Saw*.

"He was just getting ready to see the fight when the sporting editor yanked him here—tears," reported the *Evening Journal*. Herriman wrote with some detail about his cross-country train trip to "the big village in the shadow of the Metropolitan Tower." As he traveled the country, Herriman saw firsthand the nation's preoccupation with the Jeffries-Johnson fight. The trip, in fact, proved to be "a thirty-six-hundred-mile conversation" about the Battle of the Century:

The smoking car was the scene of many a hot controversy, sometimes requiring the help of the train crew to separate the controversers. While we were crossing the rather warm Colorado desert a fat man in upper number one held a levee with a deaf gent in lower thirteen as to moral propinquities of the big fight. The fat man was running well ahead of his ticket when the train hit a sharp curve and he rolled out of his bunk. The deaf man, thinking the debate still on, held loud talk with himself until breakfast time.

It is with much envy the east-bound tourists view the passing of a west-bound train. They hang out of the windows and gaze with sad and wistful eyes at the merry ones hitting the grit toward the sunset. . . .

At every water tank in Kansas you'll find a delegation of corn rustlers waiting for the train from the West to get the latest news from the camps.

Iowa farmers camp at the station to glean the last reports.

In Illinois, Indiana and Ohio the rurals are pestering everybody who rides through from California about how good Jeff's wind is, and has the big smoke got as much fire under him as reports indicate.

Well, it is an interest wide as the American continent.

Being summoned to New York was a clear sign of Herriman's growing importance to Hearst. Yet Herriman seemed far from enthusiastic about leaving California. A self-portrait shows him standing on the back of a caboose, weeping as the sun sets into the Sierras.

There are no scenes of Herriman's wife or daughters in *As George Herriman Came East—What He Saw*. Most likely, he traveled alone. Making matters even worse, he was heading into a New York

heat wave. "Hottest and Longest Day of the Year Drives Many Insane," reported the *Examiner* the next week, noting that the thermometer stayed at eighty degrees at midnight, and ten thousand people were sleeping on the sand at Coney Island. Herriman found temporary residence in a new apartment located on the same block of West Ninety-Fifth Street where he and Mabel had previously lived just a few years earlier, back when Herriman was bouncing between newspapers and selling *Lariat Pete* to the syndicates.

With Dorgan and the rest of Hearst's staff filing reports from the front lines in Reno, Herriman dedicated his cartoons to the growing national hysteria. In *What Do YOU Think About It?* suffragettes, spiritualists, astronomers, and kindergarteners are all equally preoccupied by the fight. In *Popular Education*, Herriman suggests how the fight is transforming schools across the country, with one student reciting that the United States' new capital is Reno, another declaiming that "great scientists predict that the white man will resume his burden in about the 15th round," and another saying that the imaginary line dividing the earth isn't the equator, it's the color line.

Meanwhile in Reno, hotels were all filled to capacity, with overflow beds in local funeral parlors. Reno, Beanie Walker wrote, is a "riotous carnival of excitement."

The carnival atmosphere would end, however, as soon as the fight began.

Americans—at least those who read the newspapers—had good reason to expect Jeffries to win. Most reporters had followed Jack London's lead, deluding themselves about the viability of Jim Jeffries, a man who had most recently been tending saloons and an alfalfa farm, packing what Herriman termed "a few strips of bacon" around his girth. Only readers of Hearst's papers would have known better. For weeks Herriman had been expertly lancing white hysteria, and on fight day Tad Dorgan staked his sizable reputation on the results. "In my opinion Jim Jeffries is through," he stated before the first blow

landed. "The public is just beginning to see that this black man is a great fighter. He was held down for years on account of his color."

The bout was set for forty-five rounds beneath a blazing Nevada sun. Movie cameras whirred, with films of the fight expected to later tour the country. Both Jeffries and Johnson had shrewdly sold their shares of movie proceeds, well aware that a film of a Johnson victory would be next to worthless. The day of the fight, Jeffries penned a portentous article in the Hearst newspapers. "A whole lot has been said about what would happen to Jack Johnson, if he beat me," he wrote. "They have pictured the negro as being shot, hanged or mobbed in case he won. Here is where I go on record strong. I would consider any move to intimidate Johnson as cowardly and a disgrace to the American spirit of fair play."

It was all over by the fifteenth round. After a barrage of hits, Jeffries stumbled, then collapsed. Johnson, his hands on his hips, appraised the fallen man. Jeffries started to rise, then Johnson's left hook sent him sprawling backward over the ropes. "I guess people will begin to believe that I am some fighter now," Johnson wrote the next day in the Hearst papers.

The day belonged to Johnson. Throughout the fight, he bantered with ringside fans and taunted Jim Corbett in Jeffries's corner. When he overheard Hearst reporter W. W. Naughton dictating, "Jeffries took a left hook to the jaw," he struck Jeffries even harder, calling out, "Is that all he took, Mr. Naughton?" In Jimmy Swinnerton's *Sam* comics, a black man laughs uproariously at white foibles and is beaten down for his impudence. But Jack Johnson could not be beaten, at least not in the ring on this hot, desert afternoon. Reported Jack London in anguish, "The man of summer temperament smiled and smiled."

The next day the *Evening Journal* published an array of cartoons, each one examining the fight from a different perspective. Robert Carter somberly drew a defeated Jim Jeffries. Tad Dorgan contributed

a series of respectful portraits of "Jack Johnson Before, During, and After the Battle." But the lead sports page belonged to Herriman. Between single-column articles—one penned by Johnson and the other by Jeffries—appeared his massive pen-and-ink minstrel show titled *Uncle Tom's Cabin—1910*. It is a fantasy of racial revenge: a grinning, long-limbed Uncle Tom knocks out a tiny Simon Legree. "Times hab changed Simon," gloats Tom.

S lap a coat of whitewash over Jack Johnson and he would be the most popular heavyweight champion we have ever had," Beanie Walker heard someone say in Reno, just a few hours after the bout.

Yet Johnson's victory could not be whitewashed. Immediately following the fight, race riots broke out across the country. "Negroes formed the greater number of those who were victims of the outbreaks," the *Los Angeles Examiner* reported. "They were set upon by whites and killed or wounded because of cheers for Johnson's victory." One celebrating man had his throat slit. There were threats of lynching in New Orleans. In New York, whites set fire to a tenement occupied by blacks. Reported the *Examiner*: "The irritation caused by the defeat of Jeffries at the hands of the negro caused scores of street fights, negro hunts through the streets and outbreaks all through the night."

The Hearst papers—which had devoted countless pages to stoking bloodlust for the battle—quickly turned anti-boxing. The *Evening Journal*, insisting that it had "protested against the fight from the beginning," now declared on its editorial page, "That Prize Fight Was Disgraceful, Demoralizing, Harmful." The battle between Jeffries and Johnson, it charged, was "a pitiful exhibition of degradation and cruelty. A white man, made nervous, weak and incompetent by drink and debauchery, stood in the ring to be hammered down and finally defeated by a powerful young negro."

Of most immediate concern were fight films that had been sched-
uled for screenings across the country. Cities from New York to New
Orleans to Los Angeles all tried to ban the film. "Hearst Papers in
Nation Wide War to Effect Suppression of All Fight Pictures," the
Examiner reported on its front page, adding that Hearst personally
exhorted more than fifty thousand men of influence to join the anti-
film crusade.

Once again Hearst's cartoonists weren't exactly on board with
their boss's anti-boxing efforts. Robert Carter dutifully illustrated the
newspapers' editorials, contributing drawings as ponderous as Hearst
editor Arthur Brisbane's essays. A typical cartoon shows Uncle Sam
shielding children with one hand while destroying fight films with
another. But a few pages over, in the sports section, Tad Dorgan's
rascally characters Bunk and Silk Hat Harry were cheering at the
film. Dorgan even wrote a detailed review, calling the films "the best
pictures ever shown here, and that's saying a great deal."

In what would be one of his final sports cartoons for the *Evening
Journal*, published on July 13 and titled *Moving Picture Owners Have
Their Troubles, Eh?*, Herriman offered his solution. Black and white
men are sitting together in a theater, all happily regarding the screen
through large eyeglasses. A plaid-suited salesman walks through the
aisles. "Ere y'are, get yer transformation glasses," he calls out. "They
make black, white, and white, black—you can't see the show with out
'em." Added Herriman in a caption: "Anti-race-riot glasses—see the
show without losing your goat."

The fight over, Jeffries returned to retirement, where he nursed
his bitterness and claimed that he'd been poisoned. "Then there was
all that talk about me being the hope of the white race," Jeffries told
Beanie Walker. "The way this stuff was drilled into me every day was
enough to set a man crazy."

Three years after the fight in Reno, Johnson would fall to a low
blow in the courts, where zealous prosecutors used the Mann Act to

convict him for driving his white girlfriend across state lines. He fled the country and fought mostly lackluster bouts until finally losing the championship crown in 1915. Through it all, Tad Dorgan remained a friend and supporter. "He gave me credit for everything I did and although many men tried to split us apart, Tad always stuck to me," Johnson said.

Herriman gave up sports cartoons shortly after the fight. Years later, in a letter to their mutual friend and colleague Tom McNamara, Dorgan wrote, "I still think that George is one of the best sporting artists in the world, and can't understand why he doesn't do that sort of thing." Yet Herriman did offer one more nod to the fight and its aftermath. Shortly after arriving in New York, he launched a week-day comic strip titled *The Dingbat Family*, once more adding marginal scenes of tiny animals—especially a black cat, again named Kat. The *Dingbat Family* comic that appeared on Wednesday, July 6—just two days after the Jeffries-Johnson fight—featured a scene of Kat tangling with a white dog, who growls, "You don't seem to know who you're a shovin Kat do you?"

Nearly three weeks later, on Tuesday, July 26, *Evening Journal* readers opened their newspaper to see Kat joined by a new combatant, a tiny white mouse. In each panel the mouse creeps closer. Then, without provocation, the mouse picks up a tiny object, takes aim, and launches it at Kat's head.

It started wordlessly, a pantomime. The next day the mouse greets Kat with a hello and throws a champagne glass. The day after that, he knocks Kat's head with a pipe, saying, "Fool kat."

A new battle had begun.

PART III

COCONINO

CHAPTER 12

REVOLUTIONARIES AND DINGBATS

I n lower Manhattan near Park Row, on the corner of Rose and Duane Streets, the twelve-story Rhinelander Building stood on legendary ground. Here, a sugar and molasses warehouse had served as a prison for American patriots during the Revolutionary War. A single window remained from the old building. It was said you could see ghosts stretching their arms through the window's iron bars.

Even if the Rhinelander wasn't haunted, it had its troubles. A three-hundred-strong workforce wrote, drew, edited, and printed William Randolph Hearst's *American* and *Evening Journal* newspapers in the building, which Hearst took over after moving operations from the Tribune Building in 1905. They labored under conditions that one cartoonist compared, unfavorably, to the Bowery sweatshops that Hearst attacked in editorials. The cartoonists worked on the eighth floor. "Dante would have loved the purgatorial aspects of that region of the newspaper plant," writer Gene Fowler remembered. "Sometimes molten lead from the linotype pots seeped through crevices in the floor, turned into pellets of hot hail." It could be stifling in summer months. During one heat wave, Tad Dorgan collapsed at his desk.

Yet, the room that hailed molten lead also was home to some of the greatest cartooning talent in newspaper history. In the late 1930s, writer Boyden Sparkes interviewed George Herriman and several of

his Rhinelander colleagues for a planned biography of Hearst editor Arthur Brisbane. They recalled the old office with great fondness, spinning tales of drinking, gambling, and especially inventive techniques for shirking their duties.

The cartoonists were not men to inflate reputations; their job was to puncture. Accordingly, they told tales on each other, and on themselves. George McManus recalled how Winsor McCay would fool Brisbane into thinking he was working by seating an office boy at his desk and draping his purple coat over his shoulders. Another McCay trick was to leave his hat on his chair to convince Brisbane that he would be returning, then tug on a string and pull the hat out the door behind him.

One day Brisbane brought in a basket of peaches from his gentleman farm. "The boys ate all the peaches they wanted," said cartoonist Harry Hershfield, "and then . . . they dumped them out of the window to see who they could hit, and the fellow who came up with peaches all over him was Arty Brisbane, and never from then on did they receive peaches."

They worked in a filthy room stuffed with desks and tables. Old papers blanketed a safe in the corner, and the whitewashed walls were bare, save for a few tacked-on news clippings. Many mornings the floor was littered with old bottles of Bromo-Seltzer, left there by late-working illustrator Robert Carter. Panties hung in the windows instead of curtains. ("There is no fun in such things," Brisbane had objected. "No, the fun has been taken out of them," replied cartoonist T. E. Powers.)

Brisbane made for a perfect comic foil, a lofty intellectual who might show off by speaking Greek in the office. He also vigorously opposed all gambling and drinking. One favorite tale involved a Saturday afternoon craps game when Tad Dorgan looked up from the dice to see Brisbane looming over him as ponderously as the statue of George Washington at Federal Hall. Dorgan called Brisbane "Big George" from then on. "A lot of times there were things said about

Big George in a loud voice, and we certainly felt that Mr. Brisbane could hear it through the door, but Tad always figured that Big George wouldn't think it was him," Herriman remembered.

Brisbane had a prominent forehead with a shape that Dorgan's wife once compared to the Flatiron Building. This prompted another office nickname: Double-Dome. "Mr. Brisbane had two heads, that is, one back and one forward," Herriman said. "He had a funny-shaped head, but it was loaded.

"Mr. Brisbane took a lot of interest in that old department," Herriman recalled.

> He could come in through his room to Tad's and he would have a funny way of wearing his derby. . . . He either wore [it] on the front or in the back—he couldn't straddle both of them. We could tell by the way he came in—if it was on the back, he was full of ideas; on the front he was going through to the city man.
>
> Sometimes he would give Tad an idea, and Bud Fisher, and he would walk out. When he would come back, he would say, "You young men don't like the idea. Don't use them." And nobody ever did.

There was never any doubt that Tad Dorgan was, as *Popeye* cartoonist Elzie Crisler "E. C." Segar put it, the "spirit of the art department." Years later, when interviewed by Sparkes, Herriman still relished Dorgan's exploits. In one tale Dorgan had a pet cockroach named Lolo that would visit his desk. Then Lolo went missing. "And Tad came in and he said, 'Here's the old boy, in [cartoonist Frederick] Opper's dictionary.' . . . We said, 'Are you going to throw him out of the window?' 'No,' he said, 'give Lolo a burial.' [We] put him in the middle of the drawing board, drew pictures of it, went around the City Room singing dirges. . . . Finally we found a knot hole and buried him there, and offered good wishes."

A full two decades after moving back to California, Herriman could still identify the location of each cartoonist's desk: "Well, Tad had the room next to Brisbane; Hershfield sat to the left of the door; Gus Mager sat over to the right; I sat in front of Hershfield; Bud Fisher in front of me; Tom McNamara was in front of Mager.

"But we had no particular time to come in, although we showed up around half past nine or ten o'clock," Herriman said. "The idea was just to have your drawing turned in by afternoon, and that is all there was to it. . . . I think the men gathered around there more as a club, than the work. They just liked to be together."

Not long after arriving in New York, however, Herriman found his position in the club to be in jeopardy. Following the Jeffries-Johnson prizefight, he drew few sports or news cartoons. His worth to Hearst now depended on the success of his comic strips—and Herriman's record with strips was mixed. Works such as *Mr. Proones the Plunger*, *Baron Bean*, and *Mary's Home from College* never lasted beyond a few months. "I had started a lot of series that nobody had heard of, and nobody ever knows of them," Herriman later said.

His next bid was *The Dingbat Family*, which debuted on the *Evening Journal*'s editorial page on Tuesday, June 28, 1910. A top panel introduces the cast: Ma, Imogene, Cicero, Baby, and the paterfamilias, E. Pluribus Dingbat. The first gag has E. Pluribus receiving his pay envelope and, believing his family to be gone for the night, arranging for the delivery of chutney, roast goose salami, Camembert cheese, pickled herring, caviar, Brazil nuts, a porterhouse steak, and sausages. To his dismay, he arrives home to see his family at the dinner table, eager to dig in.

E. Pluribus soon emerges as a beleaguered husband, father, and employee. Automobile drivers run over his bicycle, fellow train passengers take his seat, and an artist tells him to beat it because he's

spoiling the landscape. Dingbat shakes his fist against all "ruffians and ignoramusers," yet is powerless to stop them.

The beleaguered husband was a stock comic character already seen in Gus Mager's *Henpecko the Monk* and George McManus's *The Newly-weds*. Herriman soon struggled to come up with new ideas that would set E. Pluribus apart. He cribbed gags from his earlier strips, assigning Cicero to perform stunts like Acrobatic Archie and Bud Smith, and having Imogene return home from college. Later, Herriman would disregard *The Dingbat Family* as he did his other early strips. "Just a man and a wife doing crazy things, like all the others, but nothing striking," he said. "I had made a lot of things before that. None of them ever stuck, but this one did. Why it ever did, I don't know."

From *The Family Upstairs*, July 26, 1910

But it did stick. E. Pluribus and his family would hang on for nearly six years, frequently illuminated by flashes of absurdist humor. One month after its debut—in the same strip in which mouse and Kat first did battle—Herriman introduced a new foil for the Dingbats. The story begins with the Dingbats getting splashed by upstairs neighbors watering the window plants. When E. Pluribus complains, a flower-pot drops on his head. After that, the strip, newly named *The Family Upstairs*, was propelled by E. Pluribus's increasingly outlandish efforts to thwart the unseen occupants of the upstairs Apartment 33 of the Sooptareen Arms. Dingbat tries it all, from painting a threatening "black hand" sign to loud flute playing. Nothing dislodges the neighbors, or even gets them to show their faces. Meanwhile, in the margins, Herriman's tiny Kat and mouse wage simpler battles: Kat shoots guns and cannons at the mouse, and the mouse responds in kind. In the strip published on Thursday, August 11, 1910, the mouse answers with a hundred-pound brick.

Still, Hearst's editors remained unenthusiastic. Then Herriman received an unexpected boost from Willie Carey, the newspaper's office boy.

"I was running *The Dingbat Family*, and Willie came to work and said that was a funny picture," Herriman recalled. "He said, 'I don't mean the Dingbat picture, but I mean that Kat and mouse.'

"So I made him another one. And every day Willie would supply me with an idea. Finally Mr. Brisbane said, 'Take the Kat and mouse from the Dingbats, and use it; make an extra strip.'"

On Monday, August 15, Herriman moved his sideshow into a tiny series of horizontal panels, positioning them beneath the Dingbat family stories. The story that day concerns a battle between kittens and baby mice, and concludes with one mouse muttering, for the first time, "Krazy Kat."

Even after Krazy Kat's debut, Herriman's job was not secure. While his wife, Mabel, and his daughters, Toots and Bobbie, apparently re-

From *The Family Upstairs*, August 15, 1910

mained in Los Angeles, he worked under only a six-month contract with the *Evening Journal*. At year's end, he was summoned to the office of Hearst's business manager, Solomon Carvalho.

Carvalho cut a striking figure, with a pointed beard and a limp that Herriman said came from a wooden leg. A decade earlier Hearst had acquired Carvalho on one of his raids on Joseph Pulitzer's workforce, then steadily promoted him to eventually become general manager of his newspapers. Workers recall him as severe. Even Arthur Brisbane called him "Iago." "He collected rare old china, and also grudges," writer Gene Fowler remembered.

Carvalho was married with two daughters, a detail that would prove to be crucial to Herriman's future. "About six months later my contract was over, and I had to face the big boss, Carvalho," Herriman recalled. "He said, 'You know, we were going to let you go.' I said, 'I expected it.' From year to year I was always coming in and going out. I was going to bow out, but he called me back and said, 'My little daughters Chu-Chu and Fi-Fi like that cat that you make.' So he said, 'I am going to keep you.'"

Herriman added that he never met Chu-Chu and Fi-Fi, but he was grateful to them for saving his career.

B y the end of 1910, Herriman was working to bring his Kat-and-mouse sideshow into the center ring. He set off his newest comic with a title panel that might in turns be poetic ("In the shadows of a great city behold") or philosophical ("Shifting the scenes on the stage of life we pass wearily on"), or it might draw directly from the interlocutor's command in minstrel shows ("Gentlemen!! Be seated clack clack."). He tried out alternate names for his lead character, including "Krummy Kat" and "Knutty Kat," but settled on "Krazy Kat." He hadn't yet decided on a name for his antagonist, when inspiration walked through the Rhinelander door.

Recalled cartoonist Ed Wheelan: "Several of us were in the Art Department of the *New York Journal* one afternoon when in breezed Harry Hershfield, famous *Abie the Agent* cartoonist, with a tale about a trip to Coney Island with some fellows, including a real character named Ignatz who had a never-ending fund of funny stories. Harry kept on talking about Ignatz, telling many of the man's Yiddish dialect stories until he had us all in stitches. George Herriman was taking it all in with intense interest."

Herriman began tagging the name "Ignatz" to various characters in the Dingbat stories, including a janitor, bullfighter, and weight-

lifter, as well as a dog he named Ignotts. Then, in the strip published on Friday, December 30, Herriman gave the Dingbats a day off. *The Family Upstairs—They Are Resting To-Day, but the Krazy Kat Is on the Job* is an eight-panel New Year's resolution by the newly named Ignatz Mouse, identified here as "a soldierly gentleman who has undertaken the monumental task of liberating the entire rodent kingdom from the rule of the despotic 'kats.'" A wanted poster shows Krazy Kat with the caption, "This is the unfortunate individual Mr. Ignatz Mouse has picked out to soak daily with a brick during A.D. 1911."

By year's end, Herriman has set his primary action—Ignatz throwing a brick at Krazy Kat—into its perpetual motion. Gooseberry Sprig and a still-unnamed pup have joined the cast. Even more remarkably, Herriman already has introduced an odd ambiguity regarding his main character—an ambiguity that, over time, would vex some readers while being celebrated by others.

"No one, not even Herriman, knew whether Krazy was a her, a him or an it," Ed Wheelan said. In fact, nearly from the start Herriman employed both "he" and "she" to refer to his Kat. It was no mere accident of pronouns, for Herriman wove this ambiguity into his story lines. In some early strips, Krazy and Ignatz are romantic rivals for a hen or a showgirl. On other days, a romantic interest grows between Kat and mouse. In one episode Ignatz gets drunk on claret and flirts with the "Kute Lil Kat." In another, published on Wednesday, December 20, 1911, Ignatz has fallen asleep and is dreaming of his foe:

> **KRAZY:** Why are you sore at poor little me?
> **IGNATZ:** I ain't sore Kat—I like you—
> **KRAZY:** You dear little angel

It is the first utterance of "Li'l Anjil," Krazy's pet name for Ignatz.

From the start, Herriman also allegorized race in his all-animal stories, bringing back the mistaken-identity themes of *Musical Mose*

with new twists. Now, instead of the mob uncovering Mose, Ignatz discovers that a hypnotist, cop, or society lady is really Krazy Kat. Herriman made no secret of his intentions in an episode set in a train car, in which a porter, depicted as a black crow and speaking in dialect, kicks Ignatz from a room, saying that a rich man "got dis berth." Ignatz mutters "Krazy Koon" at the porter. Then Ignatz sees the rich man is really Krazy Kat, and tosses the pretender off the train.

Other strips also refer to race, including an unusual three-day series that begins with Ignatz rushing to grab an iron, a stick, and some string, then ironing Krazy's tail. Krazy howls in pain and, puzzled, looks at the now-straightened and bound appendage. "Now Kat," Ignatz says, "you look kute." At the time of the series, Madam C. J. Walker, a black Louisiana native, was well on her way to becoming the first female millionaire by offering a line of hair-care products for black women, which included techniques for hair straightening. The series was the first of many *Krazy Kat* comics to use Krazy's crooked tail as a stand-in for kinky hair.

Herriman followed this series with another overtly racial gag: a single-panel cartoon titled *1911 Resolutions* that showed how "Krazy Kat starts the New Year by consulting the eminent phrenologist, Professor Ignatz Mouse." Phrenology—also lampooned in song by Bert Williams in "The Phrenologist Coon"—sought to link skull shape to intelligence and personality. By the early twentieth century it was a discredited pseudoscience, even if its language, such as "highbrow" and "lowbrow," remained in currency. In Herriman's panel, Ignatz would not be denied. "It is—the finest konk to peg a dornick at Ive ever witnessed," he says, peering at Krazy's skull.

Before long, Herriman started hearing from the first fans of *Krazy Kat*. "You have no conception, Mr. Herriman, how much your Krazy Kat series in the *New York Journal* means to me," wrote a

Delaware woman in early 1911. "Not only do they afford me inno-cent merriment, but they cheer the dull life of an invalid mother." The fan then added a special request: "Would it be a bother if I should ask you to send me a wee original of the sophisticated mouse with the word 'Phoowy' issuing from his mouth?" Herriman obliged.

Herriman received another fan request that year. "In 1911, I got a letter from a man named Van Hook, from Princeton, Indiana," Herriman recalled. "He said, 'I am about to be married, but I can't do that until I get one of your infernal drawings. The girl I am going to marry likes those Krazy Kats that you draw, and said that I must get an original from you before she said, 'Yes.' And he said, 'For goodness sake, help a man out, and send this girl a Krazy Kat, and let me get married.' And I did, and I wrote him a little note. A few months later I got a big box of oranges from Florida: 'This is from Van Hook—we are still enjoying our honeymoon. Here's a present for helping me get the girl.'"

In April, the *Evening Journal* moved Herriman's comics from the sports section to its "Magazine Page," where *The Family Upstairs* and *Krazy Kat* appeared alongside a serialized novel by H. G. Wells. Herriman introduced new characters to his cast: a gang of noisy Mexican revolutionaries. These seemed to be inspired by Herriman's evenings at Joel's Bohemian Refreshery, a unique all-night dining and drinking establishment near Times Square. At Joel's, cartoons decorated the walls, and the menu included Herriman's favorite meal of chili con carne. A *New York Times* profile listed Joel's clientele: musicians, artists, newspapermen, and Mexican revolutionaries. Regulars included Herriman's old friend Roy McCardell and cartoonist Carlo de Fornaro, another former *World* colleague.

Proprietor Joel Rinaldo was a self-styled intellectual. As tango dancers strutted around him, he would recite from his own work *Rinaldo's Polygeneric Theory*, a refutation of Darwin. In *Krazy Kat* on May 18, 1911, Herriman paid direct homage to Rinaldo as well as

riffed on the racial implications of evolution. In Herriman's story, Ignatz comes across Krazy, who is reading a book titled *Darwin Theory* and marveling how kats and mice are related. Ignatz brandishes a book of his own:

> IGNATZ: This book, "Kat," is my old pal Rinaldo's "Polygeneric Theory." *He* says that Darwin is a rhummy and that you kats were always kats and we mouses always mouses, so you see we're not related, I said you see it don't you?—
>
> KRAZY: Why so it does, doesn't it—
>
> IGNATZ (throwing the book): Krazy Kat
>
> KRAZY: Oh dear, I'm so disappointed in Mr. Darwin's theory

Herriman found new ways to bring Krazy Kat and Ignatz to center stage. In July he sent the Dingbats on a two-week vacation, replacing them temporarily with *Krazy Kat and Ignatz*. On the first of August, the newly christened Mr. B. Pup (not yet an officer) launched his lifelong mission of thwarting Ignatz. That same month Herriman showed Krazy tearfully wailing, "Here it is pretty near the last picture and 'Ignatz' hasn't soaked me with a brick yet." In the final panel Ignatz finally flings the brick. "Hoo-roar," celebrates Krazy, "now I'm a heppy, heppy 'kat.'"

In less than a year, Herriman had transformed Ignatz's assault on Krazy Kat into something far removed from the Jeffries-Johnson prizefight. Now Krazy received Ignatz's bricks as love letters. The "heppy" line also pointed the way to the future "hep" language of jazz; a quarter century later bandleader Cab Calloway would define "hepcat" as a "guy who . . . understands jive." In fact, Krazy Kat's association with jazz was already evident in these early years: in 1911, composer and publisher Ben Ritchie released his new instrumental, "Krazy Kat Rag," with Herriman contributing a drawing of Krazy Kat and Ignatz for the cover of the sheet music.

From *The Family Upstairs*, December 14, 1911

One of the odder indications of Herriman's growing popularity came when wealthy Colonel John Jacob Astor named his favorite Airedale terrier Ignatz. Herriman acknowledged the namesake in a strip that ran on August 18, 1911, shortly before Astor's much-publicized wedding. In it, Ignatz fumes: "That's just like those millionaires, they glom every thing in sight and reach out for more." Following the wedding, Astor and his new wife took an extended trip abroad that was cut short when she discovered she was pregnant. Fatefully, they boarded the *Titanic* for home. The Astors were accompanied by their dogs; presumably, their Ignatz perished in the ocean.

Fan letters, ragtime tunes, and millionaires' pets must have convinced Herriman that his job at the *Evening Journal* had grown more secure, for in late 1911 or early 1912 he sent for his wife, Mabel, to join him in New York. Their two daughters, Toots and

Bobbie, apparently made the trip east, along with Florence Harkey, a twenty-two-year-old farmer's daughter from Illinois who now was in the Herrimans' employ.

The Herrimans moved to a new home in the recently built six-story Onondaga Apartments, located in Washington Heights on the corner of Riverside Drive and 152nd Street. The Onondaga was advertised as a modern building, with six families occupying each floor; it was a step up from Herriman's previous residence, even if it was a more modest address than the Upper West Side apartments of other Hearst newspapermen, including Herriman's friend Damon Runyon.

"This is our address now," wrote Herriman on September 8, 1911, drawing an arrow that pointed to the Onondaga letterhead. The letter was to Homer Lea, an author and adventurer who, by 1911, had become a military adviser to the Chinese revolutionary leader Dr. Sun Yat-sen. Herriman's letter is the only remaining document in what appears to have been a series of exchanges between the two remarkable men.

Herriman had met Lea in Los Angeles. They shared numerous friends, including Charles Van Loan, Beanie Walker, and Harry Carr. Herriman and Lea also shared a love for the works of the Persian poet Omar Khayyám and, apparently from the letter, the product of the Los Angeles–based brewery Maier & Zobelein. Each also was a thin man with health troubles. At the time of Herriman's letter, Lea had barely more than a year to live.

That summer Lea had been in New York to deliver a speech. He and his new wife departed to Wiesbaden, Germany, where Lea consulted a doctor about his failing eyesight. There are no surviving letters from Lea to Herriman, so we don't know if he discussed his role in the revolution in China. Herriman, for his part, avoided politics in his correspondence, just as he largely did in his comics. He mostly filled his letter with jokes about Van Loan, Germany, drinking, and what appears to be their favorite saloon in Los Angeles, tended by a man named Schneider.

Van Loan, called by Herriman "that corpulent hound of calamity," was the first of many targets. "I herewith hasten to comply with all the copyright laws of the universe, and give one 'Wan Loan' full credit for use of the personal pronoun, first person, singular number—each and every one forth with contained in this letter—" Herriman wrote.

Herriman then thanked Lea for his letters and their "effusive and eclative descriptions of your 'Rhine Expedition.'" Herriman clearly longed for travel, even though there are no records that he ever traveled overseas. "I felt as if I were with you, I'd like to see that dear Teutonic 'arroya' with the good old ruins of them there ancient German Baronial Bungalows around it—Yea, and I would e'en like to linger a while at Munich and joust with a few flagons of their justly famous Brew, I'm told that they are very liberal with it, and that the charges are mere nothing, and as for quality, it has Maier & Zobelein's looking pale and anaemic—"

In his only comment on Lea's revolutionary activities, Herriman employs an image straight from his new *Krazy Kat* stories. "If some day I hear of a prominent young Martian bouncing a siedel of hops off the Emperor's konk and giving said 'war lord' a few pointers on things Military, why I shall know that you have had 'wrastled' a few quarterns of Rhune wine—and these antics were but the ultimate consequences."

Herriman closed with a few notes about their mutual friends, complaining that Beanie Walker now ignores him and adding that Harry Carr sends him "Japanese comic papers." Frustratingly, Herriman offered no further details about those comic papers or what he might have thought of them.

One month after Herriman and Lea traded letters, the Wuchang Uprising sparked the overthrow of China's last imperial dynasty, leading to the eventual birth of the Republic of China. Sun Yat-sen was elected China's first president, and Lea expected to become the new army's chief of staff. However, Yat-sen soon resigned; Lea's health worsened and he returned to Los Angeles. He died at the end of the year.

I n *The Family Upstairs* on Wednesday, November 15, 1911, E. Pluribus and Mrs. Dingbat are quietly having dinner, when pieces of plaster begin to drop from the ceiling. They hide beneath the table as the roof caves in. Next, a worker stands over them, carrying a pickax. "The family wot used to live up here moved out yesterday," he said, "you'd better get out before I get to you." From the bottom of the rubble, the Dingbats cheer. The final panel shows a sign standing in front of an empty lot. It reads, "On this spot formerly the home of Mr. & Mrs. E. Pluribus Dingbat will be erected a two story department store."

It seemed to be the end of the Dingbats, or so Herriman might have thought. The next day a *Krazy Kat and Ignatz* strip stretched across the top of the page. Herriman, freed from the Sooptareen Arms, threw himself into his new strip. He forsook conventional panels for adventurous compositions filled with lush landscapes, and numbered his panels in German and French. He added a new character: a dog named Kelly who owned a brickyard.

Herriman added more comics with Krazy Kat when he joined Gus Mager and other cartoonists in covering a horse show in Madison Square Garden. But his break from the Dingbats was short lived, for on November 22, 1911, the family returned to the *Evening Journal*, albeit with a few changes. There is no more upstairs family. E. Pluribus had grown a beard during the break. The Dingbat children are now named Sapolia and Cicero, and there is now a college girl named Mary.

In the revised *Dingbat Family*, Herriman spoofed old friends by introducing characters named Beanie Waukup and Tubby Van Loon. He added dogs and cats to the Dingbat household, and made more frequent references to Yorba Linda in California and Coconino County in Arizona. Gags about Ma Dingbat and Mary's desire to employ household servants would soon be echoed by George McManus for

a new comic titled *Bringing Up Father*, about a sweepstakes-winning Irishman named Jiggs and his social-climbing wife, Maggie.

The definitive, wrecking-ball finish that Herriman had earlier given *The Family Upstairs* suggests that the Dingbat revival wasn't all the cartoonist's choice. His editors' need for the strip would become clear when readers opened the *Evening Journal* on Wednesday, January 31, 1912. Topping the newspaper's seventeenth page was Tad Dorgan's *Silk Hat Harry's Divorce Suit*. Immediately below it was *The Dingbat Family*, followed by the diminutive (and untitled) Krazy Kat and Ignatz strip. Below that was Harry Hershfield's cliffhanger adventure series *Desperate Desmond*, and then *Us Boys*, a Tom McNamara comic about sandlot children. There were no sports results on the page, nor editorials, nor serialized fiction. William Randolph Hearst had inaugurated his first daily comic page, and two of the five strips were by Herriman.

KAT DESCENDING A STAIRCASE

I n September 1912, just a little more than two years after he was summoned to New York, George Herriman was temporarily called back to Los Angeles. Coming home with his wife, Mabel, and two daughters, he was treated in the Hearst press as a returning celebrity. "George Herriman, the noted cartoonist, who is visiting his old home here after an absence of several years, marveled at the great changes Los Angeles has undergone from a commercial and financial standpoint," the *Evening Herald* reported on its front page. Next to a large photograph of the artist were drawings of Krazy Kat galloping over the Rocky Mountains and of Herriman himself leading the Dingbats out of New York. Sighs Minnie Dingbat, "I'll miss them giddy lights so much."

A brief article, written by Herriman, hit a nostalgic note: "The old town don't look the same. But not looking the same is a habit with this little pueblo. They're shooting across so many two million-dollar temples of commerce that it looks like a misdeal somewhere."

The Herrimans might have traveled west with Charles Van Loan, for that same month Beanie Walker reported in the *Examiner* that Van Loan was also in town. Walker packed his article with jokes about Van Loan's new fame in New York, comparing them to the old days when Van Loan would smoke bad cigarettes and associate with actors and boxers.

Herriman's return appears to have been connected to yet another Hearst newspaper acquisition. The current ownership of the *Evening Herald* had become a matter of debate, with some saying *Los Angeles Times* owner Harrison Gray Otis had purchased the newspaper. According to most histories, Hearst didn't acquire the *Evening Herald* until much later, eventually merging it with *Evening Express* in 1931. However, all one had to do was look at the funnies to see who was in charge. In 1911, the *Evening Herald* had announced the addition of "irresistible fun makers" such as Herriman, Harry Hershfield, Gus Mager, and Tom McNamara. Even more tellingly, the newspaper published a front-page article celebrating the seventieth birthday of William Randolph Hearst's mother, Phoebe Hearst. The *Evening Herald*, King Features head Moses Koenigsberg would later write, was "the most successful of Hearst's camouflaged deals."

One of the new *Evening Herald*'s first moves was to give top billing to Herriman, who apparently agreed to sign on, at least temporarily, as a staff artist. Front-page notices promised new boxing cartoons from Herriman, lauded as "one of the foremost cartoonists in the United States." In early October, former *Examiner* cartoonist Dan Leno, now with the *Evening Herald*, welcomed his old colleague with a cartoon of his own. "Dingbat, my hero, I'm going to like our new town," says Mrs. Dingbat, before she runs screaming in pain after her first taste of a chili pepper.

In November 1912 Herriman made a rare public appearance as the star of the *Evening Herald*'s presidential election coverage. The nation faced a three-way challenge for the White House between President William Howard Taft and hopefuls Theodore Roosevelt and Woodrow Wilson. The *Evening Herald* teamed with local utilities for a novel scheme: Wilson's victory would be signaled by two five-second power outages, Roosevelt's by three outages, and Taft's by four. For readers who went down to the newspaper's offices on Broadway between First and Second Streets, Herriman would "fur-

nish funny sketches between bulletins." Herriman's friend and colleague, cartoonist Ralph "Pinky" Springer, back in Los Angeles from Colorado, worked a second *Evening Herald* board at Casino Billiard Parlors on Spring Street.

By its own account, the *Evening Herald*'s plan was a great success, power outages and all. More than one hundred thousand citizens reportedly gathered at two bulletin boards. "George Herriman and Ralph Springer, The *Evening Herald*'s famous cartoonists, thoroughly amused the crowds with their cartoons and humorous sketches," reported the *Evening Herald*. "Cheer after cheer greeted the appearance of each bulletin while the cheers turned to hearty laughs when the cartoons, apropos to the results, were flashed."

Herriman might not have known it, but in Woodrow Wilson the country had just elected a new president with a taste for newspaper comics. The *Evening Journal* would publish a photograph of Wilson and his vice president, Thomas Marshall, sharing a laugh over a Tad Dorgan–style joke. Later in his presidency, Wilson developed a specific taste for *Krazy Kat*. Wrote Martin Sheridan in his 1942 book *Comics and Their Creators*: "During the first World War, when everyone turned to the comics for relief from distressing reports, the late President Wilson read Krazy Kat before entering his war cabinet meetings. Mr. Wilson's secretary, Joseph Tumulty, can vouch for this."

Herriman remained in Los Angeles at least until the end of the year. During this time *The Dingbat Family* and *Krazy Kat* reflected current California events, suggesting that he was completing his work at the *Evening Herald* office and sending it to New York. He also seems to have taken another sojourn to Arizona, for he began saturating the Dingbats' apartment in Navajo designs, and adding desert landscapes to *Krazy Kat*.

On special assignment from the *Evening Herald*, Herriman re-

turned to his old haunts in Vernon to cover a lightweight boxing match. His cartoon imagined a brawl between fans over the proper way to pronounce fighter Joe "Baker Boy" Mandot's last name. "A-ah, I tell you it's pronounced Man dot—like a man dotting a eye—" says one man, with the other insisting, "And I say it's mando as in mandoleen—you ball faced gazooni." It's easy to see why the gag appealed to Herriman, for Mandot was, like him, a French-speaking son of New Orleans.

Personally, Herriman's return to Los Angeles afforded him the first chance to join his family in grieving the loss of his mother, who had passed away the previous November. On Monday, November 6, 1911, Clara Herriman, just fifty-four years old, had died at home following a six-month illness. (For her death certificate, the family reported that both Clara and her parents were from France.) The Herrimans had held her funeral at St. Vincent's Church, but George was in New York and did not attend.

Herriman caught up on other family news. His sister, Ruby, had found work as a stenographer at the Mason Theatre; the *Los Angeles Times* noted that she "adjusted her hair to the latest mode" in anticipation of a visit by actor Wallace Munro. Henry Herriman worked as a plumber and still lived at home. Herriman's father, George Herriman Jr., had started going by his middle name, Gustave—perhaps to avoid being confused for his increasingly famous son.

Twenty-two years after first settling in Los Angeles, George Joseph Herriman had become the family's only clear success. Now he was making plans to someday return to California for good. In October, Mabel Herriman took out help-wanted ads in the *Los Angeles Times* for a "girl for general housework." She eventually would hire seventeen-year-old Vivian Hammerly, a midwestern farmer's daughter of Irish-German stock. Hammerly would live with the Herrimans for the next two decades, serving as a close companion to Bobbie and caring for her when she experienced seizures.

In his *Examiner* column "Pipe Dreams" on November 14, 1912, Beanie Walker took public notice of his old friend's return to Los Angeles. Walker printed a mock letter that played off George Herriman's nickname as well as the recent entry of Greece into the Balkan Wars:

> Yorba Linda, Calif., Nov. 13.
> Sporting Editor Los Angeles "Examiner":
>
> Dear Sir—I think I saw Van Loan on the street here. He used to work on your paper, and if I am not mistaken I have also seen within a week or two a Chap we used to know as "George the Greek." Seems to me he used to draw things for Van Loan that were funny sometimes. If the man I saw on the street is the right one, I want to ask "WHY IS HE HERE?" All of his countrymen are over on the other side fighting for their country. I thought he looked sort of uneasy and was stepping very softly. It's none of my Butt-in, you know, but I was sort of curious about him.
>
> He used to have a fierce bulldog, if that will help identify him.
>
> *A REGULAR GUY.*

Walker appended the "letter," adding, "Now that I have been reminded of it, I believe there was some 'scandal' to the effect that George was 'hiding out' in Los Angeles to avoid service. Why not sign him and Abdo the Turk up for a ten-round go?"

Two weeks later Walker snuck a few more gags about Herriman into his column. Along with lines about Herriman's voracious appetite and artistic temperament—both already well established—Walker

revealed that Herriman, at thirty-two, was suffering from swollen feet in addition to rheumatism. Walker pointed to a growing reclusiveness in his old friend, and made mention of "wens" (cysts) under his scalp and "hair inclined to be curly"—both of which would later be cited as reasons why Herriman constantly wore a hat. It's also one of the first acknowledgments, however in jest, of Herriman suffering from occasional dark moods.

My friend, Mr. Van Loan, asks that I put "a little ad, in the paper" for him. I don't know what it's all about, but "Van" says the right parties will grab the bait. Here she is:

LOST, STRAYED OR STOLEN—Cross between a Hungarian hen hound and a tamale terrier; color white with liver spots; hair inclined to be curly; may be identified by a slight impediment in his gait caused by kidney feet; also has a few wens under his scalp, and is sensitive about them; disposition morose and retiring; temperament highly artistic; was raised a pet, but of late years has had some hard treatment; got lots of friends, but forgets them easily; knows several tricks; always hungry; great traveler; not much for looks, but has a good heart; hangs out Joe Margolis' enchilada palace and Teabone Riley's beef bazar; wears collar with inscription "G. the G." Send word to C. E. Van Loan, who will pay car fare and small reward.

Two days passed. Then Walker reported in his December 4 column that he'd received a reply from none other than Jimmy Swinnerton:

WORDS OF CHEER FOR MR. VAN LOAN.

Palm Springs, Cal., Dec. 2

My Dear Walker: I see by the papers that a Mr. V. Loan is advertising for a Hungarian hen hound, lost, strayed or stolen, and bearing the tag "G. the G." If it is not the same hen hound that has recently been in these parts, it's a cinch nobody would steal him. He drifted into our fair city a few weeks ago since his paws were all curled up with rheumatism, but was so benefited by our salubrious climate that he was able to go out of town a mile a minute, pursued by several of our leading citizens.

Is there any reward for him, dead or alive; because if there is, the boys are thinking of getting up a posse, and what would his pelt be worth at a fur store?

Yours very truly,

JAMES JASPER SWINNERTON.

Answer to correspondent:
Nothing at a fur store, but maybe a dollar and a half at a tannery. Report that his bite is dangerous is denied. He has no teeth.

Herriman stayed in Los Angeles at least through the holidays. The *Evening Herald* led off its coverage of a New Year's Eve boxing match—a battle that established Luther McCarty as the world's "White Heavyweight Champion"—with a Herriman cartoon drawn from ringside. This time Herriman ignored the racial angles, instead riffing on loser Al Palzer's "Eddie Foy smile," referring to a comedian known for dressing in drag.

With that, Herriman was finished with the *Evening Herald* and, for a time, with Los Angeles. He returned to New York, where the *Evening Journal* was welcoming its newest cartoonist, Cliff Sterrett,

whose strip *Positive Polly* (soon to be renamed *Polly and Her Pals*) took Herriman's college-girl-back-home conceit to spectacular heights. Impressed, Herriman began dropping friendly mentions of "Precipice Sterrett" into his comics.

Back at the Rhinelander, Herriman hadn't been forgotten by Tad Dorgan and his other *Evening Journal* colleagues, who frequently had been adding lines about the Dingbats and Krazy Kat into their gags. ("Strike me Ignatz!! Then I'll know you love me," wrote Dorgan in one comic.) Herriman returned the flattery, with a nod to "T. Aloysius Dorgan the great dog artist" and Ignatz capping his final brick toss of 1912 with a reference to Gus Mager's Groucho, Knocko, and other *Henpecko the Monk* characters: "As 'Gustivus Maguerre' would say—Krazo the Kat."

Then, at the dawn of the new year, Herriman's desk at the Rhinelander would provide him with another ringside seat, this one for a bout over the future of art.

I t was a year of cultural revolutions. In Vienna, audiences revolted over Arnold Schoenberg's experiments with atonal music; in Paris the outrage was over the premiere of Igor Stravinsky's *Le Sacre du Printemps*. A shock of similar magnitude hit New York on Monday, February 17, 1913, when the Association of American Painters and Sculptors opened the one-month International Exhibition of Modern Art, held in the cavernous Sixty-Ninth Regiment Armory at Lexington Avenue and Twenty-Fifth Street. The Armory Show is famous for changing the world of art. It is not so well-known that it led to the first stand-alone *Krazy Kat* strips.

The show began without controversy: on opening night, four thousand artists and patrons milled through eighteen octagon-shaped rooms that were partitioned in burlap and brimming with more than twelve hundred works of art from the United States and abroad. The

Armory Show served as point of entry for modernism in America, featuring artists such as Paul Gauguin, Henri Matisse, Pablo Picasso, and Marcel Duchamp, and ideas such as the vivid fauvism and the multiple perspectives of cubism. It was the latter movement that would set New York society into a near panic and provide cartoonists with ample material.

Cubism honored poet Stéphane Mallarmé's dictum to "paint not the thing itself, but the effect it produces." One way to achieve this was to depict a subject from multiple points of view. At the Armory much of the furor centered on a single oil painting: *Nude Descending a Staircase, No. 2*, in which French artist Marcel Duchamp, inspired by photography and film, painted a series of overlaid, abstract figures to convey the idea of motion. "The whole idea of movement, of speed, was in the air," Duchamp said.

The painting became notorious. Crowds stormed the room, pushing for a view. Detractors nicknamed the cubist room "the Chamber of Horrors." Even former president Theodore Roosevelt entered the fray, offering a critique that Herriman must have appreciated: "There is in my bathroom a really good Navajo rug which, on any proper interpretation of the Cubist theory, is a far more satisfactory and decorative picture."

Cartoonists filled the newspapers with cubism parodies, to the offense of some critics. Wrote art historian Milton W. Brown, "[It was when] the know-nothing yellow press found in some of the exhibits a source of low humor that the tide began to turn and the public came to gape, snicker, and jeer." Others, including Armory Show artist Stuart Davis, credited the cartoonists for helping to usher in modern art. "If the whole thing is too damned serious, look out," Davis said.

Yet Brown and other critics missed the cartoonists' point. The *Evening Journal* nearly exploded with cartoon cubism, especially parodies of *Nude Descending a Staircase, No. 2*, but these were jokes among friends. The Armory Show had special appeal to the eighth floor of

the Rhinelander for good reason: it was the brainchild of one of their own, artist and cartoonist Walt Kuhn.

Born in New York in 1877, Kuhn started his career in art by selling drawings to local magazines. He met Rudolph and Gus Dirks shortly after the brothers arrived in town, and together the three enjoyed a bohemian life befitting young artists. At twenty-four Kuhn set out for Europe to study art, but upon his return he also kept up his cartooning work. In addition to Rudolph Dirks, his friends included Gus Mager and Herriman. Years before the Armory Show, he organized events such as the Kit Kat Club Ball, an annual social event for New York cartoonists and illustrators that likely inspired Krazy Kat's name.

It was no coincidence, then, that the Armory Show featured paintings by well-known cartoonists, including Dirks, Mager, and Kuhn himself. Herriman was not represented—but not because his friends didn't try to include him. Dirks and others repeatedly coaxed Herriman to attempt painting, but to no avail. Recalled Herriman: "Rudy [Dirks] said 'Try it again.' I did, but it was no good. So I quit for good. I like colors, I like painting, but I can't. I wish I could, because there are a lot of things I could do just to please myself." Kuhn did collaborate with Herriman—in some fashion—for a collage portrait of Frederick James Gregg, a writer who served as public relations director for the Armory Show. Titled *The Publicity Man*, the work includes a pasted-on head that closely resembles E. Pluribus Dingbat; it is either Herriman's work or, possibly, drawn by Kuhn in Herriman's style.

When Herriman and the other Rhinelander cartoonists saw how their friend Kuhn was stirring passions with his Armory Show, they unsurprisingly joined in the fun. Frederick Opper's *The "New Art!" With Explanatory Diagram* lampooned the hysteria, showing a simple drawing of a girl and cow that was "supposed to have started the riot," and "recent work by 'nuttists,' 'dope-ists,' 'topsy-turvists,' 'inside-outists,' and 'toodle-doodle-ists.'" In his strip *Dauntless Durham of*

the *U.S.A.*, Harry Hershfield spun a tale whereby "Crafty Desmond Models a Cubist Bust and Wins the Fair Katrina." And in a *Dingbat Family* episode titled "Just a Few Examples of Artistic Expression," Dingbat stands on his head and kicks his legs in the air, telling his wife that he is an "advanced cubist expression."

As usual, it was Tad Dorgan who most vividly captured the cartoonists' mood. The Chicago Cubs' Heinie Zimmerman had penned an article about Giants pitcher Jeff Tesreau, and Dorgan added a cartoon of a pitcher in full windup, arms and legs spinning in all directions. The caption read, "This is not a cubist picture. It is just as Tesreau looks to Zim when he winds up." It is no less an

The Publicity Man by Walt Kuhn, c. 1912

abstraction of motion than Duchamp's *Nude Descending a Staircase, No. 2*. It's also not too different from previous sports cartoons by Dorgan, Herriman, and others, who had been trying out new ways of showing motion for the past decade. In many ways, Duchamp was just catching up.

A schism over the Armory Show developed in Hearst's newspapers between cartoonists and editorialists that was not unlike the previous divide over boxing. While the cartoonists had their fun, the *Evening Journal* sympathetically quoted an arts patron who huffed, "These pictures are an excrescence of art, the disgorging of a curdled imagination." Over time, however, the cartoonists' good humor would prevail. "The Armory Show affected the whole culture of America," Kuhn later recalled. "Drabness, awkwardness began to disappear from American life, and color and grace stepped in."

The Armory Show also prompted a small but significant change on the comics page of the *Evening Journal*. On Friday, April 4, 1913, the newspaper launched a vertical strip along the right side of the page, which various cartoonists used for experimenting with vertical action, frequently offering direct parodies of *Nude Descending a Staircase, No. 2*.

The first installments were by Winsor McCay, hired by Hearst in 1911, who inaugurated the strip with a scene of a worker falling from the top of a building. The next day McCay drew water cascading through a series of apartment floors, starting with a top-floor bathtub and finally reaching a janitor's basement bedroom. Other cartoonists delivered actual staircase gags, and others used the space to joke about cubism. Gus Mager drew an apple being dislodged from a top branch of a tree, and Sterrett drew tenants on a multistory fire escape. McCay returned with a masterful single panel of fourteen boys standing on each other's shoulders to peek over a fence. Herriman joined in with *Button, Button, Butt In*, about a man who dives downward through comic panels to retrieve a lost collar button.

On Wednesday, September 10, Herriman extended the action from *Krazy Kat*, which was still appearing as a smaller strip below *The Dingbat Family*, into the vertical strip. On Tuesday, October 28, *Krazy Kat* fully settled into the vertical space, now positioned on the left side of the *Evening Journal* comics page. A note at the bottom promised "Krazier Than Ever To-Morrow." That next strip, the second in the new series, featured eight panels of Krazy Kat descending a staircase.

By now, Krazy Kat and Ignatz had launched into a daily routine that was equal parts minstrel show and Socratic dialogue:

IGNATZ: Then you admit that you are not always intelligent, eh, 'Krazy'?
KRAZY: Well you see it's because most of the time I am intellectual

IGNATZ: When a man collides with another man, what happens, Krazy?
KRAZY: They mix
IGNATZ: Ah, but should one spirit collide with another spirit what happens?
KRAZY: That I cannot say, as I never mix my drinks

IGNATZ: Harmony, Krazy, is the tie which binds souls together . . .
KRAZY: I like most any kind of hominy, zlong as it's got milk and sugar on it

On some days, gags were secondary concerns as Krazy Kat and Ignatz pushed past all limitations, including their own comic.

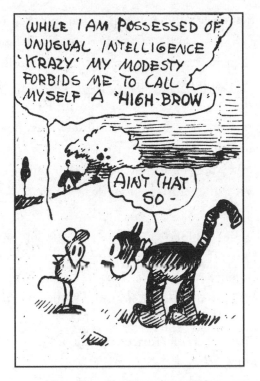

From *Krazy Kat*, November 1, 1913

KRAZY: Well here we is again "Ignatzy" old Topsy

IGNATZ: Here we are for a fact "Krazy"

KRAZY: And again is it all a mystery to me.

IGNATZ: How's that, mystery?

KRAZY (pointing upward): Why, where was we before we came into that "first" picture up there?

IGNATZ: Who knows

KRAZY (pointing downward): And again, where do we go after that "fifth" picture down there?

IGNATZ (throwing rock): Aaah-h, don't ask so many fool questions

KRAZY (knocked off feet): Well, where do we?

Herriman first staged these interrogations on the same simple set he'd been using in past comics: a gently rolling landscape with a rooftop or two. Then he struck the set, opting for a rolling backdrop. Krazy discusses "that boy who stood up on that burning deck" while engulfed in flames. A conversation starts with Krazy and Ignatz first strolling on farmland, then into a dark tunnel, then floating in a pool of water, then hiking up the side of a mountain. They recline on cannonballs as they are fired; they lie together in bed. They are targets in a carnival game, talking about death.

> KRAZY: On the road of life's journey we gotta pass just so many "Xmases" just like we pass so many tellygreff poles on a railroads journey.
> IGNATZ: And when there are no more "Xmases" to pass, what then?
> KRAZY: Then the conductor comes out and says "All out" end of the line.

The vertical strip that ran down the side of the *Evening Journal* and Hearst papers nationwide had declared itself to be like no other comic. Cue the tellygreff poles: for Herriman and Krazy Kat, the journey had begun.

THE KAT AND THE TRAMP

Sunrise, and a man stands against a post, blindfolded, sweat beading his brow. A hand-lettered sign above him reads, "Old Man Rheumatism." Before him, a grizzled gent cocks a rifle and shouts, "Monster!!"

The single-panel cartoon, *What Herriman Wants*, ran in Hearst newspapers at the end of 1915. Throughout the past two years frequent jokes about rheumatism had cycled through both

From the *Chicago American*, December 18, 1915

The Dingbat Family and *Krazy Kat.* Now there could be no doubt that Herriman was living with pain.

The *Evening Journal* ran numerous advertisements and articles concerning the latest rheumatism remedies, from various medicines to jars of live bees, marketed with the promise that there is "nothing like a couple of dozen bee stings for rheumatic pains." Herriman joked about such cures in a pair of editorial comics that also featured self-portraits, including one that showed Herriman walking with two canes. In the first comic, titled *Rheumatism*, Herriman is offered a mug of something called "sodium nucks-vomica, do-do eggs, hair-oil, hungarian gravo." Herriman opts to stick with the "rheumatiz." In the second comic, titled *More Rheumatism*, Herriman is advised to carry a potato in his pocket.

It had been a difficult period for some of Herriman's friends and family members as well. In May 1914, Herriman made another trip to California and reunited with old *Examiner* friends Beanie Walker and Charles Van Loan as well as another newspaper colleague, Clyde Bruckman (later to write screenplays for W. C. Fields and Buster Keaton). Van Loan led the group on a fishing expedition, driving his

From *Krazy Kat*, November 25, 1916

Cadillac on precarious mountain roads in San Bernardino County. It was a jovial trip. They fished for trout, hiked, and camped, with Walker later describing how the rotund Van Loan stripped to his BVDs to stand over a hot stove to cook the fish: "His first words came at the finish an' all he said was 'Now some o' you lazy hounds wash the dishes.'"

Two months later Herriman was back in New York. Van Loan and Bruckman took another camping trip in the same mountains. This time, however, Van Loan lost control of his Cadillac and plunged to the bottom of a thirty-foot embankment. He was thrown from the car, which rolled over him. Van Loan suffered head injuries, five breaks in his left arm, and a jaw that went "tangoing" down his vest, as he later would describe it. Bandaged and in traction, Van Loan tried to make light of the accident, insisting that he could still beat the gang at poker. Yet he never would fully recover.

Herriman's brother, Henry, was also having hard times. In November 1912, at the age of thirty, he had enlisted in the Marines. By February 1915, with the United States still two years away from entering World War I, Henry Herriman was bound for the Philippines. By now he had moved up the ranks to corporal—but then things unraveled. Henry was cited and fined for minor offenses, then in Hong Kong was charged for desertion and sentenced to nine months of hard labor at a naval prison. He got in more trouble for "making unfavorable remarks about the mess" and would be confined "for safekeeping," according to military records. Meanwhile, Herriman's oldest sister, Ruby, was trying her hand at acting. She was thirty and performing in a traveling show in Ohio when, in April 1916, she met and married a New York playwright named Willis Maxwell Goodhue. The marriage quickly failed.

George Herriman, now in his early thirties, would be slowed by neither bad health nor bad news. In New York he threw himself into an active social life, joining an expanding group of cartoonists and

painters who took trips to the home of artist George Overbury "Pop" Hart, in Fort Lee, New Jersey. The gang would meet in the Palisades to eat German food. Gus Mager and Walt Kuhn might break out the banjo and guitar, with Pop Hart joining in on bones. Rudolph Dirks and T. E. Powers also were regulars, along with painter Thomas Hart Benton and the future *New Yorker* cartoonist George Price, who lived near Hart. "Having Pop Hart as a neighbor changed my life," Price later said. "The comic-strip guys would do their stuff for Hearst in New York, then come out with Pop for the weekend."

Herriman's affection for his colleagues ran deep, as seen in several *Krazy Kat* strips during this time with gags that that only his friends would appreciate. He compared "Michael Enjello" to Tad Dorgan; repeatedly brought up the dollar and ten cents apparently owed him

From *Krazy Kat*, October 31, 1914

by Tom McNamara, whom he renamed "McNaborrow"; and sent Krazy Kat to "Dog-hole, Minnie-zotta" to visit Cliff Sterrett.

The newest member to the circle was cartoonist Walter Hoban, creator of the kid comic *Jerry on the Job*. Hoban was ten years Herriman's junior, but they became good friends and, in September 1916, voyaged together on a five-day cruise on the steamship *SS Stephano*, visiting New Brunswick and Halifax. As on the camping trip with Van Loan, Herriman narrowly skirted tragedy: just one month after his cruise, the *Stephano* was sunk by German submarines.

The legendary gathering of artists and wits at Hearst's newspapers—Herriman, Dorgan, Hershfield, Hoban, Sterrett, and McNamara, along with T. E. Powers—is immortalized in Dorgan's cartoons. In one, an editor hovers over a young cartoonist, who is panicking be-

From *Krazy Kat*, December 22, 1916

cause he doesn't know how to spell "nickel." "Make it a dime an' get through," says one colleague. "Wait a minute I'll ring up Herriman hed know he went to college," says another. Another cartoon used a favorite nickname, "Garge," a gag about Herriman's mysterious Southern drawl. Titled *Boxing in the Art Room with Garge Herriman the Greek*, the cartoon shows Herriman squaring off with Dorgan, saying, "Take that cigawr out of your mouth." The other artists gather around, as if to place bets. "Go on Greek knock him stiff," says Hoban.

Dorgan brought other office jokes to the pages of the *Evening Journal*. Harry Hershfield, it seems, had long been searching for a book of pictures from the Chicago World's Fair. One day Herriman overheard him. Dorgan cast what transpired in a parody of newspaper humorist Kenneth Carroll Beaton's "Ye Towne Gossip" poems:

YESTERDAY IN the office here.
HE TALKED about.
THAT BOOK again.
GEO. HERRIMAN.
WHO DRAWS Krazykat.
SAID THAT he had one.
HERSHFIELD WAS all excited.
HERRIMAN DUG it up.
"THAT'S IT!" yelled.
HERSHFIELD, HIS eyes
STICKING WAY out.
"GEE, I'VE hunted for.
THAT BOOK for years."
"WANNA BUY it?" said.
HERRIMAN WITH surprise.
HERSHFIELD KEPT looking.
THROUGH THE book.
HE WAS all smoked up.

FINALLY HE asked.
HOW MUCH?
HERRIMAN SAID.
"ONE DOLLAR."
HERSHFIELD LOOKED over
AND THOUGHT.
THEN HE handed it.
BACK TO Mr. Herriman.
AND SAID.
"OH, NEVER mind."

When the fun spilled out of the Rhinelander, it landed in a pair of raucous taverns that catered to newspapermen. One December afternoon in 1916, Herriman and Hershfield faced off at Doyle's Billiard Academy on Broadway and Forty-Second Street in Times Square. As they played a billiards variation called "golf pool," Dorgan was eyeing the proceedings. Trouble began when Hershfield started trailing. "He was squawking, howling, kicking and pounding his cue on the floor so hard that half the people in the place stopped playing to listen to him yell," Dorgan said. Dorgan didn't reveal who won that match, but the cartoonists would return to Doyle's over the next several years, with Robert Ripley (of "Believe It or Not!" fame) finally besting the others.

The most storied institution was a sprawling midtown bar and restaurant on Sixth Avenue named the Manhattan Oyster and Chop House, but known to everyone as "Jack's," after its owner, Jack Dunston. Jack's sat across the street from the Hippodrome, where the Sports could catch everything from boxing matches to circuses. The Hippodrome crowd flocked to Jack's, as did celebrities such as Charlie Chaplin and President Woodrow Wilson. Once again the acknowledged ringleader was Tad Dorgan, who presided over gatherings that, in addition to the Rhinelander cartoonists, included writers Damon Runyon, Ring Lardner, Frank Ward O'Malley, and Wilson Mizner.

There was no place quite like Jack's, where the walls featured massive murals of Grimms' fairy tales, as well as mounted animals that included Dunston's own deceased pet dog. Diners feasted on scrambled eggs and Irish bacon, kidney stew, and twenty-cent brandy. Waiters were known to evict troublesome patrons with a six-man hold called the "flying wedge."

Dunston himself was an Irishman with bushy eyebrows and a thick mustache. Sporting a white flower in his lapel, Jack would "totter through the aisles of the restaurant wagging his white head like a Russian chorusman," Dorgan said. The cartoonists stashed a ukulele in a cellar fish bin; late at night, after Dunston retired to bed, cartoonist and boxing writer Hype Igoe would play sad songs. For a quick nap before work, the revelers might crawl into Jack's linen hampers. After one memorable night, Herriman reportedly staggered back to the Rhinelander and crawled on top of some file cabinets to sleep it off. His colleagues helpfully covered him in old newspapers.

S hortly after creating *The Dingbat Family* and *Krazy Kat*, Herriman could only watch as his characters began to take on lives of their own. From 1912 through 1916 newspapers across the country and in Canada published notices for stage productions of *The Dingbat Family*, including a version by the Leffler-Bratton Company with a script by Frank Stammers, who had previously adapted L. Frank Baum's *Tik-Tok of Oz*. John Walter Bratton, composer of the novelty song "Teddy Bear's Picnic," wrote the music. Herriman received credit for the story, but his role appears to have been limited. The two-act play was set in a rooftop garden and in the "Dingbat Restaurant," featuring a waiter named "Seldom Seen" and a cabaret segment that included the tango, the "barber poll," and other New York dance crazes. None of this came from Herriman's strip.

Actor Bobby Barry, a seasoned vaudeville and blackface comic, took on the part of Mr. Dingbat, joined by a promised "big company of fifty folks, including a stunning chorus that will make you sit up and take notice." The show traveled to North Carolina, where even a Krazy Kat character couldn't save this "fair-to-middling musical comedy," as it was described in the *Greensboro Daily News*. "The wit is not much to brag about, but the chorus is reasonably good looking," added the *Daily News'* reviewer.

Even if other reviews were similarly tepid, the shows helped bring Herriman's name and characters to new audiences across the country. A Vermont newspaper reported that the phrase "Hang onto my coat-tail Dingbat" could be heard on football fields. A Washington paper used "Mr. Dingbat" to deride a political figure.

As for the comic strip *The Dingbat Family*, a reintroduction of Joe Beamish completed the transformation to *Mary's Home from College* under a different title. There were jokes about the Dingbats' efforts to improve Mary's social standing by staging a play. Other episodes were a mash of broad slapstick and topical gags. With headlines about World War I on the front pages, Herriman sent the Dingbats into their own trenches, with Mr. Dingbat refusing to come out to go shopping in Yorba Linda.

The Dingbat Family started out 1916 with a few gags about New Year's resolutions. Then, on Tuesday, January 4, the comic vanished. This time there was no wrecking crew. In fact, nothing in the final installments indicates that Herriman suspected the five-and-a-half-year run of *The Dingbat Family* was about to conclude. He later revealed that the order came suddenly from Hearst's manager, Solomon Carvalho. "The Dingbats just died overnight," Herriman said. "It wasn't a slow death. When Carvalho said, 'Off with their heads,' off they went."

Yet, Herriman might not have been completely surprised by Carvalho's command, for he had a new strip ready to go. The day after the final appearance of *The Dingbat Family*, he debuted *Baron Bean*,

From *The Dingbat Family*, February 13, 1912

a strip based on a memorable new character who was inspired by something that *Motion Picture* magazine was calling a national disease: "Chaplinitis."

Herriman possibly first saw Charles Spencer Chaplin when the actor arrived in New York in 1910, on tour from England as part of *Karno's Speechless Comedians*. Or Herriman might have caught Chaplin's act on another American tour two years later. There is no doubt, however, that as he developed *Baron Bean*, Herriman was watching Chaplin's first movies and that he was deeply impressed by what he was seeing.

In November 1913, Chaplin signed to Mack Sennett's Keystone Film Company, then moved to the Essanay studio in 1915. In New York Chaplin's movies played at the Hippodrome, across from Jack's. In the early films, as in his stage shows, the actor shifted from one character to the next, even proving to be an uncanny female imper-

sonator. Stories were constructed from sight gags, physical stunts, and slapstick, including repeated brick throwing in short films such as *The Fatal Mallet*.

Chaplin eventually settled on a persona that he called "the Little Fellow" but whom fans would embrace as "the Tramp," a sympathetic soul in a shabby suit. The Tramp's appearance alone was a clever sight gag. "Chaplin's costume personifies shabby gentility—the fallen aristocrat at grips with poverty," wrote early biographer Theodore Huff. "The cane is a symbol of attempted dignity, the pert moustache a sign of vanity."

From the start, Chaplin left no doubt that he aspired to be an artist working in a popular medium. "Even in slapstick comedy there is an art," he told an interviewer in 1915. A custard pie, he said, can be thrown either artistically or coarsely. The difference between brutality and humor was in timing. Chaplin "invented a rhythm," as poet T. S. Eliot said.

Cartoonists set out to capture Chaplin's rhythm on paper and in animated films. Pat Sullivan, a former cartoonist for the *New York World*, started his own animation studio in 1916 and hired *World* colleague Otto Messmer to work on a series of Chaplin cartoons. Messmer made a close study of Chaplin for these films (as well as for a more successful series about a black cat named Felix). "Chaplin sent us at least thirty photographs of himself in different poses," Messmer recalled. "He encouraged us, and autographed these photographs, and we copied every little movement that he did."

In Chicago the *Herald* hired young newspaper cartoonist Elzie "E. C." Segar to draw a strip titled *Charlie Chaplin's Comic Capers*, which also served to launch the career of Segar, later to create Popeye the Sailor. The *New York Evening Journal* didn't publish Segar's Chaplin strip, but the Tramp made frequent appearances in Herriman's and Dorgan's cartoons. In *If the Movie Fans Were Sculptors*, Dorgan recast Chaplin as the subject of famous statues, including Rodin's *Thinker*

and the George Washington statue at Federal Hall. In an episode of Dorgan's cartoon *Indoor Sports* a boss walks in just as an office worker is doing a Chaplin impression ("Here's the Chaplin glide—did you ever see him turn a corner?"). Herriman added Chaplin gags to *The Dingbat Family*, including a scene of Tobias Dingbat in full Tramp costume, as well as to a *Krazy Kat* story in which Krazy's tail is snipped off by Mr. Pupp (not yet a lawman) to make a "Charlies Cheplin" mustache.

Baron Bean debuted in Hearst newspapers on Wednesday, January 5, 1916. Herriman's rush to produce a substitute for *The Dingbat Family* brought a visual roughness to the first three strips. A false signature suggests these initial strips might have even been at least partially "ghosted" by another artist. Yet, from the start, *Baron Bean* also

LOOK AT MR. PUPP "IGNATZ" UNDER HIS NOSE IS THE MISSING LINK OF MY TAIL — NOW DO YOU SEE WHERE MR. CHEPLIN IS BY A MEASURE TO BLAME

From *Krazy Kat*, October 26, 1915

reveals the depth of Herriman's admiration for Chaplin. There are overt cinematic references, right up to panels that announce a pause in the action so reels can be changed. Bean himself is tall and lanky, dressed in a baggy suit. He holds a cane and sports a small mustache. Even in a top hat instead of a bowler, the similarity is unmistakable. "The Dickens mode operated in 'Baron Bean,'" critic Gilbert Seldes wrote, "a figure half Micawber, half Charlie Chaplin as man of the world."

Baron Bean chronicles the misadventures of a destitute aristocrat. Like *Baron Mooch*, its comedy often results from outlandish disguises and extravagant plot turns. Herriman had first taken on this character as early as 1901, in a cartoon for the *Evening Journal* about a count who owns nothing but "zee title." More recently, Herriman likely was inspired by themes of social pretending in Charlie Chaplin's recent Essanay film *A Jitney Elopement*, in which Chaplin masquerades as a "Count Chloride de Lime" in order to rescue his beloved from an arranged marriage. Baron Bean also sprang from numerous true-life tales of tattered royalty in the newspapers, such as Ernest Mueller, a former ratcatcher who posed as "Baron Von Senden" and swindled $15,000, and Richard Von Arkovy, a self-created "Baron in the Hungarian peerage" who was facing two charges of swindling and one charge of carrying brass knuckles.

When readers first encounter Baron Bean, he is seated on a barstool. Then he spots a misplaced purse. "Something tells me, I'm going to meet a nice young lady," he says, hooking the purse with his cane with an elegant, Chaplinesque flourish. The next day's *Baron Bean* opens with a graceful bit of stage business: Baron Bean sidles up alongside a judge at a bar, who is sharing a laugh with the bartender. Bean laughs along while deftly using his cane to spear some food at a nearby table.

The free-lunch gags came straight from *Baron Mooch*, as did a scene in which Baron Bean visits the newspaper art department. There is

another Herriman nod to Miguel de Cervantes when a valet named Grimes is introduced to accompany Baron Bean's flights of fancy. This Sancho Panza, however, is even more delusional than his Don Quixote.

The Bean–Grimes pairing also recalled Bud Fisher's highly successful *Mutt and Jeff* comic. It's possible that Herriman had been charged with creating a strip to take on Fisher, who was embroiled in a copyright dispute with Hearst. As comics scholar Jared Gardner has noted, an early *Baron Bean* storyline lifts an idea straight out of *Mutt and Jeff* when Bean and Grimes take off for a two-week vacation with two dollars and forty cents to spend. Each strip ends with a tally of expenditures, much as Fisher had ended early strips with a tally of Mutt's racetrack wins and losses.

Baron Bean is, however, a much more lavish comic than *Mutt and Jeff*. As in *Baron Mooch* and *The Dingbat Family*, Herriman creates panels rich in tiny visual absurdities, such as a last morsel of food weakly crying for help before being consumed. Herriman's set is lovingly decorated in southwestern designs, and he nods to *Krazy Kat* with character names such as "Ignacio Raton" and "the Duke of Gooseberry."

Many early gags in *Baron Bean* turn on social pretensions. In one strip Bean has purchased a ten-cent watch chain to earn Grimes's respect for his "nobbil linnage" and "the affluence that dangles upon my boozum." Yet social satire quickly gives way to screwball humor. Once Herriman established Baron Bean and Grimes's characters, he sent them off on improbable adventures, first to the North Woods, then to the United States–Mexican border. They were joined by an odd circus of animals, including a moose, an ostrich, a gnu, and a Chihuahua. Herriman slid in a few jokes about Yorba Linda and Tony's chili foundry. He dedicated a few jokes to his friends by making "Harry Hash" (Harry Hershfield) a clothier and "Tomas Dorgano" (Thomas Dorgan) a tamale vendor. He also added a barber named

From *Baron Bean*, September 1, 1917

William Bollyn, the name of the real-life barber at the Hotel Alexandria near his old *Examiner* office.

Midway through the strip's first year, Herriman brought in wives for both Baron Bean and Grimes. The women began haranguing their husbands to take baths and find jobs, and the strip started to replicate the shackled-husband humor of *The Dingbat Family*. Herriman also introduced a black character named Mr. Sneeze, a sympathetic "low sorta person" who nonetheless wears a high hat to his lodge, the Glorified Sons of Ham. The minstrel humor lacks the bite of *Musical Mose* or Herriman's sharpest sports cartoons. However, Mr. Sneeze, like Jimmy Swinnerton's Sam, is a sympathetic character who usually enjoys the last laugh.

With the singular exception of *Krazy Kat*, Herriman's early dailies might best be seen as one continuous comic under different titles. Herriman preferred to circle around to his favorite themes, layering more and more gags about obsessive personalities, insecure class standings, henpecked husbands, and social masquerades—and, of course, Joe Beamish, who manages to show up in *Mary's Home from College, The Dingbat Family*, and *Baron Bean*.

Yet, with Chaplin as with Baron Bean, the first and best laughs come just from beholding the character and his stylized movements. Said Herriman of Chaplin, "He is the only one who really tells laughs in pictures." A similar compliment was paid to Herriman by *Popeye* cartoonist E. C. Segar. "You remember Baron Bean, all those years ago?" Segar asked an interviewer, decades after the last *Baron Bean* had been printed. "He could draw a fellow so flat on the floor that he'd sink. Here would come Baron Bean around the corner, that thing alone is worth more than all the comics put together."

Charlie Chaplin's influence on Herriman extended far beyond *Baron Bean*. Chaplin would also usher in a new personality for Krazy Kat, ultimately helping Herriman take his title character far beyond its early origins in the margins of *The Dingbat Family*.

Herriman made no secret of his devotion to Chaplin. In fact, said Tad Dorgan, it could be difficult to get him to talk about anything else. "Garge is a great reader and a great movie fan," wrote Dorgan. "His favorite author is CHORLES DICKENS and his favorite movie guy is CHORLIE CHAPLIN. He will sit by the hour and talk of them."

Harry Carr once recalled how Herriman rhapsodized about Chaplin's entrance in *The Kid*, released in 1921. In the movie, the Tramp waddles through a back alley and is pummeled by some bricks dropped from above. He stops, pulls out a sardine can from his pocket, and carefully chooses a cigarette butt. Said Carr, "Mr. Herriman has called my attention to the subtle finish of this scene—how the little tramp makes you feel that his sardine can is a diamond-encrusted case and his 'snipes' from the gutter 'smokes' made to his order with his monogram."

Herriman found a similar wonderment in *The Gold Rush*, commenting (in the voice of Krazy Kat) in *Motion Picture Classic* magazine

on the famous scene in which a starving Chaplin eats his own shoe: "What chef kould have brewed a stew from a shoe, from which would arise such gastronomic ecstasy—and what more perfect host than he—the white meat giving to his 'guest,' with the grand gesture."

Most tellingly, Herriman went on to describe the Tramp with the same word that he used to describe Krazy Kat: "sprite." With a name derived from the Latin *spiritus*, meaning spirit, a sprite is a mythical creature, belonging more to air or water than earth. In literature, the best-known sprite is Shakespeare's Ariel, from *The Tempest*, who is imprisoned by a witch for having "a spirit too delicate / to act her earthy and abhorr'd commands." This magical creature is observed by Herriman in *The Gold Rush*:

> There is no question of why he is here, slipping, sliding or scampering over the ice, no talk of the danger all about, depths below, heights above, bears behind, and ice all about—and we following, following, ever following. We have waited long to katch this sprite at play, so let no one stay our step while we have him—we will follow—whither he wills until he loses us in the mists and we flounder back to earth again.

Herriman used similar language in one of his most famous descriptions of Krazy Kat, from a panel in a 1917 comic:

> You have written truth, you friends
> of the "shadows," yet be not
> harsh with "Krazy"
> He is but a shadow himself,
> caught in the web of
> this mortal skein.
> We call him "Cat,"
> We call him "Crazy"

Yet is he neither.
At some time will he ride away
to you, people of the twilight,
his password will be the echoes of
a vesper bell, his coach, a
zephyr from the West
Forgive him, for you will
understand him no better than we
who linger on this side of
the pale.

Unbridled optimism and deep empathy define both the Tramp and Krazy Kat. "I think pity is a great attribute," Chaplin once said. "Without it, we would have no civilization." Critic (and Herriman friend) Gilbert Seldes agreed, writing in 1935: "If you will think back carefully, you will remember that the little man of Charlie Chaplin, the familiar figure with the derby hat and the mustache and the rattan stick and the big shoes who dangled in effigy outside dim and dirty little movie houses, was like Krazy, full of heart, full of sweetness and love. Chaplin would befriend a stray cur; Krazy bends over to say 'Hello worm!' to a caterpillar. . . . When I relate Krazy to Chaplin, I am, of course, saying as much as I can say."

For his part, Herriman described Chaplin using words that equally apply to his Kat: "The timid, hopeful little man with the big shoes and the loose pants and cane isn't any one you have ever seen; yet he is the echo of every hope and sorrow of your own heart."

In the first panel of the episode of *Krazy Kat* published on February 18, 1916, Krazy and Ignatz are sitting in a theater. "Today's the day they show our pictures, Krazy," Ignatz says. The movie opens with an announcement: "First time on any screen Krazy Kat and

Ignatz Mouse." Krazy and Ignatz leap from their seats with cries of "Looka me" until the usher finally throws them out.

On that day William Randolph Hearst's International Film Services (IFS) released the three-minute silent short *Introducing Krazy Kat and Ignatz Mouse*, the first of twenty-eight animated Krazy Kat films released by IFS over the next two years. Despite being tossed by the usher Krazy and Ignatz would play major roles in the dawn of commercial animation.

Just five years earlier, Winsor McCay had effectively launched American animation with the painstaking artistry of *Little Nemo*, followed by *The Story of a Mosquito* and *Gertie*. McCay poured himself into producing movies that were as lovely as his newspaper comics,

From *Krazy Kat*, February 18, 1916

with ten thousand original drawings animating Gertie, an insouci-
ant brontosaurus. McCay originally presented his cartoons as part of
his vaudeville show, heightening the verisimilitude by pretending to
feed Gertie apples and, for the grand finale, "riding" her offstage. It
marked, in the words of film scholar Donald Crafton, "a triumphant
moment for the animator as life giver."

Hearst, jealous for his cartoonist's time, effectively shut down
McCay's burgeoning vaudeville career, but not before McCay's film
creations had whetted a national appetite for pictures that move. Car-
toonist John Randolph Bray (whom Crafton calls the "Henry Ford of
animation") launched Bray Studios in December 1914 and busily set
about patenting animation methods, including ones that he appears to
have learned from McCay. Bray introduced assembly-line production
techniques, staffing Bray Studios with teams of pencillers and inkers.
Now studios could churn out animation just as efficiently as they did
new live-action comedies and dramas.

Hearst, never to be outdone, quickly added animation to his ever-
expanding media empire. In 1909 he had launched International News
Service to syndicate news, features, and comics to newspapers across
the country. On November 16, 1915, Hearst moved these operations
to a new company, King Features Service. (The first King Features
head, Moses Koenigsberg, inspired the name of the company: the
German *Koenig* translates to "king.") Also in 1915 Hearst added In-
ternational Film Service (IFS), which would produce cartoons based
on King Features comics to attach to the ends of newsreels. Hearst
installed his own animation studio at 729 Seventh Avenue and staffed
it with top talent that he hired away from other fledgling studios.

The scope of Herriman's involvement in the first *Krazy Kat* car-
toons isn't clear. Some cartoonists followed McCay's lead and attemp-
ted animation themselves, including Rube Goldberg, who received
$75,000 for a year of exhausting work. Herriman doesn't appear to
have worked so directly on the animations, although he did help pro-

mote them. A full-page notice in the July 1916 issue of *Photoplay* magazine featured new Herriman drawings, including caricatures of the "chorus of animators" who were bringing Krazy Kat and Ignatz to the screen: Leon Searl, Frank Moser, Bill Powers, and Bert Green. "Treat them nice, boys," Herriman wails to the men, "they're all I have."

Hearst also promoted the new cartoons with a two-day newspaper advertising campaign. Krazy Kat and Ignatz again appear, but the drawing and lettering, as well as the script, seem ghosted by another artist. Krazy uncharacteristically hurls coarse insults at Ignatz's "crude, cheap face."

It would not be the last time that Herriman's characters took on new personas for the movies. Although each IFS movie would be designated "A Cartoon by George Herriman," the series only fitfully translated Herriman's vision to the screen. A few of the cartoons adapted the wordplay and minstrel malapropisms of the daily strips, especially *Krazy Kat & Ignatz Mouse Discuss the Letter G*, composed solely of a conversation between Krazy and Ignatz about the popular people who have G as a first initial, including "G. Rusalem," "G. Hosafat," and "G. Willikins." At least two of the early scripts were based on *Krazy Kat* strips published the previous year. These included *A Duet: He Made Me Love Him*, in which Krazy Kat revamps a popular Al Jolson tune, adding the line "He made me hate him" after Ignatz knocks Krazy with a baseball bat. Another is a riff on the medical condition locomotor ataxia—the inability to control body movements—with Krazy Kat suffering "locomotive ataxia" after having been hit by a train.

The early daily strips' simple backgrounds—a horizon line dotted by a rooftop and an occasional tree—translated well to screen. Ignatz generally retained his original features (including two large, circular ears soon to be adopted by another cartoon mouse). Krazy fared worse. Gone was Herriman's humanoid feline, developed over years

of experimentation in sports cartoons and comic strips. The replacement was a simpler creature with a round, plastic face and a bit of a potbelly, and a long, dexterous, monkey-like tail.

Animator Shamus Culhane, for one, would regret these early films, comparing them unfavorably to Winsor McCay's innovative work. "Instead of showing motions by movement, as McCay had done, these pictures fell back on the symbols that had been created for comic strips," said Culhane. "It is as if McCay had designed the Rolls-Royce, and the others decided to build bullock cars."

On Sunday, April 23, 1916, Hearst introduced a new, large-scale *Krazy Kat* comic in his newspapers' weekly "City Life" section. Perhaps the newfound fame from the animation series inspired Hearst to grant Herriman the sizable new canvas. Perhaps Herriman had been requesting the opportunity to draw full-page comics, and Hearst, deciding that children wouldn't care for *Krazy Kat* in the Sunday colored supplements, opted instead for this section, where Herriman's work would appear next to syndicated poetry and other "highbrow" literary features.

On its first day, the comic took the form of seventeen panels of irregular sizes and shapes, narrating a cinematic tale of Krazy Kat,

From *Krazy Kat*, April 23, 1916

Ignatz Mouse, and Gooseberry Sprig sitting down to an ice cream picnic. Krazy suddenly takes the ice cream and dashes down a long road. The others grow suspicious, and they follow. The chase is on, with Mr. Pupp, now wearing a bobby hat borrowed from Mack Sennett's Keystone Kops, joining in. Pupp spies Krazy at the bottom of a coal chute, serving the ice cream to a litter of orphan kitties. Touched, Pupp invites Krazy to the "Patrolmen's Ice Cream Social" while the others look on in shock. By story's end, the kittens are fed. A new Krazy Kat, heart overflowing with Chaplinesque pity, had arrived.

A GENIUS OF THE COMIC PAGE

Dreamink—dreamink—talkink in my sleeps.
Wanderink in dreams lend where heppi-niss don't cost
much—
And when I unwake, things is not what they seem.
—*Krazy Kat*, April 8, 1918

T he United States' entrance into the First World War did not go well for William Randolph Hearst. In the years leading up to President Woodrow Wilson's declaration of war on April 6, 1917, Hearst assigned his cartoonists to both ridicule Wilson and thunder for peace. The war in Europe, he editorialized, was a scramble over profit and territory, not worth the sacrifice of young American lives. A greater threat, Hearst argued, was posed by Mexican revolutionaries Venustiano Carranza and Pancho Villa. Hearst's campaign for armed intervention in Mexico intensified after Pancho Villa's forces laid siege to a million-acre Hearst ranch in Chihuahua.

Hearst's critics, led by the competing *New York Tribune* and fortified by the Espionage Act and, later, the Sedition Act, branded the publisher a friend of the Kaiser. Crowds began hissing when Hearst's name appeared in International Film Service reels. There were boy-

cotts and even mass burnings of Hearst's newspapers. Federal agents kept close surveillance on Hearst, even scouring his newspapers' cartoons for coded messages to the Germans.

The cartoonists, meanwhile, had been sent to the front line of Hearst's publicity war—at least, most of them. Frederick Opper, Jimmy Swinnerton, T. E. Powers, and especially Winsor McCay provided comics that mocked Hearst's attackers, with McCay even penning a public letter denying that he had ever drawn a pro-German cartoon.

To a remarkable extent, Herriman managed to keep out of the fray. Then in May 1916, Venustiano Carranza, now ruling Mexico, wrote a letter of complaint about American troops that had crossed the border in pursuit of Pancho Villa. Hearst responded in his newspapers that "Mexico in power compared to the United States is like a small mouse compared with a big cat," and added a cartoon of Ignatz, as "Karranza," hurling Carranza's letter at Krazy Kat, or "Gato Loco," attired in Uncle Sam stars and stripes. Albeit likely drawn by another artist, it nonetheless was one of the few times Krazy Kat and Ignatz would suit up for someone else's battle.

After Wilson declared war on the German Empire, Hearst hurried to remove all doubt about his patriotism. He displayed American flags across his newspapers as well as on his newsboys. He suspended his popular German-language newspaper, and changed the name of the *Katzenjammer Kids* to the *Shenanigan Kids*. On the sports pages, cartoons of boxers and baseball players were replaced by humorless photo essays bearing titles like "How to Train at Home to Be Ready When Uncle Sam Calls You for Military Service."

Hearst also pressed his comics page into service. Fearing that a wartime paper shortage would prompt the Federal Fuel Administration to ban comic supplements, he published full-page advertisements promising "The War Time Lift of a Good Laugh" and reminding the country that "the Comic Artist has been one of the mainstays of patriotic propaganda." Hearst made sure his readers knew that cartoon-

From *Krazy Kat*, November 5, 1915

ist Walter Hoban now was in uniform, as was Winsor McCay's son, Robert, who years earlier had inspired Little Nemo. *Krazy Kat* was published in special newspapers that were distributed to the troops, such the *USS Siboney*'s *Siboney Signal*.

Hearst's changing view of the war is uniquely reflected in Herriman's daily *Krazy Kat* comics. Before the United States declared war, Krazy Kat remained blissfully naive of the events overseas. "We don't know nothing about guns-powder nor guns. Nor swords nor kennons nor forts . . . that's why we're so heppy," Krazy says on December 7, 1914. Other comics struck a pacifist tone that perhaps echoed both Hearst's stance and Herriman's own sentiments, as on May 21, 1915, when Ignatz walks into frame, grinning and wild-eyed, waving a club and calling for war. Krazy Kat looks on, commenting, "And they call me, 'Krazy.'"

By the next year, however, cannons and bayonets were dropping into *Krazy Kat* strips like props falling onto a stage. Krazy and Ignatz pick them up and start marching around with the innocence of children playing with new toys. "Gee, 'Krazy' where are you going with that cannon?" Ignatz asks, and Krazy replies, "To war . . . oh any war wodda I care." Other times Herriman ignores the sobering national mood and indulges in lighthearted wordplay. A goose enters, proud that the Germans have adopted his step. Krazy warns a snipe that a sniper is approaching. Krazy hears of shelling and is reminded of the old days as an "oysterer."

When the Hearst papers began exhorting readers to support the troops by purchasing Liberty Loans and War Savings Stamps, Her-

From *Krazy Kat*, February 8, 1919

riman fell in line, contributing humorless comics that showed Ignatz buying stamps instead of bricks, and Krazy Kat and Gooseberry Sprig rushing to a bank window to purchase Liberty Loans. Other wartime comics more artfully absorbed news of the conflict. Herriman parodied home-front shortages with "brickless days" and "katless days." For one comic, Herriman drew mere outlines, with Krazy Kat and Ignatz holding up a banner that reads, "Saving Ink." In another, neither Ignatz nor Krazy Kat will tell the readers the plot, explaining that it's a "talkliss day."

In one pantomime comic, Krazy Kat sees a cannonball and lights a cigar on its fuse, a slapstick gesture that would later be used by Buster Keaton in his 1922 movie *Cops*. Krazy Kat often expresses a certain wartime reluctance, one day expressing a hope to not give all nine lives to the effort, asking, "I wunda would my country be setisfied with eight of them." Most poignant was a wartime scene of Krazy on guard, carrying a bayonet. Krazy hears a visitor and asks, "Friend, or four?" The answer comes back, "Friend!!" In the final panel, Krazy drops the bayonet and embraces Ignatz, with a relieved "Dahlink!!!"

War occasionally intruded onto the larger stage of Herriman's new weekly *Krazy Kat* comic for Hearst's "City Life" section. Primarily, however, Herriman used his new page for graphic and narrative experimentation. One day readers might behold a densely packed series of irregularly shaped panels that track Krazy's plummet over a waterfall. On another, a tale of a lost Ignatz opens with a long, horizontal desert vista. Herriman tightly packed dialogue into some strips, while staging others, such as an ocean scene in which Krazy Kat and Ignatz are thrown into each other's boats, as silent features.

Herriman moved his stories to an imagined land called Coconino, later called Coconino County. The name, which had been appearing on various occasions in his strips for nearly ten years, is derived from

a Hopi word *kohunina*, which means "wood killers" and was used to disparage tribes that used clubs to break off live tree limbs for firewood, injuring the trees. The real Coconino County sits in northern Arizona and includes the Grand Canyon National Park and the city of Flagstaff. Herriman's Coconino County, however, lives by its own rules. Its scenery includes landforms from across Arizona, southern Utah, and western New Mexico. At any time, this landscape might become animated. Buttes and cacti stagger madly in the distance, or even become lead characters. One week a pair of Joshua trees join the fun: "And so with a sandstone moon swimming in the heat-waves, a ruisenor's canticle coming from the smoke bush, Don Kiyote ragging the scales . . . somewhere, everywhere, nowhere . . . why shouldn't Mr. & Mrs. Joshua Dance?"

Herriman began adding more decorations to his comics—especially the sun cross or wheel cross, a design common in southwestern Indian art. The symbol—a cross or X inside a circle—had special appeal to Herriman, for it also resembled the hobo symbol for a friendly household, which a decade earlier Herriman had begun using for his signature when he was a *Los Angeles Examiner* staff artist.

On February 11, 1917, readers opened the page to the weekly *Krazy Kat* to discover an extraordinary origin story that offered hints about Herriman's feelings concerning his own early life. Krazy is atop the Enchanted Mesa, an actual landform in New Mexico that Herriman now transformed into the distant home of Joe Stork, "who pilots princes and paupers, poets, and peasants, puppies, and pussy-cats across the river without any other-side to the shore of here." On this day Krazy is seated at Joe Stork's feet and raptly listening to "a tale which must never be told, and yet which everyone knows":

Yes, "Krazy," you were all brought here by me . . . "Walter Cephus Austridge" I hid as a mere egg back of a hot rock in the "Kalahari" where his mother found him . . . "Terry" Turtle,

he too was an egg, one of a dozen I had buried in the sand on the edge of the Arroyo Seco . . . "Gooseberry Sprig," another egg, him I placed in a discarded high hat . . . "Ignatz Mouse," I brought sightless, squealing and squirming, and dropped him into an empty cracker "box," . . . "Kolin Kelly," was one of six for whom I found sanctuary in a sugar barrel up a back alley . . . and you, "Krazy" with four of your kind, I made comfortable in a wash-boiler in the cellar of the haunted house . . . and so it goes . . . and so it goes.

In the next scene, the cast is gathered in a private "klub" reminiscent of the Herriman's old "Lily White Inn" that excluded black boxing champs. Gooseberry, Ignatz, and the others smoke cigars and boast about their newly discovered lineage. Krazy enters carrying the wash boiler from Joe Stork's story, singing a song based on the sentimental Samuel Woodworth poem "The Old Oaken Bucket," a favorite of minstrel shows: "How dear to my heart / Is the scene of my infint-hood / where fond reckillection / Preee-e-e-zents tham-m-m to view."

Krazy is quickly shunned as a creature of lowly birth. In the final scene Krazy lies atop a hill in the same wash boiler, lantern-lit and at peace.

From *Krazy Kat*, February 11, 1917

◇◇◇◇◇◇◇◇◇◇◇◇◇◇◇◇◇◇

On February 3, 1917, *American Art News* reported that a new artists' group calling itself the Penguins would be throwing a ball at its new clubhouse, located at 8 East Fifteenth Street, near Union Square in New York. Formed by Walt Kuhn, the Penguins were the same gathering of friends who had masked in the Kit Kat balls ten years earlier, who had been active in the Armory Show, and who had gathered on weekends at Pop Hart's place in Fort Lee, New Jersey. In addition to Kuhn, their ranks included Rudolph Dirks, Gus Mager, Alfred Frueh, and Herriman.

The Penguins were the city's "newest and nuttiest artists' club," reported the *Sun*. With the motto "We don't know where we're going, but we're on our way," the Penguins had no officers and was open to the "high and low brows of the art world." One of their favorite pranks was to tell an art critic that an event was formal, then all show up wearing rags. "We were young, full of beans, and not too well behaved," artist Louis Bouché recalled.

The clubhouse was a brownstone, with the front room used for exhibitions and the back room reserved for weekly sketch classes with a nude model. To cover expenses, the Penguins threw an annual "Fête of the Penguins" costume ball, the first of which, titled "Fête in a Spanish American Village," was a grand production with dancing girls and large papier-mâché horses. Among the artists who performed in the pageant was Herriman, attired in a red, white, and green cap, a red flannel shirt, blue overalls, and a raggedy blanket.

The Penguins caused their biggest stir the previous month when they hosted a three-week art exhibit featuring a group of avant-garde London-based artists known as the Vorticists. Named by the poet Ezra Pound, Vorticism celebrated the machine age with bold, geometric abstractions. In the first issue of the Vorticist journal *Blast*, artist Wyndham Lewis explained that Vorticism reflected a new urban environment in which impersonality is a disease and "the frontiers

interpenetrate, individual demarcations are confused and interests dispersed." The Vorticists strove to go back to fundamentals. Wrote Lewis: "WE NEED THE UNCONSCIOUS OF HUMANITY— their stupidity, animalism and dreams."

Herriman embraced the new ideas. The stark, slashing abstractions seen in the Vorticists' work soon found their way into *Krazy Kat*, with patterns of jagged lines erupting across the Coconino sky. Storylines also grew more experimental. One daily comic opens with only a tree and a note that reads, "Holding your attention for the nonce." Krazy Kat strides onto a nearly blank panel and looks up. Ignatz then appears and also looks up. "What do you see?" asks Ignatz. "Nuttin'," says Krazy. A large cactus appears behind them, and the strip is concluded.

From *Krazy Kat*, January 8, 1918

The minstrel show malapropisms and puns of previous strips carried with them the notion that things are not always what they seem. Now, emboldened by the Vorticists, the Armory Show, and other avant-garde cultural movements he'd encountered over the past several years, Herriman turned in full-blown philosophical meditations on language, identity, and the nature of reality. It was during this period that Herriman penned a daily strip that might be viewed as his own manifesto. In it, Krazy Kat and Ignatz, seated at a table, launch into a dialogue:

KRAZY: Why is "lenguage" "Ignatz"?

IGNATZ: "Language" is, that we may understand one another.

KRAZY: Is that so?

IGNATZ: Yes, that's so.

KRAZY: Can you unda-stend a Finn, or a Leplender, or a Oshkosher, huh?

IGNATZ: No—

KRAZY: Can a Finn, or a Leplender, or a Oshkosher unda-stend you?

IGNATZ: No—

KRAZY: Then, I would say, lenguage is, that we may mis-unda-stend each udda.

Such comics might confound some of Hearst's readers, but at Harvard University *Krazy Kat* was attracting a devoted following. Poet T. S. Eliot, who published work in *Blast*, had a particular fascination for *Krazy Kat* and other strips during his Harvard days. Recalled Eliot's friend Conrad Aiken: "What did we talk about? or what didn't we? It was the first 'great' era of the comic strip, of Krazy Kat, and Mutt and Jeff, and Rube Goldberg's elaborate lunacies: it was also perhaps the most creative period of American slang, and in both these departments of invention he took enormous pleasure."

In 1916, young Harvard senior Edward Estlin (E. E.) Cummings decorated his dormitory wall with *Krazy Kat* clippings, signaling the start of a lifelong devotion to the comic strip that would deeply influence his own poetry. The next year a recent Harvard graduate named Summerfield Baldwin published a lengthy appreciation of Herriman in *Cartoons Magazine*. Baldwin's essay, strikingly titled "A Genius of the Comic Page," would unleash a new torrent of popular and academic articles extolling the cartoonist and his work:

> There is a man named Herriman. All that I know of him is that he signs his name in curious letters to the most charming column of comic pictures that it has ever been my privilege to see. Do not recoil in horror before what you fear is going to be an apology for American vulgarism. The personalities that populate the world of Krazy Kat as they appear from day to day in the Hearst journals are not vulgar. They are rather the products of one of the most original and delicate of all contemporary American creative geniuses.

Baldwin analyzed a few of Herriman's stories, interpreting a comic of Krazy Kat and Ignatz grabbing each other's dialogue balloons as Herriman "emphasizing the limitations and general nature of his medium." More boldly, Baldwin saw a comic in which Krazy thwarts Joe Stork by spreading a sheet across a chimney as an "allegorical depiction of birth control." Like many *Krazy Kat* fans, Baldwin commented on the "miraculous" shift of scenery, taking note of how it often occurred during scenes of violence.

Baldwin admitted, however, that his Harvard education barely prepared him to keep up with the cartoonist's literary prowess. "In one out of every five of his columns," Baldwin wrote, "there occurs some indication that Mr. Herriman is by no means an unlettered man."

Baldwin went into careful detail on Krazy Kat's face, writing that

From *Krazy Kat*, July 15, 1917

"by almost infinitesimal variations in the position of the eyes and of the corners of the mouth, Mr. Herriman contrives to run the whole gamut of the emotions on Krazy's excessively stupid countenance. Fear, affection, devotion, wonder, surprise, amusement, content, all find a place."

After serving in World War I, Baldwin went on to head the history department at the University of Akron in Ohio. There is no record that he and Herriman ever met or that Herriman acknowledged his effusive praise. An essay by Herriman, published in September 1917, might be seen as a sort of bemused rejoinder. Herriman had been named to the advisory board of the journal *Dead-Line: A Magazine of and by Newspaper Men and Other Professional Writers for Fellows of Their Own Kind*, published by the Press Club of Chicago and edited by the fantasy writer De Lysle Ferree Cass. In the inaugural issue, Herriman described his work in considerably more modest terms:

For what we have inflicted upon the poor public in the way of "Comics" we humbly beg pardon. If we had crust enough to go back into the dark ages, we could dig up a lot of Coarse Work, but if you'll only stand for Baron Bean and Krazy Kat a little while

longer, it'll just mean that we'll be able to give the family its regular rations until they're able to shift for themselves, and turn a helping hand for the maintenance of the "Ole Man."

Throughout his life, Herriman would be relentlessly self-effacing when discussing his own work, at times to the bewilderment—even annoyance—of his friends. The letter to *Dead-Line* also introduced a new signature that Herriman would continue to use in private correspondence. At just thirty-seven years, Herriman had become the "Ole Man."

Announcing that "gloom doesn't help to win the war," the Penguins went ahead with their annual masquerade party for Friday night, February 15, 1918. For the pageant, titled "A Night of a Thousand Pierrots," Herriman and the other artists reprised their papier-mâché horses, this time performing with a Japanese acrobat and dancing "Penguinettes." The bawdy show, they promised, would make the notorious censor Anthony Comstock, who'd died just two years earlier, turn over in his grave.

Later that year Herriman kept another appointment, this one with the government. On Friday, September 13, 1918, he dutifully showed up at the draft board to answer questions and sign his little red card. He listed his occupation as newspaper cartoonist at the *New York Evening Journal*, giving his employer's name as William R. Hearst. Herriman was described as being of medium height and build, with brown hair and eyes. "Space No. 6" was to be checked if the registrant was a negro; Herriman's card was checked in the fifth space, indicating that he was white. (Interestingly, Herriman's first cousin, Hector Henry Louis Hecaud, with whom Herriman had once shared a house in New Orleans, registered just one station away that week. Hecaud's card indicates he was also passing as white; there is no evidence he and Herriman were reacquainted while in New York together.)

For his address, Herriman wrote a new location on his draft card: the Hotel McAlpin, a twenty-five-story hotel on Broadway and Thirty-Fourth Street. The McAlpin was posh, with a tearoom, a lavish dining room, and a men's writing and lounging room. The hotel kept a close relationship with Hearst newspapers, once hosting a dinner honoring Hearst cartoonists and even using George McManus comics in its advertising.

The Herriman family had by now left their Riverside apartment. George Herriman listed his wife, Mabel Herriman, as his nearest living relative even though she currently resided a continent away, raising their daughters Toots and Bobbie in a cozy two-bedroom home at 128 South Benton Way, in the then-upper-class Westlake neighborhood of Los Angeles. It's not clear how long Herriman had been separated from his wife and family, but the situation would prove to be temporary.

Armistice Day arrived on November 11, just two months following Herriman's registration. New Yorkers packed the streets to celebrate, and Walt Kuhn decided that the Penguins should join in. Each artist grabbed a papier-mâché horse and, carrying a banner that read "Penguin Cavalry," the group crashed the Armistice parade on Fifth Avenue, prancing in front of a military band.

The Penguins would throw one more ball in 1919, but the group soon disbanded as artists explored new directions following the war. So too did the days of elaborate pranks and hallway craps games at the *Evening Journal* begin to end. The big room in the Rhinelander had served as the locus of creative talent in one of the most celebrated art departments in newspaper history. However, more cartoonists now were beginning to work from home. Making matters worse, the Wartime Prohibition Act presaged the Eighteenth Amendment and the eventual shuttering of Jack's and other favorite watering holes.

In the May 1918 issue of *Cartoons Magazine,* Walter Francis Hudson—"Gunboat," as Tad Dorgan named him—wrote "Mixing

From *Krazy Kat*, December 25, 1917

with the Best of 'Em," a nostalgic tribute to the art department. Hudson had come on board as a seventeen-year-old assistant to Dorgan, and his article is an affectionate look at an old room once rich with gags and characters: "What are the office hours of these pen shovers? Oh, most any time they care to mention. It doesn't make any difference as long as they make a picture every day. . . . Their ideas? They just get to talking and telling stories and reading out-of-town papers . . ."

Hudson poked fun at cartoonists such as Cliff Sterrett and Tom McNamara for leaving the party early. "These two pen slingers do all their work at home. They claim the office is too noisy for their nerves and they can't think, but nobody down here ever accused them of thinking." Hudson wrote about Winsor McCay's prodigious work habits ("What does sixteen skyscrapers and a couple of battleships in

one picture mean to him? Nawthing, nawthing at all.") and described how Harry Hershfield got his ideas for *Abie the Agent* at Jewish restaurants. He even joked about Dorgan's mutilated right hand, calling him "the only man in the business pushing a pen from the wrong side of the shoulder."

Then, like the gang at the *Los Angeles Examiner* before him, Hudson had fun with the still-unanswered questions about Herriman's family background:

Did you ever notice all the Spanish George uses in 'Krazy Kat'? You may think it's phony, but it's not. Honest to goodness, it's on the level. He speaks about fourteen different languages—almost any language—except American. Hoban and I are the two best Irishmen in the works, and George tries to horn in, making certain claims to Celtic ancestry, but it doesn't take. Two in one room is enough to represent our nationality. And besides, if Herriman tells anyone else he's Irish, that'll be an awful knock to Hoban and me. If Herriman keeps on insisting that he's Irish, Hoban and I will both turn Swedish.

FANTASTIC LITTLE MONSTER

John and Louisa Wetherill's cedar-and-rock house stood in the sun-bleached desert settlement of Kayenta, Arizona. Inside, Navajo rugs draped over wooden rocking chairs, and colorful blankets hung next to bookshelves stuffed with Bureau of Ethnology reports. In the dining room stretched a long wooden table that sat up to forty guests, many of them artists and writers who gathered here from around the country for steaks and late-night conversations about Indian lore.

It was, the Wetherills liked to tell their guests, the farthest you could get from a post office without leaving the country.

Louisa Wetherill sat at the table's head, nearest to the kitchen. She was flanked by John at her right, and their business partner, Clyde Colville, at her left. After dinner, John Wetherill, dressed in a shirt, tie, and overalls, would excuse himself to go milk the cows, turning the evening over to his wife. "At the head of the table is Mrs. Wetherill, as regal and dominant as a monarch," recalled Ernie Pyle, one of many writers to visit Kayenta. "Her cigaret poised high, she surveys the assemblage, and joins in the repartee with an uncanny mirthless laughter in which her face never changes expression. She is a woman to cope with; a woman to have with you in the frontier life."

The Wetherills arrived in Kayenta in the winter of 1910, originally pitching two tents in the snow, living in one and using the other as

a trading post. John hailed from a Pennsylvania Quaker family and famously led the first exploring team to the majestic sandstone arch in southern Utah now known as Rainbow Bridge. Louisa taught herself the Navajo language, gaining a deep knowledge of traditional chants and practices. It was not unusual to see a medicine man come to Louisa for counsel, remembered Sarah Louise Bradley, whose father, Lee Bradley, worked for the Wetherills. "She picked up a lot of traditional songs, healing songs, and she used to teach it back to the people," Bradley said. "If they happened to forget something there that they needed, they used to ask her and she used to sit down and sing songs to them."

While Louisa welcomed visitors and Colville ran the trading post, John led packhorse excursions to Rainbow Bridge and the rocky ruins of ancient Anasazi civilizations. Up the road from Kayenta, in the vast natural sculpture garden of sandstone, siltstone, and shale

From *Krazy Kat*, May 5, 1918

known as Monument Valley, city dwellers camped on the desert floor, dwarfed by massive buttes carved by wind and water into shapes that were mythic, even mystical—such as the pair of giant weathered sandstone monuments called "the Mittens" for their striking similarity to a pair of hands that reached, godlike, from the ground. Among Wetherill's better-known clients were Theodore Roosevelt and author Zane Grey.

George Herriman appears to have first visited Arizona around 1907, initially making it only as far as the city of Flagstaff and parts of the Grand Canyon. The trading post's earliest registries have gone missing, so it is impossible to know just when Herriman first found his way to the Wetherills' table. His comics suggest that he deepened his ties to the desert around 1915, when *Krazy Kat* began featuring such local wonders as Rainbow Bridge and the Moki Buttes (also known as the Hopi Buttes), a series of volcanic plugs in northeastern Arizona. When Herriman began his larger weekly comics in 1916, he peppered his tales with gags about a "Coconino Express" railroad and a "14th Netionel Benk of Coconino." Betty Rodgers, who as a young Navajo child was raised by the Wetherills, later recalled how everyone in Kayenta would laugh at Herriman's jokes about their desert home.

Herriman's first documented visit to Kayenta occurred in late June or early July 1920, when he signed into the Wetherills' registry with his brother-in-law, Marcus Bridge, then working as a masonry contractor and managing a citrus grove (perhaps Herriman's) in Yorba Linda. There the two travelers slept in rustic guest rooms located down a narrow hall that was decorated with old Navajo tools. To reach the shared restroom, they had to stumble across an unsteady floor made from slices of duckboard laid atop mud and covered with Navajo rugs. "Guests making their way to the one bathroom which opened off that hall often gave the effect of a rough day at sea as they negotiated that tippy and unpredictable footing," remembered one visitor.

Louisa Wetherill soon found in Herriman both an attentive student and a good friend. Betty Rodgers recalled that the Wetherills didn't consider Herriman just another lodge patron. "He'd go down to his bedroom and he'd do all his work, *Krazy Kat*," she said. "And he'd get that done and he'd just come up to the living room and be treated like one of the family."

A mail truck would come and pick up the cartoons, Rodgers recalled, then Herriman would want to go meet with the locals. "He'd go out to the hogans and just spend the day just fooling around, he'd eat with them. They'd make a round bread, and he'd take one of those and dip it in a broth, or mutton stew. He just wanted to be with them, do like them."

Herriman brought his newfound knowledge onto Hearst's comics page, where his references to local life and customs went much deeper than drawings of local landmarks. In one episode of *Krazy Kat*, Krazy watches as Joe Stork pauses atop a hogan, searching for a place

From *Krazy Kat*, November 23, 1919

to drop his bundle. "My goodniss, it's at the old huntid house, where nobody lives—Mr. Stork must be mistaken, or else maybe it's a l'il infint ghost," says Krazy. The gag was based on the Navajo custom of closing up a hogan in which somebody has died, leaving it empty and abandoned.

Herriman's curiosity also sent him exploring beyond Kayenta. With his brother-in-law, he set out westward toward the Elephant's Feet, a pair of massive, side-by-side sandstone towers. In Herriman's comics, the Elephant's Feet frequently took off running across the desert. A reddish color at the base of the formations inspired one *Krazy Kat* comic about how the feet went wading in nearby Red Lake.

Herriman and Bridge visited with another trading post operator, John P. O'Farrell, a frontier storyteller who lived on Red Lake and was known for boiling down rattlesnakes and serving them to guests. O'Farrell and Herriman clearly hit it off, for six months following his visit to Arizona, Herriman sent an original cartoon to O'Farrell

From *Krazy Kat*, November 19, 1922

that showed the trader standing on his dock. While a whale spouts in Red Lake, Herriman and Bridge, shown as Indians, drop anchor and recount their travels to the towns of Kaibito and Tuba City, the Shato Valley, and Moenkopi. Herriman signed the drawing to O'Farrell, warning him to watch out for wild mermaids.

For Herriman, lantern-lit Kayenta evenings around the Wetherills' table provided a rare respite from an increasingly busy career. By the start of the twenties, *Krazy Kat* was both popular and profitable. No Hearst financial records have surfaced to reveal Herriman's salary during this time, but newspaper columnist O. O. McIntyre reported in 1918 that "comic artists are among the highest paid men in New York," with few receiving less than $15,000 a year, or nearly a quarter of a million dollars today, adding that Herriman "is said to be one of the highest salaried men in the world of the comic strip." It is unlikely, however, that Herriman's salary topped enormously successful artists such as Bud Fisher, whose *Mutt and Jeff* earned him $200,000 annually, as reported in *Editor & Publisher* in 1919.

Krazy Kat's fame increased even more when a new round of films hit the movie screens. In 1920, Bray Studios released ten new cartoons that boasted better production values than the International Film Service series. The Bray films were loosely based on some of Herriman's comics, with numerous Coconino supporting characters joining in. Herriman-style flourishes abounded in these new cartoons, as in *The Great Cheese Robbery*, in which a Hearst newspaper comes to life, personifying Ignatz's troubled conscience.

Toy shelves filled with new creations modeled after Herriman's characters. The Averill Manufacturing Company had started producing felt Krazy Kat dolls and wholesaling them to retailers for twelve dollars a dozen with the promise: "The Big Skream: Kraziest Kat You ever Looked At." Stuffed with sawdust, the Averill doll stood about

twenty inches tall with a tag nose and pointy ears, a fixed smile, and a white face on a black, purple, or orange body. Other toys included a wood-and-rope Ignatz, produced by the Cameo Doll Company, with the stamped name "Ignatz" on its chest and a small tag on the foot stating "Des. & Copyright by Geo. Herriman." A special Krazy Kat doll even showed up at a Yale football game, where it was spotted by writer Damon Runyon, who complained, "George Herriman's 'Krazy Kat,' done in Yale blue, was about the only innovation in souvenirs seen in town and they wanted five dollars for that."

Still, Herriman knew there were risks in building a career solely on talking animals. In 1920 Moses Koenigsberg, president of Hearst's King Features Syndicate, spelled out his views of what makes a good comic. Newspaper features, he emphasized, are built around human beings. "As an illustration of what I mean, let us analyze 'Bringing Up Father,' which is the strongest comic feature in the world today—the ideal 'funny,'" he wrote. Koenigsberg singled out McManus for keeping his comic "both human and humorous."

Yet Herriman's only remaining "human" strip, *Baron Bean*, had recently concluded its three-year run. As with *The Dingbat Family*, the end came suddenly. The Baron had been going on far-flung adventures that took him far from his roots in Dickens and Chaplin. Then, in the final *Baron Bean* comic on January 22, 1919, the Baron watches as Grimes plunges in an icy lake. Hoping to impress some nearby bathing beauties, the Baron considers joining him. With that, the Baron departed from Hearst's pages for good.

Shortly after Baron Bean's exit, Herriman began unrolling a new series of domestic comedies. In March 1919, he attempted to revive his decade-old title *Mary's Home from College*. Mary's beleaguered father, now named Simeon, runs a soap works—the same kind of factory that stood near Herriman's first boyhood home in downtown Los Angeles. The restaging was a sharp and focused comedy, and the

From *Mary's Home from College*, March 12, 1919

new Mary was one of Herriman's better-drawn female characters, with sly eyes and a stylish sense of fashion. The action took place in the living room and backyard of a middle-class family, with shifting Arizona landscapes hanging on the walls, and Navajo symbols decorating the clothing and furniture. Plots revolved around Simeon's attempts to not embarrass his daughter.

In one strip, Simeon chats up a sporting lad on the subject of race-horses, then adds that he likes his horses bony and cheap so he can make a better profit on his soap. Mary, mortified, begs her father to not reveal his first name:

"Now tell your ole 'dad,' what's wrong with the name of 'Simeon'?"

"Wouldn't you feel awful if some of your friends should spell your name 'S-I-M-I-A-N' instead of S-I-M-E-O-N sometime, wouldn't you?"

The joke hints at family secrets, with even a whiff of minstrel humor in the monkey reference.

Despite its considerable charms, the new *Mary's Home from College* was quietly retired. Next up was a brand-new title, *Now Listen Mabel*, which debuted in April 1919 with much more fanfare. To promote the new strip, King Features enlisted Koenigsberg's favorite, George McManus, to contribute a picture of his main character, Jiggs, reading a newspaper and laughing. Beside the drawing, McManus offered a testimonial:

Dear George:

Just a line to compliment you on your new series "Now Listen Mabel." If my judgment is worth anything I think it is going to be the one big hit—keep up the good work as you surely have a winner.

Yours truly

George McManus

Now Listen Mabel introduced Mabel and her boyfriend, a shipping clerk named Jimmie Doozinberry. Mabel and Doozinberry's boss, Mr. Sisstim, regularly conspire against Doozinberry until he finally cries out, "Now, listen, Mabel." Although "Mabel" was the name of both Herriman's wife and his oldest daughter, the likely inspiration was a popular collection of gag verses with the punch line "Ain't it awful, Mabel?" Herriman also must have noted the success of Rube Goldberg, who based several strips on catchphrases, most notably *I'm the Guy*. However, *Now Listen Mabel* was not destined to become the country's next catchphrase, and the strip concluded before the end of the year.

C oming at the height of popularity for *Krazy Kat*, George McManus's note that Herriman had finally found his "one big hit" is odd praise, suggesting that *Krazy Kat* was far from an unqualified success. Herriman's philosophical musings, literary allusions, restless desert scenery, and enigmatic lead character made for a challenging read. In fact, it's long been debated just how Herriman managed to keep *Krazy Kat* in the Hearst comics empire at all.

Comics scholars have advanced the notion that Hearst himself took a special interest in *Krazy Kat*, with the Chief even granting Herriman a lifelong contract and directly intervening when editors wanted to drop the comic. Hearst did involve himself in the selection and upkeep of cartoons in his newspapers, from his involvement in the turn-of-the-century *Yellow Kid* wars right up to personally approving the acquisition of *Beetle Bailey* in 1950. Yet there is no direct evidence that he was a particular defender of Herriman. In fact, on more than one occasion Herriman worried that readers weren't enjoying his work and that he might lose his contract altogether.

On the other hand, there can be no doubt that Hearst appreciated having an acknowledged "Genius of the Comic Page" in his employ. This is suggested in a letter that Hearst editor Arthur Brisbane wrote to editor Cissy Patterson in 1931, shortly after Patterson took charge of Hearst's Washington, D.C., newspapers. Patterson had inquired about adding a special page for refined readers. "I have been thinking about your desire to print a highbrow page," Brisbane responded. "It might be a good page, but I don't think very much of the highbrow stuff that the American is carrying. The World had it and died, which is not a good omen. I believe however that Mr. Hearst thinks very well of the page, and of course his opinion is of more importance than mine, especially in newspapers that he owns."

Notably, a centerpiece of the *New York American*'s "highbrow" page was its weekly *Krazy Kat* strip.

If Herriman was modest—even self-effacing—about his comics and their popularity, he clearly had no interest in compromising his vision for *Krazy Kat*. His disdain over drawing "idioticies for the edification of an inartistic majority" hadn't changed since his *Bookman* interview twenty years earlier. Wrote William Paul Langreich in a profile of Herriman for the January 1922 issue of *Cartoons Magazine*:

Herriman is dissatisfied with the strip. . . . While he regards his work as an inferior attempt at humor, his efforts to improve it have raised the standard of his strip to a plane far above the usual run of strips; his drawings are inimitable and his humor both subtle and original. But early in its existence, he made a mistake by allowing Ignatz to abuse Krazy. Little did he know that the public would acclaim this action as real humor and demand its repetition. As a result, he tries to omit his signature as often as the editors will let it get by, which does not happen very frequently. . . .

Authorities, too, agree with the writer that Herriman is one of the cleverest comic artists drawing for the American press and that his is the work of a genius. However, his endeavor to gear it down to the demand of the everyday newspaper reader causes a loss in value which results in work far below the standard he sets for himself and is quite capable of reaching.

Langreich also noted Herriman's knowledge of Navajo art as well as his facility with Spanish:

Languages don't faze Herriman one bit, and it is common to find a strip whose individual pictures are numbered by spelling out the names of the numbers in Spanish, French, German, or Honky Tonk. Can it be surprising, then, that his stuff shoots over the heads of his readers unless every effort is exerted on his part to "keep down to earth?"

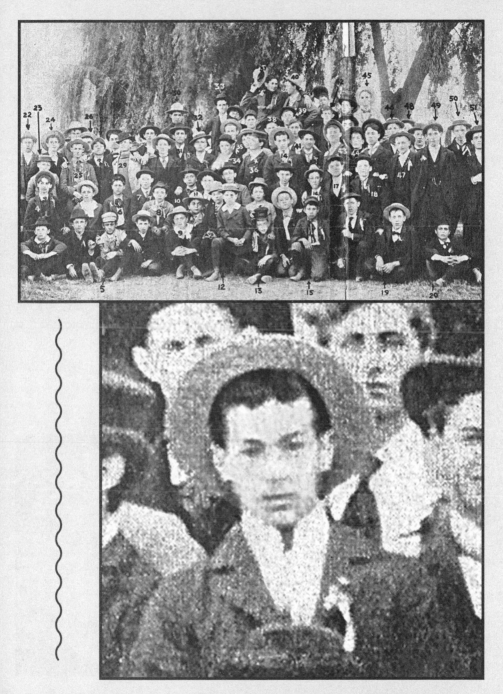

George Herriman at fifteen years old, during St. Vincent's College's field day, May 13, 1896. This is the first known photograph of Herriman.

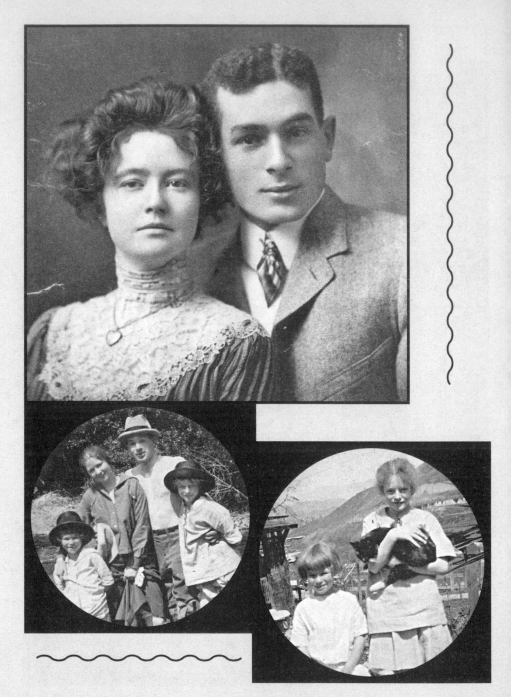

George Herriman and Mabel Bridge were married at the Bridge family home in Los Angeles on July 7, 1902, when Herriman worked for the *New York World*. Mabel "Toots" Herriman was born in New York the following year. Their second daughter, Barbara "Bobbie" Herriman, was born in Los Angeles in 1908.

(Courtesy of Dee Cox)

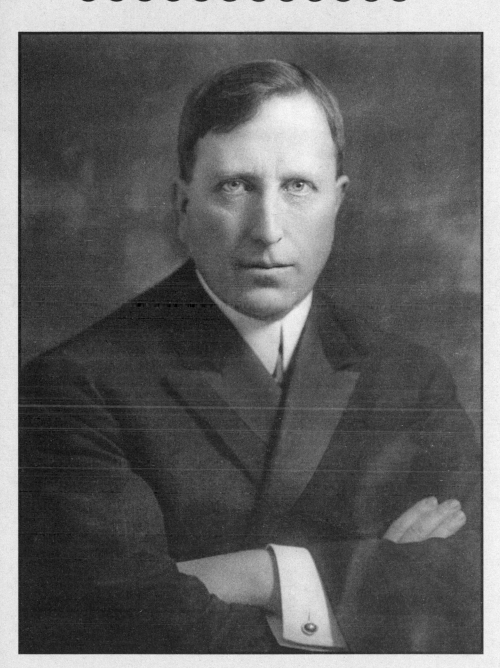

From the start, William Randolph Hearst took a special interest in the comics in his newspapers. "He never cared to have people around him who didn't understand humor," cartoonist Jimmy Swinnerton said.

(Courtesy of the Harris & Ewing Collection, Library of Congress, LC-H25- 28275-D [P&P])

(Clockwise from top left): Gus Mager, Charles H. "Duke" Wellington, George Herriman, Harold A. MacGill, Isaac Anderson, and Harry Hershfield at the *New York Evening Journal* offices on January 31, 1911.

(Clockwise from top left): Wellington, Hershfield, Mager, and Herriman. Said Herriman: "I think the men gathered around there more as a club, than the work. They just liked to be together."

(Courtesy of the Harry Hershfield Collection, The Ohio State University Billy Ireland Cartoon Library & Museum)

Cartoonist Thomas Aloysius "Tad" Dorgan, c. 1920. Herriman considered Tad "the greatest fellow that ever lived." *(Courtesy of Peter Huestis)*

Rudolph "Rudy" Dirks, Armory Show artist and creator of *The Katzenjammer Kids*, tried without success to get Herriman to attempt painting.

George Herriman, c. 1922.
(*Courtesy of Dee Cox*)

John and Louisa Wetherill (center) in front of their house in Kayenta, Arizona, with
Betty Rodgers (at John's right) and her sister Fannie (at Louisa's left), along with an
unidentified friend. Betty Rodgers later recalled how everyone in the family laughed at the
jokes about Kayenta that Herriman added to *Krazy Kat*.
(*Courtesy of Harvey Leake/Wetherill Family Archive*)

Herriman as Krazy Kat, in a drawing in the Wetherill guest lodge registry, June 1924.
(*Courtesy of Harvey Leake/Wetherill Family Archive*)

Jimmy Swinnerton with Kayenta postmaster Clyde Colville. Herriman would work closely with Colville to establish movie nights in Kayenta's tuberculosis sanitarium.
(*Courtesy of Harvey Leake/Wetherill Family Archive*)

In July 1926, Herriman immortalized an all-family visit to Kayenta with a caricature in the Wetherills' lodge registry.
(Courtesy of Harvey Leake/Wetherill Family Archive)

Herriman and cartoonist Tom McNamara look over the Grand Canyon's Isis Temple
and Cheops Pyramid following a visit to Kayenta.
*(Courtesy of the San Francisco Academy of the Comic Art Collection, The Ohio State University
Billy Ireland Cartoon Library and Museum)*

George, Toots, and Bobbie Herriman, from a late-1920s session with Hollywood photographer Will Connell. *(Courtesy of Will Connell Jr./Will Connell Collection, Department of Special Collections, Charles E. Young Research Library, UCLA)*

Will Connell's "cabinet card" series included his friend Herriman in a giant sombrero.
(Courtesy of Will Connell Jr./UCR/California Museum of Photography

Herriman with his closest friend, Harley M. "Beanie" Walker, in a photograph taken on the Hal Roach lot by Bud "Stax" Graves.
(Courtesy of Rick Marschall)

The Herriman home on Maravilla Street in the Hollywood Hills. Inside, Navajo rugs covered the floor and a thick zigzag stripe was painted down a living room wall. "Oh, it was wild," cartoonist Bud Sagendorf remembered about the house. "You'd swear to God he'd drawn it."
(Courtesy of the Bruce Torrence Collection)

Ernest Pascal with George and Bobbie Herriman, at George's home on Ernest and Bobbie's wedding day, May 22, 1932. George's wife, Mabel Herriman, had died just eight months earlier.
(Courtesy of Patti Pascal)

George Herriman with his granddaughter, Dinah "Dee" Pascal, who was born in 1935. Photographs and cartoons from this time reveal Herriman's deep affection for his daughter Bobbie's only child.
(Courtesy of Dee Cox)

In summer 1936, Herriman traveled to Arizona with Jack Roach and Jack's daughters, Barbara and Lola. "George laughed every time I got in trouble," Lola remembered, "a deep-throated, lovely laugh."
(Courtesy of Harvey Leake/Wetherill Family Archive)

A portrait of Herriman by photographer Bud "Stax" Graves from the late 1930s, apparently from a series taken for Louise Scher Swinnerton. "If you think I was having fun getting this ordeal over," Herriman wrote to Louise, "you're nutty."
(Courtesy of Rob Stolzer)

By the early 1940s, Louise Scher Swinnerton was wearing an engagement ring from Herriman, recalled her grandson Dave von Savoye.
(Courtesy of Harvey Leake/Wetherill Family Archive)

George Herriman at his desk, c. 1940.
(Courtesy of Dee Cox)

Herriman's friend Elmer Raguse, a sound engineer who worked for Hal Roach, joined Roach and
Herriman for Roach's army induction party in summer 1942. This is the last known photograph
of Herriman.
(Courtesy of Craig Raguse)

Langreich titled his profile "Toots Herriman Tells the World About Krazy Kat," and he had contacted the cartoonist's oldest daughter via Tom McNamara. The profile offers a rare, fleeting glimpse into how Herriman's wife, Mabel, and two daughters, Toots and Bobbie, felt about his work. "Both youngsters agree with their mother that the originator of Krazy is all wrong when he tries to underestimate his strip," Langreich reported.

K*razy Kat* might not have had universal appeal, but as Langreich noted, it was beloved by those readers whom Hearst most wished to impress. Artists and intellectuals in the early 1920s considered *Krazy Kat*, a self-conscious comic strip in a state of constant reinvention, an emblem of a modern age. Certainly both Hearst and Brisbane took notice when writer and Algonquin Table regular Robert Sherwood stated, "Like the rest of 'The People Who Think,' I much prefer Krazy Kat to Arthur Brisbane."

Herriman's "human" strips might have foundered, but beginning on March 4, 1920, King Features doubled down on *Krazy Kat* with a nearly yearlong long run of the "panoramic dailies," or complex, detailed daily *Krazy Kat* strips that rivaled his weekly comics in narrative and graphic splendors. On May 29, *Fourth Estate* claimed that *Krazy Kat* now was read by an impressive ten million readers in newspapers across the country, the first such accounting reported. (No data was offered to back the numbers.) The magazine also reported that Herriman, who by now appears to have left the McAlpin hotel to rejoin his family, threw a party in Los Angeles to celebrate the tenth anniversary of *Krazy Kat*, and that fan letters came from everyone from singer Enrico Caruso to Bethlehem Steel magnate Charles Schwab to writer P. G. Wodehouse, who targeted his praise to the highbrows: "In Krazy Kat Mr. Herriman has got what Wagner was groping for in 'Parsifal.' It is my opinion that, if George Ade, Velazquez, the Broth-

ers Grimm, and Lord Dunsany had got together and collaborated, they might have turned out something about as good as Krazy Kat, but I think even then that Mr. Herriman would have had the edge on them."

Herriman's most perceptive (and persistent) fan would be the critic Gilbert Seldes, who first wrote about Herriman and *Krazy Kat* in the summer of 1920 after Seldes signed on as managing editor of the literary journal the *Dial*. For Seldes, *Krazy Kat* would serve as the linchpin for his goal of expanding criticism to popular culture—the "lively arts," in Seldes's phrasing. There was no better way to spark a cultural argument than to suggest the artistic merits of a comic strip. Seldes welcomed the fight.

Only twenty-three years old when he first wrote about *Krazy Kat*, Seldes admired arts with "high spirits . . . fantasy, gayety, but above all, *intensity*," in the words of his biographer Michael Kammen. Seldes also was intellectually equipped to keep up with Herriman. He'd come of age on a utopian farm colony in southwest New Jersey, the child of a freethinking Russian Jew who made sure there were plenty of books available for both Gilbert and his older brother, George, later to become a renowned journalist. Gilbert Seldes went on to study English literature at Harvard, where he met fellow *Krazy Kat* enthusiast E. E. Cummings. Seldes didn't seem to notice the *Krazy Kat* pages on Cummings's dormitory wall, for he later recalled that he first encountered Herriman's comics when apprenticing at the *Pittsburgh Sun*, where he had been instructed to learn the contents of the comics page.

To Seldes, *Krazy Kat* was no less than the savior of the American newspaper. In his initial appraisal of *Krazy Kat*, he wrote that the "cult of the genius of the comic strip who has created the fantastic little monster is a growing one." He added: "If we have to condemn utterly the press which demoralizes all thought and makes ugly all things capable of beauty, we must still be gentle with it, because

Krazy Kat, the invincible and joyous, is a creature of the press, inconceivable without its foundation of cheapness and stupidity. He is there to enliven and encourage and to give much delight."

The wash of praise over Herriman continued when Roy McCardell published his extensive, albeit fanciful, profile of his old friend in the *New York Morning Telegraph* on Sunday, August 22. Appearing on Herriman's fortieth birthday, the article told the questionable tales of Herriman riding the rails to New York and becoming a carny barker for Bosco the snake eater. With more sincerity, McCardell added: "Of his own work, all artists, serious or comic, are unanimous in agreeing that they contain more innocent whimsicality and more real genius, more real genuine humor, than is found in the work of any other of the humorous artists of today. And all his work reflects his own quaint, modest, human, lovable personality."

Next up was Damon Runyon, who took his turn praising his friend in his syndicated column, adding just one complaint:

I don't know whether he is aware of it or not, but he is the cartoonists' cartoonist. By that I mean he is their favorite. I have talked with many of them in my time and I have yet to find one that did not immediately declare that George is the greatest of them all in point of humor, originality and execution.

Personally, Herriman is so modest and self-effacing that he is almost annoying. He talks very little, and then in a soft, low tone. He is full of sentiment and it leaks out through his pen.

A s he received adulation in the New York press, Herriman was being embraced as a kindred soul by native and expatriate writers and artists in Paris, who eagerly passed around *Krazy Kat* comics as they were developing their ideas about surrealism.

The entrance of *Krazy Kat* into postwar Paris art and literature

circles can be traced to E. E. Cummings. During World War I, Cummings volunteered as an ambulance driver; on a ship to France he met fellow volunteer William Slater Brown. The two men were imprisoned in Normandy for voicing antiwar opinions, and Brown eventually joined the circle of Harvard graduates—which included Cummings, Seldes, Summerfield Baldwin, and painter Edward Nagle—who devotedly followed the movements of Krazy Kat and Ignatz.

After the war, Cummings was in Paris, penning letters home from various hotels and restaurants, thanking Nagle and Brown for sending

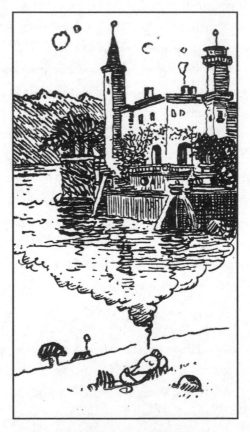

From *Krazy Kat*, July 31, 1915

him "The Krazies." These comics were jealously guarded. "Thank you moreover for a Kat of indescribable beauty," he wrote Brown. In another letter, he added, "The batch which G. Seldes brought over he wanted to put with his own collection, so I let him—keeping the later arrivals myself, as you direct." In many of his letters, Cummings added lines such as "many thank youzes." Over time, this mimicry of Krazy Kat's voice would carry forward into Cummings's own verses.

The circle of fans widened when Columbia University student Matthew Josephson traveled to Paris to make his way as a poet, befriending writer Louis Aragon. Josephson and his new friends were fond of raising hell in the public square, getting drunk and standing on chairs to recite Hugo or read from German socialist tracts. In quieter moments they reflected on the latest treasures of the comic page. Josephson later recalled how he furnished Aragon and writer Philippe Soupault with "a goodly store of recent 'Americana' in the form of 'Krazy Kat' cartoon serials by George Herriman."

The surrealists celebrated in *Krazy Kat* the complexities that some other newspaper readers were lamenting. Herriman layered *Krazy Kat* in visually and verbally dense allegories of fate and free will, good and evil, and reality and illusion:

> KRAZY: And as for that "rock," hoh-chee I fear it not—it's a mere drawing—a mere harmless delineation—
> IGNATZ (looking at reader): Somebody's told that "cat" something.

Herriman persisted in his interrogations. He toyed with notions of identity and social status, mixing up a swan for a duck, or a rash-covered lark for a robin redbreast. He switched out Krazy and Ignatz's colors as often as he did the cacti of Coconino. Some comics explicitly dealt with race—or as explicitly as possible in an all-animal comic. In one strip Ignatz lies by the sea until he has "worked up an elegant coat

of tan." Krazy, upon seeing the darkened Ignatz, offers a rare brick toss, with the line, "Dagnabya!!! Dunt think I'm no 'Desdeamonia' you Otello."

In another, Krazy Kat's tail betrays kinks similar to those in the hair that hid beneath Herriman's hat. "Gosh!! What a kinky tail," Ignatz says. "Kinky my elbow," says Krazy, "I just had it marcelled." "Marcelled" referred to using hot tongs to straighten curly hair or create a wave; at the time this comic appeared, dancer Josephine Baker was famously sporting the style in the Broadway musical *Shuffle Along.*

There are gags about "li'l Eetiyopian mice" and a "koffa-kullid kickipoo." Ignatz turns black and is shunned by Krazy. Krazy turns white and Ignatz becomes infatuated. In another comic, a black Ignatz and a white Krazy Kat regard themselves in shock as they slowly transform back to their original colors. Then they awaken in bed together, having just shared the same dream.

Such dream logic was championed by writer Andre Breton, a close colleague of Aragon and Soupault's, when he penned his first "Manifesto of Surrealism" in 1924. "Surrealism is based on the belief . . . in the omnipotence of dream, in the disinterested play of thought."

So was Coconino:

> **KRAZY**: Efta all, 'Ignatz, what's it all about anyhow?
> **IGNATZ**: What?
> **KRAZY**: I esk you, what's life?
> **IGNATZ**: Only a dream, I'd say
> **KRAZY**: Yes—and what's a drim?
> **IGNATZ** (throwing brick): Aah—shux, you want to know too dern much.

In later years *Krazy Kat* would frequently be discussed in terms of surrealism. Yet the surrealists were trading on the sort of imag-

inative wordplay and visual audacity that had been in comics for years, and had specifically been turning to *Krazy Kat* itself for inspiration. Perhaps, as comics scholar Mark Newgarden has suggested, it might be more appropriate to call the work of the surrealists "krazy."

MIST

IGNATZ: Now, "Krazy," do you look upon the future as a pessimist, or an optimist?
KRAZY: I look upon it as just mist—
　—*Krazy Kat*, April 23, 1921

From the time of his early childhood in New Orleans, George Herriman's life and career paralleled the growth of jazz and popular music in America. Herriman reviewed early-century Los Angeles ragtime concerts and visited Tin Pan Alley songwriters, and his comics revealed a broad knowledge of minstrel and vaudeville tunes. In 1917, when the word "jazz" was first beginning to show up in newspapers nationwide, he included it as one of the sounds made by the slinging of Ignatz's bricks.

That same year in Los Angeles, Herriman received a pair of visitors who would convince him to embark on his own musical venture. Composer John Alden Carpenter and his twelve-year-old daughter, Ginny, were fans of *Krazy Kat* comics, which they could read together in the *Chicago American*. While on vacation in California, they tracked down the cartoonist so Carpenter could introduce an unusual idea: adapting Herriman's characters into a jazz ballet.

"Herriman's cartoons delighted me," Carpenter later recalled. "Yet when I suggested the composition of a Krazy Kat ballet to him on the occasion of our first meeting many years ago in Los Angeles, he was frightened to death."

Carpenter enlisted his young daughter to ease Herriman's mind. "She curtsied prettily when she was introduced, and said, as she had been taught, 'I'm very pleased to meet you.' Herriman grinned broadly and answered, 'Miss Carpenter, you're very easily pleased.'"

Following their first meeting, Herriman drew Ginny a picture of Krazy Kat and Ignatz, which he mailed to the Carpenters' home in Chicago. Then, in mid-1920, perhaps nudged by Seldes's article in the *Dial*, Carpenter again contacted Herriman to discuss a ballet. He would need to speak with Moses Koenigsberg at King Features to obtain rights. Yet Carpenter didn't just want Herriman's characters—he wanted Herriman himself to collaborate on the project.

Herriman sent his reply via telegram:

BY ALL MEANS SEE KOENIGSBERG HE IS A GOOD SCOUT AND ALSO
SLIP ME A LITTLE INFORMATION ON WHAT YOU WANT ME TO DO
OPERA BALLETS AND I ARE TOTAL STRANGERS HELP THINE

GEO HERRIMAN.

Herriman then elaborated his concerns in a longer letter to the composer:

I've never had any idea that these few humble characters of mine would ever have been asked to mingle with the more aristocratic arts, and Must say it is all very shocking to me. I can't imagine K. Kat, I. Mouse, O. Pupp, and J. Stork cavorting and pirouetting en ballet to save my life. However, let's hope the audience

doesn't get their cue from Ignatz and pack a few bricks in with them—with evil intent.

Carpenter was not dissuaded, and he composed the music for *Krazy Kat—A Jazz Pantomime* in summer 1921. He scheduled a Chicago musical premiere in December, to be performed by the Chicago Symphony Orchestra in Orchestra Hall. The following month he would debut the full ballet in New York. As Carpenter had hoped, Herriman fully collaborated, even devising a method of translating the shifting scenery of Coconino to the stage by unrolling a series of original cartoons behind the main action "like a sideways paper towel," Gilbert Seldes recalled.

One memorable fall evening in Chicago, shortly before the premiere, Herriman visited Carpenter at the composer's home on Rush Street. It's not clear just how Herriman arrived in Chicago or with whom he might have been traveling. The visit was memorialized in a letter that Herriman sent a decade later to Ginny Carpenter:

> In your Chicago home one evening your Father was going over this music on the piano, and his sound effects of the winds—all vocal, was amazing—The way he Bassooned—pump-horned, & saxophoned would have made the Mills Brothers all go out and get whooping cough—and that's what a really fine man of music—gets when he attempts to raise a strip cartoonist to his level. I do hope your amiable father has lived it down.

Herriman also recalled his first meeting with Adolph Bolm, a Russia-born dancer who had agreed to choreograph the ballet and perform the role of Krazy.

> And I remember well your gifted "pappy"—I get myself a big laugh yet, when I think of the magic he had to use to

coax the great Bolm into a cat clog—it did something to his choreography—and the "Pupp Officer" had him worried too— he pulled me aside once and asked for the low down on "Officer Pupp"—wanted to know just what he was supposed to be— when I said he was a bull dog—well—the scorn of a Russian heel tapper is something to be smitten with—

Despite Herriman's recollections, Bolm actually shared both Carpenter's enthusiasm for the project and affection for *Krazy Kat*. To Bolm, *Krazy Kat* was an American folktale much like the Russian folktales that had inspired his previous dances. Wrote Bolm in his memoir: "If you seek subtlety there are fine meanings in Krazy Kat's amazing gestures. If you are blunt, there is hearty laughter in his incessant brick dodging."

In both Chicago and New York, the team of Carpenter, Bolm, and Herriman went to work. Along with designing the scenery, Herriman collaborated on costumes and wrote the story, which he previewed in

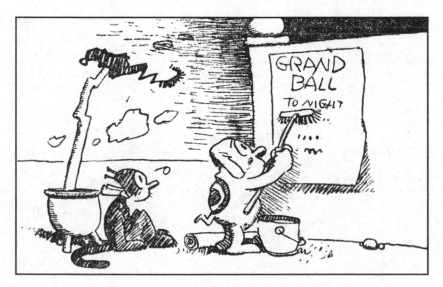

From *Krazy Kat*, July 31, 1921

a *Krazy Kat* comic. In it, Krazy Kat is asleep, and Officer Pupp walks by with an "All's well." Krazy wakes to see a sign for a grand ball. Finding a dress on a clothesline, Krazy puts it on and begins dancing. Ignatz, costumed as a mysterious stranger, brings catnip, which is inhaled deeply, leading to more feverish dancing. A brick is hurled, knocking Krazy Kat out. The story ends as it begins, with Krazy asleep and Officer Pupp walking by with another "All's well."

Carpenter scheduled the premiere for the afternoon of January 20, 1922, at Town Hall, a theater that had opened near Broadway one year earlier as a meeting hall for suffragists and had become a center for both the political and cultural vanguard. (Just a few months before the ballet, Margaret Sanger, the future founder of Planned Parenthood, was arrested onstage for advocating birth control.) A well-heeled audience filed into Town Hall that Friday afternoon, paying thirty dollars for box seats and three dollars to sit in the balcony. Actors John Barrymore and George Arliss were among those in attendance. A lengthy program preceded *Krazy Kat*, which had been scheduled to be the final act in the show. The *Krazy Kat* ballet couldn't come soon enough for music critic Deems Taylor, who reviewed the program for *Vanity Fair*:

From *Krazy Kat*, July 31, 1921

One Friday afternoon last January, about half-past five, a weary audience sat in the Town Hall, on Forty-third street, wistfully thinking of its dinner. The concert, announced for three o'clock sharp, had begun half an hour late, and amateur stage management had dragged matters abominably. The program had been long and "modern." . . . Everything had been frightfully cultured and artistic—the sort of afternoon that makes you want to rush home and tear the word modernist out of the dictionary.

It may have been the sharp contrast with what had gone before that made John Alden Carpenter's Krazy Kat ballet-pantomime seem such an important event when it finally arrived. For when the curtains parted, displaying Adolph Bolm, simply and tastefully attired as a kat, peacefully asleep in the shade of an outrageous Herriman tree, and the small orchestra manfully girded up its loins to give an excellent imitation of a snore, everybody relaxed and grinned. Nothing arty about this exhibit. Here were funny noises that were meant to be funny.

Also at Town Hall that afternoon was an unnamed critic for the *Bookman*, who noticed Herriman himself in the audience. The *Bookman* critic tried and failed to get Herriman to comment on a flattering essay that John Carpenter had written for the program:

At the Town Hall, then, one memorable afternoon recently, we beheld this "jazz pantomime." We were entranced by the whimsical black and white scenery; by the jolly burlesque of the Spanish fandango and the Al Jolson type of gamboling; by the impish gyrations of tiny white Ignatz; and by Krazy Kat's—well, his mug, if you know what we mean, and his inimitable way of sleeping, legs crossed, hands behind his head. There were gorgeous snores from the orchestra and the saxophone laughed as only a saxophone can.

There was a highfalutin paragraph in the program representing

Krazy Kat as "Don Quixote and Parsifal rolled into one." We asked Mr. Herriman about this, but he was completely dazed by the audience and expressed a desire to take his child back to the offices of the "Journal," away from the influence of these high-brows. Krazy Kat was, he explained, the result of an office boy's attaching to Mr. Herriman's drawings the picture of a cat. Like clowns, cartoonists must be serious critters; at any rate so we found Krazy Kat's parent.

The entire ballet lasted a brief ten minutes, with a modest pit orchestra similar to a small dance band providing the music. All went according to rehearsal, except for one unfortunate piece of stage business when Ignatz's brick missed Krazy Kat's head. The audience didn't seem to mind, for at Pupp's final "All's well" they erupted in applause, calling both Carpenter and Herriman to the stage to receive ovations.

Critics raved about Herriman's set. Writing in the *New Republic* about a later performance, Stark Young said, "The light is so managed that the cartoons at the back, turning on rollers and changing every two or three minutes against the action in front of them, the costumes in black and white, the walls, the grayish trees on either side, take on a strange pearl color, as if we were seeing in some crazy dream the fantastic action of these fabled creatures whose human traits are all turned now to flickering inclinations and fragile passions and the shadows of whims."

Reviewers were not so kind to Carpenter's score and Bolm's dancing. With *Krazy Kat*, Carpenter had become the first composer to bring jazz to the concert hall—Gershwin's *Rhapsody in Blue* would premiere two years later. Yet critics complained that this jazz was too tepid, with even Herriman's home newspaper, the *New York Evening Journal*, saying the music was "as mild as the cooing of a ragtime dove."

In fact, one of the harshest critics was Gilbert Seldes himself. He

applauded Carpenter and Bolm for turning to the comics page for inspiration, yet found the performance lacking. Carpenter's jazz, he said, was "sufficient." However, Seldes added, the composer "missed the enormous tenderness of Krazy's love, as Mr. Bolm missed the exquisite grace of heart in that adorably ugly body."

After two performances at Town Hall, Carpenter revived *Krazy Kat* for the annual Greenwich Village Follies, then for performances in Detroit and Boston. Later in the decade it was staged as a puppet show for a college audience in Granville, Ohio. Then the lights dimmed on *Krazy Kat—A Jazz Pantomime*. Yet, despite its modest success, the ballet elevated a reluctant Herriman into still higher cultural realms. Henrietta Straus, writing in the *Nation*, was surely unaware of Herriman's racial history when she wrote that "here at last was a representative work by a representative musician that was neither sectional nor racial in its inspirational sources, yet so purely American that it required a strong consciousness on the part of its interpreters." Added Deems Taylor: "Perhaps some of us, that afternoon, realized a little more clearly what 'American' means."

D eems Taylor, in his review of the *Krazy Kat* ballet for *Vanity Fair*, revealed the sharp divisions among readers concerning Herriman's work. "You know Krazy Kat, don't you," Taylor wrote. "It is what might be called the internecine school of humour: either you are pro-Kat, and pity the antis, or you are anti-Kat, and conspuez les pros! It's like Alice in Wonderland or French oysters: you worship or loathe."

In fact, in the summer of 1922, the popularity of *Krazy Kat* preoccupied New York magazines to a remarkable extent, especially Edmund Wilson's *Vanity Fair*. In April, *Vanity Fair* published a much-discussed "New Order of Critical Values," with ten critics offering their rankings of "the whole field of life and thought," ranging from

Shakespeare (who polled highest) to baseball player turned preacher Billy Sunday (who polled lowest). *Krazy Kat* scored somewhere in between; not surprisingly, critics Gilbert Seldes and Deems Taylor gave the comic the highest marks, with H. L. Mencken and Edmund Wilson rating it in the middle, and one critic, George Jean Nathan, ranking it at the very bottom. The *Bookman* noted that only Napoleon sparked as much dissension among the critics.

Wilson also contacted Herriman to include him in *Vanity Fair*'s April "Hall of Fame." Herriman responded by sending a sampling of photographs, along with a letter expressing his gratitude:

From *Krazy Kat*, April 16, 1922

Dear Mr. Wilson

> Here be a few photographs
> of "me" not good, because
> the subject ain't good—
> However they are the best I have,
> as I'm really a bit cagey about
> having myself mugged—
> I've never sat in a regular
> photo gallery in my life—
> these are accidentals
> Thanks for the honor
> thrust upon me—

> Thine in the Glory

Geo Herriman

Wilson selected a portrait of Herriman holding a cat, which the magazine published alongside photographs of that month's other inductees: poet Edna St. Vincent Millay, philosopher Bertrand Russell, and composer Darius Milhaud. *Vanity Fair* saluted Herriman "because he has invented in his comic series, 'Krazy Kat,' a nonsense creation which, for humor and originality is comparable only to 'Alice in Wonderland.'"

The next month's *Vanity Fair* featured yet another article about Herriman, a two-page essay by Gilbert Seldes titled "Golla, Golla, the Comic Strip's Art!" Seldes voiced his outrage that the recent book *Civilization in America* didn't give proper due to comics, which he called "our one artwork, our one contribution to world culture." Ignatz's brick, he wrote, "is the only symbol in modern art which I fully understand."

Some readers remained exasperated by *Krazy Kat* lines such as this

one: "Kuriosity has led our heroine thus far—but seeing what he sees 'kuriosity' no longer impels her—he is now actuated with a sweltering suffusion of benevolence." Here, Krazy's gender switches no fewer than three times in one sentence. Yet others embraced these absurdities, including some in the underground gay culture. As a young woman, pioneering lesbian writer Jeannette Howard Foster received a gun as a gift from her father; she named the gun "Ignatz." And in Washington, D.C., a new bohemian club opened under the name Krazy Kat. A travel article of the time described a green door in an alley that led to a large, smoke-filled room lined with cubist prints and "at least one short-haired smoking female to match the decorations."

Herriman was never in his lifetime considered an African-American cartoonist. Honors for pioneering black cartoonists rightfully go to E. Simms Campbell, whose work helped launch *Esquire* in the 1930s, and Jackie Ormes, who beginning in the late 1930s staked an impressive career in the black press. Neither is there any evidence that black readers interpreted anything in *Krazy Kat* as overtly racial messages. Yet Herriman's work was appreciated by a towering figure in the Harlem Renaissance. In 1923, poet Langston Hughes voyaged to Africa and in a letter described a shipmate from Kentucky. "He used to make up his own Blues—verses as absurd as Krazy Kat and as funny," he wrote.

As fans and critics discussed and debated his work, Herriman planned to escape the fray. He completed several strips in advance and, on Monday, July 31, 1922, departed New York, most likely by train. He arrived in the middle of the week in Tucson, Arizona. There he was greeted by an old friend and mentor who always argued for the desert over the big city: Jimmy Swinnerton.

In the years following his desert recovery, Jimmy Swinnerton had become an apostle of the Southwest, painting its hidden landforms and telling all who'd listen about its wonders. He wore tall boots

and kept his hair short, with one observer noting that he looked more like a gold panner than an "off-kilter artist" but for the "delicate sturdiness of his long fingers and a mysterious appraising look in his slate-gray eyes."

Swinnerton counted Hopi and Navajo elders among his teachers and friends, and brought his daughter to Hopi dances. "I want Mary Elizabeth . . . to see and understand them," he said. "I can't say as much for some of the dances in the ball rooms of the private homes of our best people."

After meeting Herriman at the Tucson train station, Swinnerton drove him north to Flagstaff, which had become Swinnerton's second home. There the party grew, adding Rudolph Dirks and Swinnerton's wife, Louise Scher Swinnerton.

Such a gathering of well-known cartoonists caused a stir in local society. "This year R. Dirks, originator of the Katzenjammer Kids, and George Herriman, famous originator of the Krazy Kat pictures, came to discover us and to help Jimmy enjoy his pioneer home," reported the *Coconino Sun*. "They all will leave the last of this week for Kayenta, to stay with the Wetherills for some time and explore that region, then will attend the snake dance and visit various reservations." The *Fourth Estate* noted that both Herriman and Swinnerton planned to "occupy themselves making pictures for a number of weeks after the dances are over. They will remain in Arizona, living in Indian villages until mid-autumn."

On Sunday, August 6, 1922, the Swinnertons, Dirks, and Herriman set off for Kayenta. Arriving at the Wetherills', each took a turn signing their names and drawing cartoons into the registry. Herriman added a drawing of Krazy Kat being splattered with a bucket of paint, inscribing, "At lest I am innitiated among the innamost sicrits of the painted desert, I am now a painted 'Ket.'" The next day the party was joined in Kayenta by painter Maynard Dixon, who was traveling through Arizona with his wife, photographer Dorothea Lange. For

the next several weeks this remarkable group of writers and artists used Kayenta as a base for camping trips throughout the region. John Dirks later recalled his father, Rudolph, telling him of his trips with Herriman: "They slept out, and he discovered it was pretty cold with his feet sticking out of a blanket. They would paint rocks and sand and George would laugh in his squeaky little voice."

On one trip, the party traveled by horseback to the Betatakin ruin, a cliff dwelling about fifteen miles from Kayenta. Louise Swinnerton later recalled camping under moonlight, talking in whispers about ghosts as owls screeched in the distance. They were more jocular in the daytime, with Rudy Dirks trying to fool the Wetherills by scratching a drawing of the Katzenjammer Kids on a rock and passing it off as an ancient artifact.

One horseback trip would be immortalized by Herriman in a cartoon he gave to the Swinnertons' daughter, Mary Elizabeth. In it, Krazy and Ignatz ride a pony while Officer Pupp snoozes at the base of a mesa. "Here's to you 'Mary Elizabeth' with full consent of the 'Momma' & The 'Poppa,'" Herriman wrote.

Mabel Herriman would later join her husband in Kayenta, but on this occasion she appears to have stayed home in Los Angeles with their daughters. Years later, Louise Scher Swinnerton would become romantically linked to Herriman. She would tell her grandson, Dave von Savoye, that the camping trip in Arizona marked the first stirrings of affection. "She and George had gone on a late afternoon horseback ride together in the desert, while Jimmy and my mother, Mary Elizabeth, napped," Von Savoye recalled. This, he said, inspired Herriman's cartoon, in which Officer Pupp, like Jimmy Swinnerton, slept peacefully.

There are, however, no more hints of a secret romance between Herriman and Louise. Herriman and Jimmy Swinnerton, meanwhile, remained lifelong close friends, bonded by their humor and their love of the desert. "They were wonderful friends," recalled Betty Rod-

gers, who was raised in the Wetherill family. "The jokes they told, you'd just die laughing."

After their desert explorations, Herriman, Swinnerton, and the rest of the party would return to Kayenta and gather for meals at the Wetherills' long table. Louisa Wetherill had found another attentive student in Dorothea Lange, who spent her days photographing the Hopi and Navajo.

On Tuesday evening, August 22, the group threw a party to celebrate George Herriman's forty-second birthday. Seated around the Wetherill table were Dirks, the Swinnertons, and Maynard Dixon and Dorothea Lange, along with Western painter William Robinson Leigh, Los Altas farmers Matthew and Loraine Benton, and the Wetherills' daughter, Georgia Kilcrease. Herriman was presented with a cake, which he cut and served. He also received a card that was signed by all present. Inscriptions ranged from sentimental ("Shall we ever meet again, dear Krazy Kat, the Song of Songs," wrote Lange) to joking ("Hoping I may some day get courage to have my hair cut like yours," said Benton). Jimmy Swinnerton drew his own Krazy Kat and added "Tossa los toros et procurta $ for it," which roughly translates to what appears to be his description of their profession: "Sling the bull and get paid."

Herriman and Dixon traded paintings, with Dixon presenting Herriman with a large depiction of a Navajo man on horseback, titled *Shepherd Boy*. Herriman gave Dixon and Lange an equally sizable cartoon that commemorated a journey they all took together through Monument Valley. In it, Pupp, Kat, and Ignatz stand atop the Mittens, peering down at Dixon and Lange. "Do you know who they is, 'Offissa Pupp'?" asks Krazy. "One of them is 'Maynard Dixon,' I cant make out who the other 'fella' is—" says Pupp. An ornate inscription reads, "To Mr. & Mrs. Maynard Dixon—Recalling a pleasant little pasear in that dear disierto pintado."

Herriman, deeply grateful for the day, also presented a drawing to

the Wetherills. In a wash of deep reds and oranges, Krazy is hanging from a branch while Ignatz is being chased from a cave by coyotes. On it, Herriman inscribed, "To Mr. & Mrs. John Wetherill—which is no way to repay them for their kindness & hospitality—BUT— what can you expect from a 'KRAZY KARTOONIST'?"

Before leaving Arizona, Herriman joined Jimmy Swinnerton for one more adventure. The pair traveled on horseback sixty miles out from Kayenta in search of a certain waterfall that Swinnerton hoped to paint. At one point they tied up their horses and entered a maze of tall cliffs, searching for a place to fill their canteens. A heavy mist settled over them, and Herriman and Swinnerton realized they were hopelessly lost. Two days passed; their maps and compasses were of no help, and food was running short.

From *Krazy Kat*, August 4, 1918

"It was exactly, but in deadly earnest, like being in one of those made labyrinths which used to be such a feature of expositions and amusement parks," Herriman remembered. "It was completely baffling. Every rock and rock face appeared completely like every other piece of stone, and although we gave every moment of our daylight to the search for the way out we had come in by, or some other way if there was one, we had no success whatever and were getting close in the lowest frame of mind there is—frantic despair—when at almost one and the same moment the fog was dispersed and help came."

Luckily, two local Indians had come across their horses, went searching for the lost riders, and guided them out. Their inglorious adventure completed, Swinnerton and Herriman parted ways. In mid-September, the Swinnertons returned to California. Dirks and Herriman drove to Williams, Arizona, to board a train to New York. His Kayenta birthday party far behind him, Herriman was preparing to launch yet another new comic for King Features, still looking for that one big hit.

THE LOT OF FUN

Shortly following George Herriman's return from Arizona, King Features announced that Herriman would no longer confine himself to the "land of make-believe in which Krazy Kat and his team mates, Ignatz Mouse and Officer Pupp, enact their perpetual drama of three-cornered devotion" as reported in the trade publication *Fourth Estate*. Instead, Herriman had promised "solid ground for the location of a new daily and Sunday comic strip 'Stumble Inn.'"

Herriman's frequent travels across the country might have inspired the strip, which he set, as King Features announced, in "a modern roadside hotel of the sort brought into being by the universal use of the automobile."

Herriman staged most of the action in a hotel lobby, a simple set with a front desk and an armchair. Characters conformed to a prevailing screwball style that Herriman's friend, cartoonist Walt Hoban, once described as "rubber-nosed, flat-footed little guys who give offense to no one." Visually, the proprietor, Uriah Stumble, and his wife, Ida, recall the Dingbats: a short, balding man and his taller, corpulent wife. Herriman also brought back his favorite stock player, Joe Beamish, now a loafer whom Stumble tries without success to dislodge from the lobby chair.

Visually, *Stumble Inn* was a busy strip. Speech balloons might blow

From *Stumble Inn*, November 3, 1922

up to a half panel, packed with dense dialogue laced with newspaperman slang like "pan-faced gazooni." Herriman drew the employees and patrons of Stumble Inn with a loose, active line, setting into motion a ballet of gangly arms and legs, grabby fingers, twitching mustaches, and prancing eyebrows. Hotel interiors and neighborhood landscapes were crafted in exacting detail.

Stories were lively, with some gags straight out of vaudeville. In one strip, a horse salesman tries to pawn off a horse that gallops straight into walls. The horse isn't blind, the salesman explains, he just doesn't give a darn. Other days Herriman returned to his frequent theme of social pretenders, introducing a society gent named Mortimer Van Spazzim who falls behind in his room payments. Stumble seizes his clothes, forcing Van Spazzim to go out in his pajamas and silk hat. In the final panel the sidewalks are filled with townsfolk in pajamas and silk hats, all imitating the new style.

Among the most enthusiastic fans of Herriman's new strip was the cartoonist E. C. Segar, whose success in Chicago had brought him to the *New York Journal*. In 1919, Segar introduced a new strip titled *Thimble Theatre*, with its stars Olive Oyl, Castor Oyl, and Ham Gravy (and, a decade later, the sailor Popeye). Cartoonist Bud Sagendorf, who assisted Segar and eventually took over *Popeye*, credited *Stumble Inn* as a primary inspiration. "With that, you can see where Segar took his whole style out of," Sagendorf said.

Years after the death of both Herriman and Segar, Sagendorf recalled, he and fellow cartoonist Bob Gustafson were working in the King Features offices, and they would turn to old copies of *Stumble Inn* when they needed a laugh. "Whenever we got gloomy, why, I'd say, 'Hey, let's go down to the morgue,' and we'd go down and dig out the old bound newspapers and read 'Stumble Inn,'" Sagendorf said, "because it was funny."

Although bursting with gags, *Stumble Inn* also represented a new type of strip that was starting to populate the comics pages. Sometimes called the midwestern or Chicago school of cartooning, it introduced a somewhat calmer, more observational narrative style. Pioneers include Clare Briggs and John McCutcheon, and Frank King's *Gasoline Alley*. Bricks might still fly and hats still pop off heads, yet such vaudeville touches were now put in the service of longer stories. "The first comics were wildly exaggerated affairs in which slapstick comedy and burlesque drawing played the principal parts. Then began a humanizing process," observed author and cartoonist Amram Schienfeld in a 1930 article. The popularity of comic-strip situational comedies such as *Blondie* would lead to radio and television adaptations, eventually called sitcoms.

Such changes in comedy reflected changes in the cartoonists' lifestyles. Gone were the days when Herriman and Dirks roamed Coney

Island, or when Herriman and Dorgan pranked passersby near freshly dug subway tunnels. The sporting life was fading. Cartoonists could blame both Prohibition and their own successes.

Nothing provides a better example of the taming of the Sports than the story of the stage show *Artists and Models*. For several years Herriman and others had written and performed comic revues at a private stag party sponsored by the Society of Illustrators. These were risqué affairs, warranting at least one police raid. In 1923 the Shubert brothers wanted to replicate this event on the big stage. They purchased scripts from Herriman, Tad Dorgan, Billy DeBeck, and others for the newly titled *Artists and Models*, which they billed as being "Written, Designed, and Staged by the Most Famous Artists in New York." Featuring a scandalous opening scene with topless models, *Artists and Models* became a hit, running for several years and sometimes featuring Al Jolson in a starring role. The cartoonists split one percent of the proceeds, but not everyone was happy. Some longtime Society of Illustrators members complained that their private party had been sold out from beneath them. "Oh what's the use to cuss and chafe, our brains are in the Shubert safe," complained illustrator James Montgomery Flagg.

Sadder events befalling two leading Sports—and two of Herriman's closest friends—also helped to usher in the end of the era. Charles Van Loan never fully recovered from his car crash and died in March 1919. And in September 1920, Tad Dorgan was covering a prizefight in Benton Harbor, Michigan, when he suddenly gasped and rose from his seat. Friends had to carry him from the arena. The doctor diagnosed a weak heart and strictly forbade both late-night carousing and live sporting events. Dorgan, confined to his home in Great Neck, Long Island, tried to make light of his new situation. He bylined his cartoons from exotic locales such as Shanghai and Paris. Occasionally he would steal away to New York, to sit at a top-floor window of a Broadway hotel and watch the procession of New York characters, the scams and fleeting romances—or as he put it, "lamp

the cake-eaters with their dolls . . . the gyps and the square-shooters. I get a wallop out of figuring their graft from my high perch."

Herriman helped out his old friend by filling in on the *New York American*'s sports pages. He also joined the "Tad's Terrors" baseball team for an annual game that Dorgan organized on Long Island. The match pitted actors against cartoonists, with boxer James J. Corbett—a neighbor of Dorgan's—pitching for the actors. It wasn't too serious a contest. The cartoonists—including Herriman, Cliff Sterrett, and Harry Hershfield, along with writers Damon Runyon, Ring Lardner, and Bugs Baer—once showed up to play wearing old German war helmets.

Herriman and Dorgan's friendship ran deep, based on mutual recognition of the other's great talents. "Tad's a guy who can paint pictures with a pen," fellow cartoonist Jimmy Murphy once wrote. "Herriman said so. Tad's as much at home with boxing gloves on as he is with a pen in his hand. He swings a wicked right. Herriman said so, and he knows!"

In March 1923, in King Features' *Circulation* magazine, Dorgan published an essay about Herriman titled, "This Is About Garge Herriman." In it Dorgan joked about Herriman's mysterious drawl, his enigmatic ethnicity, and most of all his humility:

Herriman. That's the monicker you see signed to the Krazy Kat drawings. His first name is George, but the boys call him Garge, because that's the way he pronounces it himself. . . .

Garge also has a peculiar way of drawling. He is never in a rush as he drawls his words. He calls garden GORDON, he calls harness HORNESS, he calls cigars CIGORS and so on.

He ALWAYS wears a hat. Like Chaplin and his cane Garge is never without his skimmer. Hershfield says that he sleeps in it.

Dorgan added that "Garge" had three hobbies: Arizona Indians,

chili con carne, and boxing gloves. He then went on to describe Herriman's quiet manner.

> The violet imitated Garge when it assumed that attitude of shyness.
>
> He thinks he's the rottenest artist that ever got behind a pen and no matter how many boosting letters he gets about his stuff he's of the same opinion still. Of course WE KNOW BETTER.
>
> Half the guys that never get a boosting letter admit that they're good. Garge doesn't and never will. He is always last. He laughs, though. Yes, he gets the giggles. When he laughs you'd think he had just taken a sniff of snuff. It isn't a laugh, it's a sort of internal explosion.

Dorgan added a cartoon showing an impromptu art room boxing match, but by now such mayhem was a nostalgic memory. Dorgan put the blame squarely on Prohibition, also known as the Volstead Act. "I'm just as glad I'm out of the swing after what Volstead did to New York newspaper life," Dorgan said. "The old days with Wilson Mizner and the gang at Jack's restaurant or Doyle's pool parlor have gone forever."

On Monday, January 15, 1923, George Herriman walked through a cold, clear New York winter day into the City Hall subway station, near the Brooklyn Bridge. He mailed a letter to Clyde Colville in Arizona, tucked inside an envelope with a whimsical cartoon framing Krazy Kat, Ignatz, and Officer Pupp in a blue heart. He didn't yet know that, on that very day in Calvary Lutheran Hospital in Los Angeles, his father, George Gustave Herriman Jr., now seventy-two years old, had lost his battle with stomach cancer. Two days later, on Wednesday, January 17, the elder Herriman was buried next to his wife in a Catholic ceremony at Calvary Cemetery.

George was the only Herriman child not in California for his father's final days. His anguish burned through an otherwise routine letter sent to Edmund Wilson at *Vanity Fair*. Herriman began with a request for photographs he'd loaned the magazine, but ended with a note that "I would have answered sooner but news of the death of my Father has so upset me that I am very neglectful—and I hope you will—pardon me—"

George Gustave Herriman had labored more than half a century as a tailor, beginning at Herriman & Son in New Orleans and ending at numerous shops in Los Angeles. Along the way he built an estate valued at about $20,000, including modest investments in real estate. He divided it into equal shares for his four surviving children: George, Henry, Ruby, and Daisy (Pearl Herriman had died sometime after 1916 and left no children). On February 4, 1924, George Herriman, by far the most financially successful member of the family, signed away his portion of the estate to his sister Daisy, who continued living in their father's home.

By the end of 1923, George Herriman's trips east were growing less frequent. He moved his family into a modest two-bedroom home at 1617 North Sierra Bonita, not far from Hollywood Boulevard. Soon after, they moved to a larger house at 1756 Orchid Street that could accommodate the four Herrimans as well as Vivian Hammerly, who, in addition to her job as a cashier at the nearby Hollywood Theatre, continued to work for the family. Although she had been originally hired as a housekeeper, her primary duty was now serving as a medical companion for Bobbie, whose seizures were continuing.

George Herriman would not choose to set up his studio in their new home on Orchid, however. Instead, he managed to locate the only place in Los Angeles that possibly could bring him as much camaraderie and humor as he had enjoyed in the old *Evening Journal* art room. Herriman found his way to movie producer Hal Roach's "Lot of Fun."

Yet again, eager young men were rushing west to strike gold, this time in a film industry now consolidating in Southern California. Among the pioneers was a young Irishman from Elmira, New York, named Harry Eugene "Hal" Roach, who in 1913 was an "adventurous drifter turned Alaskan prospector turned mule skinner," as writer and friend Richard W. Bann recalled him. Roach first signed on as an extra in the Westerns. Within a year he was producing his own comedies. His first star was a wiry actor named Harold Lloyd, who started with a Charlie Chaplin–inspired character named Lonesome Luke, then debuted a nameless everyman readily identifiable by a simple pair of black, round-frame glasses.

From *Krazy Kat*, March 18, 1921

In 1919, Roach built a studio south of Los Angeles, on nineteen acres of land provided by developer Harry Culver, the future namesake of Culver City. Roach had land and stars, but he needed writers. Herriman's friend, *Los Angeles Examiner* sportswriter H. M. "Beanie" Walker, started doing occasional work for Roach as a "titlest," penning dialogue and scene setters for silent films' title cards. Walker soon went to work for Roach full-time. There, he developed a reputation as an eccentric who passionately loved crossword puzzles (a recent invention) as well as cats, which filled his office at the Roach lot.

To start each day, Walker would take the cover off his typewriter, bang it loudly against his legs, and get to work on Roach masterpieces, ranging from Harold Lloyd's *Safety Last!* to Laurel and Hardy's *The Music Box*. His title cards could be mini-masterpieces in wordplay, from "A Man shouldn't brag because he is Self Made—so is an oyster" to "J. Quincy Quack—Has a wife and twelve children. No other responsibilities." Wrote Harry Carr in the *Los Angeles Times*: "I saw a Hal Roach comedy the other day that would have been a sad affair but for Mr. Walker's titles, which literally saved it as it was going down for the last time."

During their *Examiner* years, Herriman and Walker had cemented their friendship at prizefights in Vernon and lunches at Riley's steak joint. Walker already had introduced Roach to legendary director Leo McCarey, whose father, fight promoter Tom McCarey, had been well-known to the *Examiner* gang. Now Walker brought Herriman to Roach's studio, sparking an unusual working relationship that would continue for the next twenty years. Herriman never worked for Roach and it's not clear if he paid any rent; he appears to have just set up his desk, pens, and bristol board and worked alongside the moviemakers.

Herriman's informal residency at the Roach studios was just the latest example of the close kinship between newspaper comics and early film comedies. Before movies, radio, and television, it was the

syndicated comics page that first taught Americans to laugh all together. W. C. Fields's iconic stage and film character was seeded in Charles H. Ross's nineteenth-century cartoon superstar Ally Sloper. And when Stan Laurel was asked if he and Oliver Hardy were patterned on the dumb servants of Roman comedy, he laughed and replied, "I thought we were patterned after the Katzenjammer Kids!"

Herriman soon was joined at the studio by his old *Evening Journal* friend Tom McNamara, whose popular comic strip *Us Boys*, which chronicled the sandlot adventures of kids with names like Skinny Shaner and Shrimp Flynn, appears to have been an unacknowledged influence on Roach's *Our Gang* series. The gentle humor, chubby central character, and even the title of *Us Boys*, suggest *Our Gang*. Most tellingly, Roach brought in McNamara at the outset of the series, even giving him director credits on early films. McNamara also worked closely with Walker, adding humorous illustrations to Walker's title cards.

Before long, many of Herriman's *Krazy Kat* strips, now drawn in Walker's office on Roach's lot, looked like storyboards for silent comedies. In one five-panel comic, Krazy Kat drives a truck of lumber: the truck pulls off and the lumber, with Ignatz perched on top, stays behind. Nearly identical gags appeared frequently in Laurel and Hardy and *Our Gang* films. Herriman at times moved Krazy and Ignatz out of Coconino and onto city blocks that resembled a Hal Roach set; along with getting hit by a brick, Krazy now might fall through a manhole. One day Krazy Kat imitates "Cholla Cheplin," "Herald Lloyd," and "Fetty Arbuckle." On another, Krazy and Ignatz walk past lobby signs advertising new works by Harold Lloyd, Beanie Walker, and Hal Roach's brother, Jack Roach.

Soon the new cartoonist on the lot was being acknowledged in Roach's movies. A Krazy Kat doll made its film debut cradled in the arms of child actor Ben Alexander in the 1919 silent drama *The Better Wife*, then appeared in the 1921 Harold Lloyd film *I Do*, in which

From *Krazy Kat*, August 19, 1921

a Krazy Kat doll falls and knocks Lloyd on the head. The doll appeared in numerous *Our Gang* comedies, beginning with *Fire Fighters* in 1922. A decade later, in Laurel and Hardy's 1934 movie *Babes in Toyland*, a mouse (actually a monkey in a mouse suit) would toss a brick at a fiddle-playing cat.

At the Lot of Fun, gags flowed freely from film to comic, and back again. "The Hal E. Roach's Studio 'lot' seems to hold inspiring material for George Herriman, the cartoonist, who is turning out many of his 'Krazy Kat' cartoons there," the *Philadelphia Inquirer* reported. "Mr. Herriman listens to 'gag' talk, using discards, he says, while he has also appeared in some of the comedies as 'extra' to get a little 'color.' He gets much copy in 'Beanie' Walker's titling office, for Walker always has his wire baskets filled with favorite tabbys."

His old friends Walker and McNamara at his side, Herriman settled into another rollicking and inspiring work environment. "A lot of people wanted to have their offices at my uncle's studio because it was a fun place to be," remembered Lola Larson, Hal Roach's niece. It was not unusual for someone to wheel a piano onto a set, with Leo McCarey, Stan Laurel, Oliver Hardy, and Charley Chase belting out harmonies. In *Krazy Kat*, Herriman started adding scenes of barbershop quartets.

"The Hal Roach Studio . . . was a swinging lot in late 1924," recalled director Frank Capra, who had started as a young gag writer at the Roach lot. In his autobiography Capra revealed that he was a fan of *Krazy Kat* and that he spent hours "watching this shy humorist draw." One day, he wrote, he mustered the courage to ask Herriman the question on many readers' minds.

"I asked him," Capra said, "if Krazy Kat was a he or a she."

Capra recalled that Herriman lit a pipe and considered the question.

"You know," Herriman told Capra, "I get dozens of letters asking me the same question. I don't know. I fooled around with it once; began to think the Kat is a girl—even drew up some strips with her being pregnant. It wasn't the Kat any longer; too much concerned with her own problems—like a soap opera. Know what I mean? Then I realized Krazy was something like a sprite, an elf. They have no sex. So the Kat can't be a he or a she. The Kat's a sprite—a pixie—free to butt into anything. Don't you think so?"

That was the closest that Herriman ever came to a direct answer on the subject. Capra, realizing it would be useless to press for more details, replied, "I don't know about Krazy Kat, Mr. Herriman, but if there's any pixie around here, he's smoking a pipe."

PART IV

MARAVILLA

INFERIORITY COMPLEXION

In November 1923, John and Louisa Wetherill's daughter, Georgia Kilcrease, gave birth to a baby girl, Juanita. George Herriman sent off an affectionate welcome to the newest member of his Arizona family:

A little bit of an envelope
about as big as a postage
stamp arrives, and when
we open it, we find out
that you have decided to
make Kayenta your permanent
camp—and that you have
chosen Mr & Mrs Kilcrease
for a "Mama" & "Papa" and a lot of regular people
for Grand Ma, Grand Pa,
Uncles and Aunts—and,
For a little kid like
you Juanita, that shows
a heap of unusual brains,
or I might say—a great
power of perspicacity—
Little people picking out

their Home places dont usually
choose a wonderful spot
like your's—

The following June, Herriman and cartoonist Tom McNamara, now working at the Hal Roach studios, took a train from California for Kayenta. Herriman signed into the Wetherill guest book, drawing himself as Krazy Kat greeting Clyde Colville:

"Back again?" asks Colville.

"Sure, I are," Krazy replies, "aint that a hebit among us 'kets.'"

From Kayenta, Herriman and McNamara traveled to the south rim of the Grand Canyon. They hiked to the canyon's edge to look over the ancient peaks of the Isis Temple and Cheops Pyramid, pausing for a souvenir picture. In the photograph, McNamara, smoking a cigarette, faces the camera; Herriman gazes off to the distance, as if inspecting the reds and browns of the striped canyon walls.

With that, Herriman and McNamara were back on the train, now bound for New York. The stirring beauty of the desert once more behind him, Herriman arrived just in time for yet another storm of critical debate over his work. Once again, it was courtesy of Gilbert Seldes.

For the past year, Gilbert Seldes had exiled himself to Paris, where, armed with a folio of *Krazy Kat* comics, he penned his manifesto and defining work: *The 7 Lively Arts*. With it he made an opening bid in a discussion about high art and popular art that remains controversial today. "My theme was to be that entertainment of a high order existed in places not usually associated with Art," he wrote, "that a comic strip printed on newspulp which would tatter and rumple in a day might be as worthy of a second look as a considerable number of canvasses at most of our museums."

In *The 7 Lively Arts*, Seldes enthused about ragtime and vaudeville, and artists ranging from Charlie Chaplin to Ring Lardner to Florenz Ziegfeld Jr. Yet, of all the lively arts, he wrote, the one most despised is the comic strip. Reading a comic, Seldes noted, is seen as "a symptom of crass vulgarity, of dullness, and, for all I know, of defeated and inhibited lives." Seldes praised several cartoonists by name, among them Tad Dorgan and Tom McNamara, but only Herriman merited his own chapter. In "The Krazy Kat That Walks by Himself," Seldes extolled the exactness of Herriman's art:

> For whether he be a primitive or an expressionist, Herriman is an artist; his works are built up; there is a definite relation between his theme and his structure, and between his lines, masses, and his page. . . . The little figure of Krazy built around the navel, is amazingly adaptable, and Herriman economically makes him express all the emotions with a turn of the hand, a bending of that extraordinary starched bow he wears round the neck, or with a twist of his tail.

By this time Herriman was bringing everything he had to *Krazy Kat*: gags about boxing and Prohibition; quotations from Shakespeare and Tin Pan Alley; references to fate and spiritualism, including a postwar Ouija board craze; Navajo and Japanese myths; topical jokes about trusts, wartime profiteering, and the League of Nations; a new character named the Widow Marijuana Pelona (giving rise to decades of speculation, likely but never confirmed, about Herriman's own habits); and frequent greetings to friends such as Seldes, Pinky Springer, and Tad Dorgan.

The prose might be as brief and funny as a Beanie Walker title card, with lines such as "Having no other place to go, last night, the snow came down," or it might spool out in poetic descriptions, such as it often did when Herriman introduced the hobo character Bum Bill Bee,

From *Krazy Kat*, November 18, 1917

first seen chugging up the road carrying a bindle: "He has no friends, he has no enemies, he comes from nowhere, never departs, and never arrives, he is elusive, illusive, delusive, reclusive, and conclusive, a shifting drone, a droning shifter, a traveller on the road to no place."

Visually, Herriman might arrange the panels for his weekly comic horizontally, vertically, or diagonally, or he might opt for a single illustration of an Arizona butte, a round of cheese, or a field of "katnip." Some comics might take the forms of the Navajo rugs that decorated the Wetherills' home. Foreground and background can switch parts, just as Krazy Kat and the Dingbats once traded places in the Sooptareen Arms. While characters engage each other in bits of stage business, desert flora feverishly metastasize around them, at times overtaking the story.

Herriman drew Krazy and Ignatz in a cartoonish doodle, while rendering his landscapes in dense, shadowy crosshatchings. The contrast makes his imaginative Coconino County seem all the more real, its citizens weightless yet still corporal, like the outlines of desert spirits.

Herriman's originals reveal that, as for a jazz musician, improvisation was central to his craft. Pioneering cartoonist Rodolphe Töpffer once wrote how a story idea arose from "a single stroke of the pen and quite by accident." Cartoonist Chris Ware has pointed to this passage to explain what makes cartooning unique. Once pen touches paper, says Ware, "all bets are off." Ware has called Herriman, who

might ink atop a "scramble of notes" marked in pencil, a consummate improviser.

Yet, even as *Krazy Kat* reached full flower, both critics and the public remained divided. "If Mr. Seldes finds in Krazy Kat 'delicacy, sensitiveness,' and 'an unearthly beauty,' he may rest assured that the thousands of readers who read Krazy Kat in the New York American find none of these things," sniffed one critic. Despite Seldes's best efforts, Herriman would see such doubts repeated in newspapers around the country.

There is no indication that, despite his cross–country train trips and adventures deep in the desert, Herriman extensively employed "ghosts" to write, draw, or ink *Krazy Kat*, as did cartoonists such as Bud Fisher for *Mutt and Jeff*. But Herriman was happy to accept story ideas and dialogue from colleagues, including Gene Ahern and Harry Hershfield, and even from young writers hoping to boost their careers. Bill Cottrell, previously a cartoonist and sportswriter for the *Orange County Plain Dealer*, received a line of thanks in *Krazy Kat* from Herriman for a story about a manx cat. Later, Cottrell would work on classic Walt Disney movies such as *Snow White and the Seven Dwarves* and help develop Disneyland. He credited his work for Herriman for getting him hired by Disney. Said Cottrell, "I took along things that I'd written for newspapers, and the thing that impressed him more than anything was the stuff that George Herriman used."

Herriman made sure to find the time to draw a special *Krazy Kat* comic to promote an extravagant but forgettable 1924 silent movie titled *Janice Meredith*. Not coincidentally, the movie starred William Randolph Hearst's mistress, Marion Davies. The comic appears to have been done on the Chief's orders, for Cliff Sterrett, Jimmy Swinnerton, and other King Features cartoonists contributed similar promotional comics for Davies's movies.

On Monday, March 24, 1925, Herriman was back in New York for a meeting with fellow cartoonists Rudolph Dirks and Cliff Sterrett, as well as artists and Armory Show organizers Alfred Frueh and Walt Kuhn. With Kuhn taking the lead, the five gathered to hatch an idea for a new venture: they would sell themselves as a writing team for film comedies. All they needed was a director.

Their first choice was an unlikely one: Robert Flaherty, whose 1922 film *Nanook of the North* is credited as the first feature-length documentary. Just before his meeting with Herriman and the rest of the group, Flaherty had spent a year in Samoa to film his newest movie, a mix of ethnography and drama titled *Moana: A Romance of the Golden Age*. That Monday, Herriman and the rest of the team attended a prerelease screening of *Moana*, then met with Flaherty the next day.

Perhaps not surprisingly, the odd partnership went nowhere. By the next month Herriman was back in Los Angeles, having second thoughts about the project. He wrote to Frueh to beg out of the team. In the letter, Herriman's gags can't mask his modesty and even self-doubt:

You Old Horn Toad:—Listen !!

I've scratched around for many years looking for comical ideas to put in pictures, and I'm still scratching—and I've come to the conclusion that grass is awful short in my pasture—and as each and every one of you boys—is "fellas" that I like a whole lot—I'm not letting you take me in when I cant provide a oat for the granary—no sir—It was sure nice of you gents to let me in—but it wouldn't be nice for me to come in—knowing what I do about myself—I aint got it Al—and that's all there is to it—Don't think that I havent tried myself out—because I have,

and search as I may—my old cupboard is still shy on bones—
you've got no idea how hard I've got to dig for the stuff I do for
Mr. Koenigsberg—and after a nightly effort look what comes
out—phew!!!

Herriman insisted that his friends had all the humor and brains
they needed, asking, "what ever gave you boys the Idea that I had
ideas—or even a idea?—shame on you'se!!" He admitted that he'd
once signed on to a similar project with "Myer"—most likely car-
toonist Henry "Hy" Mayer, a longtime colleague who'd started a
film company to produce comic shorts—but said that had been just
a favor. (No surviving Mayer films credit Herriman.) Complained
Herriman, "I have so little to give, that a couple of gives—and I'd be
out of gives."

Then, as he did in his previous letter to Edmund Wilson, Herri-
man appended the breezy letter with a brief mention of painful news:
"And to add to my general idea debility, Mr Hard luck has moved
in on us—we have 'Bobbie'—my daughter in the hospital again—
playing her last card—if it aint the right one—well—I'll sure feel out
of it for keeps—nobody will hear from me—no more—The poor kid
is going through hell—"

With the single sentence "I'll sure feel out of it for keeps—nobody
will hear from me—no more," Herriman reveals the seriousness of
Bobbie Herriman's epilepsy as well as the depth of his sorrow. On
this occasion, however, Bobbie would make it out of the hospital to
resume an active life.

Much of Herriman's letter reflects a personality trait—even a psy-
chological condition—that was frequently commented upon by his
friends. Usually called shy or modest, Herriman himself suggested
a new diagnosis in a *Krazy Kat* daily comic that would be published
two days before his forty-fifth birthday, on August 20, 1925. In it,
Krazy is looking into a small mirror:

KRAZY: Hm-m-not so nice

IGNATZ: What isn't?

KRAZY: My face

IGNATZ: I've known that for a long time.

KRAZY: Golla, why din't you tell me?

IGNATZ: Tell you what?

KRAZY: That I had a "inferiority complexion."

The term "inferiority complex"—here slyly turned into a race-themed gag—had originated in the early works of Sigmund Freud and Carl Jung, and by the early 1920s had entered popular jargon. It was understood to mean a person who considers himself unworthy of success, and for whom every failure confirms this sense of unworthiness. Herriman's complex was legendary. Said cartoonist Charlie Plumb, "Herriman has the biggest inferiority complex in the craft; you could pile all the bricks that Ignatz ever threw at Krazy and not fill it up."

Herriman's "inferiority complexion" gag echoes Musical Mose's wish that his color would fade, and the phrase suggests that—although Herriman's race appears to have never become a serious career risk for him—the subject still resonated with him deeply. Similar language appears in numerous other *Krazy Kat* comics, as when Krazy Kat showers in a bottle of bleach, after saying, "This smex of a change among the kimplexion of things." That strip ends with Krazy turning completely white except for a black tail.

Despite Herriman's attempts to beg out of the film partnership, his friends prevailed. In the summer of 1925, Walt Kuhn took their effort overseas. In Germany he met with famed producer Erich Pommer, who five years earlier had established his reputation with *The Cabinet of Dr. Caligari*. The cartoonists gave Pommer and his prestigious Ufa studio their enthusiastic blessing. "I believe they will come closer to giving us the quality we are after than anyone," Frueh wrote Kuhn,

From *Krazy Kat*, March 2, 1925

reminding him how much they all enjoyed the recent Ufa movie *The Last Laugh*, about a hotel bathroom attendant who inherits a fortune. Wrote Dirks excitedly: "Those birds over in Berlin know how to put on a picture if any one does." And in October, Herriman sent an enthusiastic telegram to Kuhn:

> VERY GLAD TO HEAR OF YOUR SUCCESS IN GETTING IN TOUCH WITH GERMAN PRODUCERS ANYTHING THAT YOU MAY PROPOSE ON CONTRACT WITH THEM HAS MY FULL SANCTION AS WELL AS THAT OF OUR COLLABORATORS.

However, no movie would be made. Herriman's encouraging words are some of the last on record about the film partnership. Shortly after receiving the telegram, Kuhn suffered a nearly fatal stomach ulcer. He recovered but, after deciding that he had not yet fulfilled his destiny as a painter, he dedicated his time to creating portraits of circus folk and showgirls. The film partnership quietly dissolved.

ven if he had missed his break into filmmaking, the cartoonist
on the Hal Roach lot had become a minor Hollywood celeb-
rity. George Herriman's daughters Toots and Bobbie, now young
women, were enjoying the social benefits. They attended a luncheon
hosted by the wife of director Richard Wallace and their nightlife
companions included young actors such as John Carradine and Andy
Devine. Along with their mother, Mabel, they made it their duty
to ensure that Bobbie's medical companion, Vivian Hammerly, was
properly dressed for the Hollywood scene. "She had this huge nose
and was very thin, dark-haired, not the prettiest, but she was fun and
had a good sense of humor," remembered Hammerly's niece, Marlene
Duckworth. "Mabel and the girls took her in tow and taught her how
to put clothes together."

George Herriman also threw himself into Hollywood society, hob-
nobbing with movie stars. New haunts included Joe Winkel's rough-
and-tumble bar in Temecula, California, which boasted an upstairs
boxing arena and was a favorite stop for Buster Keaton and Fatty
Arbuckle. The bar's mentions in *Krazy Kat* were frequent enough to
be highlighted in a Federal Writers' Project guide to California.

Minor-league baseball player Arthur "Frenchy" Escallier, a relative
of Winkel's business partner, organized a quail hunting trip for Her-
riman and Beanie Walker. After spending the day in the farmlands
surrounding the San Luis Rey mission, Herriman immortalized the
trip in a drawing that he gave to "lil ole Arthur Escallier the prince
imperial of Temecula." In it, Herriman both kidded Walker and re-
vealed his sympathies to be with the quail. Says Krazy to Ignatz:
"Keep enough emmanition to shoot him 8, or 9 times more afta he is
a corpse, like Mista 'Binna Walka' does—It is considded wery, wery
scientific, and sportsmanshipful—yezza—"

Krazy Kat, meanwhile, became a household name among the Holly-
wood elite. Actress Alice Terry named her new dogs Ignatz and Krazy

From *Krazy Kat*, November 24, 1919

Kat, and famed parachute jumper and wing walker Gladys Roy named her mare Krazy Kat. The 1927 Fatty Arbuckle–directed movie *The Red Mill*—starring Marion Davies—featured a mouse named Ignatz. A Hollywood car dealer took out advertisements listing Herriman along with celebrites such as Arbuckle and Erich von Stroheim as members of the "Hollywood Film Colony" who purchased new Ford Lincolns.

Herriman's choice of car seemed to be more than for a dealership advertisement. Wilson Springer, the son of Herriman's friend Pinky Springer, recalled a discussion between Herriman and his father that suggests that the sentiments toward peace in Herriman's pre–World War I *Krazy Kat* comics were heartfelt. "One time when we went riding in George's beautiful, huge Lincoln touring car, I overheard him talking to my Dad in the front seat," wrote Springer in a letter. "He was saying that he always bought Ford products because Ford had objected to WWI and not until late in WWI would Henry Ford build weapons for the destruction of man after the Government had threatened to confiscate the Ford Plant in Dearborn. He was a great admirer of Henry Ford and it must have 'rubbed off' on my Dad, because my Dad would never buy anything but a Ford."

From *Krazy Kat*, March 6, 1921

Meanwhile, writer Harry Carr took every opportunity to flatter his old *Los Angeles Times* colleague in print. In his *Times* column, he listed Herriman among the most interesting people he'd ever met. When he began working for *Motion Picture Classic* magazine, he filled its pages with more stories about Herriman, whom he called "the most adroit critic of motion pictures I know." He quoted Herriman on Charlie Chaplin, and in one issue Herriman himself contributed a lengthy review of the new Chaplin film *The Gold Rush*. Herriman assumed the voice of Krazy in an elegant description of the movie's opening scene:

> The opening khorus in "The Gold Rush" is very, very dramatic—in fact, it is "The Gold Rush"—men milling in the snow, hurling themselves into the white maw of the Arctic—fleas scampering

across a klean sheet—you just know it's dramatics. So is a line of ducks flying from the pole to the pampas to lay an egg, or a ribbon of ants krossing the sidewalk to dissect a roach's kadaver, a Bowery bread line on Xmas Eve, a world's parade of airplanes, nose to tail, girdling the earth.

But about that Gold Rush, was it a thousand men, or a million—with their frozen sweat about them, panting up the Khilkoot—there was ages of snow beneath them, and the skies were ready to hurl ages more of it upon them—yet the writhing string moved on, squirming its way into the open jaws of the North to pry from its white fangs a bit of its yellow fillings.

A large, healthy, meaty bone upon which to do some kritical gnawing, Mr. Editor. But, out it faded, like a veil dissolving—and the march of a million men was something that had transpired eons ago—and on the echo of the last man's foot beats, the magic of transmutation takes place—from the musty metal in the krucible—arises enchantment—witchery in large flat shoes, baggy britches, swishing a reed, a billy-cock hat doffed to the universe, a gracious salutation, and the world acknowledges it with the smile of a child.

Also in *Motion Picture Magazine,* Carr recounted the details of a weekend adventure with Herriman. It all started, Carr wrote, with the actress Louise Fazenda, a former Mack Sennett player now appearing in silent features. "She has sympathy, brains and a demon determination," Carr wrote. "When Louise Frazenda hangs out the signal for a party, you can brace your cosmic soul for an unusual experience."

One night Fazenda decided that she wanted to arrange a meeting between the creators of Krazy Kat and Felix the Cat. She gathered up Herriman and animator Pat Sullivan, and instructed Carr to be at his newspaper desk at seven o'clock. "I just had to arrange a

family reunion of these two cats," she whispered to Carr when they met up.

Along with Fazenda, Carr, Sullivan, and Herriman, the group included Tom McNamara and Sullivan's wife. (Mabel Herriman appears to have stayed home.) They piled into two cars, and went on a nighttime adventure to a tiny Mexican restaurant, where they dared each other to eat the spiciest peppers, and an even tinier neighborhood theater, where a melodrama in Spanish was performed against a backdrop of brown butcher paper. It was, presumably, just one of many similar excursions that Herriman took into the Hollywood night—but it was the only one that Carr committed to print.

I n the summer of 1926, the Herriman family traveled to Kayenta together, with George Herriman memorializing the event with a colorful cartoon for the Wetherills. In it, all four Herrimans are on ponies, smoking cigarettes and wondering what to do with the bridles. George is being bucked off by his horse, who informs him, "I'll woe you."

The following year, however, George Herriman unhappily stayed home while Mabel and Bobbie took a winter vacation at Hacienda de la Osa, the Wetherills' new ranch in southern Arizona. Herriman's poor health had slowed him down. Throughout 1927, he had been adding gags about various ailments in *Krazy Kat*. In one, Krazy suffers from rheumatism. In another, Ignatz enters the hospital after some trouble with a mousetrap. The most bizarre tale concerned "Little Eppis, an orphan appendix," who jumps into a bowl of "chocolate colored, katnip flavor" batter about to be molded into Krazy Kat. Years later Krazy Kat, in acute pain, goes to the Coconino Hospital. Little Eppis is tossed out the hospital door and lands with a "plop." The strip was prophetic, for ten months after it appeared in print, Herriman

From *Krazy Kat*, December 16, 1927

suffered appendicitis and underwent surgery at Los Angeles's Osteopathic Hospital, remaining there for several weeks to recover.

Herriman, housebound and on a restricted diet, lamented his fate in a letter to John Wetherill. In it he also revealed how his daughter Toots, or Toodles, had aided him during a previous medical recovery:

> Bobbie tells me she's packing in a lot of fun riding your noble Arabian steeds around your domain and also that she's picking up some genteel amount of centavos from the Vaqueros, shooting craps—she's got those dice hypnotized—look out for her— However she can be beat at checkers . . .
>
> Maybe, it might interest you to know that the last time Toodles and I held the ranch down together—i was fed "3" times daily, on Beef or Mutton stews—now—me being on a diet—I get "soup"—it wont be long now before I get back to the old bottle—the one with the nipple on—

To Clyde Colville, Herriman sent a rare letter of complaint about his workload, which included *Krazy Kat* as well as other assignments

by King Features. Herriman ladened his letter with ethnic gags, at one point even comparing himself to a "poor ole 'Uncle Tom.'" He added that his wife, whom he called Duchess, refused to stay at home anymore. Instead, she "blows back here for a one-night stand, and grabs a rattler right back to the 'Border' the next day—she didn't unlimber a smile all the time she was here." Herriman added wistfully, "She used to think us Hollywood boys were pretty nice hombres."

But mainly Herriman groused about his work:

> Dont you know I've got eight days work to do in six days every week—I can't find time to do my regular stint let alone get myself a few days off . . .
>
> Those two goofy "old gals" you've got dont there have nothing on there minds but a marcel wave, and nothing on there hands but fingers—I've got a heap of work—hands full, but the head is empty—and yards and yards of blank paper to put comical pictures on, so that Mr. Hearst's customers can laugh in there eggs and coffee every morning—

The decade had begun with promise for both Herriman and Krazy Kat. There were animated *Krazy Kat* cartoons in the theaters, a ballet onstage, and a birthday party in Kayenta. Yet, as Herriman recovered from his surgery, he faced a syndicate and a public that seemed to be growing weary of both him and his Kat. And as difficult as it is to believe, given the unabatedly majestic *Krazy Kat* comics he was drawing during this time, he believed he was facing it with hands full and head empty.

He also suffered new restrictions on his creative vision. Starting in 1925, King Features attempted to gain new subscribers by offering two versions of the weekly *Krazy Kat* strip: a single-page comic and a version sliced into two parts to run across adjoining pages. No

longer could Joe Stork's towering Enchanted Mesa reach to the top of a newspaper page, and no longer could Krazy and Ignatz, adrift in a pair of boats, crest on a massive wave. Now Herriman had to fit his stories neatly into two sets of four panels each.

King Features had its reason for trying to entice new clients for *Krazy Kat* as well as keep the old ones. Stories were spreading about newspapers dropping Herriman. In the March 1923 edition of King Features' promotional *Circulation* magazine, Verne Marshall, the managing editor of Iowa's *Cedar Rapids Gazette*, reported that the newspaper wanted to add Billy DeBeck's *Barney Google*, whose popularity was skyrocketing thanks to that year's hit song by Billy Rose, "Barney Google (with the Goo-Goo-Googly Eyes)." Wrote Marshall, "But space requirements and that moth-eaten business office reader-ad ratio required that we eliminate some other strip to make way for the new one." The business office wanted to cancel *Krazy Kat*. But, Marshall said, "the boys in the news rooms contended that 'Krazy Kat' was too good to relinquish."

The *Gazette* ended up finding room for both strips. But similar scenes played out in newspapers across the country. On January 30, 1928, Pennsylvania's *Warren Tribune* went all in when it added *Krazy Kat*, publishing endorsements from everyone from Charles M. Schwab to Chicago Academy of Fine Arts founder Carl Werntz, who said that he used Herriman's cartoons in his lectures. Yet, just two months later, a ballot appeared on the *Tribune*'s comics page, asking readers to pick their favorites. *Krazy Kat* quickly sank to the very bottom of the list. The "doom of that gentle creature is sealed," reported the paper, noting that one subscriber said to "Throw that Cat in the river" and "dozens of others are only slightly more charitable." Another month later the newspaper announced that George McManus's *Bringing Up Father* would be taking the place of *Krazy Kat*. Wrote the editors in a lengthy explanation: "We have said before that 'Krazy Kat' is our favorite comic strip. But we aren't publishing the Tribune for our personal entertainment."

At the same time that readers were begging newspapers to drop the comic, a select readership was becoming enraptured with Herriman's work. Growing up in Washington Heights, Manhattan, young Stanley Lieber always turned to *Krazy Kat* in the newspaper. "I loved the fact that the strip looked different from all the others, read differently than the others, and was filled with odd innovations and quirks," he said. As "Stan Lee," Lieber would cocreate a pantheon of Marvel Comics superheroes such as Spider-Man and Iron Man. Herriman's work, he said, was a touchstone. "Herriman was a total stylist. He knew what he wanted to do and how he wanted to do it. To my mind George Herriman was a genius."

Theodor "Dr. Seuss" Geisel once remembered how he used to wait for his father to bring home the *Boston American* newspaper so he could turn to *Krazy Kat*. Also a childhood fan was actor Martin Landau, who credited the comics with first sparking his imagination. "New York had a lot of newspapers in those days, and all had color comic sections," he recalled. "I couldn't read yet, but those strange worlds—the Krazy Kat world, the Willie Winkie world—were all in color and all strange. . . . I could sit and look at those pictures for hours."

Despite such devotion, Herriman had real reason to worry that his contract might be canceled. Attempts to reach a larger audience were proving futile. At the start of 1926, after just a little more than three years, King Features canceled *Stumble Inn*. Two years later Herriman made one last stab at a situation comedy when he launched *Us Husbands*. It offered minor laughs about domestic strife, told neatly in twelve panels. Stories were—by Herriman standards, at least—formulaic: the husbands seek to join their single friends at parties and card games; the wives stand in their way. Herriman was clearly attempting to duplicate the success of *Bringing Up Father* and other domestic comics, but here he offered relatively little to the genre. He had more fun with the extra "topper" strips that ran

above *Us Husbands*, especially one titled *Mistakes Will Happen* that featured vaudeville-style gags dressed up in Elizabethan costuming. But *Us Husbands* ended after less than a year, taking down its toppers with it.

Once again, Herriman was alone with his Kat.

OUTPOST

E veryone who crawls to fame in any line of endeavor seems to find his chance to play at least one role in the movies, it seems," reported *Photoplay* in December 1927. "George Herriman, the Krazy Kat cartoonist, has been signed to interpret himself in the Marion Nixon–Glen Tryon newspaper picture, 'Meet the Prince,' which William Craft and Jack Foley wrote and are directing."

Canadian director William James Craft's newest comedy concerned a small-town cartoonist and a prince from a peanut-producing nation called Volgaria. The cartoonist and the prince arrive in New York and switch places, with the cartoonist inventing a peanut-shooting "Goober Gun" and winning the heart of a newspaper advice columnist. The movie changed titles several times until settling on *How to Handle Women*. As the synopsis might suggest, the movie earned mostly poor reviews. *Variety* called it an "utterly tiresome comedy," noting that Tryon seemed lost and the minor characters looked to be in "pained boredom."

The movie is most notable for featuring Herriman as well as an early screen appearance by Bela Lugosi. Sadly, no surviving prints of the film have been located. Publicity stills show Herriman and Tryon cheerfully sitting at a drawing board. Herriman is drawing Krazy Kat and Tryon appears to be drawing Oswald the Rabbit, a character recently introduced by Disney.

From *Krazy Kat*, March 2, 1927

Yet even such a modest debut as an actor burnished Herriman's credentials as an unusual yet beloved member of the Hollywood film colony. In the late twenties, after decades of trips between California and New York, he started making plans to settle in the Hollywood Hills.

The land beneath Outpost Estates had passed through celebrated hands, from *Los Angeles Times* publisher General Harrison Gray Otis to movie producer Jesse Lasky, until winding up with "the Father of Hollywood," Charles E. Toberman. A native Texan, Toberman built palatial landmarks such as Grauman's Egyptian and Chinese Theaters; now, with Outpost Estates, he was laying down a modern community of white paved roads, ornamental streetlights, freshly planted carob trees, and majestic Spanish-style homes with courtyards, fountains, and red tile rooftops. Silent film star Dolores del Río moved in and, on a late Friday afternoon in November 1926,

so did George and Mabel Herriman, who signed a $16,000 mortgage for a new house to be built at 1819 Outpost Drive, right across the street from Toberman's office.

"It was a two-story, white, Spanish-style home with an entry in Spanish tile, and several rooms were tiled floors," recalled Wilson Springer. "I still remember going out there one Sunday with my Dad after a bad rain storm and seeing the damage done to the floors from rain water coming in and mud all over the sunken living room. George always had Indian or Mexican-style throw rugs on the floors."

The property also carried a racial covenant. When Herriman purchased the lot, he signed an agreement that "no part of said land and premises shall ever at any time be used or occupied by any person other than one of the white or Caucasian race." A violation could transfer the property back to the bank. Herriman did not appear to be concerned. Promotional literature included a photograph of Herriman's house, noting that it was the home of "a cartoonist of national fame."

In fact, Herriman and Toberman had even grander plans. Within just two years the Herrimans sold their home on Outpost and temporarily moved into a four-bedroom house on Orchid Drive. On Friday, March 29, 1929, they took out a new loan, this one for $12,500, with Toberman's Hollywood Holding and Development Corporation. This helped fund a larger estate at the end of a winding drive named Maravilla—a Spanish word for "wonder"—in what Toberman was calling the "Hillside Homes of Happiness."

Nestled over Hollywood in groves of eucalyptus, sycamore, and live oak trees, beneath thirty-foot-tall red neon letters that spelled out "OUTPOST" (outshining the nearby "HOLLYWOODLAND" sign), the Hillside Homes of Happiness were designed to be "as accessible as a downtown hotel and as secluded as a mountain lodge." The Herrimans were moved into 2217 Maravilla Drive by November 1929, when George and Mabel posed with two new Buicks for a car promotion. The caption read: "George Herriman, famous car-

toonist, originator of 'Krazy Kat,' likes harmony in his family, so he purchased two cars—both 1930 Buicks. Pictured here is the satisfied couple in front of their attractive Hollywood home."

George Herriman set about transforming his new home into a satellite of Coconino County, paving his yard with flagstones and rolling in massive glazed turquoise planters. He placed Navajo rugs on the floors and even painted a thick zigzag stripe down a living room wall. "Oh, it was wild," cartoonist Bud Sagendorf remembered about the house. "You'd swear to God he'd drawn it."

Herriman purchased a smaller plot of land across the street and placed a park bench there so passersby could enjoy the view. On the roof he affixed a brightly colored weathervane that he designed with his daughter Bobbie, now a commercial artist specializing in spaghetti-limbed flapper figures in the style of magazine illustrator John Held Jr. On one end of the weathervane perched a George Herriman–style Scotty dog; on the other, one of Bobbie's wavy-haired flappers, this one an angel with a halo and harp.

Herriman tacked drawings and cartoons on his studio walls, floor to ceiling. Jimmy Swinnerton was there. So were James Montgomery Flagg, Henry Raleigh, and Maynard Dixon.

George Herriman, now fifty years old, was home.

T here are no records of Herriman traveling to the East Coast after his move to Maravilla. If he did return to New York, it would be to a city that had lost its leading light.

Tad Dorgan had spent most of the 1920s confined to his dining room in his home at Great Neck, New York. Surrounded by cardboard boxes filled with paper, he continued drawing *Indoor Sports*, *Outdoor Sports*, and other cartoons. He often added private greetings to Herriman, and Herriman responded with frequent mentions of Dorgan in *Krazy Kat*.

Around 1927, Dorgan wrote a letter to Tom McNamara telling his old friend how former Hearst office boy Gunboat Hudson had visited him in Great Neck and that Hudson, now 180 pounds, put away four or five boiled potatoes, a sirloin steak, two orders of shortcakes, two orders of peaches, two cups of a coffee, and a pack of cigarettes, and "he wasn't even out of breath." Dorgan talked about Jack's, which was closed, and Andy's, which was still open. He congratulated Mc-Namara on his movie success, then finished with a lament about their mutual friend.

"I am sorry that Herriman looks so well," Dorgan wrote. "If he ever looked the way he felt, he would be a sight."

From *Krazy Kat*, October 16, 1916

Those are Tad Dorgan's last recorded words on Herriman. In a letter to Arthur Brisbane sent in 1927, Dorgan described sleepless nights of coughing, rendering him unable to work. He turned down Brisbane's suggestion of creating topical, news-related cartoons, then abruptly ended his letter:

Twenty five years ago last Monday I came to work on the Journal.

Yours Truly,

Tad

Tad Dorgan died in his sleep on Thursday, May 2, 1929. Two days later in Madison Square Garden, as crowds settled in for the Saturday night fights, the ring announcer called for a moment of silence. He recounted Dorgan's great contributions to the sporting world, then a bugler played taps and a wreath was laid on an empty ringside chair.

More bad news came in October, when the economy plunged into the Great Depression and many cartoonists feared for their jobs. Jimmy Swinnerton, always the closest to William Randolph Hearst, lobbied for his colleagues. He complained to Hearst when sports cartoonist Austin Peterson lost his job at the *Herald Examiner*, only to have Hearst admonish him that "certain economies are necessary in these days." Swinnerton also tried to convince Hearst to give a raise to cartoonist Jimmy Hatlo, who was threatening to resign but "might have his financial rash cured by some salve but not too much."

Herriman's real estate activities suggest that his finances were in good order. Others in the industry saw him as a sturdy pillar of the

Hearst comics empire. In October 1933, sports cartoonist Webb Smith sent a telegram to Hearst after having been let go. In it Smith offered to take a salary cut, adding that he hoped to someday achieve the status of Herriman and other mainstays.

In later years two stories—neither one substantiated—would circulate concerning financial dealings between Herriman and Hearst. "One of the most lovable characters in the profession is Herriman," wrote syndicated columnist James B. Reston in the late 1930s. "They still tell around newspaper offices a story that Herriman once refused a substantial raise from his boss because he felt his present salary was sufficient." Columnist Oscar Odd "O. O." McIntyre told an even more extreme version: "George Herriman, 'Krazy Kat' artist, once told his employers they paid him too much and to cut his salary. They did!"

Herriman did call himself a financial "liability" to Hearst, but no surviving financial record indicates that he either refused a raise or requested a salary cut. Nor is there direct evidence supporting a second story, also often repeated, that Hearst gave Herriman a lifetime salary—$750 per week, according to cartoonist Bob Naylor.

In fact, by the early 1930s, Herriman was growing increasingly worried about his status with King Features. On May 7, 1930, he sent a telegram to the syndicate's general manager, Joseph Vincent "J. V." Connolly:

JOE DEAR YES GOT NOTICE OF RENEWAL OF MY CONTRACT SHOCK
HAS LEFT ME MORE SENILE THAN EVER THANKS.

Just a few years later he confessed his concerns in a letter to *Krazy Kat* ballet composer John Carpenter's daughter, Genevieve:

Krazy "Ginny" has like myself, been sort of disintegrating with age—In August, my contract ends—and I feel sure that K.K. will

fade out with the fulfillment of that agreement—I still make the large pictures—weekly—you ask about—but I don't think they use them anywhere—at least I don't see them—nor does anyone else—however, as I am paid for them—I draw them—"

When Herriman wrote that he and Krazy Kat were disintegrating, he was only a little more than fifty years old. By then King Features had given up trying to add a new Herriman strip to its roster. In 1928, perhaps to justify his salary, Herriman had taken over a stock feature titled *Embarrassing Moments*, a gag panel already six years old that had been helmed by numerous artists, including Billy DeBeck. Herriman never signed his *Embarrassing Moments* work. The art, however, was unmistakably in his style: detailed crosshatching and whim-

From *Embarrassing Moments*, December 1, 1931

sical lettering, and characters with the same dancing eyebrows and sausage-thick fingers seen on the ensemble players of *Stumble Inn* and *Us Husbands*.

Some gags are boilerplate. Lines like "You suddenly realize that you've given that 'kind kop' the loaded cigar instead of the 'good one'" seem cribbed straight from *Joe Miller's Joke Book*. Yet other panels are fresh and funny. Herriman's version of *Embarrassing Moments* added dogs, cats, birds, and various other creatures to the rotating cast. Occasionally the subject was a cartoonist who resembled Herriman himself; other times it was a lead character named Mr. Bernie Burns who endured the embarrassments. Some of the sharper cartoons were on Herriman's favorite theme of social pretenders. In one, an owl lectures an embarrassed bird while a flock of other birds look on, laughing. "Why, you're just a 'linnet' with a 'rash' on your chest,"

From *Embarrassing Moments*, December 23, 1931

the owl says, with the caption reading, "And here you were hobnob-
bing with 'robin red-breasts,' thinking you were one of them."

In the *Embarrassing Moments* panel published on January 19, 1929,
a portly gentleman sings to a child, "Climb up on my knee, 'Sonny
Boy.'" His girth extends across his knees, leaving nowhere for the
puzzled child to climb. The cartoon includes an acknowledgment
in the top corner: "To Robert B. Naylor—gracias." Naylor, a King
Features artist with a gift for cartoon mimicry, said it was the first of
more than a hundred *Embarrassing Moments* panels that were actually
his work, done in Herriman's style. It is the only substantiated in-
stance of Herriman using a "ghost" to do his work.

Naylor, who had previously worked on *Krazy Kat* animated car-
toons, had recently been hired by King Features. "After my day's
work in the art department I'd nickel-and-dime my supper in the Au-
tomat then repair to my small room on West 47th Street to work out
cartoon ideas in the hopes that I'd invent a world-shaking strip like
Mutt and Jeff or maybe Barney Google," he recalled. "One evening,
stalled on my own creative bent for new ideas, I roughed-out a few
Embarrassing Moments thoughts." Herriman liked the "Sonny Boy"
panel, which was inspired by the popular song from the recent Al Jol-
son movie *The Singing Fool*. "Over the next few months I doped out
and drew about a hundred Embarrassing Moments and mailed them
out to him in California. He used every one of them. He signed my
name to them all before mailing them into the syndicate."

Comics art editor Leo McManus ordered the Naylor signatures
removed, reported cartoonist Bob Dunn. Naylor would also state that
he assisted with both art and writing to *Krazy Kat*, but that claim has
never been substantiated.

"I knew him as a shy, modest, retiring man, yet with an inner
strength," Naylor remembered of Herriman. "He was always thought-
ful of his fellows, and a person you would want to like if you could
just figure out how to 'get to' him."

I n 1929, *Variety* reported that "Hal Roach, via M-G-M, will enter the animated sound cartoon field with dialog and sound effects. George Herriman, originator of 'Krazy Kat,' will draw the series." The tantalizing plan never materialized, possibly because Herriman's syndicate had other plans.

Attempts to translate *Krazy Kat* to the screen continued through the late 1920s and early 1930s. In 1925, a few years after the Bray Production films had run their course, Margaret Winkler's New York based Winkler Productions—which helped launch the careers of Max and Dave Fleischer and Walt Disney—had reintroduced the series to replace *Felix the Cat*, which it had lost to another distributor. Made by Ben Harrison and Manny Gould in the Krazy Kat Studio, these cartoons starred an anarchic, slap-happy Krazy Kat far removed from the wistful resident of Coconino. The same character would carry forward into later films by Screen Gems. "It had none of the whimsy of the true Krazy Kat created by George Herriman," said cartoonist Isadore Klein. "It was just a cartoon cat walking upright."

Shamus Culhane, who worked as an inker on early *Krazy Kat* films, recalled his embarrassment at how poorly the movies reflected Herriman's comics. "In short, nobody in the animation business had ever had such graphic riches and used them less," he said.

These films would, however, leave their own mark on American animation. Krazy Kat now was cast as a male character and Ignatz, inexplicably, as a black mouse. The same pairing showed up in a series of *Alice* movies, distributed by Winkler and created by a young Walt Disney, several years before the 1928 debut of Mickey Mouse. In the *Alice* movies, a live-action Alice befriends an animated black cat that eventually acquires the name Julius, making him Disney's first regularly recurring cartoon character. The 1924 installment *Alice the Peacemaker* introduced the cat's foil, a black mouse named Ike. Underscoring the debt to *Krazy Kat*, the publicity poster for *Alice the*

Peacemaker shows a spindly-legged mouse throwing a brick at a cat, whose head is surrounded, Krazy-like, by tiny hearts. The film even featured a dog as a police officer.

To what extent did Ignatz Mouse influence the development of Mickey Mouse? A near-century of mythmaking shrouds the creation of Mickey Mouse, with Clifton Meek's comic *Johnny Mouse* often cited as a probable inspiration. However, at least one cartoonist of the era thought Herriman played an important role. "But for Herriman there wouldn't have been any Mickey Mouse," insisted *Popeye* cartoonist E. C. Segar. Herriman, meanwhile, kept his feelings to himself. When directly asked by an interviewer if Mickey Mouse was "a child of Ignatz," he demurred. "Oh, I don't know anything about that," he said, politely closing the topic.

Margaret Winkler's husband, Charles Mintz, eventually took control of the *Krazy Kat* films. In 1929 the newly christened Mintz Studio struck a deal with Columbia Pictures and moved the operation to Los Angeles, launching the longest-running and highest-profile *Krazy Kat* series, with Harrison and Gould turning out nearly a hundred more cartoons—in sound—over the next decade. This Krazy Kat was little more than a round-headed, inky amalgamation of Mickey Mouse and Betty Boop's pal Bimbo, a plucky yet fully malleable adventurer complete with a girlfriend and a sidekick dog of his own.

Another wave of Krazy Kat toys hit the stores. The Knickerbocker Toy Company produced felt dolls similar to those first introduced fifteen years earlier. J. Chein & Company recycled its old Felix toy molds, slapping on Krazy's name but making few other adjustments. There were "squeaky Ignatz cycle riders" and Krazy Kat sparklers. Often toy makers made little differentiation between Krazy Kat and Felix the Cat, or Ignatz and Mickey Mouse.

In summer 1935, animator Isadore Klein approached his boss about *Krazy Kat*. "I asked Mr. Mintz why we were not following the comic strip in our Krazy Kat cartoons. . . . Mintz's answer was that if we

were to follow the strip we would confuse the movie public. The public was accepting Krazy Kat just as Mintz was presenting him, so there was no need for an Ignatz to be tormenting Krazy with a barrage of bricks. So my question was dismissed."

Shortly after that conversation, however, Gilbert Seldes, writing in *Esquire* magazine, noted that Disney was "directly or indirectly inspired by Krazy Kat." Seldes added, "I still wonder why the attempt is not made again to put Krazy Kat on the screen." Seeing that, Mintz relented and let Klein give it a try.

The resulting film, *L'il Ainjil*, was released in 1936. It was the closest any movie came during Herriman's lifetime to re-creating his Coconino setting. Desert mesas are decorated in Navajo-inspired designs. Krazy Kat, Ignatz Mouse, Officer Pupp, and Mrs. Kwakk Wakk are all nicely realized; Pupp has a gravelly voice thanks to William Costello, recently relieved by Fleischer Studios of his duties as the voice of Popeye. The story, however, devolves into a silly series of gags about a canine kidnapper. The studio just didn't have the heart for the project, Klein recalled. "Whoever was the background man

From *Krazy Kat*, June 19, 1936

there really made drawings," he said, "but it was a senseless story, throwing bricks, and that was the end of it."

Herriman never said what he thought about this or any other film versions of his comics. There are no financial records indicating whether or not he earned licensing fees for either the movies or the toys. At the very least, each cartoon on the screen brought more fame to the cartoonist and increased his job security at King Features. Klein, meanwhile, didn't hide his opinion about the *L'il Ainjil*. "I was terribly disappointed," he said.

Despite the concerns Herriman expressed to Genevieve Carpenter over the disintegration of Krazy Kat, his daily and weekly strips from the late 1920s and early 1930s show his title character to be in wondrous shape, even making star turns in a few special comics drawn for *Vanity Fair*. In 1929 King Features lifted the graphic restrictions on the weekly *Krazy Kat* layouts, no longer constraining Coconino to a comic that could be equally divided onto two newspaper pages. Perhaps the experiment had failed to attract a significant number of new papers to the comic. Whatever the reason, Herriman again was free to to draw his strip however he'd like.

As situation comedies started to dominate the comics page, Rube Goldberg penned a plaintive essay in the *Saturday Evening Post*, asking, "Where are the slapsticks of yesteryear? You might possibly find one in the Smithsonian Institution catalogued as a bludgeon of ancient warfare."

Herriman offered his own meditation on slapstick in *Krazy Kat*:

> **MRS. KWAKK WAKK**: Every day, every day, that mouse sokks you with a "brick"
> **KRAZY**: But it's nevva the same "day," and nevva the same "brick"

MRS. KWAKK WAKK: But it's the same "mouse"?
KRAZY: Yez—
MRS. KWAKK WAKK: And the same "kat"?
KRAZY: Yes . . . Sazzit should be!!!"

The writer Umberto Eco, a *Krazy Kat* fan, once praised these endless variations: "In Krazy Kat the poetry originated from a certain lyrical stubbornness in the author, who repeated his tale ad infinitum, varying it always but sticking to its theme." During this time Herriman also added new characters and created extended—and often wondrously entangled—storylines, such as a weeks-long tale about a Mr. Meeyowl, the president of the Kokonino Kounty Katnip Korporation, losing his "Kittin Ket," who has moved in with Krazy Kat (who tries to decide between being Kitten Ket's momma or poppa). In another extended storyline, infidelities fly like bricks when a French-speaking cur named Mr. Kiskidee Kuku steals Krazy's heart, inflaming both Ignatz and Officer Pupp with "jelly." The illicit romance continues even after Kuku's wife and child are introduced to the story.

Herriman, having already created a world populated by talking animals, now moved to the lower orders. He added gags about clams and worms, and in one extended story Ignatz mistakes a Mexican jumping bean for a flea, squashes it, and is haunted by the bean's ghost. Such strips seemed to spring from Herriman's own sympathies. Remembered Wilson Springer: "My Dad accompanied him once in a trip to some desolate Indian village in Arizona or New Mexico, and while driving down there a bee flew into the open window of the car. George insisted that my Dad stop the car so he could carefully 'shoo' the bee out again, saying that 'Everything has a right to live, even a bee!'"

Krazy Kat became even more musical. Herriman started turning entire strips over to gags about popular songs such as "Silver Threads Among the Gold" and "Softly the Cuckoo is Calling." He also composed new lyrics for Krazy to sing:

Krying in the bat tubs
Tear drops drip like dew
My eye is fulla soap suds
And I'm a kussing too—

And:

A l'il bee, a l'il bug.
A l'il kiss, a l'il hug.
A l'il boid, a l'il flea.
A l'il mice, and l'il me.

In one daily strip, Krazy nearly drowns and is rescued by Pupp, not for the last time. Krazy ends that story with another new tune:

I love the dear old ocean
Its kurly waves is wet
But sometimes its kimotion
gets my idas all upset.

Still other songs were blues:

Something's the metta with me,
I know not why or widda
I ain't sick, and I ain't well
Wot it is I cannot tell
Yet go I tidda, or come I hidda
Something's the metta with me

These blues were part of a theme that, in the early 1930s, was becoming more pronounced in *Krazy Kat*. Twenty years had passed since Herriman prescribed "transformation glasses" for moviegoers

wishing to watch the Jack Johnson–Jim Jeffries fight films. Following that fight and the invention of *Krazy Kat*, Herriman never again wrote so directly on the subject of race. Yet he never left it alone, either.

And so there are gags about white Ignatz being darkened in ink or smudged in a doom cloud, and about being called a "itty opium mice," and there are gags about black Krazy Kat becoming a blonde, or being completely bleached exept for the tail, and there are gags about getting that tail marcelled, and there is a gag about how the coffee is black if you "look unda the milk."

There is also a gag about the properties of colors themselves. In a daily *Krazy Kat* published on the first day of 1931, an artist comes across Krazy and Ignatz, who are sitting together on a log. "A 'study' in black & white," the artist says. "He means us—" says Krazy, "me bleck, you white." Krazy and Ignatz then try to fool the artist by switching colors. "Another study in black & white," the artist says. As

From *Krazy Kat*, August 30, 1932

comics scholar Jeet Heer has noted, "In the comics page no less than in social life, the opposition between black and white can be redefined but not abolished."

Louise Swinnerton's grandson, Dave von Savoye, recalled discussing the topic with his grandmother and how she had told him that Herriman sometimes portrayed Krazy Kat as white and Ignatz as black. "Louise said that this was George's way of stating, 'So What! And, What if?' Meaning what difference would it make either way."

Krazy Kat was a sprite and, in Herriman's words, "free to butt into anything." But there are also instances in the comic in which Krazy Kat seems clearly to be, in Heer's words, "not just a cat with black fur but also, in a profound way, an African-American cat." One of these moments happened on Herriman's fifty-second birthday—August 22, 1932—when Krazy Kat brought to Coconino his "Unkil Tomket," a white-bearded banjo player whose cabin sits in the middle of a cotton field and, who, unlike Krazy, has a temper. Uncle Tom Cat hates all mice—except for Ignatz's wife.

What was Herriman up to with all this? Bob Naylor once recalled asking Herriman about the reversals in *Krazy Kat* and why a mouse attacks a cat and a dog tries to protect a cat. Said Naylor: "His mouth twitched slightly upward as he said, 'The whole "life" complex seems so absurd I simply draw what I see. To *me* it's just as sensible as the way it *is*.'"

That is the closest Herriman ever came to giving an answer. The writer Stanley Crouch has suggested that Herriman understood that, however he might feel in private, it was the job of any good clown to "make the audience laugh, not by forgetting but by remembering just how frail and absurd are the tunings of existence."

Which is not to say that Herriman hesitated to draw dark shadows of sadness in *Krazy Kat* as well. One of his starkest stories about race harkens back to both his Johnson-Jeffries cartoons as well as the vicious insults of *Musical Mose*. The unusual four-panel comic begins

with Krazy sobbing into a handkerchief and telling Officer Pupp that Ignatz had said "something b–b–bad." Ignatz protests, saying that he merely called Krazy a puzzle. Pupp then returns to Krazy:

> **PUPP:** I guess it wasn't so bad, "Krazy"—all he said was that you were a "puzzle"—
> **KRAZY:** I had a ida he said I was a "enigma"

In the late 1920s, a journalist named Mary Landenberger interviewed Herriman for an article that International Features Service would provide to client newspapers such as the *Nashville Tennessean*, which added *Krazy Kat* to its pages on May 12, 1930, and ran Landenberger's profile the following day.

The cartoonist whom Landenberger met was "a slight, quiet man with grey eyes set in a network of laugh wrinkles." Despite Herriman's good humor, Landenberger soon found that interviewing the artist meant "outgeneraling" a reluctant subject. "I have interviewed

From *Krazy Kat*, April 3, 1932

more celebrities than I can remember—and the most interesting personality of them all is George Herriman," she wrote. "Fame means nothing to him. . . . George Herriman is a shy, wistful, embarrassed little fellow who instinctively recoils from the spotlight of publicity. This modesty is not assumed. It is reflected in every word, every action."

Convincing Herriman to pose for a picture was an even greater struggle. "The public doesn't care about my face," Herriman said. Finally he took a seat at a drawing board and rolled up his sleeves. The camera snapped away. Landenberger then asked Herriman if he would remove his grey fedora. This time, she wrote, "he couldn't be shaken." Herriman did briefly move his hat to one side "just to prove that I have hair," he told her.

"Herriman doesn't think there is anything unusual or interesting about himself," Landenberger wrote. "Although his comic creations are followed by several hundred thousand people every day he tried to convince us that we were all wrong in believing that anyone wants to know about him. But when it came to talking about Krazy Kat—now that was a different story! The artist brightened considerably, greatly relieved to get away from the subject of George Herriman."

Herriman especially loved discussing the Arizona scenery in *Krazy Kat*. "That's the country I love and that's the way I see it," Herriman said. "I can't understand why no other artists ever use it. All those Indian names mean something to me and they 'fit' somehow whether or not the readers understand their meaning. I don't think Krazy's readers care anything about that part of the strip. But it's very important to me and I like it nearly as well as the characters themselves."

Landenberger and Herriman talked at length about the creative challenges in newspaper cartooning. The cartoonist, Herriman said, has a duty to challenge readers. "The people don't know what they want. And if they get an entirely new taste of something that's good,

they'll want it until they find something better. But we've got to give them the initial taste before they start clamoring for more."

Such opinions might make another artist sound haughty, Landenberger wrote, but not Herriman. "He makes you agree wholly with everything he tells you. He is gentle and unassuming, yet he always gets his points over."

TIGER TEA

On April 15, 1930, Pinky Springer's wife, Blanche Springer, succumbed to a pulmonary illness. A former newspaper artist herself, she had been bedridden for the past decade. Before she died, she asked that her family and friends scatter her ashes in the Hollywood Hills.

The Springers and the Herrimans gathered together for the task, beginning at the Herriman home and walking along Maravilla until they reached a vacant lot. They climbed up on a bank and sent Blanche Springer's ashes soaring toward Tinseltown.

It was a time of changes for the extended Herriman family. George Herriman's brother, Henry, had put his military troubles behind him and, in a ceremony at St. Vincent's, married Grace Wheeler, a midwestern schoolteacher who most recently had worked with American Indians in South Dakota. The couple moved to Huntington Park, where Henry worked as a chauffeur, while Grace took a counselor position at a junior high school.

Ruby Herriman was working as a stenographer, but Herriman's other two sisters had died young. Pearl had passed away several years earlier, and, in 1929, Daisy died at the age of thirty-four from unreported causes. Daisy's estate included shares of several pieces of property in Southern California. She left half to her sister, Ruby, and divided the rest between Henry and George, stipulating that George

pay $1,000 each to her two nieces, Bobbie and Toots, the only children in the extended family.

As she reached adulthood, Bobbie Herriman was in frail health, but her spirit was undimmed. With her sister, Toots, and Vivian Hammerly, she frequented Hollywood parties and became romantically involved with actor Andy Devine—against her father's wishes, family members later recalled. Then in September 1931 she attended a dinner party thrown by famed Hollywood attorney Fanny Holtzmann for actor Clifton Webb, then a Broadway song-and-dance star. Guests included Douglas Fairbanks and Gloria Swanson, as well as writer and *Krazy Kat* fan P. G. Wodehouse. Yet, for Bobbie, the most important guest was a wiry, acerbic writer from England named Ernest Pascal. The London-born Pascal stood five and a half feet tall (several inches shorter than the willowy Bobbie), with a shock of black hair sprouting over a long, thin face. Bobbie and Ernest were soon engaged to be married.

George Herriman had reason to disapprove of Pascal as marriage material for his youngest daughter. The writer was twelve years Bobbie's senior, and married. A restless intellect and author of hundreds of short stories, novels, plays, and screenplays, Pascal's most recent project was *Husband's Holiday*, a racy, precode film adaptation of his 1927 play *Marriage Bed*, which had been banned in some locales, including Boston, for its frank scenes of marital infidelity. Herriman at least tacitly approved, giving Pascal a hand-drawn *Krazy Kat* card as early as 1929 with a message, "Here's looking at you 'Earnest.'" Family members later speculated that, for George Herriman, the best thing about Ernest Pascal might have been that he wasn't Andy Devine, who at that time was known for his rascally behavior around Hollywood.

Yet Bobbie Herriman's newfound happiness would soon be eclipsed by family tragedy. On Sunday night, September 27, 1931, George Herriman's wife, Mabel, was driving her Buick home from a weekend in the town of Temecula. She reached the intersection of Seventh

and Valencia Streets in Los Angeles and, seeing a car careening her way, turned sharply and crashed into a brick building. She was rushed to Monte Sano Hospital and died the next day. Her death certificate cited a traumatic rupture to the small intestine. Mabel was fifty years old; the next summer she and George Herriman would have celebrated thirty years of marriage.

Newspapers across the country ran headlines reporting "Wife of Creator of 'Krazy Kat' Is Dead." Following a funeral service at Gates, Crane & Earl in Hollywood, George Herriman buried his wife at Inglewood Park Cemetery.

Just a few months later George Herriman's personal life again made national headlines. In March 1932 newspapers reported that Ernest Pascal was heading to Reno to divorce his wife, clearing the way to marry Bobbie Herriman. On Sunday, May 22, George Herriman welcomed George Swinnerton, a minister of the Methodist Church of Canada (apparently no relation to Jimmy Swinnerton), to his home on Mar-

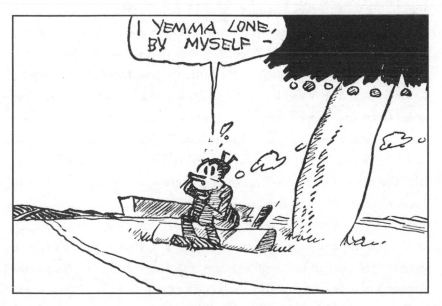

From *Krazy Kat,* January 16, 1933

avilla. It was a small ceremony of family and close friends. Herriman dressed neatly in a vest and tie and a Stetson hat. Ernest Pascal placed a flower in his suit lapel, and Bobbie Herriman stylishly attired herself in a pencil skirt and cloche hat. A portrait from that day shows the three of them together, outside. George Herriman stands between his daughter and her new husband; Bobbie turns her head to smile at the camera, holding on to her father's wrist with both of her thin hands.

Two weeks later Ernest and Bobbie Pascal sailed from New York for a monthlong European honeymoon. They returned to a secluded estate on La Brea Terrace, a short drive from Maravilla. Now living only with his oldest daughter, Toots, George Herriman had to accustom himself to a hillside home with considerable less happiness.

Even when Herriman might seem to be growing isolated, he never stopped responding to fans with enthusiasm. It has never been unusual for cartoonists to answer fan mail and even grant a small drawing, but few were ever as generous as Herriman. He gave away quick sketches, hand-colored weekly comics, and even ink-and-watercolor masterpieces. Some went to friends; others to lucky strangers.

One day in the late 1920s, Herriman opened his mail to find a letter from Byron Van Hook, the Indiana salesman who in 1911 had sent Herriman a fan request for a drawing of Krazy Kat. At the time, Van Hook had explained that his fiancee had demanded a Krazy Kat drawing before she would marry him. A few months after sending him the drawing, Herriman received a box of oranges from the Van Hooks' honeymoon in Florida.

Herriman forgot all about the letter until nearly two decades later, when another letter from Van Hook arrived. In it was the original note that Herriman had sent, along with a letter from Van Hook asking for a new drawing as an anniversary present.

Remembered Herriman: "It said, 'Here's the note you sent me when

I got married. I am sending it back because I want you to keep it. The girl I married—we are still married—we are celebrating our twentieth anniversary, and she wants to make the anniversary complete by another drawing. For goodness sake, help me out once more.' And I did."

That drawing has never been recovered, though many of Herriman's gifts have survived. They often show Krazy Kat, Ignatz, and Officer Pupp posing before a red-orange mesa. Illustrator Henry Raleigh received a Coconino vista showing the towering volcanic plug known as Agathla Peak, or El Capitan, with Krazy commenting on the marvels of "wolcennic ection." Others were customized for the occasion. In 1921 Herriman gave his old *New York Evening Journal* colleague Charles Wellington a large ink-and-watercolor cartoon honoring Wellington's Scottish terrier, Mike, who had foiled a home burglary; the painting bears a crest that reads, "In Leggus Mikus Bitum Yeggus."

Herriman's friend Beanie Walker was his favorite target, however. For Walker's forty-sixth birthday, Herriman presented him with a drawing of Joe Stork toting the infant Beanie and informing a curious rabbit, "It's a key puncher, sporting editor, movie magnate, X word puzzlist, and golf addict." Herriman also gave Walker and his wife annual anniversary gifts, again using the occasion to poke fun at his friend's crossword puzzle habits and his eccentric taste in clothing. In 1930, he drew himself frantically pumping a handcar through rolling hills named Serge, Tweed, and Worsted. "That 'Greek' aint brung our anniversary art yet—if he could understand 'American' I'd give him a severe talking at," Walker says, repeating Gunboat Hudson's joke from twelve years earlier.

Frequent inscriptions included "mitt luff and dewotion" or the Navajo greeting "Ah-hah-lah'nih," both of which Herriman might spell any number of ways. Even before turning forty he signed both letters and gifts as "Ole Man Herriman." Often he placed drawings and hand-colored strips in colorful mats and hand-painted frames, prepared by Los Angeles framer P. J. Bachman.

Herriman often went to great pains to honor requests for his orig-

inal work. When Gilbert Seldes begged Herriman for an original
Krazy Kat, Herriman contacted Leo McManus, George's brother,
who worked at King Features, to have McManus send the original
work to Herriman in California. Then Herriman wrote back to Sel-
des, telling him that he wanted to color the work before sending it,
modestly noting, "It adds a bit to it." Then he added:

> P.S. Would you
> want sometime
> a lil picture
> of them—
> a mesa, a moon
> a Kat—a Pupp—
> a mouse—
> in it—
> yes? no?
> Would it spoil
> your Xmas—
> if I sent you
> one around then

After coloring the *Krazy Kat*, Herriman sent it to Seldes with a
typically modest note:

> Your picture
> went forward
> yesterday
> —The Express
> have it in hand
> —Hope it reaches
> you in safety
> —and that you

> survive its
> advent—
> You ASKed for
> it—G. . . .
> —it seems
> even the big
> guns sometimes
> go—piff . . .

Such self-mockery frequently appeared in Herriman's letters, even when accompanied by stunning hand-painted cartoons. Herriman began drawing an annual Christmas card for the Seldes family to send out to friends. One year Herriman sent a note to Gilbert Seldes warning him that he would be tardy with the card, but "you can't dodge the affliction—I'll have it there in time—so you can still chase out and get some store cards—around the corner."

Herriman also devoted countless hours to creating both minor and large-scale masterpieces for colleagues on the Hal Roach lot. Soon others in Hollywood sent word that they'd love to have a *Krazy Kat* of their own. The English actor Roland Young, best known for starring in the *Topper* movies in the late 1930s, was a longtime fan. Herriman got word that Young hoped for an original *Krazy Kat* drawing. Before obliging, he contacted Seldes:

> Let me know
> Roland Young's
> Boarding house
> I'll punish him
> for his evil desire.

For actor and writer Carl Harbaugh, Herriman offered a racy cartoon of Joe Stork dropping a bundle labeled "gag" down the chimney

into Harbaugh's house. "Odeer," says Harbaugh. "I do hope this one lives long enough to sell down river to 'Laurel and Hardy.'" Off to the side, Krazy Kat, Ignatz, and Officer Pupp look on. "I hope it's 'original,'" says Pupp. "I hope it's 'healthy,'" says Krazy. "I hope it's 'legitimate,'" says Ignatz.

Hal Roach's film editor Richard Currier received an office scene starring one "Dick the Hurrier," who storms into Beanie Walker's office in a cloud of cartoon curses. Walker's crossword puzzles blow off his desk, a cat jumps under a desk, a mouse scrambles down a hole, and in the corner, hiding behind his drawing board, is Herriman himself, who signed this drawing, "From one of the wind-tossed."

For actress Jean Harlow and her new husband, director Hal Rosson, Herriman showed the couple nervously walking through a dense thicket of saguaro, with winged Indians—called "Arizona 'cupids'"—laying in wait. The gift lasted longer than the marriage, however, which likely was arranged only to ward off a growing scandal concerning Harlow's affair with married boxer Max Baer. Rosson and Harlow quietly separated within months.

Herriman reserved his grandest gift for Hal Roach himself. On Thursday, December 7, 1933, Roach threw a star-studded party to honor his studio's twentieth anniversary. It was a massive affair that lasted into Friday morning. There were performances by Will Rogers, Groucho Marx, Harold Lloyd, and Charley Chase. Stan Laurel and Oliver Hardy were there, along with Jean Harlow and Thelma Todd. Herriman honored the occasion with a cartoon of scenes from Roach's lot. Chase is caricatured in it, along with Lloyd and a knock-kneed Will Rogers. Stan Laurel holds a bottle for the infant Oliver Hardy, telling him, "One more wimpus out of you, and I'll cut your milk down to pre-repeal stuff." *Our Gang* director Robert McGowan is being quizzed by a carriage filled with babies about their contracts. Beanie Walker is "rhapsodizing rhetorically" while Hal Roach him-

self sails over the scene on horseback, swinging a polo mallet. "I do the hurdling and he gets the credit," complains Roach's horse.

Herriman's inscription suggests how he viewed his position in the Hal Roach studios. Dated the night of the party, it is signed, "the 'Squatter.'"

E ven as he spent hours preparing magnificent gifts for friends and admirers, depression settled over Herriman following the death of his wife. Louisa Wetherill couldn't convince her friend to visit Kayenta. She enlisted Harry Carr to help, but he was struggling just to get his friend to leave the Maravilla home at all.

"I will try my best to get George out," Carr wrote to Wetherill. "He is in a terrible state of mind. Wants to crawl off by himself. Doesn't want to see any of his friends. It would do him a world of good if I could get him out to the Navajo country. I am very anxious to go myself."

Bobbie Pascal also tried in vain to talk her father into making the trip. "Spring has come and I'm full of steam and itching to travel in your direction," she wrote to Louisa Wetherill. "Been trying to sell the idea to Pop the stubborn old louse but he says that he won't travel with me I'm too much of a pest—" She then begged Wetherill to visit Hollywood: "You know that since the Herriman family's divided up there are two houses here in Hollywood with 'welcome' written on the mat for you if you should decide to take a trip—Ernest's and mine and Dad's."

Bobbie's affection for the Wetherills rivaled her father's. In sweet, flirtatious letters, she complained about her reclusive father and her busy husband, and teased John Wetherill about beating him at checkers. She packaged up fashionable dresses as gifts and shipped them to Arizona.

In summer 1933, Ernest and Bobbie Pascal traveled to Kayenta to celebrate their one-year wedding anniversary. George Herriman

remained home but sent a check for two hundred dollars to John Wetherill and Clyde Colville to fund a surprise party. He sent along careful instructions:

> Listen, I want you two Navajo Nightingales to do me a favor—next Monday—May 22 is "Bobbies" first wedding anniversary—and I want you to get a few extra potatoes, and a few more mutton chops— make an extra cup of coffee—and maybe dig up a cake somewhere— ask a few of the neighbors over . . . and so make a bit of a time of it— It'll be something she'll sure remember—and also—I'm sure "Kitty" will like it very very much—In fact, I know she will—as She's the one who suggested this—(she tells me things)—and while my old carcass wont' be there—I'll sent my ole Spirit out—

"Kitty" was Herriman's late wife, Mabel. The note that "she tells me things," written one and a half years following her fatal crash, reveals the depth of Herriman's grief over her accident.

In another letter, Herriman congratulated Louisa Wetherill on the publication of her memoir *Traders to the Navajo*. A note to Clyde Colville seemed to underscore his current reclusiveness. He wrote that as he read the book he "got out my maps and followed you folks all over the Indian Country . . . and you busting into this country with a Derby on—Bet the Navaho are laughing yet."

After Bobbie married, Herriman's oldest daughter, Toots, became his sole companion in the house on Maravilla. That changed when Toots met Jack Wagner, a friend of John Steinbeck's who later would collaborate with Steinbeck on the screenplays for *A Medal for Benny* and *The Pearl*. In 1934, Wagner, forty-three, was one year away from celebrating an Academy Award win for a short musical comedy he cowrote, titled *La Cucaracha*. Like her younger sister, Toots Herriman married a writer more than a decade her senior. The newspapers reported an "airplane elopement" to a quick ceremony in Yuma, Arizona.

George Herriman's home was now empty but for two pet Scottish ter-
riers, Shantie and MacGregor. His deepening depression was noticed by
Minnesota artist Frances Cranmer Greenman, who had come to Holly-
wood to paint Bobbie Herriman's portrait. Greenman had looked for-
ward to meeting George Herriman, but the cartoonist turned out to be a
much different man than she had expected. The rooms in his "enormous
pink cement villa" were papered in whimsical drawings, yet the man
who sat amid the cartoons was the "saddest man I ever knew." Herriman
lived alone with his dogs, Greenman recalled, mourning the loss of his
wife. "He felt he brought bad luck to any house he stepped into," she said.

J ust as Herriman grew more concerned over the declining pop-
ularity of his comics, a passing mention in *Vanity Fair* magazine
kicked off a chain of events that returned the cartoonist to the crit-
ical limelight. It also would lead to one of the most inspired pairings
of writer and artist in American literature.

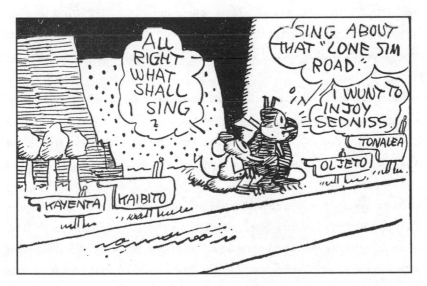

From *Krazy Kat*, June 30, 1933

In 1927, writer Donald Marquis had published the first book-length collection of his popular newspaper fables about a cockroach named Archy and a cat named Mehitabel. Humorist Corey Ford noticed a kinship to Krazy Kat and, writing in *Vanity Fair*, proposed a collaboration. "I suggested that his publishers bring out an illustrated edition of *Archy and Mehitabel* with drawings by George Herriman (another immortal) whose unconquerable Krazy Kat, half-feline and half-human, seemed to match the valiant soul of Mehitabel," Ford recalled.

Marquis, an Illinois transplant with a wide-ranging intellect, was the author of novels, plays, and poems, yet his most enduring creations proved to be Archy and Mehitabel, whom he introduced to readers in 1916 in his *New York Evening Sun* column "The Sun Dial." The pair's escapades, E. B. White once wrote, contained "cosmic reverberations along with high comedy," adding, "It was the time of 'swat the fly,' dancing the shimmy, and speakeasies. Marquis imbibed freely of this carnival air, and it all turned up, somehow, in Archy's report."

As Corey Ford realized, Archy's reports also reverberated with *Krazy Kat*. It is possible that Herriman and Marquis met, as they frequented some of the same newspaperman haunts, including Doyle's Billiard Academy. Even if they hadn't, they were surely aware of each other's work, and it is easy to see why Ford suggested the collaboration.

Marquis, like Herriman, played with conventional orthography. The poems were all written by Archy, he explained, who hurled himself headfirst at the typewriter keys. Because of such limitations, he was unable to capitalize. After an hour of labor he would crawl into a nest of poems and pass out.

As in *Krazy Kat*, there was a recurring theme of reincarnation—even theosophy. Ignatz's bricks harken to the days of Kleopatra Kat, when Egyptians inscribed their love letters on brick. Mehitabel, who now inhabits the form of a cat, is the reincarnated soul of Cleopatra. Archy is a poet lodged in a hard shell:

expression is the need of my soul
i was once a vers libre bard
but i died and my soul went into the body of a cockroach
it has given me a new outlook upon life
i see things from the under side now

Both Marquis and Herriman poked fun at postwar spiritualism fads, especially the notion of ectoplasm, which Sir Arthur Conan Doyle described as a "viscous, gelatinous substance" that mediums secreted in order to cover spirits and give them form. Krazy Kat, after learning about ectoplasm in a lecture by Joe Stork, ponders, "Just imegine having your 'ectospasm' running around william & nilliam among the unlimitliss etha." Archy, meanwhile, reports that he never personally saw any ectoplasm, but it sounds "as if it might be wonderful / stuff to mend broken furniture with."

Herriman and Marquis both filled their stories with Shakespeare and Aesop, and both dipped liberally into the inkwells of newspaper slang and popular song. Krazy Kat sighed "Watta woil" while Mehitabel moaned, "wotthehell wotthehell."

Marquis, after reading Ford's proposal in *Vanity Fair*, wrote to his editor, calling it a "swell idea." Herriman also was enthusiastic. Doubleday began planning a new edition of *Archy and Mehitabel* that would feature illustrations by Herriman on both the cover and inside pages. Herriman relished the opportunity for his work to reach a literary audience. Before sending his drawings to New York, he would excitedly stop by the *Los Angeles Herald Examiner* office to show them to his friend Pinky Springer.

Doubleday published the new edition of *Archy and Mehitabel* in 1930, with many reviewers taking special note of Herriman's contributions. Doubleday contracted Herriman for two more volumes: *Archy's Life of Mehitabel* in 1933 and *Archy Does His Part* in 1935.

Herriman did not so much invent a new world for Archy and Mehitabel as to re-create an urban Coconino County in Marquis's Shinbone Alley. Shinbone's rats are city cousins to Ignatz (Herriman even allowed himself a cartoon of Archy slinging a brick) and its cockroaches kin to Bum Bill Bee. Herriman draped Marquis's street corners in the crosshatched shadows that swept across his desert vistas, topped by the same curled sliver of a moon. In Mehitabel we can see what Krazy Kat might have looked like if Herriman had opted for a cat instead of a kat; no longer an ambiguous sprite, this feline's femininity expresses itself in a button nose, pointed ears, and long eyelashes.

Herriman, grateful for the work, colored in an illustration of Archy at the typewriter and presented it to Doubleday editor Daniel Longwell. Years later, many fans would remember Herriman as much for his Archy and Mehitabel illustrations as for *Krazy Kat*. Herriman would even cite Marquis as an influence on his own comic writing. "I asked him how, where and why he developed that swingy alliteration in his balloons and captions," said Bob Naylor, "and he modestly gave credit to Don Marquis."

Herriman's poetic flourishes, however, were well established long before he began his collaboration with Marquis. As one notable fan saw it, Herriman brought as much to Marquis as Marquis did to Herriman. "It seems to me Herriman deserves much credit for giving the right form and mien to these willful animals," E. B. White wrote. "They possess (as he drew them) the great soul."

In 1932, King Features relieved Herriman of his four-year assignment to draw *Embarrassing Moments*. It marked the end of its efforts to introduce George Herriman to a wider readership. There would be no more *Stumble Inn* or *Us Husbands*, or daily sagas of barons or college girls. For the remainder of his contract with King, Herriman's sole work would be writing and drawing *Krazy Kat*.

In 1935 the syndicate made an important change to the strip when it moved the weekly *Krazy Kat* to a Sunday comics supplement and began publishing it in color. Unlike Herriman's hand-tinted drawings, these new comics weren't lightly washed in desert tans, faded pinks, and grey-blues. Similar to works by Cliff Sterrett and other Hearst artists, they trumpeted loud blasts of yellows, greens, and reds.

These vivid colors further agitated the landscapes of Coconino. As mesas roll along behind Krazy and Ignatz, the sky might start out blue, then switch to red and yellow before settling on green. In color, distances seem to expand. The road where Krazy meets Ignatz appears to stretch longer; bricks sail farther. Herriman had always (at least when the syndicate allowed it) varied the size and shapes of his panels to change mood in his works. Now, as comics scholar Rick Marschall has said, he introduced both color and space into his cast as star players.

In a remarkable *Krazy Kat* published on April 18, 1937, Herriman introduced a baby bear that is a pale, even unearthly white. Krazy and the bear talk, and Krazy grows confused as to the bear's identity.

> **KRAZY**: I know you—l'il pertzin—you is a l'il polo bare.
> **BEAR**: Oh, nono—I'm not—I'm a little equatorial bear.
> **KRAZY**: Don't full me—the mokk of the polo riggins is all ova your fomm, shape an' figga.
> **BEAR**: That's because Mama was polar and Papa was polar.
> **KRAZY**: Norse Pole or Souse Pole?
> **BEAR**: Both—
> **KRAZY**: Wot?
> **BEAR**: Sure, Mama is from the South Pole—Papa is from the North Pole.

Krazy learns that this "equatorial bear" is the result of Mama and Papa meeting halfway on the equator. The equatorial bear, which also

appeared in the daily *Krazy Kat*, echoes Herriman's earlier cartoon about the hysteria surrounding the Jack Johnson fight, in which children are taught that the imaginary line around the globe is really the color line. Krazy remains puzzled but optimistic over the baby bear's story, offering only "Happy mittin' on the equator—is all I can say."

Like other cartoonists during this time, Herriman experimented with "continuity" strips that told a longer narrative over several weeks or even months. Continuity strips can be adventure tales such as *Buck Rogers* and *Flash Gordon*; soap operas such as *Mary Worth*; or the slice-of-life realism of *Gasoline Alley*. Some strips, such as *Little Orphan Annie*, combined all these elements. E. C. Segar was a master at screwball comedy told in longer tales, as in a Herriman-influenced tale of Bernice the Whiffle Hen that he launched in *Thimble Theatre* in 1928, right before introducing Popeye.

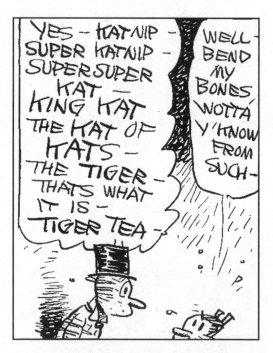

From *Krazy Kat*, July 10, 1936

Herriman tried out several continuities in his dailies, but in 1936 he launched his longest and most successful: Tiger Tea. Over nearly a year, he spun a magnificent, meandering tale out of the collapse of a company called Katnip Konsolidated. Before long, Krazy is brewing a cup of exotic catnip to see if it has a "kigg" in it, thus accidentally discovering a brew called "Tiger Tea." Ignatz, seeing that Krazy is "tippling again," waits with his brick, then is startled to hear a transformed Krazy thundering from his room: "Woowoo—I'm a wolkano . . . I'm a stempede of cyclomes . . . a poiminint tidal wave in a notion of dynamitc pow-wow!!!"

Herriman drew his saga of drug and drink straight from the headlines. When the series began in 1936, Prohibition was a recent memory and the federal Marihuana Tax Act just a year away. Herriman scattered in other topical jokes, poking fun at trusts and even the "Share Our Wealth" platform of Louisiana governor Huey P. Long. Yet such satirical notes quickly cede ground to wild fantasy, as when a tiger lily loses a fight to a violet.

Visually, Krazy has seemed to grow older along with Herriman, acquiring a rounder belly. ("You're heavier than you used to be," says Krazy's "Kousin Ketboid" while rescuing Krazy from a waterfall.) Krazy's face has taken on an occasional scowl. Other daily strips during this time started to include more and more scenes of melancholy, as when Krazy sees an empty bird's nest and wails at "the few tillity of it all." Even the effects of Tiger Tea are telling. A decade earlier, when Krazy took a snort of katnip, it led to ecstatic dancing. Now Krazy is after a cup of courage.

New life entered George Herriman's world on June 18, 1935, when Bobbie Pascal gave birth to a daughter, Dinah. Soon after that, Toots Herriman returned to live at the house on Maravilla.

"Toots got her divorce thank God," Bobbie Pascal wrote to Louisa Wetherill. "Pop's feeling pretty good & just as ornery as ever."

That summer Bobbie and Ernest Pascal invited Herriman on several occasions to their home on La Brea Terrace. There the couple filmed home movies. Footage shows young Dinah Pascal bringing her grandfather out of his isolation. Herriman, sporting a Stetson, striped shirt, and suspenders, gently lifts his granddaughter to his cheek, then smiles widely.

On another day he is formally dressed in coat, tie, and derby, looking every bit the "ole man," while the Pascals' younger friends sport casual pants and sweaters. Camera rolling, Bobbie stages a little pantomime, pulling a shawl over her head and kneeling down before her father; she cradles her baby and pretends to beg for alms. George Herriman clearly enjoys his daughter's little show.

In another short scene Bobbie spreads out a Navajo rug in the front yard to change Dinah. Her father shields the baby from the bright sun. Then he realizes he is blocking the camera and quickly steps away.

In September 1935 Gilbert Seldes reminded *Esquire* readers about Herriman and *Krazy Kat*, writing, "As he is timeless, ageless, and deathless, Krazy Kat has not been aware of his twenty-first birthday and I fancy that his creator, George Herriman, is still too modest about his masterpiece to celebrate the event. . . . I can only say that those who have once fallen under his spell can never forget him, and form a sort of secret society, bound together by their love of a gentle little monster, the first character in our popular mythology."

Herriman gratefully replied in a telegram to Seldes:

VERY NICE OF YOU TO SAY THEM PRETTY THINGS ABOUT OLE KRAZY IN 'ESQUIRE.'

In early November, Herriman finally returned with Bobbie to Kayenta and the Wetherills' guesthouse. He signed into the registry

with a tiny drawing of Ignatz and Krazy Kat, and Bobbie added a sketch of a girl with pigtails and a flower in her hat.

George was also joined on this trip by Hal Roach's older brother, Jack, who had become a close friend. Recalled by his daughters as a creative, gregarious man with a delicate disposition—he later would be hospitalized after a nervous breakdown—Jack worked as location scout and cinematographer for Hal Roach. Over the next years Jack Roach would succeed more than anyone else in convincing Herriman to travel to Arizona. Roach even managed to enlist Herriman in a celebrated and rowdy Los Angeles social organization known as the Uplifters.

The Uplifters dated to 1913, when the club was launched by businessman Harry Haldeman (grandfather of Nixon aide H. R. Haldeman) and included founding member L. Frank Baum, author of the Oz books. Baum named the group, pledging that members would strive to uplift both art and cocktails. He also created the club's symbol of a lifted hand. With composer Louis F. Gottschalk, Baum staged elaborate "High Jinks," a mix of circus acts, carnival games, drag shows, minstrelsy, and vaudeville. In the early twenties, the Uplifters purchased a sprawling ranch in Rustic Canyon, filling it with cottages, a swimming pool, a track for costumed chariot races, and a $137,000 clubhouse. Thanks to friends in local law enforcement, the fun never slowed during Prohibition.

Jack Roach likely joined the Uplifters in the early 1930s, when membership rolls swelled with movie folk, including Hal Roach, Will Rogers, Darryl Zanuck, Busby Berkeley, Douglas Fairbanks, Walt Disney, and George Herriman's old friend Leo Carrillo. It was during this time that Herriman began his association with the group, likely brought in as an "Honorary Member," a special category created for "any person distinguished in art, music, science or literature, or such person as may render the Club any signal service or benefit which it may wish to recognize in this manner."

Throughout the thirties and early forties, Herriman fulfilled his duties by caricaturing scenes at the club, including, in 1932, a series of elaborate cartoons of members, which he presented to Jack Roach with the note, "in memory of a merry moment 'up-lifting' and 'down-putting.'"

Herriman and Jack Roach made another trip to Kayenta in summer 1936, this time joined by Roach's two young daughters, Barbara and Lola. The Roach girls already knew their "Uncle George" from the Roach lot. As Hal Roach's nieces, Lola and Barbara had the run of the studio, and from time to time they appeared in *Our Gang* comedies. They might be hushed away during shootings, but both girls knew that Herriman would always welcome them into his office and show him his latest comics. "His voice was very soft and sweet," remembered Lola, "and he loved to laugh." Barbara recalled that Herriman sometimes would speak in the same manner of his characters, throwing in mixed-up words and bits of Spanish. She also remembers that he always kept a book nearby. "I suspected he was an extremely intelligent man," she said.

Years later both Barbara and Lola would remember the trip to Arizona as a grand adventure. It began on a June morning, when the girls piled into their father's Chevrolet and drove to Herriman's house. There, Herriman was waiting with his suitcase packed. On the drive through the desert, the happy gang sang Jack Roach's favorite song, "Ragtime Cowboy Joe":

> *He always sings*
> *Raggy music to the cattle*
> *As he swings*
> *Back and forward in the saddle . . .*
> *He's a high-falutin', rootin', shootin',*
> *Son of a gun from Arizona,*
> *Ragtime Cowboy Joe.*

Herriman and the Roaches made a detour to witness the final stages of construction of the Hoover Dam. They also visited the Grand Canyon, where Jack Roach struggled to keep the fearless Lola away from the canyon's edge. "George laughed every time I got in trouble," Lola said, "a deep-throated, lovely laugh." Herriman later commemorated the day with a cartoon of Lola walking a tightrope across the canyon, which he sent to Jack Roach.

Also at the Grand Canyon, Barbara recalled, the trip was delayed due to another physical ailment that plagued Herriman. Herriman, she said, suffered from migraines. "He stayed in his room for three days. We didn't see him. My father kind of passed it off, he didn't say anything. After three days he was himself."

Herriman was feeling better when the travelers reached Kayenta. He signed in for the party, drawing a family of cockroaches to represent Jack and his daughters. In Kayenta, Barbara recalled, she would occupy herself by hand-fishing for catfish and riding a horse to a piñon tree to gather nuts. There was fiddle music at the Wetherills' house at night, and the girls danced as the adults whiled away long evenings in fireside conversations.

It might have been during one of these conversations that Herriman learned that the Kayenta hospital had been converted to a tuberculosis sanitarium. In part due to overcrowding at schools and increased poverty following a federal livestock reduction policy, there was an epidemic of tuberculosis among the Navajo. With Clyde Colville, Herriman devised an elaborate plan to relieve patients' suffering at least for a few hours each week. On Saturday nights he would turn the sanitarium into a movie theater.

Back in Hollywood, Herriman purchased a projector, amplifier, film splicer and rewinder, and speakers. Colville set up a theater in the sanitarium, and Herriman arranged for weekly movies to be sent to Kayenta.

Soon, Saturdays in Kayenta became movie nights. Navajo and

From *Krazy Kat*, November 19, 1935

traders alike hitched their horses outside the sanitarium to join the patients for a cartoon and feature film. Years later John and Louisa Wetherill's grandson, William, would remember those nights clearly. "It wasn't a big room but it was big enough to show the movies," he recalled. "They had a projector sitting out in the middle and a pull-down screen." The fare was Tom Mix movies, along with Westerns that had been filmed in the area, some with local Indians as featured players. "All the Navajos were in there and every time a Navajo would say something, they'd start laughing, and you knew something was up," Wetherill remembered. When he asked his father to explain what was so funny, he was told that the Navajo actors improvised some of their own dialogue, using words that few white men would understand. "If someone would ask them a question, they'd call him a stupid *bellagonna*," Wetherill said. Mike Goulding, who ran the nearby Goulding's Lodge, also remembered those Saturday nights. "Great fun," Goulding said, "the Navajo always laughed at the sad scenes!"

Grateful Kayenta residents sent Herriman a gift of two silver dog col-

From *Krazy Kat*, December 12, 1937

lars. Herriman sent back a photograph of his Scottie dogs Shantie and MacGregor dressed in the collars and seated on a Navajo rug. "Ah-lah-hah-nih Sikis!" Herriman wrote, first greeting his friends in Navajo. "Here we are, wearing the grandest 'collars' that any 'Scottie' wore—a real royal cordon from regular folks—our good friends of Kayenta."

Even as children, Lola and Barbara Roach sensed the special bond that had formed between Herriman and Kayenta locals. When they were with Herriman, Barbara remembered, they were allowed into a Navajo sandpainting ceremony that otherwise would have been off-limits. "There were no other white people there, but under his auspices, we were allowed to come in," she said. "The Indians knew him and recognized him immediately, and trusted him as they would a friend."

Yet, for Herriman, personal losses continued to mount. One afternoon in early January 1936, Harry Carr walked into the *Los Angeles Times* office and urged some reporters to solve the mystery of

the death of actress Thelma Todd. Then he felt faint and went home. He died within days.

As had been done for Tad Dorgan in Madison Square Garden, boxers and fans at the Hollywood Legion Stadium bowed their heads in silence before the Saturday fight. A boxing bell rang ten times to count Carr out. More than a thousand mourners filled the Pierce Brothers mortuary chapel. Herriman was an honorary pallbearer, along with Mack Sennett, Harold Lloyd, Cecil B. DeMille, and Erich von Stroheim.

It was during this same time that Pinky Springer's daughter, Jeanne, died. Like Bobbie Herriman, Jeanne Springer suffered from epilepsy and underwent several operations in her lifetime. Herriman underscored his closeness to the family on a wreath that read, "Goodbye Neenie," a reference to how Jeanne, as a baby, had called herself "Neenie Pingie."

On June 23, 1937, Herriman lost his closest friend when Beanie Walker, on a golfing trip to Chicago, suffered a fatal heart attack. His body was returned from Chicago to Hollywood, where he was buried in Forest Lawn Cemetery.

Herriman and Walker's great friendship dated back to Herriman's *Los Angeles Examiner* days. Their bond was evident in photographs taken by Bud "Stax" Graves on the Hal Roach lot shortly before Walker's death. The photos show Herriman and Walker sharing wide smiles as they lean, side by side, against a wall. Their jackets are off; Walker is rumpled and looking at the camera while Herriman looks off to the distance. The pose is a jaunty joke shared by two old friends.

Shortly following Walker's death, Herriman joined his daughter and Ernest Pascal at their home for a small party to celebrate Dinah Pascal's second birthday. As before, the Pascals shot home movies. This time Herriman kept more to himself. In the film, as the children hold hands and march in a circle, Herriman sits cross-legged on the lawn, at the edge of a Navajo rug, smoking a hand-rolled Bull

Durham cigarette. It takes Dinah to draw him in. She toddles over to him and pulls on the wide brim of his hat, and Herriman gently lifts her into his lap.

The next month Bobbie and a friend took an extended trip to Kayenta and New Mexico. George Herriman did not accompany them.

T he effects on George Herriman of poor health and mounting personal losses would be witnessed firsthand by writer Boyden Sparkes. In 1937, Sparkes crisscrossed the country to gather material for a planned biography of Hearst editor Arthur Brisbane, who had recently died. Sparkes took a special interest in interviewing cartoonists, and in late September he brought his wife and secretary to Herriman's home on Maravilla.

"A few nights ago in Los Angeles, my wife and I and Miss LeSarre drove out to the Outpost, formerly the site of the home of the publisher of the 'Times' whom your husband knows," Sparkes reported to Brisbane's widow. "My errand was to see Mr. George Herriman, the creator of Krazy Kat and Ignatz Mouse, whose illegitimate child I suspect, is Mickey Mouse. He told me stories of the old days in the art department outside of Mr. Brisbane's office."

With Sparkes listening attentively, Herriman warmed up to the old tales. He recounted how Winsor McCay left his hat on his chair to fool Brisbane into thinking he was still at work, and about the time when Brisbane caught them all shooting craps. There were stories of hardworking cartoonists and tightfisted overseers like Wex Jones, who once drunkenly spit on the day's cartoons. Herriman laughed about how Walt Hoban and Cliff Sterrett would crib from the same jokebook, with Hoban sweet-talking the office girl into running his cartoon first. He told stories about throwing bananas at the time clock and peaches at Brisbane. Most of all, he spoke of Tad Dorgan, how he was the greatest fellow who ever lived, and how, when Tad was

confined to his home in Great Neck on Long Island, everyone from "yeggs" to judges would line up on the sidewalk just to wave at him.

When Sparkes and Herriman chatted about more recent times, the conversation grew strained. Joseph Connelly had been installed as head of King Features. Some cartoonists were complaining that King was no longer promoting star cartoonists, instead focusing on the success of the cartoons themselves. This did not bode well for Herriman, whose critical acclaim far outpaced his work's popular appeal.

Herriman repeated to Sparkes a recent conversation he'd had with Connelly:

HERRIMAN: He is out here a lot of times, but he never sees me. I am no asset—I am sort of a liability.

SPARKES: You are?

HERRIMAN: Oh, yes. He has told me, he said we are not selling enough of my stuff to pay my salary.

SPARKES: Well, that is his fault.

HERRIMAN: Well, you can't work with people you don't understand . . . and most people who like that work of mine are people who supply their own ideas—there is no story to it. There is no story, no characters, purely my own invention . . .

SPARKES: Well, it is still running in all the Hearst papers.

HERRIMAN: Not in all. I don't know how many are using it.

That evening, driving down winding Maravilla, Sparkes was pleased to have interviewed Herriman. He later based a chapter of his Brisbane biography, which was never published, largely on Herriman's rollicking tales. Herriman had also offered an original drawing to Sparkes, and Sparkes had eagerly accepted. "I want to thank you for your hospitality in showing us your mountain top," Sparkes wrote to Herriman. "The panorama which spread below us, amazed us all."

Later on the trip, Sparkes met up with cartoonist E. C. Segar. He spoke sadly about the man he had encountered that evening in the Hollywood Hills:

> **SPARKES**: He is as lonesome as the devil.
> **SEGAR**: Darn him he won't come down. I don't think he wants anybody around him.
> **SPARKES**: Well there is a lot of life left in him, he is just brooding and he ought to be kicked out of that place.
> **SEGAR**: I couldn't take him out to the Duck Club because he'd cry if I'd kill a duck.
> **SPARKES**: Yes.
> **SEGAR**: Oh yes. He won't kill a rattlesnake, it's been told on him that he would turn out of the road.

Sparkes asked Segar if newspapers were still running *Krazy Kat*, but Segar didn't know. "He had so much humility when he spoke about it," Sparkes said.

"If he was absolutely on top he'd be the same way, that doesn't mean a thing," Segar said. "He thinks and he told me, they're kind to me [which is] the only reason I have a job. He is the greatest artist who ever lived."

Added Segar, "I think an awful lot of him although I never see him."

POOL OF PURPLE SHADOW

PUPP: You seem to be undergoing a severe attack of fear, Krazy.

KRAZY: I am, Offissa Pupp—It's this cave—it's so dokk, so empty, so mitzterious.

PUPP: That hole was once the home of our ancestors—and now you fear its emptiness, its mystery, its darkness—shame on you, Krazy—

—*Krazy Kat*, February 28, 1938

I n April 1938, George Herriman, now fifty-seven years old, entered Good Samaritan Hospital for an emergency nephrectomy and had a kidney removed. He had been bedridden for the past month and now faced a difficult recovery.

While in the hospital, Herriman heard from an old friend: Louise Scher Swinnerton, Jimmy Swinnerton's ex-wife. On May 5, as Herriman recovered, he sent her a telegram. "MY DEAR LOUISE," he wrote, "MY SINCERE THANKS FOR YOUR KIND REMEMBRANCE GOOD THOUGHTS AND MOMENTOE IT WAS ALL MIGHTY NICE OF YOU AND I SURE APPRECIATE IT EVER THINE OLE MAN HERRIMAN"

They continued to stay in touch, often talking about their shared love of Arizona. "My dear Louise," Herriman wrote her on May 13,

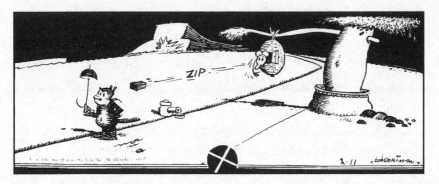

From *Krazy Kat*, February 11, 1940

"I am heading for home tomorrow wish it were right on through to where I could get a sniff of a hogan or the sight of a red butte on the horizon but three little Scotch monkeys are waiting for me so will have to forego that desire for the moment thanks again for everything Old Man Herriman."

Two years earlier Louise and Jimmy Swinnerton had divorced in Reno, with Jimmy testifying in court that domestic troubles had "made him ill and hampered his work." Swinnerton was sixty, and Louise Scher, a petite blond woman with striking pale blue eyes, was forty-eight. Her marriage to Swinnerton had been her fourth. A Michigan native of German and Swedish ancestry, Louise came from a socially prominent family and, as a young woman, launched a career as a reporter for Hearst's newspapers in San Francisco, Los Angeles, and Denver. She also served as foster mother to Japanese silent film star Tsuru Aoki. "The way of a newspaper woman lies along many roads of the world," Louise once wrote, and it well described how she lived her life.

"She was proud, sharp-witted, bright and very well read and traveled," her grandson Dave von Savoye recalled. Von Savoye believed that his grandmother's attraction to Herriman preceded both her divorce and Mabel Herriman's death, and that it had been sparked either somewhere on the Arizona desert or even earlier, when she worked

on Hearst's newspapers. Whenever and however it began, the relationship intensified after Herriman was released from the hospital. Herriman began playfully teasing Louise by calling her "Ingeborg," a nickname reflecting her Nordic ancestry. He frequently sent her photographs, drawings, and other gifts.

Only a handful of these would be preserved. One fateful day Von Savoye honored his grandmother's request to burn a stack of love letters that were bundled and tied with a purple ribbon. Still, Von Savoye added, she made sure to show her grandson enough of the correspondence to reveal that they were indeed love letters sent by Herriman.

Some missives did escape the fire. Beyond the self-deprecating jokes about his work and even his hair, the surviving letters are enough to show that Herriman, late in life and suffering from numerous physical ailments, was very much falling in love:

My Dear Louise

Yes, Ole Man Herriman is getting better—NO, I didn't do all that work while I was laid away—it's old stuff they picked out of the morgue and used over again

—My junk is so much the same—y'could use it backwards or forward—now, or then—nobody would Know the Difference—that's how come I fooled 'em for ten weeks—YOU should have known better—aint you a newspaper gal?

—I don't savvy at all why you give a mug like me so much time—writing long letters—looks to me like I'm just an excuse—so you can unload about those mesas and sunsets out in that ole pais pintado—Don't blame you for that—a taste of that stuff—sinks you—deep too

—Shux I was more than 1/2 mad at the Doctors for holding me over—I was all poised to grab me a set of wings—and blow—

—If your mind can stand it—try and imagine a Kinky headed runt—and four scotty dogs raising hell in a pool of purple shadow—Would that make the navajos sing "Coyote"— Bye Bye—THINE—Ole Man Herriman

P.S. This is the longest letter I've ever writ anybody— However I did it—I don't know—G.H.
P.P.S. I hate writing—G.

In another affectionate letter, Herriman fondly recalled the time they had met in Arizona together for his birthday party, which had been organized by Jimmy Swinnerton:

My birthday was
celebrated at that
time—I still
have the "paper"
signed by all
in the "potty"—
yours among them—
I was just a lad of 42—
a fine, upstanding bucko,
full of a fine fettle of
rheumatism—sore feet
and a bent back bone—
—T'was a jaunty journey
sweet lass—the memory lingers—
Here am I, writing—
which I dislike as much
as I do, taking a bath—
—God forgive me—
y'lured me—asking me

to send your (. . .)—this
picture—I'm a weakling—!
Yours for one country—
one friend—one woman, and one under shirt–
Thine in the glory—

"*Ole man Herriman*

P.S. and one Kidney!

In one surviving letter that was apparently sent along with a gift, Herriman made no secret of his physical attraction to Louise. "This, my good woman, was sold to me as a Bed Jacket," he wrote, then suggestively added:

all I can say for it is
it is short
it is convenient

Even more to the point, in one of numerous self-portraits Herriman sent to Louise, he drew himself leaning on a counter, a telephone receiver to his ear. "Wutcha got on?" he is asking. And in another short note Herriman suggested, "Now be a good girl and pull up your pyjamas."

On at least one occasion, Herriman's newfound randiness even spilled into *Krazy Kat*, in a Sunday page that featured Ignatz phoning up Krazy on the number "Coconino 69696" and asking, "How about a date?"

One day on the Hal Roach lot, Herriman sat down for an unusual portrait session with photographer Bud "Stax" Graves, apparently undertaken on Louise Swinnerton's urging. Herriman sent a series

of the portraits to Louise, annotating each one. In one he poses with Carroll Funk, who worked in Roach's music department. "Meet Funk!" wrote Herriman, calling his friend a "cross between a Presbyterian and a drunk and full of gossip—and good for a load of laughs."

Most captions were jokes at Herriman's own expense. "Now the repose stuff—parlor stuff—stuffed shirt," he wrote on the back of a solemn portrait. On another: "Y'should hear what a gang of ruffians are saying to me—'Kibitzers'—if you think I was having fun getting this ordeal over—you're nutty—" On a shot of Herriman resting his chin on a hand, he captioned, "Bare Knuckles got two sets of 'em." On another: "If Clark Gable gets too flossy pull this one on him—his ears will fall off."

"I think I've done my duty," he concluded on another portrait. "I'd kind a like to be sitting on that old sandstone seat at Wetherill's under the Hop Vine—looking out to the Carrizos—with church rock in the middle distance."

Louise Swinnerton's letters to Herriman have never surfaced, but she made known her affection in a letter to a friend. When *Judge* magazine nominated Herriman to join its "Newspaper Hall of Fame," she sent a clipping of the article with a note: "This . . . is my George—He is the only newspaper man whom I have really ever respected."

Louise Swinnerton lived three hundred miles away, in Palo Alto. Early in their courtship, Herriman sketched the interior of his home, which presumably she had not yet seen. He mapped out his bricked flower yard, kitchen, and dining room. He drew himself in a corner room, lying in his couch. Beside him is a worktable, piano, a phonograph, and a "couch for pups." The bathroom features a "BATH TUB UNUSED" and a "Wash basin occasionally used."

Next to his sketch of the toilet, Herriman added an unusual invitation: "wanted—someone to warm it—cold mornings."

On October 1938, E. C. Segar, just forty-three, died from liver disease. Bud Sagendorf, Segar's assistant who eventually took over duties on *Popeye*, recalled how, after the funeral, Segar's widow called him aside and asked, "Who was that gentleman in the back of the chapel?" At the time, Sagendorf had no idea. He only learned the truth years later when he met Herriman. "We were talking about Segar, and he was raving about what a tremendous cartoonist he was, and he says, 'You know, I went to his funeral.' And this was Herriman. He'd come out to go to the funeral. But he didn't introduce himself or say anything. He just disappeared."

The next year brought the news that George Herriman had long feared. On October 30, 1939, Bobbie Pascal underwent a surgery at Good Samaritan Hospital. A second surgery was performed the following week. Then there was another. "Mrs. Ernest Pascal is in the Good Samaritan Hospital for an operation," reported Louella Parsons in her syndicated column. "She is the daughter of George Herriman, creator of Krazy Kat."

At 7:30 in the morning on Tuesday, November 14, 1939, Barbara Herriman Pascal died at Good Samaritan. The cause of death was a postoperative intestinal blockage. Ernest Pascal was not in California at the time of his wife's death; George Herriman had his daughter's body cremated at Forest Lawn.

Three weeks later a full-page *Krazy Kat* comic appeared in newspapers. It begins with a desert scene: Krazy Kat lying in the dark, under a potted tree. A falling star cuts through the sky.

It is, the comic reads, "a little 'star'—just a baby 'star'—una estrellita caida—"

Krazy Kat catches the star, regards it carefully, and looks upward. Krazy then holds a pillow case over a campfire, inflating it. The makeshift hot-air balloon, with the star attached, rises upward and out of sight.

From *Krazy Kat*, December 10, 1939

Later, Ignatz and Officer Pupp come across a sleeping Krazy. A pillowcase falls at Ignatz's feet. A note is attached: "I'm back home and happy—thanks—Twinkie."

"I wonder if 'Krazy' knows anything about this?" Pupp asks.

"Him?" scoffs Ignatz.

T he poet Carl Sandburg, a devoted reader of *Krazy Kat*, once considered seeking out Herriman. "I had it in mind years ago that I'd like to look in on Herriman sometime, to see what kind of man he was," he recalled, "but then I thought, 'Hell, he can't tell me any more than what it says there in his work.'"

Not all agreed. In the late thirties and early forties, even as his health kept him confined in his home for long stretches of time, Herriman answered numerous letters from fans, some of them young cartoonists. The most devoted found their way to Maravilla Drive. Cartoonist Jud Hurd was in his midtwenties and working at the Charles Mintz Studio when Herriman invited him to visit, in 1936. He later wrote that after his trip to Maravilla, he finally

believed the story about Herriman returning a portion of his salary to Hearst. "He'd simply been working at a mere card table, not in an elaborate studio set-up," Hurd recalled, "and as he talked with me, he seemed a genuinely modest man." Hurd said that he'd tried to lavish praise on Herriman but was quickly cut off. "Oh, I'm not much of a cartoonist," Herriman said, "but Al Capp, there's a cartoonist!"

In New York, the *Herald Tribune* assigned writer Roy Wilder the job of filing an advance obituary of George Herriman. Wilder wrote to Herriman, telling him only that he wanted to interview him about comics. "I've just got nothing to talk about Roy—not a thing," Herriman wrote in reply. "I've bummed around in the cartooning pool for a lot of years but never made more than a ripple in it—If you're writing about the lads who amount to something or have meant something to the game—well—I've never got that far—I didn't have much to write about when I thought I was good—and I've less now that I know I ain't."

Herriman always had spoken modestly, but now he seemed truly self-disparaging. "My junk is not on the popularity list and I wonder just what you want the fool thing for," he answered another fan request for an original comic.

He was more responsive when, in 1938, a San Antonio high school dropout and hopeful cartoonist named Jack Kent wrote Herriman a gushing fan letter, begging for a piece of original art. Herriman sent to King Features for the original, warning Kent that "it is quite possible that it has been put out of its misery or lost." When the comic was located, Herriman added a colorful mat and frame before sending it.

After that, Kent wrote frequently, peppering Herriman with questions about every stage of the cartoonist's career, from *Baron Bean* to the *Krazy Kat* ballet. Herriman pretended to laugh it all off, but couldn't hide how deeply he was flattered:

—gosh, Johnny—dont
ask me to give you a
list of the comical
characters I've made use
of—there was a load
of them—all Flops—
—your strange interest
in my efforts sure has me
in a quandary—yes sir
I can't add it up at all–
—It must be something
you give to it—
surely nothing I'm putting
in it

In another letter to Kent, Herriman wryly detailed his medical ailments:

Didn't answer your
letter so soonly—
Ole Man Migraine
had me down—
He jumps me every
Sunday and holds
me down over till
Monday night—
I'm wobbly all
day Wednesday—
so all I've got
in days to do
my chores is
Thur. *Fri.* and

Sat—and as
my old brain
has lost its
cunning and
my old fingers
are stiff . . . This is no complaint, J.W.—
just the wail of the
wounded with age—

In the first week of October 1940, Herriman and Jack Roach took one last driving trip to Kayenta. At the end of the year Herriman heard from Kent again. The young cartoonist was entering the Army, and before shipping off he wanted to take a bus from Texas to Hollywood to meet him. Herriman said to call from the Hollywood bus station. Kent asked Herriman how he'd find him. "I'm in the book," Herriman simply replied.

"Mostly the subject of our conversation was the strip," Kent recalled. "I gushed and Herriman blushed." Sitting with his hero, Kent spelled out his theory that the comic strip was the only truly American art form and that *Krazy Kat* represented the heights of that art. "Herriman's reaction being on the order of, 'Aw, shucks,'" Kent remembered.

The visit lasted just a few hours. Kent recalled that Herriman advised him to be original in his work—advice that Kent would follow a decade later when he created *King Aroo*, a clever, wordplay-laden comic strip set in the make-believe kingdom of Myopia.

Recalled Kent of his time on Maravilla: "What does stand out clearly is my impression of the man. A gentler, kinder, more modest person there never was. To meet him was a privilege, but I knew him already through 'Krazy Kat.' The man is mirrored in his work. Unique and wonderful, both of them."

In 1897, Herriman had started his career in cartooning by scratching on chalk plates at the *Los Angeles Herald*. Forty years later he would revert to a similar technology, using a blade to carve through ink and board to create a unique, deeply textured effect. Some *Krazy Kat* comics from the late 1930s and 1940s appear to be as much chiseled as drawn.

The stories themselves also seem carved from a deeper and, at times, darker source. Themes of spirituality—in his work from the beginning—intensified. Herriman added Bible verses that he'd learned as a child, whether it's Krazy Kat casting a "loafibred in the watta" and a fish complaining that it isn't buttered, or Ignatz pondering, "What a person thinketh himself to be—he is just what he thinketh himself to be."

Herriman also returned, again and again, to the Navajo Beauty Prayer that he'd learned in Arizona:

> *In beauty I walk*
> *With beauty before me I walk*
> *With beauty behind me I walk*
> *With beauty above me I walk*
> *With beauty around me I walk . . .*

It is an anthem that Herriman plays frequently in *Krazy Kat*, as in a 1938 monologue by Officer Pupp:

> Today my world walks in beauty.
> Beneath me a good earth—a gracious glebe lies in beauty—
> Shifting sands dusts its cheeks in powdered beauty—
> And now will I turn my eye to the empyrean—where stars' gleam moon's beam—and sun's sheen abides in beauty . . .
> So—I'll nap in beauty.

As Pupp dozes, a brick sails across the desert and strikes Krazy. In the last panel Ignatz walks down the road, arms outstretched. "Today—my world walks in beauty," he says.

In many later *Krazy Kat* comics, Herriman dismissed much of his supporting cast to focus on his star characters. Narrative and art are boh reduced to essentials. Once Ignatz had eloquently lamented to Krazy Kat, "It pains me to think that both you, and I were fore-doomed at our birth." Now he simply pokes his head from his jail window and adds it all up: "Fate + Kop = Jail."

Yet, even as Herriman was stripping down *Krazy Kat* to its bones, he was creating several extravagant works for friends, including drawings for the Uplifters and gifts for his opera-loving butcher, Tony Roberge. For his dentist, Dr. Faunce Fern Petty, he drew a desert landform shaped like an upside-down molar, captioning it, "Kokonino Kounty's Krowning Kwandary." Following the death of Beanie Walker, Herriman had moved his drawing table into the of-fice of Hal Roach's sound director, Elmer Raguse. In gratitude, he presented Raguse with a cartoon of Ignatz painting Krazy Kat's por-trait while Offissa Pupp looks on. "Is *that* art?" Pupp puzzles.

On occasion Herriman even welcomed old colleagues to his home. Cartoonists George McManus, Carl Anderson, and Clare Dwiggins all made their way up Maravilla Drive one evening for dinner. They were joined there by a remarried Jimmy Swinnerton; apparently there were no hard feelings concerning Herriman's relationship with Louise.

It's not clear how many times Herriman made it to Palo Alto, or Louise Scher Swinnerton made it to Hollywood. Dave von Savoye re-called seeing Herriman and his grandmother in Palo Alto in the early forties and that Herriman had brought him boxes of circus animals and farm animals. "He sat on the floor and we played for what seemed like hours, though it might have been only minutes. We mixed the farm animals in with the circus to make it a bigger circus. He was humming 'Alexander's Ragtime Band.'"

From *Krazy Kat*, August 30, 1942

Around this time, Von Savoye remembered, he saw his grandmother with a new ring that she told him was an engagement ring. However, as Herriman's health worsened, his relationship with Louise became limited to letters and phone calls. In one drawing for Louise, Herriman holds a bowl overflowing with his tears. He added:

> Lot of weeps—
> and when I weep
> the idea is
> all my own—
> I don't blame
> nobody for
> it

He signed the drawing, "ole lachrymose Herriman."

In another letter to Louise, Herriman took a more bemused viewpoint:

Comical artists
write comical
letters—
I'd probably
write that
kind "too,"
if I writ"
—only it wouldn't
be as funny
—not being a
comical genius
—Anyhow—
what's a letter
—a match can
dispose of it
—nicely

After Bobbie Pascal died, her daughter, Dinah Cox, also known as Dee, was cared for by her aunt Toots when Dee's father, Ernest Pascal, was out of town. Cox remembered that her aunt had an upstairs bedroom on Maravilla that she shared with two cats, Lizzie and Bonnie (named for Lizzie Borden and Bonnie Parker). Her grandfather's Scottish terriers, now five in number, had the run of downstairs. The curtains were in tatters from the dogs—but when they misbehaved, Cox recalled, her grandfather just laughed and called them rascals.

When Herriman wasn't drawing, he could be found outside on his brick patio, tending to the gardenias and camellias in oversized planters. Other times, she said, he would leave the house to go see Tony Roberge, his butcher, to purchase a leg of lamb for the dogs. On one of these trips, Herriman presented Roberge with a photo of

his dogs Shantie and MacGregor. "Ooh, we smell meat," Herriman wrote next to the photo.

Cox also remembered days in which the house was kept in complete darkness. She understood that she had to keep quiet while her grandfather nursed a migraine. "You couldn't have a crack of light in the room, he would be lying there in vest and shirt," she said. "I always remember him in a vest and shirt, never saw him in bathrobe and pajamas. The shirt had a pocket so he could keep his Bull Durham in it." Herriman also suffered from edema, or dropsy, which gave him swollen legs, she said. Looking back, it seems to her that her grandfather was happiest when working, and that by then he seemed to be living more in his imaginary Coconino County than on Maravilla.

George Herriman's affection for his only grandchild is evident in drawings he gave her. He created original plates that she could paste into her books, with one showing a toy soldier standing guard over a thick volume of Plato, and a scroll that proclaims, "My army is watching so beware Mr. Rascal—Lay off of the book of Miss 'Dinah Pascal.'" For a Valentine, Herriman drew himself, tagged "Popp," seated on the desert floor against a potted cactus, singing to a shy girl standing before him, "Oh will you be my l'il ole 'Walen Dinah.'"

In another tender drawing, a curved road leads to the Enchanted Mesa, the bluff in New Mexico from which Joe Stork had launched so many nativity raids. No characters are in this drawing, just a promise: "'The Enchanted Mesa,' and Dinah, someday when you are 20. We'll come from here, to where you are, and sit a spell, with you."

In the final line Herriman promised, "It's a date."

When the United States entered World War II in December 1941, Damon Runyon reported that Herriman was joining other cartoonists in contributing art to an "Appreciate America" campaign. No Herriman contributions have surfaced, however. In con-

From *Krazy Kat*, January 20, 1943

trast to the First World War, when Herriman put the Dingbats in trenches and drew Krazy Kat and Ignatz with bombs and bayonets, the Second World War was primarily felt in Coconino County in home-front gags about rationing and wartime censorship. When Ignatz speaks of a brick, Officer Pupp quickly applies a "censored" sign over Ignatz's words. In the final panel, Ignatz puts a "censored" sign on the jail, complaining that it offends his liberty.

In a few wartime strips, Krazy Kat worked a desk at the draft board, interviewing everyone from an "ommy woim" to an "oily boid." On Saturday, April 25, 1942, Herriman visited the Los Angeles selective service board to fill out his own draft card. He registered as a white man (other listed options were "Negro," "Oriental," "Indian," and "Filipino") and was noted to have a dark complexion. At 62 years old, Herriman was measured at 5 feet 7 inches tall, weighing a slight 128 pounds. Later that year, he joined Elmer Raguse at a send-off party for Hal Roach, who had been called to duty by the Army. A photograph from the party shows Herriman arm in arm with Roach, both

smiling. But Roach's studio had been enduring hard financial times, and his departure surely signaled the end of Herriman's days on the Lot of Fun.

For Herriman the war hit closest to home sometime in 1942 or 1943, when a young Japanese-American man who helped care for Herriman—Herriman's granddaughter, Dee Cox, remembered him only as "William"—was forced to leave Maravilla Street as part of the wartime forced internment. William's ultimate fate has never been determined.

Herriman continued to seek out Westerns to ship to Kayenta's tuberculosis sanitarium. He sent *Kit Carson* and *Billy the Kid*, and hoped to get John Ford's *Stagecoach*, filmed in Monument Valley. When he learned it had been taken off the market, he sent a note of apology to Clyde Colville. For Christmas 1942, Herriman's grateful friends in Kayenta sent him a collection of Monument Valley photographs by Josef Muench and a large Navajo blanket with "Geo. Herriman" woven in the center. Herriman was deeply moved. "I'm still trying to write to the Kayenta Folks to thank them for their grand Xmas Present," he wrote to Colville. "Clyde—I'm choked—I can't find the words to say it—I'll keep on trying, or else get Winston Churchill to do it for me."

In February 1943, Herriman received a surprise visitor on Maravilla Drive: William Wetherill, John and Louisa Wetherill's fifteen-year-old grandson. Wetherill's parents, Ben and Myrtle, had recently separated, and the boy had run away from home to make his way up to Alaska, where his father was building roads. William hoped to stay in Hollywood for a while and maybe break into movies.

"I looked him up, found out where he lived, went to his house," Wetherill later recalled about visiting Herriman. "I talked to him for quite a while. He took me down and bought me a suit of clothes. He was real welcoming. He kind of lauded me as a kid who had kind of a wild imagination."

The closest young Wetherill would ever get to the movie business

From *Krazy Kat*, June 10, 1941

was working at a service station near the RKO Studios, where he parked cars for actors. "I gave him one of my suits—and also blew him to a new one—with hat—etc—" Herriman wrote Colville. "The Juvenile folk have their eye on him—He says he's 17—they say he's 15—so—if they catch up with him he'll either go home or to the Juvenile Hall—Says he's got a job at gas station—20 bux a week and a nice room—on Van Ness Ave—"

Herriman kept tabs on the Wetherill boy, who seems to have reminded him of a spirited twenty-year-old newspaper artist who once journeyed across the country to a boardinghouse in Coney Island. That spring Herriman wrote to Clyde Colville about the latest developments:

Hi Clyde.

　　Got a letter from Ben—in alaska he wants to get hold of Billy—and make a go of it together—Billy's trial comes up Thursday in Juvenile Court—I think he'll be sent back to

Myrle—she having the custody of the kids—I'll try to attend—
and see how it turns out and let Ben Know—

It was something I could do nothing about—those Juvenile
cases are rigid—

Although all concerned were very nice to me—

—There's sure a load of loose kids in this town

—Boys and Girls—nearly all movie crazy—

—It looked to me that Billy had a slight case of movie mad-
ness—

—a couple of more years and he'll be O.K.—he sure has an
imagination—wow!!!

In April 1943, Herriman joined King Features cartoonists Chic
Young, Hal Foster, and others in creating a velour-covered book
that was presented to William Randolph Hearst in honor of Hearst's
seventy-ninth birthday. Herriman drew Krazy Kat, Officer Pupp, Ig-
natz Mouse, and Mrs. Kwakk Wakk staring in wonder as Joe Stork
wings off with a bundle. Herriman wrote with affection to the man
who'd employed him for the past thirty-seven years: "Could be our
boss. Could be our chief. Could be our friend. Could *be*."

That year, Herriman learned that his friend Jack Roach's daughter
Barbara—who was along on the memorable drive when they sang
"Ragtime Cowboy Joe" all the way to Arizona—was getting married.
Herriman didn't attend, but he sent a full-color drawing of a military
wedding, complete with Krazy Kat and Officer Pupp ceremoniously
lifting swords over the couple. Perhaps the most touching drawing
from this time is a gift that Herriman gave to Helen Marie Kelley
during one of Herriman's increasingly frequent trips to Good Samar-
itan Hospital. Kelley, who had just completed her nursing training
in 1942, helped care for Herriman during his stay. Before Herriman
checked out for home, he gave Kelley cartoons drawn on hospital sta-

tionery. In one, Ignatz and Officer Pupp are wheeling Krazy into the operating room, where Kelley waits with a handsaw. "The sawing is ended, but the malady lingers on," wrote Herriman.

It was around this time that another old colleague, Ed Wheelan, made a trip to Hollywood to visit Herriman. Wheelan later recalled how Herriman felt discouraged that *Krazy Kat* wasn't selling. (A survey of newspapers from 1944 would find *Krazy Kat* in thirty-five papers, compared to more than a thousand for *Blondie*.) "I told him how great all cartoonists considered him, and that most of us had stolen bits of technique from him, but he really had the blues," Wheelan remembered.

As 1943 closed, Clyde Colville was bedridden with severe arthritis. Herriman wasn't faring any better. When he sent postage to Colville for returning films, he wrote in some detail about his ailments:

> Had to spend last
> week, in the
> Hospital—
> I'd become so
> bloated, and
> swollen with
> Dropsy—the
> Doc pulled me
> in—Drained
> my old belly—
> and being so
> weak that
> I had to have
> a 1000 c.c.'s
> of Blood plasma

Herriman spent that Christmas alone. Toots and Dinah were in New York, living in the Algonquin Hotel while Ernest Pascal worked

on his new comedy, *Peepshow*, which opened at the Fulton Theatre in February but closed in less than a month. Herriman sent a cheerful card to cartoonist Gus Mager, wishing him a "sweet and hotsy-totsy Xmas," as well as a card to Toots and Dinah with a cartoon of the pair suffering through a New York winter in puffy winter coats, hats, and hand warmers. In the corner of an otherwise festive card, Herriman added a note about some family business, writing that he had decided to accept a $20,000 offer on land in Yorba Linda. The land, he said, was getting too tough for him to hold.

In January 1944, John Wetherill was traveling in California and trying to reach his old friend. "I haven't heard from George," Wetherill wrote his wife, Louisa, "The past four days he was in the hospital. He has to telephone me, as I'm not allowed to telephone the hospital." Later that month Wetherill wrote that he finally heard from Herriman, who planned to visit him in Long Beach as soon as he got out of the hospital.

That visit still hadn't happened by February, however, when Herriman sent a letter to Colville. Next to a sketch of a man looking out over the mesas, Herriman wrote that he was still in the hospital and unable to see Wetherill. Then he asked with concern about reports that the Kayenta sanitarium was closing.

The reports turned out to be true. The government-run hospital was closing its doors so doctors and other personnel could be reassigned to aid war efforts. Colville set out to find a new home for the movie projector, eventually bringing it 120 miles south to the Winslow Indian Sanitarium. "I hope the hospital opens up again after this big rookus is over," Herriman wrote to Colville.

Then he added:

> I've been in
> the hospital
> most of the time
> lately, dropsy,

and a Bad
liver—which
Keeps me from
coming out for a
visit—I'm as
weak as dish water
and can't even, get
out in the yard—
Good luck
best regards to
all of you—
Ever thine—
Herriman—

Herriman added a sketch of a man, bundled up and in a wheel-chair, his eyes open wide in an expression of shock and misery.

It's the same expression seen on Krazy Kat's face throughout the first months of 1944. In one comic from February, Krazy leaps away from a volley of bricks and then collapses in exhaustion, sighing, "I am kapoot." An offstage voice accuses, "Quitter."

In March, Herriman settled more old business. He sent a letter to Ben Wetherill, who'd left Alaska for Seattle. He drew a picture of a man ice fishing, a desert dweller clearly out of his element. Herriman noted that he'd received Ben's letter and a twenty-dollar repayment for Herriman's help with his son William. Herriman scolded him for sending the money, demanding that he "please call the whole thing square."

Then Herriman added a few final lines about his health.

I've sure been
a pretty sick dodo—
In the

Hospital
most of the
time
Dropsy—and a Bad Liver that's
going to get me
me the rope
some day . . .
I'm so tired
all the time, I can
barely wiggle—
got to hit the couch
and ease my old bones
up a bit—

On Monday, April 24, Krazy Kat stands near the edge of a cliff, watching Ignatz pass. "A 'mice,'" Krazy says. "The 'komon kine.'" Then Ignatz passes again, this time carrying a brick. "A 'mice,'" Krazy says. "The 'betta kine.'"

That day George Herriman's liver gave out. He slipped into a coma, in which he remained until 7:25 the next evening, when, at the age of sixty-three, he was pronounced dead.

A ZEPHYR FROM THE WEST

The cause of death was hepatic coma, or a loss of consciousness due to liver failure. An autopsy revealed that George Herriman had been very sick for most of the year; he suffered from nonalcoholic cirrhosis of the liver, and he had a benign adenoma in his remaining kidney. The *New York Journal American* reported that Herriman had been confined to his house on Maravilla for the past three months but had "turned out his daily comic strip with no hint in its mirth that the artist was a sick man."

Services for Herriman took place at two o'clock in the afternoon on Thursday, April 27, 1944, at the Little Church of the Flowers in Forest Lawn Cemetery. Harold Ross Shaffer, a Presbyterian pastor, delivered the eulogy. Shaffer regularly eulogized at Forest Lawn; following the death of movie star Wallace Beery, he spoke to a crowd of thousands. The funeral for Herriman was a much smaller gathering. "It broke my heart at his funeral," cartoonist Bud Sagendorf recalled. "I don't think there were more than ten people there. This for a man who would go down in history as one of the all-time geniuses of comic art."

Herriman received greater accolades in newsprint. "Mr. Herriman's draftsmanship was said by his critics to be superb, and his character Krazy Kat, with its simplicity, its hatred of pretension, and its shrewd questioning of ordinary things, was regarded as a model of cartoonist's art," wrote the *New York Herald Tribune*. Even the

New York Times, which didn't stoop to publishing a comics page, lauded the cartoonist: "George Herriman's pictured chronicles of Krazy Kat are as much a part of journalistic history in America as the news stories."

Some of Herriman's obituaries cemented into fact many of the gags and tall tales once told by his old friends Roy McCardell and Tad Dorgan, as well as by Herriman himself. There were apocryphal stories of Herriman's Greek ancestors and of the cartoonist's youthful jobs as a baker, a house painter, and a carnival barker.

Yet all agreed on the deep affection felt for Herriman by his surviving colleagues. "If ever there was a saint on earth, it was George Herriman," Harry Hershfield said. Jimmy Swinnerton recalled their trips to Arizona and the high regard felt for Herriman by Navajo elders. Cartoonist Thomas Crawford Hill recounted driving up Maravilla to visit someone who was "always willing to help some kid who wanted to draw." Hill's homage, published in Hearst newspapers, included a single-panel cartoon titled *The Boss Is Gone*. In it, Krazy stands on a drawing table, holding a bottle of ink. "Wonder where the boss is, he's never late?" asks Krazy. "I dunno, Kat," says Ignatz, eyebrow furrowed. "Mibbie he went to see Tad."

The most perceptive tribute appeared in *Time* magazine. Writer Jane Wilson wrote how Herriman evoked James Joyce in prose such as "Just imegin having your 'ectospasm' running around, William and Nilliam, among the unlimitless etha—golla, it's imbillivibil—" She praised Herriman's "fantasy, irony, weird characterization, odd beauty," saying that Herriman made it all look as "simple as daylight." For the obituary Wilson conducted numerous interviews with Herriman's old friends, including Rudolph and Helen Dirks:

> As friends and colleagues talked of this modest little man, as he never on earth would have talked of himself, a figure of almost Franciscan sweetness emerged. . . .

Herriman believed that animals are superior to human be-
ings. . . . He tried to be a vegetarian, but had to give it up when
he became too weak. To the end of his life nearly all his ration
points for meat went to satisfy the sleek gang of stray dogs and cats
he took care of.

He was rather a dandy, in a loud way. His favorite sport was
poker. He could be a wonderfully entertaining host. William
Randolph Hearst loved him. . . .

Toward "serious" artists he felt very humble. He used to try
painting and, according to Dirks, invariably underestimated his
own work. He never got over feeling that his $750-a-week salary
was more than he was worth. . . .

He loved solitude, would often sit among people for hours
without saying a word. The one thing Herriman could always
talk about fluently and without shyness was Krazy Kat.

Herriman was crazy about Krazy Kat. In all his years of in-
timacy with him, he never got tired of the Kat. In Herriman's
30-odd years of work—always wearing his hat and usually impro-
vising fresh from the pen—he must have drawn something like
1,500 full-page Kats and 10,000 strips. . . .

Delight was Herriman's strongest point in a world where most
artists had lost it.

Gilbert Seldes later remembered a discussion he'd had with Herri-
man about mortality: "Once, while he was living in New York,
which was not where he wanted to be, he said he hoped to end his
life on the mesa lying down on a giant cactus leaf until he shriveled up
and was blown away by the wind. He almost had his wish."

Wherever Herriman's "ectospasm" might roam, he had taken care
to ensure that his mortal remains would go to the land he loved best.
"I have given . . . to my friend, Benjamin W. Shipman, instructions

as to the disposal of my remains, and it is my express wish that those instructions be fully carried out," he wrote in his will.

Following the service at Forest Lawn, Shipman, an attorney and manager for Laurel and Hardy, ensured that Herriman's ashes were shipped to Flagstaff, Arizona. The trail from Flagstaff is not documented, but it appears likely that Clyde Colville and the Wetherills collected their friend's ashes and scattered them over the Coconino and Navajo Counties that Herriman loved.

In the rest of the will, Herriman bequeathed $2,500 each to his sister Ruby and his brother Henry. He divided the remainder of the estate, valued at a little more than $90,000, between his daughter, Toots, and his granddaughter, Dinah. This amount didn't reflect Herriman's property holdings in Los Angeles and Orange County, which had become a profitable sideline. Reported income in his will included $431.98 from orange groves in Yorba Linda. Additionally, a sum of $1,821.53 was recorded as a final payment for *Krazy Kat* cartoons. The will does not state how many *Krazy Kat* strips were covered in that amount.

Over the next days and weeks, Herriman's friends would react to his death with disbelief and sadness. Ben Wetherill, stationed in a military base in Alaska, didn't want to believe initial reports. "Dear John," he wrote to his uncle. "The news came over the radio the other day that Geo Harriman [*sic*] was dead. We have not heard it verified yet. We hope that it is not the truth."

Krazy Kat ballet composer John Carpenter had recently contacted Adolph Bolm, who, twenty-two years earlier, had danced the part of Krazy Kat at Town Hall. A new version of the ballet was being staged on ice, and Carpenter had suggested Bolm attend with Herriman. Then Carpenter sent a second note. "Just before receiving your letter I had the sad news of the death of our beloved friend Herriman," Carpenter wrote. "He was such a lovely little man and certainly one of the most creative artists that this country has managed to produce."

Among the condolence letters received by Mabel Herriman was a note from Walt Disney. In it Disney freely acknowledged Herriman's influence. "As one of the pioneers in the cartoon business, his contributions to it were so numerable that they may well be never estimated," Disney wrote. "His unique style of drawing and his amazing gallery of characters not only brought a new type of humor to the American public but made him a source of inspiration to thousands of artists."

Shortly after George Herriman's death, somebody—most likely Toots Herriman—bundled up his remaining *Krazy Kat* submissions and sent them to New York. Among the posthumous comics was Herriman's final commentary on race. Mr. W. Weasel is considered a poor insurance risk when he's brown, says Officer Pupp. "Fency a color makin' a diffince in its welue," says Krazy.

Some cartoons would never be finished, including two daily strips left on the drawing table that showed Krazy Kat seated, banjo in hand, head lifted in song. Herriman had lightly penciled in a lyric: "How dip is the ocean—how high is the sky."

Other pages eventually were completed and published, however. Bud Sagendorf worked at King Features at the time, and he recalled the day that he and fellow staff member Grace Miller opened the package of Herriman's final comics. "I remember that we got a page . . . and it was a Sunday page in pencil, and Krazy Kat drowns. . . . And I remember Grace Miller—Grace sitting there, shocked, because it was after his funeral."

That final *Krazy Kat* page appeared on June 25, 1944, two months after Herriman's death. As in the final *Baron Bean* strip decades earlier, the main characters gather around an open lake. Officer Pupp stoops to examine some bubbles that are bursting from the water. He decides it's all a prank. "That 'mouse' is chousing me," he says, walking

From *Krazy Kat*, June 25, 1944

away, puffing on a cigar. Then, startled, he sees Ignatz walking from the opposite direction. "I have 'erred,'" he says, hurrying to the water. There is the silent face of Krazy Kat looking up at him from the depths. Pupp begs forgiveness and dives into the water. In the final panel, he carries an unconscious Krazy Kat across a yellow desert. Ignatz looks on, worried.

It had been thirty-four years since Ignatz first beaned Krazy beneath the floorboards of *The Family Upstairs*. Now Krazy Kat, Ignatz Mouse, and Officer Pupp had made their final appearance together, at least by Herriman's hand.

Τhe Krazy Kat cartoon strip created by George Herriman, who died recently, will be discontinued," reported newspaper columnist Leonard Lyons. "His syndicate believes that no other cartoonist can continue this strip, because Herriman's humor was so unique."

For financial reasons alone, it is unlikely that King Features would have continued the strip. By the mid-1940s, the slapstick meditations of *Krazy Kat* were hopelessly out of fashion on pages otherwise filled with wartime adventures and home-front situation comedies.

No book collections of *Krazy Kat* were published in Herriman's

lifetime. Pages of Herriman's original art piled up at King Features, where young cartoonist Mort Walker once noticed that they were being used to sop up water leaks.

Yet, when one influential fan heard the news of Herriman's death, he determined that *Krazy Kat* would not be forgotten. Poet E. E. Cummings contacted his publisher, Henry Holt and Company, to propose that he collect and edit a volume of *Krazy Kat* comics, as well as write the introduction. Gilbert Seldes was delighted to hear the news. "I am extraordinarily glad that you are going to do this," Seldes wrote to Cummings in October 1944. "May I place at your disposal my ancient and incomplete collection of these masterpieces, and give you also whatever clerical or other assistance I can."

The following September, Cummings submitted his essay "Foreword to Krazy" to the *Sewanee Review*. The next year Henry Holt published Cummings's *Krazy Kat*, announcing that the comic strip "had been away from the papers for some time now" and that it was "something for Americans to be proud of."

Cummings's book featured 310 strips, each selected by the poet. In his introduction he described a "meteoric burlesk melodrama, born of the immemorial adage *love will find a way*." Cummings wrote of Krazy as a "humbly poetic, gently clownlike, supremely innocent, and illimitably affectionate creature," understood by Officer Pupp and Ignatz no more than the "mythical denizens of a two-dimensional realm understand some threedimensional intruder." Cummings added new interpretations to Herriman's work, likening Krazy to the democracy's "spiritual values of wisdom, love, and joy," and Pupp and Ignatz to "those red-brown–and-blackshirted Puritans." With that, he joined what would become a growing chorus of writers, artists, and academics seeking to limn the mysterious devotions of Krazy, Ignatz, and Pupp.

The anthology, while far from a best seller, became a coveted treasure for fans, and its influence ran deep. In 1947, filmmaker Fritz Lang

gave a copy to a friend, inscribing, "May you acquire Krazy's philosophy which makes a brick on his—(her?)—noggin the purveyor of true love. For the Krazy's of this world there are no austerities." Animator Ralph Bakshi, who later would pay homage to Herriman in his movie *Coonskin*, recalled that he first noticed the book when he was starting out at the Terrytoons studio. "I'm eighteen and I go to [*Village Voice* cartoonist] Jules Feiffer's office and he has this book on his desk," Bakshi recalled. "That book stunned me, I've never seen such beautiful drawings in my life, I took that book at night when nobody was around." Thirty years later, Bakshi said, he finally returned the stolen book to Feiffer.

Cummings's *Krazy Kat* also fell into the hands of a young midwestern cartoonist just returned from military service. "After World War II, I began to study the Krazy Kat strip for the first time, for during my younger years I never had the opportunity to see a newspaper that carried it," recalled Charles M. Schulz. Discovering Cummings's book, Schulz said, "did much to inspire me to create a feature that went beyond the mere actions of ordinary children."

In *Peanuts*, Schulz drew deeply from Herriman's themes of love and loss, and sin and guilt. He created a world as devoid of adults as Coconino County was devoid of humans. Whether by intent or coincidence, there even were direct homages. Cummings's collection included a series, originally drawn in 1934, showing Krazy, Ignatz, and Pupp seated on a log, patiently waiting for the last "ottim liff" to fall. Schulz revisited this storyline frequently, drawing a leaf hanging on to a branch for dear life, or circling in midair for one last fling before the rake. In later comics Schulz even wrote a series of gags in which a school building tosses a brick.

Of all of Schulz's storylines, Lucy's football prank most suggested the obsessive Ignatz and his brick. In fact, a *Krazy Kat* series, first published in 1932, shows Ignatz tying a string on a football and then

From *Krazy Kat*, November 12, 1934

pulling it away when Pupp runs to kick it. Pupp, like Charlie Brown after him, lands squarely on his back.

In a conversation with *Mutts* cartoonist Patrick McDonnell, Schulz acknowledged that even Herriman's Navajo-inspired zigzag designs seemed to find their way onto Charlie Brown's iconic shirt. Said

From *Krazy Kat*, December 26, 1932

Schulz: "I always thought if I could just do something as good as Krazy Kat, I would be happy."

In the late 1940s, composer John Carpenter hoped to interest a New York childrens' orchestra in performing the music from *Krazy Kat*. His publisher sent this reply: "The only problem seems to be—and this is one that I also encountered when I spoke to others about it—that the present generation of young children doesn't know much about Krazy Kat."

Children in the early 1950s became slightly better acquainted with Krazy Kat thanks to a line of Dell Comics books drawn by John Stanley, better known for his work on *Little Lulu*. Stanley's Krazy and Ignatz had little in common with Herriman's, nor did they have much charm of their own, and the series didn't last past the decade.

After Cummings's book went out of print, *Krazy Kat* became a cult obscurity, little seen but spoken of reverently among writers, artists, and intellectuals. New York writer Pete Hamill once recalled the fifties as a time when you could "walk into the Cedar Tavern, the old one, and stand at the bar with Jackson Pollock, and sit in a booth with Franz Kline and talk about 'Krazy Kat.'" On another evening, Hamill recalled, he was at a party in the home of poet LeRoi Jones (later Amiri Baraka), talking with Jones about their shared love of Herriman's comic.

Also beginning the 1950s, an early reader of *Krazy Kat* began to publish children's books that owed a deep debt to Herriman. Many of Theodor "Dr. Seuss" Geisel's animal characters, including the Cat in the Hat, are similar in appearance to Herriman's animals, and desert landscapes in Dr. Seuss books such as *Did I Ever Tell You How Lucky You Are?* come straight from Herriman's Coconino. "At its best, the comic strip is an art form of such terrific *wumpf!* that I'd much rather spend any evening of any week re-reading the beautifully insane san-

From *Krazy Kat*, June 23, 1934

ities of George Herriman's Krazy Kat than to sit myself down in some opera house to hear some smiling Irish tenor murdering Pagliacci," Geisel said.

A unique adaption of *Krazy Kat* appeared in 1958, in the experimental *Camera Three* television program. Actors Charlotte Rae as Krazy Kat, William Hickey as Ignatz, and George S. Irving as Officer Pupp dramatized scenes from Herriman's old comics, intercut with selections from Samuel Beckett's recent play *Waiting for Godot*. Rae interpreted Krazy as a moon-eyed romantic, while Hickey played Ignatz as a sharp-tongued radical in horn-rimmed glasses, railing against cops. The program concluded that, although Herriman and Beckett were both nihilists—or at least "deeply cynical"—only Herriman offered a "faint message of hope."

Other nods came from Jack Kerouac, who in a *Playboy* essay included "Krazy Kat with the irrational brick" as a Beat progenitor. In 1962, novelist and comics fan Vladimir Nabokov added a line about

Tiger Tea to his novel *Pale Fire*. Artists inspired by Herriman included Willem de Kooning, who "would wait for the newspapers to come out and latch on to the newest 'Krazy Kat' cartoon," de Kooning's wife, Elaine, recalled.

Cartoonist Walt Kelly made sure the comic wasn't entirely forgotten in the newspapers. In the summer of 1963, Kelly devoted two weeks of his comic strip *Pogo* to honoring *Krazy Kat*. In Kelly's series, Howland Owl brings the turtle Churchy La Femme to see "a relic of a famous comical strips." A brick rests on the marshy ground of Okefenokee Swamp. "Ere the noods of nump sway into the forget . . . there lies laughs galore," Howland Owl says. In the final episode Pogo Possum and the scowling Porky Pine wander in:

POGO: Y'mean this mouse used to hit this kat with yon brick?
PORKY: Verily.
POGO: Kat must have taken it poorly.
PORKY: No . . . she loved it.

A second brick then zips over their heads. Pogo and Porky look around. "Ghosts!" says Pogo.

Krazy and Ignatz briefly found their way onto childrens' television in the early 1960s when King Features assigned animator Gene Deitch the task of creating new Krazy Kat cartoons for the small screen. Deitch was a longtime Herriman fan and his Coconino was visually more true to Herriman's vision than all previous animations, with the exception of Isadore Klein's *Li'l Ainjil*. Still, Deitch acknowledged, the attempt was doomed from the start. Right away, there was the problem of Krazy Kat's ambiguous gender. "At the time, any hint of a homosexual relationship between Krazy . . . and Ignatz mouse, an obvious male, was a loud no-no," he said. "So we declared Krazy a girl cat, and that was that!"

In the cartoons, which aired from 1962 to 1964, any visual plea-

sures are obliterated the moment that Krazy, voiced by actress Penny Phillips, starts speaking. "The poetic, pseudo-Yiddish Krazy Kat dialog had to be replaced with a sort of love-sick baby-talk," Deitch said. Officer Pupp and Ignatz, performed by veteran voice actor Paul Frees, fare better, but the damage was done. "I actually had fun doing this series, but I constantly looked over my shoulder to see if the spirit of George Herriman would zap me," Deitch said.

In the mid-1960s Herriman's comic strips started to find their way back into print, in European comics journals as well as in new anthologies published in the United States. With these comics as guides, many emerging underground cartoonists came to view Herriman as a godfather of their profession.

"For me and my generation, Herriman loomed really large, because Herriman crossed all kinds of boundaries, between high and low, between vulgar and genteel," said cartoonist Art Spiegelman. R. Crumb called Herriman the "Leonardo da Vinci of comics," while Harvey Kurtzman mounted a Sunday *Krazy Kat* page on his living room wall. Other young cartoonists, especially Denis Kitchen and Bobby London, added *Krazy Kat* parodies and homages into their work. Meanwhile, *Krazy Kat* returned briefly to childrens' television in the early seventies, with *L is for Love*, an affectionate animated short in the television series *Sesame Street*.

The discovery in 1971 of George Herriman's birth certificate intensified debate over his life and work, especially among those who knew and loved him. Dave von Savoye remembered that his grandmother, Louise Scher Swinnerton, who died in 1975, maintained that Herriman was white. "Louise told me George had been troubled all his life by rumors of his possible Creole heritage and speculation of possible black ancestry," said Von Savoye.

Even within the family, recalled Dinah "Dee" Cox, her grandfa-

ther couldn't escape kidding about his kinky hair. She recalled her father, Ernest Pascal, would frequently joke to Herriman about how he always wore his hat. Cox was living in Africa with her husband, an anthropologist, when she heard the news about Herriman's birth certificate, learning that she and her children had descended from a black Creole family from New Orleans. "I was delighted when I found out the news," she said. "It made him even more fascinating."

The opportunity to appreciate and debate Herriman's work depended on the preservation of the work itself. In 1968, author and collector Bill Blackbeard founded the San Francisco Academy of Comic Art, part of his lifelong mission to collect newspaper pages that were being dumped by libraries. Blackbeard gathered more than three tons of newsprint; his collection, as well as that of writer August Derleth, has been used in multiple printings of *Krazy Kat* and other historic comics. Over the years, pioneering scholars, among them Rick Marschall, set out to reprint all of Herriman's weekly *Krazy Kat* comics. The feat finally was completed by the Seattle-based Fantagraphics Books in 2008, with Blackbeard serving as editor.

In 1984 the International Museum of Cartoon Art in Rye Brook, New York, mounted the first major museum retrospective of Herriman's work, including original *Krazy Kat* art on loan from Dee Cox. Comics writer and scholar Brian Walker curated the exhibit, and cocurated the later touring "Masters of American Comics" show that highlighted Herriman in a pantheon of fifteen groundbreaking cartoonists. Walker, the son of *Beetle Bailey* creator Mort Walker, remained on the forefront of organizing museum exhibitions of cartoonists' works. He acknowledged challenges in negotiating the worlds of comics and fine art. "One of the things that is radically different between cartoonists today and those of my father's generation is that those older cartoonists

From *Krazy Kat*, July 31, 1932

did not think of themselves as artists," he noted. "They thought of themselves as entertainers."

In 1986, cartoonist Patrick McDonnell and his partner Karen O'Connell, along with Georgia Riley de Havenon, then working with the Graham Gallery, authored the landmark collection *Krazy Kat: The Comic Art of George Herriman*. Interest was further piqued two years later, when author Jay Cantor published his novel *Krazy Kat: A Novel in Five Panels*, which imagines that Krazy Kat has witnessed an atomic explosion in the New Mexican desert. In later years, images of Krazy Kat and Ignatz popped up everywhere from a T-shirt worn by Samuel L. Jackson in the movie *Pulp Fiction* to a pair of tattoos on rock musician Michael Stipe. Also professing his love of *Krazy Kat* was novelist Michael Chabon, who stated, "One could argue the claim, confidently, persuasively, and with an all-but-inexhaustible store of ever fresh evidence, that George Herriman was one of the very great artists in any medium of the 20th century."

At the end of the century, the *Comics Journal* came to the same conclusion, placing *Krazy Kat* at the top of its list of one hundred best comics; *Peanuts* came in second. Contemporary cartoonists continued

to be inspired by Herriman, none more so than Patrick McDonnell, who achieved in his comic strip *Mutts* what he once praised in *Krazy Kat*: a gallant exploration of the honesty of unabashed love. Bill Watterson, creator of *Calvin and Hobbes*, also professed a deep devotion to Herriman. "As a cartoonist, I read 'Krazy Kat' with awe and wonder," he said. "THIS is how good a comic strip can be." Watterson would honor Herriman by sending Calvin, as Spaceman Spiff, into a Coconino landscape. Will Eisner, pioneer of the graphic novel, considered Herriman's backgrounds a particular influence. Other cartoonist fans included Stephan Pastis and Garry Trudeau. "It seems like the perfect strip," Trudeau said.

At the time that Herriman died, there was little demand for a cartoonist's original art. King Features bundled up his pages and returned them to his family, and they ultimately would be prized as rare collectors' items. Viewing Herriman's original work is a revelation. The faint pencil marks, bold pen lines, and deep razor carvings are the marks of an artist who is imagining a story at the very time that he is bringing it to sudden, spectacular life. Herriman hid much of his own story from the world. Yet we can return to his work, again and again, to marvel at just how much of himself he brought to each page.

ACKNOWLEDGMENTS

Retracing the life of George Herriman brought me from New Orleans to California to New York to Coconino County, and into the worlds of nineteenth-century Tremé, early newspaper comics, young Hollywood, and the Navajo Nation. I am indebted to the many friends, cartoonists, and scholars who offered much help on the journey and occasionally spun the signposts to help me get back on track.

I am most indebted to Herriman's granddaughter, Dee Cox, who embraced this project and generously shared her own memories and family treasures. Joining Dee on a visit to George Herriman's beautiful old house on Maravilla will go down as one of the most magical nights of my career. Thank you to Mitch Tenzer for making that special evening possible.

I am also indebted to all who shared their precious memories of encountering Herriman: Barbara Bedwell, Lola Larson, Betty Rodgers, Betty Frickert, Marion Pickens, Dave von Savoye, Sarah Louise Bradley, Roy Wilder, and William Wetherill.

Other extended family members also offered invaluable help. Thank you to Patti Pascal for sharing her memories of her father, Ernest Pascal; and to Bruce Chessé for his wonderful tales of the Chessé family. I am especially indebted to Bruce for generously sharing the unpublished memoir of his father, the artist Ralph Chessé. Marlene Hammerly Duckworth told wonderful stories about her aunt, Vivian Hammerly, who worked for the Herriman family.

Thank you also to Morris Weiss, Garry Trudeau, Stephen Pastis, Mort Walker, Jerry Dumas, Stan Lee, and Ralph Bakshi for the discussions about Herriman and *Krazy Kat*. Special thanks to Austin "Pete" Peterson, who at 107 years old enthralled me with tales of working in William Randolph Hearst's art department, and about his friend and mentor, Jimmy Swinnerton.

This book could not have had a better friend than Tom Piazza, nor could I. Thank you for many favors, and for counsel and encouragement along the way.

Thank you to Calvert Morgan, for believing in this book, and to Timothy Wager, for helping it come to fruition. At HarperCollins, Jonathan Jao, Sofia Groopman, William Ruoto, Nate Knaebel, David Chesanow, and Gregg Kulick brought their considerable talents to this work. Special thanks to Roger Labrie for a careful edit. I am also indebted to my agent, Gary Morris, of David Black Agency, for advice and assists.

Chris Ware gave much help, not the least of which occurred during a memorable night at the Hideout in Chicago, when he scrawled the name and email address of Jeet Heer on the back of a sheet of brown paper covering a Harvey Pekar comic. Heer would prove to be invaluable, freely sharing his own research, giving an important early read on my manuscript, and providing introductions into the wild world of comics scholarship.

The many kindnesses of Patrick McDonnell and Karen O'Connell cannot be overstated. Their loving feat of art and scholarship, *Krazy Kat: The Comic Art of George Herriman*, provided a foundation for this work, and they generously opened their personal archives to my research. I will always remember our long night bathed in the fluorescent glow of a New Jersey Kinko's.

This book was sparked by the viewing of Herriman's original art in the touring show *Masters of American Comics*, during its stop at the Milwaukee Art Museum in the summer of 2006. Brian Walker co-

curated that show and, ten years later, would generously share his resources and bring his considerable expertise to improving my manuscript.

It has been a great thrill to meet artists and scholars whose work I have long admired. Rick Marshall, a true pioneer in comics scholarship, shared from his collection and thoroughly answered many queries; each email became a master class in early newspaper history. Rob Stolzer also shared his resources and knowledge, and dipped into his own wonderful collection of Herriman art and photographs. Art Spiegelman's insights and support have meant the world. Thank you to Mark Newgarden for sharing his knowledge and reminding me to keep it Plonsky. Craig Yoe offered much assistance; his book *Krazy Kat and the Art of George Herriman* serves as a wonderful showcase of Herriman masterpieces. Allan Holtz's archival work and encyclopedic knowledge proved critical on more than one occasion. At the Library of Congress, Sara Duke and Georgia Higley provided invaluable help. Thanks to Paul Tumey for help and insights into all things screwball.

I will never forget my afternoon in the home of the late Bill Blackbeard, hearing his tales while sitting in a fan's paradise of books, movies, and comics. Bill's tireless devotion to preserving old newspaper comics made so much of modern scholarship possible, including this book. I only hope that my work honors the passion and joy he brought to all his endeavors.

M. Thomas Inge generously opened his own archives of original Herriman research, which led to numerous discoveries. Among these was the news of Russell Myers's taped interview with Bud Sagendorf about Herriman. I am indebted to Myers for sharing that tape, as well as for creating one of my favorite childhood comics, *Broom Hilda*.

Thank you to Peter Maresca for numerous favors. If you'd like to read Herriman's newspaper comics as Hearst's lucky readers first encountered them, seek out *George Herriman's Krazy Kat* on Maresca's Sunday Press Books.

In addition to introducing countless new fans to George Herriman, the crew at Fantagraphics Books provided me with invaluable assistance. Thank you to Gary Groth and Eric Reynolds for your generosity. A special acknowledgment to the late Kim Thompson. I consider myself lucky that I was able to meet Kim and share a few laughs over *Krazy Kat* with him.

The Ohio State University's Billy Ireland Cartoon Library & Museum is a treasure, for both its impressive collection and its dedicated and knowledgeable staff. Thank you to Jenny Robb, Marilyn Scott, Caitlin McGurk, Susan Liberator, and Wendy Pflug, and a special thank-you to Lucy Shelton Caswell. Also at Ohio State, Jared Gardner has proven to be a trusted source of both information and perspective.

I am grateful to Brendan Burford at King Features Syndicate, and to Todd Hignite and Ed Jaster at Heritage Auctions, for their help. For many favors, I am indebted to Ron Goulart, Tom Gammill, Warren Bernard, Mark Johnson, Brian Nelson, John Batteiger, Ken Edelstein, Dean Mullaney, Peter Huestis, Sarah Boxer, John Batteiger, Dan Nadel, Huib van Opstal, David Michaelis, Chris Faucher, Susan Meffert, Eddie Campbell, Rob Pistella, Maggie Thompson, Cole Johnson, Jason Berry, Marc Voline, Christopher Stoner, John Boutté, Tom McDermott, Ulrich Merkl, David Hajdu, Eddie Campbell, Holly Devon, and Tim Samuelson.

Thanks to the efforts of my friend Lawrence Powell, I received access to Tulane University's Interlibrary Loan department, as well to as its microfilm readers. This proved to be invaluable, for I spent the better part of a year in Tulane's Microforms & Newspapers Department, spinning microfilm reels and peering at Herriman's work in numerous newspapers. Tulane is fortunate to have a wonderful staff there for its students and faculty. I also relied heavily on the Interlibrary Loan department, which expertly located microfilm, books and documents. Much gratitude to Randy Sparks and Lance Query for making this stage of research possible.

Gregory Osborne assisted me in locating treasures in the New Orleans Public Library's Louisiana Division/City Archives & Special Collections, as well as helping me better understand Creole life in old New Orleans. Thank you to Yvonne Loiselle for guiding me through the Herriman family records in the Notarial Archives Research Center. The archives of the Archdiocese of New Orleans proved to be the final key to tracing George Herriman's lineage. Thank you to Mike Courtney, Lee Leumas, and Dorenda Dupont for their assistance.

Thank you to Michael Poll for helping me better understand the role of Masons in the Herrimans' life. Melissa Daggett shared her findings about Henry Louis Rey and the Creole séance movement. Caryn Cossé Bell and Wendy Gaudin also helped me make sense of early New Orleans. Thank you to Sue Bixby, archivist for the Harriman Family Association, who is a tireless and generous researcher. It was great fun putting our heads together to solve a few Herriman mysteries. Thanks also to Steve Gauss for his help. I also received considerable assistance from Gina Greenlee, Sheila Rush, and Matt Chessé in better understanding the deep Herriman-Chessé connections. Thanks to Justin Nystrom for added help in understanding Creole New Orleans, and for generously giving his time to this work.

In Los Angeles, Stafford Poole, CM, guided me through the records of St. Vincent's College. Paul Hefti once again proved himself to be a great researcher and generous friend. I am especially grateful to Chris Bloor for hunting down the Herrimans' real estate transactions and other documents in California. Thank you to Richard Bann for providing guidance to Hal Roach's Lot of Fun, to Craig Raguse for information about his grandfather Elmer Raguse, and to Kelley Conway and Leonard Maltin for assistance with other film-related questions. Many thanks to James Knight, Khadija Anderson, and Mariama Anderson-Dione for help and support.

I was most fortunate that Herriman's dear friends in Arizona, John and Louisa Wetherill, saved their letters and other documents, and

that the storied Wetherill family has such a devoted archivist in Harvey Leake. Thank you also to Richard Mike and to Gary Fillmore, of Blue Coyote Gallery, for their help in Arizona, and to Miles Tisserand for assistance during our first visit to Coconino County.

Thanks to Jonathan Eig and Melanie Innis for professional help and good advice, and to Michael Burke, Tom and Suzy Robertson Jackson, and Alicia Ault for providing way stations on the Herriman trail. Special thanks to Philip Foster and to Tana Coman for help with photographs. Thanks and cheeseburgers to Michael Giordano for proofreading the manuscript.

I am greatly indebted to librarians and archivists across the country. They remain the unsung heroes of all biographies and works of history.

Special thanks to my mom, Marilyn Tisserand, for slogging through archival records, as well as for lifelong encouragement. To my father, the late Jerry Tisserand, who I dearly wish could have seen this book. And to Tami Hinz, Cecilia Tisserand, and Miles Tisserand, for love and laughter. Save me the funny pages.

NOTES

CHAPTER 1: ANCESTORS

3 **The cartoonist George Herriman, Berger believed** Arthur A. Berger, "Was Krazy's Creator a Black Cat?" *San Francisco Sunday Examiner and Chronicle*, Aug. 22, 1971, pp. 35, 40.

4 **"Personally speaking, I have been taught"** Ibid.

4 **"We all liked her very much"** "Talented Co-Ed in Chicago Proves to Be Negress," *Los Angeles Examiner*, July 22, 1907, p. 1.

4 **A few months later, the *Examiner* ran** "Lived as Spanish, Woman a Negress," *Los Angeles Examiner*, Oct. 4, 1907.

4 **just rub Herriman's knotty locks** "With the Fans," *Los Angeles Examiner*, April 2, 1909.

5 **"If Herriman keeps insisting"** Gunboat Hudson, "Mixing with the Best of 'Em," *Cartoons*, May 1918, p. 700.

5 **his ashes found their final home** Dinah "Dee" Cox, interview with author; George Herriman Cremation Records, Forest Lawn Memorial Park, Hollywood Hills, California.

5 **First came writer Ishmael Reed** Ishmael Reed, *Mumbo Jumbo* (New York: Scribner Paperback Fiction, 1996), p. 12.

5 **Around this time, writer Stanley Crouch** Stanley Crouch, "Blues for Krazy Kat," in *Masters of American Comics*, ed. John Carlin, Paul Karasik, and Brian Walker (New Haven, Conn.: Yale University Press with Hammer Museum and the Museum of Contemporary Art, Los Angeles, 2005), p. 194.

5 **"I never saw any indication in pigmentation"** Karl Hubenthal, "Letters," *Inks*, Nov. 1996, inside front cover.

6 **Bob Naylor, who had worked with Herriman** Bob Naylor, letter to M. Thomas Inge, M. Thomas Inge Archives, March 30, 1974.

6 **"What we don't know"** Bill Blackbeard, interview with author.

7 **Spencer's "new speculation"** "An enitrely [*sic*] new speculation!," *Otsego Herald*, Oct. 31, 1816.

7 **"black spirits and white spirits"** "Fram [*sic*] the Dutchess Observer—a Democratic Paper," *Northern Whig*, Nov. 5, 1816.

7 **At some point in their journey** Stephen Herriman family background from e-mail exchange with Sue Bixby, Harriman Family Association. Stephen Herriman relationship with George Herriman from Marriage Records, Archdiocese of New Orleans Office of Archives.

7 **Philip Spencer died** "Died," *City of Washington Gazette*, Jan. 2, 1818.

7 **In 1820, an auction was held** "Collector's Sale," *Louisiana Herald*, March 17, 1820.

7 **The next year, on May 7** "Married," *Evening Post*, June 13, 1821.

8 **His first registered ship was the steamboat *Hercules*** *Ship Registers of New Orleans, Louisiana, 1821–1830* (WPA's Survey of the Federal Archives of Louisiana, 1942).

8 **Stephen and Janett had two sons and two daughters** Vital records for Stephen Herriman and family are kept at the Erbon and Marie Wise Genealogical Library, Louisiana State Archives, Baton Rouge, Louisiana.

8 **In 1843, Stephen moved his family** Vieux Carré Survey, Historic New Orleans Collection, New Orleans, Louisiana.

8 **He became a Mason and served as grand treasurer** "Masonic Relief," *New Orleans Daily Picayune*, Sept. 10, 1853.

10 **In 1853, Herriman took out an advertisement** "Ten Dollars Reward," *Daily Picayune*, April 26, 1853.

10 **Stephen Herriman died suddenly** "Deaths," *Daily Picayune*, June 11, 1854.

10 **Janett Herriman and her children** Sue Bixby, Harriman Family Association.

11 **"a sound more strange"** Jon Kukla, *A Wilderness So Immense: The Louisiana Purchase and the Destiny of America* (New York: Anchor, 2004)

11 **As historian Gwendolyn Midlo Hall has explained** Gwendolyn Midlo Hall, *Africans in Colonial Louisiana: The Development of Afro-Creole Culture in the Eighteenth Century* (Baton Rouge: Louisiana State University Press, 1992).

12 **Wrote one traveler to the city** Harriet Martineau in *Society in America* (1837), quoted in Lyle Saxon, *Fabulous New Orleans* (Gretna, La.: Pelican Publishing Co., 1995), p. 182.

13 **For a woman, *plaçage* might offer** An extensive discussion of options for Creole women can be found in Shirley Elizabeth Thompson, *Exiles at Home: The Struggle to Become American in Creole New Orleans* (Cambridge, Mass.: Harvard University Press, 2009)

13 **Their first, Frederic Herriman** Archdiocese of New Orleans Office of Archives.

13 **Stephen Herriman's paternity does not emerge** Ibid.

13 **Within a few years of the birth of her two sons** Records for the Chessé family are in the Archdiocese of New Orleans Office of Archives, the New Orleans Notarial Archives Research Center, and the Louisiana State Archives, among other locations. I am indebted to Bruce Chessé for the historical work he has done concerning his family, as well as to the research of Michael Cahill, Gina Greenlee, JoAnne Haugen, and Paul Hefti.

13 **The earliest record for George Herriman** Archdiocese of New Orleans Office of Archives.

13 **At the time, St. Louis** James B. Bennett, *Religion and the Rise of Jim Crow in New Orleans* (Pinceton, N.J.: Princeton University Press, 2005) p. 143.

14 **Olivier bought and sold both property and slaves** New Orleans Notarial Archives Research Center.

14 **Among Olivier's Faubourg Marigny acquisitions** Ibid.

14 **These two lots became the first known addresses** *New Orleans City Directory*, *Michael & Co. New Orleans Annual*, 1846.

14 **Frederic worked as a carpenter** *New Orleans City Directory*. Documents concerning the life of Frederic Herriman are kept in the Archdiocese of New Orleans Office of Archives, the New Orleans Notarial Archives Research Center, and the Louisiana State Archives.

14 **He courted Louisa Eckel** "Herriman," *Daily Picayune*, March 3, 1902.

14 **On September 4, 1846, George Herriman** Archdiocese of New Orleans Office of Archives.

15 **By this time, George Herriman** Archdiocese of New Orleans Office of Archives, the New Orleans Notarial Archives Research Center, and the 1850 *New Orleans City Directory*.

15 **George and Louisa Herriman soon had a houseful** Lousiana State Archives.

15 **Herriman & Chessé occupied the ground floor** New Orleans Notarial Archives Research Center.

16 **This was the Herrimans' home** Ibid.

17 **Not long after Fort Sumter** "Meeting of the Free Colored Population," *Daily Picayune*, April 23, 1861, p. 1.

18 **Among the enlistees was Herriman** National Park Service, *U.S. Civil War Soldiers, 1861–1865*, via online database Ancestry.com.

18 **All eyes were on the Herrimans** "The City," *Daily Picayune*, March 3, 1862, p. 4.

18 **Among these was Arnold Bertonneau** *Liberator*, April 15, 1864, p. 3.

18 **One Native Guards member** "Letter from a Colored Soldier," *New York Times*, Nov. 20, 1862.

19 **George Herriman signed on** Jari Honora, "Cast Your Eyes upon a Loyal Population: Lincoln and Louisiana's Free People of Color," *La Creole, A Journal of Creole History and Geneology*, Oct. 2009

20 **On March 12, Roudanez and Bertonneau** Ibid.

20 **"The colored man, too, in seeing all united for him"** Richard Striner, *Father Abraham: Lincoln's Relentless Struggle to End Slavery* (New York: Oxford University Press, 2006), p. 256.

20 **In addition to offering fine silks and velvets** "Patriotic and Literary Lecture," *New Orleans Tribune*, May 4, 1865.

a

20 **Later that year, at a raucous Republican meeting** "The Republican Meeting Last Night," *New Orleans Tribune*, Nov. 14, 1865.

21 **"Carts were constantly passing"** Emily Hasen Reed, *Life of A. P. Dostie, Or, The Conflict in New Orleans* (New York: William P. Tomlinson, 1868), p. 306.

21 **Recalled *New Orleans Tribune* editor Jean-Charles Houzeau** Jean-Charles Houzeau, *My Passage at the New Orleans Tribune: A Memoir of the Civil War Era* (Baton Rouge: Louisiana State University Press, 1984), p. 128.

22 **The events inspired one of** Thomas Nast, "Amphitheatrum Johnsonianum—Massacre of the Innocents at New Orleans, July 30, 1866," *Harpers Weekly*, March 30, 1867, pp. 200–201.

22 **Four years earlier, George Herriman Sr.'s stepfather** "Suicide," *Daily Picayune*, May 8, 1862.

22 **Her steamship, the *Fashion*** "Burning of Steamer Fashion," *New York Times*, Jan. 5, 1867.

22 **A fellow passenger reported** *New Orleans Tribune*, Dec. 30, 1866, p. 1.

23 **In 1872 P. B. S. Pinchback** John W. Blassingame, *Black New Orleans 1860 –1880* (Chicago: University of Chicago Press, 1973), p. 178.

23 **With this new lodge** "Masonic," *New Orleans Tribune*, June 23, 1867.

23 **The lodge met on the corner** Minute books for Fraternité Lodge No. 20, George Longe Papers, 1849–1971, Amistad Research Center, Tulane University, New Orleans.

23 **Although Rey was a devout Catholic** Melissa Daggett, *Spiritualism in Nineteenth-Century New Orleans: The Life and Times of Henry Louis Rey* (Jackson: University Press of Mississipi, 2016).

25 **His father looked on** George Longe Papers.

25 **"He was a colored man"** James Hollandsworth, *The Louisiana Native Guards: The Black Military Experience During the Civil War* (Baton Rouge: Louisiana State University Press, 1995), p. 15.

25 **In 1871 Sauvinet** Justin A. Nystrom, *New Orleans After the Civil War: Race, Politics, and a New Birth of Freedom* (Baltimore: John Hopkins University Press, 2010).

26 **In 1873 Sauvinet was named** New Orleans Notarial Archives Research Center.

26 **Herriman and Chessé had risked** "Sauvinet's Sorrow," *New Orleans Times*, July 24, 1878.

26 **As the turbulent 1870s ended** Archdiocese of New Orleans Office of Archives.

26 **For the Herriman family** Francis P. Burns, "Burns Relates School History," *New Orleans Times-Picayune*, Oct. 26, 1961, p. 8.

CHAPTER 2: LOSING BOUNDARIES

27 **There are no further details** Ralph Chessé, *All My Yesterdays*, unpublished memoir, Bruce Chessé collection.

27 **The good news** Ancestry.com, 1880 Federal Census.

27 On Sunday, October 17 Archdiocese of New Orleans Office of Archives.

28 If young George Herriman's home Chessé, *All My Yesterdays.*

28 On the first day of January Hector Henry Hecaud, birth certificate.

28 The next year, on July 13, 1882 Ibid.

28 Yet only George would be baptized Bennett, *Religion and the Rise of Jim Crow*, p. 170.

29 Now, complained one missionary Ibid.

29 George and Clara Herriman returned to St. Augustine Archdiocese of New Orleans Office of Archives.

29 "It was a strange, mysterious" Chessé, *All My Yesterdays.*

29 Among these elders was George's aunt Ibid.

30 For drinking, rainwater was brought Ibid.

30 "Every language spoken on the globe" Frank de Caro, ed., *Louisiana Sojourns: Travelers' Tales and Literary Journeys* (Baton Rouge: Louisiana State University Press, 1998), p. 92.

30 He well might have been Ibid., p. 90.

31 "I have still filed away" Chessé, *All My Yesterdays.*

31 In Herriman's own home I am indebted to the research of Peter Hanley (doctor-jazz.co.uk) for establishing the connection between Herriman and Morton.

32 Remembered Jelly Roll Morton Jelly Roll Morton, *The Complete Library of Congress Recordings* (Nashville: Rounder Records, 2005).

32 In 1884 Herriman was chosen to serve on a jury *State of Louisiana vs Patrick Egan Jr.*, 1884. Louisiana Division/City Archives & Special Collections, New Orleans Public Library.

33 Then there were lynchings Statistics compiled by the Tuskegee Institute cited in Sylviane A. Diouf, *Dreams of Africa in Alabama: The Slave Ship Clotilda and the Story of the Last Africans Brought to America* (New York: Oxford University Press, 2007), p. 282.

33 Robert Mills Lusher Blassingame, *Black New Orleans*, p. 113.

33 After his return New Orleans Notarial Archives Research Center.

34 The next month she was baptized Archdiocese of New Orleans Office of Archives.

34 The Herriman and Chessé families Ibid.

34 On August 18, 1890, George Herriman Jr. New Orleans Notarial Archives Research Center.

35 In 1892, in a heroic effort Keith Weldon Medley, *We as Freeman: Plessy v. Ferguson* (Gretna, La.: Pelican Publishing, 2003)

35 Members of the Herriman family, it appears, were what some Creoles Author interview with Wendy Gaudin.

36 "The character who jumps the color line" Touré, "Do Not Pass," *New York Times*, Feb. 16, 2010.

36 Edward Larocque Tinker Thompson, *Exiles at Home*, p. 19.

36 Creoles in New Orleans Ibid, p. 68.

37 Yet, when questioned as part of court proceedings *C. S. Sauvinet v. J. A. Walker*, Supreme Court of Louisiana, No. 3513, 1871.

37 Another family member, J. B. Esnard *Report of the Select Committee: New Orleans Riots*.

37 Some Creoles maintained Sybil Klein, ed. *Creole: The History and Legacy of Louisiana's Free People of Color* (Baton Rouge: Louisiana State University Press, 2000), p. 305.

37 The church maintained two registers of sacraments Archdiocese of New Orleans Office of Archives.

38 "Once again here was my father" Bliss Broyard, *One Drop: My Father's Hidden Life—A Story of Race and Family Secrets* (New York: Little, Brown, 2007), p. 395

38 "The darker the skin" Wendy Gaudin, author interview.

39 At the 1909 National Negro Conference Klein, *Creole*, p. 313.

39 Bliss Broyard recalled Broyard, *One Drop*, p. 20.

40 Passage from New Orleans to California "Train Schedules," *Daily Picayune*, Aug. 19, 1890.

40 The rest of the extended Archdiocese of New Orleans Office of Archives.

40 On Sunday afternoon *Daily Picayune*, March 3, 1902

40 Five years later *Daily Picayune*, Dec 7, 1908

41 George Herriman Sr. had been careful *Succession of George Herriman and Louisa Eckel*, 1908. Civil District Court Division C. Louisiana Division/City Archives & Special Collections, New Orleans Public Library.

41 Before her death on April 8, 1928, Josephine Herriman Esnard *New Orleans Item*, July 10, 1916, p. 10.

41 On Thursday, November 29, 1934 "Owner, 10, Hopes Honey Bear Will Score in Parade," *Times-Picayune*, Nov. 27, 1934, p. 7.

CHAPTER 3: AS THE OFFICE BOY SAW IT

42 The writer Robert Louis Stevenson Robert Louis Stevenson, *Across the Plains with Other Memories and Essays* (New York: Charles Scribner's Sons, 1900), p. 31.

44 Four blocks north on Banning Street *Los Angeles City Directory*, 1891.

44 Yet Los Angeles was a city Harry Carr, *Los Angeles: City of Dreams* (New York: Grosset & Dunlap, 1935).

45 But he never established himself George Herriman Jr.'s work history can be traced through the annual *Los Angeles City Directory*.

45 The main floor "St. Vincent's," *Los Angeles Times*, Feb. 10, 1887, p. 2.

45 Father Aloysius Meyer, a German immigrant General information about St. Vincent's College and specific information about George and Henry's academic years

there are taken from the annual *Catalogue of the Officers and Students of St. Vincent's College, Los Angeles, Cal.*, DeAndreis-Rosati Memorial Archives, DePaul University Special Collections, Chicago, Illinois.

47 **Other days brought lectures** "Theosophy Explained," *Los Angeles Times*, March 24, 1892, p. 2.

47 **Humor among the boys** *S.V.C. Student*, DeAndreis-Rosati Memorial Archives, DePaul University Special Collections, Chicago, Ill.

47 **Colorful figures at St. Vincent's** *St. Vincent's College Day Book*, DeAndreis-Rosati Memorial Archives, DePaul University Special Collections, Chicago, Ill., p 307.

47 **By the time the Herriman boys** *Los Angeles City Directory*, 1892, p. 277.

48 **Five blocks from the Herrimans'** Twelfth Census of the United States, Los Angeles, Cal., 1900.

48 **It's not clear when** Roy McCardell, "George Herriman—Progenitor of Krazy Kat and the Irascible Ignatz, the Brick-Heaving Mouse," *Morning Telegraph*, Aug. 22, 1920, p. 3.

48 **Among Herriman's friends** Leo Carrillo, *The California I Love* (New York: Prentice-Hall, 1961), p. 161.

49 **By now George Herriman Jr.** *Los Angeles Times*, Dec. 11, 1894, p. 6.

49 **He moved to a new job** *Los Angeles Daily Times*, April 24, 1896, p. 5.

50 **But Herriman soon left** *Los Angeles Sunday Times*, April 11, 1897, p. 4.

50 **On the morning of May 13, 1896** "College Field Day," *Los Angeles Times*, May 14, 1896, p. 12.

51 **It is the first known photograph** "Remember When?" *Los Angeles Times*, June 19, 1934, p. G3.

53 **Writing to the *Dead-Line*** George Herriman, "George Herriman," *Dead-Line*, Sept. 1917, p. 24.

54 **In a letter to *Ziff's* magazine** George Herriman, *Ziff's*, April, 1926.

54 **In another letter, Herriman added a moral** George Herriman, *Salt Lake Telegram*, May 31, 1920, reprinted by John Adcock in "Yesterday's Papers" (john-adcock.blogspot.com), Dec. 14, 2011.

55 **It served everything from fresh crullers** "Ate Whisky Glasses," *Los Angeles Times*, July 9, 1897, p. 8.

55 **It trumpeted its coverage** "The Sunday Herald," *Los Angeles Herald*, Sept. 22, 1897.

56 **Herriman likely visited** *Los Angeles Herald*, Aug 18, 1897.

56 **A glass-paneled door** "The Evolution of a Newspaper," *Los Angeles Herald*, Nov. 21, 1897, p. 13.

56 **The head of the *Herald* art department** "Shakespearean Contest," *Los Angeles Herald*, Jan. 7, 1899.

56 **The chalk plate artist** Art Young, *Art Young: His Life and Times* (New York: Sheridan House, 1939), p. 69.

61 **In early Herriman cartoons** "Colored Republicans Hold a Jubilee," *Los Angeles Herald*, Nov. 4, 1898.

61 **In August 1898, the family reported** *Los Angeles Herald*, Aug. 6, 1898.

62 **When fingers started pointing** *Los Angeles Times*, Dec. 25, 1898.

62 **George still lived at home** *Maxwell's Los Angeles City Directory*, 1899, p. 460.

62 **The next month** "Events in Society," *Los Angeles Times*, Sept. 24, 1899, p. C2.

62 **Apparently working odd jobs** McCardell, "George Herriman," p. 3.

62 **"And beat it he did"** McCardell, "George Herriman," p. 3.

62 **"He came here on a side door Pullman"** Tad Dorgan, "This Is About Garge Herriman," *Circulation*, 1923.

62 **Herriman himself said** Herriman, *Dead-Line*, p. 24.

63 **Herriman likely just purchased** For example, *Los Angeles Herald*, April 27, 1899.

63 **"Fastest Train Across"** *Los Angeles Herald*, April 27, 1899.

CHAPTER 4: ORIGIN OF A NEW SPECIES

67 **Herriman acknowledged this** Boyden Sparkes interview with George Herriman, 1937. Brisbane Family Papers, Special Collections Research Center, Syracuse University Libraries.

67 **During the past century, Coney Island had transformed** "Coney Island," *Los Angeles Herald*, July 4, 1897.

67 **For new neighbors, Herriman could choose** "Reform at Coney Island," *New York Times*, June 4, 1900.

68 **"He used to know a girl"** Charles Van Loan, "Grand Opera Too Sad, Says Sporting Editor," *Los Angeles Examiner*, October 13, 1907.

69 **Over the years, comics developed** Mort Walker, *The Lexicon of Comicana* (Comicana Books, 1980).

71 **Also in 1883 a Hungarian-born newspaperman** James McGrath Morris, "Pulitzer: A Life in Politics, Print, and Power," in *Key Readings in Journalism*, eds. Elliot King and Jane L. Chapman (New York: Routledge, 2012), p. 182.

71 **"There is always an extra demand"** George Juergens, *Joseph Pulitzer and the New York World* (Princeton, N.J.: Princeton University Press, 1966), p. 94.

71 Among his early hires Walt McDougall, *This is the Life!* (New York: Alfred A. Knopf, 1926).

72 **"He went in for the weird and wonderful"** Roy McCardell, "Opper, Outcault and Company," *Everybody's Magazine*, January, 1905, p. 763.

72 **"The Yellow Kid was not an individual"** La Touche Hancock, "American Caricature and Comic Art, Part I," *Bookman*, Oct. 1902.

72 **In 1897 at the *Los Angeles Herald*** *Los Angeles Herald*, Oct. 10, 1897.

73 **At the *Examiner*, Swinnerton turned** Davidson, *Jimmy Swinnerton*, p. 26.

74 **"Mr. Hearst came along with money to spend"** Louis Sobol with Jimmy Swinnerton, "The Voice of Broadway" (syndicated column), Collections in the Center for American History, University of Texas at Austin.

74 **"He never cared to have people"** W. A. Swanberg, interview with Jimmy Swinnerton, Nov. 2, 1959, W. A. Swanberg Papers, Rare Books and Manuscript Library, Columbia University.

75 **The artist, Rudolph Dirks"** Jud Hurd, *Cartoonist PROfiles*, No. 19, p. 41.

75 **"People falling down stairs"** Frederick Burr Opper, "Comics and Cartoons of Earlier Days." Unpublished manuscript, Frederick B. Opper Collection, Howard Gotlieb Archival Research Center, Boston University.

76 **It was while so employed** McCardell, "George Herriman," p. 3.

77 **He first wrote about Bosco** Roy McCardell, "The Shirtwaist Girl," *Puck*, Oct. 9, 1901.

77 **In fact, Bosco gags** George Herriman, "Squad Forms Scrim and Does Some Dribbling and Kicking in Light Practice," *Los Angeles Examiner*, Oct. 5, 1907; Jimmy Swinnerton, "James—He Observes Them Devoured Alive!" *Los Angeles Examiner*, Aug. 11, 1912.

77 **Later, Herriman would make a nod** George Herriman, sports cartoon, *Los Angeles Examiner*, March 24, 1907.

77 **In 1910, Herriman would even draw** George Herriman, "The Family Upstairs," *New York Evening Journal*, Nov. 22, 1910, p. 15.

77 **"One of the familiar sights of the district"** Rube Goldberg, "Comics, New Style and Old," *Saturday Evening Post*, Dec. 15, 1928.

77 **"The first time—there wasn't any signing"** Sparkes interview with Herriman, Brisbane Family Papers.

78 **Herriman's work for Hearst** Microfilm copies of Herriman's 1901 comics for the *Evening Journal* are from the author's collection.

79 **Block must have seen something** Ibid.

79 **Most remarkably, Herriman also produced** *New York Evening Journal* published the first "Maybe You Don't Believe It" on April 4, 1904.

81 **"He gave me two weeks' salary"** Sparkes interview with Herriman, Brisbane Family Papers.

CHAPTER 5: IMPUSSANATIONS

82 **"George Herriman arguably created"** Rick Marschall, "Herriman Conquers the World," in Rick Marschall, ed., *The Komplete Kolor Krazy Kat*, Vol. 2 (Abington, Pa.: Remco Worldservice Books, 1990), p. 80.

82 **"I worked on *Judge*"** Sparkes interview with Herriman, Brisbane Family Papers.

83 **With fellow cartoonist Eugene "Zim" Zimmerman** Eugene Zimmeran, *Zim: The Autobiography of Eugene Zimmerman*, ed. Walter M. Brasch (Selinsgrove, Pa.: Susquehanna University Press, 1988).

83 ***Puck's* editors were known to be hostile** Ibid.

83 **Herriman's first cartoon for the magazine** Copies of Herriman's *Judge* comics are from the author's collection.

84 **A former Baraboo, Wisconsin, publisher** Charles A. Johanningsmeier, *Fiction and the American Literary Marketplace: The Role of Newspaper Syndicates in America, 1860–1900* (Cambridge, U.K.: Cambridge University Press, 1997), p. 36.

85 **"dog on the hunt"** Ibid., p. 67.

85 **"holy terror"** Ibid., p. 71.

85 **In 1901, McClure client newspapers** *Minneapolis Tribune*, Aug. 24, 1901, p. 1.

85 **As promised, the next day** "The Artists and Their Work of Picturing the News Events as They Develop Day After Day *Philadelphia North American*, Sept. 29, 1901, p. 5.

85 **A newspaper promotion noted** *Philadelphia North American*, Friday, Oct. 4, 1901, p. 7.

86 **Now creating full-color strips for a Sunday newspaper** Microfilm copies of Herriman's *Philadelphia North American* comics, 1901–1902, from author's collection.

87 **The *Los Angeles Times* recounted Griffith's message** "Theosophy Explained," *Los Angeles Times*, March 24, 1892, p. 2.

87 **"A pilgrim on the road to nowhere"** George Herriman, "Krazy Kat," July 23, 1916.

87 **Reincarnation propels** *Philadelphia North American*, "Dec. 29, 1901, p. 7.

88 **Years later, Herriman would pen** George Herriman, "*Krazy Kat*," April 20, 1919.

89 **Performed primarily by white men** Ralph Ellison, "Change the Joke and Slip the Yoke," *The Collected Essays of Ralph Ellison*, ed. John Callahan (New York: Modern Library, 1995), p. 100.

90 **It was the first of many nods** Camille F. Forbes, *Introducing Bert Williams: Burnt Cork, Broadway, and the Story of America's First Black Star* (New York: Basic Books, 2008), p. 298

90 **In Williams's dialect song** Ibid., p. 123.

90 **Williams also poked fun** Ibid., p. 204.

90 **The lyrics would be echoed** George Herriman, "Krazy Kat," July 10, 1933.

91 **The gag played off the numbers** Forbes, *Introducing Bert Williams*, p. 84.

93 **In his book *The Souls of Black Folk*** W. E. B. Du Bois, *The Souls of Black Folk* (Mineola, N.Y.: Dover Publications, 1994), p. 2.

93 **Herriman might not have** Ibid., p. 3.

94 **Animals briefly claimed a starring role** *New York World*, July 6, 1902.

95 **Pulitzer quickly moved Herriman** "Artist to Marry," *Los Angeles Herald*, July 6, 1902.

95 **Both Ruby and Henry lived at home** Twelfth Census of the United States, Los Angeles, Cal., 1900.

95 **Ruby had just graduated** *Los Angeles Times*, June 26, 1902.

95 **Henry worked as a lithographer** *Los Angeles Times*, July 1, 1902.

95 **On Monday, July 7, 1902, Herriman and Bridge** Ibid.

95 **Family friends William Briggs** State of California Marriage License, George Herriman and Mabel Bridge, July 7, 1902.

95 **Mabel, described as wearing** "Herriman–Bridge," *Los Angeles Times*, July 8, 1902.

96 **Herriman's granddaughter, Dee Cox** Dee Cox, interview with the author.

96 **After the wedding, George and Mabel** State of New York Birth Certificate, Mabel Herriman, May 10, 1903.

CHAPTER 6: BUBBLESPIKER

97 **In 1902 a poet named Ernest La Touche Hancock** La Touche Hancock, "American Caricature and Comic Art," *Bookman*, Oct.–Nov. 1902.

97 **Answers varied from complaints** Ibid.

97 **"Art combined with poetry"** Ibid.

98 **Concluded a jaded Herriman, all of twenty-two** Ibid.

98 **"Few thrills compared with hearing"** James McGrath Morris, *Pulitzer: A Life in Politics, Print, and Power* (New York: Harper Perennial, 2011), p. 286.

98 **To get to his new job, Herriman"** Ibid., p. 287.

99 **Here was Joseph Pulitzer's office** Sparkes interview with Herriman, Brisbane Family Papers.

99 **Herriman later remembered Hersh** Ibid.

99 **Former *World* reporter Albert Terhune** Albert Terhune, *To the Best of My Memory* (New York, Harper & Bros., 1930) p. 139.

99 **Herriman's other supervisors** Sparkes interview with Herriman, Brisbane Family Papers.

100 **New Year's 1903 dawned** *New York World*, Jan. 4, 1903.

100 **In *The Two Jolly Jackies Put Out a Fire*** *New York World*, June 14, 1903.

100 **In *The Two Jolly Jackies Impose*** *New York World*, July 19, 1903.

100 **In *The Middy Saves the Shipwrecked Jolly Jackies*** *New York World*, Sept. 20, 1903.

100 **At its best, *The Two Jolly Jackies*** *New York World*, May 10, 1903.

100 **In *The Jolly Jackies and the "Lost" Dog*** *New York World*, Oct. 11, 1903.

101 **And in *The Jolly Jackies Both Invest*** *New York World*, Nov. 15, 1903.

101 **On Sunday, May 10** State of New York Birth Certificate, Mabel Herriman. May 10, 1903.

101 **The partnership sparked** Roy McCardell, "George Herriman," *Morning Telegraph*, p. 3.

101 **Early adventures included taking** Roy McCardell and George Herriman (illus.), "A Day at Glen Island with the Hindoo Fakirs," *New York World*, July 5, 1903.

102 **Urban exotica fueled the team's next adventure** Roy McCardell and George Herriman (illus.), "A Visit to 'Japan by Night' on the Madison Square Roof, New York," *New York World*, July 12, 1903.

102 **Herriman and McCardell then went to Coney Island** Roy McCardell and George Herriman (illus.), "A Combat to the Death with New York's Man-Eating Mosquitoes," *New York World*, July 19, 1903.

102 **The team made an inspired expedition** Roy McCardell and George Herriman (illus.), "A Vacation on the Isle of Safety at Fifth Avenue and Twenty-Third Street," *New York World*, Aug. 16, 1903.

103 **The team returned to Coney Island** Roy McCardell and George Herriman (illus.), "Terrific Encounters with Hyenas, Bears, Tigers and Lions at Coney Island," *New York World*, July 26, 1903.

103 **"Vaudeville Farmers"** Roy McCardell and George Herriman (illus.), "A Visit to the Centreport (Long Island) Burlesque Farm, Where Staid Variety Actors and Actresses and Their Children Spend These Summer Days," *New York World*, Aug. 2, 1903.

103 **In August 1903, Herriman began** George Herriman, "Two Newest Mysteries of the Deep," *New York Evening World*, Aug. 15, 1903.

104 **In one *Mrs. Waitaminnit*** George Herriman, "Mrs. Waitaminnit—the Woman Who Is Always Late," *New York Evening World*, Sept. 22, 1903.

104 **A baby showed up** Herriman, "Mrs. Waitaminnit," *New York Evening World*, Oct. 12, 1903.

105 **Herriman attempted another daily** George Herriman, "Little Tommy Tattles," *New York Daily World*, Oct. 5, 1903.

105 **Herriman's contributions to the page** Ferd G. Long, "Little Boy Black," *New York Evening World*, Oct. 29, 1903.

105 **Meanwhile, the Geographical Survey excursions** Roy McCardell and George Herriman (illus.), "McCardell, the Reckless Explorer, and His Trusty Band Dare the Terrors of Two Hells with Dante and Ulysses," *New York World*, Nov. 1, 1903.

106 **Herriman closed out the year** George Herriman, "Santa Claus Finds Changes in the Children," *New York World*, Dec. 13, 1903.

107 **That Christmas, the popularity** "Lady Bountiful Now on Exhibition," *New York World*, Nov. 25, 1903.

107 **After Benjamin Wood's death** Karen Abbott, "Everything Was Fake but Her Wealth," Smithsonian.com, Jan. 23, 2013.

108 **Wrote Allen Churchill** Allen Churchill, *Park Row* (New York: Rinehart & Company, 1958), p. 294.

108 **An editorial in the *Daily News'*** "When We Get Into the Swing," *New York Daily News*, Jan. 2, 1904.

108 **The paper finally hit the newsstands** "Masses and Classes Alike Welcome new 'Daily News,'" *New York Daily News*, Jan. 4, 1904.

109 **Frank Munsey struck a business arrangement** E-mail exchange between the author and Allan Holtz, Jan.–June, 2012.

109 **Reported Herriman for the *World*** "These Are the Days When the Cranks Are Thickest About Madison Square," *New York World*, Oct. 25, 1903.

109 **He boards a ship** George Herriman, "Major Ozone's Fresh Air Crusade," *New York Daily News*, Jan. 16, 1904.

109 **He joyfully sits** George Herriman, "Major Ozone's Fresh Air Crusade," *New York Daily News*, Feb. 23, 1904.

109 **Ozone is beaten** George Herriman, "Major Ozone's Fresh Air Crusade," *New York Daily News*, March 6, 1904 and April 3, 1904.

109 **In one of the strip's loveliest** George Herriman, "Major Ozone's Fresh Air Crusade," *New York Daily News*, March 13, 1904.

111 **He returned to Madison Square Garden** George Herriman, "Fuss and Feathers Colony at the Garden Enjoys Itself Despite the Cold," *New York Daily News*, Jan. 6, 1904.

111 **Boxing in New York** George Herriman, "Some Events of the Week in Sports as Seen by Cartoonist Herriman," *New York Daily News*, Feb. 13, 1904.

111 **Big fights were permitted in Philadelphia** "Boxers Silent; Money Talking," *New York Daily News*, Feb. 27, 1904.

111 **The Sharkey-Munroe fight would inspire** George Herriman, "Sharkey, in Sleeping Flight of Fancy, Sees Himself the Mightiest Roman," *New York Daily News*, Jan. 9, 1904.

112 **Neither Edgren nor Dorgan** George Herriman, "Sharkey and Munroe Having Trouble Getting Bids for Proposed Fight, *New York Daily News*, Jan. 21, 1904.

112 **"Bruised, cut, bleeding"** "Munroe and Jeffries will Clasp Hands To-Day on Match," *New York Daily News*, Feb. 29, 1904.

113 **The Women's Health Protective Association** "Near-Side Rule is Kept by the Men Sufferers Chose," *New York Daily News*, Jan. 30, 1904, p. 1.

113 **Herriman launched his first salvo** George Herriman, "This is Not a Cartoon," *New York Daily News*, Jan. 26, 1904, p. 1.

113 **A leering train car** George Herriman, "Some of the Perils Mr. Creeland Saves Us from—in His Dreams—by Witholding Transfers," *The New York Daily News*, Jan. 26, 1904, p. 10.

113 **In *If Parsifal Came To*** George Herriman, "If Parsifal Came to New York," *New York Daily News*, Jan. 14, 1904, p. 10.

113 **Here, Herriman anticipated** *New Castle News*, June 1, 1920.

113 **As when he had caricatured** George Herriman, "Cartoonist Herriman Has Some Fun With Cartoonist Davenport," *New York Daily News*, Jan. 22, 1904, p. 5.

114 **Published just four times** George Herriman, "Home, Sweet Home," *The New York Daily News*, March 4, 1904,

115 **The team first visited the palatial** Walter S. Murphy and George Herriman (illus.), "Broadway Paddock Legend Cut Down to Bare, Bald Facts by the Bubblespikers," *New York Daily News*, March 6, 1904, Metropolitan Section, p. 1.

116 **Murphy's writing is not as fanciful** Walter S. Murphy and George Herriman (illus.), "The National Popular Song of 1904," *New York Daily News*, March 20, 1904, Metropolitan Section, p. 1.

116 **The Bubblespikers' most rollicking** Walter S. Murphy and George Herriman (illus.), "Where, Oh, Where are Those Luxurious Chop Suey Joints of the Darling Devotees of Society, Fashion and Art?" *New York Daily News*, April 3, 1904, Metropolitan Section, p. 1.

CHAPTER 7: TAD

118 **Former Hearst photographer Harry J. Coleman** Harry J. *Coleman, Give Us a Little Smile, Baby* (New York, E. P. Dutton & Co., 1943), p. 78.

118 **A photograph dated January 1904** "New York Evening Journal Staff, 1904 Jan.," Paul Bransom Papers, Archives of American Art.

119 **"You know in the old days"** Boyden Sparkes interview with George McManus. Brisbane Family Papers, Special Collections Research Center, Syracuse University Libraries.

119 **One day, Harry Coleman remembered** Coleman, *Give Us a Little Smile, Baby*, p. 35.

119 **Yet, sports-themed masterpieces** "Charles Somerville, the Reporter, Is Dead," *New York Times*, Dec. 26, 1931.

120 **It was Herriman's good fortune** Charles Somerville, "Taylor's Curves Blank Brooklyns; Giants' Batting is Wofully [*sic*] Weak," *New York American*, June 18, 1904.

121 **"Tad was for years"** O. O. McIntyre, "TAD: A Close-up of a Man Who Amuses the World and Keeps His Troubles to Himself," *Cosmopolitan*, March 1927.

121 **The Sports' motto** Ibid.

121 **Dorgan has been credited** H. L. Mencken, *The American Language* (New York: Alfred A. Knopf, 1985) p. 210.

121 **"Oh, yes, there was the greatest fellow"** Boyden Sparkes interview with George Herriman, 1937. Brisbane Family Papers, Special Collections Research Center, Syracuse University Libraries.

123 **Dorgan later remembered** O. O. McIntyre, "TAD: A Close-up of a Man Who Amuses the World and Keeps His Troubles to Himself," *Cosmopolitan*, March 1927.

123 **Dorgan summed up his acerbic point of view** Tad Dorgan, "This Is a Fighting World," *San Francisco Bulletin*, Oct. 14, 1899. Reprinted in Amy McCrory, "Sports Cartoons in Context: Tad Dorgan and Multi-Genre Cartooning in Early Twentieth-Century Newspapers," *American Periodicals: A Journal of History, Criticism, and Bibliography*, 2008, p. 51.

123 **In 1903 Dorgan started contributing** Tad Dorgan, "How Corbett is 'Building Up' to Beat Jim Jeffries," *New York Evening World*, July 28, 1903.

123 **"He sent him a wire"** Boyden Sparkes interview with George Herriman, 1937. Brisbane Family Papers, Special Collections Research Center, Syracuse University Libraries.

123 **"Brisbane used to say"** Ibid.

124 **The news from San Francisco** George Herriman, "Frisco Reports Munroe Miss-

ing—Herriman Supplies Some Hints on Where He Might Be Found," *New York American*, May 19, 1904.

125 **Somerville reported that the punches** Charles Somerville, "Weak Efforts of M'Coy and O'Brien Put Stamp of Suspicion on Bout," *New York American*, May 16, 1904.

125 **Herriman offered irreverent scenes** George Herriman, "Enlivening Incidents of the M'Coy–O'Brien Battle in Philadelphia on Saturday Night—Sketched at the Ringside by Artist Herriman," *New York American*, May 16, 1904.

125 **Cartoonists making cameo appearances** George Herriman, "How the Big College Elevens Are Training for Their Final Games," *New York American*, Nov. 2, 1904.

125 **Tad Dorgan, however, claimed** George Herriman, "Should Heenan and Sayers Return to Life, Here are a Few of the Things That Might Cause Them to Hurry Back Again," *New York American*, May 23, 1904.

125 **Herriman's baseball cartoons** Charles Somerville (article) and George Herriman (cartoon), "Giants and Yankees Shut Out Opponents," *New York American*, May 3, 1904.

126 **At times, Somerville cast his report** Charles Somerville, "Mathewson Has Brooklyns Guessing," *New York American*, May 28, 1904.

126 **If there was a rainout** George Herriman, "Prominent Features of That Exciting Game at the Polo Grounds—Drawn by Herriman," *New York American*, June 3, 1904.

126 **Another cartoon riffed on minstrelsy** George Herriman, "Artist Herriman's Conception of the Flirtation 'Mistah' Munroe Has Begun with Miss Championship, the Pugilistic Coquette," *New York American*, June 15, 1904.

128 **As the much-delayed Jeffries-Munroe bout** George Herriman, "Jeffries as the Modern Jason," *New York American*, Aug. 14, 1904.

129 **They were even more amused** Coleman, *Give Us a Little Smile, Baby*, p. 65.

129 **"Temptingly near the door"** Ibid., p. 64.

129 **"Suddenly the papier-mâché begonias"** Ibid.

129 **"Tad winked at Herriman"** Ibid., p. 65.

130 **one showing a tag** George Herriman, "Fitzsimmons Gives an Exhibition of Archery," *New York American*, Jan. 8, 1905.

130 **Herriman also contributed** Coleman, *Give Us a Little Smile, Baby*, p. 66.

130 **Carrillo specialized in animal mimicry** Ibid., p. 67.

131 **"Crowds of night rovers"** Ibid.

131 **"As dawn broke"** Ibid., p. 68.

131 **On the last weekend of August** Copies of photographs in collection of Patrick McDonnell and Karen O'Connell.

132 **In short time, Herriman's little doodles** *New York American*, Dec. 5, 1904.

132 **In a baseball cartoon** George Herriman, "It's Fascinating the Fans," *New York American*, Sept. 17, 1904, p. 8.

132 **one of Herriman's most striking** George Herriman, "Cartoonist Herriman's Idea of the Sad Fate That Will Befall the Tailenders of the Big Baseball Leagues," *New York American and Journal*, Sept. 18, 1904, p. 48.

133 **In *Who Will Come Out*** George Herriman, "Who Will Come Out of the Small End of the Pugilistic Horn?" *New York American and Journal*, Oct. 30, 1904, p. 57.

133 **In the ironically titled *Charms of Training*** George Herriman, "Charms of Training at Gravesend Track these Days," *New York American*, Dec. 12, 1904.

133 **Beginning in December** George Herriman, "Smoking Him Out," *New York American*, Dec. 12, 1904, p. 3.

133 **Perhaps inspired by the elegant prose** George Herriman, "The Master Juggler," *New York American*, Feb. 24, 1905.

134 **That spring, Herriman contributed** George Herriman, "It Grew While the People Slept," *New York American*, March 23, 1905, p. 1.

134 **A Herriman cartoon on the Battle of Mukden** George Herriman, "Deelighte-dosaki," *New York American*, March 13, 1905.

134 **Hawthorne and Herriman** Bob Callahan, "Geo. Herriman's Los Angeles," *Krazy & Ignatz, Vol. Five, 1920: Pilgrims on the Road to Nowhere* (Forestville, Cal.: Eclipse Books/Turtle Island Foundation, 1990), p. 1.

135 **Herriman's former collaborator Charles Somerville** Julian Hawthorne, "Keene's Delhi, Favorite, Wins $16,000 Brooklyn Handicap. 30,000 Persons See the Race," *New York American*, May 26, 1905, p. 1.

136 **An explanation wouldn't appear** Ed Ainsworth, *Painters of the Desert* (Palm Desert, Cal.: Desert Magazine, 1961), p. 29.

CHAPTER 8: HOBO CORNER

137 **In the summer of 1905** Los Angeles City Directory, 1906, p. 786.

137 **Herriman's grandmother, Louisa Eckel** *Succession of George Herriman and Louisa Eckel*, 1908. Copy in author's collection, from Louisiana Division/City Archies & Special Collections, New Orleans Public Library.

137 **A political cartoon drawn by Herriman** George Herriman, "The Gang on the Qui Vive," *Los Angeles Times*, Feb. 10, 1906.

138 **In late summer, World Color Printing** *Chillicothe Daily Constitution*, Chillicothe, Mo., Sept. 6, 1905.

138 **A *Major Ozone* from October** George Herriman, "Major Ozone," *San Francisco Call*, Oct. 15, 1905.

139 **Otis and Chandler had a prominent detractor** Dennis McDougal, *Privileged Son: Otis Chandler and the Rise and Fall of the L.A. Times Dynasty* (Cambridge, Mass.: Perseus Publishing, 2001), p. 40.

140 **Hearst, campaigning for the United States presidency** Ibid., p. 42.

140 **"Hearst himself has no more moral sense"** "The Lancer," *Los Angeles Times*, April 15, 1906.

140 **while editorial cartoonist A. J. Taylor** A. J. Taylor, "Hearst—His Plant and His Planets," *Los Angeles Times*, May 12, 1906.

140 **Dodge's San Francisco friends included Tad** Arthur Miller, "Clifford McBride's Book Tribute to 'Boss' Dodge," *Los Angeles Times*, Sept. 30, 1945, p. B1.

141 **He attended a performance by actor Joseph Galbraith** George Herriman, "Mr. Galbraith as Tom Harrington," *Los Angeles Times*, Feb. 25, 1906.

141 **Herriman occasionally drew multiple-panel scenes** George Herriman, "Signor He a Bath Did Take," *Los Angeles Times*, Feb. 3, 1906.

141 **On February 22, Herriman attended** George Herriman (illus., "Sparkling Spread, Happy Banqueters, *Los Angeles Times*, Feb. 23, 1906

141 **In early March, Herriman took** Harry C. Carr and George Herriman (illus.), "The Powder Rag and Shiny Boots," *Los Angeles Times*, March 4, 1906.

142 **A dogged cub reporter with a nervous temperament** "Life of Writer Rivaled Narratives from His Pen," *Los Angeles Times*, Jan. 11, 1936, p. 3.

143 **The month after climbing Mount Wilson** Ibid., p. 3.

143 **Although Herriman doesn't mention it** George Herriman (illus.), "'Sandy' Sees City's Sights," *Los Angeles Times*, May 25, 1906.

143 **Described by admirers as a man of high ideals in greasy trousers** George Herriman (illus.), "Joe Margolis Sings Reform," *Los Angeles Times*, June 23, 1906.

143 **Herriman also chronicled the battle** George Herriman (illus.), "Vegetables Must Bear Union Label," *Los Angeles Times*, May 29, 1906.

144 **Reported the *Times* from Naud Junction** "Attell Whips Neil in Bloody Fight," *Los Angeles Times*, July 5, 1906.

144 **"Many an old sport"** Harry Carr and George Harriman (illus.), "He-Cow 'Fighting' Tame as Ping Pong," *Los Angeles Times*, July 29, 1906.

144 **Herriman's centerpiece drawing** Ibid.

145 **Harry Carr further detailed** Ibid.

145 **Carr described in grisly detail** Ibid.

145 **Nor did he note that the heckler** Harry Carr, "The Lancer," *Los Angeles Times*, May 24, 1931, p. A1.

145 **His editors appear to have most appreciated an antiunion cartoon** George Herriman, "The Trust," *Los Angeles Times*, Aug. 5, 1906.

146 **One campaign was growing particularly contentious** George Herriman (illus.), "How Werdin Chug-Chugs Hot After Sheriff's Job," *Los Angeles Times*, Aug. 8, 1906.

146 **Then on Tuesday, August 14, Herriman became personally involved in the sheriff's campaign** "White Capper Buys Votes of Reporters," *Los Angeles Times*, Aug. 15, 1906.

147 **Carr took the bait** Ibid.

147 **Vignes denied the charges** "Vignes Must Face Trial," *Los Angeles Times*, Aug. 16, 1906.

147 **The newspaper dredged up charges** "Vignes Has a Lurid Past," *Los Angeles Times*, Aug. 17, 1906.

147 **In an editorial titled "Vignes, Ballot-Debaucher** "Vignes, Ballot-Debaucher, *Los Angeles Times*, Aug. 18, 1906.

148 **Hearst's *Examiner*, not surprisingly** "Accuses Deputy of Trying to Bribe Voter at Polls," *Los Angeles Examiner*, Aug. 16, 1906.

148 **He was included in a 1906** "Press Artists' Exhibit," *Los Angeles Times*, Dec. 20, 1906.

149 **That same week, a grand jury convened** "Is After Vignes," *Los Angeles Times*, Sept. 5, 1906.

149 **Herriman was given a choice** "Fines Cartoonist Herriman," *Los Angeles Herald*, Sept. 7, 1906, p. 11.

149 **In late September, Vignes was arraigned** "Vignes Rearrested," *Los Angeles Times*, Oct. 13, 1906.

149 **His cartoons mocked both Republicans and Democrats** George Herriman (illus.), "This Is YOUR Day. How Are YOU Going to Vote?" *Los Angeles Examiner*, Nov. 6, 1906.

150 **Herriman based another anti–Southern Pacific cartoon** George Herriman, "The Hand of the Oppressed," *Los Angeles Examiner*, Nov. 5, 1906.

150 **Carr took the stand first** "Witness Fails in His Identification," *Los Angeles Herald*, Dec. 20, 1906, p. 9.

150 **The defense then called a Main Street saloonkeeper** "Not Guilty is Verdict of Jury," *Los Angeles Herald*, Dec. 21, 1906, p. 12.

CHAPTER 9: KID HERRIMAN

152 **Pandemonium might erupt during prizefights** "Examiner Crowds Block Streets," *Los Angeles Examiner*, Sept. 4, 1906.

152 **After his time at the *Examiner*, Van Loan** *Decatur Herald*, Dec. 17, 1922.

153 **As *Examiner* men, they had reserved seats** George Herriman, "People One Meets in Los Angeles, as Seen by Herriman," *Los Angeles Examiner*, May 28, 1908, p. 3.

153 **"So I thought I would take George the Greek"** Charles Van Loan, "The Sporting Editor at the Opera: He Hears 'Aida,'" *Los Angeles Examiner*, Nov. 12, 1906.

153 **"None of us knew what he was"** Tad Dorgan, "This Is About Garge Herriman," *Circulation*, 1923.

154 **Herriman illustrated an article** "Says Cry of Baby Indicates Deep Spiritual Need," *Los Angeles Examiner*, July 17, 1906.

154 **"Kinky" was also the name given** H. M. Walker, "Pipe Dreams," *Los Angeles Examiner*, Nov. 15, 1908, p. 2.

154 **Artists constantly joked to Herriman** Recalled by Maggie Thompson, 1990.

154 **At the *Examiner*, one of these gags** "With the Fans," *Los Angeles Examiner*, April 12, 1909, p. 7.

154 **It was sparked by *Examiner* theater critic Otheman Stevens** Charles Van Loan, "The Sporting Editor at the Opera: He Hears 'Aida,'" *Los Angeles Examiner*, Nov. 12, 1906.

154 **In the next day's newspaper, Van Loan** Ibid.

154 **Herriman illustrated Van Loan's article** George Herriman, "A Cartoonist's View of Grand Opera," *Los Angeles Examiner*, Nov. 12, 1906.

155 **And just a few months after starting at the** *Examiner* George Herriman, "The Shopping Season Is Now On," *Los Angeles Examiner*, Dec. 10, 1906.

156 **Los Angeles celebrated** Frederic Pabst, "Auto Show Opens With Millions in Cars on Floor," *Los Angeles Examiner*, Jan. 22, 1907.

156 **Suffering from what Herriman termed "automobilitis"** George Herriman, "Automobilitis Brings an Unconquerable Trading Habit," *Los Angeles Examiner*, March 10, 1907

156 **"This auto show is but the beginning"** Charles Van Loan, "Big Display Is a Sermon on Progress," *Los Angeles Examiner*, Jan. 22, 1907.

157 **These works were among his most visually adventurous** Allan Holtz, "Stripper's Guide," Aug. 2 2008, for George Herriman, "Brainstorm of an Amateur Scorcher," *Los Angeles Examiner*, April 7, 1907.

157 **Herriman seemed to suffer his own case** Frederic Pabst, "People Who Can Hardly Buy Gasoline Cherish Ambitions to Own Machine," *Los Angeles Examiner*, March 10, 1907.

157 **In late 1906 or early 1907, he moved Mabel and Toots** *Los Angeles City Directory, 1907*, p. 681.

157 **George Herriman also joined a local fishing club** "Anglers Give Fish Feast," *Los Angeles Times*, July 22, 1907.

158 **Another Rod and Reel Club outing** George Herriman, "50 Men Catch 3 Fish; 2 Floaters," *Los Angeles Examiner*, May 25, 1906.

158 **One adventure took place right in the *Examiner* office** Charles Van Loan, "Van's Column," *Los Angeles Examiner*, April 8, 1906.

159 **The cartoonist apparently joined the thousands** Charles Van Loan, *Los Angeles Examiner*, May 8, 1907.

159 **"The other night a very affable gentleman"** Charles Van Loan, "Match Now Over; Score Only 121–72," *Los Angeles Examiner*, May 31, 1907, p. 15.

160 **The Sports also were abuzz about a big minstrel show** Otheman Stevens, "Minstrelsy Devotees Given Real Brand by Dockstader's Troupe," *Los Angeles Examiner*, June 6, 1906.

160 **"Why don't you come out to the far Southwest"** "James Swinnerton Loves the Desert, the Canyon, the Big Sky," *New York Evening Journal*, June 10, 1911.

161 **One time, according to Payne's friend Richard Sprang** Koppany, Bob, ed. *The Art of Richard W. Sprang* (Striking Impressions, 1998), p. 35.

161 **Additionally, Herriman and Payne's friendship** From the collection of Dee Cox.

161 **Herriman went to Naples** *Los Angeles Examiner*, Sept. 13, 1907.

161 **Herriman also illustrated an article about the swastika** Hector Alliot and George Herriman (illus.), "Latest Fad is Craze for the Swastika Talisman," *Los Angeles Examiner*, Sept. 8, 1907.

161 **In April 1908, he added Navajo designs** George Herriman, "'Big Injun' Pinnance Gets Out His Tomahawk and Lands Scalps," *Los Angeles Examiner*, April 16, 1908, p. 15.

161 **Herriman's first published reference to Coconino County** George Herriman, "Stage Beauties Cheer Hartmans as They Beat Girl Questioners," *Los Angeles Examiner*, Oct. 30, 1909.

162 **A visiting club of newspaper humorists** Charles Van Loan and George Herriman (illus.), "Press Humorists Climb the Steep Trail up Mount Lowe," *Los Angeles Examiner*, Sept. 19, 1907; "Jesters Turn Lecturers," *Los Angeles Herald*, Sept. 21, 1907, p. 6.

162 **"The Greek's seats were down in front"** Charles Van Loan, "Grand Opera Too Sad, Says Sporting Editor," *Los Angeles Examiner*, Oct. 13, 1907.

163 **So did frequent mentions of his peers** George Herriman, "What Herriman Saw at the Britt Training Camp," *Los Angeles Examiner*, p. 13.

163 **His editors played along** "Kid Herriman (133) Does a Bit of Infighting at Battling Johnson's Camp," *Los Angeles Examiner*, March 19, 1908, p. 11.

163 **"Herriman said he would rather go to the circus"** Charles Van Loan and George Herriman (illus.), "Seely Immense in a Fat Man's Role," *Los Angeles Examiner*, Nov 19, 1907, p. 6.

163 **Herriman had more fun at** George Herriman, "Herriman Looks in at Clown Luncheon Given by 'Herb' Cornish to Spader Johnson and Friends," *Los Angeles Exmainer*, April 10, 1908, p. 1.

164 **Unlike friends such as Jimmy Swinnerton** "Jimmy Is to Play Hookey Once More," *Los Angeles Examiner*, April 27, 1908.

164 **In May 1908, Herriman listed his fears** George Herriman's letter to Ralph Springer, and Wilson Springer's letter about his father, are both from the collection of Patrick McDonnell and Karen O'Connell.

165 **"George seemed to suffer"** Wilson Springer letter from the collection of Patrick McDonnell and Karen O'Connell

165 **Known as "Curser Coates"** Albert Terhune, *To the Best of My Memory* (New York: Harper & Bros., 1930), p. 113.

CHAPTER 10: PROONES, MOOCH, AND GOOSEBERRY SPRIG

168 **On December 6, 1907, George Herriman's grandfather** *Succession of George Herriman and Louisa Eckel*, 1908. Copy in author's collection, from Louisiana Division/City Archies & Special Collections, New Orleans Public Library.

168 **In Los Angeles, the Herriman family gathered** "Young Women to Present Colonial Reminiscences," *Los Angeles Sunday Herald*, Feb. 21, 1909.

169 **"Daisy Herriman drew a picture"** "Junior Artists Draw Many May Day Queens," *Los Angeles Sunday Herald*, May 9, 1909.

169 **The Herriman family soon would have another reason to celebrate** County of Los Angeles, Certificate of Birth, Barbara May Herriman. May 15, 1908.

169 **George was not home for the delivery** George Herriman, "Conspicuous Figures in State Republican Convention Sketched While in Action by Cartoonist Herriman," *Los Angeles Herald*, May 16, 1908.

170 **Proones first appeared just three days after** "7000 Turn Out to Dedicate Arcadia Track," *Los Angeles Examiner*, Dec. 8, 1907, p. 1.

172 **Ferris was the most celebrated among them** Beanie Walker, "Pipe Dreams," *Los Angeles Examiner*, Nov. 22, p. 2.

172 **"The parties who enjoyed this personally conducted excursion"** Beanie Walker, "With the Fans," *Los Angeles Examiner*, Oct. 31, 1908, p. 10.

173 **Ferris took the wheel** Beanie Walker, "With the Fans," *Los Angeles Examiner*, Nov. 17, 1908, p. 10.

173 **For lunch, Herriman could predictably be found** Charles Van Loan, "Van's Column," *Los Angeles Examiner*, Nov. 8, 1907.

173 **Herriman, befitting his Louisiana childhood** Beanie Walker, "*With the Fans*," Nov. 8, 1908.

174 **The *Examiner* continued to indulge** George Herriman, "'Critique' Sees Class in 'Under Two Flags,'" *Los Angeles Examiner*, June 2, 1909.

175 **At an evening gathering, when Mary's guests** George Herriman, "Mary's Home from College," March 19, 1909.

176 **The spelling might have been inspired by the Kit Kat Klub** "Police Drop In on Kit Kat," *Sun*, Feb. 17, 1909, p. 1.

176 **In a series of cartoons about a fishing trip** George Herriman, "Bat Nelson in Sea Togs Hunts Monsters of the Deep," *Los Angeles Examiner*, Feb 26, 1908, p. 9.

177 **At the end of the year, Herriman revived the strip** George Herriman, "Mary's Home from College," *Los Angeles Examiner*, Dec. 20, 1909, p. 9.

178 **In July 1909, he joined Walker** "Scribes Meet Mike Donlin at Dinner," *Los Angeles Herald*, July 2, 1909, p. 4.

178 **Later that month, the *Examiner* welcomed a massive Elks convention** "'Examiner's' Display Admired by Crowds," *Los Angeles Examiner*, July 11, 1909.

178 **At the dinner, held at the Casa Verdugo** "Visiting Scribes Given Banquet," *Los Angeles Herald*, July 15, 1909, p. 8.

178 **Having conquered San Francisco, Fisher's strip** Beanie Walker, "Oakland Submits Meekly to 5 to 0 Slaughter at Hands of Champion Angels," *Los Angeles Examiner*, May 27, 1909.

178 *Examiner* running a story about a Cambridge English professor "Mutt and Jeff May Be Regarded as Classic," *Los Angeles Examiner*, June 6, 1910.

178 Years later Herriman would be credited as an influence on Fisher *Cartoonist Profiles*, Feb. 1970.

179 However, in October 1909, the *Examiner* published *Los Angeles Examiner*, Oct. 3 and 10, 1909.

179 A few Herriman comics had been running in the syndicates For example, George Herriman, "The Amours of Marie Anne Magee," *Marion Daily Mirror*, June–August 1909.

179 A half-page *Daniel and Pansy* For example, George Herriman, "Daniel and Pansy," *Nashville Banner*, Nov.–Dec. 1909.

180 In one clever scene Herriman nods to his Ashcan artist friends George Herriman, "Alexander Doesn't Catch the Rat, But Smashes the Hat!" *Nashville Banner*, Jan. 8, 1910.

180 Other Herriman flourishes include Navajo designs George Herriman, "Alexander Is the Champion 'Dog-Catcher'—Eh?" *Nashville Banner*, Nov 13, 1909.

182 The previous year Herriman had dedicated a sports cartoon George Herriman, "The 'Ticket Moocher'—You Can't Lose Him," *Los Angeles Examiner*, Nov. 30, 1908.

182 By March 1909, Beanie Walker was railing Beanie Walker, "Ticket Moochers' Days Are Short," *Los Angeles Examiner*, March 21, 1909, p. 4.

182 Mooch poses for a portrait George Herriman, "Baron Mooch—He Runs Ahead of His Ticket," *Los Angeles Examiner*, Nov. 11, 1909, p. 17. The Baron Mooch comic strips have been collected in: Bill Blackbeard, ed., *By George! The Komplete Daily Komic Strips of George Herriman, Vol. One* (Manitou Springs, Col.: SPEC Productions, 2005).

184 Mooch escapes the mine work George Herriman, "Baron Mooch—A Fairy Comes to the Rescue—Oh Shucks!" *Los Angeles Examiner*, Nov. 29, 1909, p. 9.

185 "Woman—woman bleached or unbleached" George Herriman, "Baron Mooch—He Is a Deceitful Trifler," *Los Angeles Examiner*, Dec. 15, 1909, p. 16.

187 "This conquest of the air" "Help Make Aviation Week a Big Success," *Los Angeles Examiner*, Jan. 10, 1910.

187 Before week's end, William Randolph Hearst himself "Mr. Hearst Makes Long Flight with Air-King Paulhan," *Los Angeles Examiner*, Jan. 20, 1903.

188 *Gooseberry Sprig* had made liftoff Bill Blackbeard, "A Sprig of Gooseberry for Krazy Kat," *Texas Trends in Art Education*, Fall 1980, p. 44.

188 Drawn with what *Mutts* cartoonist Interview with the author, 2016.

189 For the parade, he took to the streets "All-Star Minstrels Ready for Great Actors' Benefit," *Los Angeles Examiner*, April 11, 1910.

189 Then he and Swinnerton stepped forward "Minstrel Men Make Merry," *Los Angeles Daily Times*, April 13, 1910, p. 7.

CHAPTER 11: TRANSFORMATION GLASSES

191 **In 1892, bare-knuckle champion** "Sullivan's Castor," *Los Angeles Herald*, March 6, 1892.

191 **In his *Examiner* column, Beanie Walker** Beanie Walker, "With the Fans," *Los Angeles Examiner*, May 6, 1908, p. 12.

191 **"There was to be a battle of men"** George Herriman, "Prehistoric Ringside Dope," *Los Angeles Times*, July 15, 1906.

192 **A noisy throng of socially prominent local blacks** Charles Van Loan and George Herriman (illus.), "Gans Arrives and Begins Work," *Los Angeles Examiner*, Aug. 3, 1907.

193 **In one he portrayed him** George Herriman, "Only Two Lightweight Plums Left for Champion to Pick," *Los Angeles Examiner*, Sept. 22, 1907, p. 5.

193 **In another he mocked a Gans opponent** George Herriman, "Cartoonist Herriman's Views on Today's Britt-Gans Battle," *Los Angeles Examiner*, Sept. 9, 1907.

193 **Gans easily defeated Britt** Charles Van Loan, "Native Son Helpless After First Round," *Los Angeles Examiner*, September 10, 1907.

193 **But the next day, a curious front-page *Examiner* headline** Joaquin Miller, "Joaquin Miller, Famous California Poet, Describes Battle for the Examiner," *Los Angeles Examiner*, Sept. 10, 1907, p. 1.

193 **A subsequent Herriman cartoon about duck hunting** "Stories of Record Trips Vie with Tales of Birds," *Los Angeles Examiner*, Oct. 27, 1907.

193 **Herriman celebrated the Gans win** George Herriman, "Here Is What Cartoonist Herriman Thinks About the Way Gans Trimmed Britt," *Los Angeles Examiner*, Sept. 10, 1907.

194 **Tad Dorgan first took notice of Johnson** Geoffrey C. Ward, *Unforgivable Blackness: The Rise and Fall of Jack Johnson* (New York: Vintage Books, 2006), p. 52.

195 **In early 1908 Herriman and Van Loan** George Herriman, "The Color Line Mostly in Black, as George Herriman Conceives It Is Drawn in Fight Circles Today," *Los Angeles Examiner*, Jan. 26, 1908, p. 5.

195 **In August, Johnson was traveling Europe** Beanie Walker, "With the Fans," *Los Angeles Examiner*, Aug. 2, 1908, p. 5.

195 **They lasted fourteen rounds** "Johnson Beats Burns in 14 Furious Rounds, Winning World's Title," *Los Angeles Examiner*, Dec. 26, 1908, p. 1.

196 **They were joined at the newspaper** Jim Jeffries, "Money-Mad Burns Sells His Pride," *Los Angeles Examiner*, Dec. 26, 1908.

196 **Herriman's cartoon capped the day's sports page** George Herriman, "Johnson Paints His Christmas Present Black," *Los Angeles Examiner*, Dec. 26, 1908, p. 10.

197 **The cries for a black-white "Battle of the Century" grew louder** Jack London, "London Says Johnson Made a Noise Like a Lullaby with His Fists as He Tucked

Burns in His Little Crib in Sleepy Hollow, with a Laugh," *New York Herald*, Dec. 27, 1908, p. 5.

197 **Among those who applauded Johnson's success** W. W. Naughton, "Coils Tighten on Jeffries, Says Naughton," *Los Angeles Examiner*, Jan. 14, 1909, p. 17.

197 **Some of Herriman's cartoons during this time** George Herriman, "The Man in the Moon," *Los Angeles Examiner*, Aug. 12, 1909.

198 **The next day in Los Angeles** Beanie Walker, "Promoter M'Carey Will Try to Land Jeffries-Johnson Battle for Los Angeles," *Los Angeles Examiner*, April 22, 1909.

200 **Jeffries frequently visited the newspaper** George Herriman, "This Is the Kind of Happy New Year Jim Jeffries Is Going to Have," *Los Angeles Examiner*, Dec. 29, 2908

201 **Arthur Conan Doyle and Booker T. Washington** Ward, *Unforgivable Blackness*, p. 172.

201 **By this time he had begun frequently caricaturing** George Herriman, "How Aesthetic Rowardennan May Effect Jeff's Camp," *Los Angeles Examiner*, April 7, 1910, p. 13.

203 **In June, with the proposed fight just a month away** Ward, *Unforgivable Blackness*, p. 192.

203 **Hearst also sprang into action** Tad Dorgan, "Tad Visits Jack Johnson's Training Camp at Ocean Beach," *Los Angeles Examiner*, June 8, 1910, p. 11.

203 **One day a black hen** George Herriman, "Take a Plunge the Water Is Fine," *Los Angeles Examiner*, May 29, 1910, p. 4.

203 **On another a circus performer** George Herriman, "Ready to Enter the Ring," *Los Angeles Examiner*, June 5, 1910, p. 3.

204 **Tad Dorgan, already in California** Tad Dorgan, *Circulation*, April, 1923.

204 **Dorgan arrived in Reno** Tad Dorgan, "Negro Champion Orders Split of Ale and Six Good Chickens; Then Sails in," *Los Angeles Examiner*, June 25, 1910.

204 **Also in Reno to cover the fight was Jimmy Swinnerton** "World-Famous Experts to Cover Big Fight for Examiner," *Los Angeles Examiner*, June 26, 1910.

205 **Making matters even worse** "Scores Slain by Terrific Heat Wave in East," *Los Angeles Examiner*, June 22, 1910, p. 1.

206 **Herriman found temporary residence** *Trow's City Directory for Manhattan and the Bronx*, 1912.

206 **With Dorgan and the others filing reports** George Herriman, "What Do YOU Think About it?" *New York Evening Journal*, June 16, 1910.

206 **Reno, Beanie Walker wrote** Beanie Walker, "Reno Is Now Capital of the Sporting World," *Los Angeles Examiner*, July 3, 1910.

206 **Only readers of Hearst's papers** Tad Dorgan, "Tad Picks Johnson to Win Battle," *New York Evening Journal*, July 4, 1910, p. 3.

207 **The day of the fight, Jeffries penned a portentous article** "Jeffries Demands Protection for Negro in the Event Johnson Wins the Big Fight," *Los Angeles Examiner*, July 4, 1910.

207 **"I guess people will begin to believe that I am some fighter now"** Jack
Johnson, "Johnson Surprised by the Ease of His Victory," *New York Evening Journal,*
July 5, 1910, p. 3.

207 **When he overheard Hearst reporter W. W. Naughton dictating** Ward, *Unforgiv-
able Blackness,* p. 207.

207 **The next day the *Evening Journal* published an array of cartoons** *New York Eve-
ning Journal,* July 5, 1910.

208 **"Slap a coat of whitewash"** Beanie Walker, "Negro Has All Elements of Popular-
ity," *Los Angeles Examiner,* July 10, 1910.

208 **"Negroes formed the greater number"** "Reno Fight Causes Race Riot; 11
Killed," *Los Angeles Examiner,* July 5, 1910.

208 **"The irritation caused by the defeat"** "100 Negroes Drive Judge from Court,"
Los Angeles Examiner, July 6, 1910.

208 **The Hearst papers—which had devoted countless pages to stoking bloodlust**
"That Prize Fight Was Disgraceful, Demoralizing, Harmful," *New York Evening Jour-
nal,* July 9, 1910.

209 **But a few pages over in the sports section** Tad Dorgan, "Bunk Takes Silk Hat
Harry to See the Fight Pictures" and "Tad Sees Big Battle on Screen," *New York Eve-
ning Journal,* July 19, 1910.

209 **The fight over, Jeffries returned to retirement** Beanie Walker, "Jim Jeffries Re-
turns to His Old Home; Slips into Town Unnoticed; Ex-Champion May Fight Jack
Johnson Again Within Next Six Months," *Los Angeles Examiner,* July 9, 1910.

209 **Three years after the fight in Reno** Ward, *Unforgivable Blackness,* p. 328.

210 **Through it all, Tad Dorgan remained a friend and supporter** Jack Johnson, "Jack
Johnson's Own Story," *Saskatoon Star-Phoenix,* May 8, 1929. Reprinted in "Yester-
day's Papers," john-adcock.blogspot.com, Feb. 2, 2011.

CHAPTER 12: REVOLUTIONARIES AND DINGBATS

213 **It was said you could see ghosts** John McNamara, "British Prison Wall Stands in
Park Here," *Riverdale Review,* April 16, 1959, reprinted by New York Correction
History Society, correctionhistory.org.

213 **Even if the Rhinelander wasn't haunted** Gene Fowler, *Skyline: A Reporter's Rem-
iniscence of the '20s* (New York: Viking, 1961) p. 65.

213 **During one heat wave** "Tad, Cartoonist, Is Prostrated by Heat," *Los Angeles Ex-
aminer,* July 13, 1912.

214 **George McManus recalled how Winsor McCay** Boyden Sparkes interview with
George McManus. Brisbane Family Papers, Special Collections Research Center,
Syracuse University Libraries.

214 **One day Brisbane brought in a basket of peaches** Boyden Sparkes interview
with Harry Hershfield. Brisbane Family Papers, Special Collections Research
Center, Syracuse University Libraries.

214 **Many mornings the floor was littered with old bottles** Boyden Sparkes interviews. Brisbane Family Papers, Special Collections Research Center, Syracuse University Libraries.

214 **Brisbane made for a perfect comic foil** Boyden Sparkes interview with George Herriman, 1937. Brisbane Family Papers, Special Collections Research Center, Syracuse University Libraries.

215 **Brisbane had a prominent forehead** Ibid.

215 **There was never any doubt that Tad Dorgan was** Boyden Sparkes interview with E. C. Segar. Brisbane Family Papers, Special Collections Research Center, Syracuse University Libraries.

215 **Years later, when interviewed by Sparkes** Boyden Sparkes interview with George Herriman, 1937. Brisbane Family Papers, Special Collections Research Center, Syracuse University Libraries.

216 **A full two decades after moving back to California** Ibid.

216 **"I had started a lot of series"** Ibid.

217 **Dingbat shakes his fist** George Herriman, "Mr. Dingbat Knows His Rights," *New York Evening Journal*, July 20, 1910.

217 **Later, Herriman would disregard** Boyden Sparkes interview with George Herriman, 1937. Brisbane Family Papers, Special Collections Research Center, Syracuse University Libraries.

218 **One month after its debut** George Herriman, "Mr. Dingbat Demands His Rights from the Family Up Stairs," *New York Evening Journal*, July 25, 1910, p. 11.

218 **Then Herriman received an unexpected boost** Boyden Sparkes interview with George Herriman, 1937. Brisbane Family Papers, Special Collections Research Center, Syracuse University Libraries.

219 **Even Arthur Brisbane called him** Boyden Sparkes interviews. Brisbane Family Papers, Special Collections Research Center, Syracuse University Libraries.

219 **"He collected rare old china"** Fowler, *Skyline*, p. 64.

220 **"About six months later my contract was over"** Boyden Sparkes interview with George Herriman, 1937. Brisbane Family Papers, Special Collections Research Center, Syracuse University Libraries.

220 **"In the shadows of a great city behold"** George Herriman, "The Family Upstairs," *New York Evening Journal*, Aug. 17, 1910.

220 **"Shifting the scenes on the stage of life"** George Herriman, "The Family Upstairs," *New York Evening Journal*, Aug. 25, 1910.

220 **"Gentlemen!! be seated clack clack"** George Herriman, "The Family Upstairs," *New York Evening Journal*, Aug. 18, 1910.

220 **Recalled cartoonist Ed Wheelan** "The Naming of Ignatz," *Comic Art*, Spring, 1962.

221 **"No one, not even Herriman, knew"** Ibid.

222 **Herriman made no secret of his intentions** George Herriman, "The Family Up-

stairs—They Are the Cause of Dingbat's Unquenchable Thirst," *New York Evening Journal*, Dec. 5, 1910, p. 13.

222 **Other strips also refer to race** George Herriman, "The Family Upstairs—They Know Dingbat's Name Better Than the Professor," *New York Evening Journal*, Dec. 8, 1910, p. 18.

222 **Herriman followed this series** George Herriman, "1911 Resolutions," *New York Evening Journal*, Jan. 3, 1911, p. 3.

223 **Before long, Herriman started hearing** George Herriman, "By Request—Here It Is!" *New York Evening Journal*, March 3, 1911.

223 **Herriman received another fan request** Boyden Sparkes interview with George Herriman, 1937. Brisbane Family Papers, Special Collections Research Center, Syracuse University Libraries.

223 **These seemed to be inspired by Herriman's evenings at Joel's** "You Mustn't Crack Up the Darwinian Theory at Joel's," *New York Times*, Nov. 2, 1913.

226 **Their two daughters, Toots and Bobbie** 1910 United States Federal Census, Los Angeles.

226 **The letter was to Homer Lea** George Herriman letter to Homer Lea, Joshua B. Powers Collection, Box no. 1, Hoover Institution Archives.

228 **Herriman added more comics with Krazy Kat** George Herriman, "Krazy Kat at the Horse Show—Military Riders and Box Scene," *New York Evening Journal*, Nov. 23, 1911, p. 3.

228 **In the revised *Dingbat Family*** For example, a "yodler" [*sic*] sings a melody that was the "pride of Coconino County" in: George Herriman, "The Dingbat Family," *New York Evening Journal*, Nov. 22, 1911.

CHAPTER 13: KAT DESCENDING A STAIRCASE

230 **Coming home with his wife, Mabel** George Herriman, "Yes, L.A. is Growing Just Listen to Herriman," *Los Angeles Evening Herald*, Sept. 30, 1912.

230 **A brief article, written by Herriman** Ibid.

230 **The Herrimans might have traveled west** Beanie Walker, "Pipe Dreams," *Los Angeles Examiner*, Sept. 11, 1911.

231 **The current ownership of the *Evening Herald*** "Earl Hurls Paper Bomb at Gen. Otis," *San Francisco Call*, June 26, 1911. *The Evening Herald* addressed those rumors in an unsigned front-page cartoon, "Alive and Untroubled," July 4, 1911.

231 **According to most histories** For just one example, David Nasaw, *The Chief: The Life of William Randolph Hearst* (New York: Mariner Books, 2001), p. 315.

231 **The *Evening Herald*, King Features head Moses Koenigsberg** Moses Koenigsberg, *King News* (Freeport, N.Y.: Books for Libraries Press, 1972), p. 350.

231 **Front-page notices promised new boxing cartoons** "Don't Miss George Herriman's Cartoon on Tonight's Fights! It Will Appear Exclusively in The Evening Herald Tomorrow," *Los Angeles Evening Herald*, Oct. 1, 1912.

231 **In early October, former *Examiner* cartoonist Dan Leno** Dan Leno, "That Spanish Feed," *Los Angeles Evening Herald*, Oct. 3, 1912.

231 **In November 1912 Herriman made a rare public appearance** "Watch Evening Herald Illustrated Stereopticons for First and Most Complete Election Returns," *Los Angeles Evening Herald*, Nov. 4, 1912.

232 **More than one hundred thousand citizens** "Evening Herald Gives Election News First," *Los Angeles Evening Herald*, Nov. 6, 1912, p. 1.

232 **The *Evening Journal* would publish a photograph of Wilson** "Wilson's Little Joke," *New York Evening Journal*, March 6, 1913.

232 **Wrote Martin Sheridan in his 1942 book** Martin Sheridan, *Comics and Their Creators: Life Stories of American Cartoonists* (Boston: Hale, Cushman & Flint, 1942), p. 65.

232 **On special assignment from the *Evening Herald*** George Herriman, "Vernon Sidelights," *Los Angeles Evening Herald*, Nov. 29, 1912, p. 11.

233 **On Monday, November 6, 1911** County of Los Angeles Death Certificate, Clara Morel.

233 **The Herrimans had held her funeral** "Deaths," *Los Angeles Times*, Nov. 8.

233 **His sister, Ruby** "Des Roches Fifty Flip," *Los Angeles Times*, Oct. 19, 1912.

233 **Henry Herriman worked as a plumber** *Los Angeles City Directory*, 1912, p. 737.

233 **In October, Mabel Herriman** *Los Angeles Times*, Oct. 13.

233 **She eventually would hire seventeen-year-old Vivian Hammerly** *Los Angeles City Directory*; author interview with Marlene Duckworth.

234 **Two weeks later Walker snuck a few more gags** Beanie Walker, "Pipe Dreams," *Los Angeles Examiner*, Dec. 2, 1912.

236 **The *Evening Herald* led off its coverage** George Herriman, "Alvin's Nosito Stopped a Few," *Los Angeles Evening Herald*, Jan. 2, 1913.

237 **Back at the Rhinelander, Herriman hadn't been forgotten** Tad Dorgan, "Daffydils," *Los Angeles Examiner*, April 29, 1912.

237 **Herriman returned the flattery** George Herriman, "The Dingbat Family," *New York Evening Journal*, Dec. 31, 1912.

237 **The show began without controversy** Milton W. Brown, *The Story of the Armory Show* (New York: Abbeville Press, 1988), p. 42.

238 **"The whole idea of movement"** Katherine Kuh, *The Artist's Voice: Talks With Seventeen Modern Artists* (New York: Da Capo Press, 2000), p. 83.

238 **Even former president Theodore Roosevelt entered the fray** Theodore Roosevelt, *History as Literature and Other Essays* (New York: Charles Scribner's Sons, 1913), p. 306.

238 **Wrote art historian Milton W. Brown** Brown, *The Story of the Armory Show*, p. 45.

238 **Others, including Armory Show artist Stuart Davis** "Fabled Art Show is Re-created on 50th Anniversary," *St. Louis Post-Dispatch*, May 5, 1963.

238 **The Armory Show had special appeal to the eighth floor of the Rhinelander**

Walt Kuhn's early exploits and the friendships between Kuhn and other cartoonists are documented in photographs and letters in the Smithsonian Archives of American Art, Walt Kuhn, Kuhn Family Papers, and Armory Show Records, 1859–1984; and the Rudolph Dirks Papers, 1860–1971.

239 **Herriman was not represented** Boyden Sparkes interview with George Herriman, 1937. Brisbane Family Papers, Special Collections Research Center, Syracuse University Libraries.

239 **Kuhn did collaborate with Herriman** Brown, *The Armory Show*, p. 81.

239 **Frederick Opper's *The "New Art!"*** Frederick Opper, "The 'New Art!'" *Los Angeles Examiner*, March 5, 1913.

239 **In his strip "Dauntless Durham of the U.S.A."** Harry Hershfield, "Dauntless Durham of the U.S.A.," *New York Evening Journal*, May 7, 1913.

240 **And in a *Dingbat Family* episode** George Herriman, "The Dingbat Family," *New York Evening Journal*, May 31, 1913.

241 **As usual, it was Tad Dorgan** "Tad Shows How the Goat Passes from Batter to Pitcher and Vice Versa," *New York Evening Journal*, July 12, 1913, p. 6.

241 **While the cartoonists had their fun** Margaret Hubbard Ayer, "Calls Futurist and Cubist Art Brain Vagaries," *New York Evening Journal*, March 1, 1913.

241 **Over time, however, the cartoonists' good humor** Smithsonian Archives of American Art, Walt Kuhn, Kuhn Family Papers, and Armory Show Records, 1859–1984.

242 **Then you admit** "Krazy Kat," March 15, 1913.

242 **When a man collides** "Krazy Kat," Oct. 4, 1913.

242 **Harmony, Krazy, is** "Krazy Kat," Oct. 24, 1913.

243 **Well here we is again "Ignatzy" old Topsy** George Herriman, "Krazy Kat," April 17, 1914.

244 **"On the road of life's journey"** George Herriman, "Krazy Kat," Oct. 19, 1914.

CHAPTER 14: THE KAT AND THE TRAMP

245 **The single-panel cartoon *What Herriman Wants*** George Herriman, "What Herriman Wants," *Chicago Evening American*, Dec. 18, 1915.

246 **The *Evening Journal* ran numerous** "Bee Stings the Latest Cure for Rheumatism," *New York Evening Journal*, Dec. 8, 1913.

246 **In the first comic, titled *Rheumatism*** George Herriman, "Rheumatism," *New York Evening Journal*, Sept. 20, 1913.

246 **In the second comic, titled *More Rheumatism*** George Herriman, "More Rheumatism," *New York Evening Journal*, Sept. 22, 1913.

247 **This time, however, Van Loan lost control** Otheman Stevens, "Boulevard Bouquets," *Los Angeles Examiner*, July 31, 1914.

247 **Herriman's brother, Henry** U.S. Marine Corps Muster Rolls, 1798–1940, record for Henry W. Herriman.

247 **Meanwhile, Herriman's oldest sister, Ruby** Cuyahoga County, Ohio, Marriage Records and Indexes, 1810–1973 for Ruby E. Herriman.

248 **Gus Mager and Walt Kuhn** "George Overbury "Pop" Hart, Walt Kuhn, and Gus Mager, ca. 1915," photographic print, Walt Kuhn, Kuhn Family Papers, and Armory Show Records, 1859–1984, Smithsonian Archives of American Art

248 **"Having Pop Hart as a neighbor"** "George Price, 93, Cartoonist of Oddities, Dies," *New York Times*, Jan. 14, 1995.

248 **He compared "Michael Enjello" to Tad Dorgan** George Herriman, "Krazy Kat," Oct. 27, 1914.

248 **repeatedly brought up the dollar and ten cents** George Herriman, "Krazy Kat," Oct. 31, 1914.

249 **sent Krazy Kat to "Dog-hole, Minnie-zotta" to visit Cliff Sterrett** George Herriman, "Krazy Kat," Dec. 22, 1916

249 **The newest member to the circle** New York, Passenger Lists, 1820–1957.

249 **The legendary gathering of artists and wits** Tad Dorgan, "Indoor Sports," *Los Angeles Examiner*, Nov. 14, 1914.

250 **Titled** *Boxing in the Art Room with Garge Herriman the Greek* *Circulation*, March 1923.

250 **Dorgan brought other office jokes to the pages** Tad Dorgan, "Tad's Tid-Bits," *New York Evening Journal*, Sept. 30, 1906.

251 **When the fun spilled out of the Rhinelander** Tad Dorgan, "Tad's Tid-Bits," *New York Evening Journal*, Dec. 7, 1916.

251 **Dorgan didn't reveal who won that match** Neal Thompson, *A Curious Man: The Strange and Brilliant Life of Robert "Believe It or Not!" Ripley* (New York: Three Rivers Press, 2014), p. 76.

252 **There was no place quite like Jack's** Benjamin De Casseres, "Jack's," *American Mercury*, Nov. 1932, pps. 348–54.

252 **Sporting a white flower in his lapel** John B. Kennedy, *The New Age Illustrated*, nd.

252 **The cartoonists stashed a ukulele** De Casseres, "Jack's."

252 **After one memorable night, Herriman reportedly staggered** Patrick McDonnell, Karen O'Connell, and Georgia Riley de Havenon, *Krazy Kat: The Comic Art of George Herriman* (New York: Harry N. Abrams, 1986), p. 44.

252 **Shortly after creating** *The Dingbat Family* "With Shows and Show People Coming Attractions at Grand," *Greensboro Daily News*, Sept. 6, 1914.

253 **Actor Bobby Barry, a seasoned vaudeville** *Variety*, Nov. 1913.

253 **The show traveled to North Carolina** *Greensboro Daily News,* Sept. 11, 1914.

253 **A Vermont newspaper reported** *St. Albans Messenger*, Oct. 10, 1914.

253 **A Washington paper** *Bee*, Nov. 21, 1914.

253 **As for the comic strip** *The Dingbat Family* George Herriman, "The Dingbat Family," Nov. 10, 1914.

253 **With headlines about World War I** George Herriman, "The Dingbat Family," Dec. 16, 1915.

253 **He later revealed that the order came suddenly** Boyden Sparkes interview with

George Herriman, 1937. Brisbane Family Papers, Special Collections Research Center, Syracuse University Libraries.

253 **The day after the final appearance of** *The Dingbat Family* Charles J. McGuirk, "Chaplinitis," *Motion Picture,* July, 1915.

255 **"Chaplin's costume personifies shabby gentility"** Theodore Huff, *Charlie Chaplin* (New York: Schuman, 1951), p. 33.

255 **"Even in slapstick comedy"** Victor Eubank, "The Funniest Man on the Screen," *Motion Picture*, March 1915. Reprinted in Kevin J. Hayes, ed., *Charlie Chaplin Interviews* (Jackson, Miss.: University Press of Mississippi, 2005).

255 **Chaplin "invented a rhythm"** David E. Chinitz, *T.S. Eliot and the Cultural Divide* (Chicago: The University of Chicago Press, 2003), p. 101.

255 **Messmer made a close study of Chaplin** John Canemaker "Otto Messmer and Felix the Cat," *Cartoonist PROfiles*, March 1978.

256 **In** *If the Movie Fans Were Sculptors* Tad Dorgan, "If the Movie Fans Were Sculptors," *New York Evening Journal*, Sept. 20, 1915.

256 **In an episode of Dorgan's cartoon** Tad Dorgan, "Indoor Sports," *New York Evening Journal*, May 28, 1915.

256 **Herriman added Chaplin gags** George Herriman, "The Dingbat Family," Oct. 25, 1915; "Krazy Kat," Oct. 26, 1915.

257 **"The Dickens mode operated in 'Baron Bean'"** Gilbert Seldes, *The 7 Lively Arts* (New York: Harper & Brothers, 1924), p. 232.

257 **Herriman had first taken on this character** George Herriman, "The Difference," *New York Evening Journal*, March 29, 1901.

257 **Baron Bean also sprang from numerous true-life tales** "'Baron,' Freed, Now Sued by Girl for $1,000," *New York Evening Journal*, March 4, 1911.

257 **When readers first encounter Baron Bean** George Herriman, "Baron Bean," Jan. 5, 1916.

257 **The next day's** *Baron Bean* **opens** George Herriman, "Baron Bean," Jan. 6, 1916.

258 **As comics scholar Jared Gardner has noted** Jared Gardner, "Of Barons, Dukes, and New World Aristocrats," *Geo. Herriman, Baron Bean: The Complete First Year* (San Diego, Cal.: IDW Publishing, 2012).

258 **Herriman's set is lovingly decorated in southwestern designs** George Herriman, "Baron Bean," Jan. 12, 1916.

260 **Said Herriman of Chaplin** Harry Carr, "The War of the Comedians," *Motion Picture Classic*, August 1925, p. 19.

260 **"You remember Baron Bean, all those years ago?"** Boyden Sparkes interview with Elzie "E. C." Segar. Brisbane Family Papers, Special Collections Research Center, Syracuse University Libraries.

260 **In fact, said Tad Dorgan, it could be difficult** Tad Dorgan, "This Is About Garge Herriman," *Circulation*, March 1923.

260 **Harry Carr once recalled how Herriman rhapsodized** Harry Carr, "Harry Carr's Page," *Los Angeles Times*, Jan. 21, 1925.

260 **Herriman found a similar wonderment** George Herriman, "The Gold Rush as Seen by Krazy Kat," *Motion Picture Classic*, Oct. 1925, p. 43.

261 **"There is no question of why he is here"** Ibid.

261 **"You have written truth"** George Herriman, "Krazy Kat," June 17, 1917.

262 **"I think pity is a great attribute"** Kenneth S. Lynn, *Charlie Chaplin and His Times* (New York: Cooper Square Press, 2002), p. 465.

262 **Critic (and Herriman friend) Gilbert Seldes** Gilbert Seldes, "The Kat Comes of Age," *Esquire*, Sept. 1935.

262 **"The timid, hopeful little man"** Harry Carr, "The War of the Comedians," *Motion Picture Classic*, August 1925, p. 19.

264 **It marked, in the words of film scholar Donald Crafton** Donald Crafton, *Before Mickey: The Animated Film, 1898–1928* (Chicago: University of Chicago Press, 1993), p. 113.

264 **Cartoonist John Randolph Bray** Ibid., p. 137.

264 **The first King Features head** Bruce Canwell, "Gags, Situation Comedies, and the Birth of King Features," in Dean Mullaney, ed., *King of the Comics: 100 Years of King Features* (San Diego, Cal.: IDW Publishing, 2015), p. 39.

264 **Hearst installed his own animation studio** Crafton, *Before Mickey*, p. 178.

264 **Some cartoonists followed McCay's lead** Peter Marzio, *Rube Goldberg: His Life and Work* (New York: Harper & Row, 1973), p. 86.

265 **Hearst also promoted the new cartoons** "George Herriman Remembers," "Yesterday's Papers," john-adcock.blogspot.com, Dec. 14, 2011.

265 **These included *A Duet: He Made Me Love Him*** George Herriman, "Krazy Kat," Jan. 6, 1915.

265 **Another is a riff on the medical condition** George Herriman, "Krazy Kat," April 16, 1915.

266 **Animator Shamus Culhane, for one, would regret** Shamus Culhane, *Talking Animals and Other People* (New York: Da Capo Press, 1998), p. 2.

CHAPTER 15: A GENIUS OF THE COMIC PAGE

269 **Federal agents kept close surveillance on Hearst** Nasaw, *The Chief*, p. 261.

269 **Frederick Opper, Jimmy Swinnerton, T. E. Powers and especially Winsor McCay** Ben Procter, *William Randolph Hearst: The Later Years, 1911–1951* (New York: Oxford University Press, 2007), p. 71.

269 **Hearst responded in his newspapers** George Herriman, "Ignatz Mexico and Krazy Kat U.S." *New York Evening Journal*, June 30, 1916.

269 **On the sports pages, cartoons of boxers and baseball players were replaced** *New York Evening Journal*, April 10, 1917.

269 **Fearing that a wartime paper shortage** *Editor & Publisher*, Sept. 28, 1918.

269 **Hearst made sure readers knew that cartoonist Walter Hoban** Walter Hoban, "Promoted How He Feels About It," *New York Evening Journal*, June 4, 1918.

270 *Krazy Kat* **was published in special newspapers** August William Derleth Papers, 1858, 1907–1978, Wisconsin Historical Society.

271 **"Gee, 'Krazy' where are you going with that cannon?"** George Herriman, "Krazy Kat," Jan. 20, 1915.

271 **A goose enters** George Herriman, "Krazy Kat," Nov. 6, 1916.

272 **In another, neither Ignatz nor Krazy Kat** George Herriman, "Krazy Kat," Feb. 25, 1918.

272 **In one pantomime comic, Krazy Kat sees a cannonball** George Herriman, "Krazy Kat," Feb. 8, 1919.

272 **Krazy Kat often expresses a certain wartime relunctance** George Herriman, "Krazy Kat," Sept. 25, 1918.

272 **Most poignant was a wartime scene** George Herriman, "Krazy Kat," Sept. 12, 1918.

272 **Herriman tightly packed dialogue into some strips, while staging others** George Herriman, "Krazy Kat," Sept. 3, 1916.

272 **The name, which had been appearing** Flora Gregg Iliff, *People of the Blue Water: A Record of Life Among the Walapai and Havasupai Indians* (Tucson, Ariz.: The University of Arizona Press, 1985), p. 99.

273 **One week a pair of Joshua trees join the fun** George Herriman, "Krazy Kat," Jan. 7, 1917.

275 **The Penguins were the city's** "No Fake Bohemian Can Join Penguins," *Sun*, Jan. 8, 1917, p. 6.

275 **"We were young, full of beans"** Louis Bouché papers, 1880–2007, Smithsonian Archives of American Art.

275 **Among the artists who performed in the pageant was Herriman** "No Fake Bohemian Can Join Penguins," *Sun*, Jan. 8, 1917, p. 6.

275 **In the first issue of the Vorticist journal** *Blast*, June 20, 1914.

276 **One daily comic opens with only a tree and a note** George Herriman, "Krazy Kat," March 26, 1917.

277 **It was during this period that Herriman** George Herriman, "Krazy Kat," Jan. 8, 1918.

277 **Poet T. S. Eliot, who published work in** *Blast* Chinitz, *T. S. Eliot and the Cultural Divide*, p. 13.

278 **In 1916, young Harvard senior Edward Estlin (E. E.) Cummings** Susan Cheever, *E.E. Cummings: A Life* (New York: Vintage, 2015), p. 35.

278 **The next year a recent Harvard graduate named Summerfield Baldwin** Summerfield Baldwin, "A Genius of the Comic Page," *Cartoons*, Vol. 2, 1917, pp. 802–808.

280 **Announcing that "gloom doesn't help to win the war"** "Penguins Declare War on Dull Care," *Sun*, Feb. 11, 1918, p. 9.

280 **On Friday, September 13, 1918 he dutifully showed up** George Joseph Herriman, U.S. World War I Draft Registration Cards, 1917–1918.

280 **Interestingly, Herriman's first cousin** Hector Henry Hecaud, U.S. World War I Draft Registration Cards, 1917–1918.

281 **The hotel kept a close relationship** *Cartoons*, February 1917.

281 **George Herriman listed his wife, Mabel Herriman** *Los Angeles City Directory*, 1918.

281 **New Yorkers packed the streets** Louis Bouché papers, 1880–2007, Smithsonian Archives of American Art.

CHAPTER 16: FANTASTIC LITTLE MONSTER

284 **"At the head of the table is Mrs. Wetherill"** Ernie Pyle, "Rambling Reporter," *Pittsburgh Press*, Aug. 8, 1939.

285 **It was not unusual to see a medicine man come to Louisa** Sarah Louise Bradley, interview with the author.

286 **Betty Rodgers, who as a young Navajo child** Betty Rodgers, interview with the author.

286 **Herriman's first documented visit to Kayenta** Wetherill Guest Register, Harvey Leake, Wetherill Family Archives.

286 **To reach the shared restroom, they would have had to stumble** Elizabeth Compton Hegemann, *Navajo Trading Days* (Albuquerque, N.M.: University of New Mexico Press, 2004).

287 **Betty Rodgers recalled that the Wetherills** Betty Rodgers, interview with the author.

287 **"He'd go out to the hogans"** Ibid.

287 **Herriman brought his newfound knowledge onto the comics page** George Herriman, "Krazy Kat," Nov. 23, 1919.

288 **Herriman and Bridge visited with another trading post operator** From the collection of Tom Bertino, reprinted in *Krazy & Ignatz: 1937–1938*. "Shifting Sands Dusts Its Cheeks in Powdered Beauty" (Seattle, Wash.: Fantagraphics, 2006).

289 **No Hearst financial records have surfaced** *Washington Herald*, Feb. 19, 1918, p. 6.

289 **The Bray films were loosely based on some of Herriman's comics** Information about Bray Studios' "Krazy Kat" films on "The Bray Animation Project" (brayanimation.weebly.com).

289 **The Averill Manufacturing Company** Bob Laughlin, "Kollecting Krazy Kat," *Collector's Showcase*, July/August 1984, courtesy M. Thomas Inge.

290 **A special Krazy Kat doll even showed up at a Yale football game** Damon Runyon, "Harvard's Mighty Booters and Yale's Stiff Defense Feature Game Says Runyon," *Trenton Evening Times*, Nov. 21, 1920.

290 **In 1920 Moses Koenigsberg, president of Hearst's King Features Syndicate** "'Habit' the Sure Basis of Stability," *Fourth Estate*, Sept. 11, 1920, p. 12.

291 **In one strip, Simeon chats up a sporting lad** The run of the 1919 "Marys Home from College" series is available online at Coconino World, www.old-coconino.com.

292 **To promote the new strip, King Features enlisted** George McManus papers (Collection 322). Department of Special Collections, Charles E. Young Research Library, UCLA.

295 **Certainly both Hearst and Brisbane took notice** Robert E. Sherwood, "Silent Drama," *Life*, May 18, 1922.

296 **Only twenty-three years old when he first wrote** Michael Kammen, *The Lively Arts: Gilbert Seldes and the Transformation of Cultural Criticism in the United States* (New York: Oxford University Press, 1996), p. 9.

296 **He'd come of age on a utopian farm colony** Ibid., p. 27.

296 **Seldes didn't seem to notice** Gilbert Seldes, "The Kat Comes of Age," *Esquire*, Sept 1935, p. 103.

296 **To Seldes, *Krazy Kat* was no less than the savior** Gilbert Seldes, "Comment," *Dial*, July 1920, p. 107.

297 **The wash of praise over Herriman continued** Roy McCardell, "George Herriman—Progenitor of Krazy Kat and the Irascible Ignatz, the Brick-Heaving Mouse," *Morning Telegraph*, Aug. 22, 1920, p. 3.

297 **Next up was Damon Runyon** Damon Runyon, "The Father of 'Krazy Kat,'" *Pittsburgh Press*, Nov. 26, 1920.

298 **After the war, Cummings was in Paris, penning letters** F. W. Depee and George Stade, eds., *Selected Letters of E.E. Cummings* (New York: Harcourt, Brace & World, 1969), p. 95.

299 **In many of his letters, Cummings added lines** Ibid., p. 91.

299 **Josephson later recalled how he furnished** Matthew Josephson, *Life Among the Surrealists* (New York: Holt, Rinehart and Winston, 1962), p. 124.

299 **Herriman layered *Krazy Kat* in visually** George Herriman, "Krazy Kat," July 29, 1915.

299 **In one strip Ignatz awakens by the sea** George Herriman, "Krazy Kat," July 26, 1921.

300 **In another, Krazy Kat's tail betrays kinks** George Herriman, "Krazy Kat," April 2, 1921.

300 **In another comic, a black Ignatz and a white Krazy Kat** George Herriman, "Krazy Kat," Dec. 16, 1916.

300 **So was Coconino** George Herriman, "Krazy Kat," Feb. 25, 1919.

301 **Perhaps, as comics scholar Mark Newgarden** Mark Newgarden, interview with author.

CHAPTER 17: MIST

302 **In 1917, when the word "jazz" was first** George Herriman, "Krazy Kat," Sept. 19, 1917.

302 **That same year in Los Angeles, Herriman received a pair of visitors** Irene Al-

exander, "Rudolph Ganz to Play Work of Peninsula Composer," *Monterey Peninsula Herald*, March 24, 1949.

303 **Following their first meeting** John Alden Carpenter Papers, 1876–1951, Newberry Library, Chicago, Ill.

303 **Herriman sent his reply via telegram** John Alden Carpenter Collection, Library of Congress, Music Division.

303 **Herriman then elaborated his concerns** Ibid.

304 **"In your Chicago home one evening"** John Alden Carpenter Papers, 1876–1951, Newberry Library, Chicago, Ill.

304 **"And I remember well your gifted 'pappy'"** Ibid.

305 **Despite Herriman's recollections, Bolm actually shared** Lynn Garafola and Nancy Van Norman Baer, eds., *The Ballets Russes and Its World* (New Haven, Conn.: Yale University Press, 1999), p. 228.

305 **Along with designing the scenery** George Herriman, "Krazy Kat," July 31, 1921.

306 **The *Krazy Kat* ballet couldn't come soon enough** Deems Taylor, "America's First Dramatic Composer," *Vanity Fair*, April 1922, p. 59.

307 **The *Bookman* critic tried and failed** "The Gossip Shop," *Bookman*, March 1922.

308 **Writing in the *New Republic*** Stark Young "Krazy Kat," *The New Republic*, Oct. 11, 1922, p. 175.

308 **Yet critics complained that this jazz** "'Krazy Kat' in Ballet Danced at Town Hall," *New York Evening Journal*, Jan. 21, 1922.

308 **In fact, one of the harshest critics was Gilbert Seldes** Gilbert Seldes, "The Theatre," *Dial*, March 1922.

309 **Henrietta Straus, writing in the *Nation*** Henrietta Straus, "Marking the Miles," *Nation*, March 8, 1922.

309 **Added Deems Taylor** Deems Taylor, "America's First Dramatic Composer," *Vanity Fair*, April 1922, p. 59.

309 **Deems Taylor, in his review of the *Krazy Kat* ballet** Deems Taylor, "America's First Dramatic Composer," *Vanity Fair*, April 1922, p. 59.

310 ***The Bookman* noted that only Napoleon** "Spring Elections on Mount Olympus," *Bookman*, May 1922.

310 **Wilson also contacted Herriman** Edmund Wilson Papers. Yale Collection of American Literature, Beinecke Rare Book and Manuscript Library.

311 **Some readers remained exasperated** George Herriman, "Krazy Kat," March 21, 1921. The author first became aware of this line from an online comment by Bruce Triggs.

312 **As a young woman, pioneering lesbian writer** Joanne Passet, *Sex Variant Woman: The Life of Jeanette Howard Foster* (New York: Da Capo Press, 2008), p. 53.

312 **A travel article of the time** "Travelette," *El Paso Herald*, Jan. 27, 1919.

312 **Yet Herriman's work was appreciated** Arnold Rampersad, David Roussel and Christa Fratantoro, eds. *Selected Letters of Langston Hughes* (New York: Knopf, 2015), p. 46.

312 **He wore tall boots** Evelyn Wells, *Coconino Sun*, June 3, 1921.

313 **Swinnerton counted Hopi and Navajo elders** Alice Rohe, "James A. Swinnerton, Painter, Has a Story That Is Revealed in His Art—Here's That Story," copied from Center for American History, University of Texas at Austin, no publication title.

313 **Such a gathering of well-known cartoonists** "Cheerful Chirps," *Coconino Sun*, Aug. 11, 1922, p. 2.

313 **The *Fourth Estate* noted that both Herriman and Swinnerton** "Herriman and Swinnerton Hobnob with Indians in Torrid Arizona," *Fourth Estate*, Aug. 5, 1922, p. 20.

313 **Arriving at the Wetherills, each took a turn signing** Wetherill Guest Register, Harvey Leake, Wetherill Family Archives.

314 **John Dirks later recalled his father** Jud Hurd, *Cartoonist PROfiles*, No. 19, p. 41.

314 **On one trip, the party traveled by horseback** "Artists Draw Cartoons Amid Ruins of Ancient American Civilization," *Palo Alto Times*, Sept. 18, 1922.

314 **One horseback trip would be immortalized** From the collection of Dave von Savoye.

314 **Years later, Louise Scher Swinnerton** Dave von Savoye, interview with the author.

315 **Herriman and Jimmy Swinnerton** Betty Rodgers, interview with the author.

315 **On Tuesday evening, August 22** Herriman birthday party register, Harvey Leake, Wetherill Family Archive.

315 **Herriman, deeply grateful for the day** The drawings for Dixon and Lange, and for the Wetherills, can be seen in Craig Yoe, ed., *Krazy Kat & the Art of George Herriman: A Celebration* (New York: Abrams, 2011)

316 **Before leaving Arizona, Herriman joined Jimmy Swinnerton** Gene K. Campbell, *Lincoln Star*, Oct. 11, 1922. Campbell, a recent hire on the King Features publicity staff, wrote the article, which was placed in newspapers around the country.

CHAPTER 18: THE LOT OF FUN

318 **Shortly following George Herriman's return** "King Features Offers New Herriman Strip," *Fourth Estate*, Nov. 11, 1922, p. 20.

318 **Herriman's frequent travels** Ibid., p. 20.

318 **Characters conformed to a prevailing screwball style** Gilbert Seldes, "Golla, Golla, the Comic Strips Art!" *Vanity Fair*, May 1922, p. 71.

319 **Stories were lively** George Herriman, "Stumble Inn," Dec. 27, 1922.

319 **Other days Herriman returns to his frequent theme of social pretenders** George Herriman, "Stumble Inn," Nov. 21, 1922.

320 **Cartoonist Bud Sagendorf, who assisted Segar** Bud Sagendorf, interview with Russell Myers, courtesy Russell Myers.

320 **Years after the death of both Herriman and Segar** Ibid.

320 **Sometimes called the Midwestern or Chicago school of cartooning** Jeet Heer,

"Notes on the Midwestern School of Comics," comicscomicsmag.com, Dec. 29, 2009.

321 **They purchased scripts by Herriman** *New York Times*, Aug. 19, 1923.

321 **Some longtime Society of Illustrators members** "Flagg Creates Stir at Show of Artists," *New York Times*, May 23, 1924.

321 **Charles Van Loan never fully recovered** "Charles E. Van Loan Dies," *Los Angeles Times*, March 3, 1919.

321 **Occasionally, he would steal away to New York** O. O. McIntyre, "TAD, A Close-up of a Man Who Amuses the World and Keeps His Troubles to Himself," *Cosmopolitan*, March 1927, p. 90.

322 **He also joined the "Tad's Terrors" baseball team** *New York Evening Journal*, July 12, 1921, and Aug. 5, 1921.

322 **Herriman and Dorgan's friendship ran deep** Jimmy Murphy, "Some Inside Dope on My Fellow 'Comickers,'" *Circulation*, April 1923.

323 **Dorgan put the blame squarely on Prohibition** John B. Kennedy, *New Age Illustrated*, no date.

323 **On Monday, January 15, 1923** Harvey Leake, Wetherill Family Archives.

323 **He didn't yet know** County of Los Angeles Death Certificate, George G. Herriman.

324 **His anguish burned through an otherwise routine letter** Edmund Wilson Papers. Yale Collection of American Literature, Beinecke Rare Book and Manuscript Library.

324 **George Gustave Herriman had labored** Will and Estate Documents for George G. Herriman, County of Los Angeles.

324 **By the end of 1923** Herriman family addresses from *Los Angeles City Directory* and correspondence in Harvey Leake, Wetherill Family Archives.

324 **Although she had been originally hired as a housekeeper** Marlene Duckworth, interview with the author.

325 **Among the pioneers was a young Irishman** Leonard Maltin and Richard W. Bann, *Our Gang: The Life and Times of the Little Rascals* (New York: Crown Publishers, 1977), p. 10.

326 **There, he developed a reputation as an eccentric** Scretvedt, Randy. *Laurel and Hardy: The Magic Behind the Movies.* (Beverly Hills, Cal.: Moonstone Press, 1987).

326 **Wrote Harry Carr in the *Los Angeles Times*** Harry Carr, "Harry Carr's Page," *Los Angeles Times*, Aug. 20, 1924, p. E2.

327 **And when Stan Laurel was asked if he and Oliver Hardy** John McCabe, foreword, in Scott Allen Nollen, *The Boys: The Cinematic World of Laurel and Hardy* (Jefferson, N.C.: McFarland & Company, 1989)

327 **In one five-panel comic** George Herriman, "Krazy Kat," Jan. 28, 1921.

327 **Herriman at times moved Krazy and Ignatz out of Coconino** George Herriman, "Krazy Kat," Dec. 27, 1921.

327 **One day Krazy Kat imitates "Cholla Cheplin"** George Herriman, "Krazy Kat," March 18, 1921.

327 **On another, Krazy and Ignatz walk past lobby signs** George Herriman, "Krazy Kat," Aug. 19, 1921

328 **"The Hal E. Roach's Studio"** "Stage and Screen Bits," *Philadelphia Inquirer,* Aug. 14, 1921.

329 **"A lot of people wanted to have their offices"** Lola Larson, interview with the author.

329 **"The Hal Roach Studio . . . was a swinging lot"** Frank Capra, *The Name Above the Title: An Autobiography* (New York: Macmillan, 1971), p. 40.

CHAPTER 19: INFERIORITY COMPLEXION

333 **In November 1923, John and Louisa Wetherill's daughter** Harvey Leake, Wetherill Family Archives.

334 **The following summer, Herriman and cartoonist Tom McNamara** Ibid.

334 **From Kayenta, Herriman and McNamara traveled** Patrick McDonnell, Karen O'Connell, and Georgia Riley de Havenon, *Krazy Kat: The Comic Art of George Herriman* (New York: Harry N. Abrams, 1986), p. 72.

334 **For the past year, Gilbert Seldes had exiled himself to Paris** Gilbert Seldes, "A Personal Preface," in the revised *7 Lively Arts* (New York: Sagamore Press, 1957), p. 3.

335 **The prose might be as brief and funny** George Herriman, "Krazy Kat," April 27, 1919.

336 **Pioneering cartoonist Rodolphe Töpffer** Ben Schwartz, ed. *The Best American Comics Criticism* (Seattle, Wash.: Fantagraphics, 2010), p. 225.

337 **Yet, even as *Krazy Kat* reached** D. G. Van Doren, "Mr. Seldes Patronizes," *Forum,* Aug. 1924.

337 **Bill Cottrell, previously a cartoonist and sportswriter** George Herriman, "Krazy Kat," Oct. 12, 1924.

337 **He credited his work for Herriman** Jeff Kurtti, *Walt Disney's Imagineering Legends and the Genesis of the Disney Theme Park* (Glendale, Cal.: Disney Editions, 2007), p. 26.

337 **Herriman made sure to find the time to draw** George Herriman, "Krazy Kat Sees Miss Davies in 'Janice Meredith,'" reprinted in *Krazy & Ignatz 1925–1926: "There is a Heppy Lend Fur Fur Awa-a-ay,"* Bill Blackbeard, ed. (Seattle: Fantagraphics, 2002)

338 **On Monday, March 24, 1925, Herriman was back in New York** Smithsonian Archives of American Art, Walt Kuhn, Kuhn Family Papers, and Armory Show Records, 1859–1984.

338 **That Monday, Herriman and the rest of the team** Ibid.

338 **He wrote to Frueh to beg out** Smithsonian Archives of American Art, Alfred J. Frueh Papers, 1904–1993.

340 **Herriman's complex was legendary.** Charlie Plumb, "Inside the Funny Page," *Esquire*, April 1942, p. 57.

340 **Similar language appears** George Herriman, "Krazy Kat," Dec. 31, 1930.

340 **Despite Herriman's attempts to beg out** Smithsonian Archives of American Art, Walt Kuhn, Kuhn Family Papers, and Armory Show Records, 1859–1984.

342 **They attended a luncheon hosted by the wife of director Richard Wallace** Isabel Stuyvesant, "Society of Cinemaland," *Los Angeles Times*, Oct. 22, 1926.

342 **their nightlife companions included young actors** Dee Cox, interview with the author.

342 **Along with their mother, Mabel** Marlene Duckworth, interview with the author.

342 **The bar's mentions in *Krazy Kat* were frequent** Federal Writers' Project, *The WPA Guide to California: The Golden State*, 1939.

342 **Minor-league baseball player Arthur "Frenchy" Escallier** Craig Yoe, ed., *Krazy Kat & the Art of George Herriman: A Celebration* (New York: Abrams, 2011), p. 102.

342 **Actress Alice Terry named her new dogs** "Names Her Dogs," *Los Angeles Times*, July 22, 1923.

343 **famed parachute jumper** Fred Gilman Jopp, "Hail, Caesar! We Who Are About to Die, Salute Thee!" *Los Angeles Times*, Feb. 8, 1925.

343 **A Hollywood car dealer took out advertisements** *Los Angeles Times*, Oct. 3, 1926.

343 **Wilson Springer, the son of Herriman's friend Pinky Springer** Letter from the collection of Patrick McDonnell and Karen O'Connell.

344 **In his *Times* column, he listed Herriman** Harry Carr, "The Lancer," *Los Angeles Times*, Aug. 11, 1926.

344 **When he began working for *Motion Picture Classic*** Harry Carr, "The War of the Comedians," *Motion Picture Classic*, Aug. 1925.

344 **He quoted Herriman on Charlie Chaplin** George Herriman, "'The Gold Rush' as Seen by Krazy Kat," *Motion Picture Classic*, Oct. 1925, p. 43.

345 **It all started, Carr wrote, with the actress Louise Fazenda** Harry Carr, "Louise Gives a Party," *Motion Picture Classic*, April 1925, p. 20.

346 **In the summer of 1926, the Herriman family traveled** Harvey Leake, Wetherill Family Archives.

346 **The most bizarre tale** George Herriman, "Krazy Kat," Jan. 16, 1927.

346 **The strip was prophetic** "Cartoonist Herriman Rallies in Hospital," *Los Angeles Times*, Nov. 6, 1927.

347 **Herriman, homebound and on a restricted diet** Harvey Leake, Wetherill Family Archives.

347 **To Clyde Colville, Herriman sent a rare letter** Harvey Leake, Wetherill Family Archives.

349 **Pennsylvania's *Warren Tribune* went all in** "A Few Notes from the Chorus of Joy Over 'Krazy Kat,'" *Warren Tribune*, Feb. 21, 1928.

349 **Yet, just a month later, a ballot** "Popularity Contest," *Warren Tribune*, March 28, 1928.

349 ***Krazy Kat* quickly sank** "Popularity Contest Dooms 'Krazy Kat,'" *Warren Tribune*, April 9, 1928.

349 **Another month later the newspaper announced** "Circulation," *Warren Tribune*, May 11, 1928.

350 **Growing up in Washington Heights** Stan Lee, interview with the author.

350 **Theodor "Dr. Seuss" Geisel once remembered** *Springfield Herald*, June 22, 1967, cited in Judith and Neil Morgan, *Dr. Seuss and Mr. Geisel: A Biography* (New York: Da Capo Press, 1996), p. 12.

350 **Also a childhood fan was actor Martin Landau** Rob Kendt, "Martin Landau Speaks Out About the Actor's Responsibility to the Audience and to the World," *Motion Picture*, 2005.

CHAPTER 20: OUTPOST

352 **As the synopsis might suggest** *How to Handle Women*, *Variety*, June 28, 1928.

353 **The land beneath Outpost Estates** Cecilia Rasmussen, "Hidden Hollywood Sign Uncovers History," *Los Angeles Times*, Feb. 17, 2008.

353 **A native Texan, Toberman built palatial landmarks** *Outpost*, Oct. 1927, published by C. E. Toberman, posted on outpostestates.com.

353 **Silent film star Dolores Del Rio moved in** Los Angeles County real estate records for George and Mabel Herriman.

354 **"It was a two-story, white, Spanish-style home"** Wilson Springer letter in collection of Patrick McDonnell and Karen O'Connell.

354 **The property also carried a racial covenant.** Los Angeles County real estate records for George and Mabel Herriman.

354 **Promotional literature included a photograph** *Outpost*, Oct. 1927, published by C. E. Toberman, posted on outpostestates.com.

354 **Within just two years, the Herrimans sold their home** Los Angeles County real estate records for George and Mabel Herriman.

354 **Nestled over Hollywood in groves of eucalyptus** *Outpost*, Oct. 1927, published by C. E. Toberman, posted on outpostestates.com.

354 **The Herrimans were moved into 2217 Maravilla Drive** *Oregon Statesman*, Nov. 17, 1929.

355 **"Oh, it was wild"** Bud Sagendorf interview with Russell Myers, courtesy Russell Myers.

355 **On the roof he affixed a brightly colored weathervane** Dee Cox, interview with the author.

355 **Herriman tacked drawings and cartoons** Bud Sagendorf interview with Russell Myers, courtesy Russell Myers.

356 **Around 1927, Dorgan wrote a letter to Tom McNamara** Tad Dorgan letter from collection of Ron Goulart.

357 **In a letter to Arthur Brisbane, sent in 1927** Brisbane Family Papers, Special Collections Research Center, Syracuse University Libraries.

357 **Two days later in Madison Square Garden** "Boxing Pays Final Tribute to Tad," *New York Evenng Journal*, May 4, 1929.

357 **He complained to Hearst when sports cartoonist Austin Peterson** William Randolph Hearst Papers, 1874–1951, The Bancroft Library, University of California Berkeley.

357 **Swinnerton also tried to convince** Hearst Ibid.

358 **In October 1933, sports cartoonist Webb Smith** Ibid.

358 **"One of the most lovable characters in the profession"** James B. Reston, "New Yorker at Large," *Dallas Morning News*, Feb. 27, 1936.

358 **Columnist Oscar Odd "O.O." McIntyre** O. O. McIntyre, "New York Day by Day," *Fresno Bee*, Jan. 28, 1938.

358 **Nor is there direct evidence supporting a second story** Bob Naylor, letter to M. Thomas Inge, M. Thomas Inge Archives.

358 **On May 7, 1930, he sent a telegram** From the collection of Patrick McDonnell and Karen O'Connell.

359 **Just a few years later he confessed his concerns** John Alden Carpenter Papers, 1876–1951, Newberry Library, Chicago, Ill.

360 **In one, an owl lectures an embarrassed bird** George Herriman, "Embarrassing Moments," Dec. 23, 1931.

361 **"After my day's work in the art department"** Thomas Inge, M. Thomas Inge archives.

361 **"I knew him as a shy, modest, retiring man"** Bob Naylor, letter to Thomas Inge, March 30, 1974. M. Thomas Inge archives.

362 **"It had none of the whimsy"** I. Klein, "'Screen Gems' Made of Paste," *Funnyworld* no. 20, 1999, p. 40.

362 **Shamus Culhane, who worked as an inker** Shamus Culhane, *Talking Animals and Other People*, p. 25.

363 **"But for Herriman there wouldn't have been"** Boyden Sparkes interview with Elzie "E. C." Segar. Brisbane Family Papers, Special Collections Research Center, Syracuse University Libraries.

363 **When directly asked by an interviewer** Boyden Sparkes interview with George Herriman, 1937. Brisbane Family Papers, Special Collections Research Center, Syracuse University Libraries.

365 **In summer 1935, animator Isadore Klein** Leonard Maltin, *Of Mice and Magic: A History of American Animated Cartoons* (New York, Plume, 1987), p. 215.

365 **Klein, meanwhile, didn't hide his opinion** Ibid., p. 215.

365 **As situation comedies started to dominate** Rube Goldberg, "Comics, New Style and Old," *Saturday Evening Post*, Dec. 15, 1928.

365 **Herriman offered his own meditation on slapstick** George Herriman, "Krazy Kat," Jan. 1, 1926.

366 **"In Krazy Kat the poetry originated"** Umberto Eco, "On 'Krazy Kat' and 'Peanuts,'" *New York Review of Books*, June 13, 1985.

366 **During this time Herriman also added new characters** George Herriman, "Krazy Kat," Jan. 18, 1926.

366 **In another extended storyline, infidelities fly like bricks** George Herriman, "Krazy Kat," June 17, 1930.

366 **He added gags about clams and worms** George Herriman, "Krazy Kat," March 24, 1930.

366 **Remembered Wilson Springer** Wilson Springer's letters from the collection of Patrick McDonnell and Karen O'Connell.

366 *Krazy Kat* **became even more musical** George Herriman, "Krazy Kat," March 31, 1930.

367 **"A l'il bee, a l'il bug."** George Herriman, "Krazy Kat," April 1, 1930.

367 **In one daily strip, Krazy nearly drowns** George Herriman, "Krazy Kat," Feb. 18, 1930.

367 **Still other songs were blues** George Herriman, "Krazy Kat," May 9, 1930.

368 **And so there are gags about white Ignatz** George Herriman, "Krazy Kat," Feb. 21, 1931.

368 **As comics scholar Jeet Heer** Jeet Heer, "The Kolors of Krazy Kat" in Bill Blackbeard, ed., *Krazy & Ignatz, 1935–1936: "A Wild Warmth of Chromatic Gravy"* (Seattle: Fantagraphics, 2005), p. 13.

369 **Louise Swinnerton's grandson, Dave von Savoye** Dave von Savoye, interview with the author.

369 **Bob Naylor once recalled asking Herriman about the reversals** Bob Naylor, M. Thomas Inge Archives.

369 **"make the audience laugh"** Stanley Crouch, "Blues for Krazy Kat," in *Masters of American Comics*, ed. John Carlin, Paul Karasik, and Brian Walker (New Haven, Conn.: Yale University Press with Hammer Museum and the Museum of Contemporary Art, Los Angeles, 2005), p. 200.

369 **One of his starkest stories about race** George Herriman, "Krazy Kat," April 4, 1932.

370 **"a slight, quiet man"** Mary Landenberger, "George Herriman's [*sic*] Stumbles on Krazy Kat and Has Been Embarrassed Ever Since," *Nashville Tennessean*, May 13, 1930, p. 16.

CHAPTER 21: TIGER TEA

373 **On April 15, 1930, Pinky Springer's wife** Wilson Springer's letters from the collection of Patrick McDonnell and Karen O'Connell.

373 **George Herriman's brother, Henry** *Minnesota Alumni Weekly,* Thursday, Oct. 25, 1923, p. 107.

373 **The couple moved to Huntington Park** *Fifteenth Census of the United States, 1930,* Huntington Park, Los Angeles County.

373 **Daisy's estate included shares of several pieces of property** Daisy Herriman, will and estate documents, County of Los Angeles.

374 **With her sister, Toots, and Vivian Hammerly** Dee Cox, interview with the author.

374 **In September 1931 she attended a dinner party** Margaret Nye, "Society of Cinemaland," *Los Angeles Times,* Sept. 13, 1931, sec. III, p. 25.

374 **Herriman at least tacitly approved** Dee Cox, interview with the author.

374 **On Sunday night, September 27, 1931, George Herriman's wife, Mabel** *Los Angeles Examiner;* Wilson Springer letter in collection of Patrick McDonnell and Karen O'Connell.

375 **She was rushed to Monte Sano Hospital** Mabel Lillian Herriman, Death Certificate, County of Los Angeles.

375 **Just a few months later, George Herriman's personal life** "Artist's Daughter to Wed," *Fresno Bee,* March 1, 1933, p. 3A.

375 **On Sunday, May 22, George Herriman welcomed George Swinnerton** "George Herriman's Daughter Marries," *Los Angeles Examiner,* May 23, 1932.

376 **A portrait from that day** Author's collection.

376 **Two weeks later Ernest and Bobbie Pascal** "George Herriman's Daughter Marries," *Los Angeles Examiner,* May 23, 1932.

376 **Even when Herriman might seem** Boyden Sparkes interview with George Herriman, 1937. Brisbane Family Papers, Special Collections Research Center, Syracuse University Libraries.

377 **Illustrator Henry Raleigh received a Coconino vista** Patrick McDonnell, Karen O'Connell and Georgia Riley de Havenon, *Krazy Kat: The Comic Art of George Herriman* (New York: Harry N. Abrams, 1986), p. 75.

377 **In 1921 Herriman gave his old** *New York Evening Journal* **colleague Charles Wellington** Bill Blackbeard, Ed., *Krazy & Ignatz, 1943–1944: "He Nods in Quiescent Siesta"* (Seattle: Fantagraphics, 2008)

377 **Herriman's friend Beanie Walker** From the collection of Rob Pistella.

377 **Herriman also gave Walker and his wife annual anniversary gifts** From the collection of the Fawcett's Maine Antique Toy & Art Museum.

378 **When Gilbert Seldes begged Herriman** Gilbert Seldes letters courtesy the collection of Patrick McDonnell and Karen O'Connell.

378 After coloring the *Krazy Kat* Ibid.

379 Herriman sent a note to Gilbert Seldes Ibid.

379 The English actor Roland Young Ibid.

379 For actor and writer Carl Harbaugh Patrick McDonnell, Karen O'Connell, and Georgia Riley de Havenon, *Krazy Kat: The Comic Art of George Herriman* (New York: Harry N. Abrams, 1986), p. 79.

380 Hal Roach's film editor Richard Currier Craig Yoe, ed., *Krazy Kat & the Art of George Herriman: A Celebration* (New York: Abrams, 2011), p. 34.

380 For actress Jean Harlow and her new husband From the collection of the Fawcett's Maine Antique Toy & Art Museum.

380 On Thursday, December 7, 1933, Roach threw a star-studded party *Los Angeles Times*, Dec. 10, 1933.

380 Herriman honored the occasion Photograph of the drawing from the collection of Lola Larsen.

381 "I will try my best to get George out" Harvey Leake, Wetherill Family Archives.

381 Bobbie Pascal also tried in vain Ibid.

382 George Herriman remained home but sent a check Ibid.

382 In another letter, Herriman congratulated Louisa Wetherill Ibid.

382 The newspapers reported an "airplane elopement" "Miss Herriman Weds Wagner," *Los Angeles Examiner*, Sept. 11, 1934.

383 His deepening depression was noticed Frances Cranmer Greenman, *Higher Than the Sky* (New York: Harper & Bros., 1954), p. 222.

384 Humorist Corey Ford noticed a kinship to Krazy Kat Corey Ford, *The Time of Laughter* (New York: Little Brown, 1967), p. 70.

384 The pair's escapades, E. B. White once wrote E. B. White, introduction to Don Marquis, *The Lives and Times of Archy and Mehitabel* (New York: Doubleday, 1950).

385 "expression is the need of my soul" Don Marquis, "The Coming of Archy," *Archy and Mehitabel* (New York: Doubleday, 1927).

385 Both Marquis and Herriman poked fun at post-war spiritualism Refugio Donahoo, *The Esoteric Codex: Paranormal Hoaxes* (lulu.com: 2015), p. 43.

385 Krazy Kat, after learning about ectoplasm in a lecture by Joe Stork George Herriman, "Krazy Kat," June 11, 1922.

385 Archy, meanwhile, reports Don Marquis, "Ghosts," in *The Lives and Times of Archy and Mehitabel* (New York: Doubleday, 1950).

386 Herriman would even cite Marquis Bob Naylor, M. Thomas Inge archives.

386 "It seems to me Herriman deserves much credit" E. B. White, introduction to Don Marquis, *The Lives and Times of Archy and Mehitabel* (New York: Doubleday, 1950).

389 Over nearly a year, he spun a magnificent, meandering tale George Herriman's "Tiger Tea" comics have been collected in Craig Yoe, ed., *Krazy & Ignatz in "Tiger Tea"* (San Diego: IDW Publishing, 2010).

389 **Other daily strips during this time** George Herriman, "Krazy Kat," Jan. 5, 1935.

390 **"Toots got her divorce"** Harvey Leake, Wetherill Family Archive.

390 **Herriman gratefully replied** From the collection of Patrick McDonnell and Karen O'Connell.

390 **He signed into the registry** Harvey Leake, Wetherill Family Archives.

391 **The Uplifters dated to 1913** Uplifters Club Records (Collection 2062), Department of Special Collections, Charles E. Young Research Library, UCLA.

391 **It was during this time that Herriman began his association** Ibid.

392 **Throughout the thirties and early forties, Herriman fulfilled his duties by caricaturing scenes at the club** From the collection of the Rustic Canyon Recreation Center.

392 **"His voice was very soft and sweet"** Lola Larson, interview with the author.

392 **Barbara recalled that Herriman sometimes would speak** Barbara Bedwell, interview with the author.

392 **There, Herriman was waiting** Lola Larson, interview with the author.

393 **"He stayed in his room for three days"** Barbara Bedwell, interview with the author.

393 **He signed in for the party** Harvey Leake, Wetherill Family Archives.

393 **With Clyde Colville, Herriman devised an elaborate plan** Herriman's correspondence with Colville about the Kayenta movies from Harvey Leake, Wetherill Family Archives.

394 **Years later John and Louisa Wetherill's grandson** William Wetherill, interview with the author.

394 **"All the Navajos were in there"** Ibid.

394 **Mike Goulding, who ran the nearby Goulding's Lodge** Letter from Mike Goulding from the collection of Patrick McDonnell and Karen O'Connell.

395 **Herriman sent back a photograph of his Scottie dogs** Copy of photograph courtesy Kenneth Douthitt.

395 **When they were with Herriman** Barbara Bedwell, interview with the author.

395 **One afternoon in early January 1936, Harry Carr** "Death Answers Question Lancer Asked in Column," *Los Angeles Times*, Jan. 11, 1936.

396 **As had been done for Tad Dorgan in Madison Square Garden** "Men of All Walks Will Serve as Pallbearers," *Los Angeles Times*, Jan. 12, 1936.

396 **It was during this same time that Pinky Springer's daughter** Wilson Springer, the collection of Patrick McDonnell and Karen O'Connell.

396 **The photos show Herriman and Walker** From the collection of Rick Marschall.

397 **In the film, as the children hold hands** Courtesy Dee Cox.

397 **The next month Bobbie and a friend** Harvey Leake, Wetherill Family Register.

397 **In 1937, Sparkes crisscrossed the country** Sparkes' interviews and other materials concerning his planned Brisbane biography are at Brisbane Family Papers, Special Collections Research Center, Syracuse University Libraries.

398 **Herriman had also offered an original drawing** Letter from Sparkes at Brisbane

Family Papers, Special Collections Research Center, Syracuse University Librar-
ies. Drawing by Herriman for Sparkes at Billy Ireland Cartoon Library & Museum,
Ohio State University Libraries.

399 **Later on the trip, Sparkes met up with cartoonist E. C. Segar.** Sparkes interview
with E. C. Segar at Brisbane Family Papers, Special Collections Research Center,
Syracuse University Libraries.

CHAPTER 22: POOL OF PURPLE SHADOW

400 **In April 1938, George Herriman** "Artist Harriman [*sic*] Undergoes Operation,"
Los Angeles Times, April 24, 1938.

400 **On May 5, as Herriman recovered, he sent** From the collection of Patrick Mc-
Donnell and Karen O'Connell.

400 **They continued to stay in touch** Ibid.

401 **Two years earlier, Louise and Jimmy Swinnerton had divorced** "Divorce Given
to Cartoonist," *Reno Gazette,* Jan. 16, 1936, p. 8.

401 **"The way of a newspaper woman"** Louise Scher, "A Flower of Japan," *Photoplay,*
June 1916, p. 110.

401 **"She was proud, sharp-witted"** Dave von Savoye, interview with the author.

402 **Some missives did escape** From the collection of Patrick McDonnell and Karen
O'Connell.

403 **In another affectionate letter** From the collection of Chris Ware.

404 **In one surviving letter that was apparently sent** Ibid.

404 **Even more to the point** Craig Yoe, ed., *Krazy Kat & the Art of George Herriman: A
Celebration* (New York: Abrams, 2011)

404 **And in another short note** From the collection of Patrick McDonnell and Karen
O'Connell.

404 **On at least one occasion, Herriman's newfound randiness** George Herriman,
"Krazy Kat," Nov. 17, 1940.

404 **One day on the Hal Roach lot** From the collection of Rick Marschall.

405 **Louise Swinnerton's letters to Herriman** From the collection of Patrick Mc-
Donnell and Karen O'Connell.

405 **Louise Swinnerton lived three hundred miles away** Ibid.

406 **Bud Sagendorf, Segar's assistant** Bud Sagendorf, interview with Russell Myers,
courtesy Russell Myers.

406 **At 7:30 in the morning on Tuesday, November 14, 1939, Barbara Herriman
Pascal died** Barbara Herriman Pascal death certificate, County of Los Angeles.

406 **It begins with a desert scene** George Herriman, "Krazy Kat," Dec. 10, 1939.

407 **The poet Carl Sandburg** *Cartoonist,* Summer 1957, posted in "Stripper's Guide,"
strippersguide.blogspot.com, on March 11, 2008.

407 **Cartoonist Jud Hurd was in his midtwenties** Jud Hurd, "To Cartooning": 60
Years of Magic (Fairfield, Conn.: PROfiles Press, 1993), p. 75.

408 In New York, the *Herald Tribune* assigned writer Roy Wilder Herriman letter from the collection of Marc Voline.

408 "My junk is not on the popularity list" From the collection of Patrick McDonnell and Karen O'Connell.

408 Herriman sent to King Features Ibid.

409 "gosh, Johnny—dont ask me to give you" Ibid.

409 "Didn't answer your letter" Ibid.

410 "Mostly the subject of our conversation" Ibid.

411 Themes of spirituality George Herriman, "Krazy Kat," Jan. 10, 1939.

411 or Ignatz pondering George Herriman, "Krazy Kat," Nov. 14, 1938.

411 Herriman also returned, again and again Betty Rodgers, interview with the author.

411 "Today my world walks in beauty" George Herriman, "Krazy Kat," Sept. 11, 1938.

412 Now he simply pokes his head George Herriman, "Krazy Kat," June 5, 1940.

412 Yet, even as Herriman was stripping down Bill Blackbeard, ed., *Krazy & Ignatz 1919 – 1921: "A Kind, Benevolent and Amiable Brick"* (Seattle: Fantagraphics, 2011), p. 171.

412 For his dentist, Dr. Faunce Fern Petty Bill Blackbeard, Ed., *Krazy & Ignatz, 1943–1944: "He Nods in Quiescent Siesta,"* (Seattle: Fantagraphics, 2008).

412 Following the death of Beanie Walker Craig Yoe, ed., *Krazy Kat & the Art of George Herriman: A Celebration* (New York: Abrams, 2011), p. 1.

412 On occasion Herriman even welcomed old colleagues Courtesy Rob Stolzer, from the August William Derleth Papers, 1858, 1907–1978, Wisconsin Historical Society.

412 Dave von Savoye recalled seeing Herriman Dave von Savoye, interview with the author.

413 In one drawing for Louise, Herriman holds a bowl Craig Yoe, ed., *Krazy Kat & the Art of George Herriman: A Celebration* (New York: Abrams, 2011), p. 33.

413 In another letter to Louise, Herriman took From the collection of Patrick McDonnell and Karen O'Connell.

414 After Bobbie Pascal died, her daughter, Dinah Cox, interview with the author.

414 On one of these trips, Herriman presented Roberge Photograph from the author's collection.

415 Cox also remembered days in which the house Dee Cox, interview with the author.

415 He created original plates Craig Yoe, ed., *Krazy Kat & the Art of George Herriman: A Celebration* (New York: Abrams, 2011), endpaper.

415 For a Valentine, Herriman drew himself Ibid, p. 131.

415 In another tender drawing, a curved road leads Ibid, p. 141.

416 When Ignatz speaks of a brick George Herriman, "Krazy Kat," Aug. 2, 1942.

416 **In a few wartime strips** George Herriman, "Krazy Kat," Jan. 11, 1943, and Jan. 21, 1943.

417 **For Herriman the war hit closest to home** Dee Cox, interview with the author.

417 **Herriman continued to seek out Westerns** Harvey Leake, Wetherill Family Archive.

417 **"I looked him up, found out where he lived"** William Wetherill, interview with the author.

418 **"I gave him one of my suits"** Harvey Leake, Wetherill Family Archive.

418 **That spring Herriman wrote to Clyde** Harvey Leake, Wetherill Family Archive.

419 **Herriman wrote with affection to the man** Copy of cartoon courtesy Heritage Auctions.

420 **It was around this time that another old colleague** "The Naming of Ignatz," *Comic Art*, Spring, 1962.

419 **A survey of newspapers from 1944** Patrick McDonnell, Karen O'Connell, and Georgia Riley de Havenon, *Krazy Kat: The Comic Art of George Herriman* (New York: Harry N. Abrams, 1986), p. 82.

420 **When he sent postage to Colville** Harvey Leake, Wetherill Family Archive.

421 **Toots and Dinah were in New York** Dee Cox, interview with the author.

421 **Herriman sent a cheerful card to cartoonist Gus Mager** Patrick McDonnell, Karen O'Connell, and Georgia Riley de Havenon, *Krazy Kat: The Comic Art of George Herriman* (New York: Harry N. Abrams, 1986), p. 87; Craig Yoe, ed., *Krazy Kat & the Art of George Herriman: A Celebration* (New York: Abrams, 2011), p. 132.

421 **In January 1944, John Wetherill was traveling** Harvey Leake, Wetherill Family Archive.

422 **In one comic from February** George Herriman, "Krazy Kat," Feb. 3, 1944.

423 **He sent a letter to Ben Wetherill** Harvey Leake, Wetherill Family Archive.

423 **That day George Herriman's liver gave out.** George Joseph Herriman, Death Certificate, County of Los Angeles.

CODA: A ZEPHYR FROM THE WEST

424 **The cause of death was hepatic coma** Ibid.

424 **The *New York Journal American* reported** *New York Journal American*, April 27, 1944.

424 **Services for Herriman took place** "Herriman, Comic Strip Creator, Dies," *Los Angeles Times*, April 27, 1944.

424 **Harold Ross Shaffer, a Presbyterian pastor** "Herriman Rites Today," *Los Angeles Herald Examiner*, April 28, 1944.

424 **"It broke my heart at his funeral"** Bud Sagendorf, interview with Russell Myers, courtesy Russell Myers.

424 **"Mr. Herriman's draftsmanship"** "Herriman Dies, Creator of the Krazy Kat Strip," *New York Herald Tribune*, April 26, 1944.

424 **Even the *New York Times*, which didn't stoop** "Topics of the Times," *New York Times*, April 28, 1944.

425 **"If ever there was a saint on earth"** "Among the Unlimitless Etha," *Time*, May 8, 1944.

425 **Jimmy Swinnerton recalled their trips** "Herriman Dies, Creator of the Krazy Kat Strip," *New York Herald Tribune*, April 26, 1944.

425 **Cartoonist Thomas Crawford Hill recounted trips to Maravilla** Thomas Crawford Hill, "G. Herriman," *New York Journal American*, April 29, 1944.

425 **The most perceptive tribute appeared in** "Among the Unlimitless Etha," *Time*, May 8, 1944.

426 **Gilbert Seldes later remembered a discussion** Gilbert Seldes in the revised 7 *Lively Arts* (New York: Sagamore Press, 1957).

426 **"I have given . . . to my friend, Benjamin W. Shipman"** Will and Estate Documents for George Joseph Herriman, County of Los Angeles.

427 **Following the service at Forest Lawn** George Herriman Cremation Records, Forest Lawn Memorial Park, Hollywood Hills, California.

427 **In the rest of the will, Herriman bequeathed** Will and Estate Documents for George Joseph Herriman, County of Los Angeles.

427 **Ben Wetherill, stationed in a military base in Alaska** Harvey Leake, Wetherill Family Archive.

427 *Krazy Kat* **ballet composer John Carpenter** John Alden Carpenter Collection, Library of Congress, Music Division.

428 **Among the condolence letters received by Mabel Herriman** Craig Yoe, ed., *Krazy Kat & the Art of George Herriman: A Celebration* (New York: Abrams, 2011), p. 171.

428 **Among the posthumous** comics George Herriman, "Krazy Kat," May 21, 1944.

428 **Some cartoons never would be finished** From the collection of Tim Samuelson and Chris Ware.

428 **Other pages eventually were completed and published** Bud Sagendorf, interview with Russell Myers, courtesy Russell Myers.

429 **"Krazy Kat"** Leonard Lyons, "Heard in New York," *Dallas Morning News*, Feb. 3, 1944.

430 **Pages of Herriman's original art** Mort Walker, interview with the author.

430 **Gilbert Seldes was delighted** E. E. Cummings Additional Papers, 1870–1969 (MS Am 1892-1892.11). Houghton Library, Harvard University.

430 **The next year Henry Holt published** Ibid.

430 **Cummings's book featured 310 strips** George Herriman, *Krazy Kat* (New York: Henry Holt and Co., 1946).

430 **In 1947 filmmaker Fritz Lang** Harry Siegel, "Krazy's America—No Austerities," *New Partisan*, March 12, 2004.

431 **Animator Ralph Bakshi, who later would pay homage to Herriman** Ralph Bakshi, interview with the author.

431 **"After World War II, I began to study the Krazy Kat strip"** Charles M. Schulz, *My Life with Charlie Brown* (Jackson: University Press of Mississippi, 2010), p. 6.

431 Cummings's collection included a series George Herriman, "Krazy Kat," Nov. 12, 1934.

431 In later comics Schulz even wrote a series of gags Charles Schulz, "Peanuts," Sept. 18, 1974.

432 Of all of Schulz's storylines George Herriman, "Krazy Kat," Dec. 26, 1932. This series was not included in E. E. Cummings collection.

432 In a conversation with *Mutts* cartoonist Patrick McDonnell Interview with the author.

433 "I always thought if I could just do something as good" Interview with Mary Harrington Hall in M. Thomas Inge, ed., *Charles M. Schulz: Conversations* (Jackson: University Press of Mississippi, 2000), p. 55.

433 In the late 1940s, composer John Carpenter John Alden Carpenter Papers, 1876–1951, Newberry Library, Chicago, Ill.

433 New York writer Pete Hamill once recalled Boris Kachka, "Q&A with Gotham Scribes Pete Hamill and Tama Janowitz," *New York Magazine*, Dec. 6, 2004.

433 On another evening, Hamill recalled Pete Hamill, *Downtown: My Manhattan* (New York: Little, Brown and Co., 2004), p. 220.

433 "At its best, the comic strip is an art form of such terrific *wumpf*!" Philip Nel, *Dr. Seuss: American Icon* (London: Bloomsbury Academic, 2003), p. 70.

434 A unique experimental adaption of *Krazy Kat* appeared in 1958 The Motion Picture & Television Reading Room in the Library of Congress has a copy of *Waiting for Krazy*, viewed by author.

434 Other nods came from Jack Kerouac Jack Kerouac, "The Origins of the Beat Generation," *Playboy*, June 1959.

435 Artists inspired by Herriman included Willem de Kooning From the collection of Patrick McDonnell and Karen O'Connell.

435 In the final episode Pogo Possum Walt Kelly, "Pogo," July 20, 1963.

435 "At the time, any hint of a homosexual relationship" Gene Deitch, "How to Succeed in Animation, Chapter 22: Spinach and Bricks," Nov. 19, 2013, Animation World Network, awn.com.

435 In the cartoons, which aired from 1962 to 1964 Ibid.

436 "For me and my generation, Herriman loomed really large" Art Spiegelman, interviewed by Jacques Samson, Cité internationale de la bande dessinée et de l'image, January 2012.

436 R. Crumb called Herriman Sam Leith, "Funsters and Fantasts," *Spectator*, Jan. 7, 2006.

436 Dave von Savoye remembered that his grandmother Dave von Savoye, interview with the author.

436 Even within the family, recalled Dinah "Dee" Cox Dee Cox, interview with the author.

437 **"One of the things that is radically different"** Todd Hignite, "'Masters of American Comics': An Interview with Exhibition Co-Curator Brian Walker," The Professional Association for Design (aiga.org), Jan. 3, 2006.

438 **Also professing his love of** *Krazy Kat* **was novelist Michael Chabon** Bill Blackbeard, ed., *Krazy & Ignatz, 1933-1934: "Necromancy by the Blue Bean Bush"* (Seattle: Fantagraphics, 2005)

438 **At the end of the century** *Comics Journal*, February 1999.

439 **Bill Watterson, creator of** *Calvin and Hobbes* Rick Marschall, ed., *The Komplete Kolor "Krazy Kat"*: Vol. 1, 1935–1936 (Abington, Pa.: Remco Worldservice Books, 1990), p. 7.

439 **"It seems like the perfect strip"** Garry Trudeau, interview with the author.

BIBLIOGRAPHY

ARCHIVES

Alfred J. Frueh Papers, 1904–2010. Smithsonian Archives of American Art, Washington, D.C.

Archdiocese of New Orleans Office of the Archives, New Orleans, La.

Art Wood Collection of Cartoon and Caricature, Library of Congress, Washington, D.C.

August William Derleth Papers, 1858, 1907–1978. Wisconsin Historical Society, Madison, Wisc.

Billy Ireland Cartoon Library & Museum, Ohio State University Libraries, Columbus, Ohio.

Brisbane Family Papers, Special Collections Research Center, Syracuse University Libraries, Syracuse, N.Y.

California State Library, Sacramento, Calif.

DeAndreis-Rosati Memorial Archives, DePaul University Special Collections, Chicago, Ill.

Edmund Wilson Papers, Yale Collection of American Literature, Beinecke Rare Book and Manuscript Library, Yale University, New Haven, Conn.

E. E. Cummings Additional Papers, 1870–1969. Houghton Library, Harvard University, Cambridge, Mass.

Erbon and Marie Wise Genealogical Library, Louisiana State Archives, Baton Rouge, La.

Frederic B. Opper Collection, Howard Gotlieb Archival Research Center, Boston University, Boston, Mass.

George Longe Papers, 1849–1971. Amistad Research Center, Tulane University, New Orleans, La.

George McManus papers. Department of Special Collections, Charles E. Young Research Library, UCLA, Los Angeles, Calif.

Harvey Leake, Wetherill Family Archives, Prescott, Ariz.

Historic New Orleans Collection, New Orleans, La.

History & Genealogy Department, Los Angeles Public Library, Los Angeles, Calif.

Irma and Paul Milstein Division of United States History, Local History and Genealogy, New York Public Library, New York, N.Y.

John Alden Carpenter Collection, Music Division, Library of Congress, Washington, D.C.

John Alden Carpenter Papers, Newberry Library, Chicago, Ill.

Joshua B. Powers Collection, Hoover Institution Archives, Stanford, Calif.

Los Angeles Examiner Collection, USC Special Collections, Doheny Memorial Library, USC, Los Angeles, Calif.

Louis Bouché papers, 1880–2007. Smithsonian Archives of American Art, Washington, D.C.

Louisiana Division, City Archives & Special Collections, New Orleans Public Library, New Orleans, La.

Microforms Reading Room, New York Public Library, New York, N.Y.

Motion Picture, Broadcasting & Recorded Sound Division, Library of Congress, Washington, D.C.

M. Thomas Inge, personal archive.

Newspapers and Current Periodical Reading Room, Library of Congress, Washington, D.C.

Notarial Archives Research Center, New Orleans, La.

Patrick McDonnell and Karen O'Connell, personal archive.

Paul Bransom Papers 1862–1985. Smithsonian Archives of American Art, Washington, D.C.

Records of St. Vincent's College, Los Angeles, Calif.

René Grandjean Collection, Earl K. Long Library, University of New Orleans, New Orleans, La.

Rudolph Dirks papers, 1860–1971. Smithsonian Archives of American Art, Washington, D.C.

Uplifters Club Records, Department of Special Collections, Charles E. Young Research Library, UCLA.

Swann Collection of Caricature and Cartoon, Library of Congress, Washington, D.C.

Walt Kuhn, Kuhn Family Papers, and Armory Show Records, 1859–1984, Bulk 1900–1949, Smithsonian Archives of American Art, Washington, D.C.

W. A. Swanberg Papers, ca. 1927–1992, Rare Book and Manuscript Library, Columbia University, New York, N.Y.

William Randolph Hearst Papers, 1874–1951, Bancroft Library, University of California, Berkeley.

Additional genealogical information, census reports, city directories, military records and other documents were accessed online at ancestry.com and genealogybank.com.

WEB SITES

"Animation Resources," animationresources.org

"Barnacle Press," barnaclepress.com

"The Bray Animation Project," brayanimation.weebly.com

"Coconino World," old-coconino.com
"The Comics Journal," tcj.com
"George Herriman, Kreator of 'Krazy Kat,'" by Craig Yoe, georgeherriman.com
"Hogan's Alley," cartoonician.com
"Lambiek Comiclopedia," lambiek.net/comiclopedia.html
"The Masters of Screwball Comics," by Paul Tumey, screwballcomics.blogspot.com
"Stripper's Guide," by Allan Holtz, strippersguide.blogspot.com
"Yesterday's Papers," by John Adcock, john-adcock.blogspot.com

NEWSPAPERS

Newspapers cited in endnotes were primarily accessed through microfilm or digitally through chroniclingamerica.loc.gov, genealogybank.com, ancestry.com, or newspapers.com.

The following newspapers featuring work by George Herriman were primarily accessed in either microfilm or digital form.

Boston Sunday Post, Nov. 1901–Dec. 1901
Los Angeles Examiner, Aug. 1906–May 1916
Los Angeles Evening Herald, July 1911–Jan. 1913
Los Angeles Herald, Jan. 1897–June 1899
Los Angeles Times, Jan. 1906–Aug. 1906
Minneapolis Tribune, Sept. 1901–Nov. 1904
Nashville Tennessean, May 1930
Newark Advertiser, Sept. 1906
New York American, April 1904–June 1905; Jan.–May 1922
New York Daily News, Jan.–June 1904
New York Evening Journal, Jan.–May 1901; Jan. 1909–Jan. 1919; July–Dec. 1922
New York Evening World, Feb. 1903–Nov. 1903
New York Journal and Advertiser, Jan.–June 1901
New York Press, Oct.–Dec. 1901
New York World, Dec. 1902–Jan. 1904
Philadelphia North American, Sept.–Dec. 1901
San Francisco Call, Sept.–Nov. 1905
Seattle Post-Intelligencer, May–Dec. 1906

The following is a select list of newspaper articles used in research for this book.

"A Few Notes from the Chorus of Joy over 'Krazy Kat,'" *Warren Tribune*, Feb. 21, 1928.
Alexander, Irene. "Rudolph Ganz to Play Work of Peninsula Composer," *Monterey Peninsula Herald*, March 24, 1949.

Berger, Arthur A. "Was Krazy's Creator a Black Cat?" *San Francisco Sunday Examiner and Chronicle*, Aug. 22, 1971.

"Boxing Pays Final Tribute to Tad," *New York Evening Journal*, May 4, 1929.

Campbell, Gene K. *Lincoln Star*, Oct. 11, 1922.

"George Herriman, Noted Cartoonist," *New York Times*, April 27, 1944.

"Herriman Dies, Creator of the Krazy Kat Strip," *New York Herald Tribune*, April 26, 1944.

Herriman, George. *Salt Lake Telegram*, May 31, 1920

"Herriman Rites Today," *Los Angeles Herald Examiner*, April 28, 1944.

Hill, Thomas Crawford. "G. Herriman," *New York Journal American*, April 29, 1944.

Landenberger, Mary. "George Herriman's [sic] Stumbles on Krazy Kat and Has Been Embarrassed Ever Since," *Nashville Tennessean*, May 13, 1930.

McCardell, Roy. "George Herriman—Progenitor of Krazy Kat and the Irascible Ignatz, the Brick-Heaving Mouse, *Morning Telegraph*, Aug. 22, 1920.

Naylor, Bob. "When Comics Were Young . . ." *Sunday Record*, Monroe, N.Y., Oct. 21, 1973.

Rasmussen, Cecilia. "Hidden Hollywood Sign Uncovers History," *Los Angeles Times*, Feb. 17, 2008.

"Remember When?" *Los Angeles Times*, June 19, 1934.

Runyon, Damon. "The Brighter Side," *Daily Mirror*, Jan. 25, 1930.

———. "The Father of 'Krazy Kat,'" *Pittsburgh Press*, Nov. 26, 1920.

———. "Father of Krazy Kat Admired as Mild Mannered Genius," *Arizona Gazette*, Aug. 13, 1921.

———. "George Know [sic] His Comics," *Rochester Democrat and Chronicle*, Jan. 22, 1939.

Touré. "Do Not Pass," *New York Times*, Feb. 16, 2010.

PERIODICALS

The following periodicals are devoted to comics history, criticism, and culture. See endnotes for specific articles used in research for this book.

Cartoonist PROfiles, 1969–2005. Founded and edited by Jud Hurd.

Cartoons Magazine, 1913–1921. Published by H. H. Windsor.

Circulation: A Magazine for Newspaper-Makers. Published as a promotional magazine by King Features. Circa 1921–1927; no complete run of issues currently available.

Comics Journal, 1977–Present. Published by Fantagraphics Books. Cocreated by Gary Groth and Michael Catron; edited by Gary Groth.

Hogans Alley: The Magazine of the Cartoon Arts, 1994–Present. Published by Bull Moose Publishing, Atlanta, Ga. Cocreated by Rick Marschall and Tom Heintjes; edited by Tom Heintjes.

Inks: Cartoon and Comic Art Studies, 1994–1997. Published by the Ohio State University Press. Edited by Lucy Shelton Caswell.

Nemo: The Classic Comics Library, 1983–1990. Published by Fantagraphics Books, Seattle, Wash.; created and primarily edited by Rick Marschall.

The following is a select list of articles in academic and general-interest periodicals that were used in research for this book.

Abbott, Karen. "Everything Was Fake but Her Wealth," Smithsonian.com, Jan. 23, 2013.

Amiran, Eyal. "George Herriman's Black Sentence: The Legibility of Race in *Krazy Kat*," *Mosaic*, Sept. 2000.

"Among the Unlimitless Etha," *Time*, May 8, 1944.

Baldwin, Summerfield. "A Genius of the Comic Page," *Cartoons*, Vol. 2, 1917.

Berger, Arthur Asa. "Of Mice and Men," *Journal of Homosexuality*, 1991.

Blackbeard, Bill. "A sprig of gooseberry for Krazy Kat." *Texas Trends in Art Education*, Fall 1980.

Blackmore, Tim. "Krazy as a Fool," *Journal of Popular Culture*, Winter 1997.

Boxer, Sarah. "His Inner Cat," *New York Review of Books*, June 14, 2007.

Carr, Harry. "Louise Gives a Party," *Motion Picture Classic*, April 1925.

———. "The War of the Comedians," *Motion Picture Classic*, Aug. 1925.

Carrier, David. "Comics and the Art of Moving Pictures," *Words & Image*, Oct. 1997.

Crocker, Elisabeth. "Some Say It with a Brick," www.virginia.edu.

———. "'To He, I Am for Evva True': Krazy Kat's Indeterminate Gender," *Postmodern Culture*, Jan. 1994.

De Casseres, Benjamin. "Jack's," *American Mercury*, Nov. 1932.

Eco, Umberto. "On 'Krazy Kat' and 'Peanuts,'" *New York Review of Books*, June 13, 1985.

"The Funny Papers," *Fortune*, April 1933.

Goldberg, Rube. "Comics, New Style and Old," *Saturday Evening Post*, Dec. 15, 1928.

Gopnik, Adam. "The Genius of George Herriman." *New York Review of Books*, Dec. 18, 1986.

"The Gossip Shop," *Bookman*, March 1922.

Hancock, La Touche. "American Caricature and Comic Art, Part I," *Bookman*, Oct. 1902.

———. "American Caricature and Comic Art, Part II," *Bookman*, Nov. 1902.

Heer, Jeet. "Krazy Kat's Kolors," *Lingua Franca*, Sept. 2001.

Herriman, George. "George Herriman," *Dead-Line*, Sept. 1917.

———. "'The Gold Rush' as Seen by Krazy Kat," *Motion Picture Classic*, Oct. 1925.

———. *Judge*, 1901 and 1903.

———. "Krazy Kat," *Golden Book*, June 1929.

———. *Ziff's Magazine*, April 1926.

———. "Krazy Kat," *Vanity Fair*, 1930.

"Herriman and Swinnerton Hobnob with Indians in Torrid Arizona," *Fourth Estate*, Aug. 5, 1922.

Hignite, Todd. "'Masters of American Comics': An Interview with Exhibition Co-Curator Brian Walker," Professional Association for Design (aiga.org).

Honora, Jari. "Cast Your Eyes upon a Loyal Population: Lincoln and Louisiana's Free People of Color," *La Creole: A Journal of Creole History and Genealogy*, Oct. 2009.

"How to Handle Women," *Variety*, June 28, 1928.

Hudson, Gunboat. "Mixing with the Best of 'Em," *Cartoons*, May, 1918.

Jensen, Michael P. "Krazy Shakespeare," *Shakespeare Newsletter*, Winter 2005.

Kendt, Rob. "Martin Landau Speaks Out About the Actor's Responsibility to the Audience and to the World," *Motion Picture*, 2005.

Kerouac, Jack. "The Origins of the Beat Generation," *Playboy*, June 1959.

"King Features Offers New Herriman Strip," *Fourth Estate*, Nov. 11, 1922, p. 20.

Klein, I. "'Screen Gems' Made of Paste," *Funnyworld,* No. 20, 1999.

Laughlin, Bob. "Kollecting Krazy Kat," *Collector's Showcase*, July/August 1984.

McCardell, Roy. "Opper, Outcault and Company," *Everybody's Magazine*, January 1905.

———. "The Shirtwaist Girl," *Puck*, Oct. 9, 1901.

McCrory, Amy. "Sports Cartoons in Context: TAD Dorgan and Multi-Genre Cartooning in Early Twentieth-Century Newspapers." *American Periodicals: A Journal of History, Criticism, and Bibliography*, 2008.

McGuirk, Charles J. "Chaplinitis*," Motion Picture*, July 1915.

McIntyre, O. O. "TAD: A Close-up of a Man Who Amuses the World and Keeps His Troubles to Himself," *Cosmopolitan*, March 1927.

Mattingly, Ignatius G. "Some Cultural Aspects of Serial Cartoons," *Harper's*, Dec. 1955.

Mencken, H. L. *The American Language*. New York: Alfred A. Knopf, 1985.

Opper, Frederick Burr. "Comics and Cartoons of Earlier Days," unpublished manuscript.

Plumb, Charlie. "Inside the Funny Page," *Esquire*, April 1942, p. 57.

Sattler, Peter. "Ballet Méchanique: The Art of George Herriman," *Words & Image*, April 1992.

Schoenfeld, Amram. "The Laugh Industry," *Saturday Evening Post*, Feb. 1, 1930.

———. "Golla, Golla, the Comic Strips Art!" *Vanity Fair*, May 1922.

———. "The Kat Comes of Age," *Esquire*, Sept. 1935.

Seldes, Gilbert. "The Theatre," *Dial*, March 1922.

Sherwood, Robert E. "Silent Drama," *Life*, May 18, 1922.

Siegel, Harry. "Krazy's America—No Austerities," *New Partisan*, March 12, 2004.

Smith, S. M. "Friends of the Family," *Pictorial Review*, Jan. 1935.

Taylor, Deems. "America's First Dramatic Composer," *Vanity Fair*, April 1922.

Toberman, C. E. *Outpost*, Oct. 1927.

Van Doren, D. G. "Mr. Seldes Patronizes," *Forum*, Aug. 1924.

"We Nominate for the Hall of Fame," *Vanity Fair*, April 1923.

Whalen, Ed. "The Naming of Ignatz," *Comic Art*, Spring, 1962.

Winkler, John K. "Notes on an American Phenomenon—II." *New Yorker*, April 30, 1927.

Wood, Joe. "Face to Black: Once upon a Time in Multiracial America," *Village Voice*, Dec. 6, 1994.

Young, Stark. "Krazy Kat," *New Republic*, Oct. 11, 1922.

BOOKS

Works by George Herriman

The following are major collections of George Herriman's comics. Most volumes include original essays by scholars, along with photographs and other historic material. In addition to these works, in 2012 the publisher Les Rêveurs began a notable series of *Krazy Kat* anthologies translated into French by Marc Voline.

ECLIPSE BOOKS/TURTLE ISLAND FOUNDATION

Geo. Herriman's Krazy + Ignatz: The Komplete Kat Comics, Vol. 1—1916. Series introductions by Bill Blackbeard; edited by Bob Callahan. Forestville, Cal.: Eclipse Books/Turtle Island Foundation, 1988.

The Other-Side to the Shore of Here, Vol. 2—1917. Forestville, Cal.: Eclipse Books/Turtle Island Foundation, 1989.

The Limbo of Useless Unconsciousness, Vol. 3—1918. Forestville, Cal.: Eclipse Books/Turtle Island Foundation, 1989.

Howling Among the Halls at Night, Vol. 4—1919. Forestville, Cal.: Eclipse Books/Turtle Island Foundation, 1989.

Pilgrims on the Road to Nowhere, Vol. 5—1920. Forestville, Cal.: Eclipse Books/Turtle Island Foundation, 1990.

Sure as Moons Is Cheeses, Vol. 6—1921. Forestville, Cal.: Eclipse Books/Turtle Island Foundation, 1990.

A Katnip Kantata in the Key of K, Vol. 7—1922. Forestville, Cal.: Eclipse Books/Turtle Island Foundation, 1991.

Inna Yott on the Muddy Geranium, Vol. 8—1923. Forestville, Cal.: Eclipse Books/Turtle Island Foundation, 1991.

Shed a Soft Mongolian Tear, Vol. 9—1924. Forestville, Cal.: Eclipse Books/Turtle Island Foundation, 1992.

FANTAGRAPHICS BOOKS

Ataker, Derya, ed. *The Kat Who Walked in Beauty: The Panoramic Dailies of 1920.* Seattle, Wash.: Fantagraphics Books, 2007.

Krazy & Ignatz: The Complete Full-Page Comic Strips:

Blackbeard, Bill, ed. *"Love in a Kestle or Love in a Hat," 1916–1918*, Seattle, Wash.: Fantagraphics Books, 2010.

———. *"A Kind, Benevlolent and Amiable Brick," 1919–1921*, Seattle, Wash.: Fantagraphics Books, 2011.

———. *"At Last My Drim of Life has Come True," 1922–1944*, Seattle, Wash.: Fantagraphics Books, 2012.

———. *"There Is a Heppy Lend—Fur, Fur Awa-a-ay," 1925–1926*. Seattle, Wash.: Fantagraphics Books, 2002.

———. *"Love Letters in Ancient Brick," 1927–1928*. Seattle, Wash.: Fantagraphics Books, 2002.

———. *"A Mice, a Brick, a Lovely Night," 1929–1930*. Seattle, Wash.: Fantagraphics Books, 2003.

Blackbeard, Bill, and Derya Ataker, eds. *"A Kat a'Lilt with Song," 1931–1932*. Seattle, Wash.: Fantagraphics Books, 2004.

———. *"Necromancy by the Blue Bean Bush," 1933–1934*. Seattle, Wash.: Fantagraphics Books, 2004.

Blackbeard, Bill, ed. *"A Wild Warmth of Chromatic Gravy," 1935–1936*. Seattle, Wash.: Fantagraphics Books, 2005.

———. *"Shifting Sands Dusts Its Cheeks in Powdered Beauty," 1937–1938*. Seattle, Wash.: Fantagraphics Books, 2006.

———. *"A Brick Stuffed with Moom-bims," 1939–1940*. Seattle, Wash.: Fantagraphics Books, 2007.

———. *"A Ragout of Raspberries," 1941–1942*. Seattle, Wash.: Fantagraphics Books, 2007.

———. *"He Nod in Quiescent Siesta," 1943–1944*. Seattle, Wash.: Fantagraphics Books, 2008.

G. SHIRMER

Krazy Kat: A Jazz-Pantomime (Program for Town Hall performances Jan. 20–21, 1922). New York: G. Schirmer, 1922.

HARRY N. ABRAMS

McDonnell, Patrick, Karen O'Connell, and Georgia Riley de Havenon. *Krazy Kat: The Comic Art of George Herriman*. New York: Harry N. Abrams, 1986.

Yoe, Craig, ed. *Krazy Kat & the Art of George Herriman: A Celebration*. New York: Abrams ComicArts, 2011.

HYPERION LIBRARY OF CLASSIC AMERICAN COMIC STRIPS

Blackbeard, Bill, ed. *Baron Bean A Complete Compilation: 1916–1917*. Westport, Conn.: Hyperion Press, 1977.
———. *The Family Upstairs Introducing Krazy Kat: 1910–1912*. Westport, Conn.: Hyperion Press, 1977.

IDW PUBLISHING/THE LIBRARY OF AMERICAN COMICS

Mullaney, Dean, ed. *Baron Bean, 1916*. San Diego, Cal.: IDW Publishing, 2012.
———. *Baron Bean, 1917*. San Diego, Cal.: IDW Publishing, 2015.
———. *Krazy Kat, 1934*. San Diego, Cal.: IDW Publishing, 2016.
Yoe, Craig, ed. *Krazy + Ignatz: Tiger Tea*. San Diego, Cal.: IDW Publishing, 2010.

OHIO STATE UNIVERSITY

Scenes of My Infint-hood: Celebrating the Birth of Krazy Kat. Columbus, Ohio: 2010 Festival of Cartoon Art catalogue, sponsored by Ohio State University Billy Ireland Cartoon Library & Museum and Wexner Center for the Arts, 2010.

PACIFIC COMICS CLUB

Krazy and Ignatz Daily Strips, 1/1/1921–12/31/1921. Long Beach, Cal.: Pacific Comics Club, 2003.
Krazy & Ignatz, Vol. 2, 1922. Long Beach, Cal.: Pacific Comics Club, 2004.
Krazy Kat, 1923. Long Beach, Cal.: Pacific Comics Club, 2005.

REMCO/KITCHEN SINK PRESS

Rick Marschall, ed. *The Komplete Kolor Krazy Kat, Vol. 1: 1935–1936*. Abington, Penn.: Remco Worldservice Books, 1990.
———. *The Komplete Kolor Krazy Kat, Vol. 2: 1936–1937*. Abington, Penn.: Remco Worldservice Books, 1990.

SUNDAY PRESS BOOKS

McDonnell, Patrick and Peter Maresca, eds. *George Herriman's Krazy Kat: A Celebration of Sundays*. Palo Alto, Cal.: Sunday Press Books, 2010.

SPEC PRODUCTIONS

By George! The Komplete Daily Komic Strips of George Herriman
Series editor Bill Blackbeard
Vol. 1: *Baron Mooch* and *Gooseberry Sprig*. Manitou Springs, Col.: Spec Publications, 2005.
Vol. 2: *The Family Upstairs: Introducing Krazy Kat*. Manitou Springs, Col.: Spec Publications, n/d.
Vol. 3: *The Family Upstairs: Featuring Krazy Kat*. Manitou Springs, Col.: Spec Publications, 2003.
Vol. 4: *The Family Upstairs: Featuring Krazy Kat*. Manitou Springs, Col.: Spec Publications, n/d.
Vol. 5: *The Family Upstairs: Featuring Krazy Kat*. Manitou Springs, Col.: Spec Publications, n/d.
Vol. 6: *The Family Upstairs: Featuring Krazy Kat*. Manitou Springs, Col.: Spec Publications, n/d.

OTHER PUBLISHERS

Cummings, E. E., ed. *Krazy Kat*. New York: Henry Holt and Co., 1946.
Greene, Joseph, and Rex Chessman, eds. *"Krazy Kat."* New York: Grosset & Dunlap, 1977.

COMICS AND CARTOONS: HISTORY, CRITICISM AND CULTURE

Baker, Nicholson and Margaret Brentano. *The World on Sunday: Graphic Art in Joseph Pulitzer's Newspaper* (1898–1911). New York: Bulfinch Press, 2005.
Beaty, Bart. *Comics Versus Art*. Toronto: University of Toronto Press, 2012.
Becker, Stephen. *Comic Art in America*. New York: Simon & Schuster, 1959.
Beffel, John Nicholas, ed. *Art Young: His Life and Times*. New York: Sheridan House, 1939.
Blackbeard, Bill, and Martin Williams, eds. *The Smithsonian Collection of Newspaper Comics*. Washington, D.C., and New York: Smithsonian Institution Press and Harry N. Abrams, 1977.
Brasch, Walter M., ed. *ZIM: The Autobiography of Eugene Zimmerman*. Cranbury, N.J.: Associated University Presses, 1988.
Canemaker, John. *Winsor McCay: His Life and Art*. New York: Abbeville Press, 1987.
Carlin, John, Paul Karasik, and Brian Walker, eds. *Masters of American Comics*. New Haven: Yale University Press with Hammer Museum and the Museum of Contemporary Art, 2005.
Couperie, Pierre, and Maurice C. Horn. *A History of the Comic Strip*. 1968. New York: Crown, 1971.

Crafton, Donald. *Before Mickey: The Animated Film, 1898–1928*. 1982. Cambridge, Mass.: MIT Press, 1987.

Culhane, Shamus. *Talking Animals and Other People*. New York: Da Capo Press, 1998.

Davidson, Harold G. *Jimmy Swinnerton: The Artist and His Work*. New York: Hearst Books, 1985.

Fillmore, Gary. *Desert Horizons: Images of James Swinnerton's Southwest*. Cave Creek, Ariz.: Blue Coyote Gallery, 2009.

Gaines, M. C. *Narrative Illustration: The Story of the Comics*. N/p, 1942.

Gardner, Jared. *Projections: Comics and the History of Twenty-First-Century Storytelling*. Stanford, Cal.: Stanford University Press, 2012.

Gordon, Ian. *Comic Strips and Consumer Culture, 1890–1945*. Washington, D.C.: Smithsonian Institution Press, 1998.

Goulart, Ron. *The Funnies: 100 Years of American Comic Strips*. Holbrook, Mass.: Adams, 1995.

———, ed. *The Encyclopedia of American Comics*. New York: Facts on File, 1990.

Harvey, Robert C. *Children of the Yellow Kid: The Evolution of the American Comic Strip*. Seattle: University of Washington Press/Frye Art Museum, 1998.

Heer, Jeet, and Kent Worcester, eds. *A Comics Study Reader*. Jackson: University Press of Mississippi, 2009.

———. *Arguing Comics: Literary Masters on a Popular Medium*. Jackson: University Press of Mississippi, 2004.

Holtz, Allan. *American Newspaper Comics: An Encyclopedic Reference Guide*. Ann Arbor: University of Michigan Press, 2012.

Inge, M. Thomas. *Comics as Culture*. Jackson: University Press of Mississippi, 1990.

———, ed., *Charles M. Schulz: Conversations*. Jackson: University Press of Mississippi, 2000.

Katz, Harry, ed. *Cartoon America: Comic Art in the Library of Congress*. New York: Harry N. Abrams, 2006.

Maresca, Peter, ed. *Society is Nix: Gleeful Anarchy at the Dawn of the American Comic Strip 1895–1915*. Palo Alto, Cal.: Sunday Press Books, 2013.

Marschall, Richard. *America's Great Comic-Strip Artists: From the Yellow Kid to Peanuts*. 1989. New York: Stewart, Tabori & Chang, 1997.

Marschall, Rick, and Warren Bernard, eds. *Drawing Power: A Compendium of Cartoon Advertising, 1870s–1940s*. Seattle: Fantagraphics Books, 2011.

Marzio, Peter C. *Rube Goldberg: His Life and Work*. New York: Harper & Row, 1973.

McCloud, Scott. *Understanding Comics: The Invisible Art*. New York: William Morrow, 1994.

McDougall, Walt. *This is the Life!* New York: Alfred A. Knopf, 1926.

Meyer, Susan E. *James Montgomery Flagg*. New York: Watson-Guptill Publications, 1974.

Michaelis, David. *Schulz and Peanuts: A Biography*. New York: HarperCollins, 2007.

Mullaney, Dean, ed. *King of the Comics: 100 Years of King Features*. San Diego: IDW Publishing, 2015.

Murrell, William. *A History of American Graphic Humor,* Vols. I and II. New York: Cooper Square Publishers, 1967.

Nadel, Dan, ed. *Art Out of Time: Unknown Comics Visionaries, 1900–1969*. New York, Harry N. Abrams, 2006.

O'Sullivan, Judith. *The Great American Comic Strip*. Boston, Mass.: Little, Brown and Co., 1990.

Paine, Albert Bigelow. *Th. Nast: His Period and His Pictures*. 1904. Princeton, N.J.: Pyne Press, 1980.

Phelps, Donald. *Reading the Funnies: Essays on Comic Strips*. Seattle: Fantagraphics Books, 2001.

Robinson, Jerry. *The Comics: An Illustrated History of Comic Strip Art*. New York: G. P. Putman's Sons, 1974.

Schulz, Charles M. *My Life With Charlie Brown*. Jackson: University Press of Mississippi, 2010.

———. *Peanuts: A Golden Celebration*. New York: HarperCollins, 1999.

———. *Peanuts: The Art of Charles M. Schulz*, ed. Chip Kidd. New York: Pantheon Books, 2001.

———. *You Don't Look 35, Charlie Brown!* New York: Holt, Rinehart and Winston, 1985.

Schwartz, Ben, ed. *The Best American Comics Criticism*. Seattle: Fantagraphics, 2010.

Seldes, Gilbert. *The 7 Lively Arts*. 1924. New York: Sagamore Press, 1957.

Sheridan, Martin. *Comics and Their Creators*. 1942. Westport, Conn.: Hyperion Press, 1977.

Stein, Daniel, "The Comic Modernism of George Herriman," in Jakaitis, Jake, and James F. Wurtz, eds. *Crossing Boundaries in Graphic Narrative: Essays on Forms, Series and Genres*. Jefferson, N.C.: McFarland & Co., 2012.

Thompson, Neal. *A Curious Man: The Strange & Brilliant Life of Robert "Believe It or Not!" Ripley*. New York: Crown Archetype, 2013.

Walker, Brian. *The Comics Before 1945*. New York: Harry N. Abrams, 2004.

Walker, Mort. *The Lexicon of Comicana*. Comicana Books, 1980.

Waugh, Coulton. *The Comics*. 1947. New York: Luna Press, 1974.

Yoe, Craig. *Clean Cartoonists' Dirty Drawings*. San Francisco: Last Gasp, 2007.

GENERAL BIBLIOGRAPHY

Ainsworth, Ed. *Painters of the Desert*. Palm Desert, Cal.: Desert Magazine, 1961.

Anderson, Eric Gary. *American Indian Literature & the Southwest*. Austin: University of Texas Press, 1999.

Antliff, Mark, and Vivien Greene, eds. *The Vorticists: Manifesto for a Modern World*. 2010. London: Tate, 2011.

Anthony, Edward. *O Rare Don Marquis*. Garden City, N.Y.: Doubleday & Co., 1962.

Baars, Donald L. *A Traveler's Guide to the Geology of the Colorado Plateau*. Salt Lake City: University of Utah Press, 2002.

Bean, Annemarie, James V. Hatch and Brooks McNamara. *Inside the Minstrel Mask: Readings in Nineteenth-Century Blackface Minstrelsy*. Middletown, Conn.: Wesleyan University Press, 1996.

Bell, Caryn Cossé. *Revolution, Romanticism, and the Afro-Creole Protest Tradition in Louisiana 1718–1868*. 1997. Baton Rouge.: Louisiana State University Press, 2004.

Bennett, James B. *Religion and the Rise of Jim Crow in New Orleans*. Princeton, N.J.: Princeton University Press, 2005.

Blackburn, Fred M. *The Wetherills: Friends of Mesa Verde*. Durango, Col.: Durango Herald Small Press, 2006.

Blassingame, John W. *Black New Orleans, 1860–1880*. Chicago: University of Chicago Press, 1973.

Boyarsky, Bill. *Inventing L.A.: The Chandlers and Their Times*. Santa Monica, Cal.: Angel City Press, 2009.

Brasseaux, Carl A. and Glenn R. Conrad, eds. *The Road to Louisiana: The Saint-Domingue Refugees 1792–1809*. Lafayette: Center for Louisiana Studies, 1992.

Breslin, Jimmy. *Damon Runyon*. New York: Ticknor & Fields, 1991.

Britt, George. *Forty Years—Forty Millions: The Career of Frank A. Munsey*. New York: Farrar & Rinehart, 1935.

Brown, Milton W. *The Story of the Armory Show*. New York: Abbeville Press, 1988.

Broyard, Bliss. *One Drop: My Father's Hidden Life—A Story of Race and Family Secrets*. New York: Little, Brown, 2007.

Cantor, Jay. *Krazy Kat: A Novel*. 1987. New York: Vintage Books, 2004.

Capra, Frank. *The Name Above the Title: An Autobiography*. New York: Macmillan, 1971.

Carr, Harry. *Los Angeles: City of Dreams*. New York: Grossett & Dunlap, 1935.

Leo Carrillo, *The California I Love*. New York: Prentice-Hall, 1961.

Cheever, Susan. *E.E. Cummings: A Life*. New York: Vintage, 2015.

Chessé, Ralph. *All My Yesterdays*, unpublished memoir, Bruce Chessé collection.

Chinitz, David E. *T.S. Eliot and the Cultural Divide*. Chicago: University of Chicago Press, 2003.

Chronic, Halka. *Roadside Geology of Arizona*. 1983. Missoula, Mont.: Mountain Press, 1991.

Chude-Sokei, Louis. *The Last "Darky": Bert Williams, Black-on-Black Minstrelsy, and the African Diaspora*. Durham, N.C.: Duke University Press, 2006.

Churchill, Allen. *Park Row*. New York: Rinehart, 1958.

Clark, Tom. *The World of Damon Runyon*. New York: Harper & Row, 1978.

Coleman, Harry J. *Give Us a Little Smile, Baby*. New York: E. P. Dutton, 1943.

Craven, Thomas, ed. *Cartoon Calvacade*. New York: Simon & Schuster, 1945.

Daggett, Melissa. *Spiritualism in Nineteenth-Century New Orleans: The Life and Times of Henry Louis Rey* (Jackson: University Press of Mississipi, 2016).

Davis, Carolyn O'Bagy, and Harvey Leake. *Kayenta and Monument Valley.* Charleston, S.C.: Arcadia Publishing, 2010.

De Caro, Frank, ed. *Louisiana Sojourns: Travelers' Tales and Literary Journeys.* Baton Rouge: Louisiana State University Press, 1998.

Denson, Charles. *Coney Island Lost and Found.* New York: Crown, 2002.

Depee, F. W., and George Stade, eds., *Selected Letters of E. E. Cummings.* New York: Harcourt, Brace & World, 1969.

Diouf, Sylviane A. *Dreams of Africa in Alabama: The Slave Ship Clotilda and the Story of the Last Africans Brought to America.* New York: Oxford University Press, 2007.

Donahoo, Refugio. *The Esoteric Codex: Paranormal Hoaxes.* Lulu.com: 2015.

Du Bois, W. E. B. *The Souls of Black Folk.* 2003. Mineola, New York: Dover Publications, 1994.

Ellison, Ralph. *The Collected Essays of Ralph Ellison,* ed. John F. Callahan. New York: Modern Library, 1995.

Federal Writers' Project, *The WPA Guide to California: The Golden State,* 1939.

Fillmore, Gary. *Shadows on the Mesa: Artists of the Painted Desert and Beyond.* Atglen, Pa.: Schiffer Publishing, 2012.

Fireside, Harvey. *Separate and Unequal: Homer Plessy and the Supreme Court Decision that Legalized Racism.* 2004. New York: Carroll & Graf, 2005.

Forbes, Camille F. *Introducing Bert Williams: Burnt Cork, Broadway, and the Story of America's First Black Star.* New York: Basic Civitas Books, 2008.

Ford, Corey. *The Time of Laughter.* Boston: Little, Brown, 1967.

Ford, James L. *Forty-Odd Years in the Literary Shop.* 1921. New York: E. P. Dutton, 1922.

Fowler, Gene. *Skyline: A Reporter's Reminiscence of the '20s.* New York: Viking Press, 1961.

Garafola, Lynn, and Nancy Van Norman Baer, eds. *The Ballets Russes and Its World.* New Haven, Conn.: Yale University Press, 1999.

Gillmor, Frances, and Louisa Wade Wetherill. *Traders to the Navajos: The Story of the Wetherills of Kayenta.* 1934. Albuquerque: University of New Mexico Press, 1983.

Goldbarth, Albert. *Great Topics of the World.* 1994. New York: Picador, 1996.

Gordon, Linda. *Dorothea Lange: A Life Beyond Limits.* 2009. London: W. W. Norton, 2010.

Hardy, C., and G. F. Stern, eds., *Ethnic Images in the Comics* (exhibition catalogue). Philadelphia, Pa.: Balch Institute for Ethnic Studies, 1986.

Hall, Gwendolyn Midlo. *Africans in Colonial Louisiana: The Development of Afro-Creole Culture in the Eighteenth Century.* Baton Rouge: Louisiana State University Press, 1992.

Hamill, Pete. *Downtown: My Manhattan.* New York: Little, Brown, 2004.

Harvey, Thomas J. *Rainbow Bridge to Monument Valley: Making the Modern Old West.* Norman: University of Oklahoma Press, 2011.

Hayes, Kevin J., ed., *Charlie Chaplin Interviews.* Jackson: University Press of Mississippi, 2005.

Hegemann, Elizabeth Compton. *Navaho Trading Days.* Albuquerque: University of New Mexico Press, 1963.

Hollandsworth, James G., Jr. *An Absolute Massacre: The New Orleans Race Riot of July 30, 1866.* Baton Rouge: Louisiana State University Press, 2001.

———. *The Louisiana Native Guards: The Black Military Experience During the Civil War.* Baton Rouge: Louisiana State University Press, 1995.

Houzeau, Jean-Charles. *My Passage at the New Orleans Tribune: A Memoir of the Civil War Era.* Baton Rouge: Louisiana State University Press, 1984.

Hoyt, Edwin P. *A Gentleman of Broadway: The Story of Damon Runyon.* Boston: Little, Brown, 1964.

Huff, Theodore. *Charlie Chaplin.* New York: Schuman, 1951.

Iliff, Flora Gregg. *People of the Blue Water: A Record of Life Among the Walapai and Havasupai Indians.* Tucson: University of Arizona Press, 1985.

Iverson, Peter. *Diné: A History of the Navajos.* Albuquerque: University of New Mexico Press, 2002.

James, Edward T. *Dictionary of American Biography, Supplement Three, 1941–1945.* New York: Charles Scribner's Sons, 1973.

Johanningsmeier, Charles A. *Fiction and the American Literary Marketplace: The Role of Newspaper Syndicates in America, 1860–1900.* Cambridge, U.K.: Cambridge University Press, 1997.

Josephson, Matthew. *Life Among the Surrealists.* New York: Holt, Rinehart and Winston, 1962.

Juergens, George. *Joseph Pulitzer and the* New York World. Princeton, N.J.: Princeton University Press, 1966.

Kammen, Michael. *The Lively Arts: Gilbert Seldes and the Transformation of Cultural Criticism in the United States.* New York: Oxford University Press, 1996.

Kelley, Klara Bonsack, and Harris Francis. *Navajo Sacred Places.* Bloomington: Indiana University Press, 1994.

King, Elliot, and Jane L. Chapman, eds. *Key Readings in Journalism.* New York: Routledge, 2012.

Klinck, Richard E. *Land of Room Enough and Time Enough.* 1953. Heber City, Utah: Parish Publishing, 1995.

Koenigsberg, Moses. *King News.* 1941. Freeport, N.Y.: Books for Libraries Press, 1972.

Koppany, Bob, ed. *The Art of Richard W. Sprang.* Hawthorne, Calif.: Striking Impressions, 1998.

Kukla, Jon. *A Wilderness So Immense: The Louisiana Purchase and the Destiny of America.* New York: Anchor, 2004.

Kurtti, Jeff. *Walt Disney's Imagineering Legends and the Genesis of the Disney Theme Park.* Glendale, Calif.: Disney Editions, 2007.

Larsen, Nella. *Passing.* 1929. New York: Penguin Books, 1997.

Linford, Laurance D. *Navajo Places: History, Legend, Landscape.* Salt Lake City: University of Utah Press, 2000.

Lively, Adam. *Masks: Blackness, Race & the Imagination.* Oxford, U.K.: Oxford University Press, 1998.

Lomax, Alan. *Mister Jelly Roll.* 1950. Berkeley: University of California Press, 2001.

Lott, Eric. *Love & Theft: Blackface Minstrelsy and the American Working Class.* New York: Oxford University Press, 1993.

Lynn, Kenneth S. *Charlie Chaplin and His Times.* New York: Cooper Square Press, 2002.

MacDonald, Robert R., John R. Kemp, and Edward F. Haas, eds. *Louisiana's Black Heritage.* New Orleans: Louisiana State Museum, 1979.

McGrath, Melanie. *The Long Exile: A True Story of Deception and Survival in the Canadian Arctic.* 2006. London: Harper Perennial, 2007.

McDougal, Dennis. *Privileged Son: Otis Chandler and the Rise and Fall of the L.A. Times Dynasty.* Cambridge, Mass.: Perseus, 2001.

McNitt, Frank. *Richard Wetherill: Anasazi.* 1957. Albuquerque: University of New Mexico Press, 1986.

McWilliams, Carey. *Southern California: An Island on the Land.* 1946. Santa Barbara, Cal.: Peregrine Smith, 1973.

Maltin, Leonard, and Richard W. Bann. *Our Gang: The Life and Times of the Little Rascals.* New York: Crown, 1977.

Marquis, Don. *Archy and Mehitabel.* 1927. Garden City, N.Y.: Doubleday, 1930.

———. *Archy Does His Part.* Garden City, N.Y.: Doubleday, Doran & Co., 1935.

Medley, Keith Weldon. *We as Freeman: Plessy v. Ferguson.* Gretna, La., 2003.

Mellow, James R. *Charmed Circle: Gertrude Stein and Company.* 1974. New York: Avon Books, 1975.

Morgan, Judith and Neil. *Dr. Seuss and Mr. Geisel: A Biography.* New York: Da Capo Press, 1996.

Morris, James McGrath. *Pulitzer: A Life in Politics, Print, and Power.* New York: HarperCollins, 2010.

Morton, Jelly Roll. *The Complete Library of Congress Recordings.* Nashville: Rounder Records, 2005.

Mott, Frank Luther. *A History of American Magazines, 1885–1905.* Cambridge, Mass.: Harvard University Press, 1957.

Nasaw, David. *The Chief: The Life of William Randolph Hearst.* 2000. New York: Mariner, 2001.

Nel, Philip. *Dr. Seuss: American Icon.* London: Bloomsbury Academic, 2003.

Nollen, Scott Allen. *The Boys: The Cinematic World of Laurel and Hardy.* Jefferson, N.C.: McFarland & Company, 1989.

Nystrom, Justin A. *New Orleans After the Civil War: Race, Politics, and a New Birth of Freedom*. Baltimore, Md.: John Hopkins University Press, 2010.

O'Bagy Davis, Carolyn, and Harvey Leake. *Images of America: Kayenta and Monument Valley*. Charleston, S.C.: Arcadia, 2010.

Passet, Joanne. *Sex Variant Woman: The Life of Jeanette Howard Foster*. New York: Da Capo Press, 2008.

Pollack, Howard. *John Alden Carpenter: A Chicago Composer*. 1995. Urbana: University of Illinois Press, 2001.

Powell, Lawrence N. *The Accidental City: Improvising New Orleans*. Cambridge, Mass.: Harvard University Press, 2013.

Procter, Ben. *William Randolph Hearst: The Early Years, 1863–1910*. New York: Oxford University Press, 1998.

Procter, Ben. *William Randolph Hearst: The Later Years, 1911–1951*. New York: Oxford University Press, 2007.

Rampersad, Arnold, David Roussel, and Christa Fratantoro, eds. *Selected Letters of Langston Hughes*. New York: Knopf, 2015.

Reed, Emily Hasen. *Life of A. P. Dostie, Or, The Conflict in New Orleans*. New York: William P. Tomlinson, 1868.

Reed, Ishmael. *Mumbo Jumbo*. 1972. New York: Scribner, 1996.

Reich, Howard, and William Gaines. *Jelly's Blues: The Life, Music, and Redemption of Jelly Roll Morton*. New York: Da Capo Press, 2003.

Roosevelt, Theodore. *History as Literature and Other Essays*. New York: Charles Scribner's Sons, 1913.

Rosemont, Franklin. *Surrealism and Its Popular Accomplices*. City Light Books, 1980.

Saxon, Lyle. *Fabulous New Orleans*. Gretna, Louisiana: Pelican, 1995.

Scot, James B. *Outline of the Rise and Progress of Freemasonry in Louisiana*. 1873. New Orleans: Cornerstone, 2008.

Scretvedt, Randy. *Laurel and Hardy: The Magic Behind the Movies*. Beverly Hills, Cal.: Moonstone Press, 1987.

Sharfstein, Daniel J. *The Invisible Line: Three American Families and the Secret Journey from Black to White*. New York: Penguin Press, 2011.

Spencer, David R. *The Yellow Journalism: The Press and America's Emergence as a World Power*. Evanston, Ill.: Northwestern University Press, 2007.

Starr, Kevin. *Inventing the Dream: California Through the Progressive Era*. New York: Oxford University Press, 1985.

Stevenson, Robert Louis. *Across the Plains with Other Memories and Essays*. New York: Charles Scribner's Sons, 1900.

Strausbaugh, John. *Black Like You: Blackface, Whiteface, Insult & Imitation in American Popular Culture*. 2006. New York: Penguin, 2007.

Striner, Richard. *Father Abraham: Lincoln's Relentless Struggle to End Slavery*. New York: Oxford University Press, 2006.

Sublette, Ned. *The World That Made New Orleans: From Spanish Silver to Congo Square.* Chicago: Lawrence Hill Books, 2009.

Sullivan, Edward Dean. *The Fabulous Wilson Mizner.* New York: Henkle, 1935.

Swanberg, W. A. *Citizen Hearst.* 1961. New York: Scribner/Collier, 1986.

Terhune, Albert. *To the Best of My Memory.* New York, Harper & Bros., 1930.

Thompson, Shirley Elizabeth. *Exiles at Home: The Struggle to Become American in Creole New Orleans.* Cambridge, Mass.: Harvard University Press, 2009.

Toledano, Roulhac, and Mary Louise Christovich. *New Orleans Architecture,* Vol. VI: Faubourg Tremé and the Bayou Road. 1980. Gretna, La.: Pelican, 2003.

Tragard, Louise, Patricia E. Hart, and W. L. Copithorne. *Ogunquit, Maine's Art Colony: A Century of Color, 1886–1986.* Ogunquit, Maine: Barn Gallery Associates, 1987.

Ward, Geoffrey C. *Unforgivable Blackness: The Rise and Fall of Jack Johnson.* New York: Alfred A. Knopf, 2004.

Ward, Richard Lewis. *A History of the Hal Roach Studios.* Carbondale: Southern Illinois University Press, 2005.

Wetherill, Louisa, and Harvey Leake. *Wolfkiller: Wisdom from a Nineteenth-Century Navajo Shepherd.* Salt Lake City: Gibbs Smith, 2007.

Whyte, Kenneth. *The Uncrowned King: The Sensational Rise of William Randolph Hearst.* Berkeley, Cal.: Counterpoint, 2009.

Wheeler, John. *I've Got News for You.* New York: E. P. Dutton, 1961.

Yagoda, Ben. *Will Rogers: A Biography.* New York: Knopf, 1993.

Yardley, Jonathan. *Ring: A Biography of Ring Lardner.* New York: Random House, 1977.

INTERVIEWS WITH THE AUTHOR.

Bakshi, Ralph. 2009.

Bedwell, Barbara. 2008.

Bradley, Sarah Louise. 2010.

Cox, Dee. 2008 and 2010.

Duckworth, Marlene. 2011.

Frickert, Betty. 2014.

Gaudin, Wendy. 2011.

Larson, Lola. 2008 and 2014.

Lee, Stan. Interview via email. 2012.

McDonnell, Patrick. 2010.

Pastis, Stephen. 2012.

Rodgers, Betty. 2009.

Trudeau, Garry. Interview via email, 2012.

Von Savoye, Dave. 2012.
Walker, Mort. 2011.
Wetherill, William. 2008.

OTHER INTERVIEWS

Sagendorf, Bud, with Russell Myers. 1973. Courtesy Russell Myers.

INDEX

Page numbers in *italics* refer to illustrations.

ABOUT THE AUTHOR

ICHAEL TISSERAND is the author of *The Kingdom of Zydeco*, which won the ASCAP Foundation Deems Taylor Award for music writing, and the Hurricane Katrina memoir *Sugarcane Academy.* He lives in New Orleans, Louisiana.

www.MichaelTisserand.com

Insights,
Interviews
& More . . .

About the author

About the book

Read on

A "Konversation" with Michael Tisserand

By Paul C. Tumey

A version of this interview originally appeared in The Comics Journal.

Paul C. Tumey: *You spent about ten years writing* Krazy: George Herriman, A Life in Black and White. *What first put the idea in your mind to write a book on Herriman?*

Michael Tisserand: I had started research when I was editor of *Gambit*, the alternative newsweekly in New Orleans, but abandoned it after we moved to Chicago for a couple years after the levees broke following Hurricane Katrina. During that time, I took my son to see the *Masters of American Comics* exhibit when it stopped in Milwaukee. It featured original works by cartoonists from Winsor McCay to Robert Crumb. I remember I was carrying my son around the Herriman room, reading the comics to him and laughing with him at the sight of the thumb of conscience pressing down on Krazy Kat. That's exactly the moment when I knew I wanted to write Herriman's biography.

PT: *How much did you know about comics coming into your Herriman biography?*

MT: My first books were on zydeco music and a memoir about life after Katrina, but I've read and loved comics since I was a kid. I used to beg my mom to let me spend the day by myself at the Willard Library in downtown Evansville, Indiana. There I discovered the wonders of the 741.5 section, which I can still remember being on the bottom shelves in a back corner of the main room of this old creaky library. I would just sit on the floor there and go through all the books I could find.

PT: *741.5 has always been a magical number for me too.*

MT: 741.5 was amazing! I found the old comics anthologies by Bill Blackbeard and others. There was simply nothing else like old *Katzenjammer Kids* or *Dick Tracy* comics. Chester Gould was my Tarantino. A librarian showed me how to read old newspapers on microfilm, and I zoomed through the news pages to the funnies. For the most part, I just became obsessed with *Peanuts*, and with Charlie Brown.

PT: *Speaking of* **Peanuts,** *I wanted to ask if David Michaelis's lengthy 2008 biography,* **Schulz and Peanuts:** A Biography, *was an inspiration or model for* **Krazy:** George Herriman, A Life in Black and White?

MT: I certainly hoped to make something as readable as Michaelis's book. The major difference from Michaelis's book is that Michaelis could base much of his work on interviews that he conducted himself, which was how I was used to working, as well. Here, I had to construct a narrative largely based on letters, newspaper articles, and official records like census reports and city directories. The problem I didn't really have, however, was contending with personal narratives that might reflect different experiences, which was a challenge that Michaelis faced.

PT: *For almost a hundred years, people have been writing about the life and work of George Herriman. Gilbert Seldes sang his praises in 1924. In 1986, Patrick McDonnell and Karen O'Connell published what was then regarded as the definitive book on the subject,* **Krazy Kat: The Comic Art of George Herriman.** *One would think all the stories were told, and the subject was exhausted. And yet, in 2016, you've given us something new and, I think, quite magical: a five-hundred-page, detailed biography of Herriman. Can you talk a little more about the research methods you used to deepen and broaden Herriman's story?*

MT: Patrick and Karen's work was the foundation. Their writing about Herriman is ▶

A "Konversation" with Michael Tisserand (*continued*)

beautiful and timeless, as is Gilbert Seldes's. But of course, none of these writers had the internet to make it possible to do a more exhaustive search. One of my writing gurus was the late alt-weekly editor and *New York Times* writer David Carr, and he instructed reporters to "avail themselves of all available knowledge" before writing about a topic. Which I did, to the best of my ability. Which also helps explain the ten years.

PT: *Can you give an example of a trail you followed that led to a new discovery?*

MT: Using archival and personal collections, I made a list of all gifts of comics and comic art that Herriman had given people over the years. Then I conducted searches on the names of all the recipients. This is how I found Boyden Sparkes's lengthy interviews with Herriman and other cartoonists, which were pretty much buried in the archives at Syracuse University. Such interviews are rare and they were invaluable in bringing the voices of these artists into my story.

PT: *I know you didn't just sit at a computer. You actually traveled all around to explore obscure archives and meet various people. In the back of the book there's a list of people you interviewed, including Herriman's granddaughter, Dee Cox.*

MT: My first call was to Dee Cox. At that point, I didn't know how she felt about discussing her family background, with all the new information about the family's life in Creole New Orleans that I was uncovering. I called her and asked if we could talk about her grandfather, and her immediate response was, "My favorite subject!" She's been immeasurably helpful and getting to know her has been a real highlight.

PT: *I have to ask: Did Dee Cox happen to have a cache of previously unseen material and art of her grandfather's? I would think there could be letters or diaries, even. The mind reels!*

MT: Not really. But she shared what she had,

and of course, her personal memories were most precious.

That's also when I realized I would have to patch this book together from lots of little bits and pieces. Which meant travel, in addition to lots of time spooling out the microfilm of years of old newspapers. But it was George Herriman. One can't mess around when trying to tell the story of George Herriman. I felt a deep sense of responsibility.

PT: *I know you managed to find and speak with others who actually knew George Herriman.*

MT: Yes, Herriman died in 1944, so I was delighted—amazed, actually—to find so many people who actually spent time with him! I learned many of these names from Harvey Leake, who is the family historian for the Wetherills, Herriman's friends in Arizona. For example, Herriman signed a page of the Wetherill guest registry with a note about the Roach family, and he drew a cartoon of three little cockroaches, whom he named. I researched the names and found that they belonged to the brother and nieces of movie producer Hal Roach, and they had all traveled with Herriman to Arizona. And that both nieces were still alive and healthy and filled with warm and vivid memories of their time with the man they knew as "Uncle George."

PT: *When I was reading the first chapters of your book, I was struck by how far back in time you had to go to tell Herriman's story. Usually, biographers start with the parents of their subject—or, in some cases, the grandparents. But you go back to the winter of 1816 and begin with Herriman's great-grandfather. Why was it necessary to begin the story of the cartoonist George Joseph Herriman, born in 1880, so far back in time?*

MT: I knew I was taking a chance. Certainly few people can pull that off the way Robert Caro did, when he started his multivolume ▶

A "Konversation" with Michael Tisserand *(continued)*

biography of Lyndon Johnson with descriptions of the soil and grass of Texas. But when I dug into the records and found riots and séances and Jelly Roll Morton and all the rest, I knew I had to tell it. Understanding Herriman's family history also helped me better understand one of the central themes of his life: his race, what it means, what it might have meant to him, what it means to his comics, and what it means to us. When I read a classic Krazy Kat line such as "lenguage is that we may mis-unda-stend each udda," it seems pretty clear that Herriman had a deep understanding of what we now consider to be modern notions of the slipperiness of language and a sort of permeability of identity.

PT: *I think the identity theme particularly looms large in* **The Family Upstairs.** *The main characters, and the reader by default, are always trying to learn the identity of the mysterious family that lives upstairs. It's never revealed, which gives the whole thing an existential,* **Waiting for Godot** *aspect.*

MT: The parade of characters going up and down the stairs, and in and out of that upstairs doorway, is endlessly entertaining. He throws so much into those scenes. It's another example of Herriman playing variations on a theme. But you're right, there's a great mystery of identity at the center of it. Plus, it's worth noting here that throughout his life, Herriman was living in places where African-Americans weren't allowed to own or rent property.

PT: *One of the more poignant moments in the story you tell is when you point out that, if Herriman was legally classified as an African American, he would not have been allowed to own the homes he bought. Am I getting that right?*

MT: Absolutely. I've seen the racial covenant that was attached to his beloved home in the Hollywood Hills. It's sobering to read.

PT: *In your reading of* **Krazy Kat,** *did you see many examples of Herriman's "hidden"*

commentaries on society's racial intolerance?
This might be a good place to ask if you might
talk for a moment about the connection you
make in the book between the great heavyweight
champion boxer Jack Johnson and the evolution
of Krazy Kat.

MT: The fight in Reno was on July 4, 1910.
Twenty-two days later, on July 26, Ignatz first
beaned Krazy, who was now beginning to
resemble Herriman's caricatures of black
boxers in his sports cartoons. As is often the
case with Herriman, I don't see this as a direct
commentary, but as another example where he's
throwing in all this material and letting us sort it
out. It's like Herriman's finding a side door into
this conversation, and inviting us in.

PT· *That is a great example of how restoring*
cultural and historical context adds so much
depth and power to a comic.

MT: When I reeled through the microfilm of
old *Los Angeles Examiner*s and *New York Evening*
*Journal*s, I realized how much is lost when we
read these comics in anthologies. God bless the
anthologies, but seeing how the comics talk to
the news stories and sports stories, and to each
other, returns them to history yet also frees
them, bringing jokes to life that had been
dormant.

PT: *There's a kind of "code" aspect to* Krazy
Kat *that I think your book also helps restore. I*
kept thinking about the Uncle Remus Br'er
Rabbit stories that tell stories of oppressed black
slaves in disguise, as funny animal stories.

MT: There are Creole French versions of
those Uncle Remus tales that were collected on
the Laura Plantation, outside of New Orleans,
right before Herriman's birth, and it's certainly
fun to speculate that Herriman heard some of
these as a child. Plus, Herriman's first weekday
strip was the four-panel *Maybe You Don't*
Believe It, from 1901, in which he reworked
Aesop's fables and gave them happy endings. ▶

7

A "Konversation" with Michael Tisserand *(continued)*

It only lasted for five episodes but it provides an early glimpse of the world that would become Coconino County. And he was all of twenty-one years old!

PT: *So maybe one way to understand* Krazy Kat *and some of Herriman's other work with animal strips is to see it as a sort of comic reversal on popular folklore of his day.*

MT: There's an amazing conversation relayed by Robert Naylor, who helped Herriman with the cartoon *Embarrassing Moments*. Naylor said he once asked Herriman why he "reversed natural phenomena" with a mouse attacking a cat while being thwarted by a dog. Herriman replied that life is so absurd, he simply draws what he sees.

PT: *And uses the alchemy of comics to transform some of life's pain into entertainment, and, I think, art.*

MT: Herriman was talking about race and identity—as profoundly as anyone has, in my opinion—but I never see that as his big "Topic." It was just part of his world, and the world he created, even if others were slow to recognize it.

PT: *In your book, there are some colorful stories about Herriman's first years working in newspapers in California and New York. He connected with several other cartoonists and writers, like Tad Dorgan and Jimmy Swinnerton—and attending and writing about sports events was a major focus for them. They lived large and had many adventures. You call them "Sports." Did you coin that term yourself?*

MT: Sort of. There is talk about the "sports" in the papers, and what constitutes a sport. But I admit to capitalizing the "S" to elevate it to being a literary movement. People usually call that slangy style of writing about lowlife urban characters "Runyonesque," but I'd argue that gives short shrift to the other Sports, especially the illustrious Tad.

PT: *Speaking of Sports, did you know that*

Rube Goldberg was once arrested in 1908? He was a timekeeper for an illegal fight match and got rounded up with the fighters!

MT: They arrested Goldberg but he invented an elaborate escape machine?

PT: *No, they let him go because he invented a simple twenty-six-step device to turn on the light switch in the police station.*

MT: I spent quite a bit of time trying to learn more about a Prohibition-related arrest of George Herriman. Paid a couple hundred dollars for some trial transcripts. Then I found out there was another George Herriman living in southern California at the time. But can you imagine how excited I was when the package of trial transcripts arrived in the mail?

PT: *You did find home movies of Herriman!*

MT: Yes, thanks to Dee Cox. There aren't a lot of scenes with George, but each one is precious. There is one beautiful scene in which Bobbie Herriman is changing baby Dee's diaper, and Herriman is shielding their eyes from the sun. When he realizes that he's in the way of the camera, he quickly steps aside. You can actually witness the shy, humble, even self-effacing character that his friends always talk about.

PT: *I was struck by how slight and skinny he was.*

MT: And how big his hands appear to be!

PT: *Yes, those hands of Herriman's look magical. I loved reading about how, after he settled in Los Angeles, Herriman worked in the middle of the studio where the Our Gang, Harold Lloyd, and Laurel and Hardy comedies were made.*

MT: I like to think of Herriman moving back to California and managing to find the one place that was as rollicking and joyful as the *New York Evening Journal* art room—the Hal Roach studio. Herriman became a regular fishing partner of Hal Roach, and a close friend to Hal's brother, Jack Roach. Supposedly Herriman stood in as ▶

A "Konversation" with Michael Tisserand *(continued)*

an extra when needed, but I never could find him in a crowd shot. I'm still looking!

PT: *Yet in Herriman's later years, it seems that after all those years of hanging out with fellow artists and colleagues, and traveling all through the Southwest, he became somewhat reclusive. Is that right—and if so, why?*

MT: He did. Undeniably. His granddaughter commented on it. So did Boyden Sparkes and *Popeye* cartoonist E. C. Segar. One time, his friend Harry Carr wrote to the Wetherills about how he couldn't get George to go to Arizona, and how much it would help if George would go.

Shortly after Herriman's wife died, an artist arrived to paint Bobbie's picture. In her memoir, she said that it was the car crash that killed Herriman's wife that had made Herriman so isolated and depressed. She actually wrote that Herriman was consumed with guilt because he was driving the car, but this is contradicted by family stories and all the news accounts of the accident, and so it doesn't ring true to me.

He also suffered from bad health, including debilitating migraines. Remember that he was making cartoons about suffering rheumatism when he was barely thirty years old.

PT: *I know that in some cases arthritis can lead to depression, which can certainly cause one to become isolated.*

MT: I never want to diagnose Herriman. But certainly it seems he was depressed in some fashion. And his contemporaries specifically talked about Herriman having an inferiority complex. In letter after letter, he disparages his work, or at least its lack of popularity. Yet the work itself is so confident in its own beauty.

PT: *Herriman does seem to have been very self-effacing. That aspect of his personality comes through in your book.*

MT: Yes, and racial passing is to literally self-efface. Again, however, I tried very hard to not try to say what is going on inside Herriman's

head. I just kept asking myself, "What do I know for sure?"

PT: *And you wrote five hundred pages! Do you think Herriman was close to his wife? I remember reading in* Krazy *that he traveled a lot without her. It made me wonder a few times about their marriage.*

MT: George and Mabel's marriage remains perhaps the biggest mystery. The sole letter I found shedding some real light on it was written by George to the Wetherills. He was planning a surprise party for his daughter, and he wrote that the idea for the party was Mabel's. He then added she tells him things sometimes. And the letter was written after Mabel died. You can feel his sadness.

PT: *It seems he was such a private person it's difficult to know for sure how he felt about his marriage.*

MT: It is one of the most tempting places for conjecture, which I resisted. Imagine trying to draw a credible picture of a marriage from a letter and a few mentions in comics. But his feelings during his later romance with Louise Scher Swinnerton—a remarkable woman whose story I was able to tell in some detail—are pretty transparent. In the letters that survive, it's clear he was smitten. If his health had been better, it seems likely they'd have married.

I have a copy of a little map that Herriman drew for Louise, of the interior of his house. A "rough idea of the dump," he said. He drew a bathtub, which he said was unused, and a washbasin, which he said was occasionally used, and a toilet, for which he noted "Wanted: someone to warm it—cold evenings." Now, that's romantic.

PT: *That is very sweet—a perfect flirt for a cartoonist. I think of George Herriman not just as a great cartoonist, but as one of the great American artists of the twentieth century. It's terrific to have a book like this on him.*

MT: If one is going to spend ten years on a ▶

A "Konversation" with Michael Tisserand *(continued)*

single subject, Herriman is a good one. Letter after letter revealed how much people loved him. How much they were in awe of him. What a deep connection they felt to his work. That shone through my interviews with people who knew him. And that's how I still feel, too. ∾

Paul C. Tumey is a writer, designer, and comics historian in Seattle, Washington. He is the author of Screwball! The Cartoonists Who Made the Funnies Funny *(IDW Library of American Comics, 2018). He also coedited and wrote for* The Art of Rube Goldberg *(Abrams ComicArts, 2013).*

To Walk in Beauty
An Essay by Chris Ware

This essay originally appeared in the catalog for the exhibition **George Herriman: Krazy Kat is Krazy Kat is Krazy Kat,** *at the Museo Nacional Centro de Arte Reina Sofía, in Madrid, Spain, and was first published in English by the* **New York Review of Books** *on January 29, 2017. It is used with permission.*

Chris Ware is the author of **Building Stories** *and a regular contributor to* **The New Yorker.**

FOR ONE OF THE MOST PROLIFIC and highly praised cartoonists who ever lived, George Herriman, the creator of *Krazy Kat* (1913–1944), didn't like talking about himself. Recoiling from photographers and brushing off personal questions with elliptical answers and even occasional fabrications, George or "Garge" or "The Greek" always preferred the focus to be on the multivalent, multifarious, and multicultural characters who populated the inner world he made every day with the scratchings of his pen. A direct throughline of thought-to-gesture in black ink on white paper, George Herriman's drawings come alive before the reader's eye with a vital, persuasive complexity previously unknown in the history of art. Krazy Kat lived on the page—but he—or she—had a secret. And so did George Herriman.

Krazy Kat has been described as a parable of love, a metaphor for democracy, a "surrealistic" poem, unfolding over years and years. It is all of these, but so much more: it is a portrait of America, a self-portrait of Herriman, and, I believe, the first attempt to paint the full range of human consciousness in the language of the comic strip. Like the America it portrays, Herriman's identity has been poised for a ▸

To Walk in Beauty *(continued)*

revision for many decades now. Michael
Tisserand's new biography *Krazy* does just that,
clearing the shifting sands and shadows of
Herriman's ancestry, the discovery in the early
1970s of a birth certificate which described
Herriman as "colored" sending up a flag among
comics researchers and aficionados. Tisserand
confirms what for years was hiding in plain
sight in the tangled brush of Coconino County,
Arizona, where *Krazy Kat* is supposedly set:
Herriman, of mixed African-American ancestry,
spent his entire adult life passing as white.
He had been born in the African-American
neighborhood of racially mixed, culturally
polyglot 1880s New Orleans, but within a
decade Herriman's parents moved George and
his three siblings to the small but growing town
of Los Angeles to escape the increasing bigotry
and racial animosity of postbellum Louisiana.
The Herrimans melted into California life, and
it was there that George, with brief professional
spates in New York, would remain for the rest of
his life.

 But imagine knowing something about
yourself that's considered so damning, so dire, so
disgusting, that you must, at all cost, never tell
anyone. Imagine leaving behind a life to which
you cannot claim allegiance or affection.
Imagine suddenly gaining advantages and
opportunity while you see others like you, who
have not followed in the footsteps of your
deception, suffering. Herriman, once he was
considered white, didn't even have a way of
voicing this identity. Until he started drawing
Krazy Kat.

 I may be in the minority here, but I really
think that most if not all readers of *Krazy Kat*
during Herriman's lifetime would have had a
hard time thinking of Krazy as anything *but*
African-American. Krazy's patois, social status,
stereotypical "happy-go-lucky despite it all"
disposition all funnel into a rather pointed

African-American identity. And Herriman, confoundingly, was not above using racial and even racist imagery himself, his early work especially filled with eye-popping stereotypes and blackface caricatures. At the turn of the century, when Herriman was just starting his career, the nineteenth-century cultural phenomenon of blackface minstrelsy, while admittedly in the early process of passing into nostalgia, was still prevalent. Large orchestral shows of dozens of performers like Haverly's and Christy's Minstrels, grotesquely metastasized from the already ghastly four-person troupes, filled vaudeville halls and theaters; blackface performances, in a cruel twist of cultural fairness, were the first places for African-American performers to find a foothold. (W. C. Fields called Bert Williams, probably still the best known African-American entertainer from this era, "the saddest man I ever knew.")

At the same time, a reader alive in the early part of the twentieth century probably didn't really have to think about these associations any more specifically than we think the "Minions" sound vaguely Latino, or why Felix the Cat or Mickey and his minstrel mouse gloves were so funny. Of course Krazy Kat was black. A funny black cat. Just the right amount of slippage and shift in Krazy's animus, helped along by a tradition of children's animal stories, was all that was necessary for him/her to be two things—and nothing—all at once.

Nevertheless, one detail in Herriman's strip that would have absolutely cemented this identity in the minds of contemporary readers has since passed into obscurity: Krazy Kat's banjo. Through received clichés and shifts of poverty and culture in America, the banjo has come to be thought of as an instrument of poor whites, but at the turn of the century, it was as emblematic as a watermelon as part of the ▶

To Walk in Beauty *(continued)*

African-American stereotype. In fact, the banjo has a solemn origin: descended from the West African *akonting*, *xalam*, and *ngoni* instruments, played as an accompaniment to storytelling by Wolof griots in Senegal or the Jola in Gambia, early instruments like what became the American banjo were re-created by American slaves from whatever plantation materials were at hand—gourds, turtle shells, coconuts, animal skins—to try to hold on to a memory of life and culture torn from their grasp.

To the modern reader, the banjo in *Krazy Kat* might seem a lighthearted accessory, but when Krazy picks it up to sing "There Is a Heppy Land Fur, Fur Away," the meaning, to thoughtful readers of the 1920s to the 1940s, would have been clear. Even more astonishingly, Krazy never plays a "proper" banjo, but plays the gourd or coconut banjo, the origins of which by the time of the strip's appearance would indeed *have* been obscure. Herriman knew what he was doing, and it's not insignificant that the very last strip he left unfinished on his drawing table showed Krazy playing a gourd banjo. The earliest representation known of such an instrument appears in the watercolor *The Old Plantation*, painted by South Carolina slaveholder John Rose in the late eighteenth century.

What do these racial and cultural connections mean for how we see Herriman's work? From their dimming over the years compared with *Krazy Kat*'s increasing artistic incandescence, they are clearly not necessary to an appreciation of the strip. But put yourself in Herriman's shoes, and then reread *Krazy Kat* with this knowledge rewoven into the tapestry of his work. Think of pink Ignatz, the mouse who is Krazy's constant tormentor. Think of the brick. Think of what W. E. B. Du Bois called the "dual consciousness" of African-Americans, think of the brick hitting Krazy, over and over and over again. (Tisserand

shrewdly notes that a July 30, 1866, New Orleans race riot, which Herriman's father may have witnessed, started when a white boy threatened to throw a brick at African-American soldiers parading through the town.) Think of what recasting that gesture of hate as one of love actually means to its recipient. Think of the lynchings of the 1910s, the race riots of the 1960s, the American police shootings of 2016, the iPhone videos that continually show the treatment of African-Americans as property. Think of Barack Obama, half Scotch-Irish, half African.

George Herriman saw the history of America and its future and wrote it in ink as a dream on paper, and it is a dream that is still coming true. In December, disparate Native-American tribes and activists who had gathered in North Dakota for months staved off an oil pipeline that would have cut through ancestral Sioux burial lands; Herriman began visiting the Diné, or Navajo, nation and befriending its citizens before some western states were even twenty-five years old. Navajo rug patterns and the folklore of Monument Valley came to define the very cosmos of *Krazy Kat*. (A wonderful detail in Tisserand's book recalls Herriman, who had Hollywood friends, setting up a private screening of older Western movies with actual Navajo supporting actors for a Navajo audience, solely because the actors had said insulting things in their native language that only the Native audience could understand.)

And our most recent election involved debates about the equality of transgender teens, of those trapped inside a body by which they feel betrayed. Krazy Kat's self-defining gender-switching—"I don't know if I should take a husband or a wife," Krazy once remarks—couldn't be more timely, more oracular. Nor, sadly, could Ignatz's seemingly implacable ▸

hatred. Even sadder, in that same American election, Ignatz won.

Everyone "passes" in some way or another; everyone has something they'd rather not discuss, something of their history they're trying to downplay or hide, some story that doesn't jibe with the vision and identity they'd prefer to have. This is the essence of fiction. Every one of us nightly, daily, hourly—every minute—reviews, sorts, discards, rewrites details that allow us to somehow get on with our lives, unrecorded acts of revision tantamount to what a writer commits professionally on a page. Do it well, and you're mentally healthy. Do it badly, and you're crazy. Fundamentally, we understand others only as refractions through the optic of ourselves, and fiction not only offers an alternative construct, but in its finest form allows the reader to inhabit, and most importantly, to empathize with another consciousness. (Or in Herriman's case, with a cartoon cat.) So is kaleidoscopic Krazy really the crazy one, whom Ignatz can only understand through the reducing lens of his narrow, white mind?

Lately, I've been wondering if Herriman knew that one day his secret-in-plain-sight would be uncovered, that America would change, adapt, and grow up enough as a people to understand *Krazy Kat* in all its psychological and poetic depth. I'm not sure if we've yet reached that point, but what myself and other cartoonists already knew—that the strip was the greatest ever drawn—is now magnified, multiplied, and maximized. *Krazy Kat* is not just one of the greatest comic strips, it's one of the strangest, most inventive, emotional, and personal works of art of the twentieth century. In their admiration for Herriman, Philip Guston, Willem de Kooning, and Jack Kerouac sensed something in his line and voice that was endemically American, deeply felt. Herriman should now take his rightful place as one of the

most original African-American voices of the early twentieth century, contemporary with, if not predating, Richard Wright and Zora Neale Hurston as one of the first writers to understand the racial animus of America and to try to fix the essence of black consciousness on paper. That Herriman made it come alive, sing, dance, and suffer in an art form barely fifty years old is all the more astonishing. For decades, we've all been reading and laughing and, most of all, feeling for Krazy Kat, who passed right under our eyes as a living drawing on a page. But what we were really feeling came straight from the heart. It was the very soul of George Herriman himself. ∽

The Gender Fluidity of Krazy Kat

By Gabrielle Bellot

This essay originally appeared in The New Yorker *on January 19, 2017, and is reprinted with permission.*

Gabrielle Bellot is a staff writer for Literary Hub. *Her web site is GabrielleBellot.com.*

KRAZY KAT, GEORGE HERRIMAN's exuberant and idiosyncratic newspaper comic, was never broadly popular. From the beginning, though, it found fans among writers and artists. P. G. Wodehouse compared it favorably to Wagner's *Parsifal*; Jack Kerouac later said it influenced the Beats. The strip ran from 1913 until 1944, the year that Herriman died. It is set in a dreamlike place called Coconino County, where a black cat named Krazy loves a white mouse named Ignatz, who throws bricks at Krazy's head. Krazy interprets the bricks as "love letters." Meanwhile, a police-officer dog, Offisa Pupp, tries to protect Krazy, with whom he is smitten. The structure of the strip was built on reversals: a cat loves a mouse, a dog protects a feline, and, at a time when antimiscegenation laws held sway in most of the United States, a black animal yearns for a white one.

That last detail took on additional resonance in 1971, when Arthur Asa Berger published a story about Herriman's birth certificate. The certificate described Herriman's race as "colored," Berger revealed, to the astonishment of many readers (Ralph Ellison among them). Herriman was born in New Orleans, in 1880, to a mixed-race family; his great-grandfather, Stephen Herriman, was a white New Yorker who had children with a "free woman of color," Justine Olivier, in what was then a common social arrangement in New Orleans called

plaçage. George Herriman was one of the class of Louisianans known as *blanc fo'cé*: Creoles who actively tried to pass as white. In adulthood, Herriman frequently covered his tight curls with a hat, and invented fanciful origin stories that attributed his light brown skin to years living under the sun of Greece. Sometimes he claimed that his ancestors were French or Irish—anything that might sow confusion.

In the years following Berger's initial reporting, a number of writers have grappled with this aspect of Herriman's work. "In the comics page no less than in social life, the opposition between black and white can be redefined but not abolished," the journalist and comics scholar Jeet Heer has written. As Michael Tisserand points out in his new biography, *Krazy*, Herriman might have lost his job as a cartoonist had he been outed as black. When Herriman worked at the *Los Angeles Examiner*, as a staff artist, the paper published multiple articles about light-skinned African-Americans who had tried to pass as white and were subsequently "exposed." But *Krazy* also helps to expand the meaning of the comic's subversive play with identity beyond race. In an era when books depicting homosexuality and gender nonconformity could lead to charges of obscenity, *Krazy Kat*, Tisserand notes, featured a gender-shifting protagonist who was in love with a male character.

Krazy's gender, to the consternation of many readers, was never stable. Herriman would switch the cat's pronouns every so often, sometimes within a strip; in one, from 1921, Krazy switches gender three times in a single sentence. When Krazy is portrayed as male, the comic becomes the story of one male character openly pining for another—in some touching scenes, the characters even nestle together to sleep. For all his pestering and punishing of Krazy, Ignatz ultimately seems to have a soft spot for the ingenuous cat; when Krazy plants a kiss on a ▶

sleeping Ignatz in one daily, Ignatz's dreams, suddenly visible to the reader, become filled with little cupids and hearts. In two strips from 1915, Krazy wonders aloud "whether to take unto myself a 'wife' or a 'husband.' " In a strip from 1922, an owl attempts to find out Krazy's gender by knocking on the cat's door and asking if the lady or gentleman of the house is in, only to find that Krazy answers to both titles. At the end of the exchange, Krazy charmingly self-identifies simply as "me."

Some fans of *Krazy Kat* were mystified by all of this. In his autobiography, the director Frank Capra described a conversation he had with Herriman on the subject. "I asked him if Krazy Kat was a he or a she," he writes. Herriman, Capra tells us, lit his pipe before answering. "I get dozens of letters asking me the same question," Herriman told Capra. "I don't know. I fooled around with it once; began to think the Kat is a girl—even drew up some strips with her being pregnant. It wasn't the Kat any longer; too much concerned with her own problems—like a soap opera. . . . Then I realized Krazy was something like a sprite, an elf," he continued, according to Capra. "They have no sex. So the Kat can't be a he or a she. The Kat's a spirit—a pixie— free to butt into anything." Capra, bemused by the answer, remarked, "If there's any pixie around here, he's smoking a pipe."

In the nineteen-sixties, the American animator Gene Deitch, famed for his work on *Popeye* and other cartoons, was commissioned to adapt *Krazy Kat* for television. But, Tisserand writes, "there was the problem of Krazy Kat's ambiguous gender." Deitch himself recalls, "At the time, any hint of a homosexual relationship between Krazy . . . and Ignatz mouse, an obvious male, was a loud no-no. So we declared Krazy a girl cat, and that was that!" (In film adaptations, made decades earlier, Krazy "was

cast as a male character and Ignatz, inexplicably, as a black mouse," Tisserand writes.) Assuming that Krazy was exclusively female was a common response. In a 1946 reflection on the comic, E. E. Cummings acknowledged that Krazy's gender was fluid, but still identified the feline as female throughout, calling "our heroine" Krazy "the adorably helpless incarnation of saintliness."

Of course, some readers embraced this aspect of the character. A well-known bohemian bar in Washington, DC, that welcomed queer customers seemed to acknowledge the strip's anarchic queerness by naming itself Krazy Kat. (Its sign featured a black cat that resembled Krazy being hit by a brick.) When I corresponded with Tisserand recently, and asked him about the strip's legacy in this regard, he pointed out that the singer Michael Stipe, of the band R.E.M., who has written about his own fluid sexuality, is one of the strip's famous fans. (Stipe has two separate "Krazy Kat" tattoos.) In an essay for *The Guardian*, from 2014, Stipe wrote, "The 21st century has provided all of us, recent generations particularly, with a clearer idea of the breadth of fluidity with which sexuality and identity presents itself in each individual." In Herriman's work, Tisserand suggested, Stipe may have found "a beautiful precursor to that idea."

I asked Tisserand if he thought Herriman's own experience with racial identity and his depiction of gender in the strip were linked. Tisserand pointed me to a 1914 strip, in which Ignatz asks Krazy about sometimes being a "Miss" and sometimes a "Mr." "It's a sed story, 'Ignatz,' which will move you to a tear," Krazy says. "When us ladies first got the 'votes,' I went to a voting boot to vote. The man said to me, Is you 'Miss,' 'Mrs.,' or 'Mr.'? Not to offend him, I said, Any one which you like sir, or all three should you rather have it that way. Well, it's here my sedness begun," Krazy concludes. ▸

The Gender Fluidity of Krazy Kat *(continued)*

Tisserand said, "Herriman wouldn't have had that exact experience, but would have, at the age of nineteen, while living in a boarding house at Coney Island, had to choose his own racial designation, for the first time in his life." Herriman, like Krazy, might have decided "to choose whatever wouldn't give offense," Tisserand proposed. In a world that required rigid demarcations, being someone who didn't fit neatly could feel both dangerous and demeaning.

Nearly a century later, perhaps as much has changed as not. "Herriman speaks very urgently to our time, in a work that recalls both the great moments of pain in our country as well as the unexpected outbursts of beauty that have arisen in such times," Tisserand wrote, in an e-mail, when I asked what *Krazy Kat* means at the dawning of a Donald Trump Administration. He invoked the epochal 1910 fight between the African-American boxer Jack Johnson and the white boxer James Jeffries; when Johnson knocked out Jeffries, race riots followed. Herriman covered the match in newspaper cartoons. "That Krazy Kat could emerge during the horrific aftermath of the Jeffries-Johnson 'color-line' boxing match, seems to me to be a little miracle of artistic creation," Tisserand wrote.

Reading *Krazy Kat* in light of Herriman's silent struggles with his identity layers a soft poignancy over its stories of a cat, a dog, and a mouse. As a trans woman who, like Herriman, is multiracial, the strip spoke to me in unexpected ways. "Lenguage is that we may mis-unda-stend each udda," Krazy tells Ignatz in one oft-quoted strip. To transition into the gender you know yourself to be can sometimes feel like learning a language you remember from an old dream—a mother tongue from a shadowy land, a language at once easy and alien. Identity is not something you suddenly excavate in full, like a buried chest; you gradually learn the vernaculars and multitudes

you may contain, whether or not you wish to know them. Herriman's vaudevillian tales of Coconino County show us not only how we continually fail to understand one another, but also how, nonetheless, we may ultimately find meaning in one another. "The whole 'life' complex seems so absurd I simply draw what I see," Herriman once said. His queer cat is foolish and tragic, a twentieth-century Don *and* Doña Quixote. That Krazy keeps dreaming of love, even when faced with an absurd, cruel world, is endearing. But Krazy can also be wise, like Sancho Panza, and admirable.

Krazy is a kind of Whitmanesque symbol for the malleability of the self, one that surely provided an outlet for Herriman. If Herriman had to hide who he was, at least his charming cat could freely be "me," out in the open. Seeking a world that represented the liberty he felt denied, Herriman created a powerful, if perhaps too-little acknowledged, addition to the canon of queer American literature. ᴄᴡ